A Continuous Revolution

Harvard East Asian Monographs 343

Printed in the United States of America

The Harvard University Asia Center publishes a monograph series and, in coordination with the Fairbank Center for Chinese Studies, the Korea Institute, the Reischauer Institute of Japanese Studies, and other faculties and institutes, administers research projects designed to further scholarly understanding of China, Japan, Vietnam, Korea, and other Asian countries. The Center also sponsors projects addressing multidisciplinary and regional issues in Asia.

Library of Congress Cataloging-in-Publication Data

Mittler, Barbara, 1968-
 A continuous revolution : making sense of Cultural Revolution culture
/ Barbara Mittler.
 p. cm. -- (Harvard East Asian monographs ; 343)
 Includes bibliographical references and index.
 ISBN 978-0-674-06581-9 (hardcover : alk. paper)
 ISBN 978-0-674-97053-3 (pbk : alk. paper)
 1. China--History--Cultural Revolution, 1966-1976--Influence. 2.
China--Civilization--1976-2012 3. China--Civilization--2012- 4. Arts,
Chinese--20th century. 5. Arts, Chinese--21st century. 6. Arts--
Political aspects--China. 7. Arts--Social aspects--China. I. Title.
 DS778.7.M59 2012
 951.05'6--dc23
 2012009697

We have done our utmost to find and contact copyright or reprint rights holders for all those items that required so and acknowledge courtesies here.

Cover & Ill. 0.5 Poster from the Ann Tompkins (Tang Fandi) and Lincoln Cushing Chinese Poster Collection, Courtesy: C. V. Starr East Asian Library, University of California, Berkeley; digital image, Courtesy: Lincoln Cushing / Docs Populi. **Ills. 4.1; 4.6; 4.14 a&b; 6.43 a&c** Courtesy: Pierre Lavigne. **Ills. 4.2; 4.4; 5.38; 5.73** Courtesy: University of Westminster Chinese Poster Collection. **Ill. 5.4.** Courtesy: Maria Galikowski. **Ills. 4.8; III.1; 5.5; 5.6; 5.17; 5.19; 5.22; 5.23; 5.34; 6.32; 6.33** Courtesy: University of California Press, Berkeley. **Ills. 4.12; 5.1; 5.3; 5.7; 5.8** Courtesy: IISH Stefan R. Landsberger Collection. **Ill. III.2** Courtesy: Michael Wolf. **Ills. 5.25; 5.43; 5.44; 5.75a** Courtesy: Zhang Hongtu. **Ill. 5.26** Courtesy: Zhu Wei. **Ills. 5.27; 5.28** Courtesy: Wang Xingwei, Galerie UrsMeile, Beijing-Lucerne. **Ill. 5.31** Courtesy: Gerhard Richter, 2012. **Ill. 5.41** Courtesy: Martina Köppel-Yang. **Ill. 5.47** Courtesy: Geremie Barmé. **Ill. 5.57** Courtesy: Ai Weiwei, Galerie UrsMeile, Beijing-Lucerne. **Ill. 5.68** Courtesy: Xue Song. **Ill. 5.69** Courtesy: Qiu Jie. **Ill. 5.74** Courtesy: Wang Keping, Zürcher Paris, NY. **Ill. 5.83** Courtesy: Yin Zhaoyang. **Ill. 6.43b** Courtesy: Andreas Seifert.

Index by the author

♾ Printed on acid-free paper

First paperback edition 2016

Last figure below indicates year of this printing
25 24 23 22 21 20 19 18 17 16

A Continuous Revolution

Making Sense of Cultural Revolution Culture

Barbara Mittler

Published by the Harvard University Asia Center
Distributed by Harvard University Press
Cambridge (Massachusetts) and London 2012

I was
Born with dreams
and I
Died of dreams.

生于梦想
死于梦想

—Wang Jingyao 王晶垚 (1920s)

EPIGRAPH Bian Zhongyun's 卞仲耘 (1916–66) husband Wang Jingyao said this about his wife's death at the beginning of the Cultural Revolution (and expressed a wish to have these words written on his urn). Bian had been vice principal of the Girls' Middle School attached to Beijing University and was one of the first victims of the Cultural Revolution. Taken from the 2006 documentary *Though I Am Gone* (我虽死去) (DACHS 2009 Hu Jie, Part 9, at 5:10 mins).

CONTENTS

PREFACE

We have to admit that the Cultural Revolution was a very interesting drama. Unfortunately, the price of the ticket was too expensive. (Huang Yongyu, 1924-)[2]

When I began my research on the topics that have some bearing on this book in 1994, my institute had just proudly acquired a full set of the infamous model works (样板戏 *yangbanxi*) from the Cultural Revolution. We were so excited about the "loot" that Rudolf Wagner, Catherine Yeh, and I organized a small workshop on Cultural Revolution Culture, watching some of these model works along with other films from the Cultural Revolution, and reading through some of the Party and Red Guard documents from the period. The last and, as it turned out, most interesting event during this workshop, however, was a "Cultural Revolution Tea Party" at which some of the Chinese members of the institute who had grown up during the Cultural Revolution spoke of their experiences.

It took some time until I realized that Cultural Revolution Culture or the cultural experience of the Cultural Revolution was not only intriguing but misunderstood enough to merit another book. When I finally decided to pursue the idea, I organized another workshop in 2001, this time on a larger scale but with a somewhat similar format, inviting scholars of the Cultural Revolution on the one hand and those who had lived through the Cultural Revolution on the other (http://www.sino.uni-heidelberg.de/conf/propaganda/).

Since these first gropings, more than a decade has gone by: two other books had to be written and published, two little boys were born and began to grow, and in the meantime, things have changed dramatically in China. No longer is owning a full set of the model works a special distinction, as they are sold (and bought) everywhere. Is it still necessary, then, to write a book about Cultural Revolution Culture? I believe it is, and perhaps even more so than before: the former excitement of playing with fire may have worn off, but it has not entirely disappeared, because it is precisely the commercial success Cultural Revolution Culture sees today that makes it a tricky topic to study. Why is it that China's people still go back to Cultural Revolution Culture in spite of the fact that many of them paid dearly—in terms of personal relationships, in terms of education and career opportunities, and in terms of economic and social growth—during the Cultural Revolution?

This book attempts to provide some tentative answers to these difficult questions. There have been many studies of the Cultural Revolution. This one aims to be different. It looks at the cultural experience of the Cultural Revolution from the point of view of both its production and its reception, exploring people's perceptual, sensory, emotional, and physical encounters with the period's cultural products not only during the Cultural Revolution but before and afterwards. It intends to show that the development and the aesthetics of revolutionary art and culture for which Cultural Revolution Culture became a symbolic stand-in is a "continuous revolution" that began sometime in the late nineteenth century and continues to the present day. This continuous revolution drew on the past and the foreign and then marched forward in its own distinctive style. The book thus attempts to fill a gap in scholarship of the Cultural Revolution by offering an analysis of some of the key media and texts propagated during this time, together with their circulations before and after the event. It intends to show the very contradictory qualities of Cultural Revolution Culture by describing it, primarily, as a lived experience. For this purpose, the book juxtaposes

2 Huang 1990.2, 132.

analyses (by way of close readings of the cultural products from this period) with a discussion of firsthand impressions given by contemporaries in a series of interviews. Here, I would like to bow to Chan Hing-yan, Catherine V. Yeh, Jeffrey Wasserstrom, and Andreas Steen for helping me find some of the three dozen or so interview partners who chose to remain anonymous. Their anonymity notwithstanding, I would like to thank all of them sincerely for generously sharing their time and insights on this knotty period in Chinese history.

It is to Rudolf Wagner, Meng Yue and Ted Huters that I must bow for "putting me on the road" to this book. I thank the participants in the 2001 conference (and especially Chen Xiaomei, Carma Hinton, and Catherine V. Yeh) for so enthusiastically sharing their insights and for being ever so patient in not yet seeing their own wonderful work done for the conference in print. I am grateful to my students in Heidelberg, Guidel and Marburg, who participated in courses dealing with Cultural Revolution Culture over the years. I thank the Popular Culture Group at Heidelberg, some of whom, like Jennifer Altehenger, Nora Frisch, Sebastian Gehrig, Huang Xuelei, Sun Liying, and Xiong Jingjing, have generously shared their own materials or helped collect and order important materials for the writing of this book. Benjamin Kemmler, Ann Katrin Dethlefsen, and Li Shuang, too, provided constant, patient, and reliable support, checking footnotes and Chinese characters and rescanning images. Christian Straube designed the digital archive going along with this book and proved a most reliable and incredibly patient help. Sylvia Schneider, Sun Hui, Lucia Banholzer and Johannes Sturm helped input metadata and locate sources for the archive. The hefty index is the work of my former student Miriam Seeger (and it would not have been but for Thomas Maissen—who always comes up with the better ideas—that I asked her to do this). I thank him as well as many other longtime friends such as Andreas Steen, Chen Xiaomei, Paola Zamperini, Hans van Ess, Christiane Brosius, and Jeffrey Wasserstrom, and my colleagues, Thomas Kampen, Susian Stähle, Gu Wen, Michael Schönhals, and Mark Elvin for critical and material input. And had it not been for the constant, encouraging and imperturbable support by Kristen Wanner at Harvard, this book would probably never have seen the light.

Last but not least, there is my family: my two wonderful sons, Thomas Adrian and Carl Benjamin, who never failed to play on their own (and thus leave me to my work) even on weekends and during their vacations, but who also continue to open my eyes and amaze me every day, allowing me to see and hear so many things I would not otherwise. I bow with grace to their nanny, Anna Ratz (and her husband, Werner), and to their grandparents, Uta and Elmar Mittler and Betty and Karl-Josef Schmitz, for keeping the children very happy while I was working away. And finally, there is Thomas, my husband, who is certainly much more than just my personal *deus ex machina* Mac-Support: an ever-patient, understanding partner who would always find a word of support or warning whenever it was necessary, in spite of the tantrum-prone treatment he sometimes received back, in short: the longest-suffering, best-ever friend.

Earlier articles of mine (some of them in German and Chinese) include material that has entered some of the chapters in changed format here. The Introduction draws on Mittler 2008 and 2008d; different examples in Chapter 1 have also been discussed in Mittler 1998, Mittler 2001, Mittler 2002, Mittler 2008a, and Mittler 2010a; Chapter 2 is prefigured in Mittler 2004a and Mittler 2007; parts of the prologue to Part II appear in Mittler 2010b; preliminary thoughts for Chapter 4 were formulated in Mittler 2008b; and elements from Chapter 5 have occurred in Mittler 2006, Mittler 2009, and Mittler 2010.

—B.M.

ILLUSTRATIONS AND ONLINE RESOURCES

As the sources for this book turned out to be more and more multimedial, the idea to have the book accompanied by an online archive offering, by way of an online exhibition, all audio-/visual materials under discussion arose. This archive is available at **http://projects.zo.uni-heidelberg.de/continuousrevolution/** and offers all resources mentioned in the book including references to our Digital Archive of Chinese Studies (DACHS). Some of the visual materials are also reprinted in the book; these resources are marked **in bold**, while all others are to be found only in the online archive.

—B.M.

List of Illustrations Appearing in This Book

INTRODUCTION

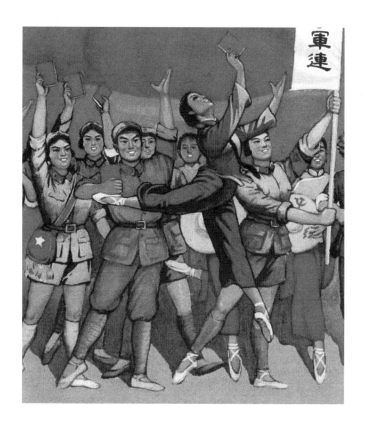

NOSE: SMELLS

I was sent down to Shanxi to do labor in 1964. I was there for fourteen years, only to come back after the Cultural Revolution had ended. When the Cultural Revolution began, in 1966, there were all these struggles. I had been sent down due to political mistakes, so I was struggled against, too. They criticized me and locked me up; there was nothing I could do. My ears were hurt because of that. But by the 1970s, I was in charge of performing the model works [样板戏 *yangbanxi*].... Because the Party representatives could not read music, they would get me out from where they had locked me up and ask me to conduct. So, the model works saved me.... We had quite an interesting orchestra: the instruments in our propaganda troupe [文工团 *wengongtuan*] were just anything we had. Many young intellectuals and sent-down youths [知青 *zhiqing*] joined the orchestra. Indeed, the troupe was made up mostly of them. Quite a few people raised in these propaganda troupes later became internationally renowned musicians. We were also in charge of creating local adaptations of the model works: quite an interesting task. (Composer, 1937–)

We will have to consider to what extent the Cultural Revolution may actually have changed our cultural environment ... Did it have the effect of transmitting cultural knowledge [传播文化 *chuanbo wenhua*]? There are two important elements to it: the journeys of youths to revolutionary sites and to the countryside [大串联 *da chuanlian*], and later the sending of youths to the countryside [上山下乡 *shangshan xiaxiang*].... The sent-down youths did indeed bring culture to the villages. Not directly, perhaps: when I was in the village, for example, I read Shakespeare, the whole of Shakespeare. But there was nobody else around who read it, apart from me. There were other things, like hygiene, for example. In the countryside, there are some people who did not wash themselves all their lives; they did not even brush their teeth. We taught them a lot, in this regard. To give a very concrete example: I would ask them where to go to the toilet—it was a big piece of news to them that people did not just go anywhere but had a separate toilet [厕所 *cesuo*] [laughs].... And then we taught in the schools. I am not saying that what we taught the children was any better than what their original teachers taught them. But I think we were able to teach them a few new things. (Intellectual, 1955–)

A lot of time and energy—months and years—was spent practicing the model works. The performances were so perfect; no performance today can ever reach that kind of standard. It was really quite a success. I really like the *Red Detachment of Women* [红色娘子军 *Hongse niangzijun*] People who were born between the 1940s and 1960s, and who actually lived through this era, still like to listen to the model works. Those even younger prefer pop songs [流行歌 *liuxingge*], which have nothing to do with the model works. I don't think those remakes of revolutionary songs, using the old words but new music and melodies, even rock and all that, are meant to be critical. Their meanings are multiple. They open up new levels of understanding. For the people who lived through this time, these songs and melodies are part of their youth, but even for them, it can also be a little bit critical, or poking fun to listen to them now. It is not really serious. You could compare it to the Mao portraits: there are so many funny ones, Mao without hair, for example. It is really impossible to know exactly what they mean, though. (Photographer, 1960–)

★★★★★

INTRODUCTION

POPULAR CULTURE AND CULTURAL REVOLUTION CULTURE: THEORY, PRACTICE, AND EXPERIENCE

In the fall of 1978, the comic magazine *Lianhuanhuabao* (连环画报) printed a short comic strip of eight images entitled *Record of Painting an Elephant* (画象记 *Huaxiangji*) (**ill. 0.0**). The strip features two persons—an unnamed painter and Jiang Qing 江青 (1914–91), Mao Zedong's (毛泽东, 1893–1976) wife who took charge of cultural production during the Cultural Revolution and whose name is added to the first image to ensure that every reader will recognize her (panel 1). The painter has outlined an elephant that, as the strip continues, goes through a number of revisions, each following Jiang Qing's angry orders (panels 2–5). At the end, the elephant looks nothing like an elephant any more. At this point, Jiang Qing is seen jumping around excitedly, just like a little child, crying out "Good! Good! Good!" while the painter looks quite baffled (panel 6). The next image under the slogan "Smashing the Gang of Four" (粉碎四人帮) shows a large fist banging down on and suffocating Jiang Qing, while the painter appears quite happy and content— the characters above his head read 大快人心, which translates as "making the people happy and content." He rejoices, as we can see in the next picture (panel 8): "Spring has come for the arts" (文艺的春天来了), and quickly retouches his image of the elephant, which is now, as in his first attempt once viciously criticized by Jiang Qing (panel 2), quite readily recognizable as an elephant again.

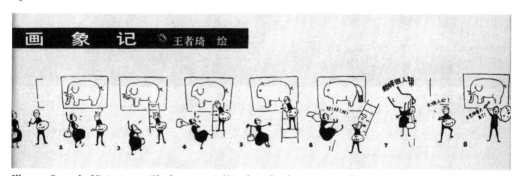

Ill. 0.0. *Record of Painting an Elephant*, 1978 (*Lianhuanhuabao* 1978.9:37).

The comic strip plays with homonyms for "elephant" (象 *xiang*) such as "portrait" (像 *xiang*) or "auspicious" (祥 *xiang*). It also plays with the several meanings of the character for "elephant" (象), which can also be read as "to imitate" as in "imitating sound" or "onomatopoeia" (象声), "to be similar/like" as in "serving the people like Lei Feng" (象雷锋一样为人民服务), or "to seem/ appear" as in "it seems that it is about to rain" (好象要下雨了).[1] With this in mind, the comic

1. All of these are examples of how 象 is translated in the *Xin Han-De Cidian* 1988, 836.

can be read as a record of painting not elephants but portraits (画像记), or rather, of painting *the portrait*, that is, the portrait of Chairman Mao, the most important hero of the Cultural Revolution. Painting *the portrait*—an act discussed in detail in Chapter 5—meant observing numerous strict rules. Failing to observe them, even if one was convinced that the end product was not only not an elephant (不象 *bu xiang*) but indeed not similar (不象 *bu xiang*) to its original, Mao himself, was indeed inauspicious (不祥 *bu xiang*) to any painter who dared do so. The comic strip is thus an illuminating commentary on (cultural) policies during the Cultural Revolution, policies that made some things appear to be what they were really not, and vice versa.

It may not be surprising, then, that the trope of "not being an elephant" (不象 *bu xiang*) or "not being similar" to what really was, or simply being not "like that," occurs in many descriptions of the Cultural Revolution as a cultural or artistic experience. The phrase, "really, it was not like that," is common in oral history. It also constantly recurs to the attentive observer who looks at the (arti-)facts of Cultural Revolution Culture and compares them with the regulations and tenets that allegedly controlled and governed them. The three interview quotes preceding this Introduction give some hints as to this aspect of the Cultural Revolution as a cultural experience: it was not such (不象 *bu xiang*) that cultural life during the Cultural Revolution was totally restrictive, although it was that, too—but indeed, it opened up opportunities for some, even saved their lives. It was not such (不象 *bu xiang*) that the Cultural Revolution absolutely destroyed the tenets of Chinese culture and civilization—it did to some extent, but then it can also be seen as a significant "enlightenment movement." And it was not such (不象 *bu xiang*) that the propaganda culture of the Cultural Revolution was entirely boring and thus repugnant to everyone: if its constantly repeated message was less than exciting, some of its products nevertheless bear unmistakable artistic qualities and are appreciated, even enjoyed, today.

What was the art and culture of the ten-year-period now called the Cultural Revolution (1966–76) like, then, in theory, practice, and experience? This introduction will provide a few first glimpses of the kinds of material and sensual worlds that this book will uncover in order to answer this question. It will place some unobtrusive scents for the reader who will begin to smell the aromas of what will be discussed more elaborately later. By describing the Cultural Revolution as a lived *experience*, this book presents first of all its contradictory qualities. For this purpose, it juxtaposes, in the attempt of applying a kind of historical hermeneutics, close readings and analyses of the cultural products from this period with the impressions given in a series of more than three dozen in-depth interviews conducted in Beijing and Shanghai in the early 2000s (most of them in Spring 2004) with representatives from many different class and generational backgrounds—from young taxi driver to elderly musician, from middle-aged journalist to housekeeper to museum curator.[2] The interviewees were randomly chosen from a group mostly involved in education, art, or media today. About half of them experienced being sent down to the countryside or working in the factories. While half of them came from working class, rural, or what would be considered "capitalist" backgrounds, the other half came from intellectual families, members of which had been criticized severely and declared Rightists before and during the Cultural Revolution. All were asked the same set of questions about their personal memories of cultural life during the Cultural Revolution, about painting Mao and reading comics, about criticizing Confucius (孔子 551–479 BCE) and watching or performing the model works, about being sent to the countryside, and about understanding the Cultural Revolution along the new Party line.[3]

2. A complete list of the interviewees, their occupations, ages, and family backgrounds is given in Appendix 1. Interviewees preferred to remain anonymous, a fact I respect even if it prevents me from thanking them by name.

3. A complete list of interview questions is included in Appendix 2.

The Introduction and the Conclusion to this book are composed primarily of evidence from the interviews (i.e., oral history), in order to shed light on what was happening on the ground, while the book's six chapters juxtapose experience (from oral history) with practice (as artifact). While neither the selection of interviewees nor the particular cultural products chosen for analysis throughout this book can in themselves be considered "statistically relevant," I am convinced by the many resonances as well as the dissonances to be found among the various different source materials studied in this book that only such a combination of readings—from cultural practice as well as from cultural experience—will enable us to understand why people reacted to Cultural Revolution artistic production the way they did (and continue to do).[4] In juxtaposing memories with close readings of the structure, motifs, aesthetics, and compositional elements of Cultural Revolution works of art or performance, and with the help of an intertextual reading of all of these different "texts," Cultural Revolution Culture begins to make sense.

The book as a whole includes, deliberately, much patch-working from the original interviews: each section and each chapter starts with a long series of quotations from them. This is done in an attempt to trace and make visible the extremely multifaceted and complicated nature of the Cultural Revolution (cultural) experience. These memories are indeed "visions of the collectively experienced past," reconstructions by those who have lived through that past. Naturally, they cannot be taken as "an objective chronology of the past" (Lee and Yang 2007, 3), but they are valuable hints as to its importance to the present. Although they are often quite distinct from official history, the official line significantly determines collective memory structures and ways of speaking about them. Whenever confronted with evidence that would suggest a reading different from the official line (but not only then), interviewees tended to get into (even more) contradictory argumentations. The phrase, "Really, it was not like that" (i.e., the elephant that does not look like one is one, after all), mentioned in so many of the interviews as well as evident from the cultural products from this period, therefore, is a staple of this book. And here, the fissures and discrepancies within and between different memories are important in their own right: it was not at all difficult to juxtapose the quotes preceding each chapter so that they represented opposite views on exactly the same matter almost all the time. Indeed, these quotes illustrate the many inconsistencies in the Cultural Revolution experience to which we may not have paid enough attention so far. This is why they are so prominently exposed: not in order to deny or beautify its horrors but in order to make visible the multifaceted experience of the Cultural Revolution. For, indeed, in taking materials such as these seriously, the student of the Cultural Revolution is navigating between Scylla and Charybdis: s/he is neither able to condemn the Cultural Revolution entirely nor to take a Maoist stance exclusively emphasizing its idealist intentions. It is the aim of this book to neither accept nor deny any of these positions—each has its merit and its justification as well as its blind spots. By scrutinizing both the material evidence and the lived experience of Cultural Revolution Culture, this book intends to complicate our view of this intensely complex and immensely important period in Chinese history. It argues for a more comprehensive view of the Cultural Revolution that acknowledges both its horrors and its pleasures, both its dictatorial and its democratic natures.

What the many sources scrutinized in this book illustrate, time and again, is that the Cultural Revolution defies categorization. The *Collection of Cultural Revolution Jokes* (文革笑料集 *Wenge*

4. See Hörning 1997, 32: "Um zu verstehen, warum Menschen das tun, was sie tun, reicht es nicht aus, die vorherrschenden kulturellen Konstrukte einer Gesellschaft zu erkennen, sondern genauso wichtig ist es, die Wege und Weisen zu analysieren, wie diese Konstrukte in die sozialen Praktiken der Menschen Eingang finden, vor allem wegen des polyphonen Charakters kultureller Realitäten." (In order to understand why people do something, it is not enough to recognize cultural constructions in a society. It is equally important to analyze the ways and methods through which these constructions enter social practices. This is so especially due to the polyphonic character of cultural realities.) All translations are, unless otherwise noted, by the author.

xiaoliao ji) published in 1988 makes this explicit: on its cover page it claims that the Cultural Revolution was a tragic, comic, hateful, and pitiful historical moment all at the same time (一段可悲复可笑可恨复可怜的历史). The joke collection is advertised as an important document for those growing up after the Cultural Revolution, so that they may understand the period even as they find some of it strange and hard to believe (70年代后长大出生的后人们，你读到这段难以置信的历史，也许会拍案惊奇吧). Most importantly, it hopes to illustrate—and this is the aim of my book as well—that the Cultural Revolution cannot be adequately discussed in simple terms and categories (不要简单地说) (*Wenge xiaoliao ji* 1988). The Cultural Revolution was *This* (read "an elephant") and *Not This* (read "not an elephant") at the same time, and accordingly, there are those who will say (and believe) *This* and *Not This* at the same time as well, and each one of them will have an important point to make. It is imperative to pay attention to all of these voices.

This book intends to listen to what they have to say about the art and culture of the Cultural Revolution while it avoids politics, which has been discussed many times and recently most masterly by Roderick MacFarquhar and Michael Schönhals (2006). Cultural life, the artistic *practice* of the Cultural Revolution, was equally (if not more significantly) a part of the Cultural Revolution as a quotidian (and aesthetic) *experience*—and thus of cultural memory today. As Wang Ban puts it:

> Much emphasis has been put on the Cultural Revolution as a political struggle among rival political groups and factions, but the most enduring memory of it is not related to committees, groups, cliques, decrees, or policies. It is, rather, an endless stream of images and patterns from daily life: ... model plays, ... Mao badges, the green army uniforms, the red armbands of Red Guard organizations, the waving of red flags, the singing of songs and shouting of slogans, the never-ending study and criticism sessions, the solemn morning prayers and evening reports at the altar of the Great Leader, the loyalty dance ... and loyalty halls ..., and the ocean of red ... the list goes on. ... The Cultural Revolution had created a life that was aesthetically driven, ritualistic, and theatrical. (1997, 208–9)

This peculiar quotidian aesthetics of Cultural Revolution China continues to haunt (or invigorate) everyday life in the twenty-first century in China. Cultural Revolution art and culture, almost always made and watched collectively, thus continues to reflect the nation's collective mentality (Chi 2007, 238). And still, this artistic and cultural practice of the Cultural Revolution has not been studied in detail:

> Few have bothered to look closely at the arts and literature of the Cultural Revolution, perhaps because of the dismissive but unquestioned assumption that the period was a cultural desert. Don't we all know that the Revolution produced nothing except the eight model plays? (Wang 1997, 196)[5]

Cultural Revolution art and culture had been dismissed for many years as "restrictive,"[6] "extremist," or "mere propaganda" before it was recently resurrected as a subject worthy of study both in China and abroad. Even within the last decade, when the situation began to change, the art and culture of the Cultural Revolution continued to be reduced to a few pages even in specialized works: in an extremely well-informed history of Chinese dance (Feng 2002), for example, the 25 years before the Cultural Revolution receive 65 pages, the 25 years since the Cultural Revolution receive 110 pages, while the ten years of the Cultural Revolution are given only fifteen pages. In a history of Chinese drama, on the other hand (Fu 2002), the 23 years before the Cultural Revolution receive 103 pages, the years since 1977 receive 50 pages, while 50 pages are devoted to a discussion of an

5. For a similar characterization of the state of the field, see Brown 2003.
6. The question of the restrictive nature of Cultural Revolution Culture, which is, indeed, often summarized in the slogan "nothing except the eight model plays," in Wang's words (1997, 196), is discussed in detail in Chapter 1.

extended Cultural Revolution period (1963–76). Perspectives are changing, then, and with the passage of time it has become ever more evident that the Cultural Revolution is an event of cultural import.[7] Recent studies have focused exclusively on the years of the Cultural Revolution, showing that politics is not all there is in explaining the Cultural Revolution. Indeed, politics often works very differently from the logic of cultural production during the Cultural Revolution, which may sometimes be inert, lethargic, and thus resistant against, or simply oblivious to, policy changes that occur too quickly. Accordingly, Cultural Revolution Culture may not be read exclusively as derivative or even correlative of Party politics. This significant disjunction has been emphasized recently by Paul Clark (2008, 1–9), who comes to clear conclusions about the possibilities and impossibilities of artistic production in China during the Cultural Revolution. What remains to be probed, however, is the relationship between artistic production on the one hand and aesthetic experience on the other, for these, too, do not necessarily work on parallel planes. That is what this book attempts to do.

In theory, if one believes that cultural production during the Cultural Revolution was all in the hands of the Party, closely watched and regulated by adherence to Mao's doctrine from the *Yan'an Talks* (Mao 1942), artistic production and artistic experience can be matched easily. If it were all "propaganda" in the commonsensical and negative understanding of the word, or *nothing but* "propaganda," there would be one reading and one understanding: restrictive, repetitive, exclusive. Yet, this theoretical construction matches neither the material nor the experiential evidence. Says Wang Ban:

> The simplest retort to this view is that literature and art created on the Yan'an principle nourished and fashioned a whole generation, or several generations of readers, who may think very differently from the detached critic. These readers did not see this brand of literature as propaganda when they first read it, and many of them were inspired by this literature to become enthusiastic participants in revolutionary movements. Even if we concede that Communist literature is propaganda, we still have to consider seriously why it worked—often effectively. (1997, 209–10)

Cultural Revolution Culture, which has repeatedly been declared an exceptional artistic culture that could but be denigrated and abhorred as "propaganda," was (and is) in practice and experience liked and enjoyed by many. This book intends to dissolve this only seemingly paradoxical phenomenon—the central contradiction of the longevity of Cultural Revolution propaganda art.

Art as Propaganda

> Goebbels is sent back at the gate of Heaven: he should go to hell. In order to incite him to go, Saint Peter allows him a gaze through a binocular. What Goebbels sees is a beautiful, elegantly decked-out bar with expensive drinks and smashing girls. When he finally arrives in hell, however, he finds something completely different. A place of horror, suffering, pain. Quite annoyed, he complains and asks whatever what he had seen was. The devil answers: "Propaganda."[8]

What this joke, popular in 1940s Germany, shows very clearly is that, at least to German ears, propaganda must be evil. It amounts to nothing but blatant lies and false pretense; it is manipulated

7. The number of specialized studies on aspects of Cultural Revolution Culture grows by the day. Here I name but a few of the more significant monographs: Dai 1994, Chen 1995, Dai 1995, Bai 1997, Yang 1998, Wang 1999, Wang and Yan 2000, Chen 2002, Feng 2002, Clark 2008.

8. The joke is retold in Bussemer 2000, 133. Throughout this book, I have tried to provide links to studies on the propaganda cultures of other states and nations, but I cannot, for reasons of space, engage in a full-fledged comparison with these other propaganda cultures. That is, however, part of a new research project.

and manipulative. The devil's techniques are precisely those of withholding vital information, of invoking heuristic devices, and of using meaningless associations to prove a point (Jowett and O'Donnell 2006, 4). Whenever propaganda has an effect, it is bound to be negative, for an enthusiastic recipient of propaganda cannot but be deluded. A system creating propaganda is to be despised, and the times in which propaganda flourishes are considered unhappy times, times that everybody hopes will quickly pass.

Taking all this at face value, it is unsettling that the propaganda from what can be considered one of the most tragic periods in Chinese history, the Great Proletarian Cultural Revolution—linked closely to one important if not unambiguous figure in Chinese history, Mao Zedong—remains popular even today. The radical politics of the Cultural Revolution brought suffering and death to many, especially intellectuals. Nevertheless, the propaganda products from this time have not disappeared. For the Chinese public, Maoist propaganda art has been reconceived and modernized for decades now: it appears in the form of jubilee editions and Karaoke versions of the infamous model works, the eighteen ballets, operas, and symphonic works canonized during the Cultural Revolution (see Chapter 1); it appears in rock and pop versions of revolutionary songs in praise of Mao (see Chapter 2); it can take the form of trendy t-shirts, watches, Ping-Pong paddles, mousepads, and even porcelain (see Chapters 4–5). Indeed, Cultural Revolution propaganda objects decorate restaurants (not just in Beijing, but in London, too) and form the props for China's growing wedding party industry.[9] Taiwan, too, has recently begun to read the *Little Red Book*,[10] and Sotheby's intermittently offers to sell a "wide selection of Cultural Revolution relics," describing Maoist propaganda art as "some of the most potent and fascinating propaganda art of the twentieth century."[11] Both inside and outside the People's Republic of China (PRC), Maoist propaganda from the Cultural Revolution sells well across generational and class lines: even the successful business manager may now be turning back to read Mao's writings for strategies of success.[12]

How does one explain why a people will not reject outright the propaganda art of a time that for many of them conjures up painful memories, memories of torture and violence, of slander and treason, of psychological strain and terror, of madness and even death? Even for research purposes, it is not so easy to get hold of the propaganda films from Germany's Nazi regime, but the propagandist model works from the Cultural Revolution are not only no longer restricted, but since the mid-1980s have been selling extremely well. In the last few years, ever-new formats and luxurious editions on VCD and DVD have emerged as their popularity continues to increase (Barmé 1996, 14). Television series and memorial publications narrate the stories of their actors, and internationally renowned stage directors such as Zhang Yimou 张艺谋 (1951–) venture revival performances of these pieces.

Why this is so is an extremely difficult question to answer. I came across it for the first time almost 20 years ago, when, while conducting research for my PhD dissertation (Mittler 1997), I interviewed some 60 Chinese composers from different generations and backgrounds. Many of

9. See DACHS 2009 Cultural Revolution Wedding Pictures.

10. See DACHS 2009 Red Book in Taiwan: "Mao Zedong's red book selling well in Taiwan," *Chinaview* 7.10.2005.

11. This advertising phrase was used for a Sotheby auction in April 2001 (DACHS 2009 Sotheby I & II). It described its auction as follows: "This online auction features a collection of remarkable artifacts, carefully selected to reflect the range of objects used to disseminate the gospel of Chairman Mao. Highlights include Nixon/Mao Ping-Pong paddles in their original packaging, portrait busts and banners of the Communist leader, as well as two rare portrait medallions of Mao ostensibly fashioned from the wreckage of US fighter planes shot down over Vietnam" (Marsha Malinowski, Director of Online Auctions, Books, and Manuscripts).

12. DACHS 2009 Mao Cult.

them told stories that were vastly different from the textbook versions of Chinese history known to me then. They described the Cultural Revolution, in my mind a time of "grand propaganda," not as a time of censorship and restrictions but of learning and discovery. Many of these composers had found their love for music during and through the Cultural Revolution. They had learned how to compose and to conduct as members of the propaganda troupes marching from village to village. Many of them had gotten to know the rich and varied traditions of Chinese folk music during this time, when intellectuals, urban youth, and students were sent to the countryside. They had seen what these folk traditions contained, quite beyond all "propaganda": pornography, poetry, and much of the everyday. Many of them had learned to read during the Cultural Revolution, and they were reading not "just propaganda" works but so-called "black literature" by writers such as Honoré de Balzac (1799–1850) as well, not unlike the Chinese seamstress that Dai Sijie 戴思杰 (1954–) talks of in a recent book (Dai 2000). Some had (been) turned to philosophy during the Anti-Confucius Campaign in the early 1970s. Others had learned to write during the Cultural Revolution: even a "big-character poster" (大字报 dazibao), which was used for political propaganda and denunciation, was an exercise in calligraphy, they would argue. Said one writer: "During the Cultural Revolution a lot of people had very good calligraphy, because we were all writing big-character posters. Now students no longer know anything about calligraphy" (Female Writer, 1958–). Another supports her view: "My father actually was very good at writing big-character posters, with very big letters. He was a good calligrapher. Often, he would actually copy big-character posters, just because of the calligraphy, and then he would ask me what they were all about" (Museum Curator, 1950s–).

None of the composers interviewed in 1992, and not one from the group of interviewees I met in the early 2000s, would condemn Cultural Revolution propaganda art outright. Many of them sang and performed for me extracts from the model works, revolutionary songs, or "loyalty dances" (忠字舞 zhongziwu),[13] often with a smile, seldom with irony, even less contempt. They would proudly show me old black-and-white photographs of themselves and their friends posing with dramatic gestures. Many even argued that their most important experiences during the Cultural Revolution were these many different intellectual and cultural activities, most of which amounted to propaganda.[14] One interviewee, an artist born in 1954, remembers: "Sure, I would have painted and drawn as long as I live, but without the propaganda troupes, many of us would not have turned into artists. The propaganda troupes brought art and artists into people's consciousness." He continues: "My older brother was a great influence on me; he plays the violin. Of course, we did not play that well; we just played. But indeed, many of the now-famous musicians and artists used to be in those propaganda troupes. It was a real opportunity. Of course, the contents were all politics, but you could also learn how to play the violin or to paint, it was all "to serve politics" (为政治服务 wei zhengzhi fuwu), but still, it was painting, so I painted a lot in the Anti-Confucius Campaign, for example, caricatures and all" (Artist, 1954–).[15]

13. Loyalty dances were dances in which one formed the character 忠 for loyalty (see Chapter 4). For short explanatory descriptions of each of these genres, see *Wenge shiqi guaishi guaiyu* 1988, 259–60.
14. An artist couple, she (born 1959) with working class background, he (born 1954) with intellectual background, would remember this as follows: She: "I had a good throat, so in the school I would sing the role of Aqingsao [from the revolutionary opera *The Village* [沙家浜 *Shajiabang*]. Both this and the model opera *The Red Lantern* [红灯记 *Hongdengji*] were performed in our school." He recalled: "The most important experiences we had during this Cultural Revolution were all these cultural activities."
15. See also the interview with a male China historian, born 1957, who said, "The interesting thing was that so many people actually learned how to play an instrument during that time." Andrews 1994, 315, supports this point when she argues that the Cultural Revolution's "rejection of professionalism in science and economics pushed many ambitious young people into the arts. Finally, its populist emphasis expanded the practice of official painting to regions of China that had previously produced little art. Government cultural and personnel policies thus produced an artistic pool of unprecedented breadth and talent."

The way they dealt with this difficult past was so different from what I had known as a German dealing with the Nazi past that I began to doubt the "basic axiom" that propaganda must always be evil. In this book, I attempt to understand the effects of Chinese revolutionary propaganda art, which is an art that is completely political, completely manipulative, and completely teleological, but, nevertheless, extremely popular in all of its meanings. As I try to make sense of this fact, I consider Chinese revolutionary propaganda art originating in the Cultural Revolution from the point of view of its *longue durée*: Cultural Revolution propaganda art did not appear out of the blue, but has a long pre- and post-history that can be traced from the late nineteenth and into the early twenty-first centuries.[16] Taking the long view makes it easier to understand the enormous effects of this propaganda. Looking at the Cultural Revolution not as a period of "cultural stagnation"[17] that lasted from 1966 to 1976 (this now-official chronology in itself is debatable),[18] but examining instead the *longue durée* of propaganda art, even disregarding the political and institutional divide of 1949 when the Chinese Communist Party (CCP) began to rule all of mainland China, I attempt an alternative way of conceptualizing modern Chinese cultural history that will be, in addition, a cultural history of production and reception.[19]

In this study, then, the propaganda art from the Cultural Revolution is to be seen as one development in the broader attempt to create a new but Chinese modern art and culture. It is in fact not the exception but the norm in cultural production in modern and revolutionary China, that is, throughout the twentieth and into the twenty-first century. Many of its contents have been communicated for generations, surviving even social and political changes and revolutions. They appear in a variety of media, can be physically experienced in propaganda events, and thus form time-resistant semantic units that become important and structuring elements in a collective cultural memory: they are, in a term coined by Rainer Gries, "propagemes."[20]

The Cultural Revolution was a pivotal moment, congealing particular revolutionary propagemes in Chinese cultural memory. During the Cultural Revolution, these propagemes—such as revolutionary songs in praise of Mao (what I have termed "MaoMusic"), Mao's portrait (which I will refer to as "MaoArt"), or his writings (for which I have adapted Apter & Saich's [1994] term "MaoSpeak")—would be considered first and foremost as persuasive communication techniques and thus as political versions of advertising, just as "popular" as advertising must be. Recalls one businesswoman about painting Mao's portrait: "We would paint his image all over the place on any wall, anywhere. Those paintings were just like advertisements today; this was their function" (Businesswoman, 1940s–). Both advertising and propaganda focus on the formation of a community, prescribe a particular lifestyle, and model particular rituals, all in order to make the product part and parcel of the consumers' everyday experience (Marschik 1997, 219). This is precisely what happens with propaganda art in China: the propagemes significant in Cultural Revolution propaganda have been interpreted and reinterpreted so many times that these interpretations and reinterpretations by a long series of communicators begin to form long-lived narratives. This book analyzes a number of these narratives in order to show how the propagemes became part of Chinese everyday life and how they may even have become resistant against newly

16. In Hung 2011, the idea that revolutionary culture as produced after 1949 was new but could build on existing models is well taken: "Liberation" in 1949 certainly puts a new quality (and a further manipulation and expansion as well as a stiffening of rules) to revolutionary culture and lifts it onto a new level. Yet, it also does not break entirely with many developments that began long before 1949.
17. Fokkema 1991, 594.
18. Schönhals 1999, 744. I return to this question of periodization in the Conclusion.
19. Cf. Gries (2005, 28).
20. Gries 2005, 22–24. Gries defines "propageme" as follows: "Contents of propaganda, rhetorical markers, markers with political content, and more or less complex narratives which have been repeatedly and successfully communicated to a target group for a longer period of time, probably across generational borders and across political and social systems, through the mass media" (2005, 13, 34).

hatched propaganda: one example of this phenomenon at work may be the attempts in the early 1980s to tear down some of the Mao statues in Chinese cities and public arenas. These attempts were met with extremely strong resistance by the Chinese public. The long-lived nature of the propagemes and their concentration during the Cultural Revolution explain their obvious impact to the present day and make it necessary to research them in detail. Thus, a study of Cultural Revolution propaganda and its diverse functions, both positive and negative, can contribute to a history of modern Chinese society at large (Gries 2005, 28).

In this Introduction, I will make a few more general statements about propaganda art (here understood simply as art that propagates a particular political line), and I provide scents which will be fleshed out in different senses in the chapters to follow. I argue that the Chinese audience has dealt with propaganda from the Cultural Revolution in a way that vacillates between a "deluded" and "passive" reception on the one hand and a "parasitic" and "subversive" one on the other (see [Subjective] Receptions of Propaganda). In many cases, it seems, the political content of propaganda art has had little or no influence on its reception. In other words, the political message is not immediately relevant to an audience's liking or disliking a piece of propaganda art. I argue, on the other hand, that it is the particular form propaganda art takes that has been crucial to its success; in Cultural Revolution propaganda, popular genres as well as select genres from the canon of high art have been chosen for particular effect (see [Objective] Forms of Propaganda). In this section of the Introduction, I also hint at a factor illustrated throughout this book: it is not just the longevity of propaganda art but, even more importantly, the context within which it appeared that is crucial to its success. Quite a bit else, apart from propaganda art, was performed and experienced during the Cultural Revolution years, even though this was not officially acknowledged. This is extremely important for the reception of Cultural Revolution propaganda art, because the idea that it was the only artistic food that China received for ten years is mistaken. This point is obvious when researching the material evidence, and it is prominent in the interviews, all of which stress restriction and variety at the same time. It is only in combination with its many unofficial alternatives that official propaganda art became effective. Whether this was part of an official strategy or a sign of the (politically determined) anarchism prevalent during the Cultural Revolution is difficult to tell, but in the end the Party's ability (and willingness) to control cultural production during the Cultural Revolution was far less pervasive and absolute than is widely assumed. In spite of all its efforts, the Party never reached the level of a mega-machine eliminating all that was unwanted and disagreeable.

(Subjective) Receptions of Propaganda

Wang Ban, who was a youth during the Cultural Revolution, remembers, somewhat bashfully, his experiences with Cultural Revolution propaganda art:

> The embarrassment comes from an experience with a Chinese film entitled *Spring Sprouts*.[21] Made during the Cultural Revolution, the film is propaganda. It depicts the power struggle of the political lines at its most bombastic and distasteful, but I was moved to tears by its high-flown drama. I believe millions of Chinese had a similar experience with other forms of propaganda if not with this particular film. Looking back, one is at a loss whether to laugh or cry. This may seem sheer folly now, but it was not folly [then]. (1997, viii)

In Jacques Ellul's classic 1965 definition, propaganda is "a set of methods employed by an organized group that wants to bring about the active or passive participation in its actions of a mass of

21. A comic version of the film, Chunmiao 春苗, is discussed below in Chapter 6.

individuals ... unified through psychological manipulation" (1965, 61). Although this definition has since been developed further, one of the common elements in nearly all of the more commonsensical conceptions of propaganda can be derived from it: the idea that propaganda is manipulative make-belief, the "catch-all for suspicious rhetoric" (Jowett and O'Donnell 2006, 3) as it brings about participation—active or passive—implicitly, against one's will. Propaganda reduces the recipient to reflex reactions: s/he is manipulated, even forced to do what the propagandist says, and every (re)action is foreordained and planned in minute detail (Bussemer 2000, v). Wang Ban's unease or even shame at his emotional, if not enthusiastic, reception of a propaganda film during the Cultural Revolution illustrates precisely this assumption that to be touched by propaganda is to have succumbed to manipulation.

And yet, the reception of Cultural Revolution propaganda does not accord with a "reflex model." This propaganda is being enjoyed and hated, debated and destroyed, but it is also being played with and parodied. It is itself manipulated in people's reactions to it and their reenactments of it. There are jokes on citations from the *Little Red Book* (see Chapter 4) and the model works,[22] there are talk and quiz shows featuring memorized quotes from Mao's works and the model works, there is advertising and art reproducing and remodeling Cultural Revolution propaganda (see Chapters 1, 4, and 5), and there are new versions of Cultural Revolution images and texts in which model heroes are recontextualized to serve, for example, the fight against SARS (ill. 0.1). Today, model heroes may be presented in personalized (sexual) fantasies, as in Wang Yigang's 王易罡 (1961–) oil painting entitled *Yang Zirong* (杨子荣) (2002), for example (ill. 0.2).

The image juxtaposes one of the main heroes from the model works (in fact not Yang Zirong from the revolutionary opera *Taking Tiger Mountain by Strategy* (智取威虎山 *Zhiqu weihushan*), as the title suggests, but Hong Changqing 洪常青 from the model ballet *Red Detachment of Women*) with the face of a beautiful woman and symbols of marriage (the sign for double happiness) and female sexual maturity: when the peony, the sign of female maidenhood seen in this image, begins to bloom, so traditional lore has it, it is picked by the young man (Eberhard 1986, 232). The fact that the hero is, consciously or not, mislabeled becomes part of the images' irreverence. The enigmatic writing connects it with other paintings in the same series, all of which juxtapose commodities (Chinese cloth patterns and symbols) with elements from Chinese propaganda art and sexually provocative images of women's bodies. The words read 微露主义永 放光芒, roughly translated as "A dogma of small revelations will always send out its rays,"[23] suggesting a mocking reading of Cultural Revolution propaganda art, which features, time and again, the rays of Mao the sun and his "revelations" (see Chapters 2, 4, and 5). With this in mind, it appears even more ironic that the painter of this image, Wang Yigang, should teach at the Lu Xun Academy of Arts 鲁迅艺术学院, the cradle of Chinese propaganda art.

The question, then, appears to be less "What does propaganda do to the people?" than "What do people do to propaganda?" Certainly, there is not just one possible reading of propaganda, otherwise the anti-Nazi film *Why We Fight*, released in 1942 by the U.S. government and directed by Frank Capra (1897–1991), would not have worked. Capra's film reproduces authentic material from Nazi propaganda films, most prominently among them Leni Riefenstahl's (1902–2003) *Triumph des Willens*, without introducing a single new scene. According to Capra, every propaganda image can serve as its own anti-propaganda piece as well: every propaganda image can be read affirmatively or subversively (Bussemer 2000, 135).

And this is certainly true for Cultural Revolution propaganda. Although it was taken for granted that most members of a select audience would recognize familiar symbols and would react

22. See *Wenge xiaoliao ji* 1988, 122–23, 123–24, 143, 146–47.
23. On some of the artist's own websites, "small revelations" is translated into the very unidiomatic "little appearances." See DACHS 2009 Wang Yigang Contemporary Art.

to them in a predictable way, no experienced propagandist could in fact expect to be able to control all of his audience all the time (Qualter 1985, 123). Accordingly, in spite of all the propagandists' efforts to deliver the one and only meaning through performances of their model works, for example, they would be "misread" constantly—whether consciously or unconsciously, deliberately or by mistake. A sent-down youth relates one such incident, which followed the performance of a model ballet in his village:

> Once we had this really funny situation. We took everybody to see the ballet *White-Haired Girl* [白毛女 *Baimaonü*]. When we came back we had a meeting and talked to everyone about what they felt about the model work. This old peasant said: "But Xi'er, really, is not a good person, how come she can be the heroine?" Everybody was quite shocked at his remark and asked why he thought so. He said: "Someone who hits an old man like she does [in a scene where her former landlord comes to the temple where she has hidden, see **ill. 6.16**] simply cannot be a good person." It was too scary. He really thought she was no good. This shows very clearly that the peasants were somehow faced with this new art, and it bewildered them: they did not understand things at all. (Intellectual, 1955–)

The old man's subjective interpretation of the propaganda piece was derived from traditional moral values, which would demand that age be respected. Even though the elderly man in the model ballet, Huang Shiren 黄世仁, is marked by all kinds of devices (his name, dress, gesture, face color, accompanying music, all of which will be discussed in Chapters 1 and 6) as an evil landlord and a negative character, these markers have escaped the old man's attention.

Propaganda's message, then, no matter how hard it tries, is never univalent. Take the phrase "Be resolute, fear no sacrifice, and surmount every difficulty to win victory" (下定决心, 不怕牺牲, 排除万难, 去争取胜利) from Chapter 19 in Mao's *Little Red Book*, from the story of the "Foolish Old Man" 愚公 who manages, in spite of everyone's skepticism, to move two mountains blocking the front entrance to his house. As will be seen in Chapter 4, every imaginable obstacle is successfully undone in Cultural Revolution propaganda art using this phrase. The phrase is helpful in overcoming sandstorms, deep waters, and difficult mathematics exercises, as well as nasty imperialists. One of its most spectacular uses is in the revolutionary opera *Song of the Dragon River* (龙江颂 *Longjiangsong*) (scene 5): a dike has broken and the peasants now form a human wall to make repair works possible (**ill. 0.3**).

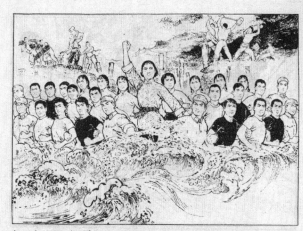

（84）军民们顶狂风，战巨浪，高声背诵着"**下定决心，不怕牺牲，排除万难，去争取胜利**"，谱下了"人定胜天"的战斗乐章。

Ill. 0.3. Human dam invigorated by Mao's words in *Song of the Dragon River*, 1974 (Comics *Longjiangsong* 1974:84).

Beating the waters in breathtaking acrobatic moves, they chant Mao's phrase at the same time.

The quote has also been turned into a quotation dance (语录舞 *yuluwu*). Two artists showed me how to dance it. Yet, they could not decide among themselves whether the citation was, after all, effective or not:

[handwritten margin note: quotation & oral history and mediation through the lens of the 1980s]

He: "We would sing 'Be resolute,' the quotation song 语录歌 *yuluge* [songs based on quotations by Mao], for example. Everybody can sing this, and everybody of course knows that it is taken from one of Mao's *Three Constantly Read Articles* [老三篇 *Lao sanpian*]." She: "But we did not quite believe what these stories told us. They did not really give us support." He: "Yes, of course, they did. For example, when I was performing ballet [one of the model works, the *Red Detachment of Women*], this quotation would keep me going when I was tired." (Artist Couple; He, 1954–, She, 1959–)

Many others echoed their ambiguous response. One remembers that he felt too manipulated to remember for the quote to actually become effective:

We had to read the story of the Foolish Old Man, and the sentence "Be resolute" and learn it by heart. So we had this pressure to learn, which is why we felt quite obstinate and opposed 反感 *fan'gan* to it. This is why it did not really become part of our own thinking: I was influenced quite strongly, I feel, but since I had to read it, it did not really impress my own thoughts that much. (Intellectual, 1955–)

Another, by contrast, attests to the importance of Mao's stories, that of the Foolish Old Man especially and "Be resolute" in particular, whenever he felt tired, although he, too, appears to have been somewhat annoyed at the many obligations to use the quote during the Cultural Revolution.[24]

My life has been influenced quite a bit by Mao's thoughts. The *Three Constantly Read Articles* are telling you to "Serve the People" [为人民服务 *wei renmin fuwu*].[25] And this in itself is just like Christian or Buddhist thought, a kind of old faith, even a religion. You should not pay too much attention to yourself: that is what it says. Those *Three Constantly Read Articles*, the stories of the "*Foolish Old Man Who Moved Mountains*" [愚公移山 *Yugong yi shan*], of Zhang Side 张思德 [1915–44] and of Norman Bethune [Bai Qiu'en 白求恩, 1890–1939], these are really good stories. We remember them even now. Back then, we all knew them by heart. I had read these stories in middle school, long before the Cultural Revolution. Mao's writings are really important. Quotations like "Be resolute!" [下定决心 *xiading juexin*], yes, I would often use them. I remember situations in which I was very tired and really felt bad, and then, I said to myself, "Be resolute!" As for the loyalty dances and all that, I did not feel opposed to these things [反感 *fan'gan*], no, none of that! It was just a bit too repetitive, perhaps, because we had to sing the quotation songs all the time. We simply did not have the choice; that was the problem. It was too restricted. Mao wanted to restrict everyone's heart to loving the Communist Party! That was a bit too much. . . . (Musician, 1942–)

Again, these are very obviously subjective interpretations of propaganda art. Thus, the idea that propaganda art is totalistic in its univalence and forces its audience to interpret it in one and one way only must be questioned. Propaganda during the Cultural Revolution was not simply received in a reflex reaction, neither was it only used parasitically or subversively, but the reality was more a mixture of both (Bussemer 2000, 135). The audience responded as it did with all artistic products: everybody in his/her own way, critically as well as creatively, and most importantly, in a participatory manner. It is crucial to the experience of Cultural Revolution Culture that its propaganda art was not just received and reacted to, but it was formed and enacted by its audience. China's revolutionary propaganda culture was meant to mobilize average people, to give them a chance to participate in discussions and to create their own works of art: quotations songs, loyalty dances, portraits of revolutionary heroes, and the like. This populist streak released the energy and creativity of portions of the population against the atrophy of the Party bureaucracy and elitism.

24. His view was refuted by others who said that if one did not like to participate it was always possible to escape. See the interview quotes in Chapter 4.
25. This is the title of another of the *Three Constantly Read Articles*, discussed in more detail in Chapter 4.

Many propaganda campaigns thus ended up not depriving but enriching people's lived experiences by offering access to new forms of art and knowledge.

One such example is the Anti-Confucius Campaign (or the Campaign to "Criticize Lin Biao and Confucius" 批林批孔 *Pi Lin pi Kong*) of the early 1970s (discussed in Chapter 3). This campaign criticized Confucius and the so-called feudal age, and it found a contemporary target in Party leader Lin Biao 林彪 (1907–71), who was accused of having had couplets from the Confucian *Analects* hanging above his bed. Lin had been Minister of Defense and designated successor to Mao but had had a falling out with the Chairman after a coup he had allegedly planned against him was discovered. Lin's life ended in a deadly flight to Mongolia in 1971. The Campaign to "Criticize Lin Biao and Confucius" issued official orders for millions of people, including factory workers and peasants, to read the Confucian Classics. Yet, they would be thinking whatever they wanted to think, no matter what the propaganda messages were saying. One would take the criticisms for black humor (Journalist, 1946–). Another would say: "I did not believe in any of the criticisms. Of course, it was not all that clear to me, then. But I just thought their logic was really not logical at all 他们的道理没有道理" (Historian, 1957–). A third would be so fed up with criticisms in general that he would refuse to listen:

> During the Anti-Confucius Campaign, we no longer believed in the propaganda media. Although the idea was to criticize Confucius, it is well possible that during this movement some people read Confucius and learned some of the Confucian morals by doing so. But we, a group of friends and myself, we were not like that. We just did not believe in these stupid criticisms anymore. (Playwright, 1956–)

Indeed, quite a few of my interviewees were critical of bashing Confucius. This did not mean they began to like the Classics, however. One remembers:

> Since 1949 there had not been much teaching in the Classics. If we read old-style poems, they were those by Mao. As for the *Three Character Classic* [三字经 *Sanzijing*], I read it when it was criticized. The same with Confucius, Mencius [孟子 372–289 BCE].... I thought the criticism was stupid, but I also did not like the books themselves. (Writer, 1958–)

While quite a few were doubtful about the effects of the movement on the general public, others recalled that they learned a great deal:

> During the Anti-Confucius Campaign we would study a lot of original material, reading all these political criticisms along with it. The official take was, of course, very biased. We did not know much about these Confucian texts. Now, we knew what kind of a person Confucius had been, what his life had been like. I am not someone who does philosophy ... but because of this movement, one would have to study these things. I wonder whether the children at the time were interested in this, however, and influenced by the campaign. They had never even read the *Three Character Classic*, nor less the *Four Books* [四书 *Sishu*]. They might have come across some things from the *Three Character Classic*, like its famous beginning lines about the goodness of human nature [人之初性本善],[26] they might even have known some Confucian thoughts in their everyday lives, but really, I think, this movement did not change [people's minds] very much. In spite of the criticism, people continued to teach their children Confucian thoughts and the *Sanzijing*. The campaign did not really matter. (*Guqin* Player, 1940s–)

Many of these views are ambiguous, then: in spite of the strong official criticism of Confucian texts, some read them defiantly. At the same time, some expressed uncertainty whether younger

26. For this passage and its significance in Cultural Revolution discourse, see Chapter 3.

generations would have had a similar experience. Another interviewee, some fifteen years younger and thus a child at the time of the campaign, shares this pessimism about the "educational effect" of the movement:

> The classical Confucian canon, the *Four Books* and the *Five Classics* [四书五经 *Sishu wujing*], had become some kind of a forbidden fruit at the time. I never would have even dreamed of actually reading from it. And during the Anti-Confucius Campaign, too, it was presented just in bits and pieces; never did we read the whole. We did not know enough about these texts. As for this movement serving to popularize the Classics ... I really think this should not be exaggerated. Although some people studied the Classics in detail, the majority were just confronted with one quote and then asked to criticize it. In these big struggle sessions, people generally got to know no more of the *Three Character Classic*, say, than the beginning, the passage about human nature being good. So there was not a great influence on people generally. Of course, there were quite a lot of specialists and professionals involved in writing these criticisms. They had to really study the texts, but for the others, there was no need to do this. ... The influence on society generally was negligible, however. (Intellectual, 1955–)

However much local and individual experience may have differed, it is clear that despite the superficial presentation of the Confucian heritage to the general public during the campaign, as well as scant prior knowledge of this heritage in the younger generation, interest in and understanding of ancient Chinese literature and philosophy was nevertheless kindled in some. For them, the propaganda campaign had a reverse effect from what its creators/initiators intended. One interviewee remembers:

> This movement was critical of Confucius, true, but since before that movement we had not actually read any Confucian stuff, it was through this movement that we learned how important Confucius actually was ... we were blind, then, of course, but somehow I did not think he was really all that bad. (Artist, 1954–)

This view is echoed by a university professor (mid-1950s–): "The Anti-Confucius Campaign actually made us study these pieces. At that time I did believe the criticism. But on the other hand, I would also read the Confucian writings and sometimes thought, hey, that is actually quite true, and to have this kind of thought could not be forbidden." Another remembers, also quite positively:

> I participated in the movement; it was quite interesting. We got to talk about history. Mao wanted us to all study history and I actually became interested in history because of that. ... The discussions were very exciting, even more exciting than now, in a way, because everybody had to participate! We criticized and studied the stuff at the same time. But even while we criticized, we would realize that there is something valuable in all that, too. (Historian, 1957–)

The most telling example of the "educational effect" this movement had on some is a man who later became the director of one of the most important research institutions in China. The son of peasant parents, both of whom were illiterate, he would never have been able to attend school, much less study Chinese history and philology, had it not been for the Anti-Confucius Campaign when, as a member of one of the criticism groups made up of laymen and specialists, he received his training in the Classics, (Historian, 1949–). An illiterate peasant boy thus became a renowned scholar by means of an iconoclastic propaganda movement, and his is not a singular case. This may or may not have been the unintended effect of propaganda in modern China. It points to the ever-renewable reserve of agency and creativity in Cultural Revolution Culture itself. Cultural Revolution (and perhaps all) propaganda was received and experienced in many different, and often contradictory, ways by individuals from different generations and backgrounds. There was incessant activity among artists involved in the production of works of art for propaganda, to be

sure, but agency falls on the receiving end as well, where people were not always just frightened and restrained but also vibrant, pluralistic, and creative.

(Objective) Forms of Propaganda

Why was Cultural Revolution propaganda as it was enacted enjoyed as well as endured, liked as well as disliked? Why did Cultural Revolution propaganda not evoke more resistance? I suggest three possible answers to this question and give more detailed examples for each of these below. First, propaganda art was the most prevalent, but by no means the exclusive fare, of what one could hear, see, or watch during the Cultural Revolution. It was effective because it appeared as a dominant and constantly repeated element in a spectrum that was officially restricted but that, unofficially, allowed for quite a lot of variation. In terms of the population, propaganda art gave the people in the countryside, for example, more regular opportunities to experience cultural performances than ever before (or after) makeshift stagings of films, theatricals, and music;[27] the sent-down youth, and artistic troupes formed by them and others, too, served as (propagandistic) educators. Propaganda art, then, was successful because, in conjunction with non-official sources of art that would (continue to) circulate, it could enrich the everyday cultural experience of the average Chinese person. Despite the repressive lid of ideological constraints, the Cultural Revolution allowed for a vibrant, creative, and interpretative energy to be brought to life through a vast range of enactments and activities.

Second, it is significant that propaganda art made use of some of the most popular art forms such as Beijing Opera and peasant painting, in addition to selecting genres from high art such as ballet dancing or oil painting, artistic forms which were then popularized. It was this variety and the particular choice of genres favored by different groups in the population that helped make this art acceptable, while structurally, as I will show, it also contained quite a few of the elements characteristic of popular culture.

Third, and this is connected to the second point, the propaganda art of the Cultural Revolution was not an invention of the Cultural Revolution but made use of long-established predecessors that had been circulating for many decades. Almost all of the model works can be traced back to earlier versions. Mao portraits came to prominence at the latest during the Zunyi 遵义 Conference in the mid-1930s; political comics and anti-Confucius campaigns, too, had their roots in the early Republican era, as far back as the 1910s. In terms of techniques, the filmed model works employ methods from 1930s commercial films, especially the so-called *Southerners*.[28] Propaganda posters were painted by those who once created the famous *yuefenpai* (月份牌), large-scale advertising posters featuring Chinese beauties that were sold as trademarked calendars. Li Mubai 李慕白 (1913–91), a prominent artist of the successful Shanghai Zhiying Studio 稚英画室, became an extremely productive painter of propaganda posters (continuing to paint, essentially, the same genre of painting) in the 1950s and early 1960s, as did Jin Meisheng 金梅生 (1902–89), another of the more famous calendar painters.[29] In the words of Ellen Laing: "Under the new regime, those who once made their living designing advertisements for commodities or services now drafted posters promoting socialist ideology. Thus, the type of realism perfected for 1920s and 1930s

27. For example photographs of cinematic performances, see DACHS 2009 Cinema Performances in the Countryside. See also the reports especially in Du 1996, ch. 3.

28. Kristine Harris has a forthcoming manuscript in which this argument will be made. See also Harris 2010.

29. Laing 2004, 198 and all of Chapter 10. See also DalLago 1999. For Jin see DACHS 2009 Landsberger: Jin Meisheng.

advertisement pictures did not disappear after 1949, rather it endured as the dominant style for brightly colored placards selling optimistic socialist and political themes" (2004, 224).

Cultural Revolution propaganda thus referred back to a long history of "pre-propaganda" (Ellul 1965, 15), and this contributed to its enormous success during and after the Cultural Revolution. Although attitudes do not immediately "change with the initial stimulus of some new information" (Qualter 1985, 81), the propagemes that mark the Cultural Revolution had become so deeply rooted in cultural memory long before 1966 that it would not have been easy to eradicate them even then, much less after the Cultural Revolution. This, too, is one reason for their continuing popularity.

Variety and Availability: Art as Education

It is a common assumption that the Cultural Revolution was a period of unprecedented cultural stagnation. Eight so-called model works (样板戏 *yangbanxi*) are taken as paradigmatic for the whole of Cultural Revolution Culture (Chapter 1), and these model works are condemned as an aberration in terms of aesthetic and cultural development. And yet, the idea that the Cultural Revolution was simply an atypical phase of political extremism, distinct from the years before and after this "unfortunate period," is misleading, especially in terms of artistic production and reception. The notion that Cultural Revolution Culture produced nothing but the "eight model plays" (a phrase for the model works used ironically in Wang 1997, 196, cited above) is historically inaccurate.[30] Although during the Cultural Revolution all artistic production was subject to extreme political regimentation, and only certain correct colors, forms, and sounds were officially acceptable, it turns out that there was a substantive difference between what was officially acceptable and what was freely available.

One artist, born in 1954, mentioned that he regularly played the *Butterfly Lovers Violin Concerto* 梁山伯与祝英台, a romantic piece based on local operatic tunes and composed in 1959 by Chen Gang 陈刚 (1935–) and He Zhanhao 何占豪 (1933–). The piece was officially condemned during the Cultural Revolution because it told a story based on romantic, individual love, not love for the Party and the Communist cause. Quite apparently, what was true for music (see Chapters 1 and 2) in terms of restrictions and their enactment was true for literature as well (see Chapters 4 and 6). One journalist, born in 1946, remembers that she would read traditional stories in the form of comics during the early years of the Cultural Revolution:

> I read all these traditional comics, although they were no longer published by then. As for the revolutionary comics, I did not read them; they were not that nice [不好看 *bu hao kan*]. Also, they were the only thing one was officially allowed to read, so this was quite boring [单调 *dandiao*]. (Journalist, 1946–)

A younger historian (1958–) would remember veritable "reading orgies" with stolen books: "We (especially the Red Guards) stole books in the library and then we would exchange these books, reading them in secret: we felt so great when we did it, but also a bit scared."[31] One musician, born in 1942, had included an old Tang poem in his black-and-white photo album, which he showed me: "Of course we would memorize these poems during the Cultural Revolution." Another

30. Eight model works were available in 1966; during the rest of the Cultural Revolution, another ten works were added to the set. See the discussion of this stubborn misconception in Chapter 1.
31. For further examples, see the quotes at the beginning of the Prologue to Part II.

remembers that he and his friends whiled away their time as sent-down youth in the countryside copying poems:

> I would copy all of these poems. A lot of my friends, too, would do that. This was around 1972/73. I would actually copy two or three books full of poems. This would make you forget your difficulties: in your mind, you had these poems. In a book on memoirs by sent-down youths that I have read,[32] there is a very interesting story that deals with Mendelssohn: the sent-down youth in the story really believes in Mendelssohn. He is like me writing these poems; he works in the fields and at the same time, he is thinking of all this romantic music. He talks about how he can forget everything when he thinks of this beautiful music: this is exactly like me. This type of situation is probably quite common. (Language Instructor, mid-1950s–)

There were those who watched foreign films (Librarian, 1950s–), others who listened to the Beatles, and almost every (sent-down) youth would carry his or her collection of *200 Famous Foreign Songs* (外国名歌二百首) with them. One such sent-down youth gives a very comprehensive description of various cultural activities in the countryside:

> This understanding of China as insular during the Cultural Revolution is total nonsense. There were all these international fashions that we were involved in: the Beatles, or singing the *200 Famous Foreign Songs*. My sister would teach me all that, we would sing Malaysian folk songs, too, basically anything sentimental. I read *Huckleberry Finn* and *Tom Sawyer* then. I was starting to learn English. Someone had given me a simplified version. Indeed, I remember reading quite well, because there was no electricity.
>
> When we were in the Northeast, you could only work six months of the year; during the other six months, it was so cold that you could not do anything. So we were reading tons of novels, all shipped from Beijing. We would bring them with us, and there was a big exchange going on: we read all these French or Russian novels. Everybody was reading this stuff, even in English, indeed, about half of my mother's library was taken by my brother. He loved *Wuthering Heights*, for example. So we would come home to visit, and then we would take books back. We could not take back records or music, so there was no music in the countryside, except singing. This is perhaps why we developed such a passion for singing: everybody sang. . . . The peasants loved our singing, and we sang everything for them. I will never forget one brilliant evening, with so many stars, when we were sitting around, playing our guitar and our harmonica and accordion and singing along. The next day, a peasant came and said it was the best singing he had ever heard in his life. (University Professor, mid-1950s–)

Cultural life, then, was quite varied, both in the cities and in the countryside, and contained a mixture of Chinese and foreign elements. One historian (born in 1949) who had grown up in the countryside, the child of illiterate peasants, mentioned the regular visit of a storyteller:

> In the countryside, there were quite a few storytellers. They would come around and stay for five to eight days or so. They did this and there were no restrictions, nobody interfered. So it is not really true to say that all of China's tradition was destroyed during the Cultural Revolution. Because China is so big, it was not possible to actually control everything and know exactly what was going on. You could perform all kinds of things, and nobody would know it. Often there were blind men as storytellers. The whole activity was organized by the village; they gave him a place to stay and eat, etc. Nobody interfered. Tradition had not been broken off then; they simply could not manage to do that.

What these examples illustrate is that official attempts to manipulate (and thus delimit) precisely the choice of cultural resources available during the Cultural Revolution (a fact constantly

32. He refers to Zou 1998, 156–60.

mentioned—with regret—in the interviews), were not entirely successful. Officially, in the years between 1965 and 1971, traditional themes and techniques in opera, literature, comics, and painting as well as foreign "capitalist" or "revisionist" art were no longer readily available (that is, for sale and in officially sanctioned open performance). This situation only changed with the beginning of Ping-Pong diplomacy in the early 1970s. Foreign orchestras were now allowed to travel to China again, and many an artist specializing in traditional painting styles and condemned in the early years of the Cultural Revolution was asked to come back from his re-educational sojourns in the countryside to create "Hotel Art" (旅馆艺术) (see Chapter 5): works for foreign guests who should be impressed with the exquisite qualities of traditional Chinese culture.

Yet, although there were harsh restrictions on the propagated official culture throughout the Cultural Revolution, manifold local and private cultures continued to exist both in urban settings and in the countryside. These have yet to garner enough attention in the scholarly literature, but they are nevertheless testimony to an important form of reciprocal learning and, as such, they stand as a significant backdrop for the experience of Cultural Revolution propaganda art. One sent-down youth remembers the Shanxi countryside as follows:

> There was a lot of music performed in the countryside—local operas [地方戏 difangxi] as well as folk songs [民歌 min'ge]. In the early years of the Cultural Revolution, people did not sing the folk songs so openly because of their content: Love and sex and these kinds of things were not supposed to be there. So they would just create new words for a song and make it into a revolutionary song. I really feel that it is too bad that I did not record these songs. The Shanxi folk song is a very old form. And I would never have known anything about these songs had I not been there, so really, not only did we teach the peasants, the peasants also taught us a lot.

> We ourselves would not be so arrogant to say we really "transmitted culture" to them, but in fact, for example, if we go back tomorrow, they would still remember who said what back then, some 30 years ago now! When I was there, I had bought this harmonica, and I also played the violin. Once I did it, an old peasant woman would come out and say: now this instrument sounds so much better than the other. I was just playing my violin with no teacher, so, of course, it did not sound all that great, but still, she heard a difference! In the countryside, I would play whatever, they did not know what I was playing. (Intellectual, 1955–)

His memories, and his description of mutual learning, tally quite closely with those of two interviewees sent to the Northeast, although their evaluation of what they learned from the peasants differs slightly:

> We were a great influence on the peasants. Of course it depends from what point of view you are looking at it. They would sing, for example, they had this special Northeastern type of melody. To the present day, I still remember this atmosphere [气 qi] and all that. On the other hand, they would listen to the model works and all of these songs that we brought with us and that influence on them, in turn, was quite deep, too. (Husband, 1950s–)

> It was very seldom that we would watch films, but we were actually faced with the culture that was there, in the countryside. There was a propaganda team [宣传队 xuanchuandui], too. They would perform the model works and revolutionary songs and all that. But most of the cultural activities were really organized by us youths. We sang extracts from revolutionary compositions, like the Long March Suite [长征组歌]. And we made quotation songs. In all this, we were kind of the teachers for the people in the countryside. And we would introduce all these new thoughts and ideas to the children of the peasants. We would teach them the songs and all that. Their education actually improved because they had these students from the cities [as their teachers]. Their world view was broadened because of us. Yes, their consciousness was really broadened. Of course, we did not really have proper teaching materials, but there was all this revolutionary material that we could use. Anyway, they did not have

any of the special knowledge from the cities. It was really useful for them. I actually taught them [the children] music and how to sing. They did not teach us anything; we taught them everything. Of course, the old people sang folk songs, so-called mountain songs [山歌 shan'ge] for us, for example. I never saw a performance of local opera there, however. Indeed, most of the performances were put on by us for them. (University Professor, mid-1950s–)

These memories by sent-down youths are matched by those of a China historian (1949–), who had grown up with peasant parents in the countryside: "In our village there were very few people who could read and write, and the sent-down youths actually taught us. They also danced and sang, so the cultural aspect was also positive. So, for the youngsters in the village, myself included, this was really good. These youths, they brought some comics, also some translations, so you could get these things from them. And they really understood something about music, too, so we would sing together." According to this evidence, it appears that cultural life during the Cultural Revolution was not "all of the same kind." In the words of one interviewee who is an artist today: "You can say a lot of bad things about the Cultural Revolution, but in terms of culture, there was a lot to be offered and learned" (Artist, 1954–).

There was quite a lot out there, then, apart from the official propaganda art, and furthermore, official propaganda art served to introduce both popular and high art forms to those who had never been exposed to them before: however superficial their impressions may have been, through propaganda art, urban youth learned about Beijing and local operas; peasants, on the other hand, learned about ballet and symphonic music.[33] There may have been skepticism and misunderstanding, but propaganda art helped to broaden the horizons of both urbanites and peasants. One sent-down youth remembers:

[The symphonic version of] *Shajia Village* [沙家浜 *Shajiabang*] had the effect of bringing people in the countryside into contact with symphonic music. When I was in the countryside, I also experienced how a piano was carried to the fields, for a performance of the *Red Lantern* [红灯记 *Hong Dengji*]. But from my point of view and from the artistic standpoint, in the end, there was not a lot of exchange. The peasants were not told, "This is a symphonic orchestra," or "This is a ballet." But of course, when they would not understand, they would ask. (Intellectual, 1955–)

Propaganda and Pop: Art for Entertainment

The cultural experience of the Cultural Revolution, both through the official propaganda art and through the unofficial clandestine spread of other forms of art to and from the countryside, could thus be educational. To some, it was entertaining, too:

We had lots of opportunities in these propaganda troupes. When we went to the countryside, our connection with the peasants was very good. The leaders wanted us to learn from the peasants, and we did learn some things. But not that much. I for one just painted and read books all the time. It was really fun. (Artist, 1954–)

One of the reasons for these very positive responses was the fact that almost everyone was involved with creating and thus embodying this cultural experience (in reenacting the model operas, singing songs, painting portraits of Mao, or drawing comics, etc.), while not necessarily accepting the propaganda messages outright but reformulating them within his or her own context.[34] It is not

33. See some of the testimonies from interviews in Chapter 1.
34. Gries 2005, 16, 18.

a given that "action makes propaganda's effect irreversible" (Ellul 1965, 29). But it has been argued that "he who acts in obedience to propaganda can never go back. He is now obliged to *believe* in that propaganda because of his past action. He is obliged to receive from it his justification and authority, without which his action will seem to him absurd or unjust, which would be intolerable" (Ellul 1965, 29). Although some of the embarrassment evident in statements on enjoying propaganda art seems to point to the fact that indeed, these actions do now seem absurd and, more importantly, "unjust and intolerable," one should also acknowledge that some consumers of Cultural Revolution propaganda derived pleasure even from a text whose ideological message they did not share or accept.

The divide between control and freedom was not as clear as it might first appear: the conception of propaganda along two alternatives—manipulative top-down control and individuals' subversive initiatives to bend it to their own purposes—misses the mobilized, inspirational, and populist character of a long tradition of propaganda in China. A rigid binary that affirms the Chinese saying, "There is policy above, and agency below" (上有政策，下有对策)[35] is too simplistic to explain the workings of Cultural Revolution Culture. A large portion of this art and the cultural experience of the Cultural Revolution generally, I will argue, was in fact based on self-organized, self-initiated grassroots activity, not simply following top-down decrees. People and artists are and were on productive and receiving ends of cultural processes: Cultural Revolution Culture is popular culture.

As shown above, what people make of propaganda is just as unpredictable as what they make of any other artistic "text" in spite of all the overdetermination worked into propaganda by the ideologues. The public will either appreciate propaganda art's aesthetic qualities or criticize them; they will either notice its political content or ignore it. This ambiguity and openness in reception explains some of the after-effects of Cultural Revolution propaganda art, which has come to be appreciated not just by those who have nostalgic memories of performing (and having fun with) it and (dis-)believing it during their youth, but also by a younger generation who never went through the Cultural Revolution at all. This younger generation, now singing Karaoke, rapping and rocking to the revolutionary songs and model works, figures prominently in a 2005 documentary on the model works (*Yang Ban Xi* 2005). It is also the generation that invited, in 2007, a group of musicians playing and dancing to Mao quotes including "Be resolute" as entertainment for their wedding celebration (vid. 0.1). A musician born in 1942 deliberates:

> My generation likes the model works, they are our youth. Yes, there are people who dislike them, too, but we really do like them. Indeed, when I was young, eighteen or so, I needed art so much, we all did. And then, there were just the model works as our food, and we actually thought they were quite great. Jiang Qing used really good performers, writers, artists, and musicians. Of course, this was propaganda for Mao's thoughts, but it was also simply good art. It is all against these imperialists and their attacks, yes, but it is also good art, really. (Musician, 1942–)

Another would judge similarly, a third would even say that his son demanded that he sing model works from time to time, while a fourth is more skeptical that the younger generation could be attracted to the model works:

> During the Cultural Revolution, we would sing some of these popular songs, the *Long March Suite* [长征组歌], for example, and some of the model works, too. I liked them a lot. Of course, there was nothing else, and they may even be rather crude artistically, but I liked them, nevertheless, especially *Azalea Mountain* [杜鹃山 *Dujuanshan*] and *Red Lantern*. In fact, I liked the operas best. And even now, there are still quite a lot of people who like the model works! (China Historian, 1949–)

35. I thank Wang Ban for this idea.

During the Cultural Revolution, I was told: "Why don't you study a little bit of Beijing Opera." And so I did . . . I can still sing some of the arias. My son often calls on me to sing them. (Intellectual, 1958–)

The model works now still have an audience, but it is all people like us. It has nothing to do with their artistic value, it is really only nostalgia. Very few actually consider them art; most who go to see them do so for different reasons. It is a phenomenon similar to the sent-down youths' restaurants [知青餐厅 zhiqing canting]. The younger generation will find this very strange. They will not like the model works. Even if some may carry Mao buttons, the model works will not appeal to them. (China Historian, 1957–)

The subjective *pleasure* which some of these contemporaries experienced while watching the model works, then, may be derived from sources that have nothing to do with the original message or artistic quality of the art work at all (Bussemer 2000, 69). One artist, documented in *Yang Ban Xi*, remembers how much he liked to watch the model ballet *Red Detachment of Women*, not for its political content but because the women were wearing extremely short shorts and he thought this was very sexy (and this may have been Wang Yigang's association, too, in surrounding Yang Zirong in his painting with symbols of female sexual maturity, see ill. 0.2). Another of the model ballets, *Children of the Grasslands* (草原儿女 Caoyuan ernü), features a dance in which one can even see under the girls' skirts.[36] There are those who would deny such readings,[37] or who would argue that "of course they are sexy, but in the type of context in which we were brought up then, we would not actually think of that" (Playwright, 1956–). Yet, examples like these may explain—in opposition to the predictions made by the China historian quoted above—why the generation born after the Cultural Revolution, in a kind of "Art Retro" Movement, also finds some of the art and culture of the Cultural Revolution fascinating, why they flock to Cultural Revolution restaurants, why they buy expensive collections of the model works and Red Sun CDs with remakes of revolutionary songs in praise of Mao, and why they visit Cultural Revolution flea markets. When it comes to Cultural Revolution propaganda, the concept of *pleasure* as well as ideas about forceful seduction and brainwashing manipulation have important explanatory power. What we observe, then, is semiotic competition for the interpretative power of propaganda. Some people continue to engage in it, even today, for very different reasons—to relieve themselves of its trauma or, quite contrarily, to relive its fun. Messages and contents of propaganda are being negotiated between those who created the propaganda and those who receive it. Clearly, the makers of Cultural Revolution propaganda art were well familiar with the rules of how to make art popular.

Because they understood that the medium was not the message, but that the medium in fact "changes the number and variety of messages and the character of the audiences" (Qualter 1985, 196), and in order to draw in as many audiences as possible for their propaganda art, the message would be packaged in as many media as possible, ranging from revolutionary operas to ballet, from symphonic music to oil paintings—successfully, so it seems. As Fiske puts it: "A popular text, to be popular must have points of relevance to a variety of readers in a variety of social contexts, and so must be polysemic in itself" (Fiske 1989, 141). In order best to address itself to the crowd and be effective, reiterates Ellul, popular art (and propaganda) "must touch each individual in that crowd . . . it must give the impression of being personal, for we must never forget that the mass is

36. For a discussion of sexual elements in the model works and other model art during the Cultural Revolution, see Chapters 1 and 6. See also Chen 2002, 37, 116; Kim 2005, 253; and Roberts 2010. A rather mistaken view in this regard is voiced in Yang 1999. She takes prescribed asexuality at face value.

37. One artist couple (He, 1954–; She, 1959–) was quite adamant about this sexual reading being unacceptable. He: "Nobody would be thinking that way." She: "No, really, nobody would have such thoughts The people and their thoughts at the time were very healthy [健康 jiankang], nobody would think of sex, they were all thinking of the story."

composed of individuals, and is in fact nothing but assembled individuals." Therefore, "all modern propaganda profits from the structure of the mass, but exploits the individual's need for self-affirmation" (1965, 7–8). By creating a propaganda art that advocated the same message in a myriad of different cultural registers, genres, and forms (see Bussemer 2000, 78), the Chinese state, in its attempt to prevent the creation of popular art from below, produced precisely such art from above, and—judging from hindsight—it did so rather successfully.[38] One young photographer, then, a schoolboy during the Cultural Revolution, describes the propaganda art of the Cultural Revolution as popular culture:

> Things that are popular [流行 liuxing] must really be rather low art, because they are for a lot of people ... and this is what Jiang Qing wanted: she really did not want high art in that elitist sense. And therefore, the model works serve the same function as the pop songs [流行歌曲 liuxing gequ] do today. Before, their being popular was manipulated, the real popularity comes from the people, of course. (Photographer, 1960–)

Chinese propaganda art is successful, even if it is read today as well as in the past, in ways that were not intended. The state's claims for Chinese propaganda art are twofold: it aspires to be popular art and high art at the same time. In his Yan'an Talks, Mao rages against a crude poster and slogan style (Mao 1942), arguing that art's artistic value is dependent on how well it "serves the people" (为人民服务 wei renmin fuwu).[39] By nature of this ideology (and in complete negation of any Benjaminian or even commonsense theory),[40] the more popular the art work, the higher its artistic achievement—regardless of its artistic quality. State engagement in entertainment culture during the Cultural Revolution was an attempt to establish a monopoly on popular culture. State propaganda culture is therefore determined less ideologically than structurally. As in Huxley's Brave New World, in the art of the Cultural Revolution "there are no masterpieces, for masterpieces appeal only to a limited audience" (1965, 43); the propagandist, by contrast, has to reach as many people as possible. And indeed, each of the main heroes in the model works, such as Yang Zirong 杨子荣 in Taking Tiger Mountain by Strategy or Fang Haizhen 方海珍 in On the Docks (海港 Haigang) (ill. 0.1) or Hong Changqing 洪常青 in Red Detachment of Women (ill. 0.2), are each one of them more of a Superhero than a Hamlet. Compared with popular and mass culture rather than elite art and culture, Cultural Revolutionary propaganda art begins to make sense. As Fiske tells us, popular culture tends to be "excessive," its brush strokes "crude," its colors "striking." Its overabundance calls on those who reject and despise popular culture to say that it is "vulgar," "melodramatic," "superficial," "sensational," and "transparent" (1997, 74). All of these are descriptions that would fit easily the art of the Cultural Revolution as well. According to Fiske, the broad consumption and, at the same time, broad condescension toward a cultural product is usually evidence of its popularity (1997, 67). He explains this by taking the example of popular language: we may sigh over simple word games, he says, but we will still be amused. If Cultural Revolution propaganda is criticized for its lack of aesthetic value, this is because, when seen from the vista of "high culture," it lacks precisely that. The rhetoric of the "deficient character" of cultural products from the Cultural Revolution is identical to the critique high culture habitually offers of popular culture (Fiske 1997, 76). And popular culture is exactly what Cultural Revolution Culture is and aspires to be. It is just as effective as popular culture because it is, after all, nothing but popular culture (Fiske 1997, 76; Edelstein 1997; Snow 2010).

38. The Nazi State was similarly successful with projects such as Deutsche Arbeitsfront or Kraft durch Freude, which were offerings from above tailored to become popular below (Bussemer 2000, 78).
39. See Wang 1997, 210; Bussemer 2000, 96.
40. Benjamin 1963.

Continuity and Repetition: Art in History

According to Ellul, propaganda can only be effective when it is applied over a long period of time (Ellul 1965, 18). Taking the Mao Cult as one example, we can see a continuity of more than half a century. At least since the 1935 Zunyi Conference, Mao had become the main leader of the Chinese revolution. Symbolic affirmation of this fact is given repeatedly and on various platforms and media: with the adoption of the folk song turned revolutionary song, "Red is the East, rises the sun, China has brought forth a Mao Zedong" in 1942 (see Chapter 2),[41] with the decision to make "Mao Zedong Thought" part of the constitution in 1945 (see Chapter 4), and with the erection of Mao statues in public institutions and places since 1949. Mao's portrait, permanently installed on Tian'anmen since 1966, continues to play an evolving but ever-propagandistic role (see Chapter 5). According to Ellul:

> Continuous propaganda exceeds the individual's capacities for attention or adaptation and thus his capabilities of resistance. This trait of continuity explains why propaganda can indulge in sudden twists and turns. It is always surprising that the content of propaganda can be so inconsistent that it can approve today what it condemned yesterday.... Actually it is only an indication of the grip it exerts, of the reality of its effects. We must not think that a man ceases to follow the line when there is a sharp turn. He continues to follow it because he is caught up in the system. (1965, 18)

These observations are directly relevant with regard to the Mao Cult (see Chapters 2, 4 and 5). To the present day, even under an exceedingly non-Maoist policy of "socialist capitalism," Mao plays an increasingly important role. Reverence and love for Mao is, paradoxically, also voiced by those who suffered most during the Cultural Revolution and the years preceding it. Some of them even say that during the Cultural Revolution, a time of mutual distrust and slander, people were more honest and altruistic than they are in today's egotistical world, where every individual is for himself and exclusively interested in his own profit, and all former communal values have been lost. Others argue the opposite and see the decline of moral values rooted precisely in the Cultural Revolution:

> At that time, we were studying the heroic image of Lei Feng [雷锋 1940–62].[42] Our value structure was all about communal cooperation and altruism, about the other and not the self. During this time in the Cultural Revolution, what Mao Zedong really fought against was the self—the Cultural Revolution was a campaign to fight the self [斗私运动 dou si yundong]. You cannot just think about yourself, because our country is really dependent on our being unified. From when we were very small we received this kind of education and values; it was Mao who gave us these ideals and values. His *Three Constantly Read Articles*, we had to learn by heart—and we did so when in the countryside. (University Professor, mid-1950s–)

> I had to go there and tell the student leader that it is no good if you beat your teacher. You should not lead the younger students to beat the teachers. So I went there and said: "Mao instructs us that one should not beat and curse others" [毛主席教导我们说: 不能打人骂人]. He said: "I did not beat him." I said: "But I saw you beat him." He said: "He is not a human being, thus I can beat him." This kind of destruction [破坏 pohuai] of human values is something that happened throughout the Cultural Revolution, and its influence is still felt today. Today, there is no reverence for teachers and superiors anymore. Society has lost this value. (Musicologist, 1922–)

41. See DACHS 2009 Dongfang Hong Red Is the East, original words.
42. A more detailed discussion of Lei Feng is found in Chapter 4. For image material on Lei Feng, see DACHS 2009 Landsberger: Lei Feng.

Although each of these speakers comes to a different conclusion as to the significance of the Cultural Revolution on the development of altruistic values in Chinese society, in both cases, Mao comes to stand for the old and cherished values in a world gone by and, increasingly, he becomes the glue that holds Chinese society—disintegrating quickly with the effects of "socialist capitalism"—together, after all.[43] Not a particular message but a particular feeling is associated with Mao, the most prominent and long-lived symbol of Cultural Revolution propaganda art. What Ellul writes about the effects of propaganda is absolutely true for Mao: "It is no longer to change adherence to a doctrine, but to make the individual cling irrationally to a process of action. It is no longer to lead to a choice, but to loosen the reflexes. It is no longer to transform an opinion, but to arouse an active and mythical belief" (1965, 25).

Propagemes like Mao, his image, and his words, grown and consolidated over time, represent and serve very basic timely and culturally dependent needs. They are not only what they appear to be, but much more: symbolizations. As shared formulations, they are attempts to express particular (and changing) emotional, cognitive, and mental needs (Gries 2005, 32). Mao, the propageme, serves to fulfill people's need for security, for example. The repetitive use of the propageme creates a feeling of trust. Through the propageme, a framework is established that makes it possible for Chinese society to stick together (Gries 2005, 31–32). Daily invocations of Mao provide a "moral economy" for assessing and understanding the present. Many recall the days under Mao as "a time of employment security, clean government, and relative social equality," therefore, and even though they have "equally vivid critical reminiscences of cadre tyranny, grinding poverty, violence, and fear inflicted by political campaigns," they will stick to their hero (Lee and Yang 2007, 7–8). One journalist explains:

> There are many reasons for the Mao Fever today. One is the fact that we still have a lot of very poor. They always loved Mao: he was for a very egalitarian society. They of course are nostalgic for that time because it was more egalitarian then; now the differences are much, much greater! (Journalist, 1946–)

A musicologist who is a few years his junior reasons:

> Are people nostalgic for the equality [they experienced] during the Cultural Revolution? Yes, I think so! . . . The relationships between people at the time were much different from today, there was much greater social cohesion, and the workers were really considered very high in the hierarchy, because of Mao. They did not eat better than now (indeed, worse), but their position in society was much better then. Now, their position is just like before 1949, so it is understandable that people have this kind of nostalgia. But I also think it is very dangerous. (Musicologist, 1950s–)

A Shanghai musician, slightly older than the two, reckons:

> Why is Mao popular again? Well, it may have something to do with the massacre on Tian'anmen . . . We realized that in spite of Deng Xiaoping's reform policies, there would still be political trouble. In Mao's time everybody was the same, everybody wore the same clothes. But now, everybody is different, of course, now everybody has a telephone, etc., but so many people now have much, much more than others, so those remakes of revolutionary songs in praise of Mao, for example, are in part nostalgic. (Musician, 1942)

43. Chen (1999, 19) also relates positive attitudes toward Maoist times: "When asked about the impression they had obtained of the Cultural Revolution from their parents, young people described it as an era when people were sincere, passionate, and enthusiastic about their ideals. The parents characterized the period as free, one in which drugs and prostitution were unknown, with low and stable grocery prices, a low crime rate, and more honest officials."

The new Mao (and Cultural Revolution propaganda) Cult that has been blooming since the late 1980s is not just a popular movement; it is more or less openly supported by the Chinese government. What Mao and Cultural Revolution propaganda art actually mean to the individual is not immediately relevant to this movement, however. Mao is thus recognized for all his worth by different communicators and audiences within Chinese society: as a semantic marker, a mediator for things that may indeed have very little to do with each other (Gries 2005, 22).

Propaganda as Art

In a study on propaganda and opinion control, Terence Qualter writes:

> It is always difficult to discuss propaganda objectively because the pejorative connotations of the word in English have largely reduced it to a device for destroying the credibility of opponents. Arguments labeled propaganda can be dismissed as invalid, dishonest, and unworthy of further attention. Charged with being propagandists, we tend to go on the defensive, denying the accusation. (1985, 107)

In this book, I attempt to deal with art and cultural products that have been conceived precisely under this negative label "propaganda," with all its baggage. I am aware that some of the arguments put forth so far—arguments trying to understand the long-lasting impact as well as the popularity of propaganda art from the Cultural Revolution, or simply trying to reconceive this propaganda as art—can easily be misunderstood, because the "reconstruction of a fascination" undertaken here is easily mistaken for a "fascinated reconstruction" (Felbinger and Scherl 2005, 126). It by no means is, however. In this book, I do not intend to deny or beautify the horrors of the Cultural Revolution. All I try to do is to add to the exclusively negative understanding of "propaganda" an alternative reading which, in combination with the first, might do better justice to the complex experience of Cultural Revolution Culture: during this time all officially produced and accepted art was "propaganda," but this does not preclude the possibility of propaganda being "art," too.

In this book, therefore, I am interested in understanding the mechanisms that make the propaganda accompanying this period attractive, because present-day Chinese politics, and more importantly for this study, the everyday experience of life in China are determined by this very propaganda. Jung Chang 张戎 (1952–) in her voluminous biography of Mao entitled *Mao: The Unknown Story* (Chang and Halliday 2005), which was extremely well-received in the popular media worldwide, nowhere addresses this issue.[44] Few Sinologists would disagree with the fact that the main figure in her book, Mao Zedong, was a political leader who led his Party comrades, and then the entire country, through a series of cataclysms. And still, many specialists would declare the book to be, as Thomas Bernstein aptly put it, a "major disaster for the contemporary China field" (DACHS 2006 Bernstein, Thomas). They would do so not because it introduces a story as "unknown" that has long been known. They would do so because Mao the "monster" is not a figure which, in the minds of contemporary Chinese, is the most privileged and prominent reality. This is so in spite of the fact that the many horrors mentioned in the book have been known in China for quite some time. What Jung Chang forgets in her very angry attack of Mao "the monster" is the fact that this "monster" Mao is not the only relevant Mao to contemporary China; he remains, for many, the symbol of an egalitarian, altruistic past, a past which has only recently been buried with

44. For a number of critical reviews, see the selection in the Heidelberg Digital Archive for Chinese Studies (DACHS 2007 Mao, the Unknown Story).

the victory of "socialist capitalism." This is why Mao appears as a star in many blockbuster movies and pop songs (see Chapter 2 and ill. 0.4), why he can function (with his successors Deng Xiaoping and Jiang Zemin 江泽民 (1926–) as a New Year's god, and why he can serve as a talisman for taxi drivers, hanging from their mirrors (see Chapter 5, **ills. 5.77** and 5.76 respectively). Not everyone is happy about this:

> The fact that the taxi drivers do this is quite annoying. It all depends on how you see the Cultural Revolution. We have been treated badly by Mao, so we are not for this kind of behavior, really. But quite a few, especially the young people, and especially workers and peasants who have not read any books and who don't know how to think, they seem to think that times were better under Mao, and even these intellectuals, the new Left—they, too, are saying that the Cultural Revolution was good 文 革好. Really, they are all too romantic. (Editor, 1930s–)

Not only to these "romantics," as this editor calls them, Mao "the monster" and Mao "the man" have somehow become decoupled, a phenomenon one could observe with Adolf Hitler (1889–1945) in Nazi Germany, as well. The sentence "Wenn der Führer das wüßte . . ." (If our leader were to know of this . . .) is evidence of this (see Bussemer 2000, 121). Similarly, Mao "the man" is not made responsible for many of the things that Mao "the monster" actually did. Why this is so and what this means—these questions and thoughts never occur to Jung Chang. She does not ask why a man, Mao Zedong, and the propaganda of his time, a time of extreme cultural repression, remains so popular even today. It is the riddle this book sets out to unravel.

It approaches this riddle not from the point of view of political science, sociology, or historiography, however. Instead, it takes the aesthetic experience of the Cultural Revolution as its base. In trying to "make sense" of Cultural Revolution propaganda art, it does not question propaganda as art so much as it probes its functions, both for the artist and for the audience, and its impact. This is something that was once suggested in an interview by Liu Chunhua 刘春华 (1944–), painter of one of the most famous portraits of Mao, *Chairman Mao Goes to Anyuan* (毛主席去安源) (see **ill. 5.1**), seen incessantly during the Cultural Revolution:

> *How would you evaluate Chinese revolutionary art, or art that expresses revolutionary themes, and its place in the history of Chinese art? Some consider that these are only forms of political propaganda; others believe them to be masterpieces of twentieth-century Chinese art. What is your view on this?*
>
> I haven't really given this question much thought. People of later generations will have a different evaluation, but the facts of history will remain the same. From the time the Communist Party assumed political power and established the People's Republic of China, under the leadership of Chairman Mao and other party leaders, creative work in literature and the arts was carried out according to the proletarian revolutionary line; over the decades a large number of such works were produced. I don't think these works can be overlooked or disavowed. They are the expressions of the sincere emotions of the artists who worked during those years and under those historical conditions. At the same time, regardless of whether we are talking about them as a reflection of history or of real life, what they express are facts. Of course, those works that are able to stand the test of history must be sincere, regardless of whether their style is traditional or modern, realist or abstract. What value a work of art has in the long flow of history is not something I can judge. But if it has character, if it has unique characteristics, if it has had an impact, then it is certainly exceptional and worthy of praise.[45]

As a study of the function, impact, and consequences of propaganda art, this book looks at and plays with the "senses" as it deals with the perceptual, sensory, emotional, and physical encounters with the cultural products of the Cultural Revolution (Wang 1997, 7). In three parts comprising

45. The interview with Liu is published in Zheng 2008, 129.

two chapters each, the book covers the ears, or musical aspects (in a discussion of revolutionary "MaoMusic," or songs in praise of Mao, and the importance of foreign-styled and traditional Chinese music in the model works); the mouth, or literary aspects (in a study of the uses and abuses of Mao Zedong Thought or "MaoSpeak," and of the childhood primer *Three Character Classic* during, before, and after the Cultural Revolution); and the eyes, or visual aspects (in a discussion of "MaoArt," i.e., Mao portraits, and Cultural Revolution comics and their significance). The Introduction and Conclusion are patterned after the nose and the hands, signifying smell and touch, respectively, introducing at first some "odors" or ideas on art, propaganda, and popular culture, while touching ground at the end with a number of deliberations on the importance of time (periodization), space (locality), and techniques (grammar) in the experience of Cultural Revolution Culture.

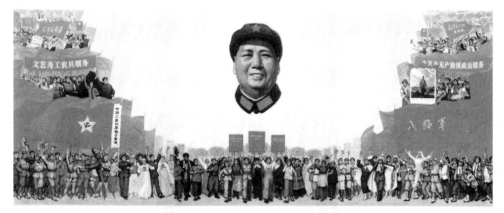

Ill. 0.5. *Moving Forward, Following the Victory of Mao's Revolutionary Line in Art and Literature—* a propaganda poster with emblematic examples of Cultural Revolution Culture, 1968 (Cushing and Tompkins 2007, 101).

A 1968 poster entitled *Moving Forward, Following the Victory of (Chairman) Mao's Revolutionary Line in Art and Literature* (沿着毛主席的革命文艺路线胜利前进) (**ill. 0.5**) shows a huge parade of happy people, holding up the most important cultural products epitomizing "Mao's Revolutionary Line." Each one of these is central to my discussion of cultural production under Mao: model music (featuring, on the poster, performers from ballets like the *White-Haired Girl* on the right, from operas like *Taking Tiger Mountain by Strategy* in the middle, and from instrumental music like *Red Lantern* with piano accompaniment on the left), model words/works (the poster includes participants holding up several volumes from the *Selected Works of Mao Zedong* and the *Little Red Book*), and model images, foremost among them *Chairman Mao Goes to Anyuan*, a huge sample of which is carried by some participants on the right in the procession depicted in the poster. Accordingly, this book studies, analyzes, reads, and questions the reception of some of the most visible official propaganda art from the Cultural Revolution, tracing its origins and its afterlives. In probing views from oral history, it also deals with the many unofficial cultural experiences that characterized the Cultural Revolution. What it cannot offer is a more elaborate reading of unofficial or underground art, nor does it manage to probe deeply into the thriving art practices beyond the mainstream. These lacunae must be filled in future studies to come.

Throughout, the book argues that one of the most obvious characteristics of Cultural Revolution Culture is that the same message was repeated over and over again, synchronically, on all different

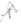

levels of the art work and in all different kinds of artistic media in order to reach as broad a public as possible. On the other hand, one of the most obvious characteristics of Cultural Revolution propaganda art is the fact that the same message was repeated over and over again, diachronically, at different times throughout Chinese revolutionary history.[46] Thus does propaganda become so powerful: it draws the individual into its net, using each of its techniques in its very own specific way, fusing it with many other media, each of them reaching the individual in a specific fashion and making him/her react again and again, over space and time, to the same message, with the same direction of impact, but somewhat *differently* each time (Ellul 1965, 10).

While focusing on one particular type of cultural product, each of the chapters will investigate it both synchronically and diachronically. The very nature of Cultural Revolution Culture, which can perhaps most adequately be characterized by its redundant interlocking mechanisms, makes it possible for every one of the emblematic works studied here as signposts of Cultural Revolution Culture to be connected more or less visibly by more than one thread to themes, topics, and rhetorical styles or techniques also addressed in other chapters. In three of the six chapters, the book itself practices quite explicitly the propagandistic "art of networked repetition" dealing with different reincarnations of Mao—in music, in language, and in image; MaoMusic, MaoSpeak, MaoArt—for Mao was what Cultural Revolution Culture was all about.

The book will undo the idea that Cultural Revolution Culture was exceptional; it will argue that it was neither particularly xenophobic nor iconoclastic,[47] and, most importantly, that it was not without historical precedents. It will show that Cultural Revolution propaganda art merely brought to an extreme cultural practices established many years before. Cultural Revolution propaganda art created an acute impact that ensured its continued importance in the decades after the Cultural Revolution. This is the reason for the book's title: *A Continuous Revolution*. Mao's aim with his continuous revolution (继续革命 *jixu geming*) was to create—by means of class struggle—a society with selected roots and memories to the past, created in the present to realize a future utopia of Chinese modernity (Bakken 2000, 1). Mao came to regard eternal struggle as the basis of all existence (Michael 1977, vii). In essence, then, his continuous revolution was one that sought to define and bring to life a utopian Chinese modernity. His burden was shared by many others who, during the twentieth century, became obsessed with finding ways to adapt China's tradition and culture in order to ensure their nation's survival in the modern age.

Only in creating an art that, at least in theory, allowed for one and only one interpretation, an art of absolute monolithic quality (一元化), of perfect univalence, did Cultural Revolution art and culture differ from art created before and after this period. However, even the idea of monolithic culture in itself was not unique to the Cultural Revolution. Many of the arguments used and abused during the Cultural Revolution to streamline art and cultural production can be traced back to ideas that came into being in the late nineteenth and early twentieth century—ideas that flourished during a period that is now often termed the most "liberal" period (and a cultural revolution in its own right) in Chinese cultural history: the May Fourth Movement of the 1910s to 1930s. Accordingly, the Cultural Revolution has been seen as "a distortion of May Fourth values, though its genealogy was clear" (Mitter 2004, 240).

In the same way that the Cultural Revolution has been mythologized, so, too, has the May Fourth Movement. But although the two movements share a similar anti-Confucian stance[48] (one was in fact consciously used by the other)[49] and although, accordingly, in terms of negative effects

46. Bussemer (2000, 22–23) remarks on the importance of synchronous and diachronous repetition in propaganda art.
47. These arguments are discussed in detail in Mitter 2004, 241.
48. See the definitive work on this topic, Chow 1960, 288–312.
49. One of many examples of such use is the re-publication of Lu Xun's 鲁迅 (1881–1936) criticisms of Confucianism during the Anti-Confucius Campaign in the early 1970s. See Louie 1980, 11. In note 38 Louie mentions the publication of Lu Xun's 鲁迅批孔反儒文集 in 1975.

on traditional Chinese culture, the two movements might well be considered equals, one is evaluated both in China and in the West in a much more positive light than the other. Science and democracy are considered part of the May Fourth legacy (as is quite obvious in Carma Hinton's film *Gate of Heavenly Peace*, for example), along with its iconoclasm, which is often taken as a crucial element for China's opening up to foreign ideas. It is not often realized, however, that this iconoclasm also entailed the destruction of much of the material culture that went along with this heritage. Rana Mitter, who follows these stereotypical categorizations while expanding them in interesting ways, argues that "the mindset that inspired Mao, who had been in the thick of May Fourth and shaped by it in many ways, bears many indelible marks of the earlier era,"[50] and acknowledges that the idea of Mao as the "saviour of the Chinese people" (so prominently featured in that Cultural Revolution song hit "Red is the East" discussed in Chapter 2), too, could be rooted in the May Fourth Movement. Mitter points out that "one of the most powerful cultural threads of May Fourth Romanticism encouraged the belief in a transcendent hero, in a figure who could drag an entire people into the future through the force of sheer will" (2004, 232). He has recently characterized the relationship between the two Chinese Cultural Revolutions as follows:

> The Cultural Revolution in China was largely caused by the obsessions of one man concerned both with the purity of his revolution and his own personal position. However, the patterns of thought that defined the path he took were largely ones that had shaped him in May Fourth. Mao's Cultural Revolution is an explicable end-point of the darkest side of May Fourth—obsession with youth, destruction of the past, arrogance about the superiority of one's own chosen system of thought—without the enlightenment that tempered the original—cosmopolitanism, critical enquiry, and universalism (2004, 208).[51]

The hysterics of the Great Proletarian Cultural Revolution have important but often neglected (or deliberately forgotten) precedents during this earlier period, including the belief in youth as a moving factor in history, the destruction of the Confucian heritage (under the slogan of "Beat down the Confucius shop" 打倒孔家店),[52] of temples and ritual objects in a fight against "superstition" (迷信),[53] and of the creation of a new audience: the masses.

This last idea was never successfully implemented during the May Fourth period, however. May Fourth art, in spite of its proletarian leanings, remained elitist. Cultural Revolution propaganda attempted to finally achieve the goal of popularization (大众化 *dazhonghua*) to which its popularity in recent years bears testimony. This again puts into question its monolithic and univalent qualities:

50. Rana Mitter further explains: "The May Fourth era was associated most with nationalism, 'science and democracy,' enlightenment, and openness to the outside world. Surely it is hard to claim that the Cultural Revolution, notable for its xenophobia, intolerance, and scorn for technical knowledge, is the child of that earlier period of possibility? Mao's use of the term 'Cultural Revolution' . . . made the events of the 1960s his self-declared follow-up to the original May Fourth. In this, it is different from, say, the Tian'anmen Square uprising of 1989, which . . . very consciously took on the mantle of the earlier movement at a grassroots level. However, the Cultural Revolution was not an uncomplicated inheritor of May Fourth's legacy. Its xenophobia, if nothing else, means that it was a distorted interpretation of the values of the New Culture Movement" (2004, 230).

51. Louie (1980, 144) expresses a similar view in saying that there is one crucial difference between the two movements: "The critics of 1916 . . . desired all that would strengthen and unify the country as well as make possible more individual liberty and initiative. They were in quest of pluralism, even if this quest was soon to transform itself for many of the leading critics into a quest for an alternative ideology." During the Cultural Revolution, on the other hand, it was "in the name of this alternative ideology that Confucius is being attacked and vilified. This alternative ideology has also received credit for whatever progress the Chinese nation has achieved in politico-military and other areas. Individual liberty and initiative have been set aside for the sake of collective liberty, the freedom from imperialism, and for equality."

52. For the missing origins of this slogan in May Fourth rhetorics, see May 2008.

53. For the continuities between these movements, see Ho 2009, ch. 4. See also Mitter 2004, 232; Duara 1995, 107–10.

the recent popular reception thrives on ambiguities of interpretation that are obviously possible even in spite of its overdetermined nature. As seen above, it may be worthwhile to question our perception of the restrictive manipulative, predictable quality of Cultural Revolution art and culture, alias propaganda, which has been emphasized in many a study on Chinese cultural production.

In studying the sensual experience that the Cultural Revolution was—its images, its sounds, its smells, and its touch—I will argue that, as an experience, the Cultural Revolution was much less restrictive than is often argued. If looked at more closely, Cultural Revolution propaganda actually allowed for quite a few variations, and, most importantly, the Cultural Revolution cannot be seen as one period of one type of homogenous cultural production. There are significant differences between propaganda art in the late 1960s and early 1970s, and there are important variations within the late 1960s and early 70s. Moreover, the theoretical ideal of Cultural Revolution art as envisaged by the cultural makers around Jiang Qing and the practical experience of what kinds of art and culture were available during the Cultural Revolution (inclusive of the many things that were not being actively produced but still available throughout this ten-year period) were very much at variance. The experience of art and culture during the Cultural Revolution was not singular: it differed substantially depending on the class background of a particular participant, his or her geographical standpoint, educational background, closeness to high revolutionary personnel, and many other factors, but it was determined for all by the mechanisms of continuous revolution: first, it slowly created a climate, and then, it prevented the individual from noticing particular propaganda operations. As this book attempts to show, it was this constant play with incessantly moving targets that eventually made Cultural Revolution propaganda so "incredibly effective" (Ellul 1965, 20).

PART I

EARS: SOUNDS

We organized these underground concerts and listened to a lot of records: Beethoven [1770–1824], *Carmen* by Bizet [1838–75], Schubert [1797–1828]! Really, we were so fed up with the revolutionary songs, so listening to this was simply great! Also *Turandot, Aida*.... Our parents did not know anything about this, because we would have our "concerts" in the homes of those children whose parents had "disappeared".... In the 1980s when I heard Beethoven again, I was so surprised; I just could not quite remember why I knew this music so well. (Writer, 1958–)

At first, it appears that these years were a kind of blank [空白时期], but if we look back, there was something quite valuable in them, too.... I learned a lot about folk songs, for example. Really, through the Cultural Revolution, the musical world of each one of us has broadened, it was opened up: China is so big, and there are so many differences in musical style. Folk music [民间音乐] has only reallly been understood since then. (Ethnomusicologist, 1940–)

In those precarious years, whenever I felt inspired to compose something, the first thought that came to my mind was not about what kind of method, texture, form, orchestration or harmony I was going to apply, but the following fears, excruciating fears:
 Shall I be able to avoid being trapped into the "Capitalist School"? Shall I be immune from being capped a Rightist again? Shall I be able to express the common emotions of the workers, peasants, soldiers instead of my own bourgeois sentiments? Shall I be exempt from being accused of "disparaging the present by extolling the past?" Shall I be able to avoid infringing on the proletarian line of literature and art enacted by Chairman Mao? Shall I ...?
 These "Shall I's" always served as a wet blanket to dampen any enthusiasm that happened to grace me, and I wonder how anyone could write anything of any worth on the tenterhooks of so many "Shall I's." (Mao 1991, 123–24)

In the countryside, we made our own music. I learned to play the accordion, and there was a guitarist—he played Western, classical guitar music, wonderful music. In 1968 we bought our first tape recorder from a Brazilian leaving China. Then we made recordings: I have a tape with us singing Russian songs—very blue, beautiful, sad music. (University Professor, mid-1950s–)

I had to do all kinds of work in the countryside, so I did not really have the chance to play. There was no time, we had to take part in all these meetings in the beginning of the Cultural Revolution. Also, you felt that it was not quite fitting to play the *guqin* [古琴, a type of Chinese zither played traditionally by the literati], of all instruments. They [the government] considered this music "feudal" 封建 [*fengjian*], and it is true, it was developed during that period of time, and there are all these Confucian ideas that have to do with this instrument. In the second part of the Cultural Revolution, we began to play again. We took part in performances and worked on the reform of the instruments. In 1975, I went to Japan and performed there. Whenever they [the government] had a need for it, we would be made to play. (*Guqin* Player, 1940s–)

In some of the second-hand shops, we were able to buy all kinds of things, old records, old literature, Western classical music. Of course these were extremely dirty, but we would clean them and put them on. The family and the neighbors—everybody would come to listen. That way, we encountered classical music. It was the first time for me to listen to Beethoven and Tchaikovsky [1840–93]. (Intellectual, 1958–)

In the Cultural Revolution, we did not learn anything. Families with intellectual backgrounds, they could rely on themselves to teach. But not us. Records? No, we did not have any. I only got in contact with symphonic music rather late. (Photographer, 1960–)

He: 1969 when I was in the countryside in the Northeast, you could listen to everything. After 1970 even more so; there was absolutely no pressure, we all had our own little huts. She: Yes, we would sing all these Russian songs and all that. (Laughs.) They did not know what it was, but they liked listening to it: it sounded good.... We were around eighteen to twenty or so, so in a way, we had our own literature and music, the model works were not the most important thing for us. He: As for folk music, ... we did not really like it. My uncle, when I was small, would sing these Hebei folk songs, I thought it was incredibly strange. I did not really think it was music. (Housewife with Husband, mid-1950s–)

✱✱✱✱✱

PROLOGUE

> Whereas the literati had previously held the highest rank in society, followed by farmers, then workers, and last by businessmen, the consequence of these social upheavals was a total reversal of China's traditional order of social ranking. Intellectuals and artists, now lowest on the social scale, found their creativity severely censored, as they were coerced into producing popular works that would appeal to peasants and soldiers, or which would support the Maoist cause. . . . Of all the art forms affected by this new ethos of appealing to the masses, music was perhaps most affected. (Chen 1995, 8)

"Get rid of what is stale and bring out the new" (推陈出新) is the title of a calendar produced in 1975. Before a pale blue background, a girl, dressed in a pink sweater, plays the *guqin*, an age-old seven-stringed Chinese zither (ill. I.1). Another calendar from the same year shows a much younger girl, a child still. She holds, quite lovingly, a small violin, a foreign instrument to China until the late nineteenth century: the title of this calendar is "Little Performer" (小演员) (ill. I.2). If one assumes—and this is accepted manner of speech (提法 *tifa*) in both official and unofficial writings about China—that the Great Proletarian Cultural Revolution, which was launched by Mao in 1966, carried out by the "Gang of Four" and, according to the now official version of history manifested in the Party Resolution of 1981, ended with his death in 1976, was nothing but a "period of chaos and destruction" (Resolution 1981, 21; Schönhals 1999), one may also agree with the common view that in the field of culture, the Cultural Revolution was indeed an "exceptional period of stagnation" (Fokkema 1991, 594), a "cultural desert." Therefore, it should not surprise us that veteran composer Du Mingxin 杜鸣心 (1928–) says in *Broken Silence*, a Dutch documentary dealing with contemporary Chinese music, that the Cultural Revolution was a period with "no music."[1] However, in the very same cut, one can see him, with a happy smile, conducting to the music of the *Red Detachment of Women* (红色娘子军 *Hongse niangzijun*), a ballet that attained the status of a model and was played incessantly during the Cultural Revolution and that Du Mingxin is proud to have helped compose (*Broken Silence* 1995 & interview with Du Mingxin, Beijing, 5 October 1992).

What does all this mean? Of course, the Cultural Revolution was accompanied by music, of course there were "sounds amidst the fury," but Du Mingxin's point, in accordance with officially prescribed amnesia about all cultural production during the Cultural Revolution, is in fact that music, just like all other artistic production, was subject to extreme political regimentation during this period; that only certain correct colors, forms, and sounds were officially acceptable: Wolfgang Amadeus Mozart (1756–91), Ludwig van Beethoven, Franz Schubert, and Johannes Brahms (1833–97) were condemned due to their "bourgeois" background or upbringing; Arnold Schönberg (1874–1951) and Claude Debussy (1862–1918) were considered "formalists"; Pyotr Ilyich Tchaikovsky and Sergei Rachmaninoff (1873–1943) were said to be (pre-)representatives of the "revisionist" Soviet regime and thus could not be performed; sounds of the *guqin* were unacceptable, as they were associated with the "aristocratic" literati of "feudal" China; and traditional Chinese operas were said to bring too many "emperors and ladies," and too few "workers, peasants, and soldiers" onto the stage. And this list could be continued.

1. Sue Tuohy (2001) begins her essay with a long series of examples from reference works on music from the late 1970s and early 1980s that almost completely neglect musical and artistic developments during the Cultural Revolution. One of them states: "That period had no art, only politics."

Thus, the musical repertoire during the Cultural Revolution period was highly regimented. Its basic staple were revolutionary songs and the so-called model works (样板戏 *yangbanxi*), eight in number at the beginning of the Cultural Revolution, eighteen by the time it is said to have officially ended. These model works, the great (and exclusive) models for all musical production, including ten operas, four ballets, two symphonies, and two piano pieces, tell stories from China's recent past: mostly episodes from the Sino-Japanese War (1937–45) and the civil war period (1945–49), but also from the Korean War (1950–53) and from the early 1960s. The model works depict the Chinese people's "determined struggle" against outer and inner enemies, they glorify the close cooperation between the People's Liberation Army (PLA) and the common people, and they emphasize the decisive role of Mao Zedong and his thought for the final victory of socialism in China. This is the stuff that many a revolutionary song is made of as well.

For many Chinese (especially intellectuals), revolutionary songs and the model works epitomize the tragic and chaotic years that the Cultural Revolution brought them and their families. Post-Cultural Revolution politics wanted these works forgotten. Ironically, it thus inversely replicated Cultural Revolution practice. Colin Mackerras (1983, 170) points out: "When the Gang of Four was in control, nobody said anything positive about the theater creations of the years 1949–66. . . . Now, however, the line has changed to the other extreme. It is difficult to find serious criticism or something other than praise for theatrical works of the pre–Cultural Revolution period, it is the decade of the Gang of Four that produced nothing worthwhile. Models worth emulation come unfailingly from before 1966, negative examples from the black years 1966–76." A 1980s Party School publication entitled *Strange Happenings and Strange Expressions from Cultural Revolution Times* (文革时期怪事怪语 *Wenge shiqi guaishi guaiyu*), for example, mentions that many of the model works were based on earlier productions made "with the heart blood of many very talented musicians," but that Jiang Qing, Mao's wife responsible for the production of the model works during the Cultural Revolution, had simply "gulped up and usurped them" and, in her efforts to streamline these works politically, destroyed all that was good in them (*Wenge shiqi guaishi guaiyu* 1988, 300).

Condemnation of the model works reigned since the late 1970s, but in China today both the model works and revolutionary songs, the very stuff that the Cultural Revolution was made of, musically speaking, are far from forgotten. The mid-1980s marked the beginning of a veritable revival to which the government has not only turned a blind eye (Barmé 1999, 14)[2] but, more recently, in an effort to bring opera back into the schools, has even played a supportive role by choosing quite a few of the model works for the official curriculum.[3] Equally prominently, Red Sun Music—retakes of the revolutionary songs in rock, pop, and jazz rhythm—have seen skyrocketing sales since the 1990s.

In discussing model works and revolutionary songs, this first part of my book tries to address some of the more obstinate myths about musical production and musical life during the Cultural Revolution by tracing the history of some of the "sounds amid the fury" to the continuous musical revolutions that occurred throughout China's twentieth century. While every one of these myths has an element of truth (which is why they are taken very seriously throughout), I attempt here to fill in the background around them, which has become so powerfully simplified by political *fiat*, thus turning them into largely unproven collective beliefs. The first such myth is the assumption that the Cultural Revolution was xenophobic and that, accordingly, during the Cultural Revolution, no foreign music could be heard and played. It is true that officially only very few pieces of the Western musical repertoire were deemed "correct sounds" during the Cultural Revolution,

2. For more on the revival, see Barmé 1987 and Barmé 1996, 14.
3. See DACHS 2008 Zhang Yihe.

and many remember not being able to "play and listen to Chopin [1810–49]" (China Historian, 1957–), for example, but quite a few music lovers also told how they could in fact listen to their classical records (if they had not been smashed by the Red Guards) and even play Mozart and Beethoven in a string quartet, if nobody who knew this music and could therefore identify it as "bourgeois" was around (Mittler 1997). One interviewee, also mentioned in the Introduction, even remembers listening to the Beatles in 1969 (University Professor, mid-1950s–). Another talks of friends meeting in the library, listening to records of foreign music together: "The records in our library were all kept intact. And we often listened to stuff you were not allowed to listen to, for example, Wagner [1813–83] songs. It was a great atmosphere, really!" (Musician, 1930s–) Others, such as a violinist who began to play the instrument in the early 1970s, explains that "actually, at that time, there were no restrictions as to the playing of either particular instruments or pieces. All the etudes we played came from the West. We just played everything" (Artist, 1959–). The "little performer" girl on the calendar (see ill. I.2) produced in 1975, too, speaks for herself: Western instrumental traditions were rejuvenated in the 1970s when, due to Ping-Pong diplomacy, many foreign orchestras began to perform in China. These traditions were, however, not entirely disrupted by the Cultural Revolution.

Even more important than the continuous clandestine presence of foreign music is the fact that foreign sounds were heard and officially propagated throughout the Cultural Revolution in the form of China's propaganda art, represented by the model works and revolutionary songs that epitomize the essence of Cultural Revolution music. According to the principles Mao Zedong had advocated in his Yan'an Talks, when he reminded his audience that in creating a proletarian culture, one "may not reject the ancients and foreigners as models" (Mao 1942, 69), this music is characterized by a style I call "pentatonic romanticism," which combines foreign functional harmony with pentatonic scales (Mittler 1997, 33). My purpose in the first part of this book is to illustrate, through the examples of the model works on the one hand and revolutionary songs in praise of Mao on the other, how pervasive and important was the influence of "foreign sounds" through the perpetuation of pentatonic romanticism in the production of Cultural Revolution music.

A second myth I hope to revisit is the belief that the Cultural Revolution was iconoclastic and destroyed Chinese traditional music: many Chinese instruments associated with the literati tradition—the guqin, for example—and many traditional operas could not be played openly for some years. Chen Kaige's 陈凯歌 (1952–) 1993 film Farewell My Concubine (霸王别姬 Bawang Bieji) epitomizes this.[4] It begins with a scene showing two opera singers walking into a theater in the early 1980s, after twenty years of not having played the traditional opera Farewell My Concubine together. This, so they say, "is all due to the Gang of Four." They conclude by pronouncing: "But now it is better."

Indeed, those who were not willing or able to let go of the traditional repertoire would disappear from the stages for some years to come after the beginning of the Cultural Revolution. For a number of years, the study or performance of operas with traditional themes was officially forbidden. In terms of traditional repertory, some of the practitioners of opera, performers and musicians alike, missed out on years of practice. Whether or not this led to a veritable "crisis" for operatic performance practice, as some would contend, is debatable, however.[5] As I will show in more detail below, exceptions were made not all that rarely, and especially since the early 1970s the

4. DACHS 2008 Farewell My Concubine.
5. Zhang Yihe speaks of two different sorts of "crisis" for Beijing Opera, one during and after the Cultural Revolution, when the situation was politically difficult and one today, when the art is gradually exterminated and forgotten (DACHS 2008 Zhang Yihe).

traditional repertoire returned and was even officially sanctioned: by the mid-1970s, as the other calendar girl suggests, the *guqin* could be used as a sign of "modernization" again.

In Chapter 1, I will show that traditional opera and revolutionary opera share a number of important characteristics. I will also argue that transformation and change, which are part of the development of revolutionary opera, are in fact intrinsic elements in the very form and makeup of traditional operatic genres as well. Accordingly, I will demonstrate that the Cultural Revolution certainly restricted, but at the same time caused to flower, particular parts of China's musical tradition. Although the ten revolutionary operas themselves are often accused of having destroyed, through politicization, the subtleties of Beijing Opera, for many specialists (e.g., Zhao 1969, 169) they in fact constitute a high point in the development of traditional Chinese opera in the twentieth century (Wang 1999; Mackerras 1983; Wichmann 1983; Yung 1984). According to these specialists, the revolutionary operas served to perpetuate and spread some of the symbolic and musical intricacies of this traditional Chinese musical style to a greater audience than ever before. The present popularity and successful commercialization of the model works may be taken to illustrate that the Cultural Revolution somehow "saved the folk tradition" precisely by reforming and modernizing it, and did not "destroy" it, as some have alleged.

The third myth I would like to address is the idea that music from the Cultural Revolution forms a special and despicable category of propaganda music unlike all other music created before or after. By drawing, in these first two chapters, a "wide-angle" *longue durée* picture of musical production, considering Cultural Revolution music within the context of the production of a foreign-style New Chinese Music 新音乐 in the twentieth century generally, and not just in the PRC but also in Hong Kong and Taiwan (Liu 1998; Mittler 1997), and by looking back at Chinese musical practice in history, I will illustrate that Cultural Revolution music cannot be considered the perversion of the Maoist experiment of reinventing a new Chinese revolutionary culture. Cultural Revolution music is one manifestation of the attempt to create a distinct New Music for China with its own national style. Time and again, New Chinese Music—to be found in Taiwan, the PRC, and Chinese communities abroad—has applied methods and ideas rather similar to those used in the model works of China's Great Proletarian Cultural Revolution, combining what is best from China with what is best from "the West" in musical terms (Yung 1984). In tracing the many predecessors and repercussions of the sounds from the Cultural Revolution, I argue that the cultural revolution in music, which essentially answers the question of how to combine foreign and Chinese musical styles into one modern Chinese style, began in the late nineteenth century and continues to the present day. I also argue that one seemingly unique quality of Cultural Revolution music—its political nature and its (heavy) didacticism—is one that can be traced back centuries and that continues to live and thrive even today.[6] Music practices of Cultural Revolution music display the artful and ideologically driven appropriation of the foreign and the traditional, borrowing from one and inheriting from the other as part of an impulse to mark one's own distinctive national style.

6. Zhang Yihe, in her discussion of the need to take opera to the schools, refutes the critics' idea that this is a "rehatch of *yangbanxi* practice." She, too, makes the connection to earlier didactic practice. See DACHS 2008 Zhang Yihe.

CHAPTER 1

FROM MOZART TO MAO TO MOZART: MUSICAL REVOLUTIONS IN CHINA

> The model works are a reminder of this very hard and very bitter time. We heard them from where we were locked up in those "cowsheds" [牛棚], and we found this extremely difficult to bear [难受]. Zhu Jian'er's [朱践耳, 1922–] *First Symphony* [1977–86] is criticizing precisely this: the model works are a symbol for how society has been destroyed at that time. (Musician, 1930s–)
>
> I thought I had forgotten about the model works. But then, accidentally during the Spring Festival, I heard someone singing tunes from one of them. They gave me such a creepy feeling that I began having nightmares. . . . the model works had been forged indelibly on my heart. (Ba Jin, Writer, 1904–2005)[1]

Prelude: Chinese Music and New Chinese Music

When did China's Cultural Revolution begin? From the point of view of cultural production, China's Cultural Revolution did not last just the ten years (1966–76) assigned to it by political *fiat* since the Party Resolution in 1981. On the contrary, seen from the perspective of cultural production, the Cultural Revolution originated some time in the late nineteenth century. In showing the indebtedness of the infamous Cultural Revolution model works to the form and rhetoric of foreign musical style and composition introduced to China since that time, this chapter will argue that foreign music was in fact heard and played all throughout the Cultural Revolution. Second, the indebtedness of the model works to the form and rhetoric of traditional musical genres such as Beijing Opera shows that some traditional music was, in fact, redeveloped rather than destroyed during the Cultural Revolution. In describing the nature of the synthesis between foreign and Chinese musical heritage as found in the model works, this chapter will suggest that they are, yet again, manifestations of the attempt to create a New Chinese Music, a music with national style (民族性 *minzuxing* or 民族风格 *minzu fengge*). A short history of opera reform throughout the twentieth century will show that the politicized nature of the model works was also not an affair of the Cultural Revolution alone. Politics and the dictum to "Serve the People" (为人民服务 *wei renmin fuwu*), musically as well as in everything else, has played a role in the production of Chinese art and culture throughout the twentieth century.

Finally, I will argue that composers who emerged out of the Cultural Revolution—those urbanites who may have suffered greatly from having been sent to the countryside during this time or who had become members of the numerous music ensembles and propaganda troupes traveling around the country—were confronted in a much more intimate manner with the rich traditions of Chinese folk music than many a generation of Chinese composers before. Their particular understanding and reinterpretation of traditional and folk music became a crucial element in the new types of synthesis with the forms and styles of contemporary music, or "New Music," proffered since the mid-1980s: their "Chinese New Music," yet again, shows new variations of music in the so-called "national style" (民族风格 *minzu fengge*) and thus offers the possibility of reviving rather

1. Ba Jin is cited in Liu 1990a, 159.

than destroying the traditional music of China, a practice they had learned to appreciate during the Cultural Revolution (Kouwenhoven 1990–92; Mittler 1997; Tuohy 2001a; Yu 2004). Thus, this chapter will maintain that to talk about Cultural Revolution music is not to talk about the music of a single decade, but to deal with a continuous revolution of particular musical trends dominant throughout the twentieth century and into the twenty-first. As one artist put it, "Behind all the theater a greater reality is hidden" (Xu Yihui 徐一晖, Artist, 1964–, in *Yang Ban Xi* 2005).

But let us start at the beginning.[2] What is it that constituted "Chinese Music" in the late nineteenth century, the waning years of the Manchu Qing (1644–1911) dynasty? If we were to return to those years, we would find music for the *guqin* (古琴), one of the oldest instruments in Chinese (and world) history. We would also find music played on the *pipa* (琵琶), a "Chinese" lute imported to China from Central Asia in the eighth century, as well as hundreds of rich localized traditions of musical theater and folk songs. All of these are examples from a long tradition whose most distinctive quality is the ability to artfully absorb outside influences. It is a tradition based on melodic and rhythmic patterns that are transmitted orally, and one that does not know the concept of a "composer." The exclusive reign of this musical tradition in China ended in the final decades of the crumbling Qing dynasty with the arrival of foreign missionaries, armies, and merchants who brought the musical fare of their own, very distant, cultures. This is how Mozart came to China, too.

For in the wake of this foreign invasion, a new type of "Chinese Music" arose, a music which makes use of violins, organs, pianos and clarinets, a music which is to be performed according to strict notation, which is linked with the name of a particular composer. This music was, if anything, a new (type and concept) of music to China soon assimilated into the Chinese musical universe to such an extent that a song like "Frère Jacques" could be considered a "Chinese folk song" (mus. 1.1). In the course of this chapter, I will provide a brief sketch over the history and the development of this New Chinese Music in China. This (longish) sketch will be presented in three-partite structure (ABA') dealing in its first part, entitled "China and Mozart," with the rise of this foreign-style New Chinese Music from the early years of the twentieth century to the beginning of the Great Proletarian Cultural Revolution in 1966 when, according to many, the practice and reception of foreign music in China was interrupted. The second part of this chapter, entitled "Mao," will then deal with the fate of foreign-style Chinese music during the so-called "ten-year-period" of "cultural stagnation," the Cultural Revolution itself. It will discuss the production of the model works from different angles, examining traditional and foreign elements, as well as their inherent politics and their artistic quality, and it will include two historical excursions to trace their origins in Chinese opera (Excursion 1) and opera reform (Excursion 2).

In the third part of the chapter, returning to the theme of "China and Mozart" again, I will trace new developments in the production of "foreign-style" Chinese music from the end of the Cultural Revolution in 1976 to the present. I will argue that throughout these three periods in Chinese history, it was primarily certain styles, melodies, and sounds of foreign music that dominated the musical horizon of an average Chinese person: works from the repertoire of classical and romantic music. The sounds of contemporary music, too, could be heard in China, especially during the twenties and thirties and again since the eighties, but they have never played a dominant role in

2. This retelling of the history of New Chinese Music is based in part on earlier scholarship by others and by me. References and primary sources especially for the sections retelling the historical background can be found in Mittler 1997. The history of New Chinese Music has only recently become a topic of scholarly interest both in China and the West. Particularly noteworthy are the efforts of Frank Kouwenhoven, Liu Ching-chih, Nancy Rao, Christian Utz, and Yu Siu-wah.

Chinese concert life. Accordingly, in spite of many obvious differences between these three periods in Chinese history—and in spite of the fact that the New Chinese Music produced during this century can indeed most satisfactorily be described as a music of many styles (Mittler 1994; Mittler 1997)—it is one style in particular, "pentatonic romanticism," which can be found in many compositions from the earliest days of foreign-style music in China up to the present (Mittler 1997, 33). In this style, elements and melodies from Chinese folk music are fitted to a framework of functional harmony reminiscent of the musical idiom of foreign romantic music. I will illustrate how even the model works of the Cultural Revolution took up this particular musical style.

Exposition: China and Mozart

Le us return once more to the beginning of the story: When did New Chinese Music emerge? It was during the second half of the nineteenth century, when China suffered a number of defeats at the hands of foreign armies who pressed their way into trade relations with China. Eventually, China agreed to open a number of so-called treaty-ports along the coast. These treaty-ports would become centers of intellectual and cultural exchange between China and the West as Chinese intellectuals became more and more convinced that there was a need to learn from the West, for had not the West defeated their mother country in recent battles? Foreign technology and knowledge were imported and translated, and military music was one of the first things adapted by General Yuan Shikai 袁世凯 (1859–1916) when forming his "New Army" in the final years of the nineteenth century. Music education as practiced in missionary schools was taken as a model for the national educational reforms initiated in 1902. Among the first "compositions" of New Chinese Music were, accordingly, "school-songs" (学堂歌 *xuetangge*). Some were based on foreign tunes, while others were first attempts at composition in a new, foreign style. Some used simple harmonies, while others aspired to the romantic art song tradition. These songs advocated new values, such as the beauty of natural (not bound) feet or the importance of physical education and new ideologies like liberation and socialism (ill. 1.1).

During the first two decades of the twentieth century, a growing number of music societies were founded. These were organizations that promoted both the practice of traditional Chinese music and foreign instruments. In the wake of the iconoclastic May Fourth Movement of 1919, when foreign values were firmly established as superior to Chinese values, the first attempts were made to "improve" Chinese instruments to make them sound like foreign instruments. The strings of stringed instruments were no longer made of silk but of metal (for a more sonorous sound that would fill the newly built large concert halls). The *erhu* (二胡), a two-stringed high-pitched fiddle, was "revamped" and provided with an entire family in the alto, tenor, and bass ranges, and Chinese orchestral performances were now given in concert halls where no one was allowed to talk or eat, as had been common practice when music was performed in traditional tea houses. In 1927, the Shanghai Conservatory was founded, and with it began the professional training of musicians on both foreign and Chinese traditional instruments. Among the teachers in the composition department were many foreigners, including two Jewish students of Alban Berg (1885–1935) and Arnold Schönberg (1874–1951), Julius Schloss (1902–73) and Wolfgang Fränkel (1897–1983), as well as Boris Zakharoff (1888–1943), Aaron Avshalomov (1894–1965), and, temporarily, Alexander Tcherepnin (1899–1977). Sergei Rachmaninoff (1873–1943) and Fritz Kreisler (1875–1962), Jacques Thibaut (1880–1953) and Jascha Heifetz (1901–87) all performed in Shanghai. All of these were important influences on the development of New Chinese Music (Melvin and Cai 2004).

Whereas the earliest pieces of New Chinese Music were all songs, these decades—the teens and particularly the twenties—witnessed the creation of the first instrumental works. One of these was Huang Zi's 黄自 (1904–38) orchestral overture *Remembering* (怀旧 *Huaijiu*) of 1929, the first large-scale symphonic and polyphonic work composed in China.[3] The 1930s also brought world recognition of New Chinese Music: in 1934, composer Alexander Tcherepnin inaugurated a competition for piano pieces in Chinese style. The first and second prizes went to two of He Luting's 贺绿汀 (1903–99) little pentatonic character pieces for piano. Stylistically, these compositions attempted to combine pentatonicism with functional harmony. In the case of He Luting, his idiom is tonal—until his death he remained an ardent supporter of melodic tonal music, denying any sense of beauty in "calculating serialism" or "ear-splitting atonality," as he calls them. One of Tcherepnin's students, Taiwanese-born composer Jiang Wenye 江文也 (1910–83), won a first international composition prize at the Berlin Olympics in 1936 for his orchestral piece *Taiwan Dance* (台湾舞曲 *Taiwan wuqu*), and he was successful again in 1938 at the Fourth International Contemporary Music Festival in Venice with his *Five Sketches for Piano* (五首素描 *Wushou sumiao*). His music is clearly influenced by the teachings of Tcherepnin, who advocated that the Chinese ought not to burden themselves with learning all about foreign compositional styles from the nineteenth century, but ought rather to study contemporary foreign music, which was just as alien to them but more progressive. Accordingly, the percussive sounds of Béla Bartók (1881–1945) on the one hand and the fragile impressionism of Debussy on the other, combined with the pentatonicism of Chinese melody, have deeply influenced Jiang's style (Kung 2001).

In the 1940s there appeared a few more "modernists" such as Tan Xiaolin 谭小麟 (1911–48), a student of Paul Hindemith (1895–1963) and an influential composition teacher at the Shanghai Conservatory. At the same time, however, a greater number of composers chose a different road: Ma Sicong 马思聪 (1912–87) composed Chinese-style music in the grand manner of Tchaikovsky and Rachmaninoff, while Xian Xinghai 冼星海 (1905–45), hailed as the "People's Composer" (人民作曲家 *Renmin Zuoqujia*) after his untimely death in Moscow, chose the same compositional techniques in order to fulfill what would be dictated in Mao's *Yan'an Talks* (Mao 1942)—that all music composed in Communist China must serve the people and the revolution.

Xian Xinghai had grown up among the fishermen of Guangdong province and had later studied some music in Paris. With his "lowly" class background combined with some formal training, he was idealized as being able to synthesize in his music the sentiments of both the (bourgeois) intellectuals and the masses of workers and peasants. This made him an ideal teacher at the Lu Xun Academy in Yan'an, where he taught the young cadres how to compose songs and organize or conduct choral groups (Chen 1995, 19–20). His own skills at orchestration are debated,[4] but he allegedly wrote the *Production Movement Cantata* (生产运动大合唱 *Shengchan yundong dahechang*) and a theatrical entitled *The Soldiers Advance* (军民进行曲 *Junmin jinxingqu*). His most famous composition, discussed below, is the anti-Japanese *Yellow River Cantata* (黄河大合唱 *Huanghe dahechang*), written in 1939. All of these pieces are fine examples of "pentatonic romanticism."

In 1949, with the Communist victory won, the history of New Chinese Music splits into three locations, with separate if only slightly different developments occurring in the People's Republic of China, the Nationalist Republic of Taiwan, and British Colonial Hong Kong. Each of these

3. Much of this short history can be reread in more detail in Mittler 1997. Recordings of most of the pieces mentioned in this chapter are now available as a digital archive in the C.C. Liu Music Collection at Heidelberg University.

4. His published compositions are essentially recompositions of works by trained composers who, although known, remain officially unnamed. This well-known insider lore is also mentioned in an interview with an Intellectual (1955–).

developments shows that in spite of different political systems and directions, "pentatonic romanticism" remained a dominant style. Although a British colony and thus unimpeded by direct political interference, Hong Kong's music did not immediately take off in the early period. Hong Kong was dominated by business interests during the 1950s and 1960s, and cultural developments therefore did not play a significant role or find particular sponsorship there. Lin Sheng-shih 林声翕 (1915–91) and Shi Kumpor 施金泼 (1932–), who write music in a pleasant pentatonic idiom, were the most influential Chinese composers active in Hong Kong at the time. It was only during the governorship of Crawford Murray MacLehose (1971–82) that cultural activities picked up: the Hong Kong Philharmonic turned professional, the Hong Kong Chinese Orchestra was founded, the Hong Kong Music Office and the Hong Kong Arts Centre were inaugurated, and a number of cultural venues were built. Some composers who had studied abroad returned to Hong Kong during this period, bringing with them the new techniques and sounds they had heard. Presented to largely conservative audiences, modernist compositions by Doming Lam 林乐陪 (1935–), Law Wing-fai 罗永晖 (1949–), and Tseng Yip-fat 曾叶发 (1952–) scandalized audiences or drew none at all.

Hong Kong composers cannot make a living from their art alone; all of them either teach or write pop and film music on the side. Thus, even though politically unbound—at least before 1997—the Hong Kong composer was influenced by the demands of the market, something that has become more and more of a reality in the PRC today as well. It is not the politicians railing against unintelligible music but the inability of Hong Kong audiences to understand that has driven Hong Kong composers to write music in more "conservative" styles. Wong Yokyee 黄育义 (1924–) in some of his compositions has adapted a particularly clever method to deal with this problem: he hides his idiosyncratic twelve-tone music behind a (romantically) pentatonic structure: "Contemporary music is too far from the audience," he says. "But my music certainly does not sound all that modern and new. One perceives its pentatonicism but not its twelve-tone technique. I want people to understand my music, so I cheat them by using twelve-tone technique without letting them know."[5]

When the Nationalist Party (国民党 *Guomindang*, GMD) under Chiang Kaishek 蒋介石 (1887–1975) moved to Taiwan, on the other hand, the musical infrastructure they found was—rather differently from Hong Kong—already well-established. Japanese colonialists had left a state inclusive of an educational system in full working order. The Nationalists simply took over the positions once held by Japanese, which meant that the tension between Japanese and Taiwanese was now substituted by a tension between Mainlanders and Taiwanese, and this was practiced in teaching positions in music as well as everywhere else. Unlike intellectuals and artists in Hong Kong, those in Taiwan were subject to constant government supervision and propaganda efforts. The two most important aims of all art until the late 1970s consisted of demonizing the Communists and strengthening the reign of Mainlanders over Taiwanese in Taiwan. Chiang Kaishek insisted that all the arts be utilized towards "combating Communist bandits" (打共匪 *da gongfei*). At the same time, the Nationalists wanted to surpass the Communists by preserving their national heritage (whereas the iconoclastic Communists were said to destroy it). This root-seeking prescribed by the Taiwanese government was primarily interested in Mainlander Chinese culture, however. The choreographer, producer, or composer expected to produce "national art works" was thus caught between the Scylla of not being able to use mainland material (suspect of Communism) on the one hand and the Charybdis of not being allowed to quote from genuine Taiwanese traditions (suspect of calling for Taiwan independence) on the other.

5. This is taken from an interview with Wong Yokyee in Hong Kong on 27 October 1992. For more information on Wong, see Mittler 1997.

This ambiguity in government cultural policy was prevalent throughout the 1960s and 1970s in Taiwan, and it meant, for example, that the "Sunflower Group" (向日葵乐会 *xiangrikui yuehui*), a composers' association organizing concerts with New Chinese Music active in the late 1960s, had to change their name, as sunflowers were too closely associated with Mao (the sun) and his China. This kind of policy could—if not necessarily—still be a problem as late as the late 1970s: a composition such as Zeng Xingkui's 曾兴魁 (1946–) Woodwind Quartet (1977), which integrates both a folk song from Xinjiang province on the mainland and a song of the Taiwanese mountain people, could easily have caused political trouble for the composer, but in this case it did not. The Yayin Opera Ensemble (雅音小集 *Yayin Xiaoji*), on the other hand, which was founded in 1979 and attempted to adapt Beijing Opera in a modernist way, was at first accused of copying the Communist model works produced during the Cultural Revolution.

Essentially, the government policies to support new but Chinese-style arts resulted in a paradox. Pan Shiji 潘世姬 (1957–) observed: "On the one hand they wanted you to go back to your own tradition, on the other hand they did not want anything from mainland China to come in. So obviously it was easier to just let the Western stuff in—at least this would not have any Communist poison."[6] Music education in Taiwan reflected this dilemma: music textbooks written before the late seventies were based on Western music history alone.

A more or less moderate musical modernism with minimal references to Chinese tradition, although it did not have an easy time finding its audience in the 1960s and 1970s, was the result of political safe-play by Taiwan composers, then, since Western-sounding music was not condemned in the same way that "Communist" music was. At the same time, politically condoned compositions, those that won national prizes or were composed for official events, were often written in the style of "pentatonic romanticism."[7] Eventually, the increased politicization of the seventies and eighties somewhat diminished artists' fears to tackle the blatant ambiguities of government policy. A "homeland" (乡土 *xiangtu*) movement spread from literature to other arts, inclusive of music. Folk singers stopped blandly imitating Western music and tried to express the Taiwanese experience. Composers such as Xu Changhui 许常惠 (1929–2001) and Shi Weiliang 史惟亮 (1925–77) started to conduct ethnomusicological fieldwork in the Taiwanese countryside. When the movement became openly political, it was stopped by the government, but a ball had already been set rolling. In 1975, Lin Huaimin 林懷民 (1947–) founded what was to become one of the most successful Taiwanese cultural endeavors, the ballet troupe Cloud Gate Theater (云门舞集 *Yunmen Wuji*). Their mission was to perform "Music composed by Chinese, choreographed by Chinese, for Chinese to enjoy" (Xu 1990, 225).

In the last two decades, Taiwan folk opera and the Taiwanese language, scorned in the past, have regained "new nobility." On university campuses, clubs devoted to the study of Taiwanese history and the Taiwanese language have sprung up. Taiwanese schools and universities have likewise begun to include China's and Taiwan's musical traditions in their curriculum. Under successive Taiwanese heads of state, the government has turned to an open endorsement of both indigenous Taiwanese as well as Mainland Chinese traditions, which found its reflection, for example, in the support for compositions written by Taiwanese composers for Chinese instruments.

The relaxation of government policies is also a response to the softening of the radical denial of "Chineseness" in favor of exclusive "Taiwaneseness" prevalent in the earlier homeland movement, especially since travel to and contact with mainland China have become possible. In the late 1980s, the "Roots Fever" (寻根热 *xungen re*) movement began to include the ancestral mainland.

6. Interview with Pan Shiji, Taibei, 23 September 1992.
7. See the yearbooks published by the Asian Composers League, R.O.C. National Committee.

Accordingly, Taiwanese composers now turn more and more frequently toward this musical heritage, be it Chinese or Taiwanese, and include references to it in their music. The dominant mode of politically endorsed compositions is no longer exclusively that of "pentatonic romanticism." Other, more contemporary styles have made their way into the approved repertoire of New Chinese Music from Taiwan.

In mainland China during the 1950s, on the other hand, musical education was influenced by the Soviet model. The Zhdanov Doctrine of 1948, which condemned musical modernism as formalist, determined the educational style not just in the Tchaikovsky Conservatory in Moscow, where many Chinese musicians were trained, but also in China's own conservatories. The Chinese music journal *People's Music* (人民音乐 *Renmin yinyue*) openly castigated compositions by Igor Stravinsky (1882–1971), Arnold Schönberg, and Paul Hindemith. During the Anti-Rightist Campaign of 1957, many a Chinese "modernist" such as Jiang Wenye was harshly criticized. So, too, were those composers who were not modernists at all and wrote works of perfect "pentatonic romanticism" but who had lived and worked in Nationalist areas during the 1930s and 1940s, such as Ma Sicong. One indication of the extent to which music was viewed through Soviet eyes can be seen in a *People's Daily* (人民日报 *Renmin Ribao*) article commemorating the 200th anniversary of Mozart's birth in which Mozart is praised as a "musical nationalist" for his pioneering use of German in opera. His departure from Salzburg is presented as an act of rebellion against the control of music by a "moribund feudal order" (RMRB 27 January 1956). During these years, then, the door to foreign music was slowly drawn to a close.

It did not yet shut out Mozart, though: The celebrations of the ten-year anniversary of the PRC witnessed the composition of many a colossal symphonic work praising the victory of the revolution. These compositions served to establish the style of "pentatonic romanticism" as the orthodox and binding musical language for Communist China (although the example of Ma Sicong later criticized as a rightist shows that to compose in this "correct" musical style was no guarantee for personal security and even less for political success). Ding Shande 丁善德 (1911–95) for example, in his *Long March Symphony* (长征交响曲 *Changzheng jiaoxiangqu*), works folk songs from the Yao minority into a patchwork of functional classico-romantic harmonies. Chen Gang (1935–) and He Zhanhao (1933–) employ a similar method in their famous *Butterfly Lovers Violin Concerto* (梁山伯与祝英台 *Liang Shanbo yu Zhu Yingtai*), one of the most well-known pieces of New Chinese Music worldwide, based on Shaoxing opera melodies.

During the early 1960s, contact with the Soviet Union was broken off, and Chinese composers and musicians were increasingly exhorted to write music in "national style" and to perform works not by Western but by Chinese composers. What exactly this epithet "national style" meant was never made explicit, but officially approved works generally held to the style of "pentatonic romanticism" (Mittler 1997, Chapter 4). The ensuing Great Proletarian Cultural Revolution, so it is generally contended, shut the door completely to foreign music, yet it perpetuated, as I will show below, this very style of "pentatonic romanticism."

Development: Mao

"Turn on your television—[you'll see] model operas," said Professor Wang. "Turn on your radio—[you'll hear] model operas. Go to the movies—[you'll watch] model operas. That's all you saw." (Wang Renyuan, Intellectual, 1949–)[8]

We saw all the different versions of the model works and memorized them; we thought this was so much fun! (Writer, 1958–)

However you look at it, there were only the eight models. How dried out and boring cultural life was need not be mentioned. (*Wenge xiaoliao ji* 1988, 146)

One of the most frequently cited phrases sustaining the idea of the Cultural Revolution as a period of cultural stagnation is the one claiming that throughout those ten years, nothing but "eight model operas"[9]—or, more accurately, eight model works (八个样板戏 *bage yangbanxi*)—were performed on China's stages. The Cultural Revolution had in stock, so it is said, "eight (theatrical) works for 800 million people, and that was all" (8亿人民8台戏).[10] It is true that by 1966, eight theatrical works (戏) had been declared "models" by Jiang Qing, but as the Cultural Revolution went on, a second set of models was created, and by 1976 their number had increased to eighteen, only ten of which were operas. To Mao's criticism in July 1975 that "there are too few model works," Jiang Qing is said to have replied: "There are people who say that there are too few models works, that there are just eight, but it is not true! Already now there are eighteen" (有人说样板戏少只有八个不对! 现在已有十八个了嘛). Although a number of new model operas derived from the mid-70s films produced under the supervision of Jiang Qing were in the planning stages, *Spring Sprouts* 春苗 *Chunmiao* and *Breaking with Old Ideas* (决裂 *Juelie*) among them (Dai 1995, 230), no more were finished by the time the Cultural Revolution ended (ill. 1.2).[11]

The model works included operas, ballets, and symphonic works. The translation terminology is confused because the Chinese term 戏 *xi* is ambiguous and can mean "opera" or any other staged performance art. Accordingly, one interviewee insisted that the *Yellow River Piano Concerto* (黄河钢琴协奏曲 *Huanghe Gangqin Xiezouqu*) was not a model work (Beijing Taxi Driver, 1958–). He was echoed by another who would contend: "There are just ten model works: *Shajia Village* (沙家浜 *Shajiabang*), *On the Docks* (海港 *Haigang*), *Song of the Dragon River* (龙江颂 *Longjiangsong*), *Red Lantern* (红灯记 *Hongdengji*), *Red Detachment of Women* (红色娘子军 *Hongse niangzijun*), *Boulder Bay* (磐石湾 *Panshiwan*), *Raid on White Tiger Regiment* (奇袭白虎团 *Qixi baihutuan*), *Taking Tiger Mountain by Strategy* (智取威虎山 *Zhiqu weihushan*)—these are the operas (京剧 *jingju*). As for ballets (舞剧 *wuju*), there are *White-Haired Girl* (白毛女 *Baimaonü*), *Ode to Yi Mountain* (沂蒙颂 *Yimengsong*), *Red Detachment of Women*, and *Children of the Grasslands* (草原儿女 *Caoyuan ernü*), but this last does not count as a model work" (Photographer, 1960–).[12]

Neither eight nor ten is the correct number for the model works, however. Yet, while confusion abides, even among those who lived through the Cultural Revolution, the faulty phrase *bage yangbanxi*, translated as "eight model operas," has become well-established both in Chinese and Western media and scholarly writings since the mid-1970s. As late as 2005, an otherwise

8. DACHS 2008 Melvin/Cai.

9. This incorrect standard translation does not account for the fact that not all of these model works were in fact operas.

10. See, e.g., *Wenge shiqi guaishi guaiyu* 1988, 300; *Wenge xiaoliao ji* 1988, 146. Bryant 2004, 77 also cites an interview in which the polemic phrase is mentioned.

11. A genealogy of the production of the first and second set of model works is given below.

12. The interviewee correctly counts *Red Detachment of Women* twice, first as an opera and then as a ballet, but he leaves out a number of model works. Thus, in the end, he comes up with twelve (not ten, as he says) out of eighteen model works.

informative and open-minded Dutch documentary on the model works talks of the "eight model operas" in its prologue, only to focus on the ballet *Red Detachment of Women* throughout most of the film (*Yang Ban Xi* 2005).

The term itself is not a Cultural Revolution term. It was used for the original 1966 set of eight pieces proclaimed as models in the early years of the Cultural Revolution but no longer used as the number of models increased. The term is integral to the polemic of cultural stagnation and the criticism of the so-called "Gang of Four," however. A search of the *People's Daily* finds mention of the term only eight times in the entire period 1967–76 but fifteen times in the late 1970s.[13] Accordingly, it is not surprising that a post–Cultural Revolution Party School publication uses the phrase (*Wenge shiqi guaishi guaiyu* 1988, 299–300) and that almost none of my interview partners were clear about its being inaccurate: only one of my interview partners immediately identified the term as rhetorical "manner of speech" (提法 *tifa*): "The *tifa* is "eight model works" *bage yangbanxi* It was the *tifa* for the criticism of the *Gang of Four*: we would have to say that we could only see the *bage yangbanxi*. . . . During the Cultural Revolution there was never any talk about these *bage yangbanxi*; this was the polemic against the Cultural Revolution. It was a slogan for their criticism [批判符号]" (Museum Curator, 1950s–).

The fact that many people's memories (and this is true for different generations) did not serve them well on this point is significant: it shows very clearly to what extent Party history and rhetoric (i.e., *tifa*) shape people's memories. Many responded, "Model works? Yes, there are eight. Eighteen, you say? No, I don't know about that" (Editor, 1930s–). Some would comment, "I was not aware that there were eighteen model works. I did not know they added new model works; the eight from the beginning had the greatest influence, and we can't remember the later ones, like *Azalea Mountain*. No, my memory is not very clear at all" (Journalist, 1946–). And another stated: "Eighteen model works? No, this is not very clear to people" (Photographer, 1960–). Or else they were simply unconcerned: "I would not care whether there are eight or eighteen or twenty-eight; some of them were better, some worse. When they say 'eight model works' [*bage yangbanxi*], they also do not necessarily mean exactly eight, this expression is a kind of political attitude; it talks about the modernization of theater and all that. It is not about the number, really, it is just an attitude" (Playwright, 1956–).

The polemic term "eight model operas" has found its way not just into popular memory and media, however, but into scholarly writings even outside of China. The phrase recurs in an authoritative 1998 Harvard bibliography of the Cultural Revolution (Wu 1998, 263). Many a thorough study of Cultural Revolution art and culture does not stop short of talking of the "eight." For example, Wang Ban, in his otherwise meticulous discussion of Cultural Revolution Culture, consistently talks of "eight model plays," and so does Lei Bryant in her impressive study of Cultural Revolution song (Wang 1997, 213; Bryant 2004, 3). Worse, a number of recent dissertations devoted exclusively to the model operas among the model works again include the slogan-phrase without specifying its meaning (e.g., Lu 1997; He 1992; see also Michael 1977, 250). In her study of the *Yellow River Concerto*, a model work that did not premier until 1969 as part of the second set of model works, Shing-Lih Chen writes that this piece and the version of *Red Lantern* accompanied by piano (which also came later as part of the second set) were part of the "eight model works," in other words, the first set (Chen 1995, 24–25). More recent Chinese scholarship focused on the model works, however, very clearly separates the two sets and only talks of eight model works (*bage yangbanxi*) when referring to the first set (e.g., Dai 1995, 42–120; Fu 2002, 119–34), while making clear that among these (stage performance) works (*xi*) there are not just

13. Thanks to my student Jennifer May for help with the statistics.

operas, but ballets and symphonic pieces as well (e.g., Wang 1999, 1; Feng 2002, 69–74).[14] Western-language scholarship, on the other hand, continues to perpetuate the polemical phrase and the faulty translation of "model operas" for the much more encompassing term *yangbanxi*.

The Cultural Revolution Group surrounding Jiang Qing certainly attempted to make the model works into the exclusive musical fare. But it seems that they were not entirely successful. The propaganda media suggest that the model works were ever present during the Cultural Revolution—they were performed in schools, in factories, and in the fields; during lunch breaks, groups of people would stand together and recite from them. They were carried to the countryside by numerous performing troupes: one catalog shows a porcelain vase decorated with model opera performances in the countryside (*Wenge ciqi tujian* 2002, 157), and there are many more such examples. Some of these troupes, for lack of "red" talent, were even made up of "counterrevolutionaries." One of these people, whose experience is voiced in the Introduction to this book, remembers being freed by music:

> Because the Party representatives could not read music, they would get me out of the place where they had locked me up, and I was asked to conduct. So, one could say, the model works, or music, saved me. We would perform the ballets *Red Detachment of Women* and *White-Haired Girl*. We had quite an interesting orchestra; the instruments were just anything we had on hand. Many young intellectuals and sent-down youths [知青 *zhiqing*] would join the orchestra. . . . In the end we even organized a big festival there. . . . Propaganda troupes came from all over China to play their music. (Composer, 1937–)

So the model works were everywhere (Wang 1999, 6). They were the staple of daily radio broadcasts, and on the streets they were blasted from loudspeakers. Instrumental teaching, too, was officially based almost entirely on variations of revolutionary songs or melodies from the model works. One interviewee remembers that even Chen Gang (who was criticized for his composition of the *Butterfly Lovers Violin Concerto*, which was considered a eulogy of romantic love) wrote such music:

> There were no pieces to be played on the violin, then, so this violinist friend of mine went to Chen Gang, and he wrote him a piece based on the model works. He had to write this in secret, because he had been criticized severely. . . . This was really quite impressive. He was criticized so harshly, and he knew that we were among those who had criticized him, and still he helped us out. (Musicologist, 1922–)

Another interviewee stresses the quality of some of the pieces that were the result of this type of musical translation:

> Indeed, there was this string quartet in the Shanghai Conservatory; they were actually very good. But during the Cultural Revolution, they were not allowed to play a lot of foreign music, so they used *On the Docks* to write a string quartet. Nowadays, in class, when explaining the form of the string quartet, I always use this piece, and the students are invariably very impressed, for to rewrite a Beijing Opera in the form of a string quartet is not at all easy. (Musicologist, 1922–)

Pretty much all throughout the period now habitually described as the "Cultural Revolution," the model works were everywhere, and it was not long before they had proliferated into

14. Wang, however, also mistakenly talks of seventeen model works in all, leaving out *Boulder Bay* (Wang 1999, 5–6). Dai does not include the symphony *Taking Tiger Mountain by Strategy* in his list (Dai 1995, 224) but instead includes another opera, *Red Cloud Ridge* (红云岗 *Hongyungang*), although earlier he states clearly that this opera was never officially declared a model (Dai 1995, 222).

every possible form, too: one could buy them on cheap LPs and as comic books (discussed in Chapter 6);[15] one could see their heroes on posters, postcards, and stamps,[16] as well as on cushions, plates (ill. 1.3a),[17] teapots, cups,[18] and candy wrappers (ill. 1.3b);[19] as cut-out and ceramic figures and plaques;[20] on washing basins, handbags, cigarette packs,[21] vases,[22] and calendars—in short, on almost all the paraphernalia of daily (if perhaps predominantly urban) use.

Every revised version of the model works was a national event, promulgated with great pomp on the first page of the *People's Daily*. The complete libretti of the model works were reprinted in the Party's highest theoretical organ, the Party journal *Red Flag* (红旗 *Hongqi*). In May 1970, a new step was taken to further popularize them: no longer were they to appear just in the form of stage productions and radio broadcasts, but after numerous revisions, the finalized versions were filmed and distributed nationwide, now reaching, theoretically at least, even the most remote corners of the country. Especially in the second half of the Cultural Revolution, they were also adapted into different local dialects and styles. Within a few years, about 100 local opera forms had been "revived," mainly for this purpose of rewriting the model works (Dittmer and Chen 1981, 73; cf. also Yung 1984).

For an entire decade, then, the model works preoccupied—but only officially monopolized— China's theatrical and musical stages. Performances were much more rare in the countryside than in the city, and tickets were generally hard to obtain, although the propaganda media suggested that they were available everywhere. A depiction from a 1975 issue of *Lianhuanhuabao*, which shows peasants in intimate dialogue with the performers of *Red Lantern*, suggests that in the countryside and among the minorities the model works were also intended to be well-known (ill. 1.4). One China historian (1957–) remembers:

> We all went together with our teacher to watch the filmed model works. I saw *Taking Tiger Mountain by Strategy* three times. The others, yes, I have seen them all. In the city, it was easy to see them. In the countryside, it was perhaps a bit more difficult. But they were shown in the marketplace, for example.

Another interviewee who was sent to the countryside during the Cultural Revolution supports this view:

> The people in the countryside knew about the model works. But they were not able to sing them as we did. . . . I did not learn anything about the model works in the countryside. I picked them up in the city. They are, really, an elite cultural program. (University Professor, mid-1950s–)

Statistics suggest that during the height of the Cultural Revolution, every Chinese man, woman, and child would have watched model works more than twice a year on average (Clark 1987, 145).[23] In the Beijing performances in May and June 1967 alone, the first set of model works had been performed for 37 days, 218 times, and to an audience of 330,000 people (DACHS 2008 Yizhi

15. E.g., *Wenge yiwu* 2000, 73.
16. Posters: *Wenge yiwu* 2000, 107–10. Postcards and stamps: Ibid., 120.
17. Cf. also *Wenge ciqi tujian* 2002, 220–26, which includes depictions from *Jiang Jie*, an opera also criticized at one point during the Cultural Revolution; and Ibid., 232–33, 236.
18. Teapots: *Wenge ciqi tujian* 2002, 279. Cups: *Wenge ciqi tujian* 2002, 260.
19. *Wenge yiwu* 2000, 145.
20. DACHS Mao Ceramics; *Wenge yiwu* 2000, 5–6; *Wenge ciqi tujian* 2002, 87–103; *Wenge ciqi tujian* 2002, 189–93.
21. *Wenge yiwu* 2000, 61–63.
22. *Wenge ciqi tujian* 2002, 156–59.
23. "Fictional evidence" (i.e., from soap opera series such as "Yearning" [渴望 *Kewang*] of the 1990s and works such as Wang Shuo's 王朔 (1958–) "Waiting" (等待 *Dengdai*) of 1978 suggests that the model works were heard and seen constantly: through the loudspeakers, on the radio, and on publicly available television sets.

yangbanxi). For some of the earlier pieces, this number could be tripled or multiplied even more. One contemporary points to the many different media forms that confronted everyone with the model works almost all the time:

> We saw performances of, for example, *Red Lantern*, and then it was made into a film, and these films were really influential. Of course, these loudspeakers everywhere, yes, they, too, would play the model works. But the sound was not very clear. The films, on the other hand, they were really an experience. We would see every one of them two or three times, depending on whether we got a chance. They would perform in the Beijing Sports Academy [北京体育学院], for example, in that huge gymnasium. I remember watching *Shajia Village* there. And then, a lot of us would learn how to sing the model works with friends [*sings*]. I also sang parts in school. There, we would sing these arias, some four or five of us together. We would simplify them, of course. Every time a new model work came out, we would talk about it in music class. (Intellectual, 1958–)

It is undeniable, then, as Bell Yung points out, that the model works have "influenced the musical taste both of musicians and, more importantly, of the masses in the period since the Cultural Revolution" (1984, 163). Ample documentary film and television material produced in recent years attests to the continuing importance of the model works in Chinese cultural memory. One such series explains: "The model works are simply a part of our life" (是我们生活的一部分) (*Fengyu Yangbanxi* VCD, 1: *Hongdengji*). Interest in the model works surged in the mid-1980s to continue on an even larger scale in the 1990s. They were performed frequently, in sell-out events receiving extremely enthusiastic audience responses (Chen 2002, 143; Li 1997, 1; *Yang Ban Xi* 2005; Barmé 1999, 14; *Far Eastern Economic Review* 1987); they were sold as tapes, CDs, VCDs, and DVDs on the open market (Barmé 1999, 231). Notwithstanding our aesthetic or political judgment, then, the model works are an important element in Chinese cultural history that must not be overlooked.

Reverberations of the model works can be found almost everywhere in contemporary Chinese culture—from the fine arts to spoken theater, from literature to music. They have left their mark on China's recent pop and rock music, and even its burgeoning jazz scene, and they have influenced China's classical art music traditions as well: Zhu Jianer's *First Symphony* and Bright Sheng's 盛宗亮 (1955–) 2003 opera *Madame Mao* (Mittler 2007), as well as Tan Dun's 谭盾 (1957–) *Red Forecast: Orchestral Theater III* (1996) (discussed in the next chapter) are typical examples.

<p style="text-align:center">★★★★★</p>

EXCURSION 1
Chinese Opera as a Genre of Change: A View from History

It is not traditional opera but revolutionary Beijing Opera that fills the theaters in China today. This is so in spite of a widely held view that the Cultural Revolution, and the revolutionary operas borne of it, destroyed the traditional Chinese art of opera (see, e.g., Zhao 1969, 177). This apparent paradox of popularity can be explained from the history of Chinese opera: revolutionary Beijing Opera must be understood as one (radical but characteristic) development from this tradition. Neither from a historical nor from an artistic point of view can it be called an exception or perversion of the art of opera; indeed, it can be considered a rather commonplace and natural stage in the development of Chinese opera. Why is this so? Because revolutionary opera, not unlike earlier traditional opera, which came into being in an ongoing exchange between elite and

mass culture and is characterized by its ability to change and adapt constantly, is a synthetic product stemming from a dialogue between high art and popular culture.

One criticism made of the creators of revolutionary opera is that by changing the setting, the costumes, the content, and the musical structure of traditional Beijing Opera, they have stripped Beijing Opera of its identity. It has been said that in its revolutionary form, Beijing Opera is no longer Beijing Opera. This is true, but not as a statement about revolutionary opera alone. Indeed, it can be shown to be a basic principle in the history of Chinese opera, which is a history of "continuous revolution." In a way, one could say that Chinese opera has never been "what it once was."

The variability of Chinese opera was already evident in the beginnings of the form, which can be traced back to the thirteenth century when "mixed theater" (杂剧 *zaju*) was invented. It brought together different art forms: song and recitation, dance and acrobatics, costume and setting. These many different art forms each stemmed from much earlier sources, a fact that made *zaju*'s final rise in the thirteenth century possible. In the dances of shamans, practiced perhaps as early as the third century BCE, for example, long flowing so-called "water sleeves"(水袖 *shuixiu*), which would later become an essential factor in operatic gesture, already played an important role. Acrobatics, which would be integrated into *zaju* as well, entered China from Central Asia around the second century BCE. In the form of martial arts, acrobatic practice was perpetuated and refined in Daoist and Buddhist temples, especially between the third and sixth century CE. Buddhist religious stories in the form of so-called "Transformation Texts" (变文 *bianwen*), performed in a mixture of recitation and singing, were further sources for what later became *zaju*. The developing repertoire of musical suites (in the form of *Tang Daqu* [唐大曲] and *Zhugongdiao* [诸宫调]) and entertaining songs (*Song ci* 宋词), too, as well as the art of storytelling (说书 *shuoshu*), all entered into the grand synthesis that would become the basis for the specific formation of *zaju* theater.

Zaju as a synthetic genre was derived from many different and regionally varied artistic forms, all of which shared both elite and popular cultural origins. It was divided into four movements with rhymed songs, each corresponding to one act. In every act, one of four different role types (male, female, evil/clever, comic) was stressed in particular. In early *zaju* only the leading role type within each act would sing. As early as the Ming (1368–1644), when new and popular theatrical forms developed and influenced *zaju* (which by then had become part of the elitist court culture), these rules were discarded. Thus, duets and even choral singing were introduced to the opera stage. In some local variants of opera that developed during this time, the commentator-choir, which does not appear on stage but comments on stage-action, was introduced. This practice continued within Sichuan Opera and Gaoqiang Opera (operatic forms in which percussion is the only instrumental accompaniment and in which the choir substitutes for the melody instruments), and it is also included in the practice of revolutionary opera (and even ballet).

The following centuries saw the rise of many different regional opera forms. With its specific instrumentarium of bamboo flute (笛子 *dizi*), mouth organ (笙 *sheng*), *pipa*, and moon guitar *yueqin* (月琴), Kun opera (*kunqu* 昆曲) was different from the clapper operas (梆子腔 *bangzi qiang*), which appeared around the same time but which employed the *huqin* (胡琴, a type of two-stringed fiddle), the *yueqin*, and the clapper (梆子 *bangzi*). While clapper opera gained popularity throughout the seventeenth and eighteenth centuries, *kunqu* became the preferred opera style by literati and aristocracy before eventually declining as popular folk theater. Meanwhile, in the mid-eighteenth century, a new type of opera began its rise to fame and popularity: Beijing Opera.

The creation of Beijing Opera is often associated with the meeting of regional opera troupes in Beijing for birthday celebrations by the art-loving Qing emperor Qianlong 乾隆 (1711–99) in Beijing in 1790. The development of Beijing Opera, however, not unlike the creation of many earlier historical operatic styles, was in fact the product of a long process of synthesis in which four

different regional styles played an important role: the music from Yiyang (弋阳腔 *Yiyang qiang*) in Jiangxi, which sprang up as a popular form of the aristocratic music drama *zaju* around the fourteenth century; *kunqu*, the theatrical music from Kunshan in Jiangsu that originated in the sixteenth century; the clapper opera from Kunshan in Jiangsu, which can also be traced back to the sixteenth century and Shanxi; and finally, the so-called "Pi-Huang Operas" (皮黄戏 *pihuang xi*), which came into being between the seventeenth and eighteenth century in Anhui. The presence of four role types and the combination of rhymed and colloquial speech in Beijing Opera are taken from the music of Yiyang; the varieties in singing styles, melisma, and syllabic passages are taken from the traditions in *kunqu*, the music of Yiyang, and clapper opera. The latter was the model for the emphasis on the rhythmic element characteristic of Beijing Opera. Clapper opera also was the source of the particular instrumentation used in Beijing Opera. The use of two different types of aria, *xipi* (西皮) and *erhuang* (二黄), on the other hand, was derived from the Anhui Pi-Huang Opera tradition.

It is often said that Beijing Opera became popular throughout China because it masterfully adapted and combined the structures and methods of several different regional styles. In the history of China's operatic tradition, however, Beijing Opera is only following a well-trodden path: the "tradition" of Chinese opera is a synthetic tradition in which constant reforms and revolutions play a decisive role. The fusion of several elements into one "national style" such as that of Beijing Opera, as well as the genesis of the several different local styles in previous centuries, can be explained by the increasing mobility of merchants especially since the Ming: wherever they went, they found guilds and provincial associations (同乡会 *tongxianghui*) in which local opera traditions were handed down. The central position of local opera in Chinese everyday routine cannot be underestimated: it was not just entertainment for the cultural elite of literati, but it was an integral part of the ancestor cult and all religious feasts and holidays. In the provincial associations of larger trading cities and in the temples often associated or connected with them, local opera forms hitherto unknown to the audience were thus introduced.

The parallels between different local styles, their enormous variety, and the competition between them necessitated mutual influences and the formation of ever-new styles that would blend anew various elements. Accordingly, Beijing Opera was really just one prominent example of this widespread practice. In all of this, the innovative potential of popular forms in particular is evident: again and again they would influence refined operatic forms such as *zaju* or *Kunqu,* only to supersede them eventually.

One reason Chinese opera developed within this synthetic and reformist tradition was because it was transmitted orally. An opera was not, in the same way as in European traditions, the work of one (genius) composer—if perhaps a librettist. Chinese opera is based on a set repertory of melodic and rhythmic modules, which could be interpreted by singers and musicians in a way they saw fit. They would recombine and rewrite the bone structure of an opera, some of which may be noted down in a score: a Chinese opera score would usually contain the text, some cues to indicate when the actors are to enter and leave, and where singing is supposed to vary with recitation, and finally, the literary name of the melody module, which was to provide the appropriate atmosphere for a particular dramatic situation.

Within this very flexible structure, China's theater workers could freely borrow from elsewhere or include new materials in their operas as long as they thought these new materials would be appreciated by their audiences. And it is this openness to constant reform and change that may also be the clue to the enduring power of China's operatic tradition. It is for this reason that one cannot sentence Chinese opera to stay as put, to remain "that which it once was"—for even such a "that" would always already be fictional and past. The fact that not only local, regional, and national but also international operatic traditions played a role in the development of China's operatic

tradition in the twentieth century is simply a broadening of a long-since established historical principle guiding the development of Chinese opera as a genre. If, therefore, in the beginning of the twenty-first century, a number of Chinese operatic styles in which foreign influences can be traced (the revolutionary operas being one such example) have found their way onto China's stages next to several hundred local operatic traditions, this is not a revolutionary break, but indeed, nothing but the logical continuation of a well-established, age-old tradition. Even though in revolutionary Beijing Opera traditional libretti and costumes were substituted almost completely by modern content, the model operas made clever use of a number of basic elements from the old operatic tradition in order to propagate new and political values. This is how one musicologist expressed it:

> Traditional culture in China is different from everywhere else. It is a kind of sand; there is constant renewal and constant change. That is the tradition. . . . Every time social circumstances change, a new type of opera comes up. So Chinese drama, really, follows the rhythm of life. And what was the rhythm of life in the 1960s? Of course, they had to change Beijing Opera to adapt it to the circumstances, so the long sleeves were no longer any good. It was a very natural process. (Musicologist, 1950s–)

✦✦✦✦✦

"To Wield through the Old to Create the New" (古为今用): Musical Traditions in the Model Works

During the Cultural Revolution, all musical production and performance—and this was a political dictate not open to debate—had to follow the framework set by the model works, be it in terms of theory, form, content, or even performance practice. Cultural Revolution propaganda art was meant to be a monoculture. Cultural politics during the Cultural Revolution was the gigantic and in many ways destructive attempt to establish one, and only one, acceptable artistic taste for all. The result was, as composer Du Mingxin had pointed out,[24] that apart from variations on the theme of the model works, there was indeed "no music," officially—and no traditional music, to be sure. Yet, it is not all that difficult to find people who lived through the Cultural Revolution and tell a different story.[25] One musicologist was quite adamant about the proliferation of traditional music during the Cultural Revolution:

> When we talk about the Cultural Revolution, we often talk about the restriction of traditional culture, but really, it continued to live in our hearts. And not only that, but Shanghai's sent-down youth, like my wife who went to Anhui, listened to a lot of local performances of opera, and she, for one, really liked it. The precise knowledge of this art may have been lost in a way, because officially they only wanted things like the model works, something new, with modern themes, so the officials were against the tradition. As for the common people [老百姓 laobaixing], no, for them it was not like that. All throughout the Cultural Revolution, there was very deliberate support for some parts of tradition and then there was another culture, too, that was still there, if not officially acknowledged. They were two different things. So really, we cannot talk about a break with tradition, with everything before, no. If this had been the case, it would not have been possible to take up the thread so quickly after the fall of the Gang of Four. These things were still there, and not just in our hearts. (Musicologist, 1950s–)

Many remember performances of different types of local theatricals and mountain songs when they were sent to the countryside (Female Artist, 1959–; University Professor, mid-1950s–). They

24. See the Prologue to Part I.
25. Some examples are given in the Introduction and in the Prologue to Part I.

would listen more or less secretly to local opera performances and records even of ghost and other traditional plays. One remembers: "There were a lot of people who objected to Mao's *Yan'an Talks*, because it basically meant you could not perform this or that old play. It is true that during the Cultural Revolution, a lot of things could not be performed, but people had these records and they would listen to these things anyway in their homes" (Librarian, mid-1950s–). Many speak of restrictions and fears of being caught performing "unwanted" music (see the discussion in Tuohy 2001, 16) while acknowledging that musical traditions were never completely cut off. One journalist (1946–) remembers watching quite a few operas that were not model works (all of them with contemporary topics, however), and her father singing arias in the old style and from the old operas at home: "My father would sing this secretly, a lot, in the style of Ma Lianliang [马连良, 1901–66, the famous singer of *laosheng* roles]. We would not dare have this kind of performance when others were there, not even the neighbors. Remember how Chen Kaige would tell on his own father for singing some old opera?"

It is obvious from many of these often internally contradictory accounts that individual memory is readjusted in accordance with official and unofficial strains prescribing the conception of the Cultural Revolution as cultural history and postulating that there were "eight model operas" and nothing else. One China historian (1957–), for example, remembers, with quite some indecision:

> During the Cultural Revolution there were absolutely no traditional operas with love [才子佳人 *caizi jiaren*] stories, or ghost operas [鬼戏 *guixi*], no, we would not see them, not even underground: how would you dare put up a performance? So that part of tradition was actually cut off completely, really, there was no such thing during that time! But we had a cousin who sang Beijing Opera and other operatic forms—he was in the opera troupe. In his house, he would sing old operas, even during the Cultural Revolution, so in private this was still possible, but not in public and not if others were to see him. Then, he would be too afraid! So in a way, then, this was not really lost after all. (China Historian, 1957–)

It is notoriously difficult to try and distill "historical fact" from such ambiguous remarks. Statistics and news reports as well as ethnographies testify to the fact that Chinese opera, not just in the form of the model works, continued to be performed and practiced all throughout the Cultural Revolution. Even some of the propaganda publications such as *Pictorial China*[26] (人民画报 *Renmin Huabao*) and *People's China* (中国人民 *Zhongguo Renmin*) and, since 1972, the serial *Literary and Art Programs* (文艺节目 *Wenwu jiemu*), mention official performances of many operas and theatricals other than those declared to be models (Mackerras 1973; Mackerras 1975; Tuohy 2001, 6–7). To be sure, then, China's stages were not exclusively occupied by "eight model operas" between 1966 and 1976 (see, for example, the discussion of local ritual opera performances in Jones 1999). Dragon dances were being performed all through the Cultural Revolution and by Red Guards, even, in the early years (Brandl 2001, I:83). Moreover, the late 1960s saw the formation of a campaign encouraging the creation of local operatic versions of the revolutionary Beijing Operas (so-called transplant model works [移植样板戏 *yizhi yangbanxi*]). It was officially promoted with great pomp and quite a few *People's Daily* articles.[27] This also meant that at least some of these local styles not only continued to exist but thrived even in changed form in the second half of the Cultural Revolution (Musician, 1930s–; Fu 2002, 135–39; Clark 2008, 73–80).[28] One ethnomusicologist evaluates the situation as follows:

26. This, and *People's China*, are the English titles provided by the journals, not accurate translations of the Chinese titles.
27. This movement is remembered by a few interviewees. See, e.g., the testimony from a musician, born in the 1930s.
28. See, for example, *RMRB* 3 June 1972, *RMRB* 29 March 1973, *RMRB* 11 August 1973, *RMRB* 20 November 1974, *RMRB* 2 December 1975, *RMRB* 9 December 1975, *RMRB* 8 March 1976, *RMRB* 7 September 1976.

In terms of local operas [地方戏 *difangxi*], the Cultural Revolution had quite a significant effect on them. They were redeveloped, indeed, there were a lot of changes, especially musical changes, due to the influence of the model works. After the Cultural Revolution, these "transplant model works" were not destroyed, although generally people returned to the more traditional topics and types. But the old forms had already changed with all this adding of harmony, for example. During my time in the opera troupe, in the early 1970s, there was a lot of development; we had so little to do, so we concentrated on these different local opera forms, *Huangmeixi* [黄梅戏] most notably among them. (Ethnomusicologist, 1940–)

Another interviewee remembers the situation much more bleakly, but implicitly acknowledges that performances of local opera were disrupted and stopped (if at all) for a much shorter time than is generally assumed:

Traditional culture was actually completely destroyed during the Cultural Revolution; it is terrible, really. As for the local operas, they are so different from the model operas. We really could not combine the two. It was a great destruction. This whole idea of transplant model works simply did not work. Therefore, this was a real destruction, not a success. . . . In the 1970s, I tried once more to recover this kind of music, local operas. . . . The singers were all very young. It was a very precious experience, and after the Cultural Revolution we made a recording that is now extremely valuable because nobody really does research on these local opera forms. Nevertheless, it must be said that the origins of the local operas are now already lost. So few people can sing them, and there is really no interest in them. I would say it was the model works that destroyed this form of theater. (Composer, 1937–)

Many voices stress the difficulty and absurdity of producing the transplant model works. This is somewhat astonishing, for looking back at the engendering of many of the model works, precisely this process plays out in reverse many times: almost all of the model operas among the model works have roots in earlier local opera versions that were then "transplanted" to become revolutionary Beijing Opera:

Really, it was quite difficult to make these transplant model works. And it was quite absurd [荒唐 *huangtang*], too. Nevertheless, there are a lot of transplant model works, and when the films came out, they were even officially certified. (Musicologist, 1922–)

It is obvious, even from these few examples, that music did play a role during the Cultural Revolution, that people did indeed listen to, practice, and perform music other than the model works or revolutionary songs. All kinds of music—some supposedly forbidden—were still played during the Cultural Revolution, and traditional music, too, could be heard, if heavily muted, during this time. On the one hand, due to government restrictions, the production of the model works, including the ten modified Beijing Operas, is intimately connected with many a tragic story of persecution and destruction of a musician's career (e.g., *Yang Ban Xi* 2005; Dai 1995; Mittler 1997). Even those intricately involved in the reform and revolution of Chinese traditional music in the model works, only precarious heroes and heroines of the time, could and would be prosecuted and made to suffer during or after the Cultural Revolution.[29] On the other hand, the Cultural Revolution can be considered a time when more people than ever before were exposed to traditional music, especially the music of Beijing Opera, precisely because of the prevalence of modified Beijing Operas among the model works: they succeeded in reaching practically every household (Pian 1984). This may be one reason to explain the popularity of the revolutionary

29. Many examples are given in Dai 1995 and *Fengyu Yangbanxi* (c. 2004). For the production of revolutionary songs, a similar situation prevailed, see (Bryant 2004, 71–72).

operas to the present day, something that was echoed, time and again, in my interviews. Some would argue:

> Definitely, yes, we can talk of the Cultural Revolution as a time when Beijing Opera as a form was popularized [京剧的普及]. (Musician, 1930s–)

> I used to never watch Beijing Opera—I did not like it. But the model operas were such that they actually made you like Beijing Opera, or perhaps you just got used to it. Anyway, a lot more people actually were confronted with and in the end knew something about Beijing Opera this way. (Artist, 1954–)

> The model operas are real Beijing Operas, or better, they are a very important redevelopment of Beijing Opera. However, if you have seen these, you still do not understand traditional Beijing Opera. You don't understand the rhymed speech in Beijing Opera, for example. But the model works are, of course, a real step forward in the development of Beijing Opera insofar as they popularized the form [普及化, 大众化京剧] and gave it an important push. (Intellectual, 1958–)

So the question of whether or not the model operas were in fact "real Beijing Operas," and whether, therefore, one could actually learn or understand more about traditional opera by watching them, was contended. Some would say:

> The revolutionary Beijing Operas are a continuation of tradition, in terms of structure. They are just like traditional opera, using the same meters and all that—*daoban* [导板], *erliu* [二流], etc. Of course there is change, innovation. But the basis is really quite traditional, and the changes are made to fit the tradition [符合传统]. (*Guqin* Player, 1940s–)

Others argued much differently:

> A lot of people in my generation and in my field have not received any training in understanding traditional opera forms. We did not know anything about this during the Cultural Revolution, either, so nowadays, we listen to it and don't understand it. Model operas and traditional plays are two completely different things. Of course, the model operas are reformed Beijing Operas, but their nature, the way they are being performed, is really not at all the same. Of course, there are some symbolic gestures in the model operas, too, like going on a boat or riding a horse, but some other things are really much more abstract in the original Beijing Opera. With Jiang Qing's model operas, even if you have a very low cultural level, you are able to understand them. With traditional Beijing Opera, on the other hand, you need special training in order to be able to understand [them]; you must go see it often, every day, but we did not have this kind of environment when we were small. (Photographer, 1960–)

How traditional are the revolutionary model operas, then? Below, I probe this question, arguing that even if one were to take seriously the verdict that the musical horizon during the Cultural Revolution consisted only of revolutionary songs and the model works, one could still argue that, as such, this musical universe did not exclude traditional music. For if one looks at the model works more closely, one understands that they can be considered traditional music. The revolutionary Beijing Operas among them do make use of traditional operatic techniques in order to make themselves understood by a popular audience well familiar with operatic conventions.

That the model works furnished role models to their audiences, for example, is nothing surprising to the Chinese theatergoer. Many a traditional opera served didactic ends (Michel 1982, 165). Certain masks, costumes and movements, language, and musical accompaniment contrasted good and bad characters, or negative and positive characters, in traditional operas (Michel 1982, 184). By close adherence to (or the simple transfer of) some of these traditional symbols in the

model works, even hidden enemies could be recognized from their first appearance. And people were very aware of these conventions. Says one artist (1954–): "We knew immediately when they came out: this is a good guy, this is a bad guy. The reason we now think the foreign movies are interesting is because you don't know from the beginning who is who." He also remarked: "The colors are also significant. White and black is used for the bad guys, for example." And indeed, face color and costume color are adjusted in the model operas according to practices from traditional opera where variations in facial makeup symbolize the disposition of the character. Red indicates devotion, courage, and uprightness. Yellow signifies fierceness, ambition, and cool-headedness. Blue represents staunchness, fierceness, and astuteness. White suggests all that is sinister, treacherous, suspicious, and crafty. Black symbolizes the rough and tough. Purple stands for sophistication and cool-headedness. Gold and silver are usually used for gods and spirits.

In the model operas, a red face still marks a person who is upright and loyal; greenish-white, as in tradition, are the faces of the sinister, the treacherous, the stubborn and impetuous, and this is emphasized by lighting effects. Even the modern costumes used in the revolutionary operas keep to certain traditional conventions: red is the color of happiness both in tradition and in Communism, while blue and green are the clothes of the virtuous and good. Constant Treasure (常宝 Chang Bao) wears a blue dress, the soldiers green uniforms, and the characters of the friendly old woman (the mother of Courageous Li [李勇奇 Li Yongqi] in *Taking Tiger Mountain by Strategy* and Granny Sha 沙奶奶 in *Shajia Village*, for example) wear pale blue just as they would in a traditional setting (Zung 1962, Chapter 2). Constant Treasure wears a red tie in her hair, and while the photos of a 1964 production still show bandits with red bands, in later model versions of the opera, this color is reserved exclusively for positive characters.[30]

Accordingly, Jiang Shuiying 江水英 in her first and last appearance (scenes 1 and 8) in *Song of the Dragon River* is wearing red (later she dons a flowery blouse), and the inside of Yan Weicai's 严伟才 jacket in *Raid on White Tiger Regiment* is red. Zhao Yonggang 赵勇刚, too, wears a red vest in *Fighting on the Plain* (平原作战 Pingyuan zuozhan, e.g., in scene 4). Li Tiemei 李铁梅 (from *Red Lantern*) wears red, notably in the scene where both her father and her grandmother become martyrs to the Communist cause. And Constant Treasure in *Taking Tiger Mountain by Strategy*, when she offers to join the fight, wears red, too.

These conventions from Chinese opera are translated into ballet as well: the same color symbolisms are applied there. The boy in *Children of the Grasslands* wears a red scarf, the girl red shoes. Eventually, both are used as a sign by the children so that the villagers can find them. In *White-Haired Girl*, in the final apotheosis, the white-haired girl wears red; in *Red Detachment of Women*, Wu Qinghua 吴清华, too, is depicted in red in the beginning scenes, when she is shown defying brutal landlord Nan Batian 南霸天.

The villains, on the other hand, are clad in dark colors, which were usually reserved for the fierce and negative characters in traditional opera as well (e.g., Qian Shouwei 钱守维 in *On the Docks* or Zuo Shandiao 座山雕 in *Taking Tiger Mountain by Strategy*). They are also shown—due to their missing virility (see Roberts 2010)—as bald-headed (e.g., Hatoyama 鸠山 in *Red Lantern* and Hu Chuankui 胡传魁 in *Shajia Village*) or with greasy long hair (e.g., the American commander in *Raid on White Tiger Regiment*, Nan Batian in *Red Detachment of Women*, the traitor Sun Shoucai 孙守财 in *Fighting on the Plain*, and one of the bandits, Pi Degui 皮德贵, in the model ballet *Ode to Yi Mountain*).

Another of these methods of marking virtue and vice taken from the traditional operatic repertoire is the use of a restricted role canon of stock characters. Certainly, Communist model

30. Denton 1987, 125. An elaborate study of costume and color significance in the *yangbanxi* can be found in Roberts 2010, 85–112.

theater no longer finds a place for the smooth and delicate female characters, or *dan* 旦, such as the maidenly woman (闺门旦 *guimendan*), the virtuous woman (青衣 *qingyi*), or the flirtatious woman (花旦 *huadan*). Revolutionary opera also modifies each role type according to standards of psychological realism, as, for example, when Aqingsao's 阿庆嫂 *huadan*-style singing is changed to sound more decisive in *Shajia Village* (Zhao 1969, 173). Still, similarities with traditional operatic role types abound: the kind elderly woman resembling some of the traditional old woman (*laodan* 老旦) characters appears and reappears (e.g., Aunt Choe 崔大娘 in *Raid on White Tiger Regiment*, Granny Sha in *Shajia Village*, Granny Li 李奶奶 in *Red Lantern*, and Aunt Zhang 张大娘 in *Fighting on the Plain*). The young women to be met in the model revolutionary operas, on the other hand, are often eager to join the battle: Constant Treasure in *Taking Tiger Mountain by Strategy* is reminiscent of some of the strong and forceful women characters from traditional opera, such as female military generals (刀马旦 *daomadan*) or female acrobats (武旦 *wudan*).[31] Chang's bravery is emphasized even more when she sings in the style of a young male character (小生 *xiaosheng*).[32]

The importance of female heroines in traditional opera is echoed in the model works, where the heroine is often accompanied by a young courageous Party hero; in *Taking Tiger Mountain by Strategy*, for example, this is Yang Zirong (杨子荣), a modern *xiaosheng*.[33] And all of the model works invariably feature an old wavering or outright vicious man, such as Zuo Shandiao in *Taking Tiger Mountain by Strategy*. He is hunched over, ugly like the comic (*chou* 丑) or the painted-face role (*jing* 净) from traditional Chinese opera (Judd 1991, 272).

The emphasis on role types is supported by the use of typified names or name calling: the names of the protagonists, some of them literally, others by use of homonyms, always illustrate a person's attitude and mental makeup, too. Negative characters are often associated with animals, such as "vulture" (Zuo Shandiao in *Taking Tiger Mountain by Strategy*), "pigeons' mountain" (Hatoyama in *Red Lantern*), and "tortoise field" (Kameta 龟田 in *Fighting on the Plain*). They might show through their names that they will bring chaos (乱 *luan*) to where everything has been peaceful (平 *ping*) (i.e., Luan Ping 栾平 in *Taking Tiger Mountain by Strategy*); they might be characterized as tyrannical, arrogant, selfish, and profiteering, as with the peasant Chang Fu 常富 who is "always rich" in *Song of the Dragon River*, Qian Shouwei 钱守维, who would "keep his money" in *On the Docks*, Sun Shoucai 孙守财 who "stores up treasures" in *Fighting on the Plain*, tyrannic Nan Batian 南霸天, in *Red Detachment of Women*, and Diao Deyi 刁德一, the landlord who is always "full of himself" (得意 *deyi*) in *Shajia Village*.

Sometimes their names are ironic or contain "feudal" thought: the rich landlord who mistreats the white-haired girl, for example, is called Huang Shiren 黄世仁 (one who has practiced the Confucian virtue of humanity for generations); the villain in *Song of the Dragon River* is Huang Guozhong 黄国忠 (one who is "loyal to the motherland"); and one of the bandits in *Ode to Yi Mountain*, Pi Degui 皮德贵, is "virtuous and precious." Sometimes, the negative characters remain unnamed or are simply called "false commanders" (伪参谋长 *wei canmouzhang*) or "false soldiers from the White Tiger Regiment" (伪白虎团士兵 *wei Baihutuan shibing*) as in *Raid on White Tiger Regiment*. Heroes and heroines, on the other hand, are "iron maidens" (Li Tiemei 李铁妹 in *Red*

31. Roberts 2010, 191–214 provides an elaborate analysis of this parallel.

32. *Sheng* 生 is the general term for male characters in traditional opera, *laosheng* (老生) is the old man, *xiaosheng* the young man, *wusheng* (武生) the acrobatic/military man.

33. The predominance of female heroes is particularly striking in the second set of model works (e.g., *Azalea Mountain*, *Song of the Dragon River*, and *On the Docks*), but the earlier model works, too, have female heroines (e.g., Li Tiemei in *Red Lantern*, Wu Qinghua in *Red Detachment of Women*, Aunt Choe in *Raid on White Tiger Regiment*). A number of fine studies on the model works have dealt with questions of gender and family that will not be touched upon here (Meng 1993; Bai 1997; Chen 2002; Kim 2005; and most brilliantly Roberts 2010).

Lantern) or "great talents" (Yan Weicai 严伟才 in *Raid on White Tiger Regiment*), they are "courageous and tough" as Zhao Yonggang 赵勇刚 in *Fighting on the Plain*, can "build for their country a bright future" (e.g., Guo Jianguang 郭建光 as 国建光 in *Shajia Village*), or have put their "ambition on the fields" upon which peasants must rely for survival (as Li Zhitian 李志田 in *Song of the Dragon River*). They may be named "Pure China" or "Everlasting Spring" (like Wu Qinghua 吴清华 and Hong Changqing 洪常青 in *Red Detachment of Women*).

This consequent use of very literal names is one aspect in which revolutionary Beijing Opera is sometimes even more straightforward than its traditional predecessors. Easy intelligibility is also the reason why, in the dialogues, spoken vernacular rather than lyrics (so-called 韵白 *yunbai*) were employed (e.g., Zhao 1969, 180). Positive characters and negative characters are clearly differentiated in their use of language, and this effect increases over time in successive revisions: the 1972 version of *Raid on White Tiger Regiment* (scene 2), for example, has the American commander react in a much more brutalized manner and language in ordering the killing of Aunt Choe than in the 1967 version of the opera.

Although spoken vernacular is introduced as a break from tradition with didactic intention, many of the other declamatory practices (念 *nian*) in the revolutionary operas, pregnant with meaning, would have been taken directly from Chinese operatic traditions, for reasons of political didacticism. Close to twenty different types of laughter have been inherited from that tradition—there is friendly laughter, wicked laughter, happy laughter, intelligent laughter, etc. In *Taking Tiger Mountain by Strategy*, for example, the friendly laughter of Yang and his regiment's commander Shao practicing Yang's entrance into the bandits' cave (scene 4) is stunningly different from the bandits' wicked laughter when they see Luan Ping, their collaborator, dead on the ground (scene 10). Aunt Choe's superior laughter when she is speaking to the Americans (in *Raid on White Tiger Regiment*) and Yang Zirong's sly laugher when he is confronted on Tiger Mountain with Luan Ping, who has just escaped custody with the Communists and thus knows Yang, or the friendly laughter of Old Ma Hongliang 马洪亮 who is so happy to return to his former place of work (in *On the Docks*)—all of these are examples of the effective employment of this traditional technique of declamation.

In terms of gestures (做 *zuo*), too, a number of corresponding elements between traditional and revolutionary theater serve a didactic purpose. Whatever the experienced opera audience understands semantically can be used for a purpose by the makers of revolutionary opera: the big strides of the old man (*laosheng*) in traditional opera, for example, express his fearlessness,

Ill. 1.5. Depiction of negative characters in the model works: Main hero Yang Zirong meets Zuo Shandiao and his men in *Taking Tiger Mountain by Strategy*, 1970 (Postcard Collection, Beijing: Foreign Languages Press, 1970).

his mental superiority. The movement thus represents an inner attitude, the figure's mental makeup, giving expression not only to certain actions but also their motivations. This aspect is perpetuated in the model works. Negative characters, such as Huang Guozhong and Chang Fu in *Song of the Dragon River*, walk in strides that, in traditional opera, are reserved for negative or "lesser" characters: they are clumsy and awkward (**ill. 1.5**); they stumble, waver, and totter about (which, especially in battle scenes, becomes a thrill for the audience to watch, as in *Fighting on the Plain*, scene 10). Not unlike the clown in traditional opera—a modern version of

which appears in the form of the Korean who keeps coming up with wrong rhymes in *Raid on White Tiger Regiment* (scene 6)—the negative characters in the model operas all appear slumped or hunched, with their faces down, avoiding the audience (sometimes their awkward appearance is stressed by their deliberately badly cut clothes, as in the case of the American military officer in *Raid on White Tiger Regiment*. They are also filmed from below (as in *Song of the Dragon River,* scene 4) or above (as in *Raid on White Tiger Regiment,* scene 2 or *Fighting on the Plain,* scenes 4, 7, and 8) and these skewed filmic perspectives all suggest the same semantics. The operatic practice is also translated into ballet, as in scene 5 of the model ballet *White-Haired Girl,* where Huang Shiren and his servant, hiding from a thunderstorm in a temple, are shown to walk with the same awkward strides that would be used in traditional opera.

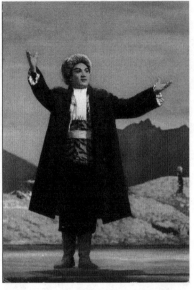

The positive characters, on the other hand, enter the stage proudly and ceremoniously, with their arms raised and palms out, in dramatic poses (亮相 *liangxiang*) taken from Beijing Opera, displaying their good faces directly to the audience (**ill. 1.6**).[34] The tragedy of Aunt Choe's unjust death is marked in introducing Sister Choe 崔大嫂, who is first shown close-up when she enters and then again when she breaks down, crying next to Aunt Choe's dead body (*Raid on White Tiger Regiment,* scene 2). In scene 1 of *Song of the Dragon River,* Jiang Shuiying's first appearance on a boat contains all the typical traditional stylized hand movements, even though the boat and the punting stick are

Ill. 1.6. Depiction of positive characters in the model works: Yang Zirong, main hero of *Taking Tiger Mountain by Strategy,* 1970 (Postcard Collection, Beijing: Foreign Languages Press, 1970).

Ill. 1.7. Use of traditional operatic gestures: Yang Zirong rides a horse, 1970 (Postcard Collection, Beijing: Foreign Languages Press, 1970).

no longer just imaginary but real props. Han Xiaoqiang 韩小强 and Old Ma rub their tears away in striking traditional moves in *On the Docks* (scene 6) and Yang Zirong rides an imaginary horse in the manner typical of Chinese operatic pantomime (scene 5, **ill. 1.7**) in *Taking Tiger Mountain by Strategy.* In *Song of the Dragon River,* the brigade members who rush to the broken dam, supported by the troupes from the PLA, do so with extensive percussion accompaniment in the manner of traditional military marches in Beijing Opera (scene 5).

34. Denton 1987, 127 mentions the interesting symbolic play on *yin* and *yang* analogies here, which opens up yet another level of signification: water, standing for *yin,* the negative, weak, and dark, moves downward, and thus negative persons are cringing downwards. Fire, on the other hand, the positive, strong and bright, the force of *yang,* is directed upwards just like the positive characters in their gestures. See also Roberts, 2010.

This is also taken up in the ballet *Children of the Grasslands* and in *Fighting on the Plain* (e.g., scene 4). The same must be said for the appearance of Korean and Chinese troupes in the beginning scene of *Raid on White Tiger Regiment*. The model operas and the model ballets also feature the same type of sewing (also to be seen in *White-Haired Girl*, scene 1), the same type of drinking, and the same type of walking as traditional operas do. Only slight modifications are made to serve the ideal of "Revolutionary Romanticism": horses might neigh audibly, or props might be used (traditionally they were reduced to a minimum).

The use of spectacular acrobatics (打 *da*) from Beijing Opera in the revolutionary operas is certainly one of the reasons why this art form has always been so popular. There are unforgettable moments in some of these operas: the decapping of landmines, for example, is done in a dance-like fashion in *Raid on White Tiger Regiment*. Similarly spectacular are the cargo- and sack-carrying dances in *On the Docks*. Breathtaking, too, is the scene showing the militia moving up Tiger Mountain on skis in *Taking Tiger Mountain by Strategy* (ill. 1.8). Arguably one of the most beautiful scenes in the model works is one already mentioned in the Introduction to this book: in *Song of the Dragon River* (scene 5), heroine Jiang Shuiying and other members of the brigade create a human barricade against the roaring waters while others repair the broken portion of the dam. In this scene, too, the acrobatic abilities of the performers are spectacularly showcased: the actors perform long and incredibly fast successions of flip-flops and somersaults, they build bridges for each other and jump over them, and so on. The preceding fight over firewood, too (scene 4), reminds the audience of elements well known from man-to-man assaults in Beijing Opera: sudden clashes, somersaults, and more or less exciting or awkward falls. The good and the bad are demarcated in the acrobatic movements in traditional opera, and the revolutionary operas make no exception to this rule—indeed, all of them use such fighting scenes to add to their particular dramatic effect, and this dramatic effect is translated into model ballets, too.

In their use of arias and instrumental passages (唱 *chang*), the revolutionary operas again draw on traditional semantics in order to speak effectively. Traditional operatic percussion (Chinese drums, clappers, large and small gongs and cymbals) accompanies every kind of stage movement, from long battle scenes to the roll of an eye. It also reflects the actors' thoughts and emotions, introduces sung passages, and occasionally imitates the sounds of swords or nonexistent stage props such as a boat rocking in the water. Both the model operas and model ballets make frequent use of these traditional semantic functions of operatic percussion. In *Ode to Yi Mountain* and *Red Detachment of Women*, percussion is often used to mark the careful walking steps of the protagonists: when evil Huang Guozhong in *Song of the Dragon River* realizes he has betrayed himself by reacting to his former name, he sinks to the ground, accompanied in characteristic manner by heavy percussion sounds (scene 8, see *Longjiangsong* 1975, 42). When the Korean deserter suddenly faces the Communist army, agitated percussion expresses his confusion and shock (*Raid on White Tiger Regiment*, scene 6); when Sister Choe is seen passing through enemy ground (scene 8), her careful consideration is expressed through effectively tense percussion accompaniment. The battle scene at the end of *Taking Tiger Mountain by Strategy* is accompanied by typical "war percussion": Luan Ping's fear in facing Yang Zirong for the first time (scene 4), seen in the sudden shocks and shivers of fright going down his spine during the conversation, are punctuated by percussion beats. And similarly, the scene in which Yang and regiment commander Shao have decided on a plan for Yang's going up to Tiger Mountain in disguise ends with Yang's words, "This is a well-considered plan, it is decided"—and after a short pause, these words are followed by a beat of percussion: well-considered and—decided.

Song of the Dragon River contains another example of percussion reflecting the thoughts and emotions of the protagonist: we hear heroine Jiang Shuiying's regular heartbeats, for example, in

her monologue in scene 5 (*Longjiangsong* 1975, 152–53). Percussion punctuation is also used in a traditional way to dramatize some of the dialogues—in order to express the surprise of a person, for example. When Jiang Shuiying compares the situation in her brigade to a game of Chinese chess and argues that sacrifice is sometimes needed, it is like a blow to the mind for Li Zhitian, her fellow brigade member, and this blow is expressed musically, with a sharp percussion beat (scene 2, *Longjiangsong* 1975, 12). The argument in a later scene over firewood (whether to use it to heat the brick oven or to prop up the hole in the dam), too, is accompanied effectively by percussion punctuation (scene 4, *Longjiangsong* 1975, 23). Here, every one of her arguments is supported by one or sometimes two reassuring percussion beats:

That is wrong. [BEAT]
How are we supposed to prop up the hole without the wood, and if we do not prop up the hole, how can we finish the dam? [BEAT]
And if we do not finish the dam and move the water to the drought area, how can we fulfill the task the Party has set for us? [BEAT BEAT]

When, in the final scene, Li Zhitian agrees to close the lock (Chang Fu and Huang Guozhong had advised him to do so because they intended to sabotage the whole task in order to save their own houses and fields) and shouts: "Close it," a veritable percussion storm begins and is then held under a long fermata. Thus, tension rises until Jiang Shuiying appears and sings, in an extremely high register and at a very fast pace in a 西皮快板 *xipi kuaiban* aria, accompanied by a steady drum beat: "To close the gate and stop the water" [three beats] "would be a serious mistake," followed by ever faster tremolo beats (scene 8, *Longjiangsong* 1975, 306–7). Her authority is underlined by the percussion beats, and the danger of the situation is emphasized by the quickening percussion tremolo. In a similarly effective manner, percussion is used in *Raid on White Tiger Regiment* (scene 2) when Aunt Choe and the American commander argue and she calls him a traitor, a liar, and a sycophant, her words always accompanied by appropriate percussion beats. The technique is also used in *On the Docks* (scene 4) when Fang Haizhen 方海珍 and Zhao Zhenshan 赵震山 disagree on whether to take care of the African or the Scandinavian delivery first, and a deep gong of "foreboding" is added whenever Fang expresses her concern and fear that Zhao would make a mistake and forget about class struggle.

Percussion accompaniment thus marks particular emotions and characters, serving, once again, to distinguish good and bad. As such it could be recognized as perpetuating a propaganda message easily understood. One interview partner remembers: "It is Beijing Opera, in a way, because you can see exactly who is good and who is bad. From the makeup and all this, and then the music: when you hear the music, immediately, you will know: okay, a bad guy is coming." (Photographer, 1960–)

Another such musico-semantic element taken from the repertoire of Beijing Opera for the purpose of political didacticism is the employment of certain aria-types. As mentioned above, Beijing Opera features two kinds of arias, *erhuang* and *xipi*, both of which can appear in different meters (板眼 *banyan*). *Erhuang* is often used to mark reflective and reminiscing moments. Accordingly, Jiang Shuiying in *Song of the Dragon River* sings an *erhuang* aria (scene 2) when describing the difficulties in cultivating the 300 *mu* of land that now must be flooded in order to assist the mountain brigade nearby. She does so in her attempt to persuade Li Zhitian that she is well aware of the sacrifice she asks of her own brigade members. Panshuima's explanation of Huang Guozhong's abominable role in the old society and her son's death is again presented in an *erhuang* aria. The same pattern applies in the other operatic model works: In *Red Lantern*, Granny Li uses an *erhuang* aria to tell the story of her "revolutionary family," which consists not of blood

bonds but of victims from different assaults (scene 5 of *Red Lantern*). Granny Sha in *Shajia Village* similarly describes her past difficulties in the old society with an *erhuang* aria (scene 2).

Fan erhuang 反二黄 arias in particular are traditionally used to express tragedy or melancholy. Chang Bao's song of bitterness in scene 3 of *Taking Tiger Mountain by Strategy* is one such example. Jiang Shuiying's aria (scene 8), within which she encourages the brigade members to make ever more sacrifices, even to accept the loss of their homes, begins with a description of the situation three years earlier, when, during a flood, many brigade members lost their homes and their lives. This aria is aptly presented as a *fan erhuang* (*Longjiangsong* 1975, 309). Jiang's shock and disgust at the fact that Li Zhitian is too narrow-minded to see the importance of such a sacrifice is again expressed in the form of a *fan erhuang* aria.

Erhuang can also be used to introduce an important person in the so-called *erhuang daoban* (二黄导板), which is a particular type of *erhuang* aria that begins with a line sung offstage (Denton 1987, 131). This aria type is employed twice in *Taking Tiger Mountain by Strategy* to introduce the main hero, Yang Zirong (in scene 5, when he rides up the mountain, and in scene 8, when he deposits the message to the other fighters). The choice of aria type in these instances thus becomes a sign to the audience, identifying the main hero in the opera, and this effect is used at least once in all of the operatic model works (e.g., in scene 8 of *Red Lantern*, when Li is entering the execution ground).[35] Jiang Shuiying's monologue aria in scene 5 is an *erhuang daoban* aria, too. It begins with the line sung *offstage* ("the waves hitting the dam are pounding like my heart"). When Jiang Shuiying is finally seen in full, she stands in front of a red morning sky (another standard sign not to be left out in such scenes), lost in thought about the heroes from Dragon River Brigade who had been able to build the dam (meter: *huilong* 回龙; *manban* 慢板). She then turns, in thought, to the draught areas (meter: *kuai sanyan* 快三眼) and continues to muse on Huang's doubtful endeavors (meter: *yuanban* 原板). She knows very well that it is necessary not just to fight wind and waves, but also to stand up to class enemies such as Huang. She ends her monologue with an ambitious call: they will be able to raise the water level! Thinking of Beijing (and Mao), her heart is filled with revolutionary fervor and pride (meter: *erliu* 二流). The entire self-reflection is held in *erhuang*. But the aria is played, in accordance with the content and the mood of the text, in different meters, faster or slower, a traditional technique here adapted and amplified for psychological realism.[36] The meters used here are taken from the traditional system of meters *banqiangti* (板腔体) and are mostly part of the traditional canon. Yet, some adaptations of the system are made. At the end of Jiang Shuiying's aria, for example, when she is filled with revolutionary ardor, she turns to a fast *erliu* meter usually only employed in *xipi* arias.

Xipi, the second aria type employed in Beijing Opera, is faster and more energetic than *erhuang*. Unlike *erhuang*, it begins on an upbeat. Accordingly, it is used in tense and suspenseful situations. *Xipi* arias occur frequently throughout *Taking Tiger Mountain by Strategy*: Yang's excitement when he enters the bandits' cave is marked through the use of such an aria (scene 6), and his pretended fury at Luan Ping, his scolding tirade, is also effectively held in *xipi* (scene 10). When, in *Song of the Dragon River*, it is reported that the dam has broken, this is done in a *xipi kuaiban* (西皮快板) aria, a *xipi* in extremely fast meter, which traditionally is also used to express agitation, excitement, and anger and accompanied by a regular percussion beat (at the end of scene 3). The fight over firewood, too, is accompanied by an angry, excited trio in *xipi*, yet in a new type of meter, *kuai liushui* (快流水), derived from the traditional canon. Jiang Shuiying's anger over Chang Fu's

35. Jiang Shuiying's first appearance, when she enters on a boat, also begins with a line sung *offstage*, but in this case hers is a *xipi* aria (*Longjiangsong* 1975, 22).

36. For the meters, see Michel 1982, 193–95; for the use of "realistic" vocal timbre, see Wang 1999, 60–61.

egotism and his denunciation of her, too, are expressed in the form of a *xipi* aria, in the fast meter *erliu* (scene 6, *Longjiangsong* 1975, 224). And finally, when the attempted penetration through the mountain continues to be without success and Jiang Shuiying is told, in addition, that her village rice paddies are now flooded, she sings a nervous and troubled *xipi* aria in *sanban* 散板, a free, medium tempo meter (scene 7, *Longjiangsong* 1975, 284).

Similar things can be observed in the other model operas: Li Yuhe answers with an excited and angered *xipi kuaiban* to Hatoyama's attempts at (falsely) making him into a traitor (*Red Lantern*, scene 6), and Guo Jianguang's aria in *Shajia Village*, shortly before he attacks the fellow travelers of the Japanese, too, is a *xipi kuaiban* (scene 8). Preserving the traditional symbolism of certain aria types was a clever and effective way of employing their suggestive powers for one's own semantic ends.

Each of these opera's plots is typical for the model works: the main hero is confronted with a heap of problems and contradictions caused by enemies as well as wavering characters; usually, the series of crises is topped (according to the principle of pathetic fallacy) by natural calamities, such as a thunderstorm in the case of *Song of the Dragon River*, *On the Docks*, and the ballet *Ode to Yi Mountain*; lightning in *Taking Tiger Mountain by Strategy*; or heavy rains in *Raid on White Tiger Regiment* and *Shajia Village*. This list could go on; all model works use this device. Accordingly, the heroes' ambitions appear ever more impossible to realize, but each time they manage, because they have a secret source of strength: Mao Zedong Thought. At every climax, at every crisis, a hero consults or cites from Mao Zedong Thought, the sun eventually shines, and everybody dances in happiness. Thus, *Song of the Dragon River* and all of the other model works prove the might of Mao's words by illustrating their "power to change the world," as mentioned in the introduction to the 1975 score.

The predictable structure of the model works as a journey from crisis to victory, in spite of all its political determinism, again parallels traditional Chinese operatic theater, which always ends in a scene of happiness and consolidation, the so-called *da tuanyuan* (大团圆), the Great Reunion or Happy End in traditional Chinese theater. Good always prevails in the end, and thus both traditional and modern theater demonstrate to the audience that it is worthwhile to follow the good and fight the bad (see Michel 1982, 165).

Although Chinese opera—a genre that itself epitomizes change—"changed face" quite considerably in order to serve political ends and become a perfect "model" for everyone to emulate, revolutionary Beijing Opera also perpetuates many crucial elements from China's operatic tradition, as shown above. Thus, it fulfills the first part of a 1964 slogan by Mao that calls on artists "to wield through the old to create the new, and to wield through the foreign to create a Chinese national art" (古为今用洋为中用) (Mao 1964a). Traditional elements cannot be neglected in a discussion of the model works, and the fact that they were disseminated so broadly meant that some of these traditional popular forms of entertainment became national forms of entertainment well-known both in the cities and in the countryside.

"To Wield through the Foreign to Create a Chinese National Art" (洋为中用): Approaches to Foreign Music in the Model Works

If "no music" did not mean that there was no traditional music, after all—as the model works can be said to have perpetuated rather than only to have destroyed Chinese traditional culture—was it more true, then, that no foreign music could be heard? Isaac Stern, invited to China by the Chinese government, was told exactly this story during a concert and teaching tour that allowed for the production of the documentary *From Mao to Mozart* in June 1979. In its voice-over and some of

the discussions Stern participates in, the film deals with many important issues in China's history of Western-style music-making since 1949, for example the problem of how to create and promote a Chinese "national music" in spite of the fact that foreign compositional methods and instruments are being used, as well as the problem of how to interpret music, a language without words and thus with no unified message, in a manner that is politically correct and acceptable. In some of the interviews, a veritable clash of cultures is documented, with Isaac Stern slightly bemused, if not shocked, at interpretations of Mozart's music and that of other classical composers according to their respective class backgrounds and material conditions (e.g., DACHS 2008 *Mao to Mozart* Part 2, 5.05ff.). Most importantly, however, the film takes up the particular and destructive influence of the Great Proletarian Cultural Revolution on musical practice and production in China.

The discourse Stern is confronted with is dismal: there was no music during the Cultural Revolution; classical musicians were not allowed to practice their instruments. The Cultural Revolution is presented in a well-familiar trope: it was a period of "cultural stagnation" (see especially DACHS 2008 *Mao to Mozart* Part 9, 2.00ff.). This open discourse is somewhat subverted by the film's ever-present musical footage: it was made in June 1979, not even three years after the end of the Great Proletarian Cultural Revolution. The two extremely well-accomplished young players presented to Stern, one on cello and one on piano,[37] most certainly started to play their instruments during the Cultural Revolution, sometime in the mid-1970s. Otherwise, it is impossible to conceive how they could have reached the level of perfection they present by 1979. The same must be said for many of the other musicians performing for Stern (those on traditional instruments and the young acrobatic performers from the Beijing Opera troupe included).[38]

And indeed, it is not so difficult to find people who lived through the Cultural Revolution and tell a different story than that presented by the film: the violin-playing calendar girl from 1976 (see ill. I.2) is no exception. The same series includes a 1973 calendar illustrated with a children's string ensemble, for example (ill. 1.9). There are those who listened to concerts and recordings of the great Western classics (e.g., University Professor, mid-1950s–; Librarian, mid-1950s–), and even those who received instruction in supposedly "formalist" twelve-tone technique (Mittler 1997, Utz 2002, 493) during the years of the Cultural Revolution. According to composer Qu Xiaosong (1952–), too, revolutionary music was by no means the exclusive musical fare during the Cultural Revolution. When he formed a string quartet with some friends, they played Mozart and Beethoven in spite of official bans on "bourgeois music." Moreover, quite often, these youths did not even know of the newest campaigns criticizing specific foreign composers. Sources were scarce, and Tan Dun, for example, tells of hearing a lot about Tchaikovsky from his violin teacher who had been trained in Russia while never knowing what Tchaikovsky sounded like (Utz 2002, 493). According to them, interference with artistic practice during the Cultural Revolution was much less dramatic than is generally assumed: "Nobody knew it was 'bourgeois music' we were playing!" Qu Xiaosong says as he cites an old Chinese proverb: "Heaven is high and the Emperor is far away" (天高皇帝远).[39] Neither was the CCP so monolithic that it could ensure a tight control of ideology as consistently and systematically as is often assumed.

This part of the story is only implicitly told in *From Mao to Mozart*. And indeed, the Cultural Revolution meant many different things to Chinese music lovers, musicians, and composers: there are those, like Chen Qigang, who lost their families to reeducation and who watched with horror the brutalities committed during the first two years of Red Guard activities, when pianos, scores, and records of Western classical music were destroyed (Mittler 1997). There are many—and this is

37. See DACHS 2008 *Mao to Mozart* Part 8:4.59ff and 6.13 ff., as well as the beginning of Part 9 and 11:5–55ff. For the child prodigy who has become a well-known cellist (Wang Jian), see DACHS 2008 *Mao to Mozart* Cello Child Prodigy.
38. E.g., DACHS 2008 *Mao to Mozart* Part 3 and Part 4, as well as Part 7: 6.26 ff. and Part 8.
39. Interview with Qu Xiaosong, New York, 22 September 1992.

mentioned in a dialogue with Isaac Stern, too—whose aspirations to a professional musical career were abruptly stopped short by the beginning of the Cultural Revolution. The example of 1956 Liszt Festival prize winner and 1958 Tchaikovsky competition second-prize winner Liu Shikun 刘诗昆 (1939–), whose forearm was cracked by Red Guards and who was imprisoned for six years without a piano, is only one possible example testifying to this potential cruelty (Chen 1995, 11–12).

The experience of being sent to the countryside was grim to some of those who eventually became important musicians in the many performance troupes playing the model works.[40] Indeed, Guo Wenjing 郭文景 (1956–), Ge Ganru 葛甘孺 (1954–) and Mo Wuping 莫五平 (1958–93) found that to practice music and to become a musician was one way of escaping Red Guard street-fighting or hard physical labor in the countryside.[41] Others, like Tan Dun and Qu Xiaosong, would not have traded the time they were forced to spend in the countryside. Indeed, as Qu Xiaosong once put it: "Without the Cultural Revolution, I would have become a technician, not a musician!"[42] Luo Zhongrong 羅忠镕 (1924–), maltreated during the Cultural Revolution, still found the courage and time to work secretly on a translation of Paul Hindemith's *Unterweisung im Tonsatz*, published after the Cultural Revolution. Xi Qiming 奚其明 (1941–), who took part in the symphonic adaptation of the model opera *Shajia Village*, on the other hand, was branded "head of a counterrevolutionary music troupe" because he had inadvertently used the same three-note phrase to describe a vicious character that at one point was used to eulogize Mao.[43] In so-called "Song and Dance Troupes" (歌舞团 *gewutuan*), composers like Ge Ganru (1954–), Chen Yi 陈毅 (1953–), and Zhou Long 周龙 (1953–) were given their first chance to experiment musically. Writing adaptations of the model works and, frequently, their own compositions for unlikely ensembles made up of, say, a saxophone, a *pipa*, a *yueqin*, an accordion, an *erhu*, and a cello, and trying to achieve a homogenous sound despite the unusual mixture of instruments, these youngsters received first-rate, hands-on experience in orchestration.[44]

It is obvious even from these few examples that music, and foreign music, too, did play a role during the Cultural Revolution, that people did indeed listen to, practice, and perform music other than the model works or revolutionary songs. All kinds of music—supposedly forbidden—were still played during the Cultural Revolution, and foreign music, too, was present—if heavily muted—during this time. The immensely popular soap opera *Yearning* (渴望 *Kewang*), shown on Central Television in the early 1990s, suggests that even the *Butterfly Lovers Violin Concerto* (1959), condemned during the Cultural Revolution because of the individual love story it depicts, could after all be heard and played all throughout the Cultural Revolution. In the TV soap, the piece is played endlessly even during those scenes set during the Cultural Revolution as it becomes the leitmotif of one of the leading couples (Wang Yaru and Luo Gang). Although this soap opera has been criticized by some for not portraying the years of the Cultural Revolution realistically (Chao 1991), the fact that this allegedly forbidden music was chosen as one of the story's main themes, and even represented the Cultural Revolution years within the storyline, is nowhere mentioned: it is probably not considered unusual. Remembers one interviewee:

40. See, as an example, the memoir "Because of Mendelssohn" (因为门德尔松) in Zou 1998, 156–60.
41. Interviews with Ge Ganru (New Jersey, 6 September 1992) and Guo Wenjing (Beijing, 5 October 1992). See also the memoir stories in Du 1996, esp. 104–7.
42. Interview with Qu Xiaosong (New York, 22 September 1992).
43. Interview with Xi Qiming (Shanghai, 19 September 1992).
44. Interviews with Ge Ganru (New Jersey, 6 September 1992); Chen Yi (New York, 12 September 1992); and Zhou Long (New York, 4 September 1992).

The *Butterfly Lovers Violin Concerto* was criticized very strongly.... But we would listen to it anyway, even during the Cultural Revolution. Indeed, it was no problem at all to listen to this stuff at home. (Museum Curator, 1950s–)

One artist, born in 1954, mentions that he regularly played the piece. He remembers:

I even played the *Butterfly Lovers Violin Concerto*. Everybody who played the violin would play this piece—it simply sounded so good. Actually, nobody really cared what we played; music was never restricted all that badly—or at least we did not feel it. (Male Artist, 1954–)

This may not be how things are depicted both in foreign and in Chinese official sources dealing with the Cultural Revolution, however, and during Isaac Stern's visit, this alternative story is a constant but carefully muted ostinato bass to the documentary's main narrative of musical suppression. While the film repeats, more or less faithfully, the well-established clichéd storyline about the Cultural Revolution, some of the more paradoxical facts it presents (such as the impressive accomplishments of musicians and performers who were supposedly unable to receive an education during those years) hint at how this storyline must be questioned.

Yet, even if one were to take seriously the verdict that the musical horizon during the Cultural Revolution consisted only of revolutionary songs and the model works, one must acknowledge that this musical universe did not exclude foreign-style music. The model works themselves must be considered foreign-style music, or, more specifically, music from the classical and romantic tradition. This is so in spite of the fact that in Chinese Communist understanding, "all art has class character," and music from the classical and romantic tradition is associated with the rise of the bourgeoisie in Europe.[45] In accordance with Mao's verdict from his influential *Yan'an Talks* of 1942, even "bourgeois things" must be used—if only as models, not as substitutes (Mao 1942, 69), in the creative process. Accordingly, the model works make use of Chinese art forms as well as the bourgeois art form of classical and romantic music while filling both with new content. In Mao's view, therefore, China's composers must model themselves on the most "advanced" forms of music from the West—that is, works from the great traditions of classical and romantic music—in order to create the most powerful music for China. Mao argues:

Insofar as a work is reactionary, the more artistic it is, the more harm it can do to the people, and the more it should be rejected. The common characteristic of all literature and art of exploiting classes in their period of decline is the contradiction between their reactionary political content and their artistic form. What we demand, therefore, is a unity of politics and art, a unity of content and form, a unity of revolutionary political content and the highest artistic form possible. Works of art that lack artistry, however progressive politically, are nevertheless ineffectual. (Mao 1942, 78)

Accordingly, "pentatonic romanticism" in the model works is the means by which a formerly bourgeois art form (music from the classical and romantic traditions) becomes a perfected and thus powerful weapon in the hands of the masses against the very bourgeoisie who once created the art form. I will illustrate this point by scrutinizing, in the following pages, four of the more popular model works, two from the first set of model works presented by 1966 and two from the second set created throughout the rest of the Cultural Revolution. These are the revolutionary opera *Taking Tiger Mountain by Strategy* and the revolutionary ballet *Red Detachment of Women*

45. As mentioned above, Isaac Stern in *From Mao to Mozart* reacts in a rather surprised and bewildered manner to a class analysis of Mozart and his time by one of his Chinese colleagues, saying, "I wonder whether Mozart's genius had anything to do with that ... ?!" For a discussion of the use of class analysis in the interpretation of music, see Mittler 1997, 63–70.

from the first set, and the revolutionary opera *Song of the Dragon River* and the *Yellow River Piano Concerto* from the second set.

We begin with the two revolutionary operas: *Taking Tiger Mountain by Strategy* takes place in 1946 in Manchuria, where a group of PLA soldiers is fighting a group of bandits who are followers of the GMD. Yang Zirong ("Master of the Glory"), a clever PLA scout platoon leader, is sent by Shao Jianbo 少剑波 ("Sword-Wave Shao"), the regimental chief of staff, to enter the bandits' lair and find out the most favorable time and place for an attack against the bandit chief, Zuo Shandiao (whose name means "Vulture with his Throne on the Mountain"), and his gang. Yang Zirong successfully fulfills his mission, and Vulture and his gang are eliminated, to the great happiness of the people who had suffered terribly under his rule.

Song of the Dragon River is an opera from the second set of ten model works created after 1966. It is set in 1963 in the southeast of China, somewhere near the coast. The Party Committee has decided to build a dam in order to help an area that suffers from heavy drought. Party Secretary Jiang Shuiying ("River and Water Heroine") does everything she can, against extraordinary odds (counterrevolutionary sabotage, the flooding of village property including her own house, the breaking of the dam, etc.) to carry out her mission—and she succeeds. *Song of the Dragon River* was first introduced to the Chinese public on Chinese National Day in 1972. The plot, however, was already well-known to the audience, as it had been used in a spoken drama by a Fujian drama troupe in 1963. Several operas had been made from the play, and the variations among these different versions of the plot are important. The most significant change between spoken drama and model opera is the gender of the main protagonist. Originally, this was a male hero, Party Secretary Zheng Qiang ("Strong Zheng" 郑强). In the model opera, however, the hero becomes a heroine: Party Secretary Jiang Shuiying.[46] Jiang Qing herself had asked that the gender of the role be changed (Chen 2002, 147). She in fact so identified with the operatic heroine that she once interrupted a performance of the piece in 1974 and insisted that Jiang Shuiying should, from then on, only be addressed as "Comrade Jiang"—her own epithet (Chen 2002, 218).

As we have seen, in the revolutionary operas, the semantic power of Chinese operatic practice is used to convey the political message of each piece. But it is not traditional opera alone that is put to service here. The traditional operatic "orchestra," consisting usually of *jinghu* (京胡), the high-pitched, two-stringed principal instrument as well as *erhu*, *pipa*, and percussion, and occasionally some Chinese wind instruments, is revamped and backed by a complete (foreign-style) symphony orchestra in revolutionary Beijing Opera. A choir may be added to the scene, too (this is done in *Song of the Dragon River* in scene 1, scene 4, and in the epilogue, and in *On the Docks* in almost every scene). Music is recorded and fixed in a partition, and musico-semantic elements from foreign musical traditions and realist effects (such as the roaring of the wind in the storm scene in *Song of the Dragon River*, the use of lighting and thunder in the thunderstorm scene in *On the Docks*, and the horse's neighing in *Taking Tiger Mountain by Strategy*) are introduced. All of this creates an atmosphere of "Revolutionary Realism and Revolutionary Romanticism" (革命的现实主义和革命的浪漫主义 *Geming de xianshi zhuyi he geming de langman zhuyi*), discussed below in the next section, as had been demanded since the late 1950s for China's new revolutionary art works by none other than Mao Zedong himself.

Every one of the model works, be it an opera, a ballet, or a piece of symphonic or piano music, makes extensive use of a number of musico-semantic signs derived from the repertoire of foreign classical and romantic music. Wagnerian leitmotif technique, for example, is used throughout, either to highlight certain characters (the heroes are given particularly striking and flexible motifs,

46. For a discussion of the significance of this change in gender, see Roberts 2006 and, more elaborately, Roberts 2010. It is not a coincidence that Jiang Shuiying's surname is the same as Jiang Qing's; see Dai 1995, 191–92.

adapted to their emotional states and changing moods, whereas negative characters always display the same monotonous motifs) or certain situations. Often, as I will show in the next chapter, certain telling revolutionary melodies such as "Red Is the East" (东方红 *Dongfang Hong*)—the *de facto* national anthem during the Cultural Revolution—or the "Internationale" (国际歌 *Guojige*)[47] mark the importance of particular scenes. *Song of the Dragon River*, like all model works in which the army plays a significant role, at one point cites another "hit" in the model works, the revolutionary song "The Three Main Rules of Discipline and the Eight Points for Attention" (三大纪律八项注意 *San da jilü, ba xiang zhuyi*), for example. This "Red Army Song" based on disciplinary points made by Mao in 1928 reminds the army to help and support the people and never abuse their power when stationed in a village.[48] In *Song of the Dragon River* it is used when the army is called in to help save the broken dam (*Longjiangsong* 1975, 88).[49]

Certain instrumental groups conventionally used in Western classical music to mark particular moods or situations are also employed frequently in the model works (horns for scenes in the woods, for example, or high woodwinds for idyllic scenes, as well as the *glockenspiel* for spheric and transcendent atmospheres, reminiscent of the magic powers of the *glockenspiel* in Mozart's *The Magic Flute*, among others). In *Song of the Dragon River*, woodwinds are used in scene 5 when Panshuima's narration no longer dwells on her sufferings before liberation but talks about her newfound happiness ever since then (*Longjiangsong* 1975, 125). They also appear after the storm in *On the Docks* (scene 4) when running sixteenth notes, leftovers from the passing thunderstorm, are substituted with a slow and stately passage in harp, flute, and clarinet (i.e., high woodwinds), with Chinese-style trills sounding while a rainbow appears over the scene. A similar instrumental arrangement is found in scene 6, when Jiang Shuiying suggests that everybody should read one of Mao's so-called *Three Constantly Read Articles* (老三篇 *Lao sanpian*), all of which epitomize Maoist moral tenets and the values of altruism and selflessness.[50] The story they read together is that of Canadian doctor Norman Bethune, who helped the Chinese during the Sino-Japanese War (ill. 1.10; scene 6, *Longjiangsong* 1975, 235). Woodwinds also dominate the final scene of this and many other revolutionary operas. In *Song of the Dragon River* they accompany Jiang Shuiying's instructions to Li Zhitian, who continues to act in a manner much too short-sighted and who must be told continuously of the great advantages of liberation (*Longjiangsong* 1975, 364).

Particular interval structures and rhythms that have become musical semantic signs within the conventions of Western music—such as a falling minor second (sigh motif), an augmented fourth (the so-called *diabolus in musica*, a tritone, which, within the European musical traditions has been considered the most dissonant of intervals), or a punctuated rising fourth (also called the "march motif" within the same conventions)—are used, respectively, as markers in tragic situations, to introduce negative characters, or to mark a military setting. In *Song of the Dragon River*, for example, Pan Shuima's description of evil Huang is accompanied by constant moves in the ambitus of an augmented fourth to mark him, musically, as the devil (*Longjiangsong* 1975, 275; *Longjiangsong* Prelude to this aria, 264).

47. See Chapter 2 for a discussion of the history and significance of this song.
48. For the importance of this song, see *Xuexi yu pipan* 1974.1:3–5. Michael 1977, 34 gives a translation for the Three Rules: "1. Obedience to orders; 2. Take not a needle or thread from the people; 3. Turn in all confiscated goods," and the Eight Points: "1. Replace all doors and return all straw on which you sleep before leaving; 2. Speak courteously to the people and help them whenever possible; 3. Return all borrowed articles; 4. Pay for everything damaged; 5. Be honest in business transactions; 6. Be sanitary—dig latrines at a safe distance from the houses and fill them up with earth before leaving; 7. Never molest women; 8. Do not mistreat prisoners."
49. The song also appears in *Shajia Village* and in *Taking Tiger Mountain by Strategy* to indicate a closeness between army and people.
50. See Chapter 4 for a discussion of the *Three Constantly Read Articles*.

Finally, the model works make extensive use of musical iconography: a hero's horse swiftly galloping up a mountain is accompanied by running rising sixteenth notes (as in scene 5 of *Taking Tiger Mountain by Strategy*). A heroine falling under the brutal whipping of a tyrannical landowner is accompanied by increasingly lower stringed instruments repeating her leitmotif in ever more tragic-sounding variations in minor mode, filled with sigh motifs (*Red Detachment of Women*). Water moving up and down in huge waves is depicted in wavelike arpeggio movements in the orchestra (e.g., scene 5, *Longjiangsong* 1975, 193–94, or when opening the lock, scene 8, 368–69). When water and people crash into each other, as in scene 5 when a human dam is built in order to repair the real dam behind, this chaotic motion and the breaking of the water by the human dam are depicted in a movement of triplets against eighth notes (scene 5, *Longjiangsong* 1975, 202). Running sixteenth passages are used to depict the brigade members running around carrying materials to fill the broken dam (scene 5, *Longjiangsong* 1975, 109–13). Syncopic movements (always moving against the heavy beat in a bar) represent the impact of the explosion at the mountain that needs to be broken through (scene 7, *Longjiangsong* 1975, 253). Finally, pizzicato sounds are used to depict the dryness in the drought areas (scene 6, *Longjiangsong* 1975, 280). All of these musico-iconographic and semantic techniques can be found in other model works as well. Indeed, one could pick an arbitrary scene from any of the model works and see these same conventions at work.

One example of this practice is Yang's aria in scene 5 of *Taking Tiger Mountain by Strategy*, when Yang is about to ride up to Tiger Mountain to meet Vulture and the bandits. The scene begins with a typical operatic percussion interlude. Then, the orchestra takes over, and by use of regular eighth-movements and tremolos, it depicts—in musical iconography—Yang's galloping with his horse (*Zhiqu weihushan* 1971, 132, 134–45). As Yang climbs the mountain, these eighth- and tremolo-movements soar higher and higher (*Zhiqu weihushan* 1971, 133, 145). A romantic horn melody creates an atmosphere that a listener versed in the romantic tradition in European music will immediately associate with woods and forests (Ibid., 136–39). The *erhuang* aria mode is used in the first deliberating part of the aria to convey the hero's profound emotion as Yang sings about his dreams: "Let the red flag fly all over the world" (愿红旗五洲四海齐招展). This thought and his ardent expression of hope for a utopian future are accompanied by the higher-pitched woodwinds (flute and oboe) to mark the idyll envisaged. The beautiful picture finds its musical apotheosis in the spheric sounds of the vibraphone (Ibid., 160). After a short interlude, Yang shows his sudden excitement at being able to wipe out the bandits in changing to the *xipi* mode (Ibid., 164). The old rule that *erhuang* and *xipi* are not to be used in the same aria is here broken in order to better reveal the inner emotions and display the psychological development of the heroic character. The musical tradition of Beijing Opera is thus amplified by the telling use of foreign instruments to the Chinese "orchestra," and by the application of certain European musical conventions as the use of leitmotifs and of particular musico-iconographic concepts and the employment of peak notes and long melismas for key words and messages. Thus, the semantics of the traditional musical setting are enhanced by the use of elements from another musical tradition well-known to Chinese audiences—that of European romanticism.[51]

Although *Taking Tiger Mountain by Strategy* and *Song of the Dragon River* and all the other revolutionary operas among the model works retain the fundamental structure and many characteristic elements from Beijing Opera practice, musically they have undergone a rigorous transformation, appropriating many foreign musical traditions. This is even more true—in spite of the use of pentatonic melodies and country dances as well as Chinese instruments—of the music

51. For similar uses of music in Nazi propaganda, see Kinsky-Weinfurter 1993.

to the ballet *Red Detachment of Women* and of the *Yellow River Piano Concerto*, both of which are no longer exclusively determined by the traditions of Chinese opera.

The ballet takes place during the Chinese Civil War of 1945–49 in the tropical lushness of Hainan Island on the southern coast of Guangdong. It tells the story of an all-female Communist detachment in their battle against a local landowner, Nan Batian ("Tyrant of the South"). The heroine, Wu Qinghua 吴清华, is a defiant peasant who escapes from service in the landowner's mansion and makes her way to the Communist base area where she joins the women's detachment. There, she matures into a disciplined fighter who subordinates her urge for personal vengeance against Nan Batian to the wider purpose of the revolution. During an assault by Nan's militia, Hong Changqing, the male hero who had once found Wu Qinghua, is wounded and taken captive. He refuses to sign a confession and is executed by Nan Batian by being burnt at stake. Soon after, the Detachment of Women overcomes the evil landowner when Wu Qinghua shoots him.[52]

In the model ballet, leitmotif-technique is used throughout to guarantee easy recognition of certain characters, their idiosyncrasies and changing emotions. Wu Qinghua's motif, for instance, immediately shows her strong will and determination. When she is in agony, chained by her brutal employer Nan Batian, the Tyrant of the South, her theme starts off with a desperate accented fourth jump, ascending, then breaking off and again discharging its energy in fast thirty-second triplets, repeated with an even higher jump of an octave (*Hongse niangzijun* 1970, 8–9). It is the high strings and high wind instruments introducing her theme while the low strings are trembling (for her) in a tremolo. Next, the servants of Nan Batian arrive, introduced as negative characters by that familiar conventional quirk: the ambitus of their leitmotif is the tritone, an augmented fourth (*diabolus in musica*) introduced in the low strings and brass.[53] Other augmented and dissonant intervals are prevalent whenever Nan and his men appear (e.g., *Hongse niangzijun* 1970, 69). The arrival of Nan's servants is often announced with an ominous crescendo in the drum and chromatic runs in the manner of a so-called *passus duriusculus* (chromatic runs within the ambitus of a fourth) in the low strings, creating an eerie atmosphere (e.g., *Hongse niangzijun* 1970, 23–26).

According to the politically motivated artistic principle of "Three Prominences" (三突出 *santuchu*, to be further discussed in the next section below), the lower range instruments are habitually used to accompany the negative characters. This is one way of preventing these characters from standing out musically. A second such musical method is the monotonous and repetitive use of rhythmic and melodic motives to accompany the negative characters. Their leitmotifs almost never develop: Only once does the landlord in his desperation show some (if hypocritical) change (*Hongse niangzijun* 1970, 508). When he asks Qinghua—who is about to kill him—for forgiveness and pleads for mercy, the harsh and accentuated eighth runs of his leitmotif appear in legato, the tritone changing into a significant element of his desperate, almost pathopoic pleas (introducing extra-modal chromatic notes—*pathopoia*—as first used in European music of the sixteenth and seventeenth centuries).

Positive characters, on the other hand, are characterized by "positive" instruments, mostly high strings and wind instruments. The heroism and brilliance of the main heroes is emphasized by the clear and high-ranging sounds of the instruments accompanying them. Another way of translating the principle of Three Prominences into music is to emphasize the leitmotifs of positive characters in juxtaposition with negative characters. While Wu Qinghua is fighting with one of Nan Batian's servants, for instance, her leitmotif dominates the orchestral accompaniment, with only an

52. The following discussion is based on Mittler 1997, 83–97.
53. Indeed, this quirk is used absolutely everywhere in the model works, and it is particularly eerie in *Children of the Grasslands* when the villain, Ba Yan 巴彦, attempts to kill sheep while children are on guard.

occasional glimpse of the tritones and minor seconds marking the presence of the evil servant. In order to emphasize her strength and willpower, Wu's leitmotif is augmented and accentuated (*Hongse niangzijun* 1970, 42–43, 54–55).

Indeed, much differently from the negative characters, the leitmotifs of positive characters are flexible and frequently modified to reflect their emotions and actions. When Wu Qinghua is beaten by one of Nan Batian's servants, for example, the opening triplets of her motif are split up into staccato eighth notes and breaks, with each staccato indicating the slaps, each break the rehauling of the whip. After Nan Batian has severely beaten her, Wu Qinghua is hardly able to get up. Now, her leitmotif has slipped down iconographically; it is repeated very loudly in fortissimo (ff) and accentuated in the horns, violas, and cellos. It slips down further to the double basses in the following bars after repeated brutal slaps depicted through heavy, accented chords (*Hongse niangzijun* 1970, 67–68). Much later, after her successful escape, Wu Qinghua kneels in front of one of the girls from the Red Detachment who has offered her water. Again, Qinghua's kneeling is mirrored in the music: the viola now plays her leitmotif, not the higher ranging violin (*Hongse niangzijun* 1970, 166). Then again, at the sight of the Communist flag, Wu Qinghua is moved to tears and her motif is once more transformed. It appears in a surprising calm, as if she has come home: the radical rhythmic differences that make up the dramatic dynamics of her leitmotif are leveled down (*Hongse niangzijun* 1970, 162–63). This calm contrasts vividly with her excitement when, a little later, she narrates her painful experiences under Nan Batian to the Communist troupes (*Hongse niangzijun* 1970, 168ff). Here, her sufferings and pent-up emotions are reflected musically in constant bar changes and accents and in elaborate ornamentation depicting her torn state of mind.

Later, when Wu Qinghua and her friends from the Red Detachment observe the beating of one of the maids of Nan Batian, those cruel memories return, and Wu Qinghua's excitement is again evident in the way her leitmotif is manipulated: elements are split off, embellishments are added (*Hongse niangzijun* 1970, 235–37). Wu Qinghua attempts to shoot Nan Batian there and then, endangering her detachment's strategy. Immediately she regrets having made this decision. Accordingly, her leitmotif incorporates a sigh motif and is turned to the minor mode (*Hongse niangzijun* 1970, 273ff.). In her last fight with the tyrant Nan Batian, her theme appears in military punctuated rhythm and soars higher and higher, closer and closer to victory, until finally she shoots and kills Nan Batian (*Hongse niangzijun* 1970, 509–11).

Clearly again, this piece builds on classico-romantic musical conventions. An audience only familiar with the sounds of atonality would no longer recognize the apparent meaning attributed here to certain intervallic structures (augmented fourth, *passus duriusculus*, sigh motif). The Chinese audience, however, familiar at the time with little else but the sounds of classical romanticism, would be able to decipher the musical messages conveyed within this frame—at least those musically trained would. And even for those unfamiliar with the intricacies of musical semantics, it would be impossible to misunderstand the lowering in range when Wu Qinghua falls, the sound of the whip when she is beaten, the excitement of the battle in sixteenth runs, or the soaring toward victory when she kills Nan Batian. Musically speaking, then, the most direct "semantic" appeal in *Red Detachment of Women* is achieved through the extensive use of such musico-iconographic writing, which is supported by the ballet acting, the setting, and the lighting and thus speaks a most powerful political language. Here, indeed, the bourgeois art form of classical music becomes a mighty political weapon. It is through the model works that this tradition was spread in China.

Its advancement in Cultural Revolution China was furthered by the dissemination of the *Yellow River Piano Concerto*, which began its life as one of the models from the second set in 1969. Based on Xian Xinghai's 1939 *Yellow River Cantata*, it describes the war of resistance against Japan and

expresses the "revolutionary heroism of the proletariat, while praising the sublime courage and fighting spirit of the Chinese nation and extolling the great victory of Chairman Mao's concept of People's War"—as a program note reads (Yin 1969). It was published as a screened version together with the piano accompaniment version of *Red Lantern* and the symphony *Shajia Village*, and as such it is still sold today. Again, it borrows heavily from the musical rhetoric of the Western classico-romantic tradition. In a recent study, Shing-Lih Chen finds many overlapping musical structures with Chopin's music (piano concertos, ballades, etudes). The very beginning of the concerto, an exuberant cadenza preceding the introduction of the first important theme, replicates the grand structure of the first movement in Chopin's *Piano Concerto No. 2* (Chen 1995, 37). The similarities are of a more structural rather than specific nature: In Franz Liszt's (1811–86) *First Piano Concerto*, Rachmaninoff's *Piano Concerto No. 2*, and even Tchaikovsky's *First Piano Concerto*, the main theme's entrance is always delayed or established by repetition after a longish cadenza-like figuration in the piano solo part. The *Yellow River Concerto* thus follows not just Chopin but, more generally, these well-established structural conventions for the romantic virtuoso concerto. The borrowings may be more exact at some times than at others, as for example between the beginning of the first movement of Tchaikovsky's *First Piano Concerto* with its extensive use of chords and the last movement of the *Yellow River Concerto*, and, perhaps even more striking, in a passage found in the beginning of the last movement of the *Yellow River Concerto* and in the second section of Chopin's *Polonaise in A Flat Major*, op. 53: both pieces use exactly the same octave movement down a fourth. In the *Yellow River Concerto*, this bass motif is, however, performed in much slower tempo, creating a much more stately effect (for comparison of the scores, see Chen 1995, 74–75).

Not unlike most of the model works, the plot and music of the *Yellow River Concerto* did not originate during the Cultural Revolution. The concerto is in fact a rearrangement of undoubtedly one of the most famous compositions in the history of New Chinese Music, the *Yellow River Cantata* composed in 1939 by the "People's Composer" Xian Xinghai. In Xian's piece, as in the model piano concerto adapted from it by star pianist Yin Chengzong 殷承宗 (1941–) and his composition team,[54] the Yellow River becomes an emblem of the Chinese spirit. Chinese civilization is said to have originated in the Yellow River Valley, and the river's periodic floods continue to cause much agony and suffering even today. It evokes, therefore, strong, even tragic emotions on

54. Like the *Yellow River Cantata* itself, which, in its published form today, is nothing like the "original" composition by Xian Xinghai, the *Yellow River Concerto*, too, was (re-)composed, like all of the model works, by a composition committee, in this case consisting of members of the Central Philharmonic Orchestra, including Liu Zhuang, Chu Wanghua, Sheng Lihong, Shi Shucheng, and Xu Feixing, along with Yin Chengzong. Joint responsibility in artistic creation was the ideal of the Cultural Revolution, as it mitigated the likelihood of "individualism" infecting the music or the art; at the same time, it also lessened the danger of individual censure by the authorities (Chen 1995, 24). For people like Xian Xinghai, however, this kind of collaborative compositional method was not acknowledged after his works were created. He was styled into a genius, a Chinese Beethoven, and part of this role was the fact that he had to be the sole and heroic composer of his compositions. One of my interview partners discussed how long-lasting this type of attitude is and to what kinds of denials of reality it leads: "The creation of the *Yellow River Cantata* was such: when Xian Xinghai came to Yan'an, there was of course no symphony orchestra. But during the Sino-Japanese War, there was a military corps, and he took advantage of that. He would be given songs by other composers and would compile and connect them to form the *Yellow River Cantata*. They had hardly any instruments in this orchestra. A few violins, a few horns, Chinese percussion, so, of course, Xian Xinghai would not really be able to do great orchestration in his first draft. When he went to recuperate from his illness in Russia, he took his score and rewrote it, but he had no idea about orchestration, so, for example, he would have this huge percussion—if you had actually performed this together, it would have been impossible. For the 1959 performance, a number of people from the Central Symphony Orchestra rewrote the piece. Even in his choral writing there were a lot of problems, so this was changed, too. But when we suggested to the publishers that the names of these people should be added to the score, the idea was immediately refuted!" (Intellectual, 1955–)

the one hand, yet also collective memories of desperate perseverance in the face of adversity on the other, and it is fictionalized as such in much early Chinese poetry (Chen 1995, 1–6).

Both pieces, cantata and concerto, are set during the Sino-Japanese War and tell the story of the Yellow River (in the first movement of the concerto, "Yellow River Ode" [黄河颂 *Huanghe song*], Yin 1969, 102–7), its people (in the prelude, "Yellow River Boatmen's Song" [黄河船夫曲 *Huanghe chuanfu qu*], Yin 1969, 90–101), and their determination to fight the Japanese (in the much longer second and third movements, "Yellow River Resentment" [黄河愤 *Huanghe fen*] and "Defense of the Yellow River" [保卫黄河 *Baowei Huanghe*] Yin 1969, 108–23, 123–50). With two lengthy movements devoted to defense and rage, it is clear that the music of the *Yellow River Concerto* was indeed revised from the cantata in order to express more "indignation, resistance and struggle" (Dittmer and Chen 1981, 82). The virtuoso concerto format actually serves this purpose quite dramatically. While the original composition for chorus carried an emphasis on sorrow (much of it personal sorrow), the *Yellow River Concerto* emphasizes national rage, the eight-movement cantata features a much more balanced relation between movements describing the people (1: "Yellow River Boatmen's Song," 5: "Conversational Song along the River"), the Yellow River (2: "Yellow River Ode," 3: "Yellow River Descends from Heaven," 4: "Yellow River Ballad"), and the people's determination to fight the Japanese (6: "Yellow River Resentment," 7: "Defense of the Yellow River," 8: "Rave! Yellow River") than are found in the *Yellow River Concerto*, in which only the underlined sections have been used.

The addition of revolutionary songs such as "Red Is the East" and the "Internationale" to "Defense of the Yellow River" (to be discussed in Chapter 2) further enhances the nationalist focus of the new piece.[55] Moreover, the score of the model concerto includes exact interpretative comments as to the significance of certain musical passages, and here again, struggle and victory are foregrounded: the piano depicts the people's "strength and optimism" in brilliant runs and octave passages (Yin 1969, 95); they "see a shining victory," which is depicted with a folk melody accompanied in virtuoso style in running 32nds (Yin 1969, 98, fig. 8), their "courageous fighting spirit in striding forward" and their "revolutionary tradition" expressed typically in several chordic and punctuated passages (Yin 1969, 99, fig. 10; Yin 1969, 105, fig. 3). In spheric sixteenth runs in the high discant of the piano, the music is then to show, according to these instructions, how beautifully the "sun shines in the revolutionary base areas" (Yin 1969, 108). Typically, here, picking up both on Chinese and foreign musical semantics, this idyllic setting is characterized by the use of high woodwinds, especially (bamboo) flutes. Further on, the piece describes the "ferociousness of the Japanese attacks" in harsh accented chords and septulets with the ambitus, again, of an augmented fourth (f–b): *diabolus in musica* (Yin 1969, 113, fig. 5). The "sufferings of the Chinese people" under these ferocious attacks are expressed in a constant trembling tremolo in both piano solo part and orchestra (Yin 1969, 114, fig. 6). Still further on, the composition attempts to show that "when the river roars" (and here, the audience can hear and thus visualize the waves going up and down in the solo piano movement), "the people are full of emotion" (Yin 1969, 121).

The last movement, "Defense of the Yellow River," begins with allusions to "Red Is the East," with Mao and the Party's call to arms (Yin 1969, 123). It describes, by use of a punctuated rhythm, how the "army is fighting" and, by use of extensive chromatic scales added to the punctuated

55. Chen 1995, 57–58 also sees allusions to China's national anthem (in "Yellow River Ode," see Yin 1969, 106, fig. 5) in the concluding part of the first movement. I do not see this connection, and it would in fact not have been opportune for the composers to include such a musical allusion, as the national anthem was, during this period of the Cultural Revolution, under attack because the words were by Tian Han, who had been criticized in the early part of the Cultural Revolution.

rhythm, that "heroes fighting the enemies" are to be found everywhere (Yin 1969, 125, 135). Eventually, this movement culminates in an ode to Mao (by quoting "Red Is the East" in full) and the Communist Revolution (by quoting the "Internationale," Yin 1969, 144, fig. 19).

Through radio and later, especially, film (in 1972), the *Yellow River Piano Concerto* was made available to millions of peasants, soldiers, and workers, most of whom had never heard, much less seen, a piano or a grand symphony orchestra before (Chen 1995, 26). The concerto served, therefore, to disseminate the virtuoso tradition of classico-romantic solo concertos as far as the Chinese countryside. Although this tradition contrasts rather drastically with the humility and introspection of traditional Chinese musical practice, the *Yellow River Piano Concerto* may be seen as the apotheosis of a new Chinese style of music: that of pentatonic romanticism.

By borrowing from the *Yellow River Cantata*, the piece incorporates many elements from Chinese traditional music in order to fulfill Mao's dictum that foreign things must serve China: pentatonicism enters this piece through the use of Chinese melodic material, for example, borrowed from the boatmen's work songs (号子 *haozi*), which are used to accompany certain routine movements in physical labor (Yin 1969, 90, starting with b. 6; and again Yin 1969, 92ff., starting with fig. 1). The composition also features dialogic structures taken from Shanxi folk songs (Yin 1969, 92ff., fig. 1); it contains repetitive and intricate folk rhythms and melodies[56] and applies to the piano the instrumental techniques of Chinese instruments such as bamboo flute (at the beginning of the second movement) or *guzheng* (古筝), especially in the extensive arpeggios in the second movement,[57] and *pipa* (as, for example, in the "rolling fingers" *lunzhi* [轮指] tremolo repetitions after fig. 6).[58]

Thus, traditional and foreign elements are ingeniously combined or redeveloped in this as in all the model works. It has been my purpose to show here that their artistic structure and content make these pieces anything but the product of an iconoclastic, and even less a xenophobic era, as the Cultural Revolution is so often described. Instead, they are manifestations of a hybrid taste that calls for the transformation of Chinese tradition according to foreign standards, a taste that for a century has led to the creation of a Chinese music of foreign imprint—a taste that came into being in the waning years of the nineteenth century and continues to thrive even today: it is possible, for example, to compare how the "Yellow River Boatmen's Song," based on Shanxi dialogue singing (山西对口唱 *Shanxi duikou chang*) and featuring a male choir and a female choir, has been interpreted in a handful of different versions, each from a very different time in Chinese history. The first is the version presented in the cantata conceived by Xian Xinghai in 1939, the second is the take the piece is given in the piano concerto by Yin Chengzong in 1969 (mus. 1.2 a&b), the third is a pop version performed by a group called "Outer Space Singers" (太空人演唱组 Taikongren yanchangzu) in 1995 to mark the fiftieth anniversary of the end of the Sino-Japanese War (mus. 1.2 c), and the most recent is a multimedia performance by China's star pianist Lang Lang 郎朗 (1982–) in Hong Kong in 2007 (DACHS 2007 Yellow River, mus. 1.3).[59]

Each of these versions has its own special flavor. The 1995 version, published on a cassette tape entitled *The Chinese Soul* (中国魂 *Zhongguo hun*), replicates the choral dialogic structure from the folk tradition that had influenced Xian Xianghai's original conception. Here, the size of the choir and the orchestra is moderate, and the performance tempo is adapted to a very slow and rhythmic

56. Yin 1969, 95 after fig. 4; Yin 1969, 108, beginning of second movement. See also Chen 1995, 60, 63, 67.

57. Yin 1969, 108–9; Chen 1995, 61–62.

58. Yin 1969, 114; Chen 1995, 66–67.

59. There are many more versions, of course. Tuohy mentions one from 1995 with a thousand-person chorus performing the *Yellow River Cantata* in a concert commemorating the war anniversary (Tuohy 2001, 15).

but somewhat light mode. The effect of the Chinese melody is modified through this slow pace and the use of electronic instruments.

The heaviness of the 1939 cantata score, in contrast, is due to the use of a huge choir, very different from Chinese folk music traditions. The choir is singing in belcanto, which creates a sound effect even further away from Chinese folk soundscapes. A similar heaviness is also present in the 1969 piano concerto version, due to the large romantic orchestra employed there for dialogic singing (the piano being the other interlocutor). In the 1995 pop version, this heaviness is lightened through the use of electronic instruments, percussion, and artificial sounds. The piece is presented, so it appears, by a new generation that has long left behind the war and the difficulties of manual labor but still swells with pride in the Chinese nation.

The same can be said for the multimedia rendition of the 1969 version of the *Yellow River Concerto* by Lang Lang in August of 2007, where the *Yellow River Piano Concerto* is performed in a huge concert hall with multiple stages and video screens (DACHS 2007 Yellow River, mus. 1.3). Two of the stages feature some one hundred concert grand pianos with as many female players posing in long white concert dress all throughout the piece. Shown on the huge video screens throughout the auditorium are majestic views of the Yellow River. The entire performance is focused on the grandeur and the virtuoso spirit of the piece. The long runs and octave passages in the piano, which are interspersed by elements derived from the dialogue song, are reinforced and refocused in this performance through their pairing with visual effects from the video screens. Lang Lang is the central—and certainly a most fitting—protagonist in this extravagant rendition of the 1969 concerto, which had already eliminated some of the more linear structures from the dialogue singing still captured in the cantata in favor of interspersing virtuoso elements for the pianist. Thus, this version of the "Yellow River Boatmen's Song" perpetuates much more of the romantic virtuoso tradition than that of Shanxi dialogue singing.

To emphasize the "foreignness" of the artistic structure and form of many of the model works, the *Yellow River Concerto* being the most obvious example among them, would have brought me into trouble during the years of the Cultural Revolution.[60] Moreover, it would have been difficult to convince many members of the audience of this fact, for by the time of the Cultural Revolution, the "national style" of "pentatonic romanticism" had long since become a natural part of the Chinese musical universe. Compositions in this style (and the *Yellow River Concerto* especially) were considered "Chinese music" in the same way as some of the pieces from the traditional repertoire mentioned in the beginning of this chapter. A small listening experiment I conducted during the research for my first book on contemporary Chinese art music indicates that compositions in the style of "pentatonic romanticism" are most readily accepted by Chinese listeners to be "Chinese" in the same way that "Frère Jacques" may rightly be considered a "Chinese folk song."[61] In my recent interviews, too, this opinion was frequently heard. Some said:

> If you ask somebody, offhand, about the model works or revolutionary songs, their being foreign in style does not pop into that person's head at all. "Modernized" [现代化], yes, they would probably not say "no" to that kind of description, but "foreign"? No. After all, foreign instruments are playing Chinese melodies, aren't they? (University Professor, 1950s–)

60. It would do so even now. For example, Liu considers the *Yellow River Cantata* one of the most national(ist) compositions ever composed in China and attributes its popularity to this quality (1998, 282). The fact that it is almost inevitably performed whenever Chinese orchestras visit foreign countries and that the grand performance with Lang Lang was played for the tenth anniversary of the return of Hong Kong in 2007, supports Liu's view. See DACHS 2007 Yellow River.
61. For this experiment, see Mittler 1997.

I only got in contact with symphonic music rather late. The model works may be symphonic music, but they are still very Chinese, so they did not give me that "real" symphonic feeling. In a way, foreign instruments are here "serving Chinese music" [为中国音乐服务].[62] (Photographer, 1960–)

The argument, then, that this kind of music is in a "foreign style" and not "really Chinese" would have fallen on deaf ears with some Chinese not just during the Cultural Revolution. Yet others would disagree and argue that the model works, and Cultural Revolution music generally, sounded quite foreign:

In my opinion the music in the model works is quite foreign [比较洋]. We were used to the traditional Beijing Opera, for example, and therefore, we thought that the model operas among the model works were in fact quite foreign. (Historian, 1950s–)

In terms of harmony, these model works are very "classic" in the Western sense, and the melodies, again, are quite "romantic" in the Western sense. Those who did not understand anything of Western music thought, "This is very nice, this sounds great." Through this and other revolutionary music, they got to know what a violin is, and they started to be interested in and "understand" this type of music. And somehow, it opened up their minds a bit [开头一点]. Maybe the model works do play a role in the fact that these people can so easily enjoy [foreign] symphonic music today. (Musician, 1930s–)

It may have had a kind of enlightenment effect [启蒙效果]. If you go to listen to model works, even if you don't like symphonic music, you have actually heard it, after all, and this is a kind of enlightenment. Or it is the first time you see a ballet. (Museum Curator, 1950s–)

This kind of impression, that the model works were, after all, foreign-style music, while shared by some, often bears a particular tinge: A memoir published in Shanghai in 1998 tells the story of a young man who had once aspired to be a violinist. He had been sent to the countryside, only to be called back to play in a music troupe specializing in performances of the model works. While playing *Taking Tiger Mountain by Strategy*, the narrator keeps remembering Mendelssohn's violin concerto. "Why," the narrator asks himself, "why do I keep remembering this music that sounds like the worst salon music of the bourgeoisie?" His answer is that the model works, however grand and heroic they sound, are very similar in style—if not the same—although in the final analysis he considers them "not as great as" Mendelssohn's music.[63] Similarly, foreign critics have contended until rather recently that compositions in the style of pentatonic romanticism were "inferior" music (one Chinese scholar now residing in the United States even called them "trash music" [垃圾音乐 *laji yinyue*]; Han 1981, 138–45). They held that such music was derivative and anachronistic, that it proved that the Chinese were not interested in adapting to twentieth-century musical conventions, that they would not produce anything that could be called "New Music," and that "they appeared content to copy from the masters of the past" (Mackerras 1981; Mittler 1997, 11–12). A commemorative stamp celebrating the eightieth birthday of "People's Composer" Xian Xinghai in 1985 may be considered an ambiguous statement in this regard, pointing to the perpetual dilemma present in New Chinese Music, a dilemma that incites continuing discussions on "national style" of which the Cultural Revolution model works were one important part. On this stamp, Xian Xinghai is portrayed as a Chinese Beethoven, a point substantiated by frequent comparisons even in scholarly writings that talk of the *Yellow River Cantata* as the Eastern equivalent of Beethoven's *Ninth (Choral) Symphony* (Chen 1995, 20). This ascription may well be interpreted in two contradictory ways, epitomizing the very question New Chinese Music

62. The interviewee here parodies the Maoist dictum of "Serving the People."
63. Zou 1998, 156–60, esp. 158. This memoir is also mentioned in one of the interviews cited above in the Introduction.

constantly ruminates: either Xian Xinghai is just as great a composer as Beethoven, or Xian is but a Chinese copy (or imitator) of Beethoven (ill. 1.11).

Serving the People (为人民服务): The Politics of Model Music and Performance

The model works were the outcome of continuous attempts at music and opera reform conceived at Yan'an and even earlier. In the 1940s, and especially after Mao's *Yan'an Talks* in 1942, Chinese traditional theatricals were being adapted to fit the particular new ideological contexts that would become binding after the foundation of the PRC in 1949 (van Leeuwen 2000). From 1949 to 1955, the Chinese government set up committees and agencies in Beijing and at local centers throughout the country to oversee opera reform (Zhao 1969, 53–55; Yung 1984, 146). Many a traditional opera was modified according to the slogan "To wield through the old to create the new and through the foreign to create a Chinese national art." The Central Committee for the Improvement of Theater (中央戏剧改进委员会 *Zhongyang xiju gaijin weiyuanhui*), under the direction of Tian Han 田汉 (1898–1968), Ouyang Yuqian 欧阳予倩 (1889–1961), and Zhou Yang 周扬 (1908–89), was one of the main bodies involved in this function. Traditional works were revised, mainly in terms of plot, and new operas with contemporary and revolutionary themes were written (Zhao 1969, 55–62; Fu 2002, 3–6). Western instruments would now naturally be included in the orchestra, and a curtain would be used to hide the change of scenes. Certain elements in Chinese traditional opera were changed, especially in terms of content—ghost operas, for example, came under continued criticism (cf. Michel 1982 and Ahn 1972, 1073)[64]—but also in technique, as seen in the incessant debates on the use of Chinese versus Western singing techniques, for example (Yung 1984, 146; Michel 1982, 59–72). But as reforms were not always unidirectional, the insecurity as to the concrete content of politically correct and "healthy" theater led to a situation in which, despite clear encouragement in national performances and competitions (Zhao 1969, 64–66), very few new works were created, while many traditional works were temporarily discarded (Zhao 1969, 20–24, 117–63; Li 1996; Wagner 1990). Nevertheless, then as during the Cultural Revolution some years later, the official disapproval of particular traditional operas and themes was not mirrored in an actual lack of performances of such operas (Zhao 1969, 180). One musician (1942–) remembers:

> Already before the Cultural Revolution they had attempted to press quite a few restrictions: certain operas were not supposed to be performed. But these restrictions were really not all that effective. I, myself, for example, saw a lot of ghost plays [鬼戏 *guixi*] when I was small. They were scary, and loud, too, I found, and it was kind of like watching a thriller, but quite artistic.

This situation changed only slightly during the Great Leap Forward, when opera production quotas were introduced: quite a number of what later became model works were based on modern operas produced during this time. It was then, too, in 1958, that Mao issued a directive for artists to adhere to "Revolutionary Realism and Revolutionary Romanticism."[65] He believed art that

64. For a few concrete examples of what other kinds of topics would be criticized and changed, see Zhao 1969, 63. A list of approved and unapproved operas is given in Fu 2002, 10–30.
65. The directive was first put into writing by Zhou Yang in May 1958 in a publication on new folk songs and poetry. For a thorough discussion of this and other theoretical tenets of the Cultural Revolution, see Yang 1998, 14–31. The idea of "Revolutionary Romanticism" can be traced back to Stalinist directives from the 1930s; see Judd 1987, 99. Engels, too, had already demanded that typified characters in typified situations be shown, because it was one of the duties of art. On further Russian influences on Chinese theater, especially those of the Stanislawsky School and the debates around them, see Zhao 1969, 76–80.

realized these principles would present life "on a higher plane," that is, realistically but "more typical, more idealized" (Mao 1942, 70) or "model-like" (样板 yangban), as he termed it in his Yan'an Talks. Incidentally, yangban was used as a term for the model fields introduced during this time, too. Why should not styles of entertainment fit into the molds that had been used in agriculture, after all?[66] Nevertheless, even during the Great Leap Forward, which did see quite some development in terms of artistic output, the goal of achieving a ratio of 20–50 percent of operas on modern themes to be performed within three years was never reached. According to some statistics, up until 1963, modern operas never made up more than 1–5 percent of total theater production (Michel 1982, 96).

Still unhappy with artistic developments (or rather, the lack of them), Mao complained in 1963 that China's stage was dominated by "emperors, kings, generals, chancellors, maidens, and beauties" (帝王将相丫环小姐).[67] He wanted opera to create proletarian heroic models who would "Serve the People"[68] That was to be any artist's "basic task" (根本任务 genben renwu), a term first used by Jiang Qing in her speech on opera reform in 1964 (Jiang 1967; Judd 1991, 267; Wenge shiqi guaishi guaiyu 1988, 300–301). In order to achieve this goal, Mao demanded a more rigid policy of destruction of the old in order to construct a new revolutionary and national art. Henceforth, his wife Jiang Qing began her crusade to dominate the artistic worlds in China (Ahn 1972, 1074).

Jiang took to revising a number of Beijing Operas on modern and contemporary themes, the first two being Red Lantern and Shajia Village in 1963. Her third project was Taking Tiger Mountain by Strategy, her fourth Raid on White Tiger Regiment. These four works were performed at an opera festival in Shanghai in the summer of 1964 (June 5 to July 31, 1964), and already she was calling them model works (yangbanxi), then.[69] This led to angry remarks by Peng Zhen 彭真 (1902–97), then head of a "Group of Five in Charge of the Cultural Revolution" and since the early 1960s responsible for the coordination of cultural affairs. He complained: "What the hell are these models? I'm the head of the arts in this place, and I know nothing of models" (Terrill 1984, 249; Ahn 1972, 1076). He continued by criticizing Jiang Qing's model works as crude, comparing them to insipid, "pure boiled water," an accusation she readily retorted by saying: "Only when you have pure boiled water can you make tea and wine. No one can live without pure boiled water" (Terrill 1984, 246; for the conflict between Peng and Jiang see also Ahn 1972, esp. 1074ff.).

At a forum of theatrical workers participating in the Shanghai Festival, Jiang Qing gave her first influential speeches on the revolution of Beijing Opera, and a few years later transcripts of these speeches appeared in the most important theoretical Party publication, the journal Red Flag (Jiang 1967). During the festival, she also discovered a number of new operas to her liking, and she started revising them in 1964–65. On the Docks was her fifth model work among them. Her next project, another discovery from the festival, was the ballet Red Detachment of Women. In 1965, Jiang Qing initiated the reworking of Shajia Village into a symphony, the result of which was "hailed as a celebration of people's war, that filled the concert hall with an unaccustomed 'smell of gunpowder'" (Kraus 1989, 139). In 1966, Jiang Qing turned to ballet yet again: White-Haired Girl was her eighth model project.

In 1966 Jiang Qing was invited by Lin Biao to reside over the Forum on Literature and Art for the Armed Forces (部队文艺工作座谈会 Budui wenyi gongzuo zuotanhui), a meeting that would

66. Witke 1977, 391–92. Clark 2008, 57–59 gives a different genealogy for the term yangban.
67. Hongqi 1964, 2–3, 58–64, quote on 58; Zhao 1969, 25; Ahn 1972, 1071.
68. For the use of wei renmin fuwu in the model works see the description of Red Detachment of Women in Chinese Literature (hereafter CL) 1964.12: 100.
69. For a slightly different locus classicus, see Clark 2008, 59.

almost attain the importance of the *Yan'an Forum on Literature and Art* at which Mao had once formulated his seminal ideas for the production of art in Communist China. This forum "provided Jiang Qing with a national platform for advocating her favored model works" (Kraus 1989, 134). Thus, by the end of 1966, cultural affairs were no longer even nominally under the direction of the Group of Five under Peng Zhen, Jiang Qing's arch-enemy. They were taken over by a group including Chen Boda 陈伯达 (1904–89), Zhang Chunqiao 张春桥 (1917–2005), Yao Wenyuan 姚文元 (1931–2005), Kang Sheng 康生 (1898–1975), and Jiang Qing herself. If the Cultural Revolution really was a time of "eight theatrical works for 800 million people, and that was all,"[70] then by the time the Cultural Revolution started, it was in some ways already completed: Jiang Qing had overturned the institutional basis of cultural production, assembled a set of theoretical directives, sponsored the creation of (eight) specific works of art to exemplify them, and styled a name for them, too: "model works" (Dai 1995, 38).

The first set included the ballets *White-Haired Girl* and *Red Detachment of Women* and the symphony *Shajia Village*, all of which were declared model works in 1966.[71] Further, it included five operas, four of which had already been declared models by Jiang Qing in 1964: *Shajia Village*, *Red Lantern*, *Taking Tiger Mountain by Strategy*, and *Raid on White Tiger Regiment*. Finally, *On the Docks* became a model in 1966. Between 1966 and 1976, two more piano pieces, *The Red Lantern accompanied by Piano* (钢琴伴唱红灯记 Gangqin Banchang Hongdengji) (1967) and *The Yellow River Piano Concerto* (1969), another symphony, *Taking Tiger Mountain by Strategy* (1973), as well as two more ballets, *Ode to Yi Mountain* (1972) and *Children of the Grasslands* (1972), and five more operas—*Red Detachment of Women* (1971), *Song of the Dragon River* (1971), *Azalea Mountain* (1973), *Fighting on the Plain* (1973), and *Boulder Bay* (1975)—were added. This list, which mentions a total of eighteen model works, was published a few months before the official end of the Cultural Revolution, in March 1976, in the daily newspaper *Guangming Ribao* (光明日报) (ill. 1.2). At the time, a few model works based on the films *Breaking with Old Ideas* and *Chunmiao* (*Spring Sprouts*) were in the making, but they and the opera *Red Cloud Ridge* (红云岗 Hongyungang) no longer had the chance to become models as the Cultural Revolution drew to an end with the death of Mao in September 1976 (Dai 1995, 222–28; Fu 2002, 142–43).

Within the history of Chinese operatic reform just discussed and within the history of cultural production more generally, each of the model works, their plots and their music, has predecessors that can be traced back to quite some time before the Cultural Revolution (Wang 1999, 8). The ballet *White-Haired Girl* has the longest history of all of the model works: it can be traced back to an adapted "Rice-Sprout Song" 秧歌 (*yangge*) composed in 1944 by (among others) Ma Ke 马可 (1918–76). There are several operatic and film versions of it, too: it was made into an opera in 1945, revised in 1947 and 1949, and a film based on the story that was shot in 1950 even received the Stalin prize in 1951. In 1958, yet another Beijing Opera was made, and all of these served as foils for the model ballet produced in 1965 (see Zhao 1969, 85–87; Holm 1991; van Leeuwen 2000; Feng 2002, 65–66, 70–72). The second ballet in the first set of models, *Red Detachment of Women*, was based on a Beijing Opera performed in Shanghai in 1964 (Feng 2002, 63–65, 69–70). This Beijing Opera was later also turned into a model opera in 1971 (Dai 1995, 205). Further

70. This phrase and its origins are discussed above, at the beginning of Development: Mao.

71. Some of these dates are controversial in the literature. I separated the first batch, already declared to be model works in 1964, against Peng Zhen's protest. For the rest, I have followed Dai 1995 in most cases, as he discusses all of the model works, whereas other authors only talk about particular sets (ballets or operas) and ultimately, the *Guangming Ribao* list cited earlier.

predecessors are a 1960 film by Xie Jin 谢晋 (1923–), itself based on a novel by Liang Xin 梁信 (1926–).[72]

The model opera *Shajia Village* can be traced back to a Shanghai opera (沪剧 *Huju*) from the late 1950s entitled *Spark amidst the Reeds* (芦荡火种 *Ludang huozhong*), which in turn was based on a set of memoirs from the Sino-Japanese War compiled by Cui Zuofu 崔左夫 (1927–). Later, in 1965, the opera was also reworked into a symphonic piece (declared a model in 1966) inclusive of choral and solo singing (Zhao 1969, 169–74; Dai 1995, 51–60, 116–20; Fu 2002, 130–32).

The history of the model opera *Taking Tiger Mountain by Strategy*, too, goes back to the 1950s. It was based on a much longer 1957 novel by Qu Bo 曲波 (1923–2002) entitled *Tracks in the Snowy Forest* (林海雪原 *Linhai xueyuan*). Qu Bo's novel was, during the Great Leap Forward's push for modern plays, first turned into a spoken drama (also entitled *Tracks in the Snowy Forest*) in 1958, then into a Beijing Opera (entitled *Taking Tiger Mountain by Strategy*), which was performed in 1963 at a festival for modern Chinese plays and then turned into a model (Zhao 1969, 174–77; Dai 1995, 60–63; Fu 2002, 127–30). This version was revised several times during the Cultural Revolution and published in revision in *Red Flag* in 1967; it was later finalized in 1969. Parallel to this development, parts of the book were adapted for a 1960 feature film. For the audience of the filmed version of the model opera, which had been in the making since 1968 and was finally released in 1970,[73] the plot is thus already well-known, as it had by then been used for some thirteen years in quite a number of different formats. Later, in 1973, the opera was further transformed and made into a model symphony.

Another product of the 1950s is *Raid on White Tiger Regiment*, which recounts the efforts of a military opera troupe serving in the Korean War who, in this, their first Beijing Opera, reproduced a "real story, with real people" (Zhao 1969, 177–79; Dai 1995, 84–92, quoted on 86). It was reconceived by the Shandong Provincial Beijing Opera Troupe and first performed in 1963 at a Shandong festival for modern plays, and then selected as a model.

A second set of operas that would become models is based on material conceived in the 1960s: *Red Lantern* can be traced back to a 1963 feature film, *Naturally There Will Be Successors* (自有后来人 *Zi you houlairen*),[74] which was so successful that it was turned into a Beijing Opera (entitled 革命自有后来人 *Geming zi you houlairen*) by the Harbin Beijing Opera Troupe, two spoken dramas (entitled *Record of the Red Lantern* [红灯志 *Hongdengzhi*] and *Three Generations* [三代人 *Sandai ren*]), an opera (*Red Plum with Iron Bones* [铁骨红梅 *Tiegu hongmei*]), and a *kunqu* (*The Story of the Red Lantern* [红灯传 *Hongdengzhuan*]). This *kunqu* was then again re-adapted into a Shanghai Opera and was first performed under the title *Red Lantern* (红灯记 *Hongdengji*) in 1963 (Zhao 1969, 165–69; Dai 1995, 42; Fu 2002, 132–34). It became the backbone of a comic book first published in 1965 and reprinted many times within its first year of publication (*Fengyu Yangbanxi* VCD, booklet: 17–22). A few years later, Yin Chengzong, among others, undertook to reconceive the opera, creating the *The Red Lantern accompanied by Piano* (1967), which also attained model status. Finally, the model opera *On the Docks* (Zhao 1969, 179–80; Dai 1995, 71–81; Fu 2002, 140–41) is based on a 1963 Subei Opera (淮剧 *huaiju*) that had been transformed into a Beijing Opera entitled *Morning at the Harbor* (海港的早晨 *Haigang de Zaochen*) by 1964 and then was turned into a model (1966).[75]

72. Harris 2010 gives an even more elaborate background of the different versions of *Red Detachment of Women* preceding the production of the model ballet.

73. For the history of the making of this film, and information about its directors and staff, see Clark 2008, 123–26.

74. *Chinese Literature* contains a detailed analysis of the difference between the earlier feature film and the model opera; see CL 1973.1:78–87.

75. For a discussion of the earlier version of the opera, see *Xiju Bao* 1964.9:21–23.

The second set of model works, consisting of works declared models throughout the late 1960s and early 1970s, includes the *Yellow River Piano Concerto* based on Xian Xinghai's 1939 cantata. The model opera *Song of the Dragon River*, on the other hand, does not go back quite as far in time. The plot is based on reportage from a drought in the south of Fujian (Zhangzhou); this reportage had been used as the basis for a spoken drama *Song of the Dragon River* in 1963. In 1965 a first Beijing Opera version was created in Shanghai, and it quickly received much positive praise, even from Jiang Qing. It went through six drafts, however, before it finally became a model in 1971 (Dai 1995, 191–92; Fu 2002, 139–41). A similar story is that of *Azalea Mountain* (1973), which is also based on a spoken drama from 1963 that was turned into a Beijing Opera in the same year, later to be performed at the 1964 festival with great success (its run lasted for 200 consecutive performances). First revisions took place in 1968 when it was renamed *Azalea Spring Mountain* (杜泉山 *Duquanshan*), but it became a model only in 1973 under its former name *Azalea Mountain* (Dai 1995, 196–202; Fu 2002, 141–42).

Fighting on the Plain (1973) is yet a different case: it is based on a feature film *Guerillas on the Plain* (平原游击队 *Pingyuan youji dui*) (1955), which had been made into a Beijing Opera in 1965 (Dai 1995, 205; Fu 2002, 142–43). However, at the same time, a whole set of novels and feature films all dealing in a similar manner with guerilla troopes appeared, and all of these were influential in creating different scenes in the final model opera: there was the novel-turned-film *Iron Road Guerillas* (铁道游击队 *Tiedao youji dui*) (1956), the novel *Military Work Team Behind Enemy Lines* (敌后武工队 *Dihou wugong dui*), and the feature films *Tunnel War* (地道战 *Didaozhan*) (1962) and *Landmine War* (地雷战 *Dileizhan*) (1965), all of which became important sources for different scenes of the model work. The official filmed version of the model opera appeared in 1974, and a comic from this version also appeared in 1976 (Dai 1995, 211–14). The last of the operas, *Boulder Bay* (1975), is again based on a spoken drama dating back to the mid-1960s, *Great Wall in the South China Sea* (南海长城 *Nanhai changcheng*). First performed in 1964, it relates a true spy story that took place in October of 1962 on the southwest coast. The idea for changing it into a model opera originated in Shanghai in 1970. The piece eventually attained model status in 1975 (Fu 2002, 142).

Two more ballets included among the second set of model works, *Ode to Yi Mountain* (1972) and *Children of the Grasslands* (1972), were adaptations from earlier works: *Ode to Yi Mountain* goes back to an opera prepared for the 1964 festival entitled *Sister Red* (红嫂 *Hong Sao*), later transformed into a ballet in 1965. The opera itself was adapted from the 1960 novel of the same title by Liu Zhixia 刘知侠 (1918–91), who had been criticized during the early years of the Cultural Revolution. In the early 1970s, the plot was taken up again, transformed both into a Beijing Opera and a ballet and designated a model in 1972, together with *Children of the Grasslands*. Its plot, based on the true story of a pair of Mongolian children who get lost in the snow with their herd of sheep, was first featured as a cartoon entitled *Little Sisters of the Grasslands* (草原英雄小姐妹 *Caoyuan yingxiong xiao jiemei*) (1964) and also published as a comic (1973). Then it was made into a Beijing Opera and finally, in the early 1970s, produced as a ballet. Because of the Anti-Confucius Campaign, however, both ballets, which were filmed in 1973 and performed nationally in 1974, were not released as films until 1975 (Dai 1995, 214–20; Feng 2002, 74–77) and thus never received much of an audience.

Quite deliberately, then, each of the model works was created as a revision of an earlier work.[76] Between the model work and each of its predecessors, and also between different versions of the

76. The constant revision and reformulation of the same pieces and content is the most telling indicator of continuities and changes in China's cultural policies. Compare a similar situation in film described in Leyda (1972, 301–2): "In studying Chinese films a European or American observer has to be prepared for a situation not so evident outside China: that most Chinese films, especially those of particular importance, are based on works already developed in literature or the theater. Few films there are born as film ideas, directly."

model work itself, the story would undergo quite a number of changes: names and text passages were altered, arias were deleted or newly conceived. The audience was expected to know the preceding versions and to relate each revision to an earlier model for didactic reasons (Mittler 1998).

One example of this practice is the scene in *Taking Tiger Mountain by Strategy* in which the main hero Yang Zirong, on his ride up to Tiger Mountain, kills a tiger. In Qu Bo's book, when Yang's horse is attacked by the tiger, Yang shoots, but his pistol fails him. The tiger becomes angrier and angrier, and only after repeated shots with his mauser does Yang manage to kill the beast. Yang inspects the animal and begins to shiver with fear.

The same scene is depicted rather differently in the model opera. There, Yang kills the animal with a single shot and is completely calm throughout the scene.[77] The audience[78] has earlier depictions of him in mind as they watch Yang become the unquestioned hero—all the more so as, symbolically, the capture of tigers refers to Communist victory over Nationalists. It is by contrast that our hero rises all the higher, that he becomes the absolute and unchallenged hero of a model work. Similarly, every scene in the model works is measured with the yardstick of what came before it.

By deletion and addition, then, the model work rose above its well-known predecessors and thus fulfilled, with every revision, the political requirements made of it. At the same time, to confront the audience with ever new and more orthodox variants of already well-known pieces was to create a type of semantic overdetermination, which would make it almost impossible not to understand the underlying political premises; what was "to be" a model work was determined and highlighted by contrast with what it was "not to be" (Mittler 1998).

Revisions always followed particular principles: the "basic task" of the model works was to create proletarian heroes and thus to serve the masses through these role models. Accordingly, the model works exclusively present heroes from the lower classes of peasants, workers, and soldiers. Only among the villains are there landowners, literati, rich men, and "imperialists." In order to further underscore the proletarian nature of this theater, the heroes are shown, increasingly so in later revisions, as constantly concerned for the masses: Jiang Shuiying in *Song of the Dragon River* is shown to be particularly close to them as she cares for their homes while sacrificing her own (scene 8); she is obviously loved and revered by the people, for when they hear that she is sick, they immediately bring her chicken soup to help her regain her strength (scene 6).

In order to illustrate the heroes' closeness to the masses, the revision process often involves creating new biographies that give these heroes proletarian or revolutionary roots. New characters and whole scenes enter the revised theatrical only to make this connection clear; inevitably, the heroes will be "plain folks" who have grown up in a typical environment of class struggle. In *Taking Tiger Mountain by Strategy*, for example, the father of one of the heroic figures, Li Yongqi, is said to have died during the assassinations ordered by Chiang Kaishek in April 1927. Yang Zirong, the main hero of the opera, in the 1969 revision, is provided with an elaborate "proletarian background" that is never mentioned in earlier versions (in fact, almost all main heroes of the model works, for example Ke Xiang 柯湘 in *Azalea Mountain* or Granny Li in *Red Lantern*, reveal, at some point, their proletarian upbringing and torturous experiences). The (main) hero, the primary locus of identification, thus becomes a model of the good revolutionary. He/she is described not as an individual but as a type, a representative of China's workers, peasants, or soldiers (Michel 1982, 166).

77. Hegel 1987 gives an even earlier prototype for this scene, memorable to the Chinese audience, from *Water Margin* (水浒传 *Shuihuzhuan*).
78. For the significance of tigers in the gendering of the model works, see also Roberts 2010, 227–29.

With further revisions, the number of appearances of negative persons is reduced. In terms of placement on the stage, they are moved farther and farther to the right (e.g., Chang Fu in *Song of the Dragon River* or Qian Shouwei in *On the Docks*). Their movements are inelegant and comic; in the fighting scenes, they are always and clearly inferiors (see ill. 1.5), and they often disappear into the dark (the film versions of the model works display an effective use of shadowing, as in *Shajia Village* at the end of scene 3, for example, or in the beginning of *White-Haired Girl*, ill. 1.8). In the symphonic versions of *Shajia Village* and *Taking Tiger Mountain by Strategy* and in the piano accompaniment to *Red Lantern*, only the main heroes appear; the negative characters are eliminated altogether.

The negative characters are hardly heard, either. They sing very few arias if any, and in the few they do sing, they are accompanied only by the lower, brassy sounding instruments of the orchestra or by low-range Chinese instruments, the "lesser instruments" according to Cultural Revolution standards. Huang Guozhong, for example, sings only once in *Song of the Dragon River*—half spoken and half accompanied by the clarinet—in a short passage in scene 4 (*Longjiangsong* 1975, 121). As Panshuima explains his former bad deeds to Jiang Shuiying, only the lower strings can be heard (*Longjiangsong* 1975, 273, scene 6). If Zuo Shandiao in *Taking Tiger Mountain by Strategy* performed a number of arias in earlier versions, his singing part in the final filmed version of the model work is reduced to three croaking (if triumphant) lines without accompaniment in scene 8, when Yang Zirong gives him the secret map. The abominable "imperialist" Kameta in *Fighting on the Plain* sings just a few short interludes syllabically (which shows, in musical semantics, his lack of sophistication); his extremely crude and rough voice is accompanied only by the eerie sound of muted brass (e.g., scene 2). And the Japanese character Hatoyama is deprived of almost all opportunities to sing by the final revision of *Red Lantern*. If kept at all, the negative characters' song lines are changed to spoken dialogue (scenes 4 and 6).

All of this is arranged in such a way as to push the main actors into the foreground (Michel 1982, 190) in accordance with the theory of "Three Prominences," which postulates that (1) positive characters must be given prominence over all other characters, (2) heroic characters must be given prominence over positive ones, (3) among the heroic figures, prominence must be given to the main hero (*Tan santuchu* 1974; King 1984). The principle of Three Prominences is translated into music by means of the so-called "Four Prominences" (四突出 *situchu*) (Wang 1990,303), which outline the following guidelines: (1) among choralists and instrumentalists, choralists ought to dominate, (2) among Chinese instruments, the three main instruments in the operatic ensemble—*jinghu, erhu,* and *pipa*—ought to be emphasized, (3) among these three instruments, the fiddle *jinghu* should stand out, and (4) among Western instruments, stringed instruments ought to be foregrounded. These directives determine and delimit musical creativity; they call for a crossing of genres (choral and solo singing is employed in ballet, for example), and, as I will show in Chapter 2, they are still remembered and perhaps subconsciously made use of in pieces composed years after the Cultural Revolution, such as Tan Dun's *Red Forecast* (1996).

By use of the principles of the Three Prominences and Four Prominences, negative characters disappear almost completely from sight and sound while positive characters take center stage. While these terms were coined during the Cultural Revolution, the ideas and techniques they articulate are much older (Gao and Li 1999, 289–92). In traditional opera, only certain role types would be allowed to sing arias and to speak in rhymed language. Others—the role of the clown, for instance—which was usually the only role representing the lower classes in traditional opera, would be marked by their particular use of language and singing. Traditional opera also focused on one or two main protagonists at the expense of secondary characters, but the model works carried this practice to an even greater extreme, making it exceptionally rigid.

In *Taking Tiger Mountain by Strategy*, for example, Yang Zirong no longer sings "obscene ditties" or flirts with Zuo Shandiao's daughter (who has by this revision disappeared completely). These actions, which are elaborately described both in the 1960 feature film and in Qu Bo's book, "turned Yang . . . into a filthy-mouthed desperado and a reckless muddle-headed adventurer reeking with bandit odor from top to toe," according to one contemporary exegesis (*CL* 1970.1:58–74). This description could never be applied to a proletarian hero in the model works. Apart from Zuo Shandiao's daughter, a number of other protagonists in book and film no longer appear in the revised version of the model opera. Still others are renamed or grouped under categories such as "soldiers," "bandits," "medics," etc. The result of such changes is self-evident: by reducing the numbers of characters, especially the negative characters, more space, time, and emphasis can be given to the proletarian heroes who are so purified. The negative characters are not allowed to sully the heroes' names, and accordingly, in the final model version of *Red Lantern* (scene 4), Hatoyama and his men no longer call the Communists "devils" but instead say that "they are hard nuts to crack" (共产党厉害).

In the model version of this opera, Li Yuhe's little hut no longer is ornamented with pictures of a sexy Shanghai beauty as it would have been in the earlier feature film, and his "mother" does not use foul language anymore as she had done in a 1964 opera version (scene 7). Li Yuhe is no longer accused of heavy drinking by Granny Li, even though both film and early opera versions were full of such accusations. Thus, a totally different, purified meaning is reflected in the scene when, just before he leaves for his "last battle," she hands him a "last cup of wine" and urges him to drink (scene 5).

The clear accentuation between good and bad has visual (supported by filming techniques) and textual repercussions, too: villains are filmed from above or below, they are captured in long shots rather than close-ups, and they are not usually framed in central positions. Vulture's throne, which, in the 1960 film, is situated in the centre of the stage, is moved further and further backwards and to the right margins of the stage in the model versions. Between 1967 and 1969, stage directions were changed from "the interior of Tiger Hall, brightly lit by many lamps" (*CL* 1967.8:151) to "a gloomy cave lit by several lamps" (*CL* 1970.1:26). The extreme darkness in the depiction of the negative characters may have had an adverse effect on some viewers: Lois Wheeler-Snow in her elaborate and perceptive report of some of the model works from the first set mentions, for example, that she was in fact drawn even more to those characters because she really had to work hard to see them (1973). But the intention behind this use of staging, yet another redundant move of the propagandists, is rather clear.

Some of the bandits' murdering scenes, quite vividly depicted in both book and feature film and thus part of the thrill for the audiences, are left out in the filmed model opera version, again in order to deemphasize the negative characters. Instead, in *Taking Tiger Mountain by Strategy*, a scene in which the soldiers ask Chang Bao and her father about their sufferings is added (scene 3, see *CL* 1970.1:9). While appearances of the negative characters are radically shortened (this is blatantly obvious when comparing the 1964 version of *Red Lantern* with its later reincarnations, for example),[79] the positive characters become more and more prominently exposed. They are given positive names, they appear in the center of the stage in bright light, they talk and sing much more than the negative characters, and they have flexible musical markers—leitmotifs that often, as in *Song of the Dragon River*, became the kernel motif for the entire opera (Wang 1999, 75–84; see also Mittler 1997, 91–97).

The principle of "Revolutionary Realism and Revolutionary Romanticism" advocated by Mao since the late 1950s also helps support this positive depiction of the heroes: Yang Zirong's battle with the tiger, for example, is increasingly styled into an apotheosis presenting Mao's vision of a

79. Cf. *CL* 1965.5:3–48, vs. *CL* 1970.8:8–52.

model-like life "on a higher plane." In *Song of the Dragon River*, a scene of breathtaking acrobatics in which a human dam fends off the roaring waters is accompanied by an orchestral apotheosis and punctuated by effectively placed citations from Mao's story of the Foolish Old Man (discussed in detail in Chapter 4) (*Longjiangsong* 1974, 15–17). In *Red Detachment of Women* the main hero, Hong Changqing, is memorialized to the triumphant sounds of the "Internationale," accompanied by the performers' humming as they surround the tree under which Hong Changqing, the "Vast," had been burnt at stake. Suddenly, a red halo appears there. A similar scene, washed in red, marks Aunt Zhang's 张大娘 martyrdom in *Fighting on the Plain* (scene 5). In *On the Docks*, Fang Haizhen is seen reading the "Communiqué from the Eighth Plenary Meeting of the Tenth Central Committee" (八届十中全会公报 *Bajie shizhong quanhui gongbao*) and sings of her regained hope while a beautiful rainbow appears in front of her office (scene 4). In *Red Lantern*, Li Yuhe and Granny Li are killed as they shout the words "Long live the Revolution, long live Mao Zedong." The sounds of the "Internationale" can be heard in the background.

All of these are hyperbolic manifestations of Mao's "Revolutionary Realism and Revolutionary Romanticism," which aimed at creating realist representations on a higher, typified plane, in order to serve as models for emulation. Once again, traditional opera and revolutionary opera are not so far apart from each other even if the expression "model" (*yangban*) is not used in the traditional context: in traditional opera, too, the aim was to create models to be emulated, models of exemplary Confucian morals or military finesse and intelligence.

With this didactic purpose in mind, the successful completion of each version of a model work was accompanied by an educational campaign, with articles published in *Red Flag* or *People's Daily* and book publications collecting critical reviews elaborating even the most minute of changes.[80] And still, audiences were not always willing to believe:

> They made us go to the performances and they would write all these articles explaining the performances. Yes, we did read them—they would explain everything, giving all the details about what is good and bad, etc. They would change the [characters'] names: in the final Cultural Revolution version of *Red Detachment of Women*, the heroine was no longer a beautiful flower [Wu Qionghua 吴琼花] but became "Pure China" [Wu Qinghua 吴清华] instead. (Journalist, 1946–)

> He: Everything in these pieces was to serve the one hero. It was full of politics. This hero could not make any kind of mistake, not even the smallest. Take Yang Zirong in *Taking Tiger Mountain by Strategy*, for example. The depiction is simply not realistic. The same with the negative characters: they are so bad that it is plain unbearable. She: For example in *White-Haired Girl*, there is no longer anything about the sexual relation between landlord and Xi'er [the white-haired girl's name], so the whole story becomes unrealistic. In *Tracks in the Snowy Forest*, there was this love affair, but this is deleted in the model works. There cannot be any romantic love or anything like that. He: But art cannot be completely divorced from reality. (Businesswoman and her husband, 1940s–)

> Compare the model opera *Taking Tiger Mountain by Strategy* with Qu Bo's book: it is really not the same. I heard my older sister talk about how in the book Yang Zirong was depicted too much like a bandit, but I also remember her saying that in the model works version, [the writers] had changed too much. (Art Historian, 1940–)

> These heroes from the model works were my heroes, too. I know them all: Guo Jianguang, Li Yuhe, Jiang Shuiying, Ke Xiang, Baimaonü [the white-haired girl], Wu Qionghua [*sic*], Yang Zirong. All of these are from the first set [*sic*], so we know them best. We had of course also seen many of the films that later became the plots for the model works. Actually, comparing the films and the model works, I

80. See, for example, *Geming xiandai jingju Pingyuan zuozhan pinglunji* 革命现代京剧平原作战评论集, 1974, and *Geming xiandai jingju pinglunjizan "Pingyuan zuozhan"* 革命现代京剧评论集赞"平原作战" 1975.

liked the films better, because they were so well constructed. They were much more realistic, really, and much better. The model works with all their dancing and their singing were of course not realistic. But they were smart, they knew that everybody had liked a particular film, and therefore they changed it into this piece of music theater, but, in fact, I think most people liked the earlier versions better. And even during the Cultural Revolution people would say that they preferred the earlier versions. Not openly in a meeting, of course, but among friends, it was no problem! (Musician, 1942–)

Actually we all preferred the 1960 film to the ballet *Red Detachment of Women*. . . . but there were all these explanatory books that showed everyone who is who, and who are the good ones, etc. (China Historian, 1957–)

These memories by contemporaries illustrate that the alternate earlier versions are remembered—even relived—in watching the revised model versions, and that revised versions can therefore play on this former knowledge: if certain elements are deliberately stressed or eliminated in a later version, the audience is to learn a political lesson from these changes. The didactics of change (and transfer) were used, then, to make one particular version the unquestioned model. That this logic did not always play out in real life is evident from the many more positive responses to earlier versions recorded here, which also implies that for the models to shine as they did, performances of earlier versions of the plot would need to be banned (Chen 1995, 22).

★★★★★

EXCURSION 2
Chinese Opera Reform: A View from History

The diary of a Chinese theater connoisseur contains the following entry from 1963:

If someone asks me, "so, was this an old or a new opera which you have just seen?" I never quite know what to answer because all of these operas are quite some mix, really. The words "new" and "old" are not quite adequate for describing our musical theater today. (Dolby 1976, 250)

This is testimony of the constant, sometimes radical, changes that have marked the history of Chinese opera in the twentieth century. The reform and modernization of Chinese theater had already begun in the waning years of the nineteenth century (Li 1996 passim; Chen 2002, 93–107; Mittler 2001). There were two high points in this development: 1) the Communist reform efforts that began in the 1940s and peaked during the Cultural Revolution with the creation of model works; and 2) the earlier reform efforts in and around China's first revolution, which began around the turn of the twentieth century when the country was still under the reign of the Manchu Qing dynasty and culminated in the May Fourth Movement of the 1920s and 30s.

In this earlier phase of opera reform, voices could be heard that would foresee the imminent death of the old operatic art. If one were to agree with these predictions, then Chinese opera would have been lost at least once before already: during the iconoclastic May Fourth Movement. But it did not die then; on the contrary, one enthusiastic reformer of the time was none other than the great opera singer Mei Lanfang 梅兰芳 (1894–1961), who, through his graceful embodiment of female roles, captured the minds not just of Chinese audiences but of a Charlie Chaplin or a Bertolt Brecht. Mei Lanfang has come to epitomize the tradition of Chinese opera in China and the world (Li 1996, Yeh 2007).

What Mei would have thought of the model operas we cannot know (he died in 1961, some years before their conception). But he did indeed propagate, if decades earlier, many of the "novelties" that would play an important and characteristic role in the revolutionary Beijing Operas that later became models. In introducing these novelties, he built on his experiences in Shanghai, where he performed on a modern stage for the first time in 1913. Following the foreign model, Shanghai theaters no longer had the musicians seated on the stage. Also, the operatic orchestra often used foreign instruments in addition to Chinese instruments. The use of revolving stages and electric spotlights, too (the latter of which would become so important in model opera film), was common in early twentieth-century Shanghai; advertisements for the new-style theaters claimed that the audience would receive important "scientific" information through the use of these features. The theaters would compete over who presented the best "special effects": no longer would a chair suffice to symbolize a mountain, but there would be a model of such a mountain. The howling of the wind would be emulated; rain, snow, fire, water in which a warship would come along, and even living animals were introduced on stage. All of these realistic elements were thus not invented during the Cultural Revolution but played an important role in opera performance both before and after this time.

In the early twentieth-century discussions on the modernization of Chinese opera, the idea that "theater houses are the schools for the masses, and actors are the teachers of the people" (戏馆子是众人的大学堂, 戏子是众人大教师), voiced in 1904 by future Communist leader Chen Duxiu 陈独秀 (1879–1942),[81] proliferated. (Mao would later adapt this idea.) May Fourth writer Zheng Zhenduo 郑振铎 (1898–1958) wrote in 1921 that "art should take over part of the educator's responsibility. Since theater possesses the outstanding capability of moving the audience, it must assume a particularly huge responsibility" (Zheng 1921). And for this purpose, it was necessary, according to the early reformers, to eliminate some of the lesser elements in China's operatic tradition: not only unhealthy sexual allusions but, more importantly, immortals and ghosts were to be banned from China's stages. In some of the articles closely resembling, at least in their rhetoric, Cultural Revolution (and earlier) pamphlets against traditional operas, they are dismissed as superstitious acrobatic play. By then, traditional opera with traditional themes was judged to be unrealistic and thus in contradiction with modern life (Li 1996). The call for operas with contemporary themes and topics was heard then, and this continued right up until the conception of the revolutionary model operas.

In the words of these early reformers, theater was expected to exemplify "real life." This claim comes very close to Jiang Qing's demand for artists and performers to engage deeply with the lives of the people (深入生活 shenru shenghuo), her idea that they must live with them and know them well if they wished to describe the people in their art. In the 1920s, it was already being discussed how to most realistically express the different characters' emotional states and how to adapt aria styles from their traditional melodic modules and patterns in order to create psychological realism in the manner put to practice in the revolutionary operas.

Mei Lanfang himself had always been very impressed with these types of innovations that Shanghai brought to Chinese opera, and he soon began to integrate them in his own operatic style. As one of the first operatic actors in Chinese history, he made use of film for the propagation of his operatic art. Jiang Qing, with her filmed versions of revolutionary operas, directly inherited this early practice, which was well familiar to her through her own youthful experiences as an actress in Shanghai.

Mei was one of the first to introduce an extension of the "traditional" opera ensemble, too, adding a lower huqin next to jinghu, yueqin, and percussion. He would perform operas in

81. San Ai (i.e., Chen Duxiu) 1904. For an interpretation of this essay see Li 1996, 169–73.

contemporary costume (ill. 1.12) and rewrite the pieces he performed so they contained sections in colloquial speech and not just in difficult ryhmed speech (*yunbai*), in order to better "serve the education of the people" (another idea to be taken up in the revolutionary operas). Mei Lanfang, too, therefore, was convinced of the malleability and the revolutionary power Chinese opera held, and that it could serve a political function.

★★★★★

The Artistic Success of the Model Works

If Peng Zhen had complained of the revolutionary model operas, declaring them to be insipid as "pure boiled water," he may have been right in this judgment, for not unlike "pure boiled water" was the constantly repeated political message in these revolutionary operas and all of the model works, with their repetitive and restrictive nature of performance (and reception). One could find complete "how-to guides" prescribing exactly how much wattage the lighting should have, how one was to apply the makeup for actors (e.g., *Geming xiandai jingju* Hongdengji 1970). Remembers one son of an actor: "Where exactly the actors should stand and how they should do this or that—this was told to them, and this was very strict, too" (Music Student, 1969–). Another recalls the mandates given to his factory's performance troupe:

> I also performed in *Shajia Village*, playing Guo Jianguang. The rules governing how we were to perform it were really strict: in the factory where I worked we had a performance troupe; it was a very big factory. There was a person from the Nanjing Beijing Opera troupe who had had a political problem and therefore came to work in the factory. He would participate together with some others from different theater troupes and ballet troupes all working at the factory. The clothes, which we made ourselves, were always strictly in accordance with the official performances and the films. (Librarian, mid-1950s–)

Today, Chinese theaters are no longer restricted to the same degree as before, not in terms of the repertoire they choose nor in terms of the types of performance styles they adapt. All kinds of different operatic forms are being performed, including traditional-style operas and new historical operas whose libretti take up stories from traditional China. They are staged in a whole range of different styles and interpretations, from very restrained traditionalist-symbolist to Hollywood-esque and realist, with many special effects. In addition, one can see operas and musicals based on structures from foreign musical traditions, which take up topics from Chinese as well as foreign literature and even classics by writers like Sophocles or Shakespeare. Surprisingly, perhaps, even in this broad spectrum of different operatic forms, the revolutionary Beijing Operas from the Cultural Revolution hold a special position: even though their political message is no longer useful, they have become an integral and oft-cited element of and in Chinese theatrical heritage. In the words of one contemporary:

> They are a kind of renewal of Beijing Opera. The best people were involved in their production. And quite accordingly, they are real Beijing Operas—their rhetorics, their meter, it is all Beijing Opera. Of course, they are very political, but they are Beijing Operas all the same. (Museum Curator, 1950s–)

Thus the model works and, among them, the revolutionary operas in particular, have their place in a long series of syntheses between foreign and Chinese heritage, but theirs is a unique synthesis that appears still unrivaled today. For in striking contrast to Chinese art music, which takes foreign

compositional structures and forms and enriches them with Chinese melodies and folk songs, the revolutionary operas are a successful endeavor in the opposite direction: they begin with Chinese opera, using it as the base which is then enriched by creative borrowings from the foreign musical repertoire.

In constructing the "new system" of revolutionary opera, Jiang Qing and her teams of composers, performers, and musicians drew on the old features from Beijing Opera, adding to them elements from spoken drama (话剧 *huaju*) and from foreign operatic, ballet, and symphonic traditions, especially those classic and romantic (Mittler 2002). They added stage props and settings, and they produced film versions of the operas, a practice that again introduced new artistic practices and stylistic elements to the original art form.[82]

Wang Renyuan, in his elaborate study of musical elements in the revolutionary operas, talks of the amplifying effects that traditional opera receives by use of foreign instruments: emotions can be expressed more specifically through a wider range of instruments. On the other hand, the three most important operatic instruments—*jinghu, erhu,* and *pipa*—are further enhanced through support by instruments from the foreign-style orchestra. The use of citations from revolutionary songs, and the use of modulation, too, according to Wang, does not lead to a destruction of the traditional musical repertoire but serves rather to amplify its beauty and importance (Wang 1999, 33–37, 74, 99). Rather than constituting a "radical departure from traditional drama" (Dolby 1976, 257), the revolutionary operas simply modified Beijing Opera, changing and improving it (Wang 1999, 56–57, 134 and passim). Contemporaries, too, shared this opinion:

> The model works are really representative of Chinese culture. They were written by specialists in the world of theater. And the operas especially among the model works are very good: they combine elements from traditional Beijing Opera and then they make a few changes according to specific rules. There may have been changes in meter, for example.... Ultimately, it is all about the fact that we are supposed to love Mao; that was the real aim of these pieces. But there was a traditional base and then these foreign elements were added, the symphony orchestra and all that. (Musician, 1930s–)

In the revolutionary operas, foreign musical elements serve the Chinese structure and form, not vice versa. Therefore, in spite of all the politics they embody, the revolutionary operas are Chinese operas that have not destroyed the traditional art of opera but have actually kept it alive, for they, too, are synthetic developments that can be fitted easily into the organic development of Chinese operatic art, characterized by continuous reform and revolution. In short, the story of Chinese opera is a story in flux, as Chinese opera is a genre of change, and this change has simply taken on a new quality within the revolutionary operas among the model works. The obvious recourse to the particular style of Beijing Opera concomitant with its circulation by means of film in recent years has undoubtedly increased the Chinese population's level of understanding of the old art form of Beijing Opera:

> The model works films were all open; anybody could go and see them. And a lot of people actually liked to watch them.... There were a lot of very talented and famous people involved ... very good performers. So in terms of the technique and music, it was all very accomplished. Sure, the stories, they were restricted, but this is not what people were concerned about. Much more important was the way these actors would sing. This situation is similar to the Cao Cao [曹操, 155–220] plays, for example: the story of the *Empty City* [空城计 *Kongchengji*] is very simple, and everybody knows it, but you go there anyway, not for the story but for the singing. It was the same with the model works. You went there for the singing and the performers, really! ... Qian Haoliang [钱浩梁, 1934–], for example, who plays in *Red Lantern,* was really one of the best performers at that time. People in the 1960s would say

82. See the related essays on Chinese opera film in the special double issue of *The Opera Quarterly* (2010).

that only he could act so well, and they went to see *Red Lantern* just to watch him. They [these politicians responsible for art and cultural production during the Cultural Revolution] spent a lot of time choosing the right performers for the model works. They really wanted to choose the best! (Librarian, mid-1950s–)

Many of those who lived (and suffered) through the Cultural Revolution would thus acknowledge that in terms of quality and style of music, the "model works were unprecedented; no modern theater after the model works ever topped them" (样板戏的音乐成就是空前的, 此后的现代戏在音乐创作方面都没有超越它) (DACHS 2008 Zhang Yihe). As seen above, one of the reasons given repeatedly for the quality of the operas is the choice of performers:

As for Chinese theatricals [戏曲 *xiqu*], there was no destruction [during the Cultural Revolution]; on the contrary, there was a very strong artistic development, especially musically and also in performance there were real developments. During 1975–76 Jiang Qing would call on famous artists [优秀艺术家 *youxiu yishujia*], and she would record the most important performances by the most important musicians. . . . Jiang Qing really knew what she was doing [非常懂行 *feichang dong xing*]. There were these performers locked up in the "cowsheds" [牛棚 *niupeng*] as counterrevolutionaries, and she liberated them, asking them to come back and take part in the work. For her to ask these guys to come back was an extremely smart decision. (Ethnomusicologist, 1940–)[83]

Another frequently mentioned factor in the artistic success of the model works was the competent hand of traditional opera specialist Yu Huiyong 于会泳 (1926–77) in the conception of many of the best revolutionary operas:

One cannot simply say that the Cultural Revolution destroyed Chinese traditional culture. Take *On the Docks*, for example; Yu Huiyong renewed it. Or, for example, *Azalea Mountain*: in terms of reformed opera these are some of the highest achievements we have made so far. Even until today you still have to find an example that tops this. And indeed, Yu Huiyong's understanding of traditional music was crucial. (Musicologist, 1922–)

Produced over a long stretch of time by some of the best artists of the nation, the revolutionary operas are, so seems to be the agreement among specialists as well as the general population, artistically as accomplished as little else was in the history of cultural development throughout twentieth-century China. According to Elizabeth Wichmann, "[The] enormous range of theatrical forms and techniques in contemporary China, coupled with the variety of Western dramatic and theatrical elements becoming increasingly familiar in China, present a rich field for creative borrowing and assimilation. A literally innumerable array of music, acting, movement and dance, and staging possibilities present themselves." She concludes: "The most ambitious and far-reaching example of this sort of creative development to date remains the model works" (1983, 194–95).

The revolutionary operas are *Gesamtkunstwerke*, which accord not just with high political but high aesthetic standards as well. Says one interview partner, a playwright (1956–): "If, because politically you are against the Cultural Revolution, you say the model works are not 'artistic' [没艺

83. Not all evidence points to the importance of the original performers for the uninhibited success of the revolutionary operas, especially today: "Nowadays, there are all these DVDs and VCDs of the model works everywhere, yes, and they sell quite well. During the Cultural Revolution, we would consider them a political symbol; now, we think that they reflect the activist spirit of the time and its reflection in art. The piano and the symphonic pieces and the ballets are very enjoyable. I have myself bought *Red Detachment of Women* and *White-Haired Girl*. There have also been performances recently, and I went to those, too, with my daughter. She compared the two versions and really criticized the Cultural Revolution performance. She would have been a counterrevolutionary for saying something like that during the Cultural Revolution, for sure." (Art Historian, 1940s–)

术 mei yishu], that is not true, indeed, those are two different things." Quality may have been gained by unjust means in many cases: according to an older musicologist, Jiang Qing's models were so accomplished because she would take up, in her crusade for finding pieces that could be transformed into models, works that had already achieved great success. She would "take successful things, make the creators into counterrevolutionaries, and then get the fruits herself, just like killing the bird and taking his eggs" (Musicologist, 1922–). It is this unique quality of the revolutionary operas as the products of a long distillatory process that explains their success then and now and that may point to their lasting importance, too:

> It is true, the qualitative standard was very high with the model works. There were of course reformed and modern operas after the model works, but not that many. I saw a few of them, and neither of them superseded the model works. If you speak about it from the point of view of today, *Shajia Village, Red Detachment of Women, On the Docks,* for example, are still performed quite often. There are variations of them, too. The Central Philharmonic and Ye Xiaogang [叶小纲, 1955–], for example, did a very interesting thing with *On the Docks,* making a piano quintet from it, adding singing by the old performers. In some ways, this peculiar performance was even better than those during the Cultural Revolution. The scene in *Taking Tiger Mountain by Strategy* of Yang going up the mountain, and sections from *Shajia Village,* are still very often put up in performances. They are just very good, and therefore, they are going to last, too [它们都会留下来]. (Intellectual, 1958–)

Recapitulation: Mozart and China

In light not only of the popularity of the model works but also of the immensely successful generation of artists that came out of the Cultural Revolution and were very well received internationally—such as fifth-generation film makers, artists, musicians, and composers—it is worthwhile to rethink common clichés about musical life during the Cultural Revolution. It is too simplistic to talk only of a "lost generation," for some gained from what were only in part tragic experiences. Quite naturally, perceptions of the Cultural Revolution both in China and abroad are never free from constraints of political correctness, as well as empathy. A time that created traumatic experiences for a great portion of the population[84] cannot so easily be described as a time of unknown freedoms and possibilities, even if this was what some, especially young people, actually experienced.

For many Chinese and especially for China's musicians and composers, the end of the Cultural Revolution meant a reopening to the world: Mozart officially returned to China. The diplomatic visits by a number of Western symphony orchestras during the brief period of Ping-Pong diplomacy (1973) can be considered a prelude to this development (Mittler 2007, 135). Since that time, music students have had the chance to listen ever more frequently to music by Schubert and Beethoven, by Mendelssohn and Brahms, and not just their Chinese successors. And they would soon learn, too, that musical developments had moved on from the days and sounds of Rachmaninoff and Tchaikovsky. In the late 1970s, the conservatories opened their doors again. Alexander Goehr (1932–), a British composer and educator, was invited to the Central Conservatory in Beijing in 1980 specifically to teach modern compositional techniques to select students from Shanghai and Beijing. Goehr taught only a few students, but his influence was felt by a great many: he opened up a Pandora's Box of New Chinese Music again, as the old dusty scores left over from the golden days

84. Isaac Stern's film, discussed at the beginning of this chapter, presents tragic stories from people like violinist Tan Shuzhen, who relates the many suicides in the Shanghai Conservatory, for example. See DACHS 2008 *Mao to Mozart* Part 9:3.27; see also Melvin and Cai 2004.

of musical life in the 1930s and 40s were being rediscovered by a new generation of students. What had been silenced since the late 1940s could be heard, thought, and composed again. In the mid-1980s, for example, a group of composers who would be called composers of the "New Wave" (新潮 *xinchao*) came to prominence. Paradoxically, though, one could argue that this opening up to the world actually led to a radical sinification of foreign-style Chinese music, directing it slowly away from the "foreign" style of "pentatonic romanticism." The music of this new generation of Chinese composers is characterized, on the one hand, by a distinct familiarity with and exploration of modernist techniques and sounds, and, on the other hand, by a particular approach to Chinese tradition that sets it apart from earlier attempts at composing "national music" and in particular from works in the style of "pentatonic romanticism."

The return of Mozart to China after the Cultural Revolution, then, means neither that China's foreign-style music has become more foreign, nor that the question of how to create and compose a New Chinese Music has been resolved or pushed to the background. The reality is quite to the contrary. I return, therefore, in this final part of the chapter to the question of national style and its interpretation. My purpose is to demonstrate that the model works of the Cultural Revolution, denying and yet copying the art of Mozart, are indeed nothing but one step in this direction. They are not a deviation from the norm, but one variation in the development of foreign-style Chinese music that has been dominated by the constant worry over national style.[85] Although it was a foreigner, Alexander Tcherepnin, who, with his 1934 competition for "piano pieces in Chinese style," was the first to explicitly ask Chinese composers to write their music in national style, the question of national style still dominates discussions of New Chinese Music both within China and abroad today.

It is not as easy for a Chinese composer to simply opt for "being himself" by writing in an individual style, as Olivier Messiaen (1908–92) once suggested to his last student, Chen Qigang 陈其钢 (1951–). Foreign music critics as well as critics within China tend to judge Chinese compositions deficient if they do not betray particular national sensibilities (Mittler 2004). The question, however, of what "national style" is, exactly, remains open. In this section of the chapter, I will provide a number of examples of very different answers to that question.

In Hong Kong as well as in the PRC, on the mainland and in Taiwan, the style I have called "pentatonic romanticism" has established a constant presence (it turned out to be politically orthodox both on the Communist mainland and in Nationalist Taiwan and commercially viable in colonial Hong Kong). It makes use of Chinese raw materials such as pentatonic melodies from folk songs or opera and stylizes them by transferring them onto foreign instruments and by pressing them into a (foreign) system of notation. Chinese folk songs and operatic singing, however, are characterized by a changing irregular meter, and they make use of elaborate ornamentation and tonal inflections, the notation of which is difficult in the foreign five-staff system. These idiosyncrasies are lost in stylized composition. The model works are full of such examples (Mittler 1997, 303–13).

Some Chinese composers take a very different approach to Chinese melody, playing with rather than cleaning away its peculiarities. Their alternative can be found particularly frequently in compositions composed since the early 1980s—that is, after the Cultural Revolution—but it was a style also once in vogue in the 1940s when Sang Tong 桑桐 (1923–), for example, wrote a now-famous piano piece *In That Place, Far Far Away* (在那遥远的地方), which he later renounced (possibly by force). Because Sang Tong was attempting to capture the rhythmic as well as the tonal idiosyncrasies of Chinese folk song, his piece is polytonal and constantly changes meter. Chinese composers today have become even more radical in their translations of such idiosyncrasies into sound (Mittler 1997, 340–46, 350–57).

85. Many examples are given in Mittler 1997, Chapter 4. For a lucid discussion, see also Tuohy 2001a.

Apart from Chinese melody, Chinese instrumental techniques have also been used frequently to mark Chineseness. Again, this is seen in the stylizing approach from pentatonic romanticism, which simply transfers a Chinese instrumental technique onto a foreign instrument. This takes place in many a violin tremolo and sounds approximating the pizzicato of Chinese plucked instruments. A more radical approach, found particularly in use among composers of the "New Wave," changes the foreign instrument into one that is essentially Chinese: *erhu* playing translated onto the cello, for example, requires that the strings be lowered by a full octave. Only then do they create the same kinds of background noises that would also accompany playing on the simpler version of the *erhu* used in the countryside, where resin is dropped directly onto the body of the instrument and the bow scrapes at it every time it is drawn. Alternately, many a Chinese composer of foreign-style music has composed for Chinese instruments, again calling for various transformations and retransformations of these instruments in the process of synthetic composition between East and West (Mittler 1997, 305–7, 329).

Yet another approach to Chineseness that has been taken up by many Chinese composers throughout the twentieth century is to draw from Chinese myths and literature and to bring those into fruition in their composition. Musically speaking, compositions that fall into this category appear in a great variety of styles. Another common method is the translation of Chinese philosophical ideas into sound. Chinese composers have designed entire compositional systems based on the ideas in the *Book of Changes* (易经 *Yijing*), for example (Mittler 1997, 357–77, Utz 2002).

The emphasis on single sounds (derived from the aesthetics of *guqin* playing) and on silence is derived from the teachings of Daoism, where the greatest sound is said to be "rare, unhearable," the best instrument a *guqin* without strings.[86] This approach is epitomized in Tan Dun's *Circle* (1992), where a bar of complete silence is marked with a crescendo and a decrescendo. Silence is perhaps one of the most powerful and frequently heard elements in much New Chinese Music today, although not yet considered orthophonic by Chinese governments on either side of the Taiwan straits.

With these last examples it may have become particularly clear that some of the techniques described here as "traditional" and "Chinese"—the bruitism (here derived from *erhu* playing), the microtonal practices (from Chinese vocal and operatic practice), the silences (from *guqin* playing)—are typical trademarks in works of modernist and contemporary composers as well. As these techniques were introduced in China after the Cultural Revolution, Chinese composers, eager to learn about New Music in the West, would often have a feeling of déjà-vu. They would see mirrored in the works of contemporary composers from abroad their own traditions. This merge can be explained, at least in part, by a strong Western interest in Asian culture since the beginning of this century: composers such as Debussy, John Cage (1912–92), Karlheinz Stockhausen (1928–2007), Benjamin Britten (1913–76), and Lou Harrison (1917–2003) were fascinated by the sounds, instruments, and philosophies of Asia. And yet, the fact that fundamental Asian concepts and practices in music are unobtrusively being integrated into the mainstream of Western contemporary music cannot be explained by the strong Western interest in Asian cultures alone. Rather, there are fundamental affinities between Eastern old and foreign new techniques. The breakdown of harmony was the first step in the creation of New Music in the West. Conventional vertical structure gave way to a more linear, horizontal structure, and this type of structure is indeed typical of Chinese traditional music. The concept of sound compositions emphasizing single sounds rather than melodic developments, a technique prevalent in New Music and exemplified

86. For the political context of this approach, see Mittler 2000.

in compositions by György Ligeti (1923–2006), Witold Lutoslawski (1913–94), and Giacinto Scelsi (1905–88) among others, is a common feature of traditional Chinese music. Aleatoric approaches soften the concept of the unchanging opus and the "dictatorial" position of the composer, a concept never inherent in China's musical tradition. Complicated and polyrhythmic structures, another of the "discoveries" of New Music, are customary in China's tradition, and even the use of speech-voice in New Music is similar to some of the effects in Chinese operatic and folk song traditions (see Mittler 1997, 18–20).

Thus, Chinese music has come full circle. New Chinese Music is no longer exclusively the music of violins, organs, pianos, and clarinets, the forms it took when it originally came to China in the wake of foreign invasions. Indeed, this music has become more and more intricately involved with Chinese instruments and with the Chinese tradition itself. New Chinese Music after the Cultural Revolution no longer exclusively seeks to improve Chinese musical traditions and instruments—it no longer attempts to "bring them up" (提高 tigao) to foreign standards, as efforts at stylization and reform of Chinese instruments would do—but instead seeks to redevelop, to renew, to reinvigorate traditional Chinese music. The merging of the techniques of New Music and Chinese tradition makes it possible to both redevelop and restore the traditional heritage.

It is almost as if the eighth-century poet Bai Juyi 白居易 (772–846), to whom the following poem is attributed, had foreseen the pervasive powers that traditional music would have in contemporary China:

The Forsaken Qin	廢琴
Made of silk strings and the wood of *wutong*,	丝桐合为琴,
The *qin* pours forth the sound of antiquity.	中有太古声.
Bland and insipid? The sound of antiquity	古声淡无味,
Appeals not to the modern ear.	不称今人情.
Its jade studs lack not luster though long disused.	玉徽光彩灭,
On its red strings dust and dirt have gathered.	朱弦尘土生.
For a long time it has been abandoned	废弃来已久,
But its clear sound lingers in the air.	遗音尚泠泠.

Bai Juyi's optimism, his belief in the constancy of worthy music, has proven prophetic. Age-old musical traditions have not lost their "luster" in contemporary China. China's ancient musical heritage has not been forgotten in the days of New Music; indeed "its clear sound lingers in the air." Paradoxically enough, though, and as my listening experiment confirmed, Chinese audiences were often so bewildered by the sounds of this new New Music that they completely missed its Chinese roots (Mittler 1997, 377–87). Thus, at the point when foreign audiences and scholars begin to celebrate the fact that Chinese composers no longer "copy foreign masters of the past" (Mackerras 1981, 70; see also Xu 1964, 8–9) in producing their foreign-style Chinese music but create works in their own, supposedly Chinese style, Chinese audiences would no longer recognize this music to be Chinese. Both musical styles are synthetic products, obviously confusing outcomes of the attempt to create a New Chinese Music of foreign imprint.[87]

Very interesting points

87. These words from Goethe's *West-östlicher Divan* (The West-Eastern Divan) (1819) would seem to apply: Wer sich selbst und andre kennt/ Wird auch hier erkennen:/ Orient und Okzident/ Sind nicht mehr zu trennen.

Coda: Foreign Music and Foreign-Style Chinese Music

> The model works talk about class struggle all the time. There are really two aspects to them: they were used by the politicians, especially Jiang Qing, but in fact they are good art (and even composer Zhu Jian'er would say that). (Musician, 1930s–)

> My attitude toward the model works is very conflicted [矛盾]. On the one hand, I think that this kind of art only serves politics, but on the other hand, because I have studied music, I must say that technically, they are really quite good. And in a way, this was unavoidable, for the production of the model works meant a big concentration of the greatest talents just working on one piece—unfathomable today! (Intellectual, 1955–)

If one is to believe the official storyline about the Great Proletarian Cultural Revolution, one would have to agree that during its ten years, China's stages were dominated by a small number of "model works"—operas, ballets, and symphonic pieces—but that no foreign music could be heard. A foreign audience, however, when confronted with these model works, often points out how "familiar" they sound (Mittler 1997). This chapter has attempted to account for this paradox by arguing that the musical experience of the Cultural Revolution—even taking account of all the restrictions governing the performance and the availability of foreign music—is not all that different from developments before and after these "ten years of chaos and cultural stagnation." This is so because the model works themselves are manifestations of a particular style of Chinese music that can be termed "pentatonic romanticism" in which the foreign musical heritage plays a predominant role.

Indeed, in looking back on a century of composition of New Chinese Music, one finds what ranges from the sounds of Hindemith to those of Modest Mussorgskij (1839–1881) and Giaocomo Puccini (1858–1924), from the techniques of Ligeti to those of Rachmaninoff, from bruitism to sonorism à la Messiaen, from impressionism to musique concrète à la Pierre Schaeffer (1910–95) and back to Tchaikovsky. While much variety was available, it was works from the repertoire of classical and romantic music and Chinese compositions perpetuating these very styles, however, that dominate the musical horizon of an average Chinese citizen throughout the twentieth and into the twenty-first century. As this chapter illustrates, the model works of the Cultural Revolution, too, took up these particular musical styles. Thus, the Cultural Revolution, a period in Chinese history that set out to condemn the art and culture of capitalism and the bourgeoisie, actually perpetuated, in the form of model works for the masses, the very musical style that could ironically be called the most apt expression of the "bourgeois cult of individualism" and of the "triumph of capitalism."

Can the model works be considered the perversion of the Maoist experiment of reinventing a new Chinese revolutionary culture? In view of recent developments in foreign-style Chinese music, which also stress the importance of traditional Chinese elements, it becomes clear that the model works simply take their rightful place in a long series of attempted syntheses of foreign and Chinese heritage, among which the opera reforms of a Mei Lanfang count as much as the *Yellow River Cantata*, the *Butterfly Violin Concerto*, or Taiwan's Cloud Gate Theater, Tan Dun's eclectic classical "pop," Cui Jian's 崔健 (1961–) folksy rock, Ge Ganru's reinventions of the prepared piano as a Chinese instrument, and Liu Suola's 刘索拉 (1955–) Beijing Operatic pop. Time and again, New Chinese Music—to be found in Taiwan, the PRC, and Chinese communities abroad—has appropriated methods and ideas similar to those used in the model works of China's Cultural Revolution—used for the production of works in a "national style" and combining what is best of China with what is best from "the West" in musical terms (Yung 1984; Mittler 1997, Chapter 4, esp. 269–71). Thus, Cultural Revolution music perpetuated much of Chinese musical tradition, too, not least in terms of China's rich operatic traditions. And this is the other official storyline that I hope this chapter has questioned and redefined: traditional music not only was not destroyed during the Cultural Revolution, but it was part and parcel of the Cultural Revolution experience.

CHAPTER 2

THE SOUNDS AMIDST THE FURY: CULTURAL REVOLUTION SONGS FROM XIAN XINGHAI TO CUI JIAN

> When I was not racing the pigs, I was singing. Folk songs, foreign songs, revolutionary operas . . . Others were doing the same. I could hear them from a distance. Why did we do this? I cannot speak for others. In my case, I felt that when I started to sing, the pigs stopped running and fighting. They grew calm. (Rae Yang, 1950–)[1]

> In the loudspeakers back then, it was all revolutionary songs. Now these songs have become popular again. The reasons for this revival are complicated. We knew these songs so extremely well, and now they have changed these songs, adding rock rhythms and so on. I do like to listen to them; it is interesting what they made out of them. (Journalist, 1949–)

Model works and revolutionary songs were the accepted staple of musical life in China during the Cultural Revolution. Officially, at least, there was to be no other music. And yet, such political dictatorship over "correct sounds" is not an invention of the Cultural Revolution. Indeed, the 9,000-year-old bone flutes excavated at Jiahu in Henan, most probably the world's oldest instruments in existence and yet possessing an intricate tuning system, indicate that even during neolithic times, China's rulers believed in a close connection between the orders of music and the world.[2] Confucius and the Chinese Classics warn of the dangers of performing the wrong type of music. "If all the notes are unclear and clash disagreeably with one another, there will be general confusion and in the near future, state and people will face disaster and annihilation," warns the *Classic of Music* (乐记 *Yueji*) (Kaufmann 1976, 33). Accordingly, every ruler had to pay close attention to the sounds proliferating in his country. Changes in the musical system, so it was believed, could cause changes in the cosmos and the world. If the Yellow Bell (黄钟 *huangzhong*), since time immemorial the base note for the twelve-tone scale, was found to be out of tune, it could lead to the fall of the country. Thus, it is no surprise that Chinese rulers were meticulous in keeping the Yellow Bell tuned. They also collected folk songs in order to be informed about the state of their rulership, later revising these songs and teaching them to the people again in order to improve their minds and to stabilize their government (Kaufmann 1976, 38).

Chinese politicians of the (post-)modern age have evidently not lost this faith in the profound meaning and power of sound and music.[3] During the boycotts and demonstrations against the treaty ports that spread to all of China in the first decades of the twentieth century, songs were used to teach and unify the masses. These songs were based on the so-called school songs (学堂歌 *xuetangge*), which were in turn based on Christian hymns or children's songs, and had become part of regular school teaching since the educational reforms of 1902.[4] Song was an ideal

1. Yang 1997, 200.
2. Zhang et al., 1999. Although the flutes were only recently "discovered" with great publicity in *Nature*, the archeological find of these flutes was published in 1989 (Wei 1989; Wu 1991). It is possible to show that the six flutes, as respective pairs, represent the *yin-* and *yang*-notes of the twelve-tone scale, not unlike later calculations found in the *Huainanzi*, for example (DeWoskin 1991), where each of the twelve notes has particular cosmological significance.
3. See Perris 1983 and 1985; Holm 1984 and 1991; Wu 1994; Mittler 1996; Tuohy 2001a.
4. For the use of songs based on Christian hymns, see Wong 1984. For the school songs see Hughes 1990, Luo 1991 and ill. 1.1. An overview over the political function of the school song is given in Liu 1986; cf. also Han 1985 and, for the Communist endeavors in this regard, Trébinjac 1990 and 2000. For an emphasis on Russian influences, see Yu 2006; for a focus on the Cultural Revolution, Bryant 2004.

medium through which to spread new ideas to the uneducated and illiterate masses and even to mobilize them to participate in the making of the revolution (Chan et al. 1984, 77). All political groups made use of songs based on foreign and, less often, Chinese folk melodies that were then fitted with new texts.

After the foundation of the CCP in 1921, Soviet songs became more and more influential (Yu 2006), as the singing of songs was part and parcel of Communist guerilla practice. In 1929, during the Gutian Conference, this practice was institutionalized: singing revolutionary songs became an integral part of cadre training (Wong 1984, 121). In Yan'an, the idea was further developed at the Lu Xun Academy, founded in 1938, where it was decided that musicians and composers would go to the masses to collect folk songs and forms of folk theater. They would eradicate "feudal" and "bourgeois" remnants from these pieces of music and then, through traveling music troupes, teach them again to the people, in their now "purified" form (Holm 1991). A contemporary, the composer Zheng Lücheng 郑律成 (1918–76), remembers the all-encompassing influence of songs on life in Yan'an:

> Everyone sang then; morale was high. At first, we sang Red Army songs, like "The Three Main Rules of Discipline and The Eight Points of Attention," and we also had local folk songs. Later, the songs of Nie Er [聂耳, 1912–35], Xian Xinghai, and Lü Ji [吕骥, 1909–2002] also became popular.... Yan'an is a small place, situated between the mountain and the river. When ten thousand people sang at once, the earth seemed to move and the mountains to shake. We sang before class, we sang before eating, and the whole unit sang on the march. Students sang, cadres sang, ordinary people sang. There was solo singing, ensemble singing, and choral singing. Yan'an was not only the sacred place of the revolution, but it also became a true city of song.[5]

In 1942, when Mao formulated his famous *Yan'an Talks*, he prescribed the ultimate aim and form of all orthodox art and music, and his dictate remains binding in revolutionary China to the present day. "Correct music" is expected to be both modern and Chinese at the same time by combining the best of China's national traditions with the most useful elements from foreign traditions. It must be revolutionary (革命化 *geminghua*), have national style (民族化 *minzuhua*), and serve the masses (大众化 *dazhonghua*) (Mao 1942). Although these formulations are specific to Chinese revolutionary art at least since then, political dictatorship over "correct sounds" in general is not an invention of the Chinese revolution nor less the Cultural Revolution but can be traced back to age-old Chinese ideas about the intimate relationship between music and governance. In this chapter, I will demonstrate that even the most characteristic sounds and melodies of the Cultural Revolution, repeated *ad nauseam* as long as it lasted, were originally conceived many decades before the Cultural Revolution had begun. I will also explain why their influence has not waned even today, long after the Cultural Revolution has officially ended. The songs and melodies of China's revolution, I argue, have not changed all that dramatically since the days when Xian Xinghai wrote his "Production Cantata" in Yan'an. Indeed, until recently, even internationally recognized pop and contemporary music stars Cui Jian and Tan Dun, respectively, have been taking up, repeating, and varying on the sounds and ideas of China's "Red Revolution." Cultural Revolution music, "the sounds amidst the fury," is thus not the exceptional, unprecedented phenomenon it is quite frequently portrayed to be; it is less the deviation than the norm of (orthodox political) culture in revolutionary China.

Even the extremely politicized cultural products from the Cultural Revolution are just one small part of an organic development of China's art and culture since the beginning of the twentieth

5. Zheng Lücheng is quoted in Kraus 1989, 55.

century and well into the twenty-first, then. This is so, in spite of the fact that the alleged "Sounds of the Cultural Revolution" will cause in some (many illustrious names such as writer Ba Jin and composer Zhu Jian'er among them) feelings of extreme revulsion and even physical pain, because they force people to remember a time of terror and repression.[6] Rae Yang's loathings are surely not an exception:

"The East is red. The sun rises. China . . . Mao Zedong. . . . "
Oh. Miserable! Just as I was about to fall asleep this damn song starts. At five thirty! Every day. Seven days a week. . . . Never gives anybody a break. . . . I hate this song now! I used to love it. . . . Things change into their opposites. . . . Red Guards. Class enemies . . . I wonder if any counterrevolutionary can match me in hating this song. It's not music. It's torture! Pouring out of a loudspeaker in a pine tree just outside my bedroom window. It drives me crazy! Are there bedrooms in this college that don't have loudspeakers blaring into them? Guess not.
 At daybreak, the whole college was drowned in this deafening music. Teachers, students, workers, their families, all were forced to wake up. Other colleges and universities in Beijing were pretty much the same. When "The East is red," was playing, everybody had to get up except a few leaders, such as Chairman Mao himself.
 The broadcast, once it started, would not stop for at least two hours. The network news followed the song. Then local news, all kinds of announcements, declarations, orders, ultimatums, selected *dazibao*[7] . . . It went on and on. . . . I am willing to sell my soul to the devil himself if he can teach me how to silence that loudspeaker. Loose contact? A wire broken from the inside? Pull the magnet out? (Yang 1997, 157–58)

During the Cultural Revolution, revolutionary songs such as "Red Is the East," the "sounds amidst the fury," were inescapable. Why is much of this type of music still present in China today— not only on an official website celebrating the sixtieth anniversary of the founding of the PRC, where it is argued that revolutionary songs like "Red Is the East" have become increasingly popular over the years, thriving along with the fruits of "liberation," the rise of China, and a love for Mao and the Party[8]—but also at Tian'anmen in 1989, when students protested against their government by singing revolutionary songs (Pecore et al. 1999)? Why is this music still alive as part of the popular Mao revival of the early 1980s, which was boosted in the early 1990s with the publication of revolutionary songs to new beats (as discussed recently by Sue Tuohy and Gregory Lee)? What was the propaganda message in these songs and to what extent did the songs ever instill "blind faith" in the minds of listeners? And would this faith survive in the songs' later retakes? (Lu 2004, 122)

 It is the purpose of this chapter to deliberate these questions by discussing music that was ever present not just during the Cultural Revolution: the revolutionary songs in praise of Mao, or "MaoMusic." In doing so, I offer an alternative reading of this musical experience of the Cultural Revolution, showing how these much maligned "sounds amidst the fury" served many earlier revolutions and how they remain the staple for Chinese music-making after Mao, hitting on many a music lover's taste in a market diffused with Mao memorabilia in recent years.

6. For more on both Ba Jin and Zhu Jian'er, see the quotations in Chapter 1. For Ba Jin, see Liu 1990a, 159. For Zhu Jian'er, who in his first symphony uses, among other things, a Red Guard song *To Rebel Is Justified* (造反有理 *Zaofan you li*) and a ritornello from Beijing Opera to remind the audience of the model works, see Zhu 1987 and Mittler 1997, 97–105.
7. This refers to the *big-character-posters* (大字报) written for denunciations during the Cultural Revolution.
8. See DACHS 2009 Dongfang Hong PRC 60 years. The Chinese text reads: "多少年来，这一颂歌，随着全中国的解放，随着新中国的逐步繁荣，富强，随着人民对毛主席，共产党热爱程度的提高而愈加普及。"

"Red Is the East" 东方红

The year is 1954, and Li Zongjin 李宗津 (1916–77), a Chinese painter specializing in oils, is painting *Red Is the East* (东方红), a large canvas, soon to be reproduced as a propaganda poster, depicting Mao on a mountain path. He is looking toward the East, his hands calmly folded, his figure towering over a beautiful landscape opening up behind him, of lush fields foregrounding a huge river running beneath an imposing metal bridge, and industrial chimneys rising into a faintly reddening sky (ill. 2.1). The colors of the rising sun are matched precisely in, and seem to reach up toward, Mao's face. Mao appears in this image—which echoes rather perfectly a 1948 depiction of Stalin by Feodor Shurpin (1900–) entitled *Our Fatherland's Morning* (Liu n.d., 22)—as a god-like figure: he is, indeed, the great savior of China, and this is what the text accompanying the image, published in a collection of Mao poster images from 1994, affirms. It explains that Mao is here shown as the great ruler over a huge territory that is China and that he is able to "cure all possible ills that might befall his country" (医治中国种种疑难病症) (Zhang 1994, 59).[9]

The title of the painting, *Red Is the East*, alludes to the song that would quickly become the *de facto* national anthem of the Cultural Revolution and that emphasizes Mao's position as the savior of the Chinese people and the victorious leader of the CCP:

Red is the East, rises the sun,	东方红, 太阳升,
China has brought forth a Mao Tse-tung.	中国出了个毛泽东.
For the people's happiness he works, hu-er heiyo	他为人民谋幸福,
He's the people's great savior.	呼儿咳呀, 他是人民大救星.
Chairman Mao, loves the people,	毛泽东, 爱人民,
Chairman Mao, he is our guide.	他是我们的带路人.
To build a new China, hu-er hei yo	为了建设新中国,
He leads us, leads us forward.	呼儿咳呀, 领导我们向前进.
The Communist Party is like the sun,	共产党, 像太阳,
Bringing light wherever it shines.	照到哪里哪里亮.
Where there's the Communist Party, hu-er hei-yo	哪里有了共产党,
There the people win liberation.[10]	呼儿咳呀, 哪里人民得解放.

During the Cultural Revolution, this song appeared in many a song collection,[11] often in bold print, sometimes as an insert preceding the table of contents.[12] In the early years of the Cultural Revolution, it was sung at every meeting, small or large in scale, official or unofficial in form. For many years, it was played every morning on a two-thousand-year-old chime to start the day for China's National Radio Station (He 2003, 25). It would substitute the sound of church bells, and as such it is remembered in many a memoir or reportage story from the time.[13] The song became a

9. An almost identical image with the same title was painted in 1976 by Zhang Songhe 张松鹤 (1912–2005), see Shen 2006, 196.

10. Thanks to Michael Schönhals for pointing me to this original Cultural Revolution translation of the song (which has been adapted in spelling). It follows the text in *Wuqi* 1968, 590.

11. See, e.g., the following works within the C.C. Liu Collection Heidelberg: *Chinese Revolutionary Songs* (n.d.); *Dongting xin'ge* (1972); and *Zhandou gesheng* (1974).

12. See, e.g., within the C.C. Liu Collection Heidelberg *Dongting Xin'ge* (1972) for bold print, and *Zhandou Gesheng* (1974) for placement before the preface. Such practices were not restricted to the Cultural Revolution years exclusively; *Mao Zhuxi, Nin Shi Women Xinzhong Bu Luo de Hong Taiyang* (1977), for example, also features bold print.

13. See e.g. *Zhaoxia* 1975.6:13: "Yesterday, early in the morning, Xiao Niu heard the bells at the Customs sound their "Red Is the East," and immediately he got up and left home" (昨天一早, 小钮照例听到海关钟敲响一遍'东方红'时, 就起身出家门了).

significant marker for Red Guard rallies and meetings with Mao at Tian'anmen, there was a dance designed to fit its words (Interview, Artist Couple, 1950s–), and it was even sent into space, to bathe the universe in its sound, when China launched its first satellite named "Red Is the East No. 1" on April 24, 1970 (He 2003, 25).[14]

Not unlike the model works, the song "Red Is the East" was everywhere during the Cultural Revolution. And not unlike the model works, it came to be redundantly multiplied in every possible form: one could buy it on canvas, on cheap LPs, on post-cards and stamps, on cushions, on liquor bottles and teapots, on washing basins, on handbags, and on vases and jugs—in short, on almost all the utensils of daily life (ill. 2.2a–c). As it was considered "the most powerful song" (*CL* 1970.1:108–13) and a most efficient "battle song" (战歌

Ill. 2.3. Singing the most efficient battle song: "Red Is the East," 1974
(Zhaoxia 1974.4:3).

zhan'ge) (**ill. 2.3**), many official stories, comics (see **ill. 6.1**), and other publications during the Cultural Revolution expounded on it and the happiness its message brought to China. One such story describes a sent-down youth, quite eager to re-create his village after the model village Dazhai (大寨) (in Eastern Shanxi, see Chapter 4), who writes that every time he heard "Red Is the East," a smile would immediately appear on his face (家属听了这声，露出了幸福的笑容) (*Geming Jiebanren* 1974.3:44 "春山常青").

Another story in which "Red Is the East" is termed a "battle song" begins with a description of how the people of Shanghai, united over their criticism of Lin Biao and Confucius, were spurred on by the song's moving melody (震撼着斗争的旋律). And while the narrator is saying this rather prosaically, the crowds behind him have begun to sing "Red Is the East," so he asks readers to join them. He continues to describe hyperbolically how some two thousand people are now singing the song together—this and other songs of "independence and autocracy"—and how they keep singing until they sing themselves into a trance, and how always, when one song is finished, they call out "and another!" (*Zhaoxia* 1974.4:3–7 "浦江岸畔的战歌").

Further amplifying the importance of the original song itself, many other revolutionary songs popular during, before, and after the Cultural Revolution would take up the message of "Red Is the East." They all eulogize Mao, China's "red sun" in human form,[15] or even cite "Red Is the East" itself. This is done effectively in "We Always Want to Sing a Song of Praise to 'Red Is the East'"

14. The satellite song can be heard at DACHS 2008 Satellite "Red Is the East." On the significance of "Red Is the East" during the Cultural Revolution, see Kraus 1989, 119–21.

15. It is significant that such songs predate and postdate the Cultural Revolution; see, for example, C.C. Liu Collection Heidelberg *Dongfang Hong Gequ Ji* (1965), *Chinese Revolutionary Songs* (n.d.), *Dongting Xin'ge* (1972); *Duchang Gequ Xuan* (1973), *Duchang Gequ Ji* (1974), *Chuangzuo Gequ Xuan Vol. 3* (1975); *Mao Zhuxi* (1977), *Wo Ai Ni Zhongguo* (1982); *Meili de Caoyuan, Wo de Jia* (1982).

(东方红的颂歌永远要唱)[16] or "The Great Leader Mao Zedong" (伟大的领袖毛泽东), which begins with the line "The most resonating song is 'Red Is the East,' the greatest leader is Mao Zedong" (响亮的歌是东方红, 伟大的领袖是毛泽东) and continues:

You are the sunshine in the hearts of the revolutionary people,	你是革命人民心中的红太阳
your brilliant thought guarantees victory.	你的光辉思想是胜利的保证
Mao Zedong, Mao Zedong!	毛泽东, 毛泽东
You are the tutor of the revolutionary people,	你是革命人民的导师
your revolutionary line guides the correct voyage.	你的革命路线指引航程
We will forever love you dearly,	我们永远热爱你
great leader Mao Zedong!	伟大的领袖毛泽东
We will forever sing in praise of you,	我们永远歌唱你
great leader Mao Zedong![17]	伟大的领袖毛泽东

After Mao's death, and especially since the 1990s, the song reappears in ever-new takes, and covers of old songs continue to be made: "Every Time I Sing 'Red Is the East' I Remember Our Leader Mao Zedong," for example (每当我唱起东方红, 就想起领袖毛泽东, *Songge* 1992, 35–38), states that Mao "will live forever in my heart, you are the sun, you are our savior [here rephrasing the beginning passage from "Red Is the East"], you bring luck to the people, you are benevolent. When we think of you, our tears flow; we will continue your heritage and forever follow the Party forward." Another such song "The Fighters Sing 'Red Is the East'" (战士歌唱, '东方红') mentions that because Mao's benevolence is boundless, everybody should want to sing his song.[18] In sentiment and devotion these retakes are nowhere inferior to a Red Guard song from the early Cultural Revolution such as "Longing for Mao Zedong" (心中想念毛泽东) in which one verse reads: "My first sentence was 'make revolution,' my first song was 'Red Is the East'" (学会头一句话就是 '干革命', 会唱的第一支歌就是 '东方红'; V. Wagner 1995, Appendix 33). Another such song would be "We have seen Chairman Mao" (见到了毛主席; V. Wagner 1995, Appendix 28–30). In this song, the fourth verse takes on an international dimension to "Red Is the East" as it praises the people's love for Mao all over the world. This verse runs as follows:

The *Rewafu*-Lute[19] plays "Red Is the East."	热瓦甫弹起 '东方红', 弹起了 '东方红'
We turn toward the sun and sing the song of praise.	颂歌向着太阳唱, 向着太阳唱
We sing to our great helmsman, Chairman Mao,	歌唱伟大舵手毛主席
Who shows us the way to victory, ah!	指引着胜利的方向.
Chairman Mao, Chairman Mao,	毛主席, 毛主席,
You are the reddest red sun in our heart.	您是我们心中最红的太阳
People all over the world love you dearly, ah,	普天下人民热爱您啊
We wish you a long life, ah!	祝福您万寿无疆啊.

16. The song is to be found in C.C. Liu Collection Heidelberg *Mao Zhuxi* (1977). See also, e.g., *When the Sun Rises in Shaoshan, the East Is Red* 日出韶山东方红 (*Richu Shaoshan, Dongfang Hong*) in DACHS 2008 *Zhandi Xin'ge* (1974).

17. Full text and score of most of the songs from the five volumes of *New Battle Songs* is collected in DACHS 2008 *Zhandi Xin'ge*. This song is from Volume 1. It is cited in the preface to the memorial edition of songs at Mao's death: see C.C. Liu Collection Heidelberg *Mao Zhuxi* (1977) and in slight variation Bryant (2004, 102–3) and V. Wagner (1995, Appendix 55). Translations are my own, unless mentioned otherwise.

18. This song is re-published in one of the many 1993 *Hong Taiyang* collections.

19. The *Rewafu* (热瓦甫) is an instrument from Xinjiang. Its appearance here is to show how widespread the use of the song is, even among minority groups. *Zhandi Xin'ge* always contain a section of minority songs in praise of Mao; see Bryant 2004 and Harris 2001.

It is not surprising that "Red Is the East" had achieved the status of "Anthem of the Cultural Revolution." Not only does this song praise Mao's glorious deeds and his close relationship with the people, but it also epitomizes the artistic directives that, already formulated in the *Yan'an Talks* in 1942, would find their most accomplished fulfillment during the Cultural Revolution. Originating in Shanbei, the melody was that of a rather cheeky and sexually explicit folk song entitled "Sesame Oil" (芝麻油 *Zhimayou*), which was later transformed into an anti-Japanese folk song "Riding the White Horse" (骑白马 *Qi baima*) in the area around Yan'an.[20] The words in praise of Mao were (re-)composed, at least in some versions of the story, by none other than a poor peasant, Li Youyuan 李有源 (1903–55).[21] In this reading (there is another attributing the song to composer He Luting), "Red Is the East" is thus a real cultural product "from the masses for the masses," just as Mao had envisaged it.

The song, well-known and often sung in Yan'an, can be found in some of the earliest song collections published on a national scale after the founding of the PRC in 1949 (e.g., C.C. Liu Collection Heidelberg *Zhongguo Qunzhong Gequ Xuan* 1952). Even earlier, it is cited in a *Three Character Classic for Women* (1950) that presents Mao as a savior of women, someone who helped them attain equal rights economically and politically: 东方红太阳升毛主席大救星新中国属人民妇女们翻了身政治上经济上有权利有保障 (*FNSZJ* 1950, 3).[22] The song is cited in many a piece of instrumental music, too, so, for example, in Luo Zhongrong's *First Symphony* composed in 1959.[23] It is also set for different instruments, not least among them the literati zither *guqin*:

My father did some arrangements, but this one was in fact quite difficult, since the *guqin* is not really an instrument from the popular tradition. It was in the 1950s and 60s when he wrote this. (Guqin Player, 1940s–)

"Red Is the East" was propagated in grand style in 1964, when a song and dance epic of the same title (condemned during the Cultural Revolution, while its director would become the director of the first model opera film) was performed in honor of the fifteenth anniversary of the founding of the PRC by some 3,000 workers, peasants, and soldiers in the Hall of the People, an event that was documented on film and quickly disseminated to every corner of the country. This epic performance tells the story of the CCP's great victory. It uses the color red prominently, because red is the color of fertility, wealth, abundance (Wasserstrom 1984, 19–20), and the color of the sun (which has long since become the symbol for Mao Zedong himself). The epic begins, in grand style, with "Red Is the East," which is put in scene quite literally as the ode to the sun, to which all the sunflowers—China's workers, peasants, and soldiers—turn with great happiness and devotion (ill. 2.4). The revolutionary song "Red Is the East" is repeated and played in different variations several times at the beginning of the piece, and the first scene of the epic ends with a repetition of the first verse of the song, sung an octave higher by all musicians and singers involved in the theatrical, now collectively calling Mao the "savior of the people."

Like so much of the propaganda art of the Cultural Revolution, this grand performance has been re-published endlessly since the 1990s, showing once again that "Red Is the East," and songs

20. The words of the original are: 芝麻油, 白菜心, 要吃豆角嘛抽筋筋儿. 三天不见就想死个人儿, 呼儿嗨哟, 哎呀我的三哥哥. The anti-Japanese version, which is even more sexually explicit, reads 骑白马, 挎洋枪, 三哥哥吃了八路军的粮, 有心回家看姑娘呼儿嗨哟, 打日本就顾不上. 要穿灰, 一身身灰, 肩膀上要把枪来背, 哥哥当兵抖起来呼儿嗨哟, 家里留下小妹妹. See DACHS 2008 Zhimayou and DACHS 2008 Qi baima.
21. See Hung 1996 and Tuohy 2001, 5 for more information.
22. The underlined passage is a composite quote from the original song.
23. This symphony also cites another important song, the "The Three Main Rules of Discipline and the Eight Points for Attention" mentioned in Chapter 1, which also appears in the first movement of Ding Shande's *Long March Symphony*.

praising it, could be heard long before the Cultural Revolution and did not lose their sparkle even after the Cultural Revolution ended. A comic published in *Lianhuanhuabao* in 1977, for example, tells the moving story of the song's conception: of how Li Youyuan had seen the sun rise and then had seen the face of Mao, who had saved his life, in the image of the sun (*Lianhuanhuabao* 1977.9:35–37).

One LP dating from the same period (Hua Guofeng's 华国锋 [1921–2008] interim government right after the official end of the Cultural Revolution [1976–78]) with music in the style of Cantonese opera again mentions the song. The title song of the LP "We Will Always Follow the Golden Road Which Chairman Mao Once Showed Us" (永走毛主席指引的金光道) mentions in its second line that "songs praising 'Red Is the East' can be heard everywhere." At the end of the song, the melody of "Red Is the East" is invoked (mus. 2.1). Another LP from the same period entitled "Morning Sun" (only a rough translation of the Chinese title 旭日东升 "the [morning] sun rises in the East") incorporates traditional instruments into one song after another praising the new "sun" on Chinese skies, Hua Guofeng, by alluding time and again to the familiar melody. In the final song, entitled "Morning Sun" (旭日东升), the music finds its culmination point when the well-known Mao song is repeated over and over again, and the piece ends, in a climactic moment, with it appearing on the *glockenspiel* (mus. 2.2).[24]

Such phenomena are not just temporary afterpains. In the 1990s, MaoMusic like "Red Is the East" is still a resounding part of people's lives, pervading everything. It serves as the identification signal for the PRC's national radio station and many a a cigarette lighter plays the familiar melody when opened. "Red Is the East" is sounded on the opening page of the CCP official news site (中国共产党新闻), too (DACHS 2008 News of the Communist Party of China), and it can be heard at every hour from the clocks at Beijing's main train station.[25] It plays its role during processions at Mao's birthplace Shaoshan, such as during his 115th birthday celebrations in December 2008 (DACHS 2009 Mao Memory Dongfang Hong), and it also appears as the name of a fashion show presented at a 2006 soccer night entitled " 'Red Is the East' Night" (东方红之夜) (DACHS 2008 Dongfang Hong Sexy).

"Red Is the East" and the sun metaphor continue to feature prominently in songs published by the Party, as is obvious in publications like *Musical Life* (音乐生活 *Yinyue Shenghuo*) or *Songs* (歌曲 *Gequ*).[26] But rock and pop musicians, Cui Jian perhaps most prominently among them, have made clever use of this old symbolic language, taking up the familiar melody and equating the sun with great hope for the future. In "A Difficult Path" (艰难行 *Jiannan xing*), one of his first songs originating in the mid-1980s, Cui Jian employs Cultural Revolution rhetoric[27] to show that his faith in the sun has not completely waned: he ends a long list of calls not to give up even in spite of difficulties with the phrase, "The radiance of the sun symbolizes our tomorrow!" (太阳的万丈光辉象征着明天) (Steen 1996, 79).[28]

A few years later, in his "Leaving" (出走 *Chuzou*), the metaphor still sounds familiar: "The sun is rising, my eyes open again" (太阳爬升来我两眼又睁开). Yet, the refrain keeps asking, "How often a day does the sun shine on my head, but in my heart I am still depressed?" (多少次

24. The significance of this instrumental choice, which is typical for moments of apotheosis in revolutionary music, is discussed in the previous chapter.
25. Personal Communication, Lena Henningsen, 22 August 2009.
26. See the discussion in Lee 1995, 99.
27. For the use of demonizing vocabulary and anthropomorphic descriptions of nature, common elements in Cui Jian's creations, but also typical in Cultural Revolution poetry and songs, see V. Wagner 1995 and Liu 1998 and 1999.
28. Similarly positive associations with the sun are to be found in the song "Sun" (太阳 *Taiyang*) by the rock group Tang Dynasty. Their song keeps asking "Sun, where are you?" but it is asking for the sun to come out, after all (cf. Steen 1996, 169).

太阳一日当头, 可多少次心中一样忧愁). The old and well-established optimism associated with the sun and its powerful radiance appears fragmented, even shattered (see Steen 1996, 108). Cui Jian's "This Space" (这儿的空间 *Zhe'r de kongjian*), released in 1991, describes a love relationship that has become stagnant; the singer's former faith in the sun is turned malignant, even becoming a sexualized farce (perhaps this is a somewhat ironical comment on the original sexualized folk song from which "Red Is the East" is derived; it may also be a belated answer to the suppression of anything sexual during the Cultural Revolution years). The last verse, describing the physical act of lovemaking, ends as follows:

Heaven is a cave, surrounded by a desert.	天是个锅, 周围是沙漠
You are a dried well, but the deeper, the more beautiful,	你是口枯井, 可越深越美
only the fire in the breast and the sweat on the body,	这胸中的火, 这身上的汗
are the real sun and the real spring water.[29]	才是真的太阳, 真的泉水.

This vocabulary is reminiscent or perhaps even related to a Cui Jian song that was never officially released but was performed several times in the late 1980s. Later, in 1992, it was made into an MTV video entitled "A Piece of Red Cloth" (一块红布 *Yi kuai hongbu*). The video openly juxtaposes propaganda scenes and the beautiful face of a woman washed in red.[30] On March 12, 1989, Cui Jian sang this song at the Beijing Exhibition Hall to an audience of 18,000 fans. He took a bright red cloth from the PLA jacket he was wearing, blindfolded himself, and made these prefatory remarks: "Does everybody still remember the last time I sang this at Beijing workers' auditorium? Right, it's 'A Piece of Red Cloth'—a lot of newspaper reporters who saw that show thought the song was a kind of marriage preview. . . . This feeling really made me comfortable." (Jones 1992, 138) This sentence, used ironically here, is itself a quotation from the text of the song (underlined below), which runs as follows:

That day you used a piece of red cloth	那天是你用一块红布
To blindfold my eyes and cover up the sky	蒙住我双眼也蒙住了天
You asked me what I had seen	你问我看见了什么
I said I saw happiness.	我说我看见了幸福
This feeling really made me comfortable	这个感觉真让我舒服
Made me forget I had no place to live	它让我忘掉我没儿住
You asked where I wanted to go	你问我还要去何方
I said I want to walk your road.	我说要上你的路
I couldn't see you, and I couldn't see the road	看不见你也看不见路
You grabbed my hands and wouldn't let go	我的手也被你攥住
You asked what was I thinking,	你问我在想什么
I said I want to let you be my master.	我说我要你做主
I have a feeling that you aren't made of iron	我感觉, 你不是铁
But you seem to be as forceful as iron	却象铁一样强和烈
I felt that you had blood in your body	我感觉, 你身上有血
Because your hands were so warm.	因为你的手是热乎乎

29. A translation and interpretation is given in Steen 1996. The negative imagery now associated with the sun is continued in "Staring at Each Other" (对视 *Duishi*) from the same album. Here, it is not the morning sun rising but the evening sun setting that plays the decisive role (121–22).

30. See DACHS 2008 Cui Jian "A Piece of Red Cloth." The song has been released several times since the 1990s and can now be bought on CD.

This feeling really made me comfortable	这个感觉真让我舒服
Made me forget I had no place to live	它让我忘掉我没地儿住
You asked where I wanted to go	你问我还要去何方
I said I want to walk your road.	我说要上你的路
I had a feeling this wasn't a wilderness	我感觉,这不是荒野
Though I couldn't see it was already dry and cracked	却看不见这地已经干裂
I felt that I wanted to drink some water	我感觉,我要喝点水
But you used a kiss to block off my mouth.	可你的嘴将我的嘴堵住
I had a feeling this wasn't a wilderness	我感觉,这不是荒野
Though I couldn't see it was already dry and cracked	却看不见这地已经干裂
I felt that I wanted to drink some water	我感觉,我要喝点水
But you used a kiss to block off my mouth.	可你的嘴将我的嘴堵住
I don't want to leave and I don't want to cry	我不能走我也不能哭
Because my body is already withered and dry	因为我身体已经干枯
I want to always accompany you this way	我要永远这样陪伴着你
Because I know your suffering best.	因为我最知道你的痛苦
That day you used a piece of red cloth	那天是你用一块红布
To blindfold my eyes and cover up the sky	蒙住我双眼也蒙住了天
You asked me what I had seen	你问我看见了什么
I said I saw happiness.[31]	我说我看见了幸福

In this song, the sun is not visible, but only implicitly there, with its withering and drying capacities that are completely omitted in the original song of praise for Mao. Yet, not unlike in "Red Is the East," the sun is the guide here, too. It shows the road and leads the way; it promises happiness and appears as a savior, at least at first, for someone who has no place to live. While Cui Jian openly describes the pain of oppression from a drying and withering master, the sun, he also admits his own complicity in he process of subjugation (i.e., propaganda): isn't he happiest in the blinding, "withering" embrace of his "master" after all, does he not like to feel the warmth of his hands, his kiss?

These ambiguities of the text are captured musically, as well. In order to illustrate the dangerous qualities of this embrace with the sun, Cui uses his voice in a manner constricted to the point that he is producing a kind of quavering rasp (Jones 1992, 140–41, Lee 1995:97). He had also used this mannerism in "This Space," where the "real sun" (真的太阳 *zhende taiyang*), too, was presented in coarse, disgusted-sounding, chopped-off articulation, in marked contrast with both Cui Jian's own early efforts at rock (and sun) singing, and with prevalent singing styles of Chinese pop music (Jones 1992, 141–42). It contrasted especially crassly with those pop and rock versions of the old revolutionary songs praising the sun that began flooding the Chinese music market at around the same time, a trend culminating in the "Red Sun Fever" (红太阳热 *Hong taiyang re*) around the centenary of Mao's day of birth in 1993: millions of tapes and CDs with pop, rap, jazz, and rock versions of the old songs in praise of Mao were being released almost by the day. Within the span of a few months' time in 1991 more than one million copies sold, and the movement did not subside but continued to grow, with 14 million sold by 1993, 72 million by 2006, and 80 million by 2008 (ill. 2.5 a–d ; Barmé 1999, 186; Lee 1995, 99).

Some of these songs epitomize the romantic apotheosis that is part of earlier propaganda versions of "Red Is the East." One remake of Mao quotation songs published in 1991 on a CD entitled *Quotation Songs by Mao: A Medley of Rocksongs in Praise of a Great Man* (毛主席语录歌

31. This translation largely follows Jones 1992, 138–40.

伟人颂摇滚联唱 *Mao Zhuxi yuluge – weirensong yaogun lianchang* (mus. 2.3), for example, begins with a kitsch version of "Red Is the East" played on a slightly out-of-tune Chinese *glockenspiel* backed by a choir reciting lines from the original text of the song: "The fact that China has brought forth a Mao Zedong is the greatest pride of her people" (中国出了个毛泽东，这是中国人民的骄傲).

In another version, on the other hand, published on a CD entitled *Remembering Mao Zedong* (怀念毛泽东 *Huainian Mao Zedong*) in 1990 (mus. 2.4), constant harsh interjections in the percussion may at first suggest irony, even criticism; the mindless singing and the brutal percussion beats may be interpreted as reminiscences of the Cultural Revolution as a time of unthinking cruelty. But this ironic strand is immediately dissolved, as in many other songs of its kind, in the subsequent solo section, which is solemnly presented and harmonized in canon. One can almost picture the singer with tears in his eyes and burning heart—in just about the identical musical gesture and idiom also dominant during and before the Cultural Revolution in the service of Mao's acclaimed "Revolutionary Romanticism."

Numerous remakes of such MaoMusic have been and continue to be released. In some cases, the government plays "a role in the musical equation" (Tuohy 2001, 17), but this role remains difficult to grasp. What, for example, would the government think of one of the more ingenious variations of "Red Is the East," Zhao Dadi's 赵大地 (1965–) remake mixing elements from Chinese folk songs, *suona* (唢呐, an ear-piercing Chinese reed-instrument), Chinese gongs, Hammond organ, and pop strings?[32] Even in this exuberant version (mus. 2.5), with the interjected howls and cheers so typical of Chinese folk song and its relative lack of the seriousness and devotion that had been part and parcel of earlier versions of the song, its musical message can still be considered one of reverence or, at least, of continuous memory.

In the eyes of the contemporary Chinese audience, the message of such MaoMusic is ambiguous. Some say that Mao comes down from his pedestal as God in these numerous but more mundane musical treatments. One such voice argues: "In the Cultural Revolution we used to stand when we sang. We listened to these songs like in church, with respect. Now it's Rock & Roll—a real mess (乱七八糟 *luanqibazao*) . . . Rock & Roll expresses some anti-social ideas rather than respect. It's a big change, changing Mao Zedong from a God to an object of Rock & Roll; now you can sing whatever way you want." As if addressing Mao directly, then, this interviewee says somewhat grumpily: "Now I can sing you *this way*" (现在我可以这么唱你的了).[33]

Indeed, there appear to be numerous and ever more frivolous ways of "singing Mao this way" today: "Red Is the East" and other such songs appear at karaoke parties in private, in university talent shows in public, sung by the Chinese women's soccer team, or by foreigners at international banquets. These and many more and different versions of singing "Red Is the East" can be retrieved quickly and easily from YouTube today (vid. 2.1).[34] What exactly happens to the revolutionary song, its function and meaning, in and through this treatment? It is attached, detached, and then again reattached to countless and incommensurable contexts, thus breaking previous links and establishing new ones. Does this make a difference? Is the singer's or the audience's attitude toward the song altered accordingly?[35]

Most interviewees would agree that today, there are several functions and uses of the song: one artist explained how songs like "Red Is the East" were simply "engraved in the hearts" (刻在心里)

32. This version appears on a CD entitled *Red Songs of Praise* 1 (红色赞歌 1 *Hongse zange* 1) (mus. 2.5, ill. 2.5d), recorded from a 2003 Tianjin concert in memory of Mao's 110th birthday.

33. This Chinese voice is quoted in Tuohy 1999.

34. The videos are archived in DACHS 2008 Dongfang Hong Karaoke/Banquet Singing/Chinese Women's Soccer Team.

35. An important survey of the changes in the media and spaces of performing revolutionary songs is given in Bryant 2004, 200–201, in which the increasing importance of karaoke in recent years is illustrated.

of those who had grown up during the Cultural Revolution, and that the pop and rock versions would therefore be appreciated by many for the feelings of nostalgia they brought: "When we are relaxed we just sing these songs," one interviewee (Artist, 1959–) said, "but, when I sing these songs now, I do not think of Mao Zedong and revere him so much anymore. Rather, I actually think of this time when I was young. Directly after the Cultural Revolution, people did not dare sing these songs, but now it is much different." She also argued that those youths who had not lived through the Cultural Revolution "just liked this and the other Mao Songs for fun, finding them, indeed, quite laughable [可笑], on the one hand, but then, on the other, not so bad after all, because they actually sounded quite good." For some from this generation, then, it is pure fun, while for many others, it is also an expression of patriotism to sing these songs.[36] The generation that lived through the Cultural Revolution as youth often go back to the songs with a certain nostalgia for a lost sense of community, while those born before the Cultural Revolution react very differently and often find it important to remember in order to prevent something like the Cultural Revolution from ever happening again.[37]

The propagation of revolutionary songs during the Cultural Revolution was an attempt to mobilize the masses, to educate them in forms and styles already familiar and accessible to them. In retrospect, it appears as though, not unlike what happened with the model works, the signs and symbols themselves (i.e., the music and melodies of these songs) were powerful enough to be remembered beyond their political contexts (Bryant 2004, 222). The fact that music in itself is profoundly ambiguous, multivalent, flexible, and open to interpretation furthers this type of reception (Mittler 2007). Each of the multiple constructions of "Red Is the East" offers the potential for choice and compels active participation in their sense-making. And each of the sense-makings is done within a particular context.

There is obviously a difference between singing "Red Is the East" with a few friends in front of the karaoke TV in one's living room, and singing it among thousands of excited and youthful Red Guards at a rally on Tian'anmen; there is a difference between playing a 1990s CD sold under the generic heading of "most beloved Chinese songs," and in taking part in a dance performance of the song as a sent-down youth during the Cultural Revolution (Tuohy 2001, 4–5). Contexts frame the choice for meaning, yet within the never-ending process of redundancies, repetitions, revisions, and reversals even during the Cultural Revolution (and before and after that event), newly emerging and different interpretive frames continue to dislodge or reformulate older ones and

36. This generation features in many of the karaoke versions of the song seen on YouTube, or in the documentary *Yang Ban Xi* 2005.

37. Lei Bryant has gathered testimony from different generations about their affinity to the songs. Young people commented that "(we should) preserve how we were able to excite people; also it reflects the feeling of people at that time." They feel that "this revolutionary music will help everybody to be more patriotic" (2004, 188). They also said: "My friends and I have all received traditional education, we feel good about the country so we aren't critical of revolutionary songs. Maybe if you asked others who are not in support of the country, they may hate these songs" (2004, 189). Bryant finds, generally, that those who had lived through the Cultural Revolution as youngsters respond slightly differently. For them, it is the spirit of community these songs convey that they miss: "During the Cultural Revolution, we were always in a group, surrounded by others, the group identity was so important and we did everything together. Nowadays, the city is filled with individuals who are self-absorbed and merely interested in earning more money. There is no longer any group identity. Hearing the "New Songs" brings me back to a really exciting time of my life that was full of energy" (2004, 191–92). Finally, the socialist generation, born shortly after or before the foundation of the PRC, are interested in these songs for a very different reason: to prevent something like the Cultural Revolution from happening again: "Looking over the songbooks makes me so sad, to think about all of the young people whose lives were lost, or disrupted. To think of an entire generation who had their education thrown away and were sent out to the countryside, and for what? It is so important to study these songs and the Cultural Revolution period so nobody forgets what happened" (ibid.)

thus confuse or reinforce contextualized perceptions and interpretations.[38] What is the importance of reverence and fun, of horror and boredom, of consumerist passivity and creative activity in making sense of the revolutionary songs for the individual confronted with them? And what is the difference between these attempts to make sense of them during, before, and after the Cultural Revolution? In her study of songs from the Cultural Revolution and their impact in present-day China, Lei Bryant argues:

> Though some individuals still mourn the loss and tragedy endured in their past, a great majority of individuals look to the period in search of recovering emotions of solidarity, camaraderie and simplicity.... Music is what commonly triggers this sense of nostalgia. The emotional power of music and the meanings which individuals construct surrounding music allows basic emotions to be carried through the otherwise complex web of politics and history. In this sense, the nostalgia is an attempt to recover the positive emotions of the past, but not necessarily an attempt to recreate or rebuild the past. (2004, 219)

During the Cultural Revolution, a distinct pose of reverence would have always been prevalent in presentations of "Red Is the East." It is in this pose that the song would be quoted in the model works, as it is several times in *Taking Tiger Mountain by Strategy*. It appears in a scene when the hero Yang Zirong has just heard about little Chang Bao and her father's sufferings: he speaks of the Communist Party and Mao, the savior, who will help each one of them, and "Red Is the East" resounds (scene 3). After he enters the bandits' lair in order to spy out the most favorable time and place for an attack against the bandit-chief, Zuo Shandiao, Yang hides a message for his comrades (scene 8). This scene is accompanied by an orchestra dominated by strings and brass. Still unseen, Yang sings the first lines of the aria, which mark it as an *erhuang daoban*-aria type used to introduce important persons. Yang enters with a short quotation accompanied by the horn from "The Three Main Rules of Discipline and the Eight Points for Attention,"[39] another important revolutionary song during the Cultural Revolution.[40] By 1935, the words of this military song had been fitted to a folk song disseminated broadly among the people, especially in the Chinese army (Bryant 2004, 85–137). In Chapter 1, I discuss how this song is used in the model works to show the closeness between the military and the people.[41] In *Taking Tiger Mountain by Strategy* it is used in such a way, too, as when Commander Shao deliberates how to win over the masses (scene 7). In *Shajia Village*, the plot of which—the hiding of wounded soldiers by villagers—epitomizes the message of the song, it becomes a prominent part of the overture, the final apotheosis, and the musical setting in scene 8, which shows villagers and soldiers preparing for the final and victorious attack together. In *The White-Haired Girl*, when Dachun (whom the White-haired Girl is in love with in earlier versions of the piece) talks about the Red Army in scene 1 and when he comes to visit his village again after joining the Red Army in scene 4, the song is intoned again. It appears in *Children of the Grasslands*, too, when the villagers are supported in their search for two little children by the army; and in *Ode to Yi Mountain*, which again epitomizes good relations between the army and the people by having the heroine help out an army soldier. The song's 1971 publication in *Red Flag*, the highest theoretical Party organ, underscores its importance (*Hongqi* 1971 December 11), but it also appeared frequently in lesser publications (e.g., *Geming jiebanren* 1974.3:64).[42]

38. Tuohy 2001, 19; see also Bai 1997, 89.
39. *Zhiqu Weihushan* 1971, 280.
40. For a translation of the three rules and eight points, see Chapter 1, note 48. Based on Mao's ideas first voiced in 1928, and revised in 1929, this song was widely disseminated through all kinds of methods, one of them being a special *Three Character Classic* published in 1947 (see Chapter 3 in *XMZZY* 1975, 51–52).
41. See e.g. *Geming jiebanren* 1974.2:7; *Zhaoxia* 1974.2:6–16 "闪光的军号".
42. Uniquely, it appears in two volumes of the officially endorsed *New Battle Songs* (战地新歌 *Zhandi Xin'ge*) in 1972 and 1974.

In the scene on Tiger Mountain, Yang Zirong hears the melody of the song and is immediately reminded of his comrades. Deliberating the happy hopes of the impending battle, his feelings rise up in a long melisma (*Zhiqu weihushan* 1971, 282). In antiphon with the woodwinds, an instrumental group often used to mark idyllic situations in both Western and Chinese musical iconography, he sings of the Chinese Communist Party "warming his heart and giving him hope." A long melisma on "the Glory of Mao Zedong Thought," follows, supported again, musically, by rising wind passages. He relates that he is about to send off his message. Suddenly, for one bar, the musical scene changes drastically. The strings are silent, and only the low winds, the trombone, horns, and bassoons as well as the mouth organ *sheng* play the chromatic leitmotif of the bandits, which, in its original, has an ambitus of an augmented fourth, the interval also called *diabolus in musica*. Yang, aware of the danger around him, now decides to send his message off quickly in order not to "let the people and the Party down." On the word "Party," the top note of the aria, he again sings a long melisma before he continues with the words, "standing in the cold and melting the ice and snow, I've the morning sun in my heart" (我胸有朝阳). Into the long sustained note on "sun," the orchestra cites the line "China has brought forth a Mao Zedong" from "Red Is the East." The phrase culminates in a rising glissando in strings and winds concluding with the spherical sounds of the chimes, and Mao's apotheosis in musical terms is further underlined by Yang's wide-open shining eyes and the reddening of the sky in the background (ibid., 309–10, cf. ill. 1.6; for the score and the music, see ill. 2.6).

Thus, "Red Is the East" is used continually to mark important scenes and emotional moments in the model works. In *Shajia Village* (scene 6), A Qingsao sings an aria in which she reflects on the difficulties of communicating with the hidden soldiers and wavers between optimism and despair, but her hope is underlined, textually, by reference to the thoughts of Mao and, musically, by allusions to "Red Is the East." Scene 5 in *Raid on the White Tiger Regiment*, entitled "The Pledge before the Battle" (宣誓出发 *Xuanshi chufa*), is set completely under the red sunlight and ends with an incantation (again with *glockenspiel* accompaniment) of "Red Is the East" in which Commander Wang directs all soldiers, supported by the Korean people and the Chinese at home, to go, to fight, and to win, because Mao and Kim Il Sung are "waiting for news of our victory" (*Hongqi* 1972.11:43). In scene 5 of *Shajia Village*, the wounded soldiers are impatient to return to battle, but their leader, Guo Jianguang, in order not to risk their being discovered, has to hold them back from rash action. When he remarks that Mao and the Party should be their guides and that they must all be patient, for only then would the radiance of the red sun continue to fall upon them, "Red Is the East" is sounded (*CL* 1970.11:34). In *On the Docks*, the song appears at the beginning of scene 6, accompanying a slogan "Long Live Chairman Mao" gleaming in red neon lights and flickering onto the water and, a bit later, the crucial scene in which a wavering young worker Han is won over to the cause of the revolution (*CL* 1972.5:87 and 94).

In all of the model works, then, "Red Is the East" is cited at the most critical and pivotal points of the plot, habitually marking these in a grand final apotheosis of victory that is further underlined by musical accompaniment, gestures, and, of course, lighting and color. Quotations from the seminal songs of the Cultural Revolution at key points in the model works thus function in a manner similar to quotations from the ancient sages in traditional Chinese texts: in an act of propagandistic transfer they are invoked for their authoritative aura.[43] The use of "Red Is the East" lends legitimacy to everything and everybody it is associated with (Chen 1995, 10, and Lu 2004, 106).

43. See Mittler 2004, Chapters 2 and 4.

As such, "Red Is the East" also appears in the *Yellow River Piano Concerto*. In its final movement, called "Defense of the Yellow River" and appropriately subtitled "Chairman Mao summons the people to fight" (Yin 1969, 123), "Red Is the East" is quoted several times, first as an allusion to illuminate Mao's call to fight (Yin 1969, 123), and later in a final virtuoso apotheosis (Yin 1969, 144) culminating in an ingenious modulation by means of a Chinese folk tune leading directly from "Red Is the East" into a short quotation from the "Internationale" (Yin 1969, 149; fig. 24; mus. 2.6).

Although "Red Is the East" (or the "Internationale" for that matter) is not used in the original score of Xian Xinghai's *Yellow River Cantata*, its incorporation in the Cultural Revolution piano concerto (Chen 1995, 10) transforms the *Yellow River Concerto* into Cultural Revolution music (and often, the piece is remembered exclusively as such) in spite of the fact that, musically speaking, the elements that make up the concerto, including all of the revolutionary songs it uses, have their roots in a past preceding the Cultural Revolution.

Sounds from the *Yellow River Cantata*, or rather its revolutionary concerto version, are clearly part of the musical landscape of the Cultural Revolution—allusions appear, therefore, in other model works, so, for example, in the overture to the model opera *Fighting on the Plain*. And clearly, the sounds of the *Yellow River Cantata* are by no means forgotten in the present (so, for example, in rock and pop versions of the *Yellow River Concerto*, such as the 1995 cassette tape *The Chinese Soul* discussed in Chapter 1 and in the many recent performances by Chinese pianists both within China and abroad). Interestingly, after the Cultural Revolution, it is the Cultural Revolution version of the piece, that is, the concerto and not the cantata, that became the more successful of the two. This again supports the idea voiced in the Introduction to this book that the Cultural Revolution was a pivotal moment for cementing particular revolutionary propagemes in Chinese cultural memory. In "1989, because of what was considered to be an excessive emphasis on Maoist Communism," argues the preface to a new arrangement of the concerto, the score was revised, its "heavy political ideology" (that is the two songs, "Red Is the East" and the "Internationale") deleted and replaced with elements referring back to the (original) "Boatmen's Song." By thus reducing the emphasis on Maoism, the piece could be reclaimed, says the preface, by "all Chinese" in their fighting spirit against the Japanese (Chen 1995, 79). And yet, this "cleaned" version of the concerto was evidently not a success: even recent Taiwan performances and the one celebrating the ten-year anniversary of Hong Kong's return to China performed by Lang Lang used (sometimes inadvertently) the version containing the two political songs.[44]

New reinventions of the piano concerto continue to appear, and they all include the political songs, as in a children's choir version performed for the Opera Festival in Beijing in August 2007: there, the children are seen humming along (quite out of tune) with "Red Is the East" (DACHS 2007 Yellow River Children's Song). In each of these remakes, the reverent Cultural Revolution pose is retained. In the final movement of the multimedia performance by Chinese star pianist Lang Lang in August 2007, for example, as four Chinese symphony orchestras join together to put "Red Is the East" (Yin 1969, 144ff) in scene, one hundred female pianists all dressed in white wedding gowns join the soloist in playing the song; it is a roaring spectacle accompanied by a huge projection of a rising sun on all of the screens in the auditorium (mus. 2.6).[45] This, arguably the most sublime performance of "Red Is the East" to date, illustrates the presence of the avatar of the Cultural Revolution in the age of the global market and reinforces the idea of a continuous revolution in culture. But what does it mean?

44. Information on the Taiwan example is from Shen Tung, personal communication, September 2007. For the performance in Hong Kong, see DACHS 2009 Yellow River.
45. DACHS 2007 Yellow River. See Chapter 1 for a discussion of other movements in this performance.

The "Internationale" 国际歌

Revolutionary sounds such as "Red Is the East," the *Yellow River Concerto*, or some of the revolutionary operas or ballets declared to be models during the Cultural Revolution are all typical "sounds of the Cultural Revolution," but not of the Cultural Revolution alone. The same can be said for yet another important revolutionary song that made its imprint on Cultural Revolution music: the "Internationale." The lyrics were written by Eugène Pottier (1816–87) to praise the Paris Commune of 1871. Pierre Degeyter (1848–1932) set the words to music in 1888. The song had been known in China since at least 1923, when Qu Qiubai 瞿秋白 (1899–1935) first published a translation and the score in the progressive magazine *New Youth* (新青年 *Xin Qingnian*).[46] The classically oriented language of this version, however, is much different from the translation regularly used today, which appeared in 1926 in the first known collection of revolutionary songs published in China, the *Collection of Revolutionary Songs* (革命歌集 *Geming geji*), edited by Li Qiushi 李求实 (1903–31) (Wong 1984, 121). The first verse reads:

Arise, ye slaves afflicted by hunger and cold,	起来, 饥寒交迫的奴隶!
Arise, ye oppressed people all over the world!	起来, 全世界受苦的人!
The blood which fills my chest has boiled over,	满腔的热血已经沸腾,
Make one last war for Truth!	要为真理而斗争!
The old world,	旧世界
it shall be destroyed like fallen petals and splashed water,	打个落花流水,
Arise, ye slaves, arise!	奴隶们起来, 起来!
Do not say that we have nothing,	不要说我们一无所有,
We shall be the masters of the world!	我们要做天下的主人!
This is the final struggle,	这是最后的斗争,
Unite together towards tomorrow,	团结起来到明天,
The "Internationale"	英特纳雄耐尔
Shall certainly be realized.	就一定要实现!

Since the founding of the PRC in 1949, the song has been taught in all schools in mainland China. It was repeatedly published in official organs, such as the *People's Daily*, for example, on April 28, 1962. It also appeared as the grand final apotheosis in the last movement of the Song and Dance Epic "Red Is the East" in 1964, as a mass sing-along with the conductor turning to the audience and calling on it to participate (DACHS 2007 "Red Is the East"). Together with "Red Is the East" and "The Three Main Rules of Discipline and the Eight Points for Attention," the "Internationale," and often also "Sailing the Seas Depends on the Helmsman" (大海航行靠舵手 *Dahai hangxing kao duoshou*), forms a most powerful "trio" or "quartet," respectively, of revolutionary songs, appearing in bold print at the beginning of Chinese song collections most frequently during the Cultural Revolution but also beyond.[47] Extremely influential throughout the Cultural Revolution, the four songs are thus remembered as "sounds of the Cultural Revolution."[48] Some even make an argument of exclusiveness, similar to that of exclusive playing of the model works on China's stages (Bryant 2004, 174) with regard to these songs: they were "the only songs

46. *Xin Qingnian* 1923.1:6–16. The melody appears in the same edition: *Xin Qingnian* 1923.1:151–52.
47. E.g., in C.C. Liu Collection Heidelberg *Geming Gequ dajia chang* 1964; *Zhandi Xin'ge* 1972; *Mao Zhuxi, nin shi women xinzhong bu luo de hong taiyang* 1977; see also Liang 1993, 19.
48. A memory survey conducted in the early 2000s shows that these songs are still the best-remembered songs as well (Bryant 2004, 174).

to be sung and heard during the Cultural Revolution." Here again, the material evidence, the numerous song collections published during the Cultural Revolution, the officially endorsed *New Battle Songs* (战地新歌 *Zhandi xin'ge*) series most prominently among them, and oral history all speak a different language. These songs were important, and they did subject their listeners to nauseating redundancy and repetition, but evidence shows that there were others, too.

Like "Red Is the East," the "Internationale" is itself eulogized in other songs of this time as a song that "rouses the oppressed" (唤醒了被压迫的奴隶) and "ignites the revolutionary fire" (这歌声燃起了革命的烈火).[49] It also appears in the theoretical Party Organ *Red Flag* (*Hongqi* 1971.12:10–11; see also Kraus 1989, 173). Not unlike "Red Is the East," most of the model works cite the "Internationale" at crucial points of the plot. In the model ballet *Red Detachment of Women*, the "Internationale" is even quoted twice: first when the hero Hong Changqing is burnt at stake by rich landlord Nan Batian, and second in the final scene, when the Red Detachment—having taken over all of Nan Batian's possessions—pays respects to the memory of the revolutionary martyr. Hong Changqing's leitmotif plays one last time, first majestically in the brass, then more tragically in a minor key, merging, almost unperceived, into a quotation of the "Internationale" vocalized by the members of the Red Detachment humming; meanwhile, in his stead, a red sun-like halo appears on the tree under which he had been burnt. Similarly, in the *Red Lantern*, Li Yuhe sings on the execution grounds a long dramatic aria containing allusions to "Red Is the East" (scene 8). Then he is killed, together with Granny Li, while the sounds of the "Internationale" can be heard in the background.[50]

The "Internationale" also occurs in *Raid on White Tiger Regiment* (scene 4) when hero Yan Weicai is informed of Aunt Choe's death. He swears in a long aria that her death will be redeemed: to the sounds of "Red Is the East" and the "Internationale" he pronounces that the Communist Party leads the revolution, and they will fight to their utmost for the liberation of all people. In *On the Docks*, which deals with the delivery of shiploads to revolutionary comrades in Africa, the "Internationale" becomes an important leitmotif. It is used in the introductory prelude before scene 1, while "sunlight shimmers over the fluctuating current" (*CL* 1972.5:53), it returns in allusions at the beginning of scene 2 and in scene 4 (ibid., 72), and it is a constant counterpoint in the final scene 7 (ibid., 95–98). It also occurs in *Azalea Mountain* (scene 2).

In each of these instances, the "Internationale" is the song of the righteous and oppressed. As such, it has been used throughout the twentieth century and into the twenty-first: in 2002, around Chinese New Year, workers who had received very little money for the holidays sang the "Internationale" during a protest. One of them complained: "How could you survive a New Year Holiday with that little money?" According to him, on this kind of budget, they could not afford even cooking oil, and they were also not given a heating allowance. At the same time, in the same residential area, they would see their cadres living in big apartments, coming home from their shopping trips with so many nicely wrapped gifts: "They were celebrating bankruptcy!" Then, some elderly workers, particularly upset, sang the "Internationale." Said the worker: "I heard that several times. How the lyrics made good sense today—'Arise, ye starving slaves. Arise, ye oppressed people of the world!'" (Lee 2007, 160).

The young demonstrators on Tian'anmen Square in 1989, too, sang the "Internationale." Some would even argue that it became their "battle song" (Wagner 1992, 341). On all the loudspeakers

49. E.g., 世世代代高唱国际歌 "For Ages and Ages we will sing loudly the 'Internationale'" *Shishidaidai gaochang Guojige* in C.C. Liu Collection Heidelberg *Duchang Gequ Xuan* 1973.1:189–91.

50. In one exegesis it is alleged that some critics (in the rhetoric of the time this would be "those who advocate the black line in literature and arts") had opposed the use of the "Internationale" in this scene (*Hongqi* 1970.5:47–56), but that it had eventually been sustained.

they had put up throughout the country, this song would be played. While the Soviet Union and the Berlin Wall were crumbling, the Tian'anmen demonstrators sang this international anthem of a whole new world that was yet to be realized. What was at stake for them was not a particular, concrete vision of the future, but the very notion of a plurality of possible futures, of roads not taken (Chi 2007, 241). Yang Fan, a student at the University of Maryland in 1999, reported his very personal experience with the particular power of the "Internationale" on Tian'anmen Square in this way (the text is kept in the original unidiomatic English):

> We were debating if we should stay or go home to get some rest. All of the sudden, it started to rain. Big rain drops pounded on our face. More people leaning towards leave the square and take cover. That is when I heard someone start to sing the "Internationale." It was very little and low in tone in the beginning. Soon, more people started to sing along. Then the tone of the "Internationale" stopped all other voices. It become the dominate sound on the square. It brought few thousands of young people together from their differences. We were singing in the same rhythm. The seriousness of the song reminded us of our responsibility. It encouraged us to stand up to the highest authority in China. I forgot the cold and uncomfortable environment. I sang along. That is when I realized what kind of responsibilities I have and started to think what I can do to make the country a better place for the rest of the people. I sense the importance of freedom and democracy. Just like many other students on the square, I was ready to die for the great cause. At that instant, I grew up and become a man.

> Then the miracle happened. The rain stopped in the sound of the "Internationale." We won. Even the rain can be "stop" by our song. We cheered for our success and welcome the appearance of the magnificent morning light.[51]

Next to the "Internationale," it was the music of Cui Jian, and especially the songs collected in his 1988 album *Rock & Roll on the New Long March* (新长征路上的摇滚 *Xin changzheng lushang de yaogun*),[52] that became something of a "soundtrack" to the Tian'anmen movement (Jones 1994, 150). One song in particular, which was performed at an unofficial concert on a truck on the square only a few hours before the crackdown, quickly became a symbol for the students' feelings. Its title, "I Have Nothing" (一无所有 *Yiwu suoyou*), is a line taken directly from the "Internationale" (Steen 1996, 85). There it is said:

Arise, ye slaves, arise!	奴隶们起来，起来！
Do not say we <u>have nothing</u>,	不要说我们一无所有，
We shall be the masters of the world!	我们要做天下的主人．

Cui Jian's song was first performed in public in May 1986, and it had been officially praised for its development of a "new Chinese style" in Chinese rock, as in the interludes it employs a *suona*, next to the regular rock instrumentation.[53] The song is a love song: a young man tries to win over

51. Pecore et al. 1999, 36. I have yet to find out why Yang Fan's text version of verses 2 and 3 of the "Internationale" differs so markedly from versions printed in song collections between the 1920s to the 1970s and also again in 1992 (cf. *Geming lishi gequ jinghua* 1992, 1–2). It is also different from the version given as sung by the students on Tian'anmen Square and quoted in Calhoun 1994, 238. For changes in the lyrics see DACHS 2008 Internationale, Lyrics Changes.

52. The title of the song collection refers to one of the monumental events in China's revolutionary history, the Long March, which began in 1934 when the Red Armies escaped from Nationalist pursuit in a circling retreat from their base area in Jiangxi to the west and north, ending in Yan'an. The march traversed some 8,000 miles in about a year's time.

53. For this reason, the song was considered as something that did not simply copy the pop and rock music styles from Hong Kong and Taiwan that had flooded the Chinese market since its opening in the late 1970s and that in themselves were considered copies of foreign trends. Some of the official appraisal for this "national" song is translated and reprinted in Jones 1992, 134ff.

a girl who laughs at him at first because, so he thinks, he "has nothing," owns nothing—in short, has nothing going for him. When finally, in a last desperate attempt to convince her, he dares take her hand and pull her toward him, he realizes that she loves him dearly, and loves him for the very fact that he "has nothing"!

How long have I been asking you	我曾经问个不休
When will you come with me?	你何时跟我走
But you always laugh at me	可你却总是笑我
For I have nothing.	一无所有.
I want to give you my hope	我要给你我的追求
And my freedom.	还有我的自由
But you always laugh at me	可你却总是笑我
For I have nothing.	一无所有.
Oh ... when will you come with me?	噢 ... 你何时跟我走?
Oh ... when will you come with me?	噢 ... 你何时跟我走?
The earth is turning under your feet.	脚下的地在走
The waters of life are flowing free.	身边的水在流
But you always laugh at me	可你却总是笑我
For I have nothing.	一无所有.
Why do you laugh at the pack on my back?	为何你总笑个没够？
Why do I always keep on hoping?	为何我总要追求？
No wonder, in front of you	难道在你面前我永远是
I will forever have nothing.	一无所有.
Oh ... when will you come with me?	噢 ... 你这就跟我走
Oh ... when will you come with me?	噢 ... 你这就跟我走.
I tell you I've been waiting a long time.	告诉你我等了很久
I tell you, here's my final plea.	告诉你我最后的要求
I want to grab both your hands	我要抓起你的双手
And take you away with me.	你这就跟我走.
But then, your hands, they are trembling.	这时你的手在颤抖
But then, your eyes, they overflow with tears.	这时你的泪在流
Do you really mean to tell me	莫非你是正在告诉我
You love me who has nothing?[54]	你爱我一无所有.

Is this a love song or a political statement? The young man's words can be interpreted as the lament of a whole generation, a whole people even, who lost their education, their family, their work, and their faith in socialism (and Mao?) during the chaotic years of the Cultural Revolution and who are thus left with "nothing": no dreams, no idols, no ideals. Such laments are prevalent in many other forms of art, in so-called wound literature (伤痕文学 shanghen wenxue), wound paintings, poetry, and music. These were not only allowed to exist by the government under Deng Xiaoping, but indeed, officially sanctioned (after initial critical debates). They fit in with the politics of Deng Xiaoping's "new age" (新时期 xin shiqi) in which many of the Maoist directives from the Cultural Revolution were annihilated or even reversed. However, the final conclusion of the song is that someone who "has nothing"—no idols, no ideals—is especially loveable. The song thus denies one of the few Maoist directives still in place today, even under the reform policies, namely,

54. The translation follows Jones 1992.

the primacy of socialism. If the "Internationale" reads, "Do not say we have nothing, we will be masters of the world," it expresses optimism, hope—prescribed feelings in the People' s Republic of China to the present day. However, these feelings are denied in Cui Jian's song and substituted by resignation and nihilism. That is why, naturally, the song was political. As one critic put it: "China's youth has socialism! How can they say they have nothing?" (Bai 1988, 94; Steen 1996, 83–86)

This type of political interpretation of a love song has roots in Chinese tradition: in the prefaces to the *Book of Songs* (诗经 *Shijing*), China's oldest collection of lyrics, the compilation of which is traditionally attributed to Confucius, it is declared that poetry is to serve as a ruler's tool for educating his people and a people's tool for criticizing their ruler (Riegel 2001). A poem in which a loving wife complains about her husband being far away and having found a new lover can be interpreted, according to this tradition, as the remonstrating voice of a people urging their ruler to abandon his lascivious and wasteful activities and return to the capital to ensure peace and quiet in his country. Even love poetry can carry a potentially political message, then, and whoever writes poetry in China knows of, and makes use of, this exegetical tradition.

But does Cui Jian really criticize, and is his song an attack on the very idea of socialism? Does not his song say, very clearly, that whoever "has nothing" will in the end be loved, and is this belief and the action of finally taking the hand of the beloved and pulling her towards him not exactly the optimism of the "Internationale," the voice of conviction that slaves will be masters of the world one day? And how, if not optimistically, does one interpret the fact that the falling melodic line sung to "I have nothing" (一无所有 or "o" 噢 in the refrain) in Cui Jian's song is identical to the falling melodic line that, in the original version of the "Internationale," accords with the words "masters of the world" (天下的主人) (ill. 2.7)?

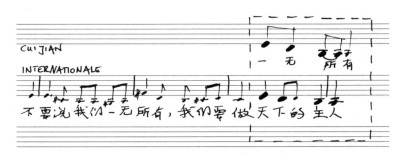

Ill. 2.7. Melodic parallelism between Cui Jian's "I Have Nothing" and the "Internationale."

Does one not have to conclude that, accordingly, those who have nothing are indeed the coming masters of the world? Or is this meant to say, after all, that to be masters of the world is a promise once made but never kept, a promise that leaves all, still, "having nothing?" Is the musical synchronicity linking the two phrases just pure coincidence? Cui Jian has openly stated more than once that rock music is ideology, that it makes political statements. Nevertheless, the message of his song remains enigmatic, and the question as to its ultimate meaning must remain unanswered.

Next to "I Have Nothing," the same "concert on a truck" on Tian'anmen in early June 1989 featured a heavy metal group Tang Dynasty (唐朝 *Tangchao*) performing yet another version of the "Internationale" (mus. 2.7). Not unlike the pop and rock medleys of songs in praise of Mao, it keeps the original melody and text but reconceives the song within the context of a new type of sound. Like many Chinese musicians—Cui Jian being perhaps the exception to prove the rule— vocalist and band leader Ding Wu 丁武 (1962–) says he is not really interested in politics. It is also difficult to envisage how and why his version of the "Internationale," doggedly faithful to the lyrics and melody of the original in spite of its radically new musical reconception, could possibly be

condemned and criticized (Xue 1993, 25; Steen 1996, 174–75). In any case, in the later months of 1989 the Party did attempt to "regulate" the singing of the "Internationale," because, according to them, it had been "defiled" through its use by those who had now been termed "counterrevolutionaries" (Wasserstrom 1991, 322). In spite of bans on the public singing of the "Internationale," however, its power appeared quite invincible: in December 1991 it rose again, now in published form (if through a Taiwanese firm) on an LP by Tang Dynasty that soon hit record sales.[55]

Medley: Mixing Sounds from amidst the Fury

The "Internationale" reappeared, next to a number of other familiar revolutionary melodies, a few years later in Tan Dun's 1996 *Red Forecast: Orchestral Theater III*.[56] By giving a short tour of this piece, I will attempt here to wrap up some of the observations I have already made about the "sounds of the Cultural Revolution" and their function(s) in revolutionary China. Tan Dun's *Red Forecast* is a multimedia work. Not unlike the model works of the Cultural Revolution that combined music, text, gestures, costumes, setting, and lighting to great (didactic) effect (Mittler 2003, Mittler 2006), *Red Forecast* juxtaposes music and text (including a recording of weather forecasts in five different languages), video footage, and light. *Red Forecast* is dominated by two major themes: the weather and the 1960s. The weather is used as a metaphor for history (and since ancient times, the weather had been read as an indicator of the will of cosmic powers in China): unpredictable and yet unchangeable, in constant motion and at times quite cruel. Holding to this interpretation of history, Tan Dun negates Marxist ideas that, according to the theories of dialectical and historical materialism, see in history an inevitable and predictable evolutionary process. The 1960s, meanwhile, symbolize for Tan Dun an idealism that was behind much of the thinking in Mao's Cultural Revolution. According to Tan Dun, however, *Red Forecast* is neither a political statement nor a reflection of nostalgic memories. Although he at times criticizes the idealism of the 1960s, in the end, Tan Dun intends this piece to be a lament for the loss of this passionate idealism, which was pervasive not just in China but throughout the entire world during this era (see also Gooi 2002, 160–61).

The piece begins quite innocently, with its first movement "Ritual," rising from darkness in jazzy solo passages.[57] Toward the end of the movement, fragments from some of the political songs prominent later in the piece can be heard as the musicians "retune" their instruments (p. 3D).[58] The second and third movements are at first accompanied by pictures of tranquility and happiness, of waves on the sea, of laughing children and busy traffic (second movement, "Snow"). With the beginning of the third movement, the pictures reflect more and faster movement, and one can see people dancing and children playing (third movement, "Cloud"). Numerous questions are raised already in these first movements with all of their complexity, and these questions become more and more pressing in subsequent movements: why, for example, in the fourth movement ("Wind"), which presents pictures from the Vietnam War, anti-war demonstrations, and the

55. Steen 1996, 174 gives 1994 sales figures for the LP of 700,000 legal copies and 1.3 million pirated copies.
56. Tan Dun's thoughts on this piece quoted throughout this chapter have been taken from the program notes for the "5. Sinfoniekonzert der Essener Philharmoniker," which took place in February of 1999. Tah Choe Gooi (2002) discusses the piece at length in Chapter 4 and also includes further remarks by Tan Dun.
57. Gooi (2002, 223) points out rightly that these passages are not representative of the type of jazz prevalent in the 1960s, however.
58. Page numbers and letters refer to the score of Tan Dun's composition; see Tan Dun 1996.

suffering Vietnamese population, did Tan Dun write a wonderfully idyllic flute passage (p. 70F) to accompany pictures of bombs falling in slow motion? And why is this falling of bombs poetically presaged and beautifully accompanied in the text of the soprano: "Wind from the West *will cause showers* to streak north into an expanse of dry weather, a wind driven, a cloud, *a cloud flying*" (p. 67–70)? Showers of bombs are released, time and again, in formation, resembling "a cloud flying." What is this, if not a romanticization of the war that otherwise appears to be attacked quite openly here, at least visually?

Why does the music accompanying pictures of bombarded Vietnamese cities (p. 73H), albeit using martial punctuation and melodic inversion techniques, remind one of the music used in connection with happy and amusing scenes of dancing and busy traffic in earlier movements (p. 11C, p. 17E)? Is this meant to suggest that one thing (tragedy) is as much as another (comedy) simply a part of human life and part of our world? Are these images, then, the price we pay for living in a world of advanced technology and accelerated development? Or could Tan Dun be saying that the 1960s were so much less about the war than they were about party and fun?

Similarly disturbing questions return in the beginning of the fifth movement ("Storm and Documentary"). It presents a surrealist collage made up of different political songs—"We Shall Overcome," the "Internationale," "Red Is the East"—as well as another important song during the Cultural Revolution, "Sailing the Seas Depends on the Helmsman." If meetings during the Cultural Revolution opened with the singing of "Red Is the East," they ended with "Sailing the Seas Depends on the Helmsman" (mus. 2.8).[59] Clearly, the song is a "sound from the Cultural Revolution," but, like so many of these sounds, it is not one engendered in, or exclusive to, the Cultural Revolution. "Sailing the Seas Depends on the Helmsman" dates back to 1964, when it was first publicized under the title "Engaging in the Revolution, We Depend on Mao Zedong Thought" (干革命靠的 是毛泽东思想 *Gan geming kaode shi Mao Zedong sixiang*) during a movement instigated by Lin Biao to further the study of Mao Zedong Thought. Zhou Enlai is said to have discovered and promoted the song in 1965, and it was mentioned as a model song in *Red Flag* that year (see *Hongqi* 1965.3:32, which includes a selection of thirteen revolutionary songs). Zhou is also said to have worked in support of the song throughout the Cultural Revolution and to have been instrumental in adding it to the first volume of the influential collection *New Battle Songs* (1972), where it was originally not to be included, perhaps because of its associations with Lin Biao's campaign to idolize Mao (Bryant 2004, 73). In a rhetoric similar to that used in "Red Is the East" (which is why the visuals of one can actually work with the soundtrack of the other as in mus. 2.8) this song praises Mao (the red sun) and his leadership qualities, which here are explicitly linked to his writings, more famously known as Mao Zedong Thought.[60] Elements from the song, and especially the idea that "fish can't leave the water," constantly reappear in the model works (e.g., in *Fighting on the Plain* as the title of scene 3).

Sailing the Seas depends on the Helmsman	大海航行靠舵手
Life and growth depends on the Sun	万物生长靠太阳
Rain and dew drops nourish the crop	雨露滋润禾苗壮
Making the revolution depends on Mao Zedong Thought.	干革命靠的是毛泽东思想.
Fish can't leave the water	鱼离不开水呀
Nor melons leave the vine,	瓜儿离不开秧
The revolutionary masses can't do without the Communist Party,	革命群众离不开共产党
Mao Zedong Thought is the sun that forever shines.	毛泽东思想是不落的太阳.

59. DACHS 2008 Sailing the Seas Depends on the Helmsman, English Version. This version ingeniously integrates the choreography from the 1964 introduction to "Red Is the East," the dance epic, with its music, see mus. 2.8.
60. For details on the background and institutionalization of the song, see DACHS 2008 Sailing the Seas Depends on the Helmsman (Background Stories).

After coming to great prominence during the Cultural Revolution, the song disappeared for a few years as did so many of the cultural products from this period, yet in the late 1980s several cheeky parodies of the song resurfaced (to the great horror of the composer, Wang Shuangyin 王双印 [1932–99], who immediately sued the plagiarists). One version, far from the determined and hopeful original, presented boredom as virtue and praised life as meaningless. Styled in the rebellious hooligan (流氓 liumang) tradition reminiscent of the language of writer Wang Shuo 王朔 (1958–) and his peers, it captured those same feelings of numbness and nihilism also present in Cui Jian's "I Have Nothing."[61] Along with "Red Is the East" and the "Internationale," then, this song was certainly one of the most frequently heard during the Cultural Revolution, and it was not forgotten in its aftermath.

"We Shall Overcome," on the other hand, which Tan Dun also uses in his medley movement, originated as the anthem of the Civil Rights Movement in the United States. Propelled by the world student movements of the late 1960s, it has come to stand for freedom, liberation, and political protest within the larger global context, and it has carried the hopes of many different people and many different causes by (1) advocating passive resistance, (2) giving people courage to stand up to unjust authority, and (3) inspiring a sense of solidarity with others working toward freedom and equality. As such, it was borrowed by the Chinese students when they faced military tanks on Tian'anmen in 1989 (DACHS 2008 We Shall Overcome, Chronology). The song was not officially propagated during the Cultural Revolution, and it was not printed in the enormously popular collection of foreign songs entitled *200 Famous Foreign Songs*,[62] carried around by almost every sent-down youth.

How, then, does one interpret the dizzying combination of the Maoist words "There will be thunderstorms, press east toward west by evening" and pictures of a red sun and Mao Zedong waving his hand up and down in fast motion, together with "We Shall Overcome" played very slowly and emotionally in the high strings in Tan Dun's piece? And what do we make of the appearance, just a fraction later, of "Sailing the Seas Depends on the Helmsman" (p. 84C, b. 43) and small fragments from both "Red Is the East" (p. 84C, b. 44/45) and the "Internationale" (Ibid., b. 46–50) in the woodwinds, again accompanied in counterpoint by "We Shall Overcome" in the strings (Ibid., b. 45)? To equate Mao's revolution to a thunderstorm pressing towards the West may be acceptable (indeed, it is his own words that the "East wind prevails over the West wind" [东风压倒西风], Mao 1957a). But to show in fast motion the image of the Great Chairman repeating the same characteristic movement again and again like a puppet, and all this to the sounds of "We Shall Overcome," a political song of American origin, that appears as a dominant counterpoint in the strings while the hymn to the Helmsman is delegated to the unimportant woodwinds and "Red Is the East" and the "Internationale" are fragmented into oblivion—this may be considered blasphemy![63] (ill. 2.8 and mus. 2.9)

61. This is the text of the parodied song (taken from DACHS 2008 "Sailing the Seas" Liumang Version):

大老爷们爱唱歌, 一天到晚乐呵呵, 闲着无聊没事做, 不唱不跳你叫我做什么?
大学没考上呀, 技校也不要我, 两手空空在家待业, 日子可不好过.
我只有喝酒来, 把时间消磨! 大老爷们爱老婆, 爱起老婆乐呵呵

The great old guys like to sing merrily from morning to night. Idle, bored, and with nothing to do, What are you asking me to do if not sing and dance?
I did not pass the university exam, And the Polytech did not want me. With both hands empty, I am waiting for work at home, It is difficult to pass the time.
All I have left is to drink, To while away the time. The old guys like old girls, And they fall in love with old girls merrily.

There is a version of "Red Is the East" entitled 东方红太阳升盲流出了个毛泽东 that similarly denatures Mao's venerated position: he is even made into one of the many itinerant workers in China, a *mangliu* (Barmé 1996, 284).

62. As another sign of the persistence of cultural products popular during the Cultural Revolution, a karaoke version of this song collection has been published recently. See DACHS 2008 Foreign Songs.

63. According to Cultural Revolution musical theory and the Four Prominences mentioned in Chapter 1, the strings were to dominate over the winds in the ensemble.

And what is it if not blasphemy when a quotation from "Red Is the East" with its Chinese-style ornamentation grows immediately out of "We Shall Overcome," with splinters from "Sailing the Seas" in the vibraphone? And what happens when all this is counterpointed not only by the beginning phrase of the "Internationale" in the double bass (not a very important instrument by Cultural Revolution standards) but by pictures of the explosion of an atomic bomb (p. 86, b.53)? China has the atomic bomb, yes, but does this have anything to do with the belief that the East is red and that, as it is remarked in the song of praise to the Helmsman, all life depends on the sun? Or is the atomic bomb, as the line from the "Internationale" cited here may suggest, the method whereby the "slaves will finally arise"? Do these juxtapositions—in line with Maoist rhetoric—play down the dangers imminent in technological progress (as atomic bombs are really to be considered "paper tigers" *zhihu* 纸虎)?

If the answer is yes, then how do we interpret the monotonous rhythms accompanying pictures of processions with huge Mao portraits and the waving of *Little Red Books*, not to mention Cultural Revolution wedding ceremonies (p. 88ff.)? How do we account for the extremely stately quotation from "We Shall Overcome" (in very strong augmentation) in the brass (beginning on p. 89, b.64), the counterpoint to which are wrongly rhythmicized passages from "Sailing the Seas" (p. 92, b.81) that finally merge into a quotation from "Red Is the East" (p. 93–94, b.88) in the trumpets, soon to be repeated wrongly again in a kind of constant hiccup in the high woodwinds? It redevelops into a stately, easily recognizable quotation from the song, but this quotation only lasts for three bars and is then constantly abridged and repeated throughout the orchestra, imitating the effect of a scratched LP running in accelerando. The "Internationale," first introduced in the trombone,[64] is treated the same way a few bars later (p. 99, b.122); it is finally rhythmically denaturized and thus confronted with an extremely long version of "We Shall Overcome" in the woodwinds (p. 100–102, b.129–38), which is answered in the strings with a line from "Sailing the Seas": "Rain and dew drops nourish the crops," followed by a variation on "Making revolution depends on Mao Zedong Thought" ending in a sliding chromatic line (p. 101, b.136). Is it irony that speaks from these juxtapositions, these denaturations, these curtailments, these overwritings?

Perhaps yes, but this interpretation again does not explain why a huge Mao portrait then floods the video screen with red, as sun rays burst from the screen like shooting stars. This picture of triumph and glory is accompanied by extremely augmented shreds from "Sailing the Seas," jazzy elements derived from the "Internationale," and, in trumpet flourishes, bits and pieces from "Red Is the East" (p. 105, ill. 2.9). The bric-à-brac of melody fragments is accompanied by a contagious monotonous rhythm that gradually takes over the entire orchestra, eventually becoming a huge din of wild and improvised noises, until everything breaks off suddenly and unexpectedly to end in a short silence (p. 107H) followed by rhythmically determined afterthoughts (p. 108). Is this a depiction of the famous chaos (乱 *luan*) that the Chairman—whose favorite maxim was "to rebel is justified" (造反有理 *zaofan you li*)—so loved? Or is this a critical attack on the vandalism that resulted when this idea became the core of Party policy?

If the latter interpretation is correct, then why does the next and last movement, programmatically entitled "Sun," begin with a heart-rending oboe melody (woodwind!) and talk, apparently quite seriously, of the sun's promise of brightness? "Sunshine, exposing sunshine, yearning. The sky will be brighter than ever" are the words sung by the soprano, if with the instruction to intone them "very sadly." Why does the sky become redder and redder around the singer and all over the video screens and the stage while she sings: "Air returns, pressure goes, rain waits, in the red

64. Jiang Qing is said to have hated the trombone; therefore, it had only ever been used for negative characters in the model works.

sunshine with clouds. Highs, highs, highs near eighty nine—ty nine" when the text is combined with the fate motif from Beethoven's Fifth Symphony, intoned, time and again, in the timpani (p. 116–117)? Does the elongation on "eighty nine" before it resolves into "(nine-)ty" as juxtaposed with Beethoven's fate motif have meaning? Does it indeed allude to the student demonstrations in 1989 as does the triumphant citation of "We Shall Overcome" throughout the piece?[65] Why then does the text say "pressure goes"? And if this is really an allusion to the bloody end of the student demonstrations in 1989, then the reappearance of the happy dance motif—not unlike the seemingly out of place treatment of war imagery in the fourth movement—makes little, if any, sense (p. 118). Is the juxtaposition of sun, clouds, and possible rain in "rain waits, in the red sunshine with clouds" perhaps a covert criticism of the red sun, Mao himself? It may very well be, especially since this is the second time Tan Dun's text talks of clouds in connection with the sun.[66]

During the Cultural Revolution, innumerable artists were punished for not painting the sun bright enough. A comic strip from 1967 shows the potentially disastrous results of attempting to "cloud over" the sun—a question discussed in more detail in Chapter 5. A painter with a bucket of black paint in his hands decides that the sun he has just painted is a bit too glaring.[67] But what happens when he attempts to darken it with black paint, is that the whole bucket of paint empties itself over him and he himself ends up blackened (ill. 2.10). The black ink spots, too, spla-

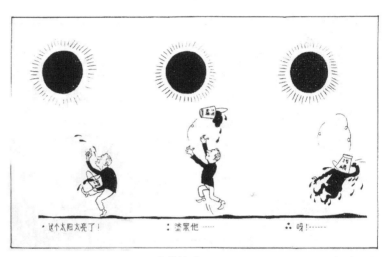

Ill. 2.10. *Blackening the Sun* (千钧棒漫画 *Qianjunbang manhua*, ed. Shoudu geming zaofanpai, Beijing 1967, reprinted in V. Wagner 1995, 136).

shed onto Mao's—the sun's human incarnation—portrait during the demonstrations in 1989 were feverishly removed, and it appeared to many of the participants as if Heaven itself was angered by the offense when a sudden thunderstorm swept across the square. The sun returned only when the portrait was clean again (see testimony in *The Gate of Heavenly Peace* 1995).

Thus, indeed, what seems to be a "non-sensical" arrangement of words (Gooi 2002, 167)—the texts from weather forecasts presented in Tan Dun's composition and recited by the singer, the conductor, the orchestra, and finally a tape recording—turns out to be extremely sensitive material in the Chinese political context. The high sensitivity of even the present Chinese government

65. Tan Dun's elegy "Snow in June" (1990) for percussion quartet and cello is another piece of wound music composed about the Tian'anmen student demonstrations. The title of this piece refers back to Guan Huanqing's 关汉卿 (c. 1230–1300) drama *Dou E Yuan* 竇娥冤 (Injustice done to Dou E) which deals with an innocent young woman wrongly condemned to death who predicts that snow will fall in June to mark the injustice. For this political reading of the piece, see Mittler 1997, 116–17.

66. The other passage in the third movement reads, "Clouds will mix with sunshine."

67. In the Chinese version, the text reads: "Not quite like it," making the comic strip a wonderful counterpoint to the strip depicting the painting of an elephant turning quite unlike an elephant under Jiang Qing's orders which was discussed at the beginning of this book's Introduction (ill. 0.0).

toward weather—which, like music, is thought to reflect the state of a ruler's government—could be seen during the 1998 Yangzi floods, for example, when the government carried out an official concealment campaign. During the Cultural Revolution, this sensitivity even caused national hysteria, evident in the example of a poor peasant who was arrested for having cursed at the wind that had blown into his face and made it hard for him to work. Someone had heard him say "damned East wind," and during those times, that was enough to get him into jail, apparently (Schönhals 1989, 567 cites the document recording the incident). Mao's dictum that the "East wind prevails over the West wind" itself takes up a quotation from Chapter 82 of the eighteenth-century novel *Dream of the Red Chamber* (红楼梦 *Hongloumeng*) and was, in the early years of the Cultural Revolution, one of the most celebrated slogans in mainland China (Mao 1957; Huang 1968, 39). If one were to read Tan Dun's composition according to these strict criteria, it would immediately become obvious that although the East appears to prevail over the other three directions in this composition (it is mentioned three out of ten times), it is not much stronger than the West after all (which appears two out of ten times). Moreover, the weather associated with the East is not exactly of the powerful, active, and strong quality that one would expect: apart from the "thunderstorm" (fifth movement), it is said that the "high pressure" building up in the East in fact "advances calm" (second movement), and again that there is "slow-motion air in the East" (fifth movement). All of these details may lead one to think that the composition in fact opposes the crucial ideas of perpetual motion and victorious activity in the East—ideas that had habitually been associated with Mao!

On the other hand, the composition ends with idyllic sounds in the woodwinds and with a stage "washed in red." Tan Dun thus repeats exactly the typical final apotheosis as found in the model works of the Cultural Revolution: they invariably end with spheric sounds, a tableau of heroes, and a stage all washed in red (ill. 2.11). Is Tan Dun's ending, then, also a carnivalization of the Cultural Revolution and its cultural aesthetics, just like the photographic backgrounds offered to Chinese parents for effective pictures of their "little heroes" at tourist places? (ill. 2.12)

In the case of Tan Dun, the immediate answer to the question is, "No." According to the composer, the last movement of his composition is a tribute to nature and the future. The color red symbolizes for Tan Dun change, revolution, and passion. In his view, the work ends in a transcendent and optimistic mode. Musically, this makes sense, as the last few bars are a recapitulation of the dance motif from earlier movements, and, even more significantly, the composition ends, as it begins, with sunshine (see Gooi 2002, 167). The work's enigmatic title *Red Forecast* is to be read, in Tan's own interpretation, as follows: the forecast for mankind in the future is a retrieval of lost ideals and passions, symbolized by the color red. There is certainty to his conviction; it is a forecast, a prediction indeed.[68] Tan Dun is convinced that in the new millennium humankind will be able to regain its idealism and spiritual powers. Yet, this cannot be achieved, as Tan Dun insists, by simply being nostalgic for past ideals—a nostalgia he observes as on the rise in his own country. Only a serious and honest engagement—so the composition seems to suggest—with the positive as well as the negative sides of this revolutionary past will make such a future scenario possible. It needs to be based on rethinking and learning a lesson from history.

And *Red Forecast* demands such serious engagement with the past from its audience. As a multimedia work, it bears many similarities to the model works from the Cultural Revolution—in

68. Gooi accuses Tan Dun of contradicting himself by choosing a title such as "forecast," which implies "some form of certainty" (2002, 164–65). He cites Tan Dun as saying that the piece "serves as a metaphor of history. A cloud in the sky, we do not know what it will become." I do not see a contradiction, however, for Tan Dun indeed makes a forecast with some level of conviction in this piece, but no forecast can ever be 100 percent certain. This, in fact, appears to me the more important message of the piece, which thrives in ambiguity.

its use of color symbolism, in its employment of telltale melodies from revolutionary songs, in its use of artistic repetition for semantic effect. But at the same time *Red Forecast* could not be more different from the model works. For when the model works combine music, text, gestures, costumes, setting, and lighting they do so in order to repeat the same message, such as "this is a bad character" or "this is the main hero," over and over again on many different levels of signification in order to make sure that the audience understands it on at least one of these levels. In Tan Dun's composition, on the other hand, the different levels say and mean many different and often contradictory things. Multiple levels are thus not used as they were during the Cultural Revolution to reinforce the one and only one message, that of people's love for and belief in Mao and the Communist victory. Quite on the contrary, multiple levels serve in Tan Dun's composition to magnify contradictions between multiple messages, which might be comprehensible when taken one by one but which become all the more impossible to decipher in combination. Thus, it is possible to see irony and doubt in the antagonistic juxtapositions of music, pictures, and effects of light and color, as well as in the false connections between and constant dismantlings of political songs such as "We Shall Overcome" and "Red Is the East." This is so even as the composer appears to negate this interpretation when he calls "red" the color of hope and thus mimics, literally, the rhetoric associated with this color during the Cultural Revolution.[69]

There is no one definitive reading of *Red Forecast*. Unlike the model works, this piece never does soothe its audience into the security of univalence—quite the opposite: it challenges us, it makes us think and rethink anew. Composed in deliberate contradictions, *Red Forecast* functions very differently from the model works and other such "sounds of the Cultural Revolution." Rather similarly to some of the other more recent remakes of the old and well-known melodies, which I have dealt with in the course of this chapter, *Red Forecast* invites multiple interpretations and denies an unequivocal interpretation.

It is not untrue, as Gooi argues, that this composition betrays only a superficial understanding of the 1960s outside of China, that the depiction is not "historically accurate," that the type of jazz styles Tan Dun uses are not in fact the styles of the 1960s, that he neglects to highlight in the visuals accompanying the score key events such as the death of Kennedy, and that he delivers a deceivingly "quiet" and "tame" depiction of the West by focusing on entertainment and consumerism (2002, 223–24). To argue that the piece offers a serious engagement with history is not to say that this piece is an accurate depiction of "historical facts," even less of "global history." For one, music is not an unambiguous language; music can never be a "dissertation."[70] Not unlike other pieces of "wound music" (discussed in Mittler 2007, for example), *Red Forecast* may be considered an emotion-filled think piece, but it does not direct our manner of thinking in one and only one way. Like rock and jazz versions of revolutionary songs, *Red Forecast* is an important *personal* interpretation of the Cultural Revolution that may offer a glimpse into the confused and confusing emotional effects this long moment in Chinese history had on China's population. Indeed, it ultimately leaves the audience feeling the "impossibility of coming to term(s) with (this) history" (Gooi 2002, 225). Later quotations of "Red Is the East" as discovered by Christian Utz in Tan Dun's *Ghost Opera* (2002, 450) and *Marco Polo* (2002, 464–66), as well as his self-fashioning in a Mao jacket (ill. 2.13), point to the importance the experience of the red 1960s in China continues to have in Tan Dun's life. In spite all of this playfulness, the piece also points to a need to deal with a harrowing memory that simply does not let go, something I will return to when discussing contemporary Mao portraits in Chapter 5.

69. Tan Dun is not alone in calling red the color of hope; many of his generation do the same. See Chen 1999, 144.
70. This is a critic's interpretation of Bright Sheng's Cultural Revolution Composition *H'un: Lacerations in Memoriam 1966–76*: "The piece is what one would expect of a dissertation on the Cultural Revolution" (for the full citation and its discussion, see Mittler 2007, 38).

If, as happens in *Red Forecast*, an agent from a sub- or non-official culture adapts symbols from dominant official discourse and reintegrates them into a new style, it forms, in a kind of bricolage effect, a new type of discourse. This unofficial discourse can then be reintegrated into official discourse again. There are many examples for this in the continuous revolution that is part and parcel in the (re-)creation of Cultural Revolution Culture. One such example would be Cui Jian's use of "Nanni Bay" (南泥湾 *Nanniwan*) (1943), another well-known revolutionary song from Yan'an days depicting the beauty of Nanni Bay in Shaanxi. Cui Jian's retake dates to 1987. The original song consist of an idyllic description of Nanni Bay, then goes on to explain, in the last verse of the song, that this idyll has only been made possible by the Red Army's great spirit of sacrifice, altruism, and determination. Cui Jian, in his retake of the song, leaves out this last verse and thus begins and ends the song as a simple description of an idyllic landscape. Immediately after the concert at which he performed this version, Cui Jian was barred from further public performance (Steen 1996, 97–98). Yet just a few years later, in 1991, the same song, packaged in another popular musical style but with lyrics identical to Cui Jian's, appeared on one of the "Red Sun" tapes[71] preparing for the centenary of Mao's birth in 1993. In 2003 it reappeared in a jazz version on a CD entitled *Red Jazz* (红色爵士 *Hongse jueshi*, see ill. 2.5), which is purely instrumental, again leaving out the words about the Red Army's importance in creating idyllic landscapes.

Thus what was once deemed subversive discourse has been reintegrated into official or at least tolerated discourse. As Sue Tuohy puts it, the irony of the post-Cultural Revolution formulation that the Cultural Revolution was unprecedented "hides both the chaos, the musical eclecticism, multiple and changing musical guidelines, the endless revision and reinterpretation of music, and the musical precedents in the practices of interpreting music and disseminating interpretations" (2001, 19). Musicians who create retakes of revolutionary songs can never be sure if they will be praised or criticized. This was certainly true during the Cultural Revolution (but not only). This is the reason for Mao Yurun's many "Shall I's" that a composer would have to consider,[72] and as I will show in the chapters to come, this would apply to artists in many other fields as well. As Tuohy puts it:

> Many clear statements were released and re-released, but official guidelines changed quickly as other people and songs were reviled as revisionists or celebrated as revolutionary exemplars. Writings from the Cultural Revolution period showed that many participants believed that a correct interpretation existed (and, the fate of many rested upon knowing it), but also that they often did not know or disagreed about which set of guidelines was ultimately the correct and authoritative version at any given point in time. The same pieces of music could be labeled incorrect, bourgeois, and revolutionary or counterrevolutionary through national and local power shifts in arts leadership and through competing interpretations of central texts. (2001, 13)

But, so Tuohy points out, although this situation may have been exacerbated during the Cultural Revolution when—contrary to its common perception as an autocratic period of dictatorship—anarchy reigned, it was prevalent before and after this period as well. The use and misuse of the original Chinese national anthem, the *March of the Volunteers* (义勇军进行曲 *Yiyongjun jinxingqu*), set to music by Nie Er and with a text by Tian Han, may be one such example: it was performed on Tian'anmen when Mao declared the founding of the PRC on October 1, 1949. On November 15,

71. This tape was produced by Red Sun China Record Company. Many of these tapes were supported by the state. See Tuohy 1999.
72. The full quotation is given in the Prologue to Part I. See also the description of the stifling effect this had on creativity and production in Bryant 2004, 74–75.

1949, it was designated, in an article in the *People's Daily*, the national anthem. Yet, only its melody is used in the song and dance epic "Red Is the East" of 1964. This attempt to write Tian Han, who composed the words to the anthem, out of revolutionary history (Lee and Yang 2007, 13; Chi 2007) continued during the Cultural Revolution when the song was internally substituted by "Red Is the East" although still played (without vocals) at occasions such as the Nixon visit in 1972 (DACHS 2008 Chinese National Anthem Story & Chronology). In 1978, the song was officially reinstated, but with the words changed. Only in 1982 were Tian Han's original words used again, intact.

Another example is that of a composer who remembers that in 1963 he committed his "biggest mistake" when, in trying to "serve politics" (为政治服务 *wei zhengzhi fuwu*), he wrote a parody of the revolutionary song "Socialism Is Good" (社会主义好 *Shehuizhuyi hao*) and was harshly criticized for it: "They were hating me!" (Composer, 1937–)[73] Today, on the other hand, subjective takes of the song abound: it can be sung in karaoke fashion (mus. 2.10) or sold by the millions in a rock version on CDs with titles like *Red Rock* (红色摇滚 *Hongse yaogun*) (2002).

I have not found evidence for how the Chinese government would react to a performance of *Red Forecast*. It has, however, solicited Tan Dun repeatedly—not least because of his international renown. He was the one the government asked to write a symphony for the takeover ceremonies in Hong Kong in the summer of 1997 (Yu 2004). Based on a similarly eclectic setup as *Red Forecast*, the symphony he composed for this event, *Symphony 1997–Heaven, Earth, Man*, brings to sound a Chinese *glockenspiel*, which symbolizes China's "5000-year-old culture," as well as the innocent voices from a children's choir and the cello as storyteller. And still, it is much easier to understand and read than is *Red Forecast*. In this composition commissioned by the Chinese state, Tan Dun works within certain basic rules that have been established by the government as orthodox. In other words, he accepts the very same rules that he so skillfully veils and subverts in *Red Forecast*.

Coda

> There were a lot of songs based on quotations by Mao and songs in praise of Mao, and we would sing them incessantly. Those new CDs with retakes of these songs are quite interesting. There has been, of course, a change in taste. They are funny, but actually, there is a lot of fighting spirit in them still. "Red Is the East" we would hear every morning from the loudspeakers. Always, in the beginning of the news, they would play it, and then read a phrase from Mao's works, and at the end they would play "Sailing the Seas Depends on the Helmsman" (Historian, 1950s–)

> Of course, the old people would sing mountain songs [山歌 *shan'ge*] for us, but most of the time it was us singing and performing for them. (University Professor, 1950s–)

The Great Proletarian Cultural Revolution must continue to be called a "period of chaos and destruction." Too many people, musicians among them, suffered during these years. In terms of the historical development of China's art and culture, however, calling the Cultural Revolution an "exceptional period of stagnation" (Fokkema 1991, 594) does not tell the whole story. To be sure, the Cultural Revolution was an extraordinary period in modern Chinese history, but it was not quite so out of the ordinary in terms of its art and culture. The cultural products of the Cultural Revolution cannot be called "deviants" from, but should more aptly be called "high points" of, the

73. This composer is quoted at the beginning of the Conclusion to this book.

revolutionary norm. From the point of view of revolutionary songs, the Cultural Revolution indeed continued a tradition of using music "to promote political ideologies and political campaigns, yet the scale and intensity was taken to all new levels" (Bryant 2004, 223). Artistically speaking, the Cultural Revolution was, indeed, "the era at which the Chinese revolution *as a norm* reached its most intense peak" (Whyte and Law 2003, 15, italics mine).

Not only are the most popular songs during the Cultural Revolution, the "sounds amidst the fury," not in the least forgotten today, but they also originate much earlier, often dating back many decades before it began. The use of old and well-known melodies is one of the main principles of Cultural Revolution Culture, and the model works were the unquestioned model for this practice. The preface to the first revolutionary song collection *New Battle Songs*, published in five volumes during the Cultural Revolution, puts it this way (Bryant 2004, 244–48):

> Since the Great Proletarian Cultural Revolution, the broad masses and amateur composers from revolutionary workers, peasants, and soldiers, guided by Chairman Mao's Revolutionary thought on art and literature and illuminated by his *Yan'an Talks*, would take as model the revolutionary model operas, and persist in working to serve the workers, peasants, and soldiers and proletarian politics; they have composed and produced a great quantity of outstanding revolutionary songs. (*Zhandi xin'ge* 1972)

The end of the Cultural Revolution did not bring to a standstill the process of constant superscription of well-known themes, melodies, and symbols with ever-new versions of themselves. But in the hands of artists such as Tan Dun, Cui Jian, Lang Lang, or Tang Dynasty, who work more or less independently from current cultural politics, as well as in the hands of artists who, in their production of politically correct pop music, are supported and sponsored by the Party, these melodies and sounds acquire new meanings that are increasingly difficult to grasp. The music, the texts, the gestures of musicians such as Cui Jian or Tan Dun—their insistence on the color red, their use of socialist rhetoric, of the sun, and of certain melodies—all of these phenomena are unthinkable without China's revolutionary past, and especially without the "perpetuating machine" that was the Cultural Revolution, even if they question the melodies' powers to instill "blind faith." They must be considered creative inheritors of a persistent Cultural Revolution legacy. And yet, they could not be more different from the original "sounds amidst the fury."

After all, the particular quality of Cultural Revolution art and music is its overdetermination, its univalence: in Barthes' words, it is myth (1957, 212).[74] During the Cultural Revolution, the play with constant revisions and superscriptions, clearly indicated and categorized by the many terms used in publications of songs, which could be simply "arranged" (编 *bian*) or "revised" (改 *gai*), but also "revised anew" (重新改 *chongxin gai*), "rewritten" (填词 *tianci*), "straightened out" (整理 *zhengli*), or "corrected and revised" (修改 *xiugai*), with each of these terms denoting both the status of the respective creator of a song and what had actually happened to it—all of this had a single goal: to serve politics.[75] Likewise, the adaptation and transformation of symbols from Chinese and foreign artistic traditions, the constant repetition of one and the same subject on all possible mediums—from LP to comic, from poster to towel or teacup, and from story to dance to song—all of these methods had a single goal. The omnipresent sounds (as well as the texts and images) of the Cultural Revolution, redundantly perpetuated, do not allow for a freedom of

74. Barthes considers this the charm of myth: it is "trop riche" in meaning (1957, 212).

75. Bryant derives these categories from her careful reading of the song collection published in five volumes between 1972 and 1976 and entitled *New Battle Songs* (2004, 65).

interpretation, they *prescribe* to their "interpretive community"[76] in every detail one and only one interpretation: "We all were supposed to love Mao, that was the real aim" (Musician, 1930s–).

Confronting the audience with ever-new variations of old melodies, plots, and stories means that even though a text can only be interpreted in the act of being performed, this "always already interpreted" is here not to be read as a sign for a reader's liberation, but in fact for his complete compulsion. The idea of the instability of the text (Fish 1980) was not accepted by Cultural Revolutionary ideology—even if it may have been practiced more or less surreptitiously by those who lived through the Cultural Revolution and sang the songs prescribed.[77] This inherent instability of the text is recovered, more thoroughly, by China's musicians, artists, and their audiences, in the multiple interpretations possible today of one and the same old theme. For to see irony or even criticism in Cui Jian's or others' versions of revolutionary songs is only one possible interpretation.

The Chinese government itself has, time and again, attempted to co-opt the protagonists in the fields of rock, pop, and even New Music. They have recovered the old songs so that they again form in China's musical universe the "main melody" (主旋律 *zhuxuanlü*), a term that has become widespread since the early 1990s as part of the resurgence of state-sponsored nationalism in the PRC: it is used metaphorically for what "the people," meaning China as a nation, is (supposed to be) talking about. Quite clearly, the government continues to believe that it must oversee and manipulate this, but their task becomes ever more complicated as forms and channels of public discourse continue to multiply: accordingly, the state has also exploited cinema, television, radio, periodicals, and, most recently, the internet for its purposes (Chi 2007, 220). But the main melody's centripetal gravity is somewhat lifted as China's artists have become more brazen in their attempts to co-opt this discourse and the symbols that come along with it. In the end, it does not matter whether this kind of co-optation is more explicitly (Cui Jian and the pop musicians working for the government) or implicitly (Tan Dun, Tang Dynasty) politically motivated. Sue Tuohy aptly describes the ambiguities of this situation:

> Some people listen to the Red Song tapes for fun; some call them officially approved. Other people perform them with no official sanctions or coercion. Some hate the sound of all of it. Others use the same songs explicitly as protest . . . against the current regime or to make fun of the past. (Tuohy 1999)

The control over orthodox revolutionary music is thus no longer a privilege of the Chinese government and its cultural politics alone. Out of the one and all-inclusive context for interpretation has grown a multiplicity of contextualities; it is this quality alone, and not the music's text or their melody, that draws the dividing line between the "sounds amidst the fury," their predecessors from the revolutionary past and their replicas in contemporary China.

76. According to Fish (1980, 306), interpretation is the function of publicly established standards that are usually not to be found inside the text but that are in fact external to it, to be found in an "interpretive community." The model works and Cultural Revolution music, generally, however, are intended to do exactly the opposite.

77. For evidence, see the quotes from interviews placed at the beginning of this chapter and at the beginning of the Prologue to Part I. See also Chen 1999.

PART II

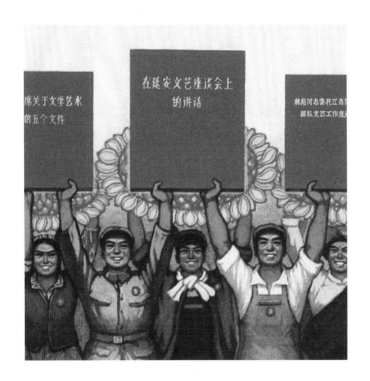

MOUTH: WORDS

During that time the eight model works were being performed, that was it, there was nothing else. The rest was all "feudal, capitalist, and revisionist" [封资修 *fengzixiu*]. But we read all kinds of things that were *fengzixiu* anyway—Honoré de Balzac [1799–1850] and Romain Rolland [1866–1944]! At the time, I was looking after an oxen, and I thought this was quite fun. I also read Guo Moruo [郭沫若, 1892–1978] then, yes, and I really enjoyed my life. (Musician, 1942–)

In the 1980s I read voraciously: I did not drink tea or smoke or chat; I just wanted to read, and I felt I must do that. Part of it was that work in the factory was really not what I wanted to do. Whenever I was reading a good book, I would develop my own thoughts. But all of this was after the Cultural Revolution. During the Cultural Revolution this kind of behavior would have been impossible. For me, these years were really lost or wasted [荒废 *huangfei*]. We did not learn anything. (Photographer, 1960–)

I did not really feel restricted, but then my situation was not a hard one: I was in the Shanghai Museum and we would simply do research. At home, we could listen to whatever we wanted and also read whatever we wanted. In the Shanghai Museum there is a very good library, so really, at that time, I could read everything, I had no restrictions, I learned a lot! Only later, when I was supposed to edit some things myself, and I was told that I should not publish this or that, I felt restricted for the first time. (Museum Curator, 1950s–)

From the 1960s onwards, there was an interesting phenomenon, the so-called forbidden books [禁书 *jinshu*]. There would always be these lists: Romain Rolland's *Jean Christophe*, for example, would be forbidden. It was too "individualistic," and we were against individualism. The Red Guards, these "little devils," would ransack the homes [抄家 *chaojia*] and hit people for owning these books, but then they would take them home and read them. (Editor, 1930s–)

As far as I know, lists of forbidden books were not published officially. Even in the middle of the Cultural Revolution they would be publishing these translations of Russian novels after all. The libraries would be closed, of course, with the explanation that "no final decision has been made about these books" [还没决定, 这些书]. There was one book that was really dangerous: a biography of Chiang Kaishek. Anything to do with Taiwan was much worse than anything to do with the West, for example. Surely, I did not take that book out of the house to read. (University Professor, mid-1950s–)

A lot of my friends would read foreign novels. I did, too. Balzac, for example, Anton Chekhov [1860–1904], Émile Zola [1840–1902]. All of these had been translated before the Cultural Revolution. Of course you would not read these things outside in the open. They were exchanged underground. Once, a very young worker informed on me that I had been reading this biography of Chiang Kaishek. So then the Party Representative took me to the side and asked me what kinds of books I was reading. I told the guy that this was just a story and asked him to reconsider: in the encyclopedic dictionary, the *Cihai* [辞海], there are a lot of "feudal" things, but does that mean that I must not look at the *Cihai* anymore? He laughed—and let me go. (Librarian, mid-1950s–)

In the shops, I found Russian literature, Leo Tolstoy [1828–1910], and some French literature, too, especially after the 1970s. Nobody cared about us reading this. (China Historian, 1957–)

He: It feels like the pressure went away pretty quickly and we were able to read whatever we wanted. She: Yes, it was not even a year or so that I did not dare to read what I wanted. He: In fact, we read and discussed a lot of the things from the 1950s, for example *Song of Youth* [青春之歌 *Qingchun zhi ge*]. We read so much, really, it is not true that during the Cultural Revolution you could not read anything. She: Indeed, the library was always open to us, even in the evening, and we would enter and just read whatever we wanted to read. So even if there was pressure, it did not destroy the culture. (Housewife with Husband, 1950s–)

PROLOGUE

> We (especially the Red Guards) stole so many books from the library, and then we would exchange these books, reading them in secret: we felt so great when we did it, but also a bit scared: I was a very fast reader when I was small, because there was always this atmosphere of secrecy in which we read. But in fact, there never was a concrete black list. They just said that things which were "feudal, capitalist, and revisionist" [*fengzixiu*] were not acceptable. But they could not enumerate everything in detail, since there was so much to be criticized, so they just used these three standards. (Writer, 1958–)

> In the 1960s, and especially during the Cultural Revolution, I read more books than ever before. Friends got these books from the library. It was all this classical literature, translated from French and German. Modern literature only started to come in after the Cultural Revolution. We also read a lot of Chinese Classics: the Ming novels, but also the *Records of the Historian* [史记 *Shiji*] or collections of philosophical works in the standard Zhu Xi 朱熹 [1130–1200] editions. (Journalist, 1949–)

There seems to be one surprising consistency among these different and, in many ways, incongruent descriptions of reading experiences during the Cultural Revolution: almost everyone felt restrictions. But this apparent consistency only superficially hides the many contradictions: if reading was restricted, where were the precise lists telling everyone what not to read? They certainly existed: Red Guard publications like *Destroying the Old World Completely* (彻底破烂旧世界 *Chedi polan jiu shijie*) are examples of this (*Chedi polan jiu shijie* 1966). But these lists also appeared in the daily newspapers and were sent internally to publishers and editors (May 2008). Was everyone aware of these lists? Probably not, and this may have been as deliberate as it was inevitable: a vague label such as "feudal, capitalist, and revisionist" (封资修 *fengzixiu*), which was used to condemn all sorts of "unhealthy" types of literature, allowed, on the one hand, for critical interpretation in all directions and instigated the greatest possible fear. This vague label was able to cover a multitude of works that would have been impossible to list one by one. Yet, as some of the interviewees suggest, even those who were in fact very aware of specific restrictions did not feel they had to adhere to these standards at all times. One editor at one of the largest Chinese publishing houses remembers the situation as slightly paradoxical:

> It was only on the surface [表面上 *biaomianshang*] that particular books were not there, but in fact, of course, they were there and they were actually [实际上 *shijishang*] quite widespread. For example, that late Ming erotic novel *The Golden Lotus* [金瓶梅 *Jin Ping Mei*], I read this, too, during this time. We would go to the old cadres and get these types of books from them. Then, in the 1970s, some of the standards were reset, and maybe ten percent of the books that had formerly been forbidden could then officially be read again—Tolstoy and Chekhov, for example. It was strange, there are things that even today we would not find in the bookstores, but because of this looting of family homes [抄家 *chaojia*], we were able to get these books back then: some young people would read Adolf Hitler's [1889–1945] *Mein Kampf*, for example. One could say that, in spite of the heavy restrictions, all the chaos that the 1960s brought also meant that there was some space. At the same time, when restrictions were slightly loosened in the 1970s, this space was no longer there. And then, as before, there was always this feeling of "covered repression" [暗中的控制 *anzhong de kongzhi*] anyway. (Editor, 1930s–)

In this description, the first part of the Cultural Revolution becomes a time that, even by way of restriction, may have for some opened up avenues hitherto unknown. Although few books were sold in bookstores, many books were nevertheless available: they would be handed on from friend

to friend after being uncovered in people's homes, seized as loot from a Red Guard ransack, or stolen from the libraries. The question of whether the libraries were open or restricted is answered very differently by different interviewees. Their contradictions suggest an enormous range of local variation, but all agree in one point: even if the doors of the libraries were closed, the books they contained were being read nevertheless. One artist remembers her clandestine reading of library books as follows:

> We all did our own thing, studying all by ourselves. We read books it was not easy to read, especially "feudal" and "bourgeois" titles. They were not supposed to be read, but we read them anyway. The books were passed on, from one to the next, [books by authors like] Romain Rolland, for example, oh, it was so interesting and so romantic! (Artist, 1954–)

Another is explicit about how to get into the libraries:

> I did not take part in the revolution; I was not really interested. I just read all the books I could get. Of course, there were not so many books. And as for the libraries, they did not let you in. But nobody was actually in charge, either, and so I climbed the wall and very quickly just grabbed any book and left again. And this is how I could read voraciously: Russian stories, Chinese old and new stories, whatever. I would read this all, except Chinese philosophical Classics. I knew nothing about them from primary school. My father would not let me read these old things. (Intellectual, 1955–)

A third even remembers complicity by a teacher:

> In fifth grade, there was a teacher in the school who would see that I was reading so much more than everybody else. He gave me this key to the school library. There were several hundred books in there. I did understand what the teacher meant by that; he did not just give this key to everybody, but just to me, because he knew that I should read some more. There were all kinds of books, mostly literature. (Intellectual, 1958–)

Books were available, then, from different sources, both clandestine and legal. Foreign books made up the bulk of the readings that have found their way into the individual memories presented here, with Romain Rolland, Leo Tolstoy, and Soviet authors most frequently mentioned. Traditional Chinese literature, too, apparently played an important role: Ming novels, the *Dream of the Red Chamber* (红楼梦 *Hongloumeng*), as well as Tang and Song poetry, too, were read during the Cultural Revolution by almost everyone interviewed. In spite of the fact that school teaching may have regularly substituted Mao's poetry for classical texts, classical poetry had not disappeared:

> Mao's poems cannot be considered Classical Chinese [文言文 *wenyanwen*], really. Of course, some of his old-style poems [旧体诗 *jiutishi*] we would read in school, but as for important Tang and Song poets, Su Shi [苏轼, 1037–1101] and Li Bai [李白, 701–63] and Du Fu [杜甫, 712–70], we would read them, too, and really it appeared to be perfectly okay to read them. (Intellectual, 1958–)

One musician (1942–) had included a Tang poem in his "revolutionary photo album" dating back to the second half of the Cultural Revolution. He was quite taken with my surprise at this: "Of course we would memorize these poems during the Cultural Revolution."

How much each individual actually read in spite of the restrictions, and how that individual reading compared to the amount of reading done before and after the Cultural Revolution in these genres, may have differed greatly from one person to the next. Many youngsters did not go to school for months on end, a factor which may (or may not) have worked favorably in terms of allowing them time and opportunities for extensive reading. And while reading remained a

primarily urban phenomenon—all of these memories of libraries are urban memories—it was carried (literally) to the countryside, as well. Dai Sijie's story *Balzac and the Little Chinese Seamstress* (Dai 2000) gives one fictionalized impression of a phenomenon frequently remembered: rusticated youths and intellectuals were reading, even in the countryside, and some of them were teaching what they read to the peasants. There is visual propaganda to support this: documentary photographs as well as fictional propaganda material published all throughout the Cultural Revolution would show young and old joining together, reading—except that it is usually Mao's works, not Tolstoy or Balzac they are reading. In one of these images, we see an old man teaching rusticated youths (**ill. 11.1**); in another, we see two rusticated youths, taking a break from their hard work to read a book together (ill 11.2).[1] To what extent this was actually taking place and was extended to readings other than Mao, thus opening possibilities for uneducated people to get to know classical and translated literature themselves, remains to be further investigated.

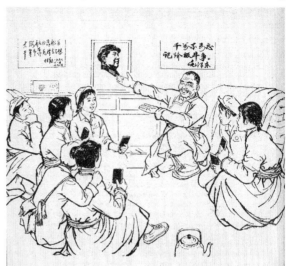

Ill. 11.1. Reading during the Cultural Revolution (*CL* 1968.11:2).

To sum up the evidence from oral history: How much an individual would have read during the Cultural Revolution depends on his or her class background (the children of workers may have read less than those of intellectuals, simply because they lacked access to a library) and the locale at which the reading took place (the countryside could offer only as many books as the sent-down youth were able to carry with them and share with each other, and there was probably little variation, whereas the situation in urban areas may have been dramatically different). One sent-down youth compares her urban and rural reading experiences as follows:

> At home, with all these girls' and boys' parents gone to labor camp, we would meet all the time. We would read things like [Rolland's] *Jean Christophe* and then listen to music by Beethoven. Everybody would do that. Really, *Jean Christophe* was one of the most popular novels all along. And what we did was somehow like group education; the books just moved from one to another and then became a topic for conversation, and we would develop these collective fantasies to write great novels ourselves. Music actually always went along with these readings. Of course, it was not allowed, and I seem to remember that all of these books that we passed on had paper covers. Yes, I remember, they all had covers. I was thirteen then. I knew and had read so little before, and so for me, this whole period at the beginning of the Cultural Revolution was like a great awakening. A few years later, in the countryside, I brought some of my own books and I borrowed books from others. I was really interested in detective stories, for example, which I discovered there. I loved reading those from the 1940s and 50s. (University Professor, mid-1950s–)

Was such reading dangerous? Many interviews seem to suggest so: one would learn to finish a book quickly because one was so afraid of being caught, one would cover the title pages of all books in paper so they would not immediately be recognized, or one would never take a suspect

1. More such images are included at the beginning of Chapter 4 (**ills. 4.1–4.6**).

book outside the confines of one's home. The many stories of being called in for reading suspect works, too, surely speak an unmistakable language. Who dared to read in spite of the dangers it may have involved and who did not again probably depended on one's respective class background and position: someone working as an editor may have felt particularly pressured to go by the (often unspoken) rules; someone whose parents had been labeled counterrevolutionaries, too, may have felt he or she had reason to do so.

> There was nothing to do, so I would just read in the library, Mao's writings, for example, his unpublished papers and all that. There was nothing else, really. They did not allow us to read any "feudal" or "bourgeois" literature. And of course we did not dare borrow books that were "feudal, capitalist, and revisionist" I did not dare read them either. I already was a counterrevolutionary's kid. I also would not say anything. They could turn everything into the "words of a counterrevolutionary." (Businesswoman, 1940s)

Yet, the question of "to read or not to read" was handled in radically different ways by families even of the same class background and political standing: while one might forbid, another might clandestinely allow, and a third might even encourage the reading of "forbidden books."[2] While one interviewee who frequently broke into libraries (see above) remembers, "my father would not let me read these old things" (Intellectual, 1955–), another with a rather similar background and from the same generation says:

> I read everything in primary school and middle school. I read Stendhal's [1783–1842] *Red and Black*, and all the books we had at home.[3] There were no restrictions on what I could read . . . at home. Indeed, my father would always make us learn things by heart—Tang poems, for example. In the 1970s, I also saw quite a lot of *spoken drama* [话剧 *huaju*] plays. (Intellectual, 1958–)

Not only were people defiant in their reading practices, then, but cases of open, outright, and witty defiance when caught with "dangerous" readings were not the exception, either. This is what one interviewee remembers:

> One day when they searched the house, they found some books and called me in. I said: "How can I criticize these books without reading them?" That killed that conversation altogether. Although I obviously was not thinking about criticizing these books, really, they could not say anything. Mao says that if you want to know how carrots taste, you have to taste them, and they knew that, too. (University Professor, mid-1950s–)

Such audacity was facilitated by the fact that a lot of reading of "black literature" actually and officially took place under the auspices of criticism movements to eradicate such literature. Black literature was widely available and earnestly discussed. Yet, whether or not this literature could in fact be appreciated while it was being criticized is a point around which memories differ quite radically from each other. One journalist (1946–) remembers that to her, even hidden enjoyment of these works would have been unthinkable:

> During the Cultural Revolution, it was not possible to borrow or officially buy these foreign books and traditional books. This was possible only during the criticism movements, but then, you would read them for criticism. If you were to use and read them, because you enjoyed them—mmh— . . . it would

2. One interesting fictional example of these different attitudes that even divided families is the discussion between Xiao Li's parents over the clandestine reading of Tolstoy's *Anna Karenina* in Wang Shuo's *Waiting* (等待 *Dengdai*). See Wang 1978.

3. For a criticism of *The Red and the Black*, see *Xuexi yu pipan* 1975:1:61–69 Liu Dajie "读红与黑."

have been strange to actually enjoy them. . . . On the other hand, there was a lot of looting of houses by Red Guards then, and such black books would be taken. Libraries, too, would be destroyed: when we stole books at these occasions, it did not really feel like stealing, and thus, we read a lot of black books just by accident, only to be astonished about the kinds of criticism raised later. (Journalist, 1946)

She admits to enjoying black books before they were officially and openly attacked and criticized, but she could not imagine enjoying them while they were being criticized. Her opinion is not shared by everyone, however. This is what a musicologist (1950s–) remembers:

In the 1970s we read quite a bit of Russian literature. . . . While there was a lot of criticism of "revisionist" literature, they published all these Russian novels as negative examples. We read them and actually thought they were great. Of course, people read their own things into such material (and this was just the same during the Campaign to Criticize Lin Biao and Confucius). All of these criticized novels in fact were an important influence on us. We were not supposed to like them but did so, anyway. It was just not the same as all this trite and predictable worker-peasant-soldier literature we had been reading!

His view is echoed by a historian from the same generation who emphasizes once more that, in spite of official restrictions, all through the Cultural Revolution years a lot of reading was done, both extensively and indiscriminately, and it encompassed both traditional and foreign works:

There was very little to read. We all thought it quite monotonous. But when there was all this criticism of the old novels we had never read, we would go off to the library to steal them and see for ourselves. The libraries kept all these "feudal," "capitalist," and "revisionist" things [封资修的东西]. On the one hand, then, we would attend these sessions and read Mao's Works, and on the other, we would also read these things—*How the Steel Was Tempered*, for example, and then this book about Chiang Kaishek, this was everyone's fare. (Historian, 1950s–)

A great many myths about Cultural Revolution Culture have been perpetuated both in foreign and in Chinese language writings. The idea that the Cultural Revolution negated foreign culture is one of them; another is that it destroyed Chinese traditional culture. It is for these reasons, too, that the Cultural Revolution is singled out—and this is a third myth—as an exceptional period in Chinese history, unprecedented in impact and scale. As with all myths, there is some truth to these: the Cultural Revolution saw the destruction of Buddhist, Daoist, and Confucian temples, representative of a so-called "feudal heritage." It was a time when artists went to prison for painting in certain styles condemned as "aristocratic" such as bird-and-flower painting (see Part III). And it was a time when traditional musical instruments such as the literati zither (古琴 *guqin*) had to be hidden away in order not to be smashed because of their association with "aristocratic intellectualism" (see Part I). While all of this is true, one cannot deny that there were other periods in China's history—most prominently the May Fourth Movement with its fight against Confucianism and superstition in the name of science—that were equally if not even more iconoclastic.[4] Yet, far from demolishing China's cultural heritage, the Cultural Revolution (and the May Fourth Movement, too) actually helped perpetuate and, more importantly, popularize other important traditions within Chinese culture, as we have already seen in the case of Beijing Opera and local popular music and song. By political *fiat* these traditions were then spread to a much greater part of China's population than ever before (or after).

Beijing Opera was accepted as a "politically correct" part of Chinese traditional culture because it had "popular origins." This art form needed to be cleansed and refined, of course, from the point

4. See Ho 2009, especially Chapter 4.

of view of the ideologues, but it was then perpetuated in the form of the infamous ten revolutionary operas among the eighteen model works. In this second part of the book, I argue that it is only at first sight that this treatment of a popular tradition such as Chinese opera during the Cultural Revolution looks radically different from that of handling elitist traditions such as the canonical classical philosophical heritage or the revolutionary canon. Chapter 3 deals with the use and abuse of a Neo-Confucian Chinese primer, the *Three Character Classic* (三字经 *Sanzijing*), and Chapter 4 discusses Mao's works as the new "Red Classics" and their status and function before, during, and after the Cultural Revolution.

The *Three Character Classic*, which, alongside two other books—the *One Hundred Surnames* (百家姓 *Baijiaxing*) and the *Thousand Character Text* (千字文 *Qianziwen*)[5]—had been used as a primary school textbook to teach the basics of Chinese writing, historiography, and Confucian and Neo-Confucian philosophy and morality to school children since around the thirteenth century, was considered part of China's "feudal" traditional heritage during the Cultural Revolution. Accordingly, it was not officially used for teaching during this time. Far from it, it was criticized on a large scale in a political campaign ranting against both Lin Biao and Confucius (and implicitly Zhou Enlai) in the mid-1970s.[6] In the course of this campaign, factory workers, peasants, and soldiers were declared the "key detachment" (主力军) and backbone of the movement (an entire issue of the journal *Study and Criticism* (学习与批判 *Xuexi yu pipan*) is so entitled (*Xuexi yu pipan* 1974.2). Quite a few songs on this topic, too, were published (ill. II.3).[7] Propaganda posters reinforced this idea; one poster shows a group of workers just putting finishing touches on the slogan, "Workers, peasants, and soldiers are the key detachment in the critique of Lin Biao and Confucius," which has been painted, in large characters, on the wall of their factory. Others in this image are seen going off in swarms, with paper and poles in hand, energetically walking towards the viewer, quite obviously to put up even more posters and slogans outside while crowds are seen in the back, reading what has been posted on the walls (ill. II.4). Documentary evidence, too, shows workers, peasants, and soldiers criticizing Lin Biao and Confucius.[8] Why were workers, peasants, and soldiers designated as the backbone of the movement? Because they, according to the song, are able to "criticize with hatred the way of Confucius and Mencius, and thus to dig deep for the roots of Lin Biao's behavior" (狠批孔孟之道深挖林彪老根). Accordingly, during the movement, workers, peasants, and soldiers were expected to read and criticize the *Three Character Classic*. Numerous commentaries and critical editions on the *Three Character Classic* were published in their name.

It will be the purpose of Chapter 3 to show that a campaign such as this one may have ultimately served the perpetuation of Chinese traditional heritage in spite of its contrary goal. As was the case with Beijing Opera, this campaign confronted a much greater part of the Chinese population with, in this case, the Confucian heritage and Confucian values than would ever have been reached even if teaching had been continued regularly and without political bias during the Cultural Revolution years. We need more empirical evidence from memoirs, for example, to examine the actual effects of this short-lived practice.[9] The obvious popularity of Confucian morals in the years after the

5. Lü Kun 吕坤 (1536–1618), a literatus from the Ming, is often mentioned as the source of this combination of textbooks; see for example *YBMXSC*, 1. Whoever had mastered these three books was able to read around 2,000 well-known characters, thought to be a minimum requirement for basic literacy. See Zhang 1962; Rawski 1979; *YBMXSC* 2.

6. See Barnouin and Yu 1993, 262–63.

7. See *Gongnongbing shi pi Lin pi Kong de zhulijun* 工农兵是批林批孔的主力军 in CC Liu Collection *Chuangzuo gequxuan* 1975: 26–32, 31–32.

8. See images collected in DACHS 2009 Documentary Photographs, Cultural Revolution, Anti-Confucius Movement, Thomas Hahn.

9. Many of the memoirs we have focus on the beginning years of the Cultural Revolution rather than its second period and thus do not discuss this campaign in great detail.

Cultural Revolution, on the other hand—as apparent in soap operas such as *Yearning* (渴望 *Kewang*) from the 1990s, to give one example (see Chao 1991), or the foundation of Confucius Institutes since the 2000s, to give another example, and, concomitantly, the renewed popular interest in the *Three Character Classic* in kindergartens and primary schools in the PRC (Xinhua 2004)—points in a certain direction: It may have less to do with a revival of a long-lost (at least "for ten years" according to the 1981 Party Resolution) tradition, than with a perpetuation of these values through so-called "Black Material" (黑资料 *hei ziliao*) even throughout the period of the Cultural Revolution. What was lost and what was found in terms of traditional cultural heritage for different social groups and different generations during the Cultural Revolution must be reconsidered.

This is all the more so in modern and contemporary times, as the traditional practice of revering sages such as Confucius and of citing from their works has been perpetuated, in a continuous revolution, through the use of Mao's words and in particular the *Little Red Book* of Mao quotations. These classic "words of the Cultural Revolution" and their function before and after this time are discussed in Chapter 4. Geremie Barmé in his *Shades of Mao* includes the photograph of a plastic-covered *Little Red Book* published by the Cultural Relics Administration of Qufu County, Confucius' birthplace in Shandong, which contains not a text authored by Mao but one by Confucius, the *Confucian Analects* (论语 *Lunyu*) (Barmé 1996, 86). This reconceived *Little Red Book* provides an ironic commentary on the perceived canonic status and authority of both texts: by transfer, they are thus made to appear as equally revered, but also as equally propagandistic, equally popular. By reconsidering the power of Mao quotations, Chapter 4 emphasizes the continuing belief in the might and power of the words of "The Canon," a belief that has shaped Chinese history for millennia and continues to be influential today. It will illustrate that the handling of the canonical classical philosophical heritage differs only at first sight from that of an equally canonical modern philosophical heritage in the form of Mao Zedong Thought, which provides the most important "words of the Cultural Revolution." This chapter argues that even while more recent uses of Mao Zedong Thought may have changed some of its meaning (not unlike recent uses of revolutionary songs and the model works), these adaptations continue to somehow revert to some of the most essential characteristics of Mao Zedong's writings, and, most importantly, their authoritative power. In excavating and discussing some of the spoken and unspoken "words of the Cultural Revolution," I will attempt, in this part of the book, to undo the myth that China's traditional philosophical heritage and canonical practice as such was utterly destroyed during and by the Cultural Revolution.

CHAPTER 3

DESTROYING THE OLD AND LEARNING FROM BLACK MATERIAL: THE POLITICAL FATE OF A FAMOUS SCHOOL PRIMER[1]

Of course the Classical tradition was destroyed by the Cultural Revolution. There was so much criticism. We had never really read the Classics in school. But in order to criticize, you do have to understand the original, and that was wonderful in the early 1970s: there were so many books sold then,[2] and, believe me, I bought a great many: I was really interested. It was great to read all these things, *Water Margin* [水浒传 *Shuihuzhuan*] among them.[3] We were so young, and we thought, "There is so much more variety now!" (Museum Curator, 1950s–)

The Classics, sure, I read them a bit at home, never in school, however. Qu Yuan [屈原, 340–278 BCE] I liked,[4] but we did not read a lot of Confucius. During the campaign to criticize Lin Biao and Confucius, we would read a lot of Han Feizi, Legalist thought, that is. I thought that this was quite interesting and fun. I did not really participate in the great criticism activities. In a way, of course, we all took part, but some more, some less. It was not like the early Cultural Revolution, when they had locked me up. Things were much more relaxed than before. So I would begin to read a lot of foreign literature, too, at that time: Aleksandr Solzhenitsyn [1918–2008], for example. (Composer, 1937–)

During the "Campaign to Criticize Lin Biao and Confucius" or, in short, the Anti-Confucius Campaign, which took place from 1973–75, the Museum of Chinese Revolutionary History in Beijing published a "Selection of *Three Character Classics* for the Workers, Peasants, and Soldiers of the New Democratic Revolutionary Age" (新民主主义革命时期工农兵三字经选 *Xin minzhu zhuyi geming shiqi gongnongbing Sanzijing xuan*, XMZZY 1975), which brings together different renditions of the *Three Character Classic* published between the 1930s and the 1940s. The collection emphasizes in its preface that these "revolutionary" versions of the *Three Character Classic* are all the result of a struggle against the hateful ideas of the original *Three Character Classic* (革命三字经就是这种斗争的产物, ibid., 4). They are renditions of the classic work that, by taking on the very form of the original, are able to fight the ideas contained therein more effectively.

1. I would like to thank Frauke Meyer, who researched the new *Three Character Classic* of 1995, for many useful hints and advice. I would also like to thank Joachim Gentz and Natascha Vittinghoff, who provided me with many more *Three Character Classic* versions than I had collected. Helpful were also Jeffrey N. Wasserstrom, who sent me a copy of Perry Link's TLS article, and Hans van Ess, who has always been a patient interlocutor for questions concerning Wang Yinglin, Neo-Confucians, strange unicorns, and many other things. My thankful bows also go to Jennifer Altehenger and Huang Xuelei, who were so kind to think of me when they came across parodies of the *Three Character Classic* in the Shanghai Library, including the one mentioned first above, which has become pivotal to my argument.
2. For evidence of the increased print runs of books on classical philosophy, etc., see Clark 2008, 224.
3. For examples of critical articles on *Water Margin* see the poetry section and the section "criticisms" in *Zhaoxia* 1975.10; *Xuexi yu pipan* (*XXYPP*) 1974.4, *XXYPP* 1975.9, and *XXYPP* 1975.10 have several sections, one of them having the "workers, peasants and soldiers criticizing *Shuihu*." The criticism series is continued in *XXYPP* 1975.11 and *XXYPP* 1975.12; see also *XXYPP* 1976.2:29–34 and *XXYPP* 1976.6:26–27.
4. For criticisms of Qu Yuan, see *XXYPP* 1973.1:53–58.

By giving a thumbnail history of the uses (and abuses) of the *Three Character Classic* between the nineteenth and twenty-first centuries, this chapter attempts to illustrate the continuous if variable presence of this "traditional" book in the "modern" Chinese educated mind and as part of the "words of the Cultural Revolution." The first section of this chapter intends to show that—just as was the case with opera reform—the *Three Character Classic* and its form underwent constant reconceptualization and redevelopment that can be traced back to its first appearance in the thirteenth century. This evolution is considered here, through the spectacles of its "modern" reinterpretations, since the late nineteenth century. Through this process of editing and rewriting, a myriad of countertexts were engendered that not only inscribed themselves in the format of the *Three Character Classic* but that each talked back to the original by changing or subverting its meaning. In framing these texts in their intertextuality, I will show what the 1975 selection of revolutionary *Three Character Classics* mentioned above suggests already: that these parodies were critical of, and in many cases even negated, the message conveyed in the original, not despite but because of their identical format. I argue that parodies of the *Three Character Classic* published before and after the Cultural Revolution can thus be read respectively as predecessors and as successors to the radical redefinition in critical editions of the *Three Character Classic* during the Anti-Confucius Campaign. During this campaign, workers, peasants, and soldiers, both old and young, were asked to (re)read the *Three Character Classic* in a new light (**ill. 3.1**): as some of the

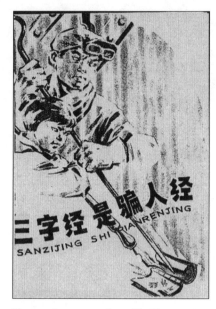

Ill. 3.1. Cover page from *The Three Character Classic Is a Cheater's Classic*, 1974 (SZJSPRJ 1974).

covers of these publications suggest, it was they, not the intellectuals, who would read and fight the *Three Character Classic* as a text that had been "cheating" them (三字经是骗人经) (*SZJSPRJ* 1974).

After a short historical survey of parodies of the *Three Character Classic*, this chapter traces the making of the peculiar rhetoric of the Anti-Confucius campaign in 1973–75. It focuses on one of the critical editions published during the Cultural Revolution Anti-Confucius Campaign, tracing the roots for such criticisms in earlier anti-Confucian movements and parodies of the work. It also discusses both the intended and the potential effects of these criticisms, as well as the effect of reading the *Three Character Classic* as black material, on the Chinese public during and after the Cultural Revolution. By stressing the continuities in the use and abuse of the Confucian Classics throughout modern Chinese history, the *Three Character Classic* being just one example, I hope in this chapter to illustrate that in its treatment of the Confucian heritage, the Cultural Revolution cannot be considered the great exception but rather follows the rules of modern Chinese cultural history.

Old and New: The *Three Character Classic* before and after the Cultural Revolution

三字经古今一奇书也.
"The *Three Character Classic* is one of the great books of all ages." (SZJPZ 1974, 3)

Not the Bible, not the Koran, but the small volume entitled *Three Character Classic* is considered by many Chinese the "most frequently read book in the world."[5] For more than six hundred years, and—with only a few exceptional periods—throughout the twentieth and into the twenty-first century, this was and is the first book given a Chinese (and Japanese, and Korean) child to read (Bischoff 2005, 7). Even those Chinese who never learned how to read and write are able to recite it:[6] primary school teaching consisted largely of the widely audible recitation of primers such as the *Three Character Classic*, and they were often read aloud at home, too.[7] Thus, in the memory of one student, "the womenfolk, though mostly illiterate, learned by ear a kind of second-hand audio-literacy and even to quote in their conversation the values in the primer, much the same as the Lord's Prayer was repeated in medieval times by illiterate Europeans" (Liu 1985, 193). Accordingly, many of its phrases have become winged words, idioms in everyday colloquial Chinese, most prominently among them the phrases pointing to the importance of teaching in Chinese culture: "Not to educate the brood is a father's blame; to teach without strictness is the teacher's negligence" (养不教, 父之过. 教不严, 师之惰.) (l. 17–20, cf. Bischoff 2005, 188–95) and "Jade that is not polished does not make a vessel [i.e., become a thing of use]" (玉不琢, 不成器) (l. 25–26, cf. Bischoff 2005, 205–13).[8]

The *Three Character Classic* has become the most popular of the old Chinese primers. It teaches the most important values in neo-Confucian philosophy in a manner easily digested even by an uneducated reading public. For this purpose, it uses very basic language and contains only a few complicated characters, with many character repetitions (Liu 1985, 191–92). Thus, it is very different from other Chinese primers such as the *Thousand Character Text*, for example, some seven centuries older, filled with sophisticated allusions and proud not to repeat a single character. It may be difficult to tell how popular the *Three Character Classic* was over time, and indeed, there are differing views on this matter. Zhang Zhigong, in his study on the Chinese education system, argues for a rather broad distribution, a view that is refuted by others, however (see Liu 1985 and Zhang 1962).

Whether or not the *Three Character Classic* was indeed taught to children in the countryside or whether reading it was more of a privilege of the educated classes, it certainly had the potential, because of its simple structure, to be widely used as teaching material for the uneducated. The regular meter and extremely short phrase length of three characters (unusual in Classical Chinese,

5. This conjecture is made in almost all of the prefaces to the *Sanzijing*, e.g., ZGFJMXWHPS 1989, 19; SZJBJXQZW 1991, 1; SZJBJXZG 1988, 2 and 99; ZGGDMXJD 1994, 2; see also Liu 1985, 191.

6. Vgl. ZGFJMXWHPS 1989, 19, SZJBJXZG 1988, 2: Both explain that every Chinese still knows a few sentences from the *Three Character Classic* by heart.

7. The school scene in the beginning of Chen Kaige's 1987 film *King of Children* (孩子王 Haiziwang) is a typical example of this.

8. On the influence of the *Three Character Classic* on Chinese culture generally, see the preface to ZGGDMXJD 1994, 2, which mentions a number of incorrect and some correct variations on phrases from the *Three Character Classic* in common use. In the introduction to SZJBJXZG 1988, 2, the author mentions that studying the *Three Character Classic* is very useful even today, as many of the proverbs in colloquial Chinese are derived from it.

although a first example can be found as early as the Han) eases the task of memorization (Liu 1985, 196). The beginning of the text reads:

Men at their birth	人之初
Are good <u>by nature</u>.	性本善
<u>By nature</u> they are *close* to <u>each other</u>	性相近
through habit they become *distanced* from <u>each other</u>.	习相远

Every three-character phrase forms a unit, and several units combine to form larger logical units (often underlined through jingle or rhyme structures, see, for example, Giles 1910, 55). From one phrase to the next, selected characters are taken up again and redeveloped. In the first lines, "nature" and "each other" are <u>repeated</u> twice, and the third and fourth line are constructed in parallel, with *antonyms* at the end of each line. It is clear that verses like these are not difficult to memorize or read.

In spite of its (relative) popularity, the origins of the *Three Character Classic* remain contested. As one recent edition puts it, "The *Three Character Classic* was the most popular primer in the Ming (1368–1644) and Qing (1644–1911) dynasties, but who exactly wrote it, when and how it was first published in book form, in all of these details we have no way of drawing accurate conclusions."[9] Almost everything we know about the original *Three Character Classic* has been put to the test over the centuries: the primer is commonly attributed to Wang Yinglin 王应麟 (a.k.a. Wang Bohou 王伯厚, 1223–96), an influential statesman and scholar who lived during the Southern Song (1127–1279) and Yuan dynasties (1279–1368).[10] This attribution generally still stands, in spite of the fact that there are references to a *Three Character Classic* even before Wang Yinglin's lifetime,[11] and in spite of the fact that the three-character format may have been used for children's instruction much earlier, perhaps during the Han (Liu 1985, 196). A veritable prototype for the extant *Three Character Classic* in terms of both form and content is Chen Chun's 陈淳 (1153–1217) *First Recitations for Primary School* (启蒙初涌 *Qimeng chuyong*) (Liu 1985, 196).[12]

In none of Wang's own works or works by his contemporaries is a *Three Character Classic* mentioned (SZJBJXZG 1988, 99). Only four centuries after Wang's death, in the commented edition by Wang Xiang 王相 (fl. seventeenth century) dated 1666,[13] Wang Yinglin appears as the author of the primer. And yet, the first extant copy of this commentary dates only to 1786 (Giles 1910). On the other hand, He Xingsi 贺兴思 (fl. 1850–60), the second important commentator on the *Three Character Classic* who worked in the Qing, follows Wang Xiang's attribution and does not question Wang Yinglin's authorship.[14] This is so in spite of the fact that at roughly the same time that Wang Xiang was working on his commentary, identifying Wang Yinglin as the author, a scholar from Canton, Qu Dajun 屈大均 (1630–96), mentioned a *Three Character Classic* in his collection of jottings, *Tidings from Guangdong* (广东新语 *Guangdong xinyu*) (*juan* 11, see Qu 1985), which he attributed not to Wang Yinglin but to Ou Shizi 區适子 (1234–1324) instead.

9. *SZJBJXZG* 1988, 99.
10. As Liu (1985) mentions, there are debates concerning his authorship; see also the Introduction to *Sanzijing* (*SZJ* 1986, 1); *ZGCTYWHPJCS* 1988, 65; *SZJBJXQZW* 1991, 1; and very elaborately in *SZJBJXZG* 1988, 99ff.
11. *SZJBJXZG* (1988, 100) mentions a certain Xiang Anshi 項安世 (d. 1208), who lived about a century earlier than Wang Yinlin and who mentions in his writings a *Three Character Classic*.
12. Cf. *SZJBJXQZW* 1991, 1.
13. The preface is reprinted in *YBMXCS*. It is cited in *SZJBJXZG* 1988, 99–100, where a number of other texts naming Wang Yinglin as author of the *Three Character Classic* are mentioned.
14. See the preface to his edition, reprinted in *CTMXCS* 1986, 43.

Other Canton authors, too, mention Ou as the author of the *Three Character Classic* (or as the author of another work entitled *Three Character Classic*).[15]

It is not only evidence such as this that makes scholars question Wang Yinglin's authorship. At least since the Qing there have been debates on the content of the *Three Character Classic*, as scholars point out mistakes in the text and contradictions between the text and the philosophical and political views that Wang Yinglin is known to have held.[16] Moreover, there are significant differences between the *Three Character Classic* and the philosophy put forth in similar sections of another primer that can be attributed with certainty to Wang Yinglin, the *Purple Pearls for the Beginner* (小学绀珠 *Xiaoxue ganzhu*). This book, for example, does not mention the *Four Books* (四书 *Sishu*) as required reading for an orthodox education, whereas the *Three Character Classic* does. Indeed, there are some who argue that the *Three Character Classic*'s very mention of the *Four Books* and the reference to Zhu Xi's primer *Elementary Learning* (小学 *Xiaoxue*), books that both became orthodox teaching materials only in the later Yuan dynasty, speak for a later date of origin in the Yuan, thus postdating Wang Yinglin (Fish 1968, 32–33).[17]

On the other hand, some scholars have pointed to Wang Yinglin's background as supporting his authorship of the *Three Character Classic*. According to some sources, Wang had worked as a teacher in a private school in his hometown and is said to have developed his own teaching methodology and to have written a number of primers (not all of which are extant) that helped students to memorize the most important facts in Chinese civilization.[18] This frame would fit precisely that of the *Three Character Classic*, which, by some commentators (He Xingsi among them) has been called a "pocketbook version" of Zhu Xi's *A Compendium to the Comprehensive Mirror* (通鉴纲目 *Tongjian gangmu*), or a comprised version of Sima Guang's 司马光 (1019–86) *Comprehensive Mirror for Aid in Government* (资治通鉴 *Zizhi tongjian*) (SZJ 1986, 2).[19]

The *Three Character Classic* advocates altruism, filial piety, and diligence, and promises that education and ardent study will lead to success. It is written in the admonishing voice of a teacher, especially dominant in the beginning and ending parts of the book. Following the opening remark on man's good nature (性善 *xing shan*) already cited above (lines 1–4) is a discourse on the usefulness of education (lines 5–44). Through stories featuring exemplary figures from Chinese

15. These details are related in *SZJBJXZG* 1988, 100. There is another, although now refuted, candidate for the authorship of the *Three Character Classic*, a certain Li Zhen 黎贞 (fl. 1380s), who lived during the late Yuan and early Ming and also wrote a three-character primer entitled *Three Character Instructions* (三字训 *Sanzixun*) (Ibid., 100–101). His authorship is easily refuted, however, as the part on history in the original *Three Character Classic* ends with the end of the Song.

16. *SZJBJXZG* 1988, 101. In his *Record from Arduous Studies* (困学记闻 *Kunxue jiwen*), for example, Wang supports the state of Shu instead of Wei during the period of the Three Kingdoms (Wang 1965). He argues that the former, owing to the kinship relations of its founding ruler, must be regarded as the legitimate successor of the Han empire. In the *Three Character Classic*, on the other hand, the state of Wei is put ahead of Shu in the historical section, thus making it the legitimate heir. It is doubtful that Wang would have done so; he therefore might not be the author of the book after all (Liu 1985, 194). On the other hand, not all editions keep to this order. Giles's edition and Zhang Taiyan's *Republished Edition* of the *Sanzijing* have it, but the *Huitu zengzhu lishi sanzijing* (*HTZZLSSZJ*, 8), for example, and other editions reverse it.

17. For a forceful argument on the Yuan origins of the *Three Character Classic* see *SZJBJXQZW* 1991, 1. It is also uncontested that Wang Yinglin, as one of the most proficient scholars of his time, was coming from a conservative philological tradition that was, at least implicitly, critical of some of the neo-Confucian ideas so prominently propagated in the *Three Character Classic*. Why, then, would he have written such a staunchly Neo-Confucian primer?

18. This view is refuted by James T.C. Liu (1985), who says that he could nowhere in the works of Wang Yinglin find mention of his teaching or textbook production.

19. Cf. *SZJBJXQZW* 1991, 3; and the Introduction in Giles 1910.

history (such as filial Huang Xiang 黄香, who would warm his parents' bed before they went to sleep in winter) the virtues to be acquired are elucidated (lines 33–44). This is followed by a section introducing general knowledge about the world (cardinal directions, different types of grain, human relationships, animals, instruments, etc., lines 45–106). Next comes a list of books that should be studied, their contents and authors (lines 107–74; this part contains a number of factual mistakes), then a short overview of Chinese history arranged by dynasty and their emperors (lines 175–266). The text ends with a section on exemplary students (lines 267–356), framed by the teacher's remonstrating voice, intimating readers to study history and to work diligently following the model of those exemplars mentioned in the text (lines 255–66; 329–56).

The *Three Character Classic* has been illustrated,[20] commented on, and translated (into Mongolian and Manchurian, for example). It has also been transformed and extended in manifold ways to be taught to contemporary school children in the ever-changing Chinese empire and beyond.[21] As its three-character format was almost immediately recognized as an effective literary didactic genre, it has throughout China's history been employed by writers of widely divergent origins and ambitions.[22] In the late Qing, a myriad of different versions circulated, including editions of the *Three Character Classic* for women, for example. The foreign missionaries active in China in the nineteenth century, especially the Protestant missionaries, all adapted their history of salvation in such a way as to fit the three-character format and called these *Three Character Classics*.[23] The Taipings, themselves influenced by the missionaries, advocated their new worldview in a short *Three Character Classic* (and they wrote their own *Thousand Character Text*, too). A *Three Character Classic of Current Affairs* (时务三字经 *Shiwu Sanzijing*) advocated institutional reform and the fight against foreign powers in China around the turn of the century;[24] those in favor of a new and reformed educational system in the early twentieth century wrote their own *Three Character Classic of New Knowledge* (新学三字经 *Xinxue Sanzijing*, XXSZJ 1902), full of new ideas, new flags, and new technologies. There were some anti-Japanese *Three Character Classics*, too, one of which was republished during the Anti-Confucius Campaign (*XMZZY* 1975, 24–28).

The Guomindang published a *Republican Three Character Classic* (中华民国共和三字经);[25] the Land Reform Movement in 1947 published its own *Emancipation Three Character Classic* (翻身三字经 *Fanshen Sanzijing*) (cf. *XMZZY* 1975, 35–41); and even under Mao, Deng Xiaoping, and their successors, hundreds of new *Three Character Classics* for women and men, for peasants,

20. The first illustrated version of the *Three Character Classic* was by Liang Yingsheng 梁應升 of the Ming (cf. *SZJBJXZG* 1988, 102).
21. These expansions were not just limited to its historical overview, which was usually lengthened by each of the respective editors up to the present of the publication. It appears that every edition would conceive of its own particular ending (see Giles 1910, Appendix III–VI; see also *SZJBJXZG* 1988, 102). For one very interesting individualist example, see the reprint of the *Three Character Classic* edition by Qi Rushan (*SZJJZ* 1988).
22. I have not been able to undertake an extensive study of all extant textbooks arranged in the three-character format (e.g., the Qing *Compass for Disciples* 弟子规 *Dizigui*, or the Ming *Girls' Classic* 女儿经 *Nü'erjing*, in some versions of which the three-character form is only used partially (both contained in *ZGFJMXWHPS* 1989). The focus in this chapter is on those that actually use the title *Three Character Classic*.
23. The Harvard-Yenching Library collection contains several editions by the London Missionary Society and Walter Henry Medhurst (the first dated 1823), and by the American Protestant missionary Henry Blodget (published in Shanghai in 1875), as well as another version annotated by Chauncey Goodrich of the American Congregational Church, with no date but published after 1875.
24. Mentioned in *SZJBJXZG* 1988, 103.
25. Mentioned in Ibid.

workers, and soldiers, and in all kinds of different formats have appeared.[26] The book's popularity has not waned in recent years, as new iterations written for specific audiences and focusing on a myriad of topics from morality to health, from television to Buddhism, continue to flood the market.[27] Most recently, the *Three Character Classic* has adapted to multimedia formats; even a cartoon trick film and interactive VCDs and DVDs have been created.

Taking a closer look at some of these more recent editions and parodied versions of the *Three Character Classic*, I will show that to reread and to recontextualize the book in accordance with pressing issues of the time, as happened during the Cultural Revolution, was not an exception but rather the rule in the treatment of this book throughout modern Chinese history (and perhaps earlier, too, but this must remain for someone else to investigate). The contextualized reading attempted here endeavors to illustrate that the *Three Character Classic* had a continuous if variable presence in the modern Chinese educated mind throughout the nineteenth and into the twentieth and twenty-first centuries, and this was not significantly interrupted by the Cultural Revolution. Indeed, as many of the earlier parodies and commented versions can be read as countertexts responding to and criticizing the original *Three Character Classic*, some of the criticisms voiced in the 1970s campaign can be shown to have roots in these earlier parodies of the original text.

The original *Three Character Classic* is openly addressed to men (or boys). It does mention a few exemplary women (e.g., Mencius' mother 孟母 [d. 317 BCE] and Cai Wenji 蔡文姬 [177–250]) but only addresses <u>boys</u> directly: at the end of the section on exemplary women, it concludes (lines 319–22): "They were girls, yet quick and clever. You <u>boys</u> ought to be on your guard. 彼女子且聪敏尔男子当自警." To write a *Three Character Classic* for women, then, was in and of itself an implicit critical response to this verdict and restriction. Similar to the *Four Books for Women* (女四书 *Nü Sishu*), which was inclusive of a "proper" *Analects for Women* (女论语 *Nü Lunyu*) so that women need not go back to the Confucian original, a whole series of *Three Character Classics* for women, rewritten and adapted from age to age, seems to exist. One of them was even compiled by none other than *Three Character Classic* commentator Wang Xiang (Hou 1986, 177). The *Four Books* and the *Three Character Classics* for women bear no relation but by name to their equivalents addressed to men. Thus, in spite of their critical potential, they inscribe themselves in the logic perpetuated through the *Three Character Classic*, which, by exclusively addressing boys, argues implicitly that male and female are different and therefore cannot be trained in the same manner. The same must be said for the Qing *Women's Three Character Classic* (朱氏女三字经 *Zhushi Nü*

26. For the 1950s and 60s alone, these are, for example, a *Three Character Classic for Women* (妇女三字经 *Funü Sanzijing*, FNSZJ 1950); a *Three Character Classic for Peasants, Workers, and Soldiers* (工农兵三字经 *Gongnongbing Sanzijing*, GNBSZJ 1951); a *Three Character Classic for Country Women* (农村妇女三字经 *Nongcun funü Sanzijing*, NCFNSZJ 1952); a *Three Character Classic* focusing on history (历史三字经 *Lishi Sanzijing*, LSSZJ 1963); a *Three Character Classic on Agricultural Techniques* (农业技术三字经 *Nongye Jishu Sanzijing*) (NYJSSZJ 1964); and a *Three Character Classic of the God of Epidemics* (送瘟神三字经 *Song Wenshen Sanzijing*) (SWSSZJ 1964). More parodies and earlier versions of the *Three Character Classic* are listed in Zhang 1962. See also ZGCTYWHPJCS 1988, 67.

27. The 1990s saw the publication of a *Morality Three Character Classic* for children (品德三字经 *Pinde Sanzijing*, PDSZJ 1994); an edition written especially for children (幼童三字经 *Youtong Sanzijing*, YTSZJ 1995); and another "newly edited" edition (新编中国三字经 *Xinbian Zhongguo Sanzijing*) with sections on morals, technology, literature, learning, geography, and history both ancient and modern (XBZGSZJ 1995). There is a *Three Character Classic* for peasants (农家三字经 *Nongjia Sanzijing*, NJSZJ 1997); one introducing Buddhist knowledge (佛教入门三字经 *Fojiao Rumen Sanzijing*, FJRMSZJ 2002); and many others, ranging from those teaching traditional knowledge and skills from ancient history to calligraphy—as in one of the *New Three Character Classics* (新三字经 *Xin Sanzijing*) published in Beijing in 1995, which presents the text in three different teaching fonts (XSZJ 1995a)—to others conveying the latest information about such things as health (防病三字经 *Fangbing Sanzijing*, FBSZJ 2004) or television and film (电视电影三字经 *Dianshi Dianying Sanzijing*, DSDYSZJ 2005).

Sanzijing) by the scholar Zhu Haowen 朱浩文 (fl. 1895) (*ZSNSZJ* 1901). It contains hardly any phrases from or references to the original (e.g., pages 8a and 29a), and there are but very few structural similarities between the two: the *Women's Three Character Classic (Zhu edition)* is also framed and punctured by the admonishing teacher's voice, and it ends with a long section of exemplars (here positive and negative, however, pages 26a–30); at the very end, it promises good repute for diligence just like the original *Three Character Classic*.

This book is not as obviously directed toward young girls as the original *Three Character Classic* is toward young boys. The implied audience, rather, is more mature: women and mothers. The book goes through all the motions of explaining how to raise well-behaved, virtuous girls, then wives, and finally mothers. It begins, quite typically for didactic literature addressed to women in the late Qing,[28] with a statement on the heavenly endowed difference between men and women, and its introduction concludes with the statement that for women, the aim of studying is to be a perfect mother (女道修母道得此始终可为则, Chapter 1, p. 2a). Accordingly, this *Three Character Classic* teaches not how to reach an official post like the original, but instead how to become a perfect, restrained, and quiet housewife and mother.

The second chapter elaborates on what are considered negative traits for a woman and provides lists of a few "do's" and many "dont's." The text is filled with all different kinds of admonitions and warnings (e.g., 毋勿无不莫). Women are advised, for example, not to be too talkative, not to jump around too much, not to go out (especially not to see plays or listen to drum-singers), not to eavesdrop, not to be outgoing, and not to reveal any part of their body. Next they are told not to drink and not to talk back. They are admonished to get up early in the morning, to take good care of their clothes, and to keep a clean house. In a later chapter, they are asked to feed the house animals, to keep the fire going and collect water at the well, and to lock up in the evening to keep robbers away. Chapter 3 teaches how to serve one's parents-in-law as well as one's husband and other members of the household, both in life and in death. Time and again, it admonishes women to be quick and honest, even about their shortcomings, and to follow instructions promptly, without asking too much, even if they realize that those giving the instructions are wrong or misguided! The fourth chapter finally teaches women to be strict and stern in raising their sons— it explains how they should clothe them, what they should give them to eat, and how they should advise their sons to study diligently—it also elaborates that one should be careful in raising daughters, too, teaching them restraint and womanly virtue (三从四德, p. 25a).

Not unlike the original *Three Character Classic*, then, this *Women's Three Character Classic (Zhu edition)* has a clearly defined purpose: to improve the morals of its readers. Not unlike the original, this text teaches the Confucian values of piety and restraint. But rather unlike the original, it does so not by introducing the universe of Chinese history and philosophy but by providing hands-on practical advice on how to deal with life and death in the home. The one repeated and only slightly amended phrase from the original that can also be found in the *Women's Three Character Classic (Zhu edition)* illustrates this perfectly: The phrase "Do this in the morning; do this in the evening" (cf. *SZJ* lines 265–66 朝于斯夕于斯 and *NSZJ* p. 8a 朝如斯夕如斯), refers to reciting and memorizing the histories in the case of the original, but to cooking, cleaning, and caring for one's parents-in-law in that of the *Women's Three Character Classic (Zhu edition)*.

The same passage is also alluded to in an early Christian version written by the Protestant Walter Henry Medhurst (1796–1857)[29] and first published in 1823 in Batavia, but in his version it refers to the necessity of daily prayers to the Lord, which should be practiced both in the morning

28. See Mittler 2004, Chapter 4.
29. Walter Henry Medhurst was the first London Missionary Society missionary in Asia. He worked in Malaysia and Batavia starting in 1817 and then in Shanghai and China after 1843 (see *JDLHWGRMCD* 1981, 323).

and in the evening (每日早当祈求又每晚不可休, lines 301–4).[30] This is not the only passage in which the Protestant *Three Character Classic* takes up gestures from the original. In another significant passage, its beginning lines—those insisting on human nature's inherent goodness—are echoed, only to be significantly changed in order to introduce the concept of original sin: "Man's nature now is inclined towards all manner of evil and does not follow what is good" (人之性今为偏向诸恶不从善, lines 53–56). In the end, this Christian *Three Character Classic* also replicates the direct appeal to the children, or, in this case, "young students" (尔小生, line 297)—significantly ungendered—but this remonstrative mode is only used at the end and not as a frame as was the case in the original.

Otherwise, Medhurst's *Three Character Classic* bears no similarities to the original. It begins with a characterization of God who created Heaven and Earth and all beings. Thus, it explicates Genesis, then goes on to introduce Jesus who has come to save mankind and to teach right and wrong (line 97ff.). The text continues to instruct how one can improve oneself and eventually receive redemption from one's bad deeds (line 146ff.); it explains the last judgment (line 255ff.) and ends with a strong appeal, even a threat, to the reader, to be good, for there is no happiness in death for the wicked (line 319). This missionary *Three Character Classic*, which, like the *Women's Three Character Classic (Zhu edition)* was written in a rather accessible and verbose colloquial style,[31] appears to have been rather popular. It was reprinted several times within only a few years.[32]

Whether the Taiping rebels—who would later be lauded by the Chinese Communists for their anti-Confucian attitudes[33] and who reigned powerfully in the heart of China for a good fifteen years (1851–64)—had seen some of the Christian *Three Character Classic* adaptations or whether their own, or their leader Hong Xiuquan's 洪秀全 (1814–64), version of the *Three Character Classic* was derived more directly from the Neo-Confucian prototype is not certain. There are textual parallels to both. In language, the Taiping *Three Character Classic* (*Taiping Sanzijing* 太平三字经 TPSZJ 1971) adheres more strictly to the terse structures of classical Chinese than do the versions of the *Three Character Classic* written by missionaries. Thus, it comes closer to the original. In terms of content, however, there are more parallels between the missionary and the Taiping texts than between either of them and the original. In its first part, the Taiping *Three Character Classic* briefly deals with God and the creation of the world, as does Medhurst's *Three Character Classic*, for example. It then turns to the Israelites' flight out of Egypt, their years of exile, and the arrival of Jesus, God's son and the world's savior: those who believe in him can be redeemed, it argues, while those who do not believe cannot (lines 1–148). The second half of the Taiping *Three Character Classic*, on the other hand, appears to be neither indebted to the original *Three Character Classic* nor to a missionary parody. It describes how the ancient wise emperors in China's mythical golden age revered God, but reverence for God diminished rapidly since the Qin dynasty (221–207 BCE) (line 169–) and was subsequently subverted or substituted with other forms of idolatry through the introduction of Buddhism during the Han dynasty (206 BCE–220 CE), for example (line 181–). Thus, God had to send another of his sons to fight the devil-demons on earth.

30. The Harvard-Yenching Library has a reprint of Medhurst from the text published in London in 1846 (Medhurst 1943). This version of the *Three Character Classic* has been translated by S.C. Malan as *The Three-Fold San-tze-king*, London 1856.

31. Unlike in the original *Three Character Classic*, logical units in these missionary parodies often consist of twelve rather than three or six characters.

32. Wylie 1867, 27 mentions the following editions: Batavia 1828, Malacca 1832, Singapore 1839 (smaller edition), Hong Kong 1843 (this revision was accompanied by a recutting of woodblocks and was printed in 1846 in London), and a new modified (?) edition that appeared in Shanghai in 1845. It was reprinted in a smaller format in Ningbo in 1848 and revised again by Medhurst in 1851, to be published in 1851 and 1856 in Shanghai, and again in 1852 in Hong Kong and Amoy. In addition, a number of editions inclusive of commentaries and illustrations also appeared.

33. These attitudes were displayed prominently during the Anti-Confucius Campaign, in *Study and Criticism*, too. See *XXYPP* 1976.4: 49–53.

This second son was Hong Xiuquan, the leader of the Taiping Rebellion, who came to the earth to separate the righteous from the wicked (lines 207–86).

Like the Protestant *Three Character Classic* discussed above, this part of the Taiping *Three Character Classic* ends with a reference to the serious consequences of the last judgment and a warning that "Hell is bitter, Heaven bliss" (地狱苦天堂乐, lines 281–82). And just as in the Christian and Confucian prototypes, the concluding section of the Taiping *Three Character Classic* addresses its readers directly (lines 287–88): the "little children" (小孩子) are here admonished to pray to God, to keep the Commandments, and to commit no sins as God is always watching over them. This is followed by a list of warnings, which comes very close to the Ten Commandments—do not lie; do not kill; do not steal; do not lust or practice lewdness (lines 327–32)—but departs markedly from any mention of Confucian virtues that are here, if implicitly, rejected. The text repeats that the good will be rewarded, the bad punished. It stresses how important it is to be honest and upright, for only thus can one be a (proper) human being, not a devil (小孩子正其身正是人邪是鬼, lines 341–46), a passage rather close to the original *Three Character Classic*, which asks, "If foolishly you do not study, how can you become (proper) human beings?" (苟不学曷为人, lines 335–36), or even worse, proclaims that one who does not study is not as good as even an animal or a thing (人不学不如物, lines 339–40). The similarities continue at the very end: both texts conclude with a distinct sense of foreboding and warning. In the original, it is said that only diligence will be rewarded (a sentence that also appeared in the *Women's Three Character Classic* [*Zhu* edition], in the section on teaching sons: "Diligence has its reward; play has no advantages. Oh, be on your guard, and put forth your strength" [lines 353–56]). In parallel, the Taiping *Three Character Classic* concludes: "God loves the upright, He hates the vicious; Little Children, be careful to avoid error" (347–50).

Once more, we observe certain structural and textual consistencies between different parodies of the *Three Character Classic*. Here as there, the simple rhythm of the short verses and a carefully selected assortment of basic Chinese characters are used to efficiently convey and propagate a particular moral code specific to a particular readership. All of these rewritings of the *Three Character Classic* make use of its obvious didactic effectiveness. Yet, by inscribing themselves in the authoritative format and filling it with entirely new content, they also change and sometimes subvert its message (exchanging Christian for Confucian values, for example).

This is all the more true for the illustrated *Three Character Classic of New Learning* by Yu Yue 俞樾 (1821–1906), which appeared in 1902 (*XXSZJ* 1902). In terms of illustrations, it keeps to a long-familiar orthodox iconography. Few images are strikingly "new" (**ill. 3.2**): the world map on the first page (T1a), the globe and setting sun (4a), the thermometer (7b), the clock (14a), the flags (19a ff.), the particular depiction of the sea (T29a), the silk factory

Ill. 3.2. Page from the *Three Character Classic of New Learning*, 1902 (*XSZJ* 1902, 7b).

(32a), a building (33b), the zoo (34a). Generally, however, the reader is presented with familiar imagery such as the allegorical depiction of a planet (2a), typically Chinese architectural features (13b, 14a, 22a ff., 30b ff.) and landscapes with their peculiar conic mountain shapes (13a, 27a ff.), their stylized bamboo, stones, and plants (24a, 26b, 6a, 12a), and their small lonely figures (2b, 25b, 25b, 39b) on minute little boats (3a).

And yet, this is a very different *Three Character Classic* from anything we have seen so far. It offers information rather than instruction, and from the complicated nature of the characters used here, it is clear that this is information not for the beginner but rather for the advanced student. This *Three Character Classic of New Learning*, then, is a handbook of scientific knowledge and lacks completely the moral exhortatory element prevalent in all of the other variants discussed above. The only reference to the Confucian prototype in this version is the very rough correspondence between the contents and the general knowledge section in the original (lines 49–106). The *Three Character Classic of New Learning* leaves out, however, all references to the roles and relations between humans, a section which reflects most clearly the (Neo-)Confucian worldview presented in the original (e.g., the 三纲 *san gang*, 53–56; the 五常 *wu chang*, 69–72; the 七情 *qi qing*, 81–84; and the 十义 *shi yi*, 89–106). The *Three Character Classic of New Learning* also leaves out all mention of plants and animals as appear in the original (73–80). It begins with thoughts on the structure of the world and the universe (51/52:1–5), the seasons and time (57–60:6–10a), the five elements (65–68:10b–12a), and the directions (61–64:12b–15a; the order is changed here with the elaborations on the five elements in the original). It then contains a geographical description of China and the world (15b–21b), introduces different geographical terms, from country to province to city to hamlet (15b–30b), and their architecture (31a–35b), then turns to rivers, deserts, and mountains (36a–38b), pre-writing, so to speak, the kinds of content that would appear in such specialized *Three Character Classics* after the founding of the PRC. Not unlike the general knowledge section in the original *Three Character Classic*, the three-character phrases here are simply lined up like lists, with no effort to form a coherent or logical narrative.

Although there is no explicit moral message propagated in the text, this *Three Character Classic of New Learning*, too, can be read as a countertext to the original. It offers no human exemplars. It does not emphasize the all-important study of history and human relations so clearly emphasized in the original. It does not ruminate on the sages of Chinese antiquity. Instead, it provides "objective," "scientific," and "technological" facts from the world at large. Thus, it looks towards the future rather than ruminating on the past. Perhaps even more radically than the parodies discussed so far, this *Three Character Classic of New Learning* offers a new view of the world, one that is indifferent to Confucian morality.

As the many commented editions published in this period illustrate, all of these parodies and redevelopments notwithstanding, the original *Three Character Classic* continued to survive throughout the Qing dynasty and into Republican years. But many of these re-publications of the original may in turn also be read intertextually as reactions to alternative editions of the *Three Character Classic* such as those discussed above. The heavy emphasis on the role of Confucius as a teacher in the *Illustrated History Three Character Classic with Commentary* (绘图增注历史三字经 *Huitu Zengzhu Lishi Sanzijing*), very sloppily produced in the early years of the Republic, appears to talk back to "secular" parodies such as the *Three Character Classic of New Learning* (ill. 3.3). Confucius and Confucian morality are prominent in illustrations and commentaries. The sage himself appears in four out of the twelve picture-commentaries (1, 5, 6, 10), and almost all other illustrations contain depictions of Confucian morals at work, such as filial piety, brotherly love (3, 4), and devotion to learning rather than making selfish profit (2, 11, 12). The remaining pictures laud the victories of Han over Qin (7), Tang over Sui (8), and the revolutionaries over the

Qing (9), stressing in each case the return to (Han) Confucian order and stability.[34] The commentary also emphasizes the necessity of studying history (a topic left completely untouched in the *Three Character Classic of New Learning* for example). As if out of spite, it argues that one *must* study history in order to understand the reasons for the rise and fall of governments (必须于历史之实录古今之事迹详加考核).

It is for this reason, too, that Qi Lingchen 齐令辰 (fl. 1900s), the father of an up-and-coming opera expert, Qi Rushan 齐如山 (1877–1962), wrote a commentary to the *Three Character Classic* for his son (Qi 1988).[35] In his edition, he substantially reworks the historical passages of the original, adding not just explanations and dates but quite a bit of moralizing and politicizing, too (as, for example, when he explicitly says that the Qin had been called an "autocratic" regime (秦嬴政专制称, 211ff., 3b). Most significantly, however, he concludes with a comment on the necessity of learning ancient Chinese history while never forgetting modern and foreign history. Again, his text and his attitudes toward what constitutes knowledge appear to have been conceived and reconceived in dialogue with other ways of learning that had since entered the world of the *Three Character Classic* and its parodies.

In Zhang Taiyan's 张太炎 (a.k.a. Zhang Binglin 炳麟, 1868–1936) roughly contemporary versions of the *Three Character Classic*, this dialogic structure (which, by referring to the past, actually makes a stab at the present) is again quite obvious. Zhang publishes two edited versions of the *Three Character Classic*: the first to appear, the *Three Character Classic Edition with Additions* (增訂本三字經 *Zengdingben Sanzijing*),[36] contains only a few changes to the original: it adds a few lines on geography and climate (after line 68 in the original) and a few lines on the arts, language, and dictionaries (after line 106 in the original). Here, Zhang also emphasizes that if one knows how to look for information in dictionaries, etc., one will be able to find everything—perhaps implying that rote memorization is no longer a prerequisite of knowledge. The historical part in this *Three Character Classic Edition with Additions* contains more details on the Qing and early Republican years than the later *Republished Edition* (重订三字经 *Chongding Sanzijing*) published under his name. It mentions the Qing emperors by name, does not leave out the rebellions under emperors Daoguang 道光 (1782–1850) and Xianfeng 咸豐 (1831–61), and speaks of difficulties with the English and the French. But the later *Republished Edition*, which came out in 1934 with a preface from 1928 (*CDSZJ* 1934), contains many additional passages and changes from the original (the text is longer than the earlier text by one-third).

In his preface to this later edition, Zhang writes that he is not willing to see China's historical heritage lost. He complains that even among university students, few people know the Chinese Classics or are familiar with the dynastic successions in Chinese history. And yet, he no longer considers trying to make them go through the rigorous training of the Classics and Histories, as was once possible, an option. On the contrary, Zhang calls this idea an attempt to "make the blind

34. In the commentary below picture no. 5, the Qin is also accused of having neglected the use of the *Zhouli* (周礼) in government. The Han, on the other hand, is said to have reinstated this usage. In the commentary to picture no. 7, the Qin are again mentioned as hegemons and great destroyers rather than good rulers. The commentary under picture no. 10 formulates that the "People's Army" rose up and retrieved Han territory (民軍起義光復漢土).

35. Qi 1988. The original is not dated, but it was reprinted in Beijing in 1988 as Qi Lingchen *Sanzijing jianzhu* (齐令辰三字经简注).

36. This version is reprinted in a Taiwanese edition of the *Three Character Classic* with explanations (XYSZJ 1992, 261–66). One PRC edition, edited by Li Hanqiu and published in Beijing, reprints the text (see XSZJ 1995a, 91–94). The publication consists, however, of nothing else but the *Republished Edition* of the *Sanzijing* (重订三字经) without commentary and with only a few emendations.

see and the lame walk." Still, he hopes that at least in the digestible form of the *Three Character Classic*, students will learn a bit about Chinese history and philosophy. In a self-congratulatory note, he judges the *Three Character Classic* (in the particular form edited and corrected by him) far superior to any other contemporary primer.

Indeed, Zhang makes quite a few philological corrections and clarifications within the text: changing a passage and thus identifying the author for the *Great Learning* (大学 *Daxue*) (orig. lines 127–28, 8b); explaining the compilation of the *Book of Rites* (礼记 *Liji*) (orig. lines 151–52, 9b);[37] adding the information that Zhu Xi took out the *Doctrine of the Mean* (中庸 *Zhongyong*), and the *Great Learning* (大学 *Daxue*) from the *Book of Rites*; explaining the nature and method of counting of the Six Classics, as well as the subsections in the *Book of Songs*; adding a remark on the different philosophical schools (8b–10b). In the history section, too, he clarifies certain names (adding that the mythical sage emperors Yao and Shun are in fact identical with Tang and Yu, for example, 11b). He also inserts some remarks on the most important historical works (e.g., the *Records of the Historian, Hanshu*, etc., 17a). Thus, Zhang transmits philologically verified traditional knowledge. Accordingly, his edition of the *Three Character Classic* is considered as one contribution to the National Essence (国粹 *guocui*) movement of the time.[38] And yet, Zhang does not disregard "new learning" either: right in the beginning, he fills in quite a bit of information that distinctly reminds the reader of the *Three Character Classic of New Learning*. He adds passages concerning geography, the climate, plants and animals, and political administration, while at the same time not omitting information about the world at large (2b–5b).[39]

His editing in some sections betrays a certain ideological bent, too. In the history section, for example, he adds a line on the quality of the Zhou (1027–256 BCE) government and calls it a *gonghe* (共和), a term that could be translated as "united in purpose," but which is more prominently used, at the time, to stand for "Republican" (12b). Later, he adds a passage on famous philosophers and mentions political figures such as Qu Yuan, Dong Zhongshu 董仲舒 (179–104 BCE), Liu Zongyuan 柳宗元 (773–819), and the Cheng Brothers (Cheng Hao 程颢 [1032–85] and Cheng Yi 程颐 [1033–1107]. His point is that their works are worth reading not so much because they were great sages but because they were "upholding the ideas of the people" (振民风 *zhi minfeng*)—in other words, idealizing some form of "democracy" (18b). He also concludes, in a slight but significant variation on the original, that one should learn and strive to perfect oneself not to serve the sovereign but to save the country and to benefit the people (幼而学壮而行上致君下泽民 [SZJ 1986, 341–44]; 幼习业壮致身上匡国下利民, CDSZJ 1934, 22a). This *Three Character Classic*, then, not by parody but by use of historical allusion, advocates—as a typical product of its age—a nationalist and patriotic republicanism.

The 1930s and 1940s saw the continued production of *Three Character Classic* parodies. The fact that some of these were reprinted during the Anti-Confucius Campaign in the early 1970s (in the selection mentioned at the beginning of this chapter, *XMZZY* 1975) is one indication that many of the criticisms launched during the Cultural Revolution against the original *Three Character Classic* indeed echoed the implicit criticisms made in alternative editions of the book produced much earlier. The justification for connecting the two periods is quite obvious when one looks closer at some of their texts: one of the alternative editions first published in the 1930s and revived in 1975 is the very short *Three Character Classic for Workers and Peasants* (工农三字经

37. He corrects the mistake in the original where the *Book of Rites* is said to be authored, rather than compiled. See *SZJBJXZG* 1988, 104.
38. See *SZJBJXQZW* 1991, 3.
39. The introduction in *SZJ* 1986, 3, which contains text from Zhang's *Republished Edition* of the *Sanzijing*, lauds Zhang's emendations and emphasizes the particular importance of knowing something about one's position in the world.

Gongnong Sanzijing, XMZZY 1975, 14–16). It talks of the difficulties for workers, peasants, and soldiers, whom it calls the "creators" (创造者) of world history in one of its initial phrases (*XMZZY* 1975, 14). How they are being suppressed and underpaid, how they suffer from having to hand over dues to exploitative landlords—all of this is the subject of the short 1930s text. The CCP and the Red Army, however, appear as *dei ex machina* in the last third of the text: they introduce land reform and help to beat up and expel corrupt landlords. The text calls on its readers to unite in order to accomplish such "great things." With this final twist, the text appears exhortative in a manner reminiscent of the original *Three Character Classic*. Yet here, the encouragement goes less in the direction of "educate oneself" and more in that of "come and join the Communist cause" (*XMZZY* 1975, 16). The Cultural Revolution edition of this *Three Character Classic* stresses its particular popularity, mentioning that many hand-copied editions of the book had been circulated and that the last page of the printed edition actually had a note saying "reprinting welcome" (欢迎翻印) (*XMZZY* 1975, 14).

Similarly popular did the Cultural Revolution editors call another *Three Character Classic for Peasants, Workers and Soldiers* (工农兵三字经 *Gongnongbing Sanzijing, XMZZY* 1975, 17–23), which probably also dates back to the 1930s and which is quite openly political in nature: it rails against "imperialists" (subsuming merchants, diplomats, missionaries, investors and industrialists), the GMD and its government, and the warlords. The language it uses is rather coarse; at one point near the end, it says, for example, that "all the –isms advocated by the counterrevolutionary Nationalist Party sound like dog farts" (反革命国民党说主义狗屁响). The "feudal system," which is still intact, according to the text, in spite of "hypocritical" assurances by the GMD to bring it to an end, must be "eradicated" (将封建都肃清).

Politics remains an important factor in the production of alternative *Three Character Classics*. The 1940s saw the publication of an *Anti-Japanese Three Character Classic* (抗日三字经 *Kangri Sanzijing, XMZZY* 1975, 24–28) which, as one of the first of its kind, mentions Mao as China's "real hero" able to unite the Chinese people to fight to the end (共产党有主张打到底不投降毛主席真英明讲政治论战争) (*XMZZY* 1975, 25). This tenor is echoed in later *Three Character Classics* such as a *New Illustrated Three Character Classic* (绘图新三字经 *Huitu Xin Sanzijing*), which may be dated to 1947 (*XMZZY* 1975, 29–34) and which calls Mao, who appears prominently in the illustrations (ill. 3.4), a "savior of the nation" (咱领袖毛主席能救国能抗日) taking up on that well familiar phrase from "Red Is the East" (*XMZZY* 1975, 29).

The Land Reform Movement, too, published its own version, the *Emancipation Three Character Classic* in 1947 (*XMZZY* 1975, 35–41). This text begins

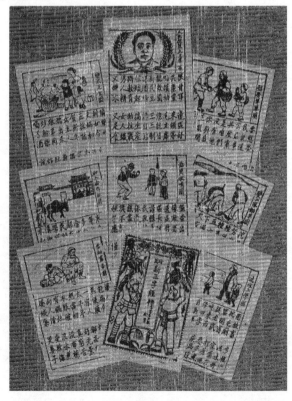

Ill. 3.4. Mao as savior in an illustrated *Three Character Classic* of 1947 (*XMZZY* 1975, 31).

with a direct criticism of the initial lines of the original *Three Character Classic* by stating, "Men at their birth were basically all equal, but later they would be divided into different classes" (人之初本平等到后来阶级分). The text then continues, "From this moment onwards, people began to bully each other, and landlords to oppress peasants" (从此起人欺人有地主压农民) (*XMZZY* 1975, 35).

Many of the themes of earlier revolutionary *Three Character Classics*—such as the criticism of feudalism and of the "old" and "suppressive" class society; the belief in the role of the masses of peasants, workers, and soldiers as "creators" (创造者) and as the new heroes in the making of history (旧英雄为个人新英雄为大众) (*XMZZY* 1975, 43, 57); and the importance of Mao Zedong and the CCP in creating an awareness of all of these facts—are taken up in another 1947 parody, the *Three Character Classic of the People's Army* (人民军队三字经 *Renmin Jundui Sanzijing, XMZZY* 1975, 42–60). In a section criticizing Chiang Kaishek and the GMD, the text proclaims, "Chiang Kaishek is our greatest enemy, the Communist Party a shining light" (蒋介石大仇人共产党是明灯) (*XMZZY* 1975, 57). A practice well familiar from the model works, of slighting negative characters by excluding them and building up heroes by allotting them more space, is evident here: while the GMD is only mentioned in eighteen three-character phrases as a whole, the CCP is praised eighteen times, and an additional twenty-one exultations deal with Mao Zedong (*XMZZY* 1975, 44–45). Many of the following sections, on the Red Army, the Long March, the Sino-Japanese War, the "People's War for Liberation" (人民解放战争), and the "Liberated Areas" (解放区) also deal, if more implicitly, with the heroic deeds of the CCP and its representatives (**ill. 3.5**). By

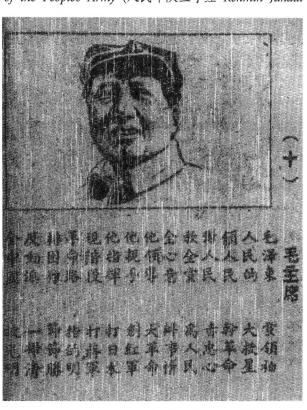

Ill. 3.5. Reverence for Mao in the *Three Character Classic of the People's Army*, 1947 (*XMZZY* 1975, 47).

including a long section on "The Three Main Rules of Discipline and the Eight Points for Attention," it focuses especially on the close connection between the Red Army and the people (*XMZZY* 1975, 51–52).[40]

Each of these *Three Character Classics* produced before the divide of 1949, then, is a distinct product of its own age and society, and each of them either silently abandons or openly criticizes the classical prototype. The same must be said for the alternative versions of the *Three Character Classic* published after the Cultural Revolution. The scientific 1980s saw new (or republished) *Three Character Classics* of medicine, geography, and history (*SZJ* 1986, 4; the online catalogue at

40. This 1928 text of an important revolutionary song is discussed in Chapters 1 and 2.

the Shanghai Library lists a dozen of these re-publications). The 1990s even brought about a production in the form of a TV cartoon. Here, children can follow the story of a future-age child, complete with robot doll and computerized household equipment, as he travels back in time to meet the heroes and exemplars of old. The cartoon is a remake of one of the many so-called *New Three Character Classics* (新三字经 *Xin Sanzijing*) that appeared all over China in 1995. The preface to the cartoon's book version states that "Every age has to have its particular *Zeitgeist* (时代精神)."[41] It argues that in this "golden age of great changes and developments," there is a "need to foster this *Zeitgeist* and the national *Geist* (民族精神)." Indeed, the preface argues, Deng Xiaoping's "socialism with Chinese characteristics" should be the kernel of the national *Geist*, and the *Zeitgeist*: "We have to teach our people, and we have to start with the small children." Accordingly, their *New Three Character Classic* is the product of an attempt to merge the virtues of socialism with those of the old Chinese primer.

All of the numerous *New Three Character Classics* that appeared in and around 1995 work according to the same pattern, a pattern we have already seen applied in earlier rewritings of the *Three Character Classic*, such as those by Zhang Taiyan or Qi Lingchen. They copy the text of the original rather closely but expand and amend it. Arguably the earliest *New Three Character Classic* (published in *Guangming Daily* [光明日报 *Guangming Ribao*] on 7 August 1994 and reprinted in book form in Beijing in March 1995) offers, according to the editorial remarks in the preface, historical, geographical, and other knowledge, intimating it through the use of exemplars and heroes (Mencius' mother and Huang Xiang from the original, as well as Deng Xiaoping and Mao Zedong from more recent times). This is done with the intent to teach China's children patriotism. This *New Three Character Classic* keeps rather closely to the order of the original text while making significant changes in content. The first four lines about the goodness of human nature, for example, are left out. Instead, the *New Three Character Classic* argues that society is made up of good and bad elements (良莠分 *liang you fen*). Differently from the original (lines 21–24), it explicitly addresses both boys *and* girls in its admonition to study diligently, emphasizing not that one should study while young but that there are myriads of things to be learned. This *New Three Character Classic* keeps up some Confucian moral virtues such as filial piety (the Huang Xiang story, for example, appears slightly earlier in lines 33–36) but neglects to stress the need for righteousness (义 *yi*) and the observance of proper rites (礼 *li*) (lines 25–32 in the original), which were particularly contested points from Confucian thought during the Cultural Revolution.

Even this short discussion of recent rewritings of the *Three Character Classic* makes clear that changes to the original are not made innocently but always with a particular ideological aim and purpose in mind. This aim and purpose—a sign of what is often called *Zeitgeist* in the paratexts accompanying these editions—contains, as we will see, remnants of some of the Marxist criticisms of the *Three Character Classic* from the time of the Cultural Revolution, as well as criticisms raised implicitly in many of the earlier parodies. Zhu Haowen's *Women's Three Character Classic*, which calls for the education of women, or the *Three Character Classic of New Learning*, which introduces new knowledge and thus looks more to the future than to the past, are earlier examples of this. However, it is a sign of the *Zeitgeist*, too, that in this 1990s *New Three Character Classic* the text of the "original *Three Character Classic*" is added without comment, at the end of the book, "in order to facilitate its study."[42] Although original texts would have been added to some of the critical

41. *XSZJ* 1995. The book was published in Guangdong in January 1995 and reprinted in Shanxi in April 1995 (*XSZJ* 1995b). The pages of the preface are not numbered.

42. The *Three Character Classic* reprinted here is Zhang Taiyan's *Republished Edition*. The text is wrongly identified as the *Zengdingben* edition (*Three Character Classic with Additions*), a fact that, in its very philological sloppiness, may well be another significant sign of the times. See the Beijing edition of *XSZJ* (1995a, 91–94), edited by Li Hanqiu.

editions in the 1970s, too, this was done to facilitate their criticism, not their study (although the latter, too, was one of its unwanted effects). It is a "sign of the *Zeitgeist*," too, that the prefatory remarks in the Beijing version of this *New Three Character Classic* mention foreign interest in the *Three Character Classic* as one of the motivations for creating the *New Three Character Classic*. And it is another sign of the *Zeitgeist* that this *Three Character Classic* was intended for private study at home (now promoted ever more forcefully in the one-child family) rather than officially in government schools.[43] It is a sign of ever-changing *Zeitgeist* that the postmodern 2000s would offer the original *Three Character Classic* in the form of a video text, introduce it as a method of studying calligraphy with the *Three Character Classic to Practice Calligraphy by Style* (钢笔书法三字经 *Gangbi shufa Sanzijing, GBSFSZJ* 2001), or present a completely multimedia version in the form of original text with *pinyin* and comics, calligraphy training, and stories and aphorisms from ancient times, as in the *More Than 137 Practical Comics of Sanzijing Stories* (多功能漫画三字经故事 *Duo gongneng manhua Sanzijing gushi, DGNMHSZJGS* 2002).

Indeed, since the early 1980s, a flood of reprintings as well as new editions of the *Three Character Classic* has appeared. The Shanghai Library Catalog lists almost one hundred publications called *Three Character Classic* since the mid-1980s alone. The version used most often is Zhang Taiyan's *Republished Edition* (*CDSZJ* 1934), which is now generally considered the best and most factually accurate version of the book. With a certain patriotic tenor, the prefaces to editions of this version of the book repeatedly mention foreign interest in the *Three Character Classic*, referencing translations into many different languages as support for this fact; the inclusion of the *Three Character Classic* in a Unesco publication on world primers is hardly ever left unmentioned in these publications.[44] Western interest inspires Chinese pride in the *Three Character Classic*. But first and foremost, the book is reprinted as "historical material" (sometimes apologetically, calling it a "feudal" primer— indeed, one of the editions is even published under the title *A Critical Evaluation of China's <u>Feudal</u> Primer Culture* (中国封建蒙学文化评述 *Zhongguo fengjian mengxue wenhua pingshu*), interlacing the prefaces with quotations from Marxist writers).[45] These re-publications argue, however, that these "feudal" elements are clearly evident and therefore not dangerous to readers (*SZJBJXQZW* 1991, 3)[46] who are able, on the other hand, by their perusal, to learn a lot about China's traditional culture (*SZJ* 1986, 2).[47] Thus, they advocate the *Three Character Classic* as a primer for private teaching and even mention that today and all throughout history, people everywhere, from little hamlet to large metropolis 遍及城乡无处不有, begin to learn how to read and write with the *Three Character Classic*.[48]

The re-publication of Qi Lingchen's Republican edition of the *Three Character Classic*, in 1988, for example, is commented upon as follows:

> The *Three Character Classic* is the most typical and most popular example of a traditional primary school textbook . . . It is written almost in a colloquial style and can be understood easily. Children like to read it. By reading it, they not only acquire the Chinese characters but broaden their knowledge, too.

43. DACHS 2004 "Old-Time Primers Revive in Modern Classroom" (*China Daily* 1 January 2004). There have been recent attempts, advised and supported by the government, to introduce the *Three Character Classic* in official kindergartens as well.

44. See *ZGFJMXSHPS* 1989, 19; *ZGGDMXJD* 1994, 2; Preface to the Beijing *XSZJ* 1995; and *ZGCTYYWHPJCS* 1988, 66–67.

45. See the preface in *ZGFJMXSHPS* 1989, 4. See also *SZJ* 1986, 2.

46. See the preface to *SZJBJXQZW* 1991, 3.

47. See also the prefaces in *ZGFJMXSHPS* 1989, 5; *YBMXCS*, 2; *ZGGDMXJD* 1994, 1 and 2–3.

48. The preface to *SZJBJXZG* 1988 mentions that in the countryside many people started learning how to read with the *Three Character Classic*. Cf. also *SZJBJXQZW* 1991, 3.

The *Three Character Classic* is an important document for the study of Chinese Culture. This is why, in recent years, it has been studied ever more often. (Qi 1988, see also SZJ 1986:2)

In order to understand to what extent these re-publications as well as the popular new versions of the *Three Character Classic* that appeared in ever growing numbers since the 1980s are reactions to earlier uses and abuses of the text, and in order to examine the presence and availability of the *Three Character Classic* even throughout the Maoist period, I will now examine the peculiar view and interpretation of the *Three Character Classic* and its message that was perpetuated during the Cultural Revolution.

Black Material: The *Three Character Classic* and the Cultural Revolution

> The black lists of the Red Guards were not important for us! We just read whatever we could find. But there were very few Confucian books. I read the *Four Books* and the *Five Classics* [四书五经 *Sishu wujing*] and all that during the campaign against Lin Biao and Confucius, when I was a soldier in Shanghai. We met in some building by the Shanghai city department—some [of us were] from the military, some workers, some from Fudan University—and then we would read together. Zhang Binglin was then considered a Legalist. The teacher we read this with had a lot of really interesting ideas . . . this is how I started reading these books. Indeed, one of the effects of this movement is that people actually read these books. Things like the old novels and all that—then, you could actually buy these books again. (China Historian, 1949–)

> I studied some Confucian Classics at home. My parents taught me; this is a very strong tradition in China. We read the *Three Character Classic* and all these things, the Confucian *Analects* [论语 *Lunyu*], too. When I grew up I would read the full texts. In everyday life, Confucian thought actually was very influential, there are some Confucian sayings that were used daily. (Journalist, 1946–)

> My experience with the Anti-Confucius Campaign is perhaps very atypical. We thought it did not really make sense, all that criticism. I read Mencius, even Laozi 老子.[49] I copied it all. I thought it was so beautiful. (China Historian, 1949–)

In his preface to the *Republished Edition*, Zhang Taiyan writes that he is not going to allow China's historical heritage to be lost. His outcry is from 1928—in the waning days of the May Fourth Movement, an iconoclastic cultural revolution that sought to do away with traditional beliefs and practices, first and foremost among them Confucianism. According to Zhang, very few students, even university students, had an understanding of the Classics and Chinese history then. He felt that many of them did not even know who the Duke of Zhou was, though he was so revered by Confucius. Zhang's grumbling remark sounds very familiar at a time when the detrimental effects on Chinese traditional learning and culture of the Great Proletarian Cultural Revolution of 1966–76, "with its attempts to shatter the traditional mould," are being reiterated frequently (Bakken 2000, 17). Recent studies indicate, however, that the alleged devastation caused by the Cultural Revolution on cultural production and educational achievements among Chinese may have been exaggerated (e.g., Pepper 1996; *Picturing Power* 1999; Feignon 2002; Han 2008). Both the verdict on the Cultural Revolution passed by the CCP in its authoritative "Resolution on Party History" ("Resolution 1981") and Zhang Taiyan's remark with regard to the earlier Cultural Revolution must be read as rhetorical, provocative in the case of Zhang, sedative in the case of the "Resolution," but not necessarily even meant to be "truthful" in either case.

49. For a typical criticism of Laozi during the campaign, see *XXYPP* 1974.10: 3–9.

The 1981 Resolution, which argues that the Cultural Revolution destroyed much of Chinese traditional Culture and that the Anti-Confucius Campaign was part of this story, does not lack an inherent logic: throughout the Cultural Revolution years, a continuous series of newspaper and magazine articles and booklets of anti-Confucian essays were printed and reprinted. This peaked in the late 1960s—in a first campaign against Liu Shaoqi 刘少奇 (1898–1969) in 1969—and again in the mid-1970s, when many of the materials written for this first PRC campaign were republished (Gregor and Chang 1979, 1076; Louie 1980, 98). The second campaign, with its aim to unify the Party behind "true" Marxism, began two days after the end of the 10th National Congress of the CCP. It was most virulent, roughly, between September 1973 and February 1975, and was accompanied by a constant flood of commentaries in the Party newspaper *People's Daily* (Goldman 1975; Starr 1974; Forster 1986; May 2008). Publications such as the Shanghai journal *Study and Criticism* (学习与批判 *Xuexi yu pipan*) or *Revolutionary Successor* (革命接班人 *Geming jiebanren*), and even the literary magazine *Aurora* (朝霞 *Zhaoxia*), (re-)published a large variety of anti-Confucian materials in the form of songs, (poster) images, poems, and articles beginning in 1973. The campaign saw its most fervent activity in 1974 and early 1975. In *Study and Criticism*, for example, critical articles accumulate between March and October 1974. The campaign slowly died down in 1976 with scattered articles on, for example, Kang Youwei 康有为 (1858–1927), Sima Guang, and Confucius as sages.[50]

In 1973, *Study and Criticism* began with quiet discussions of Confucianism, along with a biography of Confucius.[51] Other publications such as *Aurora* followed suit by offering biographical stories of the Confucian sages, such as Mencius 孟子 (c. 370–290 BCE), under disrespectable titles such as "The Second Boss in the Confucius Shop: the Story of Mencius" (孔家店二老板：孟轲的故事) (*Zhaoxia* 1974.3:64–71). Confucius' life story is told in several installments, each of them equally one-sided in its description. The sixth installment to the "Story of Confucius" (孔老二的故事) (*Zhaoxia* 1974.2:71–81) describes Confucius as he scolds his son for not having studied the rites. In the story, Confucius is described as an old man, not quite on top of the situation, who mumbles to himself. He keeps saying that everybody and everything has to go back to the *Zhouli*, the Rites of Zhou. This caricature thus epitomizes his "reactionary backwardness" for those who consider themselves true revolutionaries.

Throughout the critical months of the campaign, *Study and Criticism* introduced articles on different classical works and authors, many so-called legalists such as Shang Yang 商鞅 (d. 338 BCE), Han Feizi 韓非子 (280–33 BCE), and Li Si 李斯 (c. 280–208 BCE). It also published a number of anti-Confucian jokes from ancient writings (*XXYPP* 1974.7:23–28), as well as exegeses of the *Laozi* (老子) and the novel *Romance of the Three Kingdoms* (三国志演义 *Sanguozhi yanyi*) (e.g., *XXYPP* 1974.10:3–9). Criticism of the anonymous Ming *Girls' Classic* (女儿经 *Nü'erjing*), a parody of the *Three Character Classic* addressed to women, is published, too. The articles condemn the *Girls' Classic* because it encourages women to follow men, for example (剥开女儿经的反动画皮, *XXYPP* 1974.9:36–38). Not unlike the *Three Character Classic* itself, the *Girls' Classic* is then called a "cheater's" (and a "man-eater's") classic (女儿经是骗人经, 女儿经是吃人经) (36). Just as was the case with the *Three Character Classic*, however, even these articles acknowledge the immense popularity (进一步通俗化) of the traditional writings they criticize. The thoughts of Neo-Confucianism are considered very popular throughout, and this, so the critics contend, "makes their poisonous effect ever greater" (它流传愈广流毒也就愈深).

50. See *Xuexi yu pipan* (*XXYPP*) 1976.3: 38–43; on Sima Guang see *XXYPP* 1976.5: 67–72. Louie 1980, 98 mentions that many of these anti-Confucian articles came out in collected form by 1969 and were reprinted in the second campaign.

51. See, e.g., Liu Xiuming, 孔子传 *XXYPP* 1973.2:83–91 or *XXYPP* 1974.1:54–57 and 58–59.

The "Angry Roar" (怒吼) editorial in the March 1974 issue of *Aurora* was the first act in a long drama advocating greater involvement in the campaign against Lin Biao and Confucius in order to heighten people's awareness of the continuing so-called two-line struggle (深入批林批孔提高 路线斗争觉悟) (*Zhaoxia* 1974.3:3–6). Quoting from a discussion between Shanghai workers, the editorial suggests that involvement in the movement should be carried first and foremost by the masses of workers, peasants, and soldiers. Its first page is adorned with an image showing a factory background with tall smoke stacks; in front of it masses of people are all raising their right fists. On the left is a billboard with a number of small "big-character posters" pasted below a huge slogan "We must carry the struggle of criticizing Lin Biao and Confucius to the end!" (把批林批孔的斗 争进行到底) (*Zhaoxia* 1974.3:3–6).

Time and again, different journals and various other media[52] publish articles in which they call for the workers, peasants, and soldiers to serve as the backbone and the "key detachment" in the campaign to criticize Lin Biao and Confucius (e.g., as in the February 1974 issue of *Aurora* entitled such 工农兵是批林批孔的主力军).[53] It is the workers, peasants, and soldiers who are mentioned as authors of critical poetry (e.g., *Zhaoxia* 1974.2:3–5; also *Zhaoxia* 1974.3:22–25, 47). Aptly, this poetry also takes its metaphors from the social milieu of the workers, peasants, and soldiers. One such poem talks about the steel workers, for example, and hopes, quite cruelly, that "a wave of steel will tear down and break the Confucius shop" and that "steel water will drown Lin Biao" (钢涛 冲塌崩孔家店铁水奔腾淹林彪) (*Zhaoxia* 1974.2:3). Another equally drastically formulated poem—in which "waves of anger roll" continuously (怒涛滚滚) (*Zhaoxia* 1974.3:22–25, 24)— deals with how Confucian rites and morals (道 *dao*) hinder equality between men and women and even among men of different classes. The poem demands to "shoot them [i.e., Confucian rites and morals] with a cannon" (咱开炮), and it is this line that serves as the refrain of the poem. Ironically, with all this hefty anti-Confucian rhetoric, Cheng Renxiang 程仁祥, one of the poem's two authors, bears a "Confucian" name: 仁祥 Humanity Auspicious.

Clearly, most important about the anti-Confucius campaigns during the Cultural Revolution, and especially the second in the early 1970s, was the fact that workers, peasants, and soldiers, in other words, the common people, were to be in charge: the confident assumption, as one article puts it, that "we workers are (in fact) able to study the history of philosophy" (我们工人能够学好 哲学史) (*XXYPP* 1974.6:27–31), is substantiated and authenticated in the official media by personalizing the stories presented there. The articles assemble the subjective viewpoints of a number of different (working-class) individuals whose occupations are described in minute detail. Time and again, they are called to the fore, reminded never to stop venting their criticisms (see, e.g., the January 1975 issue of *Study and Criticism*, which carries the exhortation "Let's continue to successfully criticize Lin Biao and Confucius" [继续搞好批林批孔]).

The Cultural Revolution, so these sources suggest, was a time when Chairman Mao's call to "liberate (解放) philosophy from the confines of the philosophers' lecture rooms and textbooks in order to turn it into a sharp weapon in the hands of the masses" was heard, and his assertion that "philosophy is no mystery" did actually reach a broad audience.[54] Officially, the meaning of the

52. These articles are supported by reporting in *People's Daily* (May 2008); and they are translated into different media such as image and song, see II.3 and II.4.

53. See also some of the articles in *People's Daily* suggesting that, indeed, workers, peasants, and soldiers were to be made the "key detachments" in this campaign: *RMRB* 8 February 1974; *RMRB* 16 February 1974; *RMRB* 20 February 1974; and *RMRB* 4 March 1974.

54. *Philosophy Is No Mystery* 1972: Editor's Note. Kam Louie writes on this aspect: "Together with the call for more practical philosophy and going to the countryside, another important aspect of the Cultural Revolution policies was that the peasants themselves were encouraged to study and write philosophy. This philosophy, of course, was Marxist philosophy as interpreted by Mao in his *Quotations*" (1980, 88).

term "philosophy" (哲学) was, at the time, restricted almost exclusively to the writings of Mao himself, and, to a lesser extent, Karl Marx (1818–83). In the same way the term "literary Chinese" (文言文 *wenyanwen*) at the time was applied quite restrictively to classical poetry only by Mao Zedong. For classroom use, then, the classical texts of philosophy, history, literature, and poetry were replaced with Marx and Mao's writings, a practice discussed in more detail in the next chapter. Yet, classical texts continued to play a prominent role, especially during the anti-Confucius campaigns. Marxism would be used to evaluate Confucian writings such as the *Three Character Classic*, a fact epitomized in a Lanzhou publication entitled *Criticize the Reactionary Three Character Classic Using the Viewpoint of Marxist Thought* (用马克思主义观点批判反动的三字经 *Yong Makesi zhuyi guandian pipan fandong de Sanzijing* 1974) and taken up in one of the prefaces to a *Three Character Classic* edition published during the campaign: "We have to use Marxism-Leninism as our weapon to get rid of this poison [Confucianism] completely. The *Three Character Classic* and the teachings of Confucius and Mencius must be swept away right onto the garbage pile of history" (用马列主义武器彻底肃清其流毒, 把它与孔孟之道一起扫进历史的垃圾堆).[55]

In spite of the many vituperations, in spite of official criticism, and in spite of open neglect, Confucianism did not fare as badly as it could (or should) have at the time, however: the emphasis on "workers and peasants mastering philosophy" also meant that it was no longer the intellectuals' privilege to read and write on Confucian philosophy (Louie 1980, 94). Now, workers, peasants, and soldiers were expected to do so as well. Accordingly, brigades and factories, as well as schools and universities held study meetings and produced critical editions of Confucian works (Louie 1980, 89). A good two dozen editions of the original *Three Character Classic* (and probably many more), complete with critical commentary, were published within only a few months between late 1973 and 1974 (the Shanghai Library alone lists some 27 titles among its holdings).[56] Those who should have been reached and those who should have written (or at least participated in writing) the discussions, commentaries, and critical editions of the *Three Character Classic* were, again, the masses: that is, citizens from all walks of life, men and women, old and young, most of them unknown to posterity.

The official assumption of the widespread nature of involvement, both in terms of class and in terms of geographical spread, is reflected in the authorship of the publications accompanying this campaign: one critical edition, the *Critical Commentary to the Three Character Classic* (三字经批注 *Sanzijing pizhu*) (SZJPZ 1974), is authored by the Guangdong Railway Workers (in conjunction with experts from the Chinese Department at Sun Yatsen University). Another notorious collection of essays entitled *The Three Character Classic Is a Cheater's Classic* (三字经是骗人经 *Sanzijing shi pianrenjing*) (ill. 3.1), comes from the infamous Shanghai No. 5 Iron and Steel Plant (a stronghold of Jiang Qing's supporters). An evening school division from Linyi District in Shanxi published *The Three Character Classic Is a Classic Hurtful to the People* 三字经是害人经 *Sanzijing shi hairenjing* (SZJSHRJ 1974). In Hubei, *The Three Character Classic Is a Restorationist Classic After All* (三字经就是复辟经 *Sanzijing jiu shi fubijing*), subtitled a "selection of texts by workers peasants and soldiers criticizing Lin Biao and Confucius," appeared (SZJJSFBJ 1974). In Beijing, the topic was taken up again with *The Three Character Classic Is a Cheater's Classic of Treacherous Confucian and Mencian Teachings* (三字经是贩卖孔孟之道的骗人经 *Sanzijing shi panmai Kong Meng zhi dao de pianrenjing*) authored by a "small group" from the Beijing Measuring Instruments Factory (SZJSPMKMZDDPRJ 1974). The same group of workers was also involved in the publication of *Reference Material for Criticism of the Three Character Classic* (批判'三字经'参考材

55. SZJPZ 1974, 8; see also XMZZY 1975, 6–7.
56. Louie 1980, 127, with note 111 only mentions six editions.

料 *Pipan 'Sanzijing' cankao cailiao*), which they edited together with the Beijing Oil and Machinery Factory (*PPSZJCKCL* 1974). This and the collection of critical essays entitled *Harsh Criticisms of the Three Character Classic by Workers, Peasants, and Soldiers* (工农兵狠批三字经 *Gongnongbing henpi 'Sanzijing'*) published in Shanghai in April 1975 assemble essays from factories, army, work units, and communes in and around Shanghai and Beijing (*GNBHPSZJ* 1975). Another collection of readings on the *Three Character Classic* was published by a Wuhan cigarette factory and entitled *The Three Character Classic and Ten Such Reactionary Books: Collected Criticisms by the Wuhan Cigarette Factory* ('三字经'等十种反动读物：批注汇集武汉卷烟厂 *Sanzijing deng shizhong fandong duwu: pizhu huiji Wuhan juanyanchang*) (*SZJDSZFDDW* 1974).

These examples—themselves part of a stupendous publication record—suggest that it was (supposed to be) people from all walks of life involved in the criticisms (and thus also in collective readings) of the Confucian Classics in general and the *Three Character Classic* in particular. Children, too, originally the primary audience of the *Three Character Classic*, were presumably active in the campaign, as official editions of children's songs suggest. One such collection entitled *Songs Criticizing the Sanzijing* (批三字经口歌 *Pi Sanzijing kouge*) (*PSZJKG* 1974) can be attributed to the efforts of a small group at the First Middle School of the Gansu First Construction Works Bureau (*PSZJKG* 1974). In a review of one such children's edition, the writer quotes a young girl's experience:[57]

> When Wen Hung, grand-daughter of a revolutionary martyr, studied Chairman Mao's instructions and linked them with her own experience, she recalled the class struggle she had seen for herself when visiting a commune in the suburbs where a class enemy had plotted sabotage. She also recalled how her grandfather had been murdered by the Kuomintang reactionaries while trying to protect his comrades. These recollections filled her heart with hatred for the enemy, inducing her to make a forceful criticism of the Confucian doctrine that human nature is good. She wrote:
>
> "By nature man is good"—what bunk!
> Little Red Soldiers don't believe that lie.
> The landlords preached benevolence
> But plunged the peasants in dire misery;
> The KMT, who claimed "Man's nature's good,"
> Shed streams of blood yet didn't bat an eye . . .
> Little Red Soldiers can't be fooled, for we
> See clearly and we have the resolution
> To liquidate Lin Piao and old Confucius
> And grow up to persist in revolution.

By constantly citing these "popular" authors, the campaign projected a very "democratic" image (Gardner 1981, 332). The aim was to suggest to readers that this was indeed a campaign in which everyone, worker as well as peasant and soldier, could express their views alongside university professors and Party secretaries (Gardner 1981, 332). The high quality of these alleged "amateur" contributions, however (the commentary in the *Critical Commentary to the Three Character Classic*, for example, is extremely meticulous and philologically sound), must lead us to infer that these publications followed the standard practice of the time, one that would be pursued in all cultural fields, from music to painting: Less experienced authors and artists were guided and "assisted" to produce work that was acceptable in both a literary/aesthetic and a political sense (and in the *Critical Commentary to the Three Character Classic*, this collaboration is in fact made explicit by mentioning the "experts" from the Chinese Department at Sun Yatsen (Zhongshan) University as "collaborators"). Evidence from oral history, too, supports this practice.

57. *CL* 1975.6:107–8, see also *CL* 1974.6:86 and *CL* 1974.6:96–101.

These technical details notwithstanding, it is clear that while the Confucian writings were criticized by workers, peasants, and soldiers alike, this also meant—not just in theory—that the Confucian heritage was made accessible, presumably, to more Chinese than ever before (and after). This movement based itself on the Confucian primary materials, quoting more or less extensively from the original sources, while in earlier anti-Confucian movements (to be discussed in detail below) the arguments had been taken from the (then still more abundant) academic secondary literature.[58] The direct confrontation with the "black material," that is, Confucian texts, by anyone who chose, or was made to choose, to be involved in the movement was one of its most significant characteristics.

Theoretically, at least, the Confucian heritage was thus no longer the privilege of an elite: the Anti-Confucius Campaign may have helped to popularize readings that would never have been popular in a less political context or in another country.[59] It can be ascertained that this campaign did create a massive and promoted presence of Confucian texts (at least in the cities), rather than the more commonly decried absence of Confucian texts, at least during the years of the Anti-Confucius Campaign (1973–75). Craig Clunas is not the only one to remember buying the "seemingly randomly published classical texts that appeared without warning in the bookshops" (Clunas 1999, 49) at the time. According to Kam Louie, too, "in terms of publication of the Confucian Classics, the Anti-Confucius Campaign in the early seventies saw the greatest revival of Confucianism in modern times" (Louie 1986, 196).

Naturally, reading propaganda publications or official journals such as *Aurora* and *Study and Criticism* provides neither an extremely reliable nor realistic view of the campaign's reception. Mobilization of the masses and the mass line were of course primary objectives during the Cultural Revolution, evident in one of the key editorials published in 1966: "Our experience since Liberation proves that the transformation of customs and habits can be accelerated if the masses are fully mobilized, the mass line is implemented, and the transformation is made into a genuine mass movement" (但是解放以来的经验证明如果充分发动群众走群众路线使移风易俗成为真正广大的群众运动, 那末见效就可能快起来) (*RMRB* 1 June 1966). Yet psychological studies have shown that overly strict and inflexible discipline seldom brings about internalization of values, although it may allow for identification (Bakken 2000, 419; Pepper 1991, 541). Critical articles from "the masses," just like the children's song and the workers' poetry cited above, contained "many personal reminiscences of bitter days before liberation, and strong words of condemnation for those who, like Confucius, were said to have urged a return to a former system" (Louie 1980, 123–24). This evidence may indicate that identification with the criticisms on a personal level was common, especially among peasants, workers, and soldiers. Still, we cannot be sure how pervasive and successful the campaign was.

Secondary sources attest to only a lukewarm response to it (e.g., Barnouin and Yu 1993, 260, 265), but the empirical basis for these judgments is questionable. Foreign observers have generally been quite skeptical about political mass campaigns and their success in China. They do not acknowledge that propaganda often took the form of a self-organized grassroots activity in China. Borge Bakken's observation that in the 1980s and 1990s "mass campaigns in China have become increasingly formalistic, and their stifling character no longer has the 'building' power of

58. The reason for this fact may be that very little secondary literature had been published since the mid-1960s (Louie 1980, 89 gives statistics).

59. A similar case in point may be the fame of contemporary composers such as Qu Xiaosong and Tan Dun in China: only because they were officially declared to belong to a "Gang of Four" of composers in the late 1980s and criticized for it did they become popular public figures, an otherwise most unlikely fate for a contemporary composer anywhere in the world (Mittler 1997).

transforming people" (Bakken 2000, 432) ironically echoes the observations made by Charles Taylor, visiting China a quarter of a century earlier, in 1966, just *before* the Cultural Revolution began. Struck by an atmosphere of relaxation that "contrasted sharply with the ideological intensity of the (Great) Leap," he observed:

> The ever adaptable Chinese has learned to live with the campaigns. Bewildered at first, he has come to understand the mechanics and the methodology, since these hardly vary from campaign to campaign. Anticipating the required response, he can often beat the cadre at his own game. . . . All the evidence indicates that the reservoir of enthusiasm has been badly depleted. While it is impossible to deny that great numbers still show revolutionary fervor and genuine idealism, there is a growing apathy to the demands of the regime that borders on cynicism.[60]

If this was true in 1966, how much more would it be true in 1974? Or do we overestimate the negative effects of repetitive campaigns? How much of the alleged lack of enthusiasm is real, and how much is simply assumed by the outside observer, especially if he knows that (by the 1990s) "a major purge or large-scale political campaign has taken place on an average every second year in the entire period of the PRC's forty-five-year-long history" (Bakken 2000, 424)? Were people at all interested in the criticisms or the texts criticized during the Anti-Confucius Campaign? How much of the criticized text was ever read? Did people understand it, even like it? Or had they indeed become too tired of the successive political campaigns to even listen to this one "filled with philosophical and historical allusions"? Was the whole campaign indeed "considered by many as an esoteric intellectual discussion which failed to motivate one's daily life," as some would contend (Barnouin and Yu 1993, 258)? Did it therefore miss the very aim formulated for the Cultural Revolution: mobilization of the masses? Or did it change both people's knowledge of and their attitude toward the Confucian heritage? And if so, how?

Evidence from oral history is contradictory (and some of it was cited already in the Introduction precisely for this reason—to show that propaganda can be read in many ways). Few would contend that the campaign meant nothing to them, however:

> The Anti-Confucius Campaign certainly did nothing to popularize the Classics. It was all political, and it was all fake! The ordinary people never were confronted with the originals; they would read the modern Chinese translations, if at all. They did not actually go to the sources. (Musician, 1930s–)

Others were more positive in their judgment:

> Actually before that movement we did not read any of the Confucian stuff, and so through this movement we learned how important Kongzi [孔子] was … we were blind, then, of course, but somehow I did not think he was really bad. (Artist, 1954)

Some doubted that the campaign had an effect on "the masses"; they denied their active involvement in the movement and their knowledge of Confucianism, although not always their interest in reading the Confucian texts:

> It is true that during the Anti-Confucius Campaign many more books were available in the bookstores in order for people to criticize them. My whole family had gone to the countryside, but I stayed on, working in a factory in Beijing. I did not have a lot of contact with the workers; they called us the "intellectuals." It was difficult to be in contact with them. I understand, too, I was a pain for them.

60. He is quoted in Dittmer 1974, 51.

During the movement we did not read things together; there was a study team made up of us intellectuals, and we would read and then actually explain what we had read to the others! And really, the workers, they did not even know who this "Old Confucius" [孔老二 *Kong Lao Er*] was. So as for having these criticisms actually written by the workers themselves, no, that would not really have been possible. (Businesswoman, 1940s–)

The Anti-Confucius Campaign had its influence on the Conservatory, of course. Everybody had to take part, but they would not really tell us why we had to criticize Lin Biao and Confucius, or at least, we were not quite clear. We wrote some songs criticizing them. I remember one song with a very shrill and high note on the "Kong" for Confucius. We were teaching the students and we would meet with workers from the Shanghai Harbor and then criticize Confucius's ideas. But really, we did not understand much about this in the first place. Perhaps some of the workers took this opportunity to read some more books than before, of course. Intellectuals would always do this kind of thing anyway. The workers who supposedly published these essays did not write them; we wrote them. (Musicologist, 1922–)

Many skeptics emphasized the general ignorance about things Confucian among both intellectuals and the working classes, as well as the clear dividing line between them, in spite of years of socialist education, while admitting, between the lines, that the masses were somehow integrated into the new culture of reading after all.

I did not know anything about Confucianism. I had never read Confucian works; I really had no clue whatsoever. There were all these editorials on Confucius in the newspapers during the Anti-Confucius Campaign. But what we would study in terms of Confucianism even then was really not much. Of course there was a kind of popularization through the campaign, but the peasants—they still did not know who Confucius really is. On the other hand, they also did not care about the criticisms. But if these publications were in the name of workers and peasants, that was not real! (Intellectual, 1958–)

During the Anti-Confucius movement I was in Shandong. In fact, I was able to avoid it a lot. I did not really participate that much. Whenever you had to, of course, I would go, but otherwise, no! I was really interested in folk music at that time, not in this movement. Still, we read a lot of legalist stuff, and *yuefu* (乐府, Music Bureau Poetry), with an old teacher, and we even published and explained all these works. We studied them very thoroughly, and, in fact, I still have editions from these times. Did that popularize philosophy? I doubt it. The effect was not that great. Of course, things were collected and published. Of course, people who had never read classical authors before would read a bit of this now. For the peasants and workers, this may have been a big change. For us, too, in turn, it was really quite strange to think that *they* would now read this literature, too. (Ethnomusicologist, 1940–)

As for the Anti-Confucius Campaign, it did not help that much to educate the peasants and the factory workers in Confucianism, because they cannot read the classical language. All that *zhi hu ye* [之乎也, special particles used in the classical language] they don't understand any of it; they simply have no culture at all, really [没有文化]. But still, Confucius is great and has been great and will be great, and even those who, to the outside, criticized him then did not do so honestly. Mao always continued to read Confucius, really, so Confucius is the great sage of China and will and cannot be forgotten; it is clear they may have smashed his statue, but not to smithereens, so after the Cultural Revolution, they simply put it back together (Beijing Taxi Driver, 1958–)

Thus, quite often, they would contemplate that popularization of Confucianism may have been one effect of the campaign: if popular support for the criticisms was what the campaign aimed for, more or less widespread popular knowledge of the "black" materials, the texts and subjects criticized, may have been its *de facto* practical outcome. Many of the interviewees—from illiterate peasant to director of one of the most prestigious research institutes in China—point to the importance of this campaign for some of its participants. Quite a few would suggest that it was during the Cultural Revolution, and especially the early 1970s, that they "read more books than

ever before" (Journalist, 1949). To many, within the small reading groups they formed, the anti-Confucian criticisms were not all that important. On the contrary, these writings were read for very different reasons: "I just wanted to read the original books," said one (Musician, 1930s–). Another said, "I copied it all. I thought it was so beautiful" (China Historian, 1949–).

These experiences seem to support a conclusion also reached by Kam Louie in a study of criticisms of Confucianism since 1949: "The continual controversies surrounding Kongzi (Confucius) since 1949 testify to the intense commitment Chinese intellectuals seem to have made to Confucianism. Even when he is not supposed to matter, he matters very much." Louie concludes that people not only did not stop talking about Confucius during the Cultural Revolution, but indeed, one could argue that his conspicuous absence or negation made people want to talk about him even more (Louie 1986, 191). And clearly, this phenomenon was not just limited to intellectuals.

A final verdict on the effects of the Cultural Revolution campaigns against the Confucian heritage on the perpetuation of Confucian knowledge and Confucian values among the Chinese public, must be the subject of another book. A thorough study of textbook and curricula content used throughout the period between 1949 and 1979 and in several different areas of China would be necessary,[61] because one of the consequences of early Cultural Revolutionary policies on education was their decentralization and the strengthening of local community and Party control. This had been done in order to develop a system appropriate to the specifics of life and work in every respective community. Paradoxically, this lack of central control happened in a period perceived as dominated by an all-pervasive propaganda machine. Yet, it was only in 1977 that primary, secondary, and college curricula would be reunified again on a national basis with standard textbooks and teaching materials (Pepper 1991, 567 and 575).

It may be difficult to fathom, then, how the Cultural Revolution practice of teaching or criticizing Confucian writings influenced the perceptions of Confucius and Confucianism in China. What were the continuities with iconoclastic practices before and after the Cultural Revolution years? Findings from oral history suggest that the reception of the Anti-Confucius Campaign was extremely varied and ranged from great enthusiasm about the Confucian writings—(partly or completely) instigated (or not) by the criticism movement—to faithful belief in the campaign's propagandistic message.

In the following analysis of the particular use of the *Three Character Classic* during the Anti-Confucius Campaign in the second half of the Cultural Revolution, I am therefore interested in the intended as well as the potential (side-)effects of such anti-Confucian teachings. I will attempt to show that the reconceptualization of the *Three Character Classic* during this campaign (and throughout the period between 1949 and 1979) was an all but radical continuation of what had begun much earlier and would continue to the present day. It is my contention that this campaign, too, and the *Three Character Classic* editions and critical commentaries it engendered, merely constituted yet another inscription of new values and ideas into the form of the *Three Character Classic*, not unlike earlier alternative editions whose critical ideas this campaign often perpetuated, thereby creating yet another countertext that serves as a foil to its many successors today.

Before turning to an analysis of Cultural Revolution *Three Character Classic* editions, however, I will, in the following section, provide a short overview of some of the discussions of the Confucian heritage since the founding of the PRC,[62] analyzing a number of parodies of the *Three Character Classic* published after 1949. This will provide the background to show that (1) many of the most critical points raised during the Cultural Revolution and especially during the Anti-Confucian

61. If one were to study the effects of the May Fourth Movement and its own anti-Confucian campaigns, the period of study should be extended to an even earlier date.

62. The fate of Confucius in Communist China has been studied in two extremely useful works by Kam Louie: *Inheriting Tradition* (Louie 1986) and *Critiques of Confucius in Modern China* (Louie 1980). The following discussion is indebted to Louie's findings.

Campaign of the 1970s had in fact been gestating since at least the 1940s (and some of them go back to even earlier ideas from the May Fourth Movement), and (2) many of these points have not been resolved even today, as their peculiar treatment in the series of *New Three Character Classics* since the 1990s reveals.

Rethinking Confucius before the Cultural Revolution

> This all started from my father's generation, with the May Fourth Movement—they already had some kind of disgust for Chinese traditional culture. They thought Chinese culture hindered the development of China. (Writer, 1958–)
>
> I have always been very impressed with the May Fourth people: they actually were steeped in traditional culture. But they also studied quite a few Western things. Their scholarly roots were very strong. Their criticism of Confucianism was therefore very different from that during the Cultural Revolution: they knew there was quite a lot of good in Confucianism, after all. (Journalist, 1946–)

Why criticize Confucius? As befits Marxist conceptions of history, Confucius' class position became a matter of great importance from the days of "liberation." Information about his life would be taken from the entry in Sima Qian's 司马迁 (ca. 154–90 BCE) *Records of the Grand Historian* (Louie 1986, 62). Depending on whether one believed that Confucius originally came from a poor family and rose up into the ruling strata (a position held by an influential May Fourth figure, the poet and historian Guo Moruo 郭沫若 [1892–1978]) or that he was born into the ruling class of the so-called "slave-holding society" (a radical position supported by philosopher Yang Rongguo 楊荣国 [1907–78]), and depending on when one defined the "slave-holding society" to have ended and the "feudal age" to have begun, after the Shang (second millenium BCE) or after the Zhou (1046–256), Confucius could be interpreted as a "reformer" (predicting and embracing a new system while living in utter despair in the old) or a "reactionary" (upholding old values even when times had changed) (Louie 1986, 63). Throughout the 1950s, some argued that Confucius, who had been poor as a youth, came into contact with the lower classes, thus developing some sympathy for them. Others maintained that as he came from an aristocratic family, he was committed to supporting the old Zhou rites but was still able to recognize that they were unjust to the lower classes. In order to make them more "humane," so it was said, he came up with the concept of Confucian humanity (仁 *ren*). According to this interpretation, he is also said to have "discovered humanity in the slaves, the common people of his period, and that this recognition of their human qualities had been behind a movement to liberate them" (Louie 1980, 34). Thus, Confucius had been able to break through the confines of aristocratic thought and display the beginnings of a "democratic spirit" (Louie 1980, 35).

Guo Moruo even made a case that the Confucian concept of humanity thus had a similar function as the Maoist dictum "serve the people" (Louie 1980, 34; Louie 1986, 64, 73). He maintained that the position held by Yang Rongguo, for example, that Confucian humanity was hierarchical and class-based, was not a popular one, as clearly, throughout the 1950s, attempts were made to "save Confucius." Philosopher Feng Youlan 冯友兰 (1895–1990) was an important figure in this endeavor, arguing that some Confucian values indeed transcended class and therefore might be valid even if they derived from an "idealist" school of thought such as Confucianism. (Louie 1980, Ch. 2) In order to strengthen this argument, Feng even quoted the passage from Mao's *Yan'an Talks* that said that one "may not reject the ancients and foreigners as models" (Mao 1942, 69).

In terms of the broader national public, the Confucius debates of those days played a minor role, if any. They were of academic interest only. To intellectuals, it was clear that what was to be

inherited of Confucianism had to be measured by the criteria of Marxism (Louie 1980, 45), but, very different from the Anti-Confucius Campaign, which had publications like *Criticize the Three Character Classic Using the Viewpoint of Marxist Thought*, there were no publications stating this openly.

With the academic attitude toward Confucianism in the 1950s mildly positive, a flood of *Three Character Classic* parodies that took up some of the original's Confucian ideas, while expanding them according to the needs of the time, appeared. There were versions written specifically for women, for example the *Three Character Classic for Women* (妇女三字经 *Funü Sanzijing*, FNSZJ 1950) and the *Three Character Classic for Country Women* (农村妇女三字经 *Nongcun funü Sanzijing*, NCFNSZJ 1952), for children (e.g., *Three Character Classic for Children* 儿童三字经 *Ertong Sanzijing*, ETSZJ 1956), and for the proletariat (e.g., the *Three Character Classic for Workers, Peasants, and Soldiers* 工农兵三字经 *Gongnongbing Sanzijing*, GNBSZJ 1951). There were *Three Character Classics* against American imperialism and Japanese militarism (e.g., 反对美帝武装日本三字经 *Fandui Meidi wuzhuang Riben Sanzijing*, FDMDWZRBSZJ 1951), and there were those introducing new knowledge—whether it was about culture in general (as in the *Three Character Classic for Studying Culture* 学文化三字经 *Xue wenhua Sanzijing*, XWHSZJ 1958), or on a specific topic (as in the *Three Character Classic on Cultivating Crop in Characters and Pinyin* 汉字拼音对照种庄稼三字经 *Hanzi pinyin duizhao zhong zhuangjia Sanzijing*, HZPYDZZZJSZJ 1959). One such version, for example, very obviously in praise of the ten years since the founding of the PRC, talks of a happy people eating their fill and conquering nature as it alludes to Mao's story of the Foolish Old Man who wanted to move the mountains in front of his house (山能搬海能填, HZPYDZZZJSZJ 1959, 3), a passage discussed in Chapter 4. There were *Three Character Classics* on hygiene as well as on medicine, some warning readers very explicitly to avoid "superstitious" practices (e.g., 卫生三字经 *Weisheng Sanzijing*, WSSZJ 1951).

Serving as substitutes for the old Confucian text, each of these alternative versions of the *Three Character Classic* preaches its own morality: in the *Three Character Classic for Country Women*, for example, the importance of equality between men and women is stressed repeatedly (NCFNSZJ 1952, 7, 22). It is said, for example, that for a man to commit adultery is just as "unacceptable" 不可以 as for a woman. Similar arguments are made in the *Three Character Classic for Women* (FNSZJ 1950, 3–4). Here, the question of economic equality and economic independence is also written into the foreground (FNSZJ 1950, 5). Some of the Confucian morals proclaimed in the original *Three Character Classic*, such as the importance of education for men but not for women, are proclaimed "old-fashioned rites" and openly defied (FNSZJ 1950, 10) in a passage where the Neo-Confucian dictum that "for women to have no talents is a virtue" is also cited only to be refuted (女无才便是德旧礼教要不得). Nevertheless, some remnants of the Confucian original (and its traditional parodies written for women, which emphasized the acquisition of particular "gendered" knowledge, for example) can be clearly discerned in these new versions of the classic.

Such remnants are indicative of the mildly tolerant spirit of the times. The *Three Character Classic for Country Women*, for example, repeatedly deals with the importance of learning how to read and write (NCFNSZJ 1952, 13) and so does the *Three Character Classic for Women*, which calls for diligence and which asks women to be exemplars for their families (FNSZJ 1950). Similarly, the *Three Character Classic on Cultivating Crop in Characters and Pinyin* in its last twenty-four couplets emphasizes the importance of learning, as once did the original (HZPYDZZZJSZJ 1959, 14–15). These Communist parodies advocate that to study and to learn how to read and write, and thus to serve as a model for others, was one crucial precondition for the advancement of society (要学习多识字反封建讲民主做模仿求进步, FNSZJ 1950, 4). The *Three Character Classic for Women* also confirms that it should never be too late to begin to study (学念书看报纸年纪大也

不迟), not unlike the original *Three Character Classic* which mentions quite a few exemplars far advanced in age (*FNSZJ* 1950, 9).

The *Three Character Classic for Country Women*, too, stresses the importance of learning. It admonishes women to hand down their knowledge by instructing their children, while never being too strict nor too lax (教儿女要认眞勿太严勿放任, *NCFNSZJ* 1952, 24). Right in its first line, it calls on women directly: "Women, listen carefully, patriotism is our greatest concern" (妇女们仔细听爱国家最要紧), where the original *Three Character Classic* tells boys to learn to advance in the education system. In a similar manner, learning in the *Three Character Classic on Cultivating Crops in Characters and Pinyin*, too, is not just learning to advance in the system, but especially learning for practical effect and success: an understanding of science and technology, so the argument continues, is what will bring advancement and thus eventually happiness to the people in the countryside (有进步有发展越发展越心宽农家乐万万年, *HZPYDZZZJSZJ* 1959, 15).

Generally, then, given some room for variation, Confucian ideals are not completely discarded in these early Communist parodies of the *Three Character Classic*. This is especially obvious in the particular treatment of women's issues: not unlike the mid-Qing *Women's Three Character Classic (Zhu edition)*, the *Three Character Classic for Country Women* calls upon women not to speak too much (忌多言) and through their behavior—loving of the old and respectful of the young—to ensure peace in the family (家庭和万事兴, *NCFNSZJ* 1952, 25), thus echoing Confucian ideals from the *Great Learning*, which outlines how family peace ensures good order in the country (家齐而后国治). Not unlike the Qing *Women's Three Character Classic*, the Communist *Three Character Classic for Women*, too, calls for thriftiness in looking after the family finances and warns against corruption and wastefulness, again taking up Confucian ideals with regard to financial and family management (*FNSZJ* 1950, 7–8).

The particular choices made in these parodies of the *Three Character Classic* can be read as reverberations of a more general trend: as a whole, the period between 1957 and 1963 witnessed an attempt to re-evaluate Confucian philosophy positively, not just to tuck it away in the museum of China's past glories. It was Liu Shaoqi, head of state from 1958 to 1964, who can be said to have stood behind this heyday of Confucianism. He personally called a huge conference in Shandong in 1962 to discuss Confucian philosophy, for example. His approach was one of actively "supplementing" Communist ideology with Confucian ideals of ethics and personal cultivation (Ching 1974, 130). In 1962, Liu republished his *How to Be a Good Communist* (论共产党员的修养 *Lun Gongchandangyuan de xiuyang*), originally delivered as a speech at Yan'an in 1939 (Liu 1965).[63] The book was cited, as early as 1956, by a Western Sinologist as an exemplary synthesis of "Communist Ethics and Chinese Tradition" (Nivison 1956). In this book, Liu explains to the party cadre how to make use of Confucian ideas of (self-)cultivation in order to become a better Communist, referring frequently to the *Four Books* and other Confucian texts (Ching 1974, 136–37). His book engages in a skillful blending of quotations taken from Marxist and Confucian classics, citing Confucius and Mencius next to Mao Zedong and Stalin. Liu preaches and juxtaposes the virtues of "regular drill" (锻炼 *duanlian*), adapted from foreign military practice, and Confucian "self-cultivation" (修养 *xiuyang*). According to him, every revolutionary must constantly reform and improve himself (革命者要改造和提高自己) and must take part in "practicing the revolution" (革命实践) (Chapter 1), subordinating his personal interests (个人利益) to those of the Party (党的利益) (Chapter 6), and finding the right methods to deal with party comrades in case of "mistakes" (错误) (Chapter 9) in order to build the thought and consciousness of a properly steeled Party member.

63. For background on the polemical purpose that the book had upon re-publication, see Michael 1977, 147–48.

In the early 1960s, then (and this will be mentioned polemically in the critical editions of the Cultural Revolution *Three Character Classic* discussed below), Confucianism fared even better than it did in the 1950s. Louie found that statistically, between 1961 and 1962, more articles were published on Confucius than had been published since 1949 (Louie 1980, 55). One of these articles, entitled "On the *Three Character Classic*" (谈三字经 *Tan Sanzijing*), would be mentioned again and again in the criticism movements during the Cultural Revolution (Wu 1962, 19–22). It had been part of the collection *Random Thoughts from Three Family Village* (三家村札记 *Sanjiacun zhaji*) originating with three writers, Wu Han 吴晗 (1909–69), a leading Communist and well-known historian, and two journalist-writers, Deng Tuo 邓拓 (1912–66) and Liao Mosha 廖沫沙 (1907–90), who had published between 1961 and 1964 a series of satirical articles for the journal *Front Line* (前线 *Qianxian*). The articles told ancient stories replete with conventional wisdom in simple but elegant Chinese.[64] Wu Han and the other two writers were fiercely criticized in the early anti-Confucian years of the Cultural Revolution. In his essay Wu positively evaluated the *Three Character Classic*: according to him, although the book represented the thinking of the "feudal" ruling class, it was well written stylistically and contained important and useful general knowledge (Wu 1962, 19–22). He nowhere said that schools should adopt it as part of their curriculum, but this became one of his alleged crimes, as he was accused of having attempted to revive the education of the "old ruling class" and to "poison" the minds of New China's children (Liu 1985, 193).

Both Liu and Wu were accused of advocating so-called "black cultivation" (黑修養 *hei xiuyang*) by using too many Confucian references in their writings (Ching 1974, 136–37). Red Guard publications such as "Beat Down Liu Shaoqi: On the handling of materials relating to Liu Shaoqi" (打到刘少奇: 关于刘少奇档案材料的处理) edited by the Qinghua Jinggangshan Red Guards in February 1967 talked of *How to Be a Good Communist* as advocating the "way of self-cultivation of the feudal sages" (鼓吹封建圣贤修养之道) and criticized the book for making too few references to Mao, even attacking him on the sly (非但不提学习毛主席的著作, 反而影射攻击 毛主席, HWBZL 1980 Suppl. 1, vol. 7: 3233). Both Liu and Wu would be dragged through the mud again in 1974 during the next Anti-Confucian Campaign, even though both had since died in political imprisonment.

Liu and Wu were engaged with their appraisals of Confucianism in the early 1960s. In presumably a sign of the same *Zeitgeist*, quite a number of *Three Character Classic* parodies continued to be published. Some of them were re-publications of *Three Character Classics* that first appeared in the 1950s (such as the *Three Character Classic for Studying Culture* advocating study and literacy, the 1956 *Three Character Classic for Children*, and many of the medical *Three Character Classics*). Not unlike the 1950s, the 1960s also saw a continuous outpour of *Three Character Classics* for peasants, a good dozen or so of which can be found in the Shanghai Library Catalogue alone. One of these publications, the *Three Character Classic on Husbandry* (耕畜饲养管理三字经 *Gengchu siyang guanli Sanzijing*) published in 1963, puts into practice some of the ideas Liu Shaoqi also preaches in his *How to Be a Good Communist*. The preface states that the book has been compiled in constant exchange between the people and the writer and that its most important aim is to propagate a "collective spirit" (它的主要目的是对群众进行集体主义的思想教育) (*GCSYGLSZJ* 1963). The book begins with a short introductory passage in which the victory of the CCP and Mao's thought of "stressing agriculture" is praised (毛主席方针对农业要看重) (*GCSYGLSZJ* 1963, 3–4, quote from 4). This passage is illustrated with two images, the first of which comprises many stereotypical elements from the "grammar of propaganda" of the time: it shows a morning sun ("Red Is the East") rising and shining over a lush field, with a tractor in the

64. *Front Line* later criticized its own publication of the writings. See Barnouin and Yu 1993, 61–63.

front and a factory and bridge, as well as electric masts, in the back (ill. 3.6). The *Three Character Classic on Husbandry* then explains in detail how to raise animals: how to look after them, how to clean them properly, how to avoid disease, etc.—even describing how not to overtire the animals, especially those that are pregnant or old (*GCSYGLSZJ* 1963, 6–17). Next, it includes a passage reminding the reader how to use the communal animals responsibly and how to watch out for and identify those fellow villagers who will only abuse the animals for their own purposes (*GCSYGLSZJ* 1963, 18–19). While teaching in a manner and style far different from the original Confucian primer, the book comes back, however, to values that lie at the heart of (Neo-)Confucian philosophy: altruism and an abhorrence for selfish profit.

Another agricultural primer, the *Three Character Classic on Agricultural Techniques* (农业技术 三字经 *Nongye jishu Sanzijing*), again illustrates the pragmatic nature of these publications (*NYJSSZJ* 1964). This book, and the many variations of it published at around the same time, may be seen as a direct answer to criticisms of Confucius and Confucianism put forward then: in these discussions, the fact that Confucius did not teach practical matters about agriculture and even discouraged his students to learn anything about agriculture (Louie 1980, 72) played an important role. These new variations on the *Three Character Classic* use a Confucian template, then, to create an extremely detailed countertext to this very work and the ideas propagated therein. The text advises readers how to deal with used up and salt-washed fields, how to apply three-year circles (ill. 3.7), how best to install irrigation systems, and how to fight plant diseases and pests. Illustrations show exactly what corn looks like when fertilizer is applied properly and when it is not, for example, and what are proper hoes and which way they should be held and used with particular plants (ill. 3.8; see also *NYJSSZJ* 1964, 34). We also find exact instructions on how to apply pesticides and on how to treat those who have become ill from exposure to them (*NYJSSZJ* 1964, 42).

With its focus on all of these details, the text may appear to be, at first sight, quite far from preaching anything that could be called "Confucian morality." Surprisingly, however, it also contains Confucian ideas: one of the most significant points of the text is its admonition to heed the words of the old and thus to combine old and new knowledge to best effect: "good experiences must be handed on" (学农活问老农好经验要继承, *NYJSSZJ* 1964, 2). Reverence for the "old," which is one of the central points in the original *Three Character Classic*, is not at all discarded in this newer text. Another idea echoed here is the basic premise of the *Great Learning*, one of the canonical *Four Books*, that if one's family is in order, then the country will be governed well (家齐 而后国治). The quintessential phrase recurring throughout the text of this agricultural *Three Character Classic* is that the commune members will be wealthy (社员富) and the country will be strong (国家强) if all the things explained throughout the book are done well (e.g., *NYJSSZJ* 1964, 47, 59). Again, the text thus implicitly follows the logic of the *Great Learning* in arguing that to keep the family in order is to make the commune prosper, and to keep the commune in order is to ensure abundance and good government throughout the whole country.

Finally, this parody of the *Three Character Classic* ends with a page reminiscent of the refrain voiced forcefully in the original: the idea that only arduous study will bring success and development. Here, the acquisition of a new type of knowledge, scientific knowledge, is written into the foreground: "If we study sciences and carry out experiments, then we will be able to instigate great change in the countryside" (学科学搞试验使农业大发展), says the text. The general message, however, remains true to the original: here as there, the *Three Character Classic* calls for devoted study and practice, it calls for competition and for emulating models who, now in the form of good cadres and commune members, should go forward and lead the people to happiness (比和学赶和帮搞竞赛评模范. 好干部好社员为集体走在前). The element of

competition might be a new emphasis in this *Three Character Classic* (it is also taken up in the *Three Character Classic on Husbandry*, where one of the illustrations shows how a commune member is being presented with an award for good service [1963, 25]), but striving to emulate models is, of course, a pattern well familiar from the original *Three Character Classic*.

The argument is underlined by an image expressing the morale of this new *Three Character Classic*: it glorifies the peasant, who is inspired through the right kind of learning (**ill. 3.9**). In the background a tractor (again) moves in lush fields, below a large dam. Farther in the background stand a series of electronic masts, a factory, and, looming large above all of these, three banners invoking, albeit slightly anachronistically, the three "Red Banners" of Socialist Construction, the Great Leap Forward, and the People's Communes. In the foreground are two peasants—one female, one male, both with the typical strong features of a large face, huge hands, and tough forearms, pictorial markers that would continue to dominate propaganda publications throughout the Cultural Revolution. The two peasants are wearing Chinese-style shirts, with Chinese-made buttons. He wears a Mao cap, she a scarf around her hair. Both have, attached to their shirts, a peony, which is a sign of distinction and abundance in traditional symbolism, marking them as peasant heroes. She is holding huge bushels of plants and a hoe in her hands; he is holding, in his left hand, the first edition of Mao's *Selected Works* (which contains Mao's most important writings about peasants). Mao's book is the focal point of the image. It epitomizes the learning emphasized in the text:

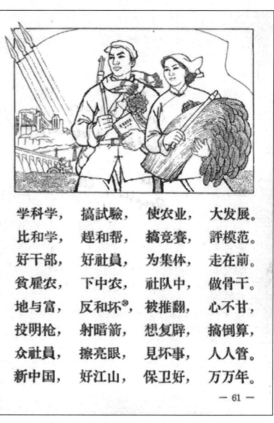

学科学， 搞試驗， 使农业， 大发展。
比和学， 趕和帮， 搞竞赛， 評模范。
好干部， 好社員， 为集体， 走在前。
贫雇农， 下中农， 社队中， 做骨干。
地与富， 反和坏， 被推翻， 心不甘，
投明枪， 射暗箭， 想复辟， 搞倒算，
众社員， 擦亮眼， 见坏事， 人人管。
新中国， 好江山， 保卫好， 万万年。

— 61 —

Ill. 3.9. Model Peasants in the *Three Character Classic on Agricultural Techniques*, 1964 (*NYJSSZJ* 1964, 61).

it is Mao Zedong Thought, scientific and progressive, that will lead these two peasants (and all Chinese peasants) forward to an ever brighter future. As they gaze toward this future, holding fast to the book, they have already started moving in the right direction.

In these new *Three Character Classics*, then, Mao and his words have come to complement or replace Confucian teachings of old. By being presented in the form of a Confucian Classic, they inherit or merge with its authoritative status while somehow tainting, if not subverting, its message as they advocate new (i.e., Maoist) knowledge for a "new society" (新社会). A typical example of such new knowledge would be the *Three Character Classic of the God of Epidemics* (送瘟神三字经 *Song Wenshen Sanzijing, SWSSZJ* 1964). Produced in handwritten calligraphy, it was deemed useful because it could be used to teach people how to write while instructing them how to ward off disease. The book begins by elaborating how difficult it was to treat the sick in the "old society." This story of "blood and tears" (血泪) is contrasted with the good tidings brought about in the "new society," in which all of these diseases will be eradicated (血泪史留至今新社会传佳音党号

召送瘟神断病源要认眞, *SWSSZJ* 1964, 12–15). It is important, so the text preaches, to develop a "strength of will" (毅力) by studying the example of the Foolish Old Man (学愚公毅力深除害尽才廿心) (ill. 3.10), an important hero in the Maoist canon whose story is discussed in Chapter 4. If one emulates him, one will have a healthy, strong body and will thus be able to work better (快治病早除根身体好劳力增). As a result, all people will live longer, and nature will flourish everywhere (人添寿五谷登看杨柳条条青). It will be beautiful everywhere, and spring will last forever (山河美万年春).

Like the agricultural parodies, the *Three Character Classics* of the early 1960s generally tend to advocate new knowledge: there is a *Three Character Classic on Chinese Geography* (*Zhongguo dili Sanzijing* 中国地理三字经, *ZGDLSZJ* 1963) and a *Three Character Classic on History* (中国历史三字经 *Zhongguo lishi Sanzijing*, *ZGLSSZJ* 1963). First printed in Beijing in August 1963, the *Three Character Classic on History* was so popular that it was in its third reprinting by December 1964. Not unlike the Taiping or the missionary *Three Character Classics*, it provides a worldview heavily influenced by evolutionary theory and scientific explanations of the world's origins. It emphasizes technological efficiency, and the engendering of science, scientific thought, and proto-Marxist reforms in early Chinese history.[65] Not unlike earlier parodies, the *Three Character Classic on History* uses phrases from the original *Three Character Classic* but recontextualizes and thus completely reinterprets them (the mythical emperors Yao and Shun, for example, are placed "scientifically" in the Stone Age, the *Spring and Autumn Annals* (春秋 *Chunqiu*) in the Iron Age, and so on). The authors of this new *Three Character Classic* have obviously made use of Zhang Taiyan's *Republished Edition*, as some of the text in fact alludes to or quotes from it. In one passage, for example, the text calls upon students to learn and to strive for perfection, yet not just to serve the sovereign (as in the original) but to save the country and, most importantly, to benefit the people. In the original *Three Character Classic*, as we might recall from the discussion above on Zhang Taiyan's version, the passage reads: "Learn while young, and when grown up apply [what you have learned], thus influencing the sovereign above and benefitting the people below" (幼而学壮而行上致君下泽民, *SZJ* 1986, 341–44). In Zhang Taiyan's version, however, it reads: "Learn a business while young, and when grown up perfect yourself, thus rectifying the state above and benefiting the people below" (幼习业壮致身上匡国下利民, *CDSZJ* 1934, 22a). Zhang's version is requoted in the new *Three Character Classic on History* in an entirely new context, however, emphasizing the importance of the three great inventions of the printing press, the compass, and gunpowder in China, which again are to "benefit the people" (三发明传世界利人民, *ZGLSSZJ* 1963, 9).

Here as elsewhere, the *Three Character Classic on History* takes up an element already evident in Zhang Taiyan and earlier revolutionary *Three Character Classic* parodies: it emphasizes the people as important players in the game of history—indeed, as the ultimate makers of history (e.g., *ZGLSSZJ* 1963, 15, 19, 23). This element would be reiterated, with verve, during the Cultural Revolution. The questions of how to benefit the people, and who can claim to have accomplished this form an important tenor in this *Three Character Classic*: medical handbooks by Li Shizhen 李时珍 (1518–93) are said to have "helped the people" (编本草李時珍治疾病济人民); Li Chuang (1606–45) 李闯, who advocated the "equal field size" (均田 *juntian*) system, is said to have been "welcomed" by the people, and Taiping Leader Hong Xiuquan allegedly "understood the people's difficulties" (e.g., *ZGLSSZJ* 1963, 9, 11–13). Finally, not unlike earlier parodies of the *Three*

65. On technological efficiency, see in this *Three Character Classic* p. 1 on water control, pp. 4 and 11 on the building of the Great Wall. On science and proto-Marxist reforms in early Chinese history, see p. 6 for scientists in the Sui; p. 7 for anti-superstition writings; p. 9 for Wang Anshi and the inventions of the printing press, compass, and gunpowder; p. 11 for medicine and Zheng He's expeditions; and p. 12 for Li Chuang's land reforms.

Character Classic, this one recovers the appellative mode of the original in its concluding sentences, adding a distinctive, yet familiar Maoist note of optimism and self-confidence: "The East is strong and will overcome the West wind. If you are willing to be victorious, then you must be willing to fight, and if you have an aim, then you will surely succeed" (东方强厌西风敢胜利敢斗争有志气定成功, *ZGLSSZJ* 1963, 26).

Thus, in many different manners and variations, and with texts directed toward a diverse readership (from women to peasants to workers and intellectuals), the many parodies of the *Three Character Classic* circulating in the early 1960s exemplified the flourishing and widespread use of Confucian ideas even in political thought. Among academics, however, huge controversies over the nature of the figure of Confucius, and whether he was a "progressive" or a "reactionary"—were being waged ever more fiercely at that time. Some argued that Confucius had opposed the official codification of penal codes (by inscribing them on a tripod) because he had wanted to oppress the slaves.[66] Others, who also saw Confucius as a member of the "slave-holding class," but a "progressive" one, argued that Confucius had been against the inscription of the penal codes exactly because they were oppressive. The latter group interpreted Confucius' preference for government based on virtue rather than law as an indication that he had been sympathetic to the slaves (Louie 1980, 57–58).

Was he an "idealist" developing in a "materialist" direction? His remarks against the voice of Heaven (天无口) were "said to have shown that Confucius had adopted a pantheistic outlook, laying the foundation for the development of materialist and atheistic strands of thought" (Louie 1980, 60). But these remarks could also be interpreted in the opposite way, for Confucius nowhere denies the existence of Heavenly beings. And was not the definition of "humanity" (仁 *ren*) as "curbing one's desires and returning to the rites" (克己复礼 *keji fuli*, from Chapter 12/1 in the Confucian Analects)—a phrase that would become extremely important during the second Anti-Confucian Campaign in the 1970s—was that not a sign of Confucius' "reactionary" nature? (Louie 1980, 63)

Some, like the philosopher Feng Youlan, disagreed fervently. Yet Feng's equation of contemporary ideas of equality with Confucian "humanity" came under attack repeatedly on the grounds that these concepts belonged to different periods in time and derived from different economic backgrounds. The question of whether a historical figure's words could be separated from his self came up time and again. If, following Yang Rongguo rather than Feng Youlan, one believed that Confucius had been a representative of the "slave-owning class," as many then contended, would his writings also have to be regarded as "reactionary"? (Louie 1980, 64)

At times, these primarily academic discussions reached the highest echelons of politics. Mao himself, in connection with his inner Party proclamation to "never forget class struggle" at the Eighth Central Committee in 1962, openly rejected Feng Youlan's description of Confucian humanity without class character. It then became increasingly difficult to disengage Confucian thought from Confucius' class background. What may have "saved" Confucius during this period were the heated discussions over the educational system, oscillating between standards set by the now-abandoned Soviet model and those of the Great Leap Forward years (1958–61) and the socialist education campaign of 1962. Before these debates, Confucius was being discussed as *the* great teacher who, with his alleged 3,000 students from all walks of life, had invented and practiced popular education, while the only problem with his educational methods was that he neglected (or even refused to teach) agriculture (Louie 1980, 67–68; Louie 1986, 63, 76, 85, 87).

Although it became increasingly difficult to support pro-Confucian positions by the 1960s, by comparison, criticisms of Confucius during the 1950s and 60s were never as harsh as, for example,

66. For the historical background, see Ames 1994, 119.

during the May Fourth Movement when the journal *New Youth* published an entire series of attacks on Confucian rites and morals (e.g., Wu 1919; Louie 1986, 89; Mittler 2007a). Indeed, the evaluations of Confucius during the 1950s and 60s "can be seen as attempts to show that Chinese history was still glorious and that there were indeed great sages in China's past" (Louie 1980, 74). Far from being "museumified," as Levenson once argued (1965, 82), Confucius and Confucian writings such as the *Three Character Classic* continued to be used and revived for all kinds of purposes under early Communist rule. Although there were obviously many contradictions between the methodological "Marxian dress" and the traditional content of much of the pro-Confucian writings of the early 1960s, the dedicated attempts to deliberate how one could be made to fit the other suggest that Confucian tradition and Communism were generally still considered to be compatible (Feuerwerker 1968, Chapter 2; Louie 1980, 74).

Rethinking Confucius during the Cultural Revolution

> It is impossible to say, generally, what people learned during the Cultural Revolution. Indeed, we would even read the *Traditions of Mr. Zuo to the Chunqiu* [左传 *Zuozhuan*] and such things during that time. At least our teacher gave us this kind of stuff. And then at university, of course, these things would come up again, like the *Book of Songs*, for example. The critique of traditional culture at the time did not mean that we did not study it at all, we were only told how to interpret these things, that was the idea. (Intellectual, 1958–)

> During the Anti-Confucius Campaign I took part in these translation groups, where we read some stuff such as Shen Gua's 沈括 [1031–95] *Brush Talks from the Dream Brook* [梦溪笔谈 *Mengxi bitan*][67] which talks about music and many other things, too: I read it because it was interesting, not because I felt I could criticize Confucius. I never thought of that; I just wanted to read books. As students and professors, we had the opportunity to find these books, although, there were not that many; the criticism was very abstract—it had nothing to do with the texts, really. (Musician, 1930s–)

The basic assumption of compatibility between Confucianism and Communism was questioned in the beginning years of the Cultural Revolution (1966–69) and again during the Anti-Confucius Campaign of the early 1970s. Red Guard publications ranted that in a "socialist new China, there is absolutely no room for Confucian concepts and capitalist and revisionist ideas which serve the exploiting classes. If these ideas are not uprooted, it will be impossible to consolidate the dictatorship of the proletariat and build socialism and Communism. In the Great Proletarian Cultural Revolution, one of our important tasks is to pull down the rigid corpse of Confucius and thoroughly eradicate the utterly reactionary Confucian concepts."[68] Whoever reveres Confucius, then, so these Red Guard sources contended, is suspected (if not accused) of revering Mao less.

Such views were voiced not just in local (and mostly urban) Red Guard publications, however, but propagated nationally on the pages of newspapers such as *People's Daily*.[69] Thus, already in the early phase of the Cultural Revolution, philosophical discussion had become part of everyday popular discourse (in this case it was the 1962 Shandong Confucius Conference initiated by Liu Shaoqi), a scenario almost unthinkable or at least rare in the Western world, where academic conferences are seldom discussed in the mainstream media (Louie 1980, 91–93). One important argument that came to the fore in these early discussions was the rejection of the notion that

67. A criticism of Shen Gua's work is published in *XXYPP* 1975.2: 61–64: Han Tianyu and Wang Guorong, "Shen Gua yu Mengxi bitan." See also *XXYPP* 1974.12: 16–19.
68. Louie 1980, 91; *HWBZL* 1980 Suppl. 1, vol. 7: 3233.
69. For a rather thorough list of newspaper articles dealing with Confucian thought, see May 2008.

certain "good" officials (such as the upright Ming official Hai Rui 海瑞 (1515–87)[70] might do good works on behalf of the masses as well as the ruling classes. Accordingly, the common argument from the 1950s (which was still upheld in the early 1960s) that Confucius may have been part of the ruling class but was nevertheless "progressive" at heart became untenable. In philosophical, historical, operatic, and all other discourse, the Cultural Revolution emphasized the idea that it was the masses alone, and not officials of any kind, much less emperors and generals, who made history. This gave rise to a renewed interest in and valorization of the role of "the people" therein (Louie 1980, 93–94)—an idea that takes root in Zhang Taiyan's *Republished Edition*.

Anti-Confucian booklets and collections of articles formerly published in newspapers such as the Shanghai daily *Wenhuibao* (文汇报) or the *Liberation Army Daily* (解放军报 *Jiefang junbao*) continued to appear regularly after 1969.[71] The publication in Shanghai in mid-1972 of a book on Qin Shihuang 秦始皇 (259–210 BCE), the first emperor of a unified China and founder of the Qin empire (r. 221–207 BCE), a feared and fearsome man who became infamous for his suppression of Confucians and Confucianism,[72] marked the beginning of another more intensified campaign, however. It featured, as one of its most important players, the philosopher Yang Rongguo, who had been behind most of the more radical ideas critical of Confucius since the 1950s. It also included veteran figures such as Guo Moruo and, later, Feng Youlan, who had formerly been perceived as standing "on the other side." The characteristic harshly anti-Confucian uniformity of viewpoint seen in publications at this time was the result more of *fiat* from above rather than of general agreement on the part of intellectuals writing on the subject below (Louie 1980, 136).

The Anti-Confucius Campaign saw the return of many of the arguments prevalent in the early years of the Cultural Revolution (Louie 1980, Ch. 5). The inauguration in September 1973 of *Study and Criticism*, which aimed to be a pendant to the Party theoretical magazine *Red Flag*, and the organization of a forum on criticism of Confucius called for by Jiang Qing in the same month were important steps in speeding up the movement. It became a large-scale campaign in late January 1974 with the organization of mass rallies—not always fully approved by the Central Committee. After February 1974, the attacks included Lin Biao, too. Earlier articles had attacked him but had not singled him out as a Confucianist. Rather, he was criticized as one of a number of leaders (Liu Shaoqi most prominent among them) whose "wrong line" had been rooted in Confucian tradition. Only when the Central Committee was presented, on January 18, 1974, with a number of Lin Biao's scrolls and notebooks (which then appeared "out of the hat," some two years after his death)—most prominently the so-called *keji fuli* scroll that contained the line from the Confucian *Analects* 克己复礼, "curbing one's desires and returning to the rites," which allegedly had been composed in calligraphy by Lin Biao in 1969 and hung over his bed—was there enough consensus to include him in the Anti-Confucius Campaign. These objects allowed for the establishment of a direct link between Lin Biao and Confucius who, according to Maoist logic, both represented retrogression and the desire to turn back the wheels of history (Barnouin and Yu 1993, 255).

As discussed earlier, the campaign was then fought out, complete with songs, rallies, and heavy use of the mass media (which even reprinted summaries of seminal books and articles that had earlier appeared in academic publications with very small print runs).[73] To criticize Confucius

70. See King and Walls 2010, 6. Hai Rui was the hero of the opera *Hai Rui ba guan* (海瑞罢官 *Hai Rui Dismissed from Office*), written by Wu Han. Not surprisingly, this opera was one of the first objects of criticism during the Cultural Revolution.

71. For examples, see Ching 1974, 140n51.

72. This book is discussed in Wang 1974. The reappraisal of Legalism associated with the reign of Qin Shihuang, who had supported Legalist tenets and philosophers such as Li Si, had started, albeit hesitatingly, in the 1950s. See Ching 1974, 118.

73. Louie 1980, 105, 114 mentions *History Research* (历史研究 *Lishi yanjiu*), *Beijing University Bulletin* (北京大学学报 *Beijing Daxue xuebao*), and *Cultural Relics* (文物 *Wenwu*).

had become part of contemporary politics, even of daily life (Louie 1980, 107n37). And it was part of this politics now to "negate everything" (否定一切 *fouding yiqie*) (RMRB 1999 April 20). Not since the May Fourth Movement had criticism of Confucius and Confucianism been so harsh. Moreover, May Fourth had been different because it had never focused on Confucius as a person, but only on his teachings. Marxist theory, on the other hand, did not allow for a separation of work and author (Louie 1980, 135).

The campaign was characterized by an unprecedented uniformity of viewpoint. First, periodization was fixed. In 1972, Guo Moruo republished a 1952 article on the topic entitled "Problems of Periodization in Ancient Chinese History," which became doctrinal (Guo 1972). It placed Confucius at the point of transition from "slave" to "feudal" society and thus showed him in an even less favorable light than if he had been judged to have lived earlier (Louie 1980, 111). Second, Confucian "humanity" was no longer accepted as a "progressive" principle. Not to alleviate the situation of the slaves but to cement hierarchical structures was now understood as the intention behind this "humanity." It was connected directly with *keji fuli*, which Yang Rongguo interpreted very sweepingly to mean "to curb your desires, set limits on your actions and return to the system of rites of Yin and Zhou slave society" (Louie 1980, 122). Accordingly, Confucian thought was now associated with the idea that everybody should be content to play the role assigned him in "slave society" without overstepping the limits of his position within the system. Slaves should be content to be slaves, and ministers and officials should be content to remain subordinate to their princes. Advocating *keji fuli*, so argued Yang, Confucius had turned against the "progressive" spirit of his own time—a spirit manifest in the actions of those rebelling slaves, some of whom had become prospering merchants or officials usurping the rites of the princes. But this was not enough: In Yang's works Confucius is discredited as a teacher as well, because in teaching, too, he is said to have served the wrong class. Advocates of this theory refuted the idea that he may have taught people from the lower echelons of society, arguing that Confucius despised them for their stupidity. Finally, Confucius is also condemned for his conviction that the genius rather than the masses made history (Louie 1980, 132).

At the same time, the history of Chinese thought was reconceived in terms of a two-line struggle: an ideological conflict between so-called Legalists and Confucians. All Chinese philosophers were recast into one mould or the other (Louie 1980, 104). The Legalists were interpreted as members of the newly emerging class (the landlords), "progressives" at the time, while Confucius and the Confucians were kept with the "slave holders": Confucius had refused to codify penal laws simply because he was afraid that everyone would be the same in the eyes of the law, thus eliminating hierarchical structures that he himself profited from considerably (Louie 1980, 111).

The references to a two-line struggle between Legalists and Confucians take the debate on Confucius completely out of an academic context and place it right in the heart of its contemporary politics. Feng Youlan's reversed judgment, after his self-criticisms of 1974, must be read precisely within this framework: In his article "On Confucius" (论孔丘 *Lun Kong Qiu*) (Feng 1975), he argues that just as Confucius had in his own time advocated the ideology of the old slave-holding class and had tried to undermine the foundations of the newly risen "feudal" society, so the "reactionary" forces and their representatives in the Party like Liu Shaoqi and Lin Biao had repeatedly praised Confucius as they attempted to restore capitalism and undermine socialism. He would say: "This was in imitation of Confucius. The times are different, but it is the same retrogressive line, out to revive the old. Their spirits are one, their aims are the same" (Feng 1975, 19).

How, precisely, does the treatment of the *Three Character Classic* during the Cultural Revolution fit into the general picture of criticisms of Confucius drawn up here? Are there intertextual

cross-references to other, earlier editions or parodies of the *Three Character Classic*? And what does the answer to this question tell us about their use during the Cultural Revolution? A study of one notoriously critical edition of the *Three Character Classic*, the Guangdong Railway Workers' *Critical Commentary to the Three Character Classic* (三字经批注 *Sanzijing pizhu*, SZJPZ 1974), will help to answer these questions. In the preface, the Guangdong Railway Workers (joined by experts from the Chinese Department at Sun Yatsen University) reject Zhang Taiyan's bleak vision, quoted above, that China's traditional heritage may be lost. Not so—unfortunately!—argue the authors: since the Southern Song and all the way up until "liberation," the *Three Character Classic* had been the first book given to children in China. This continuous transmission, and not the lack of it (as Zhang Taiyan had decried), is considered tragic by these authors; theirs is a bleak vision, too, but for reasons quite different from Zhang Taiyan's. The authors express a fear that, because of this continuous transmission, the "restorationist" and "revisionist" thoughts contained in the book have already contaminated a great many, and continue to do so (*SZJPZ* 1974, 1). The preface concludes with a remark that the *Three Character Classic* is a "poisonous weed" that has for many centuries intoxicated people. The commentary itself hopes to be a first step on the way to understanding this "poisonous weed" in order to abandon it on the "garbage pile of history" (*SZJPZ* 1974, 8).

By making these statements, the actors in the campaign admit that Confucian thought has remained known and relevant in spite of the many movements against Confucius throughout the twentieth century. The very fact that they perceived a need for such critical editions and that they propagated the eventual and final eradication of this heritage shows the strength of the influence of the *Three Character Classic* (and Confucianism more generally) even up until 1974 (why else would they feel such a need to fight it?). Ironically, one could argue that the particular methods used to eradicate this heritage by subjecting it, time and again, to detailed critical scrutiny in fact helped to perpetuate knowledge about this "black material."

The preface continues with a short history of the creation and reception of the *Three Character Classic*. The authors call the *Three Character Classic* a typical product of its age, the Southern Song, when peasants were brutally suppressed by their rulers while their own land was slipping out of their hands, accumulating in those of grand officials and powerful landlords (*SZJPZ* 1974, 1–2). They elaborate on how the peasants had already developed a certain sense of their own rights and were, in their various rebellions, calling out for peasants' rights. People in the following of Zhu Xi, however, were out to suppress this public spirit. They did so, say the editors, by popularizing the thoughts of Confucius and Mencius by means of the *Three Character Classic* (*SZJPZ* 1974, 2): pictorial editions had been published for this purpose, as well as translations into Manchu and Mongolian in huge print runs (*SZJPZ* 1974, 3). The authors contend that people like Zhu Xi (or rather, in his following, as the *Three Character Classic* was of course not extant during his lifetime),[74] these "Followers of Confucius and Mencius" (孔孟之徒) as they are called throughout, praised the *Three Character Classic* as a "pocketbook version of the *Compendium to the Comprehensive Mirror*" (通鉴纲目 *Tongjian gangmu*), that they "bragged" that it was one of the "great books of all ages," and that one could learn everything important about the philosophers, the histories, and the Classics by reading it (*SZJPZ* 1974, 3).

The authors go on to note that under the GMD the book continued to be reprinted and popularized widely. And it was promoted even in revolutionary China, due to the "doings" of Liu Shaoqi and Lin Biao. Indeed, the Three Family Village (三家村 *Sanjiacun*) writers are said to have published in 1962 a piece of writing in which the *Three Character Classic* is classified as a "good

74. Typical for its time, the text of the preface is rather imprecise and anachronistic.

book," and in which the authors, led by Wu Han, "boast" of it as a "small encyclopedia" (*SZJPZ* 1974, 3).[75] And indeed, this is what Wu Han's text says: "It is a small encyclopedia" (是一本小型 百科全书, Wu 1962, 19) and "The *Three Character Classic* is a good book, it is distressing that it has been in disuse for some decades and that nobody cares to understand it" (三字经是本好书, 可惜已经被冷落了几十年, 没有人去理会它了, ibid.). In his text Wu Han argues, so his critics say, that it is time to become heirs to this heritage again (继承这份遗产, *SZJPZ* 1974, 3). Although none of what the Guangdong Railway Workers' critical edition says is completely untrue, here they significantly turn around the original sentence in Wu's essay, thus drastically changing its meaning: Wu Han is rather cautious in his essay and only deliberates or actually asks whether it "would make sense to *critically* evaluate this heritage" (这份遗产值得批判地继承呢).

The preface to this critical edition of the *Three Character Classic* concludes that the book is "reactionary" and out to "cheat people" (反动的骗人经, *SZJPZ* 1974, 3). In its five parts it is said to advocate (1) "humanism and reactionary education" (I, 1–28), (2) "feudal hypocritical morals" (II, 29–106), (3) "the use of the wrong type of education and a reverence for the reactionary philosophy of Confucianism and Confucian writings" (III, 107–74), (4) an "idealist view of history" (IV, 175–266), and (5) through the "genius cult," the exclusive study of books to attain official posts (V, 267–356). This polemic on the structure of the *Three Character Classic* corresponds to the original as follows: sections 1 and 2 are on human nature, education, virtues (with exemplars), and general knowledge (1–106); section 3 is on the works of Chinese (not just Confucian) philosophy (107–74); section 4 is the section on Chinese history (175–266); and section 5 the examples of exemplary students (267–356) who attain official posts through book learning (*SZJPZ* 1974, 3–4).

The critical edition then explains each of these points, beginning with (1) what is wrong with "humanism and reactionary education" (I, 1–28), which is seen to be the philosophical base of the *Three Character Classic*, running through it like a "black line" (黑线 *heixian*). Using coarse language throughout, the edition calls it "nonsense" (胡说 *hushuo*) to think of human nature and other cardinal Confucian virtues such as humanity, righteousness, rites, and knowledge (*ren yi li zhi* 仁义礼智) as something Heaven endows upon everyone. According to the authors, in a class society different types of human nature correspond to the different classes, and no human nature transcends class. Speaking of humans (人 *ren*), the editors argue that the *Three Character Classic* is only concerned with people from the "land-owning class" (地主阶级 *dizhu jieji*).[76] Workers in the old society were not considered humans at all. They had to work like animals (here, four lines from the original, 333–34 and 337–38, are cited in inversion) and accordingly, the "goodness" in human nature of which the original *Three Character Classic* speaks never applied to them.

(2) The editors make a case against "feudal hypocritical morals" (such as brotherly and filial piety) in the *Three Character Classic* (II, 29–106), reiterating a number of passages from the original explaining "hierarchical" human relations—the three bonds (*sangang* 三纲, 53–56), five virtues (*wuchang* 五常, 69–72), and filial piety and brotherly love (*xiaoti* 孝悌 41–42). The ideas put forward in the *Three Character Classic* are denigrated as "endless chatter" (啰啰嗦嗦, 没完 没了 *luoluosuosuo, meiwan meiliao*) (*SZJPZ* 1974, 5). The editors are critical of the fact that these virtues and human relationships are presented in the original text (because they are arranged according to the numbers associated with them) in a list with the three luminaries—the sun, moon, and stars (三光 *sanguang*, 51–52)—and the five elements (五行 *wuxing*, 65–68). This is considered particularly heinous because the reader is lulled into thinking that people are one with

75. The three writers are Wu Han, Deng Tuo, and Liao Mosha. The essay they are referring to is Wu Han's "On the *Three Character Classic*" also discussed above (Wu 1962, 19–22).
76. To be historically correct, this should be the "slave-holding" (奴隶主 *nulizhu*) class; see below.

the natural order and that the three bonds and the five virtues are part of this natural order and therefore cannot be changed. The authors argue agitatedly against piety and brotherly love—things they view as designed to quell revolutionary thinking. To prove this point, Kong Rong 孔融 (153–208), a model of brotherly love in the original *Three Character Classic*, is uncovered as a suppressor of peasant rebellions who was later killed, fortunately, by none other than popular hero Cao Cao (*SZJPZ* 1974, 4–5).

(3) The critical commentators also explain why they consider it mistaken to "use the wrong type of education and to admire the reactionary philosophy of Confucianism and Confucian writings" (III, 107–74), warning that this type of "exploiter's attitude" is still prevalent among opportunists even in the CCP. A direct line is drawn from Chiang Kaishek, who is accused of continuing to stage his reverence for Confucius in Taiwan, to Liu Shaoqi, who, once "crawling out of the dog's kennel [that is, the white Guomindang areas] with his Four Books," would advocate "black 'cultivation'" [黑"修养" *hei "xiuyang"*]. Here, cultivation is highlighted in the text to mark its "sham" nature). Lin Biao, too, is considered to be in the same "gang" (一伙 *yihuo*), because his attitude toward study, so it is said, is only oriented at gaining a civil service post and a reputation, thus exploiting everybody else (*SZJPZ* 1974, 6).

(4 and 5) The next section explains the "mistake" of adhering to an "idealist view of history" (IV, 175–266) instead of understanding the importance of the masses for the making of history. It also deliberates the related mistake of advocating so-called "idealist apriorism" and hero worship (V, 267–356), which is revealed by the large number of stories in the *Three Character Classic* referring to child prodigies.[77] Those stories are derived, so argue the critics, from the Confucian idea of "being born with the right knowledge" (生而知之), an assumption that, according to the authors, leads immediately into the "genius cult" as practiced by Lin Biao, who advocated it in his essay "On Genius" (天才论 *Tiancailun*) and who even spoke of himself as being "especially bright" (脑袋特别灵 *naodai tebie ling*). The child prodigy stories are said to be nothing more than concoctions, and Lin Biao's advocacy of the genius cult is, according to the same logic, criticized as his way of justifying his own usurpation of power as a genius himself (*SZJPZ* 1974, 7).

The critics maintain that adhering to the "genius cult" and studying exclusively to attain official posts (V, 267–356), as well as holding an "idealist view of history" (IV, 175–266) are furthermore all mistaken views because, as the *Three Character Classic* amply shows, oppressive dynasties will inevitably and tragically fall (again such passages as the fall of the Zhou dynasty are cited, 203–4). Peasant rebels, by contrast, are not sufficiently lauded and are said to have "sprung up in thick forests" (254r).[78] Thus, in this reading, the *Three Character Classic* propagates a "reactionary view" of history, which Lin Biao, so it is said, had also supported in his writings (*SZJPZ* 1974, 7–8).

It should be apparent that the criticisms voiced here are not entirely new. Indeed, for each of the categories of "mistakes," there is corresponding textual evidence in earlier or later editions or parodies of the *Three Character Classic*. Although the criticisms voiced in the preface and the commentaries and the particular manner in which they are applied to the present (by referring to a number of "contemporary followers of Confucius") may be peculiar to their time, the gist of the argumentation can be found earlier, and the same issues were addressed again later. Critical editions published during the Cultural Revolution thus echo and respond in manifold ways to

77. Again, the text of the commentary is filled with direct quotes from the original, beginning with the story of Xiang Tuo (项橐), a contemporary of Confucius, who impressed him already as a seven-year-old child, in V, 291–92; *SZJPZ* 1974, 34.

78. This phrase is not from the original but from He Xingsi's history-adjunct to the original. This choice of edition is mentioned meticulously by the authors, *SZZPZ* 1974:3; they trace the text back to an edition published "under the Guomindang," in 1928, i.e., Zhang Taiyan's *Republished Edition* of the *Sanzijing*.

earlier types of parodies and editions of the original *Three Character Classic*. A historicized reading of the sources suggests that although treatment of the *Three Character Classic* during the Anti-Confucius Campaign of 1973–75 must be called extreme, from the point of view of cultural developments throughout the twentieth century, it is by no means completely extraordinary.

The missionary *Three Character Classic*, for example, also criticized, by implication, the assumption that human nature is good (1)—although it was not the theory of class struggle but that of original sin that was behind the criticism. A clear denial of the idea of human nature as good is given in the early land reform *Emancipation Three Character Classic* first published in the 1940s (and republished during the Anti-Confucius Campaign in *XMZZY* 1975, 35–41, 35). The *New Three Character Classic* from the mid-1990s, too, takes a different stance from the original by arguing that there are, in fact, both good and bad people (and this idea is, if only implicitly, still linked to class theory).

The several different versions of the *New Three Character Classic* published in the mid-1990s include certain "feudal values" such as filial piety and brotherly love as exemplary, while they exclude others, such as the rites, deemed so essential by Confucius himself (2). A special *Morality Three Character Classic* (品德三字经 *Pinde Sanzijing*) published in 1994 (*PDSZJ* 1994) stresses many "new morals" such as respect for the law (遵纪守法 *zunji shoufa*) and patriotism (爱国 *aiguo*). The latter is a virtue also of importance in the *Three Character Classic on Husbandry* (*GCSYGLSZJ* 1963). It includes chapters devoted to each new value, as it abandons the "old" ones, thus implicitly rewriting "feudal" morality (although it ends up borrowing many exemplary stories from Chinese history that underline continuities between old and new). Anti-"feudal" arguments were also made in the early 1960s, in the *Three Character Classic of the God of Epidemics*, which teaches not subordination but "strength of will" (毅力, *SWSSZJ* 1964, 22). "Feudal" ideas and morals are attacked implicitly and explicitly in the *Three Character Classics* published to advocate the marriage law in the years after 1949, all of which emphasize equality between men and women (e.g., the *Three Character Classic for Country Women*, *NCFNSZJ* 1952; and *Three Character Classic for Women*, *FNSZJ* 1950), and in the many *Three Character Classic* parodies for peasants and workers published throughout the 1950s and 60s. The earlier *Three Character Classic of New Learning* (*XXSZJ* 1902), too, had excluded all mention of "feudal moral relations" and talked exclusively about nature, thus evading the connection criticized during the Cultural Revolution, that between man-made and natural occurrences (*SZJPZ* 1974, 4–5).

And yet, Cultural Revolution criticisms of "feudal" morals do not always go as far as they did in earlier or later editions of the *Three Character Classic*. One, implicit in the Qing *Women's Three Character Classic* and also in the *New Three Character Classic* of the mid-1990s, for example, is the importance of learning for both men and women, implying an inclusive audience for the *Three Character Classic* in the modern age. The *Three Character Classic for Country Women*, and the *Three Character Classic for Women*, too, defied the Confucian standard that learning should be a man's privilege (*NCFNSZJ* 1952; *FNSZJ* 1950). This idea was important to Cultural Revolution discourse, too: Colin Mackerras shows how the emphasis of some of the new operas performed during the Anti-Confucius Campaign was clearly on female characters: "The emergence of this new type of heroine coincides in time with a renewed stress on equality for women which has characterized the Campaign to Criticize Lin Biao and Confucius" (Mackerras 1975, 179). Di Bai makes a similar point for the later set of model works composed around the same time, which she interprets as particularly feminist (Bai 1997). However, none of this is to be found explicitly in the critical and commented edition of the *Three Character Classic* under scrutiny here.

The "false" and "hypocritical" teachings of Confucianism are attacked, of course (3), but these accusations, again, are not all that new: the Taiping *Three Character Classic* contains harsh

condemnations of Confucianism predating Cultural Revolution criticisms by almost a century. Accordingly, our critical edition approvingly quotes Hong Xiuquan for his anti-Confucian attitude in the critical commentary (*SZJPZ* 1974, 22). Similar attacks on Confucianism as a philosophy are explicitly made in the *Three Character Classic for Workers, Peasants, and Soldiers* (reprinted in *XMZZY* 1975, 17–23) from the 1940s, to be taken up in some of the early Communist *Three Character Classics* from the 1950s. The *Three Character Classic on Hygiene* warns of superstitious practices connected with Confucian thought (*WSSZJ* 1951).

When it comes to refuting an idealist view of history (4) and promoting the idea of the people as makers of history, several earlier *Three Character Classic* parodies are good examples: Zhang Taiyan's *Republished Edition* promotes this idea and at the same time criticizes the notion of the child prodigy as put forward in some of the exemplary stories in the *Three Character Classic*. The first line of the *Three Character Classic for Workers and Peasants* from the 1930s clearly underscores the importance of workers, peasants, and soldiers: "In the world, men are the brightest, but those who are the <u>creators</u> are the workers, peasants, and soldiers" (天地间人最灵创造者工农兵) (*XMZZY* 1975, 14). The idea is taken up again in the late 1940s in the *Three Character Classic of the People's Army* (*XMZZY* 1975, 43) where there is even a clear criticism of the "old" cult of genii as makers of history (*XMZZY* 1975, 43, 57). The argument also figures prominently in the 1963 *Three Character Classic on history* (*LSSZJ* 1963).

Finally, when it comes to the idea of proper learning (i.e., not just book learning), many of the revolutionary *Three Character Classics*, the *Three Character Classic for Workers, Peasants, and Soldiers* and the *Three Character Classic on Hygiene* among them, emphasize the importance of practical knowledge (5). Learning is considered a precondition not for individual and personal advancement but for building a properly working society. This is made very clear in the *Three Character Classic on Cultivating Crop in Characters and Pinyin* (*HZPYDZZZJSZJ* 1959, 14–15) and especially in the *Three Character Classic* parodies for peasants such as the *Three Character Classic on Husbandry* (*GCSYGLSZJ* 1963) or the *Three Character Classic on Agricultural Techniques* (*NYJSSZJ* 1964), all of which emphasize pragmatic and practical elements of learning. Not unlike these agricultural parodies, the *Three Character Classics* on medicine, history, or geography of the early 1960s generally tend to advocate practical knowledge. The sheer variety of *Three Character Classic* parodies appearing since the 1930s, including those for women, peasants, and children, recognizes the idea that different people need different types of knowledge. The emphasis in the Cultural Revolution is quite exclusively on practical learning. Whereas the 1902 *Three Character Classic of New Learning*, for example, as well as that of Qi Lingchen and Zhang Taiyan from a few decades later, and even the Chinese History *Three Character Classic* of 1963 and the *New Three Character Classics* of the 1990s, most of which feature magnetic trains, airplanes, sky-rockets, and computers (e.g., *XSZJ* 1995, 78, 106, 110–11), obviously stress contemporary learning, science, and technology, the old *Three Character Classic* is not condemned there as openly for not doing so, as one could have expected.

In reading the elaborate commentaries to each small section of the *Three Character Classic* in the full body of the *Critical Commentary to the Three Character Classic*, one encounters the same arguments again and again. These are backed up with quotations from Mao (e.g., *SZJPZ* 1974, 10, 13, 17, 22–23, 31–32, 33), Lu Xun 鲁迅 (1881–1936) (these are unmarked quotations, *SZJPZ* 1974, 13), Marx, Stalin, and other Soviet thinkers (*SZJPZ* 1974, 22, 29), as well as two early thinkers who are categorized as representatives of the "Legalist School" and who thus appear as positive models who understand the danger in the Confucian classics, Shang Yang (*SZJPZ* 1974, 22) and Xunzi (*SZJPZ* 1974, 26). Confucius (*SZJPZ* 1974, 14), the *Great Learning* (*SZJPZ* 1974, 14), the *Book of Rites* (*SZJPZ* 1974, 15), Lin Biao (*SZJPZ* 1974, 19), and Wang Yinglin (*SZJPZ* 1974, 29), the purported author of the *Three Character Classic*, on the other hand, are mentioned only to be

refuted. As in the preface, the commentary abounds with impertinences, "nonsense" (*hushuo*) being used most frequently (e.g., *SZJPZ* 1974, 9, 17, 19) to describe others' ideas in the *Three Character Classic*. Derogatory expressions such as "preposterous words" (谎言 *huangyan*) also occur frequently (*SZJPZ* 1974, 39).

As in the preface, in the body of the text, history is perceived only in terms of class struggle (*SZJPZ* 1974, 10, 33). The commentary interprets the heavy leaning of the *Three Character Classic* in its section on philosophers to those from the Confucian school as typifying its class nature (*SZJPZ* 1974, 24). It is argued that the Legalists, "progressive members" of the upcoming "land-owning class" of a new and "feudal" age, are left out in the *Three Character Classic* unjustly. Alternatively, as in the case of Xunzi—who was during the campaign lauded as a Legalist and a "materialist" for holding the theory that human nature was bad—is considered to be falsely categorized as a Confucian. Why mention so many backward-looking Confucians, and a "complete jester [儒家小丑] such as Wen Zhongzi" at that, the commentary asks? Why leave out all the Legalists, who had been so important in Chinese history? In the section on history, this argument is taken up again when the author complains that Qin Shihuang, founder of China's first unified dynasty, receives too little attention (*SZJPZ* 1974, 26; and especially *SZJPZ* 1974, 29). He is not just one among the thousands of emperors in Chinese history, argue the commentators. His politics of unification and his promotion of law justify his being praised more.

As in the preface, the commentary accuses the *Three Character Classic* of propagating the wrong types of morals. All of the Confucian virtues, such as "filial piety" or "brotherly love," are out to create complacency instead of fostering the spirit of rebellion, so it is argued (29–48; *SZJPZ* 1974, 14). The same applies to the use of the "Three bonds" and "Five virtues": they serve to sedate people in order to avoid vibrant, vivacious chaos (乱 *luan*), so extolled during the Cultural Revolution, and especially by Mao (*SZJPZ* 1974, 16).

Book learning, too, is considered something used oppressively to keep people peaceful and quiet, argues the commentary (*SZJPZ* 1974, 21). To advocate book learning, then, as does the *Three Character Classic*, and to adhere to the principles taught in the Confucian books, is to deny class struggle and to keep people from attaining their rights through rebellion. Only by upholding these principles can "slave-holder society" be sustained, the authors argue (*SZJPZ* 1974, 16). It is for the same reason, they say, that a peasant rebel like Li Zicheng 李自成 (1606–44) is denied proper mention in the *Three Character Classic*. Li should not be accused for his rebellion but admired for leading a peasant uprising, sudden and strong "like a thunderstorm" (其势如暴风骤雨) (*SZJPZ* 1974, 32).

As book learning is seen to cool the rebel spirit, accordingly, education is perhaps the most frequent point of attack in the commentary. Even Mencius' mother does not get a good report for the pains she took to provide her son an excellent educational environment: the commentators complain that she was only concerned with educating her son so he could join the exploiting class of government officials (7–28; *SZJPZ* 1974, 10); this very argument returns at the end (*SZJPZ* 1974, 41). Confucius himself is also considered a poor teacher, for not only does he divorce his students from practical work, but he looks down upon those who do this kind of work, considering them "mean people" (小人 *xiaoren*) (*SZJPZ* 1974, 12). In the concluding section of the commentary, the authors sum it all up: teaching is only good if done in conjunction with productive labor. Otherwise, it is of no use (*SZJPZ* 1974, 40). The real point of studying, then, is to join in solidarity with the masses, and in order to do so, one needs to break resolutely (决裂 *juelie*)[79] with the influences of capitalism and Confucianism (和旧的传统观念实行最彻底的决裂) (*SZJPZ* 1974, 42).

79. Incidentally, 决裂 (Breaking with Old Ideas) is also the name of a 1975 film production dealing with questions of education.

None of the points made here are entirely original. All the critical editions of the *Three Character Classic* published during the Cultural Revolution, regardless of authorship, use similar rhetoric and repeat similar arguments. Some of the details mentioned in such criticisms may differ, but the general gist is always the same. A critical article on the *Three Character Classic* published in *Study and Criticism* in 1974 that includes, characteristically, a reprint of the original text illustrates this repetitive mode: Entitled "The Three Character Classic is Black Material Designed to Spread the Propaganda of Confucius and Mencius" ('三字经' 宣扬孔孟之道的黑标本), it complains that the *Three Character Classic* is an "encyclopedia of the feudal landlord class" that reflects their outlook on life and their worldview (*XXYPP* 1974.7:9–14, reprint of original on 36). The article then criticizes the "idealism" expressed in the first sentence of the work about the inherently good nature of human beings. It argues that it is highly unlikely that children by nature know how to behave, and that the idea commonly used to explain this—of a so-called "education in the womb" (胎教 *taijiao*) before the child is born—is "absurd" (荒唐 *huangtang*) (*XXYPP* 1974.7:9–10). The nature of man is always based on his class nature, and there is no such thing as a nature given one from above. In the authors' view, Confucianism advocates that those above are knowledgeable and those below are stupid (上智下愚 *shangzhi xiayu*) (*XXYPP* 1974.7:10). The good human nature they are talking about, therefore, is based, so the authors argue, on the idea that those below should be subjugated to serve those above.

This logic is deduced from the fact that the book aims to teach young men how to study to become government officials (读书做官论) (*XXYPP* 1974.7:11). Indeed, the critics count 22 instances where the *Three Character Classic* talks about such teaching and learning. They complain further that the *Three Character Classic* provides one-sided model stories: according to them, everybody should have ambitions, but the ambitions depicted in the *Three Character Classic* are those accessible to one particular class only (*XXYPP* 1974.7:12). Like the critical editions published by factory workers and peasants, this article complains that the *Three Character Classic* thus presents a distorted view of history. To make this point, it gives the identical examples as the critical edition discussed above: the "false" depiction of Qin Shihuang's reign as authoritarian, and the "downplaying" of peasant uprisings. It concludes that, accordingly, the *Three Character Classic* is not appropriate literature for workers and peasants. Rather, it "exploits" their name, finding happiness at their expense. Finally, the article concludes, the people are now able to criticize the *Three Character Classic*, a primer which had been a must-read for children for centuries (成了儿童启蒙的必读书) (*XXYPP* 1974.7:9). And it complains that even versions juxtaposing Mongol, Manchu, and Chinese had been used for many centuries to spread its teachings to absolutely everyone (家喻户晓) (*XXYPP* 1974.7:12) who had thus been "poisoned" for the longest time (*XXYPP* 1974.7:13).

There is repetition, to be sure, in argument and rhetoric. And yet, in spite of the fact that the nature of this campaign was supposed to be pervasive and that the language and the arguments were allegedly unified, even these critical editions are not always completely univocal. In a discussion on the good nature of men in the preface to the *Critical Commentary to the Three Character Classic*, "people from the land-owning class are mentioned as the only ones who would consider those from certain classes to be human [人 *ren*]" (*SZJPZ* 1974, 4, 16–17). Later in the commentary's discussion of the same passage, the term "slave-holders" (奴隶主 *nulizhu*) is used (see, e.g., *SZJPZ* 1974, 10). Through the re-publication of Guo Moruo's doctrinal article on periodization in 1972, it was made clear that Confucius was to be understood to have lived at the point of transition, according to historical materialism, from "ancient slave-holding" (which ends with the Zhou)[80] to "feudal society" (where land-owners would rule the game) and was himself a

80. This is also remarked in SZJPZ 1974, 27n2.

member of the "slave-holding class." If the conceptions of "humanity" and "good nature" in the *Three Character Classic* are attributed directly to him (in spite of the fact that the theory of the goodness of human nature really only came into the discussion with his successor Mencius, for example), then the criticism should be directed against the "slave-holding class," not the "land-owning class." Such discrepancies compel one to ask whether it was different groups writing preface and commentary. The prevalence of similar inconsistencies throughout the critical editions published during this time illustrates that Cultural Revolution Culture was by no means as rigidly streamlined and controlled as we sometimes assume.

The fact that the commentary's order of at least the last two of the five explanations of "mistakes" in the *Critical Commentary to the Three Character Classic* has been mixed up in the preface to the book (sections 4 and 5 are reversed) and that the same accusations are repeated in different sections (section 3 contains quite a lot of material on "education for official emolument" that should have gone into section 5) may be due to fast and sloppy production, too. But it is also true that many of the arguments made in one section could in fact apply to any other section: In the commentary, the possible meanings of particular passages from the *Three Character Classic* are reduced to one message, yet the arbitrariness of this one message is obvious, in turn, from the sheer number of examples that could be subsumed under it. Contrary to our assumption that what one says matters because there is meaning to one's words, here meaning becomes so obviously flexible and reversible that its only determinant is whether the person wielding the weapon of speech is powerful or not, a decisive factor to communication during the Cultural Revolution, as will be discussed in the next chapter (cf. Mitter 2004, 209).

Coming back to the quality of these writings, however, in spite of their repetitious and arbitrary nature, we must acknowledge that, indeed, it appears hardly possible that peasants and workers would have been able to write such commentaries on their own. Writing (and reading) these required not just knowledge in Maoist and Marxist historical thinking and philosophy but also in classical and historical literature. The commentaries are extremely succinct, and they all give references and full citations to passages from other (philosophical) works. It is obvious that "professionals" (专家 *zhuanjia*, in the terminology of the time, which contrasts those who are professional with those who are red [红 *hong*]) had put at least their finishing touches on these texts. Considering their high quality, in terms of philological work, and the many classical allusions and quotations in publications such as the *Critical Commentary to the Three Character Classic*, it is further questionable that there should have been a complete break with this knowledge by the end of the movement, because even if only very few people were confronted with this meticulously researched material, and even if they believed most of the criticisms, more would thus have been confronted with the original Neo-Confucian text than ever before.[81] One very young participant of the movement reports:

> The workers did not really understand when there was this talk of "Old Confucius" [孔老二 *Kong Lao Er*]. Earlier, there had been this reverent use of, "In the past, Confucius said" [过去孔子说 *guoqu Kongzi shuo*], but now Confucius and his words would have a completely different flavor. Now, he was

81. Many of the critical writings during the Anti-Confucius Campaign use allusions or examples from the traditional heritage. Readers are expected to be familiar with them. The Party propagandists thus assumed that people would in fact understand such discussions: One such example is the mention of "gentlemen's country" (君子国 *junziguo*) from the early nineteenth-century novel *Flowers in the Mirror* (镜花缘 *Jinghuayuan*) during a critique of a local opera performed at a festival in Beijing in August/September 1974, at the height of the Anti-Confucius Campaign. This is discussed in Mackerras 1975, 185; see also Barnouin and Yu 1993, 281.

a bad guy. But since we believed that what Mao said was right, this was just as it was. And I do have a feeling that this movement had a lasting influence. (Music Student, 1969–)

One thing is clear, then—and even the writers of these critical texts who kept coming back to its popularity and long unbroken tradition acknowledge this—by the time of the second PRC campaign against Confucius there were nonetheless still people steeped in the Confucian heritage. As Julia Ching puts it in 1974:

> One should not rule out the deep-seated influence which Confucianism may still exert in people's minds today. As the Chinese newspapers point out, Confucian sentiments and values are preventing the youth from fully accepting Maoist ones, and from participating wholeheartedly in the socialist reconstruction of the country as members of the agricultural or industrial work force. It seems that many young people still regard a higher, professional education as very desirable, together with urban life and climbing the social ladder, just as many members of the government administration remain supporters of an educational system which gives more importance to formal content than to political ideology. The campaign against Confucius appears designed to help uproot such "old" tendencies and make room for Marxist-Maoist values. In this sense, the entire campaign aims literally at "brain-washing" in order to assure that the great Communist revolution will have worthy successors, those with "pure minds." (Ching 1974, 140–42)

Whether the ideas propagated in anti-Confucian propaganda were directed more at urban intellectuals, or whether they were truly intended to help the masses—the workers in the cities, the peasants in the countryside, and the soldiers throughout the country—surely, they brought about change. Before the Cultural Revolution, relatively few middle schools or high schools existed in rural areas, where 85 percent of China's population then lived. Even talented rural students generally received only a limited elementary school education. In order to continue their education, rural youths needed to secure permission to leave the countryside and move to urban areas. After leaving, few returned. During the Cultural Revolution, teachers and students in rural areas heeded Mao's calls to address educational imbalances. While schools and universities in urban areas closed, Red Guards opened new ones in the countryside. Village production brigades established primary schools. In communes and districts throughout the countryside, Red Guards promoted the formation of middle schools and high schools (Pepper 1991; Han 2008). Between 1965 and 1976 enrollment numbers in primary schools went up from 85 percent of children in the general population to more than 95 percent (Peterson 1997, 148), and increased from around 116 million in 1965 to around 150 million in 1976. Middle school enrollment, too, grew from about 9 million in 1965 to some 68 million in 1977. This was tantamount to an increase of children attending middle school of more than 700 percent, or approximately thirty times the population growth during the period. This staggering change obviously had a huge impact on Chinese life (Feignon 2002, 149; see more figures in Han 2008).

Did the Anti-Confucius Campaign reach these schools? Was it even intended to? There was no central but rather only local supervision of schools, so perhaps they did not even know of the campaign or had continued to read the *Three Character Classic* as they had always done before. I have no conclusive answers. Drawing from oral history and the analysis of the continuous criticisms of the *Three Character Classic* proffered above, I would tentatively agree with the preface remark in one of the many late 1980s editions of the *Three Character Classic*, which was a reprint of the original (or Zhang Taiyan's *Republished Edition*). It argues that many people in the countryside (as well as in the cities, but the countryside is mentioned explicitly here) were now again learning to read and write with the *Three Character Classic* as they had for centuries (*SZJBJXZG* 1988). This tradition of reading was probably never completely broken off.

Memories: Reconfiguring Confucius after the Cultural Revolution

The Cultural Revolution . . . threatened the survival of this book. (Liu 1985, 193)

"Radical iconoclasm" is said to have "marked Chinese history of the 20th century" (Barmé 2008). It surely has. Frequently throughout this chapter I have referred back to the May Fourth Movement and its anti-Confucian stance, so similar to that of the Cultural Revolution (Chow 1960). And even during the Cultural Revolution itself, the parallel is invoked repeatedly: *Study and Criticism* begins its fifth volume in 1974 with a quote by Mao remarking on the fact that the May Fourth Movement already had thoroughly opposed "feudal traditions" (五四运动所进行的文化革命则是彻底地反对封建文化的运动) (*XXYPP* 1974.5:3). The Cultural Revolution also saw the re-publication of relevant works by one of the most adamant May Fourth protagonists in this iconoclastic endeavor: Lu Xun.[82] Few, however, make this connection and maintain that "the Cultural Revolution repeated a lot of what the May Fourth Movement had also done; it is really quite frightening" (Museum Curator, 1950s–). In the same way as there is a mythologized view of the Cultural Revolution, there is also one of the May Fourth Movement. But in spite of their acknowledged common aims and goals, the May Fourth myth is much more positive: science and democracy are constitutive elements of it (quite evident in the Long Bow Group's documentary *Gate of Heavenly Peace* 1995, for example); the iconoclasm and the proverbial "smashing of the Confucius shop" (打倒孔家店 *dadao Kong Jia dian*) is mentioned in this context but not related to destruction of traditional culture as a whole (May 2008). Not everyone would second the following opinion:

> We have lost the knowledge of our tradition. We have destroyed it. There is no appreciation for this kind of culture anymore. Because, for example, people don't know the texts anymore And if you are strict, this does not start with the Cultural Revolution, but with Yan'an, or even the May Fourth Movement, although then, of course, people would still have had a basis of culture from which they could start. (Intellectual, 1955–)

In spite of the fact that radical iconoclasm, backed and strengthened by politics, has defined Chinese history in the twentieth century, resilience and continuity of tradition may have mitigated its possible detrimental effects. This is all the more so as the Anti-Confucius Campaign of the early 1970s, not unlike its predecessors throughout the twentieth century beginning with the May Fourth Movement, was a short-lived event: the one-sided interpretation of Chinese history as a two-line struggle between Legalists and Confucians was soon rejected. Indeed, it was argued as early as 1976 that both groups were in fact from the "exploiting classes" and that their struggle was therefore not one "between the oppressed and the oppressors, but between two competing exploiting classes." This was, so the argument continued, fundamentally different from a struggle between the "proletariat" and the "capitalist classes," making any analogy to contemporary events "irrelevant" (Louie 1980, 142).

Confucius as a person, too, was rehabilitated, as the two most notorious articles against him, "That Man Confucius" (孔丘其人) (*RMRB* 3 April 1974) and "More on That Man Confucius" (再论孔丘其人) (*RMRB* 24 February 1976), both published by Jiang Qing's "writing school," under the name Liang Xiao 两校 (Two Schools) during the Cultural Revolution, were criticized late in

82. Louie 1980, 11 mentions *A Collection of Writings by Lu Xun Criticizing Confucius and Confucianism* (鲁迅批孔反儒文辑 *Lu Xun pi Kong fan Ru wenji*) published in 1975, for example, and there are numerous articles in *Study and Criticism* and *Aurora* on Lu Xun alone.

1976 on the pages of the *People's Daily* (*RMRB* 30.12.1976; Louie 1980, 139–40). Thus, China quickly returned to a critical but appreciative attitude towards "that man," and especially "that teacher Confucius." This was supported—not without irony, as he had been quoted most widely during the Anti-Confucius Campaign as a critic of Confucius—with a reference to Mao's advice to follow Confucius as he had urged people "to be insatiable in learning," to be "tireless in teaching others," and to "inquire into everything" (Louie 1980, 143).

In an essay "Confucius and His Modern Critics," written in 1974 in the midst of the Anti-Confucius Campaign, Julia Ching conjectures that "for a people with a great cultural past, any critique of the tradition itself, and of Confucianism in particular, must give rise to emotional problems. These may, in part, explain the vehemence of the campaign now raging." And she predicts that "if Confucianism does have some universal meaning not limited to a social class or to any period in time, then the march of history itself may yet vindicate his merits, not by placing him back on the pedestal, but by witnessing a transforming growth of the values he taught" (Ching 1974, 145).

Almost four decades later, with the establishment of so-called "Confucius Institutes" all over the world and an influential discussion begun in the 1990s over "Asian Values," at a time when Chinese and other Asian leaders attempted to define their own economic growth as a "Confucian enterprise" (Louie 2001), it is obvious that some of what Ching predicted has indeed come true. The polemical debate on Confucius fought out in full public view during the Anti-Confucius Campaign yielded no new academic discoveries, but it also did not manage to take Confucius down from his pedestal. The many references to China's 5,000-year-long history and the country's great sage Confucius, reiterated at almost any possible occasion from academic conference to business or political meeting today, shows that Confucius is still important.[83] He has not lost his former glory. Confucius' fortune as well as his misfortune was that, time and again, his name and memory should have been raised so high by political authorities of both the past and the present, using, abusing, distorting, and reinterpreting his teachings to suit their own purposes. Nevertheless, a transformed, transfigured, postmodern Confucius is alive and kicking today, in spite of the many attempts to ban him from sight.

Under Jiang Zemin and his presidency (1993–2003), the birthday celebrations for Confucius and all teachers were brought back, thus receiving official sanction (Bakken 2000, 18). How do we interpret this act? Was Jiang's action a response to popular pressures? Or was it a sycophant measure to regain international recognition? And how much does this tell us about people's attitudes toward Confucianism now and throughout the Cultural Revolution? The massive if apologetic publication boom of the "admittedly feudal" *Three Character Classic* since the early 1980s, and texts such as the many different versions of the *New Three Character Classic* of 1995— which retain the values of filial piety and brotherly love but exclude the importance of "returning to the rites" and condemn the idea of the goodness of human nature—speak their own ambiguous language, as had earlier parodies of the *Three Character Classic*.

Confucianism, it can be argued, was never completely discarded, even during the Cultural Revolution. The sweeping attacks on tradition that occurred during this time have not been repeated in a similar vein recently (Louie 1980, 93). Some elements, especially the suspicion of "feudal heritage" (already prominent in May Fourth discussions), rites, and the goodness of human nature, have survived, however. Generally, though, as in the 1950s and early 1960s, the trend in recent times has moved more and more towards a favorable evaluation of China's past and hence of "that man," Confucius.

83. See the statistical evidence from *People's Daily* and *China Academic Journals* as provided in Crone 2011.

Accordingly, management handbooks for those doing business in China today rightly teach the potential investor that Chinese society is deeply influenced by the logic of Confucianism. Cultural Revolution policies were reversed thoroughly after the end of the Cultural Revolution, but this may not be the only reason why Confucian values play a role in China today in spite of all the damage done to them then, not to mention in a series of earlier anti-Confucian movements throughout the twentieth century. Contrary to expectation, Cultural Revolution policies of vilifying Confucius, Confucianism, and Confucian writings such as the *Three Character Classic* may in fact provide one of the crucial answers to the question of this continuity: Confucian culture was perpetuated not in spite of but because of its vilification during the Cultural Revolution years. The Cultural Revolution can be seen as "an attempt to cut society off by its roots, to establish a utopian dream unencumbered by memories from the past" (Bakken 2000, 17), and the Anti-Confucius Campaign was one particularly radical example for this. Yet, it appears to have either failed or backfired. Again, the Cultural Revolution practice of struggle, criticism, and transformation (斗批改 *dou pi gai*) did not reach its conclusion: no transformation occurred.

What would the transformation have been? The aims of the Cultural Revolution, as formulated in the May 16 Circular, were to criticize and repudiate "reactionary bourgeois ideas" in all cultural spheres, including the academy, education, journalism, literature, art, and publishing, and to seize the leadership in all of these (Pepper 1991, 541). A reform of the "educational system" and all "methods of teaching" was stipulated, too, in the August 8, 1966, "Decision on the Cultural Revolution" (Schönhals 1996, 40). And indeed, the Cultural Revolution changed education and culture, but did that influence the "Confucian spirit" in China? Mao's aim for educational reform, already formulated in 1964 and set to work again during the early years of the Cultural Revolution, had been to create a system designed to reduce three distinctions, that is, between mental and manual labor, between workers and peasants, and between town and countryside (Pepper 1991, 562). With the reinstallment of Deng Xiaoping during the second half of the Cultural Revolution, a political act that, as we will see in greater detail in Part III of this book, also had profound repercussions on cultural production in China, many of the policies resulting from these initiatives were reversed. The Anti-Confucius Campaign therefore can be understood as an attempt to re-enforce Mao's more radical policies against this general trend. The (more or less fictional) emphasis on peasants and working classes taking part in the campaign and its publications—then seen as evidence for the "mass-line" in Chinese politics—must be understood in this light.

In this attempt to deliberate both the intentional and the possible effects of an openly iconoclastic period such as the Cultural Revolution on the transmission of traditional cultural heritage such as Confucian thought, and, in particular, the *Three Character Classic*, and by contextualizing this peculiar act of transmission with earlier and later models, I use "modern" and "traditional" not to mark "development" or "origin" respectively. The Chinese "modern" cultural system created throughout the twentieth century is hybrid and transcultural, containing elements that could be (and have been) called "traditional" and "modern" at the same time. This system is not a "pure" Communist creation, either. With regard to the transformative history of the *Three Character Classic* and its parodies, I attempted to show that reflexive, not determinist, cultural patterns constantly recur in the form of "memories"—in this case (inter)textual memories. Such "memories" are not only about "tradition"; they are, most often, about practical strategies of social impact and control in the respective historical present, too. This is not only obvious in criticisms of the *Three Character Classic* during the Cultural Revolution, but in the writings of the Taiping rebels, of the leaders of the May Fourth Movement, and of the missionaries as well (Bakken 2000, 9). In each case, "tradition," in the form of the *Three Character Classic*, comes back not as "re-traditionalization" but as a direct instrument of reform and modernization (Bakken 2000, 24). This discussion of the

uses of the *Three Character Classic* in modern Chinese history does not attempt, therefore, to make or even assume causal links between the Confucian tradition and the respective present. Rather, these uses of the past in the present are uncovered as repetitive and imitative cultural processes, examples of "repetition with a difference" which make the classical pattern recur in ever new, but often cross-referential, modern forms. What I would like to emphasize, then, is both the redundancy and the uniqueness of each of these forms (Bakken 2000, 10).

In terms of culture and tradition, therefore, Mao's "Continuous Revolution" was one that was to fight against unwanted parts of tradition within the utopian Chinese modernity he hoped to engender. His aim was to develop—by means of class struggle—a society with selected roots and memories to the past, created in the present, to realize a future utopia of Chinese modernity (Bakken 2000, 1). In essence, then, his Continuous Revolution sought a redefinition of a modern but Chinese culture. Taking the *Three Character Classic* as one prominent example, it may have become clear that Mao's plight was one not entirely different from that of many others who had attempted (and would continue to do so) to reform and yet make use of Chinese tradition for the modern age. The distinctively canonical use of his writings, discussed in the next chapter, shows this principle at work once more.

CHAPTER 4

THE FOOLISH OLD MAN WHO MOVED THE MOUNTAINS: SUPERSCRIBING A FOUNDATIONAL MYTH

Mao Zedong Thought is rain and dew; it is air and sunshine. Only with the moisture and nourishment of Mao Zedong Thought can we look upon thousands of doubling waves of rice and beans. Mao Zedong Thought is the soul; it is wisdom and it is strength. Only if we are armed with Mao Zedong Thought will there be heroes arising without cessation. This is the new Heaven and new Earth of the Mao Zedong period. New people and new things, our whole academy, all of China is like this, and in the future the whole world is going to be like this, too. (Guo Moruo)[1]

I just wanted to get a washbasin. There was one with a line from Mao's poetry and a very beautiful picture. I thought this much more beautiful than others. We had very few things, then, but we wanted them to be beautiful—this is my impression. There were quite a few things with Mao quotes on them. (Language Instructor, mid-1950s–)

We used Mao's quotations [语录 *yulu*] to learn foreign languages—Russian, for example. (China Historian, 1949–)

Prelude: Depicting the Power of Words

The previous chapter introduced a 1964 illustration from a *Three Character Classic* for peasants with a smiling couple, inspired by Mao's writings (see **ill. 3.9**; NYJSSZJ 1964, 61). Similarly, a propaganda poster from 1977, entitled *Let's Set off a New Upsurge in the Study of Mao's Works* (掀起学习毛主席著作的新高潮), shows a group of people—workers, peasants, and soldiers, men and women from different walks of life—each holding the newly published fifth volume of Mao's works in their hands (**ill. 4.1**). Depictions such as these, where Mao's works are dramatically put into scene by means of elevation, repetition, and accentuation—replicated, endlessly, in image, word, and song—suggest their constant presence in Chinese everyday life at least since 1949.

This presence was probably felt most prominently during the Cultural Revolution: One 1966 propaganda poster, for example, entitled *Mao Is the Red Sun in Our Hearts* (毛主席是我们心中的红太阳) (**ill. 4.2**), shows a worker hero holding up a copy of Mao's works, ornamented with Mao's standard portrait, exuding (pink) rays like the sun. The worker is flanked by a female peasant and a male soldier, while a group of people from all walks of life (and nationalities) is seen in the background, each of them holding the book with Mao's writings (also bearing his portrait) close to

Ill. 4.1. Propaganda Poster *Let's Set Off a New Upsurge in the Study of Mao's Works*, 1977 (Collection Pierre Lavigne, maopost.com 0070 001 M).

1. Guo 1968, 5.

their heart. Red Guard publications, too, include numerous (woodprint) illustrations praising the might of Mao's Thoughts.[2] In one such illustration, a volume of Mao's works is held up in the hand of a female revolutionary, who carries a sword in the other (**ill. 4.3**). The book emanates sun-like rays, which shroud the young revolutionary and her companion as they stand erect, fighting against two tiny figures, one of which is identified as Liu Shaoqi, holding up a piece of paper with "self-cultivation" written on it, the Confucian virtue advocated by Liu in his book on "How to be a good Communist" (Liu 1965).

From the same year stems another poster entitled *We Will Be Victorious Over the English in Hong Kong* (我们必胜港英必败). It shows a group of strong and youthful demonstrators, men and women alike, with typically huge forearms, moving swiftly forward (**ill. 4.4**). Each of them is holding a *Little Red Book* of Mao quotations. They are carrying, in addition, posters with Mao quotations, most of them, like "Be resolute, fear no sacrifice, and surmount every difficulty to win victory" (下定决心, 不怕牺牲, 排除万难, 去争取胜利), taken from the *Little Red Book* (and this one, in particular, from the Story of the Foolish Old Man to be discussed in this chapter).[3]

Mao's words were everywhere; they were indeed (and, ironically, not unlike the *Three Character Classic*) "well known to every family, everywhere, in the cities and the countryside" (家喻户晓), as a four-word phrase puts it.

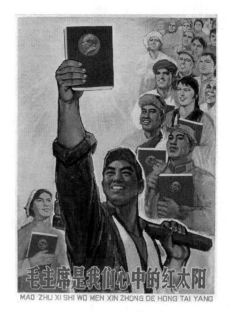

Ill. 4.2. Propaganda Poster *Mao Is the Red Sun in Our Hearts*, 1966 (DACHS 2008 Red Book Heidelberg).

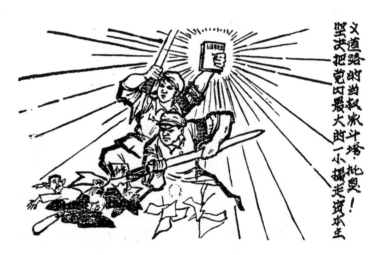

Ill. 4.3. *The Power of Mao's Words in Fighting the Enemies of the People* (*HWBZL* 1980 Suppl. 1, vol. 3: 1216, Wenge fengyun 文革风云 1967.8:25).

2. See, for example, *Hongweibing ziliao* (hereafter *HWBZL*) 1980 Suppl. 1, vol. 3, 1216 (*Wenge fengyun* 文革风云 1967 August 25); and *HWBZL* 1980 Suppl. 1, vol. 3, 1083 (*Wenge fengyun* 文革风云 1967 May 26); as well as *HWBZL* 1980 Supp. 1, vol. 2: 805 and 782 (from *Dapo dali* 大破大立 back cover page and p. 10).

3. "The Chinese people will not be humiliated," reads one of the quotes, and "Imperialism and all reactionaries are paper tigers," is the text of another (the title of Chapter 6 in the *Little Red Book*). The poster was printed in connection with the Hong Kong Riots, that raged between the spring and winter of 1967 when Communist forces had attempted to "win back Hong Kong" by manipulating strikes and demonstrations, causing widespread violence. Very differently from the message of the poster, the riots were unsuccessful and subsided by the end of the year.

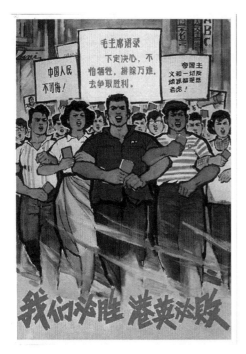

Ill. 4.4. Propaganda Poster *We Will Be Victorious and the English in Hong Kong Will Lose Out*, 1967 (DACHS 2008 Red Book Heidelberg).

One image from a 1973 comic version of what would also become the model ballet *Children of the Grasslands* shows a father explaining to his children that they must be diligent and learn from Chairman Mao (**ill. 4.5**). They are kneeling in front of a large Mao portrait. Each of them (including their father) is holding a book with Mao's writings in their hands. More such books are waiting on the table. A propaganda poster published in 1975 (**ill. 4.6**), which bears the four-word phrase as its title, shows a young girl who has hung upon a tree in the center of the image a blackboard with a quotation by Mao. People from all walks of life gather. The backdrop to the scene, which shows others reading and posting big-character posters on the surrounding walls of buildings, depicts an intense atmosphere of ideological instruction.[4]

And such images did, at least to an extent, reflect experiences made during the Cultural Revolution. Many remember acutely the heavy influence of Mao's words in their quotidian experiences: In the early years, the Red Guards had demanded that every street and lane set up quota-

tion boards (语录牌 *yulupai*), that every household and family put up Mao quotation posters, and that Mao's words adorn public parks and even buses, bicycles, and trains.[5] Mao quotations were broadcast through loudspeakers on the streets, on the radio, and on television.[6] Some recall how they would assemble near the radio to listen to Mao's newest instructions every day and then walk around, with a gong, chanting the quotations until late into the night.[7] In a

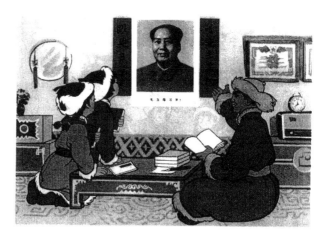

Ill. 4.5. Reading Mao (*Little Sisters of the Grasslands*, Beijing Foreign Languages Press, 1973).

4. Images of this sort were commonplace during the Cultural Revolution. In earlier parts of this book, we have already seen some, including one depicting an old man teaching a group of rusticated youth (ill. II.1), another showing two young girls reading together (ill. II.2), and a third with Jiang Shuiying, the main heroine in the model opera *Song of the Dragon River*, reading the story of the Foolish Old Man together with other brigade members (ill. 1.10). For further examples, see DACHS 2008 Red Book Landsberger and DACHS 2008 Red Book Heidelberg.

5. For some examples of such documents see Schönhals 1996:, 212–22.

6. Leese 2006, 151 finds that in May 1966 the Hebei Television Station broadcast a five-minute-long Mao quotation beginning at 6:20 a.m. every day.

7. See *Wenge xiaoliao ji* 1988, 16; and the testimony quoted at the beginning of this chapter.

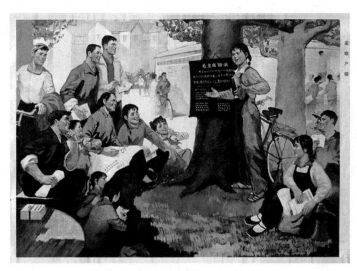

Ill. 4.6. Propaganda Poster *Well-Known to Every Family, Everywhere, in the Cities and the Countryside*, 1975 (Collection Pierre Lavigne, maopost.com C 00632).

collection of jokes from the Cultural Revolution, this activity is reflected in a little boy's question to his father: "Does Mao ever sleep, if he gives out his instructions so late at night?" (爸爸, 毛主席老是半夜三更发表指示, 他睡不睡觉呀?) (*Wenge xiaoliao ji* 1988, 21). The constant reminders never to forget to study Mao's works find their documentary[8] and photographic echo[9] and take up an important place in memoirs and oral histories as well.[10] During the Cultural Revolution (even more so than before and after it),[11] reading the words of Mao was to be everyone's daily concern: the early Cultural Revolution "Read Every Day" campaign (天天读 *tiantian du*) officially ordered the masses to set aside time each day to study Mao Zedong Thought in whatever forms it took (Bryant 2004, 48).

But what did it mean to read Mao every day? Images, jokes, and stories, as well as songs, were produced to tell everyone about it: "Sailing the Seas Depends on the Helmsman" (see Chapter 2), for example, the song that would be used to end every public meeting, every school day, explains: "Making the revolution depends on Mao Zedong Thought" (干革命靠的是毛泽东思想), as Mao's Thought is the "sun that forever shines" (毛泽东思想是不落的太阳). It is stuff that life depends on: it is as important to the (survival of the) people as water is to that of fish (鱼离不开水呀). And this is why Mao's works are what people "love reading most" (毛主席的书我最爱读), as another song explains: they strengthen them like dew nourishes a dried-up plant, they give them revolutionary optimism, a fighting spirit: they appear as the key to all questions about life.

8. A cursory survey of works such as *Xuexi yu pipan* (hereafter *XXYPP*), for example, yields rich harvests: see e.g. *XXYPP* 1973.3:3–6, and 9–10, which contains a section advocating the study of ten important pieces of Marxism, Leninism, and Mao Zedong Thought (similarly *XXYPP* 1973.4). *XXYPP* 1975.5:3 suggests that readers study some of Mao's early works on the peasants, while *XXYPP* 1975.8:18ff discusses Mao's works on the military. *XXYPP* 1976.1 contains an entire section on Mao poetry.

9. See DACHS 2009 Documentary Photographs, Cultural Revolution, Sent-down Youths I and II by Thomas Hahn.

10. *Wenhua da geming bowuguan* 1995, 244 shows a demonstration with huge numbers of Mao quotation placards; Wang and Yan 2000, 176 show a train adorned with Mao quotations and a Mao portrait at the engine; Leese 2006, 219 finds that "the daily routine of opening and closing every assembly with the collective singing of the 'East is Red' and 'Sailing the Seas on the Helmsman' along with the omnipresent group study of Mao quotations has continued to be one of the most widely shared remembrances of the Cultural Revolution by victims, opportunists, and supporters alike," a claim that is well supported by my interview findings, too.

11. The publication of each volume of Mao's works before and after the Cultural Revolution was also accompanied by a "Study Mao Zedong Thought Campaign" (Huang 1968, 44). Leese 2006, 84 mentions these campaigns began in September 1960 when the fourth volume of Mao's *Works* was published. During such campaigns, everybody would form "Study Mao Zedong Thought Classes" (毛泽东思想学习班), and the whole country was declared in the media to be a "Great School for Mao Zedong Thought" (毛泽东思想大学校).

Reading Mao, word by word, sentence by sentence, things lighten up and the sun rises in one's heart. One feels empowered, indeed: Mao's words are like a pistol in one's hands.[12]

And accordingly, everyone is happy that "Mao's words are engraved in everyone's hearts" (毛主席的话儿记在我们的心坎里),[13] for only then are they able to face all difficulties, to overcome even the most enormous obstacles, to travel even the largest distances, to suffer extreme heat and cold. In short, Mao's words are omnipotent. Following them, one always knows what to do and where to go (毛主席的著作像太阳, 字字句句闪金光, 照得战士心里亮, 工作学习有方向).[14]

In Charles Fitzgerald's words, Mao's writings had by the mid-1970s "become to his own people in his own age what the *Sayings of Confucius* [i.e., the *Analects*] were to the Chinese people for the past two thousand years: the source of inspiration and guidance in matters social, political and moral" (1976, 1). Already in November 1965, Mao himself had compared what would later be known as his *Little Red Book* or *Quotations from Chairman Mao Tse-Tung* (毛主席语录) to the short and terse works attributed to Laozi and Confucius (Leese 2006, 127). The very choice of title for this selection—"recorded words" (语录 *yulu*), a genre originally associated with Buddhist and especially Chan Buddhist masters, the latter of which detested the written word but left a recorded oral legacy—is telling. Mao thus styles himself into a producer of "recorded words" not unlike those from that early tradition, thus becoming a modern-day sage. An ironical illustration of how powerful this claim apparently was is the new *Little Red Book* sold in the 1980s: it looked precisely like its predecessors from the Cultural Revolution, complete with shiny red plastic cover and golden engraved characters. Yet the text it contained was different: the golden characters do not read "Recorded words of Chairman Mao" (毛主席语录) but "Sayings of Confucius" (论语).[15] In the minds of those who produced this *Little Red Book* for the 1980s, then, Mao's words held an authority quite comparable to that of the Confucian Classics in traditional China.

It is the purpose of this chapter to illustrate that the treatment of the canonic classical philosophical heritage in traditional China as discussed in Chapter 3 does not differ all that much from the handling of an equally canonic modern philosophical heritage in the form of Mao Zedong Thought in revolutionary China. Indeed, one could argue that quoting Mao constituted a ritual act, not unlike quoting the classical sages had been in ancient times when, in Kern's analysis, "quotation [was] the textual equivalent to ancestor worship" (2005, 295). Much of what can be

12. The Chinese text for this song is: 毛主席的书, 我最爱读, 千遍那个万遍, 下功夫, 深刻的道理, 我细心的领会, 只觉得心呀里头热乎乎, 嘿, 好象那旱地里下了一场及时雨呀, 小苗儿挂满了露水珠啊, 毛主席的雨露滋养了我呀, 我干起那革命劲头儿足, 一字字啊, 一行行, 一边读来, 一边想革命的真理, 金光闪句句话说在我的心坎上, 嘿, 好像那一把钥匙打开了千把锁呀, 心呀里头升起了红太阳, 毛主席的思想武装了我呀, 我永远握紧手中枪. This text is taken from one of the *Red Sun* (红太阳) CD volumes (no date, no publisher). Different versions, one propped up with a series of documentary photographs, others with commercial videos, and still others in private karaoke format or for traditional ensembles and instruments, are collected in DACHS 2009 Mao Songs. Some of them use a slightly different version of the text, which appears as published by Red Guards in V. Wagner 1995, Appendixes 10–11.

13. This is explained in another song (*Songge* 1992, 28–30): "We just have to remember you, Mao, and the red sun begins to rise in our hearts." The Chinese text for this song is: 毛主席你的话儿记在我们的心坎里, 喀喇昆仑冰雪封, 哨卡设在云雾中, 山当书案月当灯, 盖着蓝天铺着地, 哎, 只要想起你毛主席, 只要想起你毛主席, 红太阳升在心窝里升在心窝里, 毛主席? 亚西尔毛主席? 你的话儿记在我们心坎里. 巡逻踏遍千里雪练武只恨高山低, 山涧当做障碍跳, 风雪当做战马骑, 哎, 只要想起你毛主席, 只要想起你毛主席. 紧紧腰带又是又是一百里, 毛主席? 亚西尔毛主席? 你的话儿记在我们心坎里. 青石板上烙大饼, 罐头盒里煮大米, 身上热汗烈日晒, 满面泥土雨水洗, 哎, 只要想起你毛主席, 雪拌炒面甜如蜜甜呀甜如蜜, 毛主席? 亚夏亚夏毛主席? 你的话儿记在我们心坎里.

14. This is the message in "Mao's Works Are Like the Sun" 毛主席的著作像太阳 (*Songge* 1992, 104), which explains that his words not only brighten up people's lives and hearts but show people the right direction. See also the Red Guard song "Mao's Quotations Have Been Distributed to Us" 毛主席语录发给咱 (Wagner 1995, Appendixes 15–16).

15. This has been mentioned in the Prologue to Part II. For a photo, see Barmé 1996, 86.

observed in terms of quotation practice during the Cultural Revolution (and before and after) points in a similar direction (May 2008). In this chapter, I argue that even while new uses of Mao Zedong Thought before, during, and after the Cultural Revolution may have constantly and continually changed its meaning, it maintained some of its most essential characteristics, and, most importantly, its authoritative, canonical power.

This chapter discusses the before- and afterlife of one piece of Mao Zedong Thought, the "Story of the Foolish Old Man Who Moved Mountains" from Mao's *Little Red Book*, itself perhaps the most emblematic symbol of the power attributed to Mao's writings during the Cultural Revolution. The *Little Red Book* had been variously called a "revolutionary's dictionary," a "spiritual atom bomb," a "compass for the revolution," or the "Monkey King's cudgel" (ill. 4.7a). As an almighty panacea it could be found on numerous propaganda posters, in songs, and in the literature of the time. One could live without food or drink but not without the *Little Red Book*, so it was said. And thus the *Little Red Book*, also remembered as the "precious Red Book" (红宝书),[16] found its way onto everyday commodities such as handbags and marriage certificates (ill. 4.7 b&c).[17] Many a hero in Cultural Revolution lore would ask for his "precious Red Book" in difficult moments: the story of a self-sacrificing Party Secretary, who, ill with ulcers, fainted and, upon waking up, first demanded his "precious Red Book," is a typical example. As the story goes:[18]

> Upon being handed ... the most valuable book in the world, Chao smiled. He gazed happily at the picture of Chairman Mao, inside, and his lips formed the words: "Chairman Mao. Chairman Mao!"

After his visit to China in 1967, the Italian novelist Alberto Moravia (1907–90) even declared that there were no books in China except the *Little Red Book*, "which every Chinese carries about with him, to which he refers in all circumstances, which he knows almost by heart and where he looks, never doubting that he will find it, for the answer to any question which is not immediately obvious to him."[19] Indeed, the *Little Red Book* has a most astonishing publishing history, with publication figures that approach those of the *Three Character Classic* or the Bible, perhaps (Leese 2006, 122; Huang 1968, 1). In the first years of the Cultural Revolution some printing houses would disrupt their work on other publications in order to meet the quota of production for the *Little Red Book* and other works by Mao (Huang 1968, ii). Up until Lin Biao's death in September 1971, the *Little Red Book* had been translated into thirty-six languages, including Braille script, and it had been published in official versions in the dozens of billions within China and in the hundreds of millions abroad. Additionally, some 440 local editions have been distinguished (Leese 2006, 122). Everybody in China during those years was able to (and probably also did) possess at least one copy of this "precious book."

The story of its origins begins some time in the early 1960s, when the army's instructional blackboards were turned into "quotation boards" that could be carried along when the army conducted marches or training sessions (Leese 2006, 125). Soon thereafter newspapers began to regularly print short quotations from Mao (Huang 1968, 10). There was a problem with this practice, however—and this may illustrate the difference, at least to some degree, between the study of Mao's "Classics" and the study of the Classics in traditional China, which required that works be memorized *in toto*. There was no index to the works of Mao, and newspaper editors

16. The whole phrase, 红彤彤的革命宝书, appears in *People's Daily*. See *RMRB* 4 December 1967 "伟大领袖毛主席和 林彪副主席接见海军和通信兵等革命战士."

17. See also the everyday items and ephemera such as matchboxes and similar items collected in Shen 2006a, 79, 83, 85. Such matchboxes with quotations from the *Little Red Book* are sold again today.

18. *CL* 1970.7:3–18, "A Party Branch Secretary," 16–17.

19. His testimony is recorded in Huang 1968, 3.

found it to be quite cumbersome to identify an appropriate quote every day. The *Tianjin Daily* (天津日报) had, for this reason, copied some of the most famous passages from all four volumes of the *Selected Works* and arranged them, thematically, in card boxes. Finding a suitable quote thus became a much easier task than before. The Tianjin card box system would provide the fundament for the compilation of the *Little Red Book* (Leese 2006, 123), first put into practice at a PLA General Political Department conference in December 1963 where *Liberation Army Daily* editorial staff presented to the army the idea of publishing Mao quotations in book form for internal use. By the end of the conference, on January 5, 1964, a first issue of 200 quotations was distributed to the conference participants. On May 16, 1964 the first regular print edition appeared, classified as "internal" military reading, its size adjusted to neatly fit into the pockets of military uniforms. Not unlike other writings by Mao, the booklet was published in two versions: an ordinary edition with a white paper cover imprinted with red characters and a special edition clad in a red plastic cover (Leese 2006, 125–26).

The exact reasons why the PLA's *Little Red Book* was such a publishing success have not been studied, but the first edition of some four million was soon sold out; a second edition of some twelve million copies, now entirely clad in red plastic, followed in August 1965. Still, pressure on the Liberation Army Publishing House, whose workers were working non-stop shifts, was extremely strong. In November 1965, a decision was made to allow the distribution of paper moulds to local printing plants, paper supplies were stocked up, and thousands of additional workers hired. By February 1966, some 75 million copies had been printed, but all the same, demand far exceeded supply. Meanwhile, as late as March 1966, the State Council's Foreign Affairs department issued a circular requiring that all foreigners return their copies of the PLA volume, but this decision was recalled in April (Leese 2006, 129–31; Huang 1968, 5). Throughout 1964 and 1965 competing collections of quotations by Mao had appeared, and on January 29, 1966, the Central Propaganda Department decided to make a *People's Press* (人民出版社) version, not the PLA version, the authoritative one. Yet, this decision, too, was aborted in the turbulent summer to follow (Leese 2006, 126–28).

At a Politbureau meeting on May 18, 1966, Lin Biao declared Mao Zedong Thought sacrosanct. His idea was endorsed, and thus Mao Zedong Thought, which had been an important element in the making of the CCP's success since its first implementation in the Party constitution in 1945, was cemented as the crucial source of the regime's legitimacy (Leese 2006, 290, Apter and Saich 1994). It is the purpose of this chapter to show the longevity of the appeal of Mao Zedong Thought by uncovering the workings of its power. Especially in the form of the *Little Red Book*, Mao Zedong Thought was turned into a symbol of revolutionary conviction and loyalty to the Chairman. The words of Mao, a "living fountain of truth," now had to be constantly repeated by all who wished to avoid being branded as a counterrevolutionary: an asymmetrical type of communication evolved (Leese 2006, 290).

In tracing the history of one Mao quote from the *Little Red Book*, this chapter asks: How powerful was (and is) it? To what extent were performances of Maoist communication genuine? To what extent were they hypocritical and "flattery" alone (Leese 2006, 290)? Was the *Little Red Book* more important as a "rallying symbol than as a carefully studied Bible?" Was it indeed more "enthusiastically waved than thoughtfully read?" Did it function primarily as a "talisman," as some contemporary observers have contended? (Huang 1968, 5) And what role does the story play before, during, and after the Cultural Revolution?

The Story

> When Mao would be talking about the Foolish Old Man, it was an inspiration for the poor people, even within the greatest disasters. (Photographer, 1960s)

> We sung quotation songs, especially "Be resolute" [下定决心 *xiading juexin*]. Really everybody can sing that and knows that this is part of the *Three Constantly Read Articles* [老三篇 *Lao sanpian*].[20] I did not go to the countryside, but we would have these "work classes" [劳动课 *laodong ke*] and during those "Be resolute" was very important, it helped us go on. (Female Artist, 1959–)

> I would use "Be resolute" when I was tired, for example. When you are young, you are very impressionable. The Chinese cultural spirit is very long-lived. Our old heroes, from the *Romance of the Three Kingdoms* all have this kind of spirit. So I would memorize the *Three Articles*. Zhang Side, yes, I really believed in him; Bai Qiu'en, too, this Canadian helping us, really, he did a great job. And the Foolish Old Man, well, the story is all about this cultural spirit, this stamina, how you have to overcome all difficulties [克服困难 *kefu kunnan*]. I would say that even today this spirit is quite influential! Although, now, life is different, and perhaps we don't think about this too much anymore. But then, during the Cultural Revolution, because we had to work so hard, we would sometimes think of "Be resolute." When we had to carry all these heavy things, for example, someone would just start saying it. Actually, that happened quite often. If you were pushing something really heavy and the work was really tough, you would recite it. It was useful, it became a kind of well, a kind of slogan. I also remember that there were a lot of stories that would be using this slogan, too. (Guqin Player, 1940s–)

Chapter 21 of the *Little Red Book*, entitled "Self-Reliance and Arduous Struggle," contains the following story:

> There is an ancient Chinese fable called "The Foolish Old Man Who Moved Mountains." It tells of an old man who lived in northern China long, long ago and was known as the Foolish Old Man of the Northern Mountains. His house faced south, and in front of his doorway stood the two great peaks, Taihang and Wangwu, obstructing the way. With great determination, he picked up his hoe and led his sons in digging up these mountains. Another greybeard known as the Wise Old Man saw them and said derisively, "How silly of you to do this! It is quite impossible for you few to dig up these two huge mountains." The Foolish Old Man replied, "When I die, my sons will carry on; when they die, there will be my grandsons, and then their sons and grandsons, and so on to infinity. High as they are, the mountains cannot grow any higher, and with every bit we dig, they will be that much lower. Why can't we clear them away?" Having refuted the Wise Old Man's wrong view, he went on digging every day, unshaken in his conviction. God was moved by this, and he sent down two angels, who carried the mountains away on their backs (Mao 1966, 201–2).[21]

This story was told by Mao as part of his final speech at the Seventh National Congress meeting of the CCP on June 11, 1945, in Yan'an. It was a speech made at a time when the second United Front between the GMD and the CCP, which had been formed in response to the Japanese invasion, was slowly disintegrating in spite of American efforts to save it that had persisted into January 1945. It was a time when an end to war was not to be expected, and the Chinese were still intent on resisting the Japanese. The two main tasks that Mao defines in his speech are, therefore, to fight first against the Japanese and second against the GMD. These were the two large mountains facing everyone. He said:

20. This translation—shortened throughout this chapter to *Three Articles*—follows the official translation as used in propaganda publications such as *Chinese Literature*. Literally, the Chinese characters mean "three old articles."
21. The translation mostly follows the official translation in the English volume of the *Little Red Book*. For consistency's sake, I have made a few small stylistic amendments to the text, however (by adopting, for example, "Moved Mountains" over "Removed the Mountains").

Today, two big mountains lie like a dead weight on the Chinese people. One is imperialism, the other is feudalism. The Chinese Communist Party has long made up its mind to dig them up. We must persevere and work unceasingly, and we, too, will touch God's heart. Our God is none other than the masses of the Chinese people. If they stand up and dig together with us, why can't these two mountains be cleared away? (Mao 1966, 202)

The Seventh National Congress meeting of the CCP had begun in April and was held concurrently with the GMD's Sixth Party Congress. At that point in time, the CCP had a membership of 1.2 million and controlled a large part of North China. Mao's speech contrasts the behavior of the GMD, which had caused China to "sink into the dark," with CCP actions, which would lead China to a "bright and happy future." The story of the Foolish Old Man serves the purpose of transferring the enthusiasm and hope for victory already prevalent among supporters of the Party to the wider populace. In his speech, Mao says that it is necessary to awaken the vanguard, so that they may "be resolute, fear no sacrifice, and surmount every difficulty to win victory." Incidentally, this call for stamina and absolute devotion, which crystallizes the message of the Foolish Old Man's story, appears in another chapter (19) of the *Little Red Book* entitled "Revolutionary Heroism" (Mao 1966, 182). Mao's speech continues with an admonishment to go out and teach the people: "We must also awaken the broad masses of the people throughout the country so that they may willingly and gladly join us in the common struggle for victory. We must instill into the people throughout the country the faith that China belongs to the Chinese people and not to the reactionaries" (Mao 1956, 316). Then, he tells the Foolish Old Man's story.

Mao, a self-fashioned storyteller, expects to achieve nothing less than an awakening of China's people and a transformation of their consciousness. Not by fluke is this story told during a congress in which a new Party constitution establishes Mao Zedong Thought 毛泽东思想 as the Party's master text.[22] It was the beginnings of the Mao Cult, which was to flourish during the Cultural Revolution and for which the *Little Red Book* would become the most important symbol. The story of the Foolish Old Man and its different uses throughout Chinese revolutionary history can serve as a gauge of the significance of Mao's words—collected in numerous smaller and bigger red books.

Throughout this chapter, I will illustrate that Mao could count on the fact that—by transfer— his words would be received in revolutionary China in a way and manner very similar to how the words of Confucian sages had been received in traditional China. Confucius' words and Mao's words can be considered of the same kind—authoritative speak. However, not unlike late Qing examination helps, which provided quotations by important Chinese philosophers for memorization, studying the *Little Red Book* was no way to acquire systematic knowledge of the Canon. Instead, quotations from the *Little Red Book* simply came to be employed as a means of ultimate persuasion by invoking Mao's authority (Leese 2006, 107). Terence Qualter, in a study on opinion control, argues:

In totalitarian systems, the equivalent of Orwell's Newspeak prevails. Language becomes highly "jargonised," relying on abstract, reductive catchwords as substitutes for thought. Words and phrases like "bourgeois decadence," "progressive," "revisionist," or "proletarian standpoint," are lazy alternatives to the critical exploration of meaning. For an individual person, the effect of the language of ideological totalism can be summed up in one word: constriction. He is, so to speak, linguistically

22. The term "Mao Zedong Thought" was coined in a *Jiefang Ribao* article; see *JFRB* 8 July 1943. Ironically, the idea is said to go back to Liu Shaoqi, one of the earliest victims of the Cultural Revolution (and Mao Zedong Thought).

deprived; and since language is so central to all human experience, his capacities for thinking and feeling are immensely narrowed. (1985, 72)

It will become clear in the course of this chapter that such restrictive, authoritative "manner of speech" (提法 *tifa*) was perpetuated before, during, and after the Cultural Revolution not just in the "totalitarian" propaganda from above but in the "popular" propaganda from below as well. The textual and literary sources studied here, which thrive in employing this "authoritative speak," have not so far captured the scholarly mind, however: they are considered semantically quite empty. Their function was never to do anything but demonstrate personal loyalty to Mao; they served a ritual more than a transmissive function (Leese 2006, 230). This again may be said to have caused their long-term effects. Turning Qualter's argumentation on its head, I will argue that the Maoist language that determined much of the rhetorics of revolutionary China was, during the Cultural Revolution, formed and reformed in particular ways as a response to the special needs of specific communities, as well as the state. Yet, to the very present, Maoist language continues to sustain this community (and the state, too), preserving its unique identity in spite of the consciousness of the restrictions this very same language caused and entailed (Qualter 1985, 68).

Tracing the overwhelming presence of one Mao quotation, the story of the Foolish Old Man, in the literary, artistic, and political discourse of the Cultural Revolution, I will argue that, paradoxically, the Cultural Revolution itself may not have been the time when the quotation was at its most influential and effective, even though it was certainly most visible then. In very few of the memoirs from the Cultural Revolution, for example, does the story of the Foolish Old Man play a significant role. Some of the more irreverent parodies of the story—in jokes and caricatures, in advertising, literature, films, music, and illustrations appearing after the Cultural Revolution— also point in this direction. However, the juxtaposition of Cultural Revolutionary uses with both earlier and more recent appearances of this quote will lead me to conclude that, granted all the sarcasm, spite, and liberty of more recent depictions, they are also evidence of the long-term persuasive strengths and submissive powers of MaoSpeak (Apter and Saich 1994). Some of these later reincarnations appear to be much more deeply felt than those produced in "assembly line practice" during the Cultural Revolution.

It is not enough to say, though, that in the last few years "the language of class struggle is regaining a particular 'chique'" (Shi 2002). More important than the question of "chique" may be first, that there are quite a few who are still struggling with traumatic memories of speaking Mao, and second, that there are quite a few who are nostalgic for "the old times, when everybody was poor but everybody had a goal, even if this goal was defined by the Communist Party" (Zhou 2002). Such nostalgia as well as such trauma is not a specifically Chinese reflex reaction—recent German history after reunification shows very clearly that the two are linked. The use of the Foolish Old Man's story in recent years suggests that, at least to some, in spite of 50 years of Communism preaching progress, China's golden age (as well as its dark age) continues to be situated in the past. The use of Mao's words often suggests that his "sunny China" has, in spite of itself, attained the glory and splendor of such a golden age. The clue to this somewhat paradoxical fact—as well as to understanding the more resentful, biting uses of MaoSpeak after the Cultural Revolution—may be found in their restrictively ritual enactment during that time.

The (Hi)Story behind the Story

> For one year the schools were closed. We did not really learn anything. Then, teaching materials changed, everything became rather more revolutionary. There were lots of readings by Mao: his words, his poems, the *Three Articles*. We would memorize this every day. (China Historian, 1957–)

> Now nobody studies the *Three Articles*. Of course, when I went to school, I studied them. It was useful to use Mao's words. (Museum Curator, 1950s–)

> We had to learn the *Three Articles* by heart. They are quite good, as Mao's writings, anyway, are good, there is nothing to be compared with them, which is why, during the Cultural Revolution, when you had to listen to and discuss his latest instructions, that was actually quite useful, we all liked it. (Beijing Taxi Driver, 1958–)

> Reading the *Three Articles* is like reading the Bible—you can really think about this comparison—or it is like a Buddhist recitation. You were expected to emulate Bai Qui'en and his behavior. Just like Jesus, he served as a model for us. All these social movements the Communists initiated could have been religious movements as well. (Playwright, 1956–)

> The *Three Articles* influenced me very much. Did I believe them? Well, what Zhang Side did is really admirable—not easy, to be sure [非常不容易 *feichang bu rongyi*]. The same with Bai Qiu'en [Norman Bethune], helping fighting Chinese—that is really quite impressive! I am still struck and influenced even now. This kind of spirit [精神 *jingshen*] is really special: he came and helped China, yes, that is really admirable. (Guqin Player, 1940s–)

As this chapter deals with quotations, it should not be left unsaid that Mao's story of the Foolish Old Man is in itself a quotation, although Mao does not explicitly say so: he describes the story as a "fable" from ancient China (Mao 1956, 316).[23] The original story can be found in the fifth book of the *Liezi* (列子) (Yang 1979, 159, 161), named after Lie Yukou 列御寇 who lived around 400 BCE. The dating of the text is contested; only a few parts of the text go back to the *Liezi*'s own time. Largely reflecting Daoist thought, it is made up of a collection of parables and dialogues. For a short time, in the eighth century, it became part of the Daoist Canon (Barrett 1993). The Confucians would be attacked during the Anti-Confucius Campaign in the mid-1970s, and the more prominent Daoists such as Zhuangzi or Laozi had been controversially discussed in the 1950s for their idealism, which, according to their critics, bordered on nihilism, and for their non-activism, although Laozi was given some credit for his peasant background and his "proto-materialist" thoughts in considering the *dao* the smallest basic element of which the world was made up (Louie 1986, 97, 100, 110–11, 125). The *Liezi*, on the other hand, was obviously not a part of the "feudal heritage" prominent enough to come under attack and therefore is not mentioned in Red Guard lists of forbidden books, for example. In his quotation of the *Liezi* text, Mao keeps most of the dialogues but leaves out a number of details from the original story. It is not mentioned, for example, that the old man is already 90 years old. It is also not mentioned that during the family meeting when he proclaims his decision to move the mountains, his wife stands up against him. The prominent role of a neighbor's child who comes to the help of the Foolish Old Man is not part of Mao's story, either (Yang 1979, 159–61). According to the Three Prominences, his own later well-established rules of rhetoric, Mao, in his version of the story, focuses the event by deleting a number of minor characters, thus drawing the figure of the hero—the Foolish Old Man—in much more clear-cut fashion.

23. It is quite striking that the connection between the original and Mao's quotation is not always made explicit in some editions of the *Selected Works*: the one-volume 1964 edition reprinted during the Cultural Revolution and the 1969 edition of the relevant volume even include the entire quotation from the *Liezi* (Mao 1964; Mao 1969). For an elaborate and meticulous study of the original *Liezi* story and its later uses, see Schwermann 2006.

Not only is Mao's story not his own story, but he is not the first one to use it in order to make the past useful for the present according to his own principle of "wielding through the old to create the new" (古为今用). A man much respected by Mao in spite of his "defection" to Taiwan, Fu Sinian 傅斯年 (1896–1905), quotes and discusses the *Liezi* story and even advocates the development of a "Foolish Old Man Who Moved Mountains Theory" (Fu 2003, 92–94). In the concluding section to an essay entitled "First Attempt on the Question of Human Life" (人生问题发端 *Rensheng wenti faduan*) published in the May Fourth organ *New Wave* (新潮 *Xinchao*) in January 1919, Fu juxtaposes the free development of the individual (自由发展个人) and the public good (公众的福利) in theorizing that the individual can only develop as part of society and is thus dependent on the public good (Fu 2003, 93). In his essay Fu emphasizes several aspects of the story: (1) the individual has to work for the good of the public 努力为公; (2) humankind has the power to conquer everything in nature (群众力量可以战胜一切自然界的); (3) all human progress has been based on such methods as used by the Foolish Old Man (人类的进化, 恰合了愚公的办法) (ibid.). All cultural achievements and developments today are thus the result of people having moved mountains in the past. A call to be diligent in spirit and to continue to move mountains is the kernel of Fu Sinian's theory, and he took up exactly those issues that would, two decades later, become important to Mao, and, several decades later, to more recent Chinese leaders and thinkers as well.

In 1940, the painter Xu Beihong 徐悲鸿 (1895–1953) created *The Foolish Old Man Who Moved Mountains* (愚公移山), a monumental oil painting much admired by Mao (**ill. 4.8**). Xu, one of the most famous painters in twentieth-century China, had studied in France and Germany between 1919 and 1927 and had become one of the most important representatives of a synthetic realism and, later, Chinese socialist realism. After breaking with the Nationalists in 1947 because they had attacked him for teaching Chinese art "inadequately," he almost immediately became an important painter for the Communist movement. When the founding of the People's Republic was proclaimed on October 1, 1949, Xu was on the balcony at Tian'anmen, just behind Mao (Andrews 1994, 29–32).

Xu's *Foolish Old Man* was painted in India, where he was invited by Rabindranath Tagore (1861–1941) to be a guest lecturer at a local university. It has been said that Xu's painting was inspired by the unfaltering spirit of "Saint Gandhi" (1869–1948), as he put it, whom Xu had met through Tagore. Xu finished the painting later in Singapore, where he resided for a time. Some argue that the painting conveys anti-Japanese sentiment, that the Foolish Old Man's determination

Ill. 4.8. Xu Beihong's *The Foolish Old Man who Moved the Mountains*, 1940 (Andrews 1994, 32).

THE FOOLISH OLD MAN WHO MOVED THE MOUNTAINS 201

also stands for the Chinese people's determination in their fight against the Japanese.[24] Even if it did contain this message, it was not propagated, for with the official outbreak of the Sino-Japanese War (unofficially, hostilities had been fomenting since 1931), Xu hid the painting in a well at a local school. After the war, in 1949, the painting was given to the school principal as a sign of Xu's gratitude. It has returned to China only recently.

One element important in later Maoist interpretations of the story is already visible in this image: this is not really the portrait of an old man, that is, *one* old man, who moved mountains, but it is the portrait of a collective, a group, hacking away at the rocks. The picture does contain an old man, but with his thin, ascetic (Gandhi-like?) body, he seems rather detached and uninvolved: with his back to the action, he is talking to a woman and child (perhaps from the original *Liezi* story). In this depiction, he appears as more the father of the idea than as the active individual moving the world (and the mountains) himself. The evident strength and the dynamic gestures, obvious in the almost completely unclad muscular bodies of everybody else who is part of the collective, are visual prototypes for later Cultural Revolution depictions of the story.

Yet, Cultural Revolution depictions put greatest stress on one aspect that, incidentally, plays no role in Xu's painting: Mao Zedong Thought. This is the inspiration for the particular behavior and the strength of the *New Foolish Old Men of Dashu* (in the South of Sichuan), a sculpture completed in 1967 (ill. 4.9a). The achievement of men and women, old and young all working together to move all these huge blocks of stone is only possible with Mao Zedong Thought: to provide literal illustration of this concept, a group is shown gathering

Ill. 4.9c. Mao's words and the *New Foolish Old Men of Dashu*, 1967 (*CL* 1967.5/6).

to read during their break (ill. 4.9b). Next to this scene, a quotation board contains that significant sentence emblematic of the story's spirit, "Be resolute, fear no sacrifice" (**ill. 4.9c**).[25]

Similar things must be said for the clay sculpture *Moving Mountains*, which appeared a decade later, in 1976, as part of a group of sculptures entitled *Song of Dazhai*.[26] Again, it is the sheer

24. The story about the painting's influence in the Sino-Japanese War, told by a young Chinese journalist, must be called apocryphal, however, as the painting could not have been well known at the time: 二是徐悲鸿《愚公移山》国画. 徐悲鸿是我国现代著名画家, 美术教育家. 1940年, 他创作了国画《愚公移山》, 他创作这幅画, 立意在于以形象生动的艺术语言表达抗日民众的决心和毅力, 鼓舞人民将抗日进行到底, 并坚信一定能取得胜利. 这幅画在当时产生了很大的影响. 民族的艰辛, 胜利的渴望让潜伏在人们血液中艰苦奋斗, 不怕牺牲的精神开始沸腾. (DACHS 2008 Foolish Old Man, TV Drama 2007–8 Critical Views, 3 January 2008).

25. For a propaganda photograph echoing this scene, see DACHS 2009 Documentary Photographs, Cultural Revolution, Sent-down Youths I and II, Thomas Hahn.

26. Dazhai 大寨 in 1964 was declared a national model village in eastern Shanxi province. See below for more on the role of Dazhai in Cultural Revolution writings.

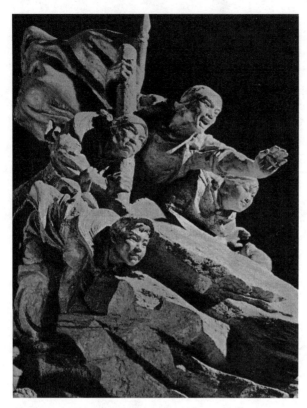

Ill. 4.10a. *Moving Mountains* from the sculpture group "Song of Dazhai"—The power of Revolutionary Romanticism (*CL* 1976.7).

strength and dynamics in this collective made up of people of different genders and ages that is noteworthy in this art piece exuding "Revolutionary Romanticism" (ill. 4.10a). And again it is Mao's words and thought as the source of this strength that is foregrounded: one group of young men and women is seen "writing revolutionary posters" (ill. 4.10b), while another group of girls, mentioned above, is studying Mao's works together (see ill. II.2).[27]

Incarnate in these images is the collective subjectivity called forth and articulated by Communist ideology, which saw the telos of history as realized in revolutionary campaigns (Wang 1997, 190). These images are supposed to be models; they are embodiments of the people's faith in the power of the collective to transform the world, which is called on allegorically in the spirit of the Foolish Old Man. The story would become the foundational myth of the PRC, a republic said to have been built upon the will and the power of the people.

Accordingly, the Foolish Old Man's story became an integral theme of official schoolbooks published in the "liberated areas" before 1949 and spread nationally afterwards (Bergman 1984, 39, 65, 76). Another hype came during the Great Leap Forward, when the Foolish Old Man could be declared, according to Chen, "the most exalted trope in the language of (the) Chinese masses today" (Chen 1960, 3–9). Fittingly, one of the *Three Character Classics* published in 1959 alludes to the story, stressing the power of the people to "move the mountains and fill in the seas" (山能搬, 海能填) (*HZPYDZZZJSZJ* 1959, 3) (see Chapter 3). In order for it to be better understood, the writers of this text substituted the more classical-style verb for "move" 移 (*yi*), with its more modern-style synonym, 搬 (*ban*).[28]

The story of the Foolish Old Man continued to be important in the early 1960s. A *Three Character Classic to the God of Epidemics*, mentioned in Chapter 3, advocates studying the Foolish Old Man's story to "strengthen one's will" in fighting diseases of all kinds (学愚公毅力深除害尽才甘心) (see ill. 3.10). Model soldier Liu Yingjun 刘英俊 (1945–66) wrote in his diary in 1964 that he had read many times the essay about the Foolish Old Man and that he felt quite inspired every time, as if he himself had made some progress by reading the story. Measuring his own

27. For this sculpture see *CL* 1976.7:113–15 "New Group Sculpture: Song of the Tachai Spirit."
28. The second phrase alludes to another mythical story taken from the *Classic of Mountains and Seas* (山海经 *Shanhaijing*) of little bird Jingwei angrily filling the sea with stones (精卫填海) because its cruel waves had drowned the goddess Nüwa. The juxtaposition of these two stories is not atypical, as will be seen in the discussion of advertisements below.

character and strength of will against that of the Foolish Old Man, he realizes that he will have to adopt the Foolish Old Man's spirit in order to progress and become a man who dares to fight and to win, and so he does (Bergman 1984, 70–71).[29]

Some years before the Cultural Revolution, in the early 1960s, the story was further propagated as part of a famous trilogy of works known as the *Lao sanpian* (老三篇, literally "Three Old Articles") with the significantly skewed but apt official English translation *Three Constantly Read Articles*.[30] A *Red Flag* article reprinted in many a Red Guard publication describes why these stories had become popular among workers, soldiers, and peasants, and argues that the people made them into their strongest and sharpest weapon in reforming the world around them. The people are quoted in a footnote: "We will follow the revolution all our lives, and we will study the *Three Articles* all our lives" (广大工农兵群众经常地反复地学习这三篇文章, 把它们作为改造主观世界的最强大最锐利的武器, 亲切地把它们简称为老三篇. 他们说: "干一辈子革命, 学一辈子老三篇").[31]

The *Three Articles* are all based on speeches made by Mao, two of them eulogies. The first of these remembers Canadian doctor Norman Bethune, who served as a doctor in the Chinese army during the Sino-Japanese War and died of blood poisoning because, so the story goes, a Japanese-GMD blockade restricted the supply of protective gloves. In his eulogy, Mao praises Bethune for his internationalism and his altruism.[32]

The second article, entitled "Serve the People" (为人民服务), is the story of Zhang Side,[33] a soldier who died in 1944 while working in a coal-burning stove that collapsed. The circumstances of his death are thus intimately connected with "civil" work, thereby permitting him to appear in three manifestations in later campaigns: as Communist hero, as civilian martyr, and as military martyr, but as a symbol of altruism on top of it all.

Together with the story of the Foolish Old Man, these texts were considered the best vehicle for transmitting the core of Mao's thought to the masses. They were therefore widely published, increasingly so after the fall of 1966, when Lin Biao once more advocated their study in a speech emphasizing the importance of Mao's works.[34] During the Cultural Revolution, the *Three Articles* were sold in mass editions and were indeed "constantly read": not just during school hours but at any possible moment during the day (Bergman 1984). School teaching, which resumed in the spring of 1967, was not unified: every province, every municipality had its own school books (Mauger et al. 1974, 50), but teaching of the *Three Articles* was guaranteed, starting in kindergarten when it was based on pictures and continuing to the higher levels when the method of instruction became more and more complicated (Mauger et al. 1974, 44, 47). One middle-school teacher remembers: "Even I could recite by rote Mao's *Three Articles*. We had nothing else to read anyway."[35] And many stories illustrate that the *Three Articles* were well-known even to illiterates.

29. For an introduction to Liu and some relevant propaganda posters, see DACHS 2009 Landsberger: Liu Yingjun.
30. Schwermann (2006, 105) notes that in 1964 the story of the Foolish Old Man was joined with the two others to form the *Three Articles*, but unfortunately he does not give a source for this information. The *locus classicus* for the name remains unclear. It is certainly not correct to date the creation of the set to as late as the fall of 1966, as the *Dictionary of the Cultural Revolution* (*Wenhua da geming cidian* 1993, 53) would have it: its authors mention that in his speech of September 18, 1966, Lin Biao calls for regular readings of the *Three Articles*. A Red Guard publication entitled "A Selection of Study Materials" (*Xuexi cailiao xuanbian*) and dated September 15, 1966, already uses the expression and explains it in a footnote. This may however show that the expression was probably not yet very well known. *HWBZL* 1980 Suppl. 1, vol. 5, 2324: *Xuexi cailiao xuanbian* 15 September 1966, 65. Cf. also Bergman 1984, 48.
31. *HWBZL* 1980 Suppl. 1, vol. 5, 2324: *Xuexi cailiao xuanbian* 15 September 1966, 65.
32. For Bethune's story and posters associated with him, see DACHS 2009 Landsberger: Norman Bethune.
33. For his life and work, see DACHS 2008 Zhang Side.
34. See CCRD 2002a. Cf. also *Wenge shiqi guaishi guaiyu* 1988, 186.
35. Feng 1991, 88; cf. also Feng 1991, 156; *Wenge xiaoliao ji* 1988, 14; Gao 1987, 155; Liang and Shapiro 1984, 175.

One such story, which relates the experiences of a young intellectual sent to Mongolia in 1967, includes the memorable tale of an old herdsman, Sanggewang, who had learned the *Three Articles* by heart by reading them aloud to himself (*CL* 1968.11:53). Considering all this, one could be convinced, as is Pär Bergmann, that the "'good old three' already have established a place for themselves among the classic writings of modern China ... studied from the moment that one begins to learn to read" (Bergman 1984, 76).

Not only taught in schools, the *Three Articles* were also perused at work and during people's free time, as the Chinese population was flooded with quotations, emblems, and heroes from the stories. The *People's Daily* would print stories and songs based on the *Three Articles*. There were even vinyl records with recitations for those who could not read (*CL* 1967.4:137).[36] The stories and their heroes would appear and reappear on posters; in poems and plays; in films, model works, and songs; and on such daily use items as Jingdezhen porcelain, cushions, washing bowls and mirrors, badges, and fingernail clippers; as well as in literature where they would either be mentioned by name or serve as models for the respective hero in the story (**ills. 4.11a, 4.11b**).[37] Accordingly, the three stories and their heroes—the Canadian doctor Norman Bethune, the Communist fighter Zhang Side, and the Foolish Old Man— became household names during the Cultural Revolution (Bergman 1984, 49), "well known to every family, everywhere, in the cities and the countryside" (家喻户晓). This point is made in a Red Guard publication that takes the four-word phrase often applied to Mao's writings in general and uses it to describe the *Three Articles*.[38]

Ill. 4.11a. Cushion expressing loyalty 忠 to Mao's *Three Old Articles*.

The prevalence of the *Three Articles* is most obvious in propaganda publications such as *Red Flag*, *Peking Review* (北京周报 *Beijing Zhoubao*), *Pictorial China*, *Chinese Literature* (中国文学 *Zhongguo Wenxue*),[39] and *People's China*, all of which also had foreign-language editions published by Foreign Languages Press in Beijing. Unlike many magazines, these propaganda outlets did not stop publication during the Cultural Revolution. They would contain material such as the following:

36. The third set of songs, RMRB, 25 October 1966, contains a quotation song from the *Three Articles*.
37. For examples, see Schrift 2001, 85; Kraus 1991, ix; DACHS 2007 Mao Paraphernalia; Bergman 1984, 54–61; Fokkema 1991, 606–7.
38. *HWBZL* 1980 Suppl. 1, vol. 5, 2324: *Xuexi cailiao xuanbian* 15 September 1966, 65.
39. *Chinese Literature* seems to be a special case. The Chinese edition of this journal was edited only in the early 1970s, not throughout the Cultural Revolution. The English edition, however, appeared without fail during the Cultural Revolution. In the years before and during the Cultural Revolution, it collected material from different (local) literary and artistic journals such as *Chinese Literature and Art* (中国文艺), *Liberation Army Literature and Art* (解放军文艺), *Liberation Army Songs* (解放军歌曲), *Beijing Literature and Art* (北京文艺 天津文艺), *Tianjin Literature and Art*, *Hunan Literature and Art* (湘江文艺), and *Changsha Literature and Art* (长沙文艺), some of which, however, were discontinued during the Cultural Revolution.

The Fountain:

At last we paused for a short halt,
In the shade beneath the trees.
We piled our rifles, opened bags,
To take out our precious red books.

Grouped together in twos and threes,
We read and then discussed,
"In Memory of Norman Bethune"
And "Serve the People."

Then from each quotation,
We learned a revolutionary truth,
And the red sun dawned in our hearts.[40]

Every moment of spare time, so these literary depictions suggest, is to be used for the study of Mao's works. Studying Mao is to "learn revolutionary truth," and it was "living study and application" (活学活用 *huoxue huoyong*) that would be constantly emphasized in literary writings about the power of Mao's works. Most prominently, Lin Biao advocated this approach in his Preface to the *Little Red Book* (Lin 1967, 2). The fact that Mao's words could (and thus should) in fact be applied everywhere, in all circumstances, and at all levels was stressed in official publications, which presented a widespread cast of characters all reading, with great verve and interest, Mao's works. His was a "literature of real significance, which unites theory with practice in a manner that would in many ways seem to be unique" (Bergman 1984, 76).

A story of a sent-down youth from Tianjin published in the journal *Revolutionary Successor* illustrates this very clearly. Eager to contribute to the transformation of the countryside, the youth finds his inspiration in the writings of Mao, especially the *Three Articles*, which he reads repeatedly.[41] In the illustration accompanying the story, sun rays emanate from the book containing the *Three Articles*, thus echoing some of the songs likening Mao's writings to the sun.[42] A similar experience is related in the story told by Lolao, a member of the Miao minority:

I was ninety-seven years old this year. People who had to hide in dark forests enjoy the rays of the sun. The Miao people are like that. Chairman Mao liberated us and we became our own masters. Nearly crushed in the bitter past, we know our happiness today is priceless.

When I studied the *Three Constantly Read Articles*, I found three heroes whose examples we should follow if we want to go on making revolution

These three articles by Chairman Mao are revolutionary treasures which open up great horizons in the mind.[43]

Lolao is quite convinced that Mao's writings were partly responsible for the toppling of the old society, which brought so much suffering to the people, and believes this is why everybody ought to study Mao. Yet, how could the old illiterate actually "read" Mao's articles? He himself learned to read from his great-grandson, who is quite shocked when told about the old man's gruesome experience in the old society and equally taken with his determination to make up for it in the new. The old man remembers: "When I finished, my great-grandson's eyes were swimming with tears. There was no more holding back, he became my fervent teacher."[44]

40. *CL* 1971.12:41–44 "Verses Composed during a March," 43.
41. *Geming jiebanren* 1974.3:47–48, 54.
42. *Geming jiebanren* 1974.3:41–49.
43. *CL* 1971.6:76–80 Lolao "An Old Man Studies Chairman Mao's Works," 76.
44. Ibid., 77.

It may be considered ironic that this story, which is one of the necessity of learning and reading, thus takes up a topos also prevalent in Confucian lore and especially in the *Three Character Classic*: one section in this old school primer consists of examples of men who, at a very old age, begin to study and make up for all they have missed in their youth (e.g., *Sanzijing* 291–304). Lolao's story falls exactly into this vein. It continues to relate how the old man repeatedly beats rain and storm, not willing to miss a collective study session of Mao's works, and describes how, in digging a ditch, the commune's elders are inspired by the Foolish Old Man's story. In confronting the village youth, they clearly state their case:

"The slope is covered with rocks; how can old men like you tackle it?" We told them, "If the Foolish Old Man dug away two big mountains, why can't we dig a little ditch?" The digging wasn't hard at first, but soon we got down to a rocky layer that blunted our hoes and stung our hands with every blow. A few of us began to waver. The Foolish Old Man didn't stop, I thought, so I said, "The rocks are hard all right, but every inch we chip away will be that much less to do. Let's work with the spirit of the Foolish Old Man." Then we got to reciting Chairman Mao's "Be resolute, fear no sacrifice, and surmount every difficulty to win victory." It was as if Chairman Mao were working with us, and our strength grew. We fought for twenty days and dug a ditch a kilometer and a half long.[45]

Mao's words bring Mao himself into the presence of the people, strengthening and encouraging them in their difficulties. There is a religious quality to these descriptions, and it becomes even stronger in the following passage, in which the old man finally reminisces upon his activities:

Every day I compare myself with the three persons in Chairman Mao's *Three Articles* to examine my enthusiasm and conscientiousness in working for the revolution. I have tried to check every act like this....

I must try hard to get rid of selfishness and unhealthy thinking. I can become like the men Chairman Mao wrote about in the *Three Articles* only if I conscientiously use his teachings to re-mould my thinking.[46]

This piece of writing, published in 1971, suggests that the early Cultural Revolution admonition to "Seek instructions in the morning and report in the evening" (早请示晚回报 *Zao qingshi wan huibao*), which is quite distinctly reminiscent of religious confessions, lived on more informally well into the 1970s, through the reading about and emulation of heroes such as those from the *Three Articles*.[47] Do the fictive characters to be met in these stories have their real-life equivalents, though? Did people actually "believe" in the stories and their heroes? Some would say yes, if somewhat apologetically:

There was so much pressure then, so what would we do? Of course we would believe in the heroes of the time. Everybody was talking about these heroes, and this really influenced young people. We had to function within this kind of rhetoric. Everybody would talk and learn about heroes; this was something we all wanted to do. I also thought that I would be able to be a hero. Even though I am not a big activist, but still, I thought this should be possible. And so we would write all these stories about ourselves and the lions, for example, and how we would fight with them. (University Professor, mid-1950s–)

The Red Guard publication mentioned above that had selected a piece on the *Three Articles* from *Red Flag*, had predicted this type of model emulation as the outcome of everyone reading the

45. Ibid., 78.
46. Ibid., 79–80.
47. Another story quoting all three of the *Three Articles* is found in *CL* 1968.5:89–99 under the heading, "Heroes in the Epoch of Mao Tse-Tung's Thought."

Three Articles. The article, written by none other than Zhao Ziyang 赵紫阳 (1919–2005), then Party Secretary of Guangdong province, who only a few months later would be condemned as a "remnant of the landlord class," shows himself convinced that these ideas would be put into practice and that they would change people:

> They have carved their way into the hearts of the people.... They are one of the sharpest weapons to change the ... world. The people call them *Three Constantly Read Articles*, and if you want to lead a revolutionary life, you must read them all your life.... The basic thoughts in these *Three Constantly Read Articles* become models of behavior for the rural population. Thus, Mao Zedong Thought opens up the peasants' horizons. Thus, they rid themselves from the fetters of egotism. Thus, they understand why we humans live and that if one loves one's country one must put the eyes on the world and take on heavy burdens for both the Chinese and the world revolution.[48]

Did these stories actually become a helpful tool in the formation of the "new Communist being" (Bergman 1984, 61)? Where they able to change people? How do we explain that, in spite of "constant reading," the *Three Articles* are in fact *not* remembered as all that significant in many of the published memoirs from the Cultural Revolution?[49] Has the Foolish Old Man, in spite of all his repeated reincarnations, *not* become as much a model as he could have if one were to believe the official lore? The *Three Articles* aspire to be Classics on par with the Confucian Classics of traditional China, that is, texts which, due to their authoritative strength and wisdom, had to be studied diligently, learned by heart, and internalized as normative rules for proper conduct as a member of society throughout one's life. Did the *Three Articles* achieve this status? How much do official prescription and unofficial reception tally or differ?

In a recent discussion of poetry recitals under Mao, John A. Crespi argues that there "can be no doubt that the *ideological programming of mass culture in China* during these years penetrated people's psyches to an unprecedented degree. Even so, it behooves us to look for the fissures that insinuate themselves into what might otherwise appear to be a totalized structure of cultural production and reception" (Crespi 2009, 150). Through the example of the model works and revolutionary songs and criticisms of the *Three Character Classic*, it is clear that even texts appearing to be perfectly univalent and closed, texts that seemingly allow for one and only one reading, are actually subject to alternative decodings. As Umberto Eco in his study on semiotics *The Role of the Reader* put it: "Those texts that obsessively aim at arousing a precise response on the part of more or less precise empirical readers ... are in fact open to any possible 'aberrant' decoding" (Eco 1979, 8). The constant repetition of a quotation does not necessarily make the reader believe in its message or its power. On the contrary, the Cultural Revolution clearly was an age of dictated as well as popularly instigated mechanical reproduction (cf. Benjamin 1963 and the Red Guard art and publications). It was a comprehensive attempt at ideologically monolithic programming of a mass culture. Nevertheless, even this may not have eliminated a different interpretation of life from that prescribed, and different readings, feelings, understandings, and thoughts on everything that propaganda would have people believe (see Bergman 1984, 77).

The fact that few of the many repetitions of the *Three Articles* are remembered, and the fact that during the Cultural Revolution some had already begun to express doubt about their usefulness and feasibility,[50] indicates such duplicities and fissures. The idealized audience appearing in and constructed by the texts—the people whose experience is recorded in stories such as that of the

48. *HWBZL* 1980 Suppl. 1. vol. 5, 2324: *Xuexi cailiao xuanbian* 15 September 1966, 65.
49. Very little mention of them was found in, e.g., Cheng 1986; Feng 1991; Feng 1996; Gao 1987; Liang and Shapiro 1984; Hunter 1969; Lo 1989; Lo 1980; Luo 1990; Niu-Niu 1995; Zhai 1992; Zhu 1998.
50. Some of my interviews discussed in the Introduction also show a rather skeptical attitude toward the story of the Foolish Old Man.

Foolish Old Man—may not (always) have constituted itself in the Cultural Revolutionary present. With regard to Cultural Revolution posters, Harriet Evans and Stephanie Donald argue that they

> supplied a visual text that acknowledged "the people" as a unified public body accustomed to reading the visual image for political meanings. They addressed "the people" through a limited repertoire of mnemonics and clues, using "the people's" experience to build a grammar of signification in public space. Through discursive analysis and semiotic scrutiny, it becomes possible to find out how a certain kind of public was addressed. The next, maybe more interesting, step is to explore how such a method of address constituted the desired public. (1999, 18)

This, precisely, is the question to be addressed here: how do the idealized "people" in the stories relate to those who actually read these stories? How convincing were they? As propagemes sometimes only become effective after their own time (Gries 2005, 13–34), and as these stories continued to exist and were used frequently (before and) after the Cultural Revolution, when did the ideal(ized) audience of Cultural Revolution Culture constitute itself?

Quoting the Story during the Cultural Revolution

> We did not study anything serious at the time. We would learn by heart things like the *Three Articles*, and Mao's thirty-seven poems [37 首 *shou*]. I can sing songs based on Mao's poetry [诗词歌 *shici ge*]. I still remember them [. . . sings]. They were very beautiful. We did not sing them much, however; more common were the quotation songs. (Housewife, 1950s–)

> Since 1968 or '69 we would go to hear Mao's highest instructions [最高指示 *zuigao zhishi*] or the newest instructions [最新指示 *zuixin zhishi*]. We would have to walk all the way to Tian'anmen and sing these quotation songs and all that. (Intellectual, 1958–)

> We sang quotation songs, usually at 8:00 in the evening; there was an editorial [社论 *shelun*] introduced with Mao's highest instructions and then some musician would play. I did not like these quotation songs; there were other things that I thought were not that bad. But the loyalty dances were even worse, feudal almost! You did not have to take part in these kinds of activities if you felt they were no fun. It was not possible openly to say no, of course. But there was in fact no strict supervision. If you were not enthusiastic, it was not necessarily realized. (China Historian, 1957–)

> We would work during the day and then, in the evening, we would study the works of Mao. (University Professor, mid-1950s–)

Lin Biao once formulated, "One sentence by Chairman Mao is worth as much as 10,000 sentences by one of us" (一句顶一万句).[51] He also said that Mao's "every sentence is the truth" (句句是真理) and that Mao must be considered an "absolute authority" (绝对权威).[52] These phrases find their popular repercussions in the images and songs of the likes discussed in the beginning of this chapter. One such song argues that although some people compare the writings of Mao to the sun, even the sun could not possibly be as great as the writings of Mao (毛主席著作最伟大, 人将毛主席著作比太阳, 我说, 太阳比不上).[53] Accordingly, if one hoped to make one's own words important, there was nothing better than to cite Mao. And, quite accordingly, quotations of words by Mao during the Cultural Revolution abound in Red Guard publications, in newspapers and magazines, in poems, short stories, and novels, in sculptures and on posters, in a new genre of

51. CCRD 2002b; see also Lin 1970, 17 and Schönhals 1992, 19.
52. CCRD 2002b; Dittmer and Chen 1981, 34.
53. The song appears on one of the many *Red Sun* (红太阳) CD volumes (CD 3 of 4), no date, no publisher.

song called "quotation song," in the even more sportive and more short-lived quotation "gymnastics" (语录操 yulucao) (see Leese 2006, 240), in the loyalty dances,[54] in the model works, in diaries of sent-down youth, and, not least importantly, in and on objects for everyday use (such as green army bags adorned with the slogan "Serve the People" or the matchboxes ornamented with select quotations from the *Little Red Book*, some of which reappeared on the market in the early 2000s).[55] When Mao is quoted during the Cultural Revolution, this is often made obvious by use of bold print,[56] by introducing the quotation with the words "Chairman Mao says" (毛主席说), or by talking of the "highest instructions."

All of this points to the symbolic capital of Mao's words. A quotation by Mao stands for correctness, wisdom, and (political) power. But what importance does this symbolic capital have for the reader? A diary entry by a sent-down youth recorded in January 1969 predicted that the current "quotation fever" would not be fashionable for long (不会流行很久). The writer did not believe that such "things" (东西 dongxi), i.e., quotation songs and similar genres, would have any influence on people's worldviews or their productivity. To him, they were nothing but "pretty pieces of red paper" (只是一层漂亮的红纸).[57] He was convinced that Mao would not be happy to know that such superficial matters as the proper use of quotations could decide whether a human being was good or bad. According to the writer, the greatest problem was not whether one was able to cry "Long Live Mao Zedong" and cite from Mao's words but whether one actually and truly believed in Mao Zedong Thought and put it into practice.

His acknowledgment of the superficiality of quoting Mao as practiced in the early years of the Cultural Revolution was prophetic: two months after the convention of the Ninth Congress, on June 12, 1969, a central document meant to curb some of the more "rampant" forms of "Mao-worship" was issued.[58] It was an attempt to stop the practice of "seeking instructions in the morning and reporting in the evening" and to put an end to ritual readings of Mao quotations before meals. It called for a reduction in the number of Mao statues, it disapproved of the wearing of Mao badges, and it advocated that newspapers refrain from using Mao's image. Mao quotations and images were no longer appreciated on commodities, especially not on porcelain ware (Leese 2006, 260). Politically, this was an important step, as the document officially called for the curbing of the outer forms of the cult. It was a first step that had the unintended consequence of making it possible, later, to build up cases against those who had "distorted" the true meanings of Mao's Thought for personal motives.[59] The question of how Mao's "genius" was to be referred to, first raised at the Congress on Mount Lu, culminated in a sequence of events with dramatic consequences, one of them an ongoing discussion in August and September 1970 on whether Mao Zedong Thought should continue to be mentioned as binding in the constitution.

All these political machinations—which once more hint at the fact that the often-invoked totalitarian monolithic structures behind the propaganda of the Cultural Revolution were actually quite fragmented—did not cause a significant decrease in the amount of Mao quotations in

54. Leese 2006, 237. The specific origins of the loyalty dance remain unknown, but by early 1968 it had spread very quickly throughout China and was featured in performances there for at least a year. It consisted of the attempt to artistically transform the body into the Chinese character 忠 (meaning "loyalty") to the sounds of Mao quotations. For the comparable use of folk dance in Nazi propaganda, see Walsdorf 2010.

55. For many examples of such daily objects, see note 17 in this chapter; see also Shen 2006a, 79, 83, 85.

56. For this practice, which was used more or less predictably during the Cultural Revolution period and beyond, see May 2008.

57. *Zhiqing riji xuanbian* 1996, 20, recorded on January 27, 1969.

58. *Jianguo yilai Mao Zedong wengao* 1998, vol. 13: 13.50.

59. These would be discussed a year later during the Second Plenum of the Ninth Congress on Mount Lu and reappear in a different guise during the Anti-Confucius Campaign a few years later.

cultural products of the time. In some of the model works written or revised in the early 1970s, and especially around 1972, quotations occur less frequently than in earlier versions of the same pieces. This may also have to do with Lin Biao's fall in 1971. It is particularly striking in two editions of *Raid on White Tiger Regiment*. The 1967 version contains about 20 Mao quotes marked in bold; the 1972 revised edition, on the other hand, has only a handful.[60] The model opera *On the Docks*, on the other hand, contains many more quotations in its 1972 revised version than in earlier versions (the 1969 version, for example, contains extremely few quotations). The 1973 filmed version contains yet more—among them, allusions to the story of the Foolish Old Man. Indeed, in all of the model works, it continues to be Mao and his words who lead the way well into the 1970s. In the late 1969 version of *Taking Tiger Mountain by Strategy*, for example, Yang Zirong had shown his determination to go to the bandits' lair (scene 4) by saying, "Like the Foolish Old Man who removed the mountains, I shall break through every obstacle. The flames that blaze in my red heart shall forge a sharp blade to kill the foe" (*CL* 1970.1:23). In a much later model work, *Fighting on the Plain*, the young peasant Xiaoying 小英 (Little Heroine) also proclaims that "unity gives the folk the strength to move mountains and regulate rivers" (心齐能让山河变哪) (*Hongqi* 1973.7:48–75, 53).

In spite of political developments, then, MaoSpeak sustained its high throughout the Cultural Revolution years (Yang 1998, 164; Bergman 1984, 59).[61] Mao's words (as well as his image, as the next chapter will show) are petrified and made into "indistinct symbols of positive integration that had to be paid ritual respects" (Leese 2006, 292). One person relates how the reading of Mao would be turned into a ritual act: "We would always put up a Mao picture and then we would read his stuff together" (Ethnomusicologist, 1940–).

Although the sent-down youth's observation about the short life of MaoSpeak would be proven wrong with the passage of time, his experience that MaoSpeak would become emptier and more deprived of meaning with its every repetition was not something many could refute. Indeed, the experience of shallow repetition rather than deep involvement with Mao Zedong Thought is epitomized by the testimony of a student from Fudan University who, upon entering the military, is astonished that he is looked at askance for actually reading Mao. A friend even warns him: "People are talking about you. You shouldn't go on reading those things." He does not understand what his friend is getting at and asks: "Why? *On Practice* was written by Chairman Mao!" The friend tells him earnestly: "*On Contradiction* and *On Practice* are for the leadership to read. For us ordinary soldiers, reading the 'Three Old Articles' is enough. If you don't stop what you're doing, it may affect your advancement!" (Schönhals 1996, 333–34) Indeed, one slightly polemic Party School publication attributes Lin Biao with having said that it was more than enough to study the *Three Articles* (*Wenge shiqi guaishi guaiyu* 1988, 124, 186).

The sent-down youth speaks, decidedly, against the rote repetition of Mao sayings caused by such superficial and restricted reading: according to him, this practice leads to blind imitation rather than an "expansion of the rural horizon." Thus applied, Mao's words would never become the "sharpest weapon to change the world." In this young man's view, years of revolutionary fighting would be necessary to understand the thoughts of Mao and to apply them properly. He recorded these thoughts in his diary, on January 29, 1969:

> Even though in the last few years political work has been carried out with great vigor, it is still not enough. The books of Chairman Mao have arrived in the commune, the commune members all know

60. Cf. the scripts in *CL* 1967.10:13–58 and *Hongqi* 1972.11:26–54.
61. Yang finds that novels such as Hao Ran's 浩然 (1932–2008) *Golden Road* (金光大道 *Jinguang dadao*) even show a great increase of Mao quotations (only to be used by positive characters, of course) (Yang 1998, 164).

them, they can talk about them and recite them. But how to connect these thoughts with one's own situation and how to use them to reform and change one's own place, that is not something they have learned yet. (*Zhiqing riji xuanbian* 1996, 21)

Even though the propaganda media invoke "living study and application", even though they attempt to create a story for "everyman" and "everywoman" (even "everychild") so that each has their own and very personal model to follow, thus making it possible that every individual experience can later be amalgamated into a collective experience (Apter and Saich 1994, 70), this student doubts whether these attempts have been successful. (Why) is the constant reference to a common text, the constant moment of recognition, no longer able to create the same type of "exegetical bonding" between text and recipient that, according to Apter and Saich, had been prevalent in the Yan'an community (1994, esp. 5–71)? In order to answer these questions, I will turn back to the story of the Foolish Old Man and its use in Chinese art and literature. How does it appear in such texts from the Cultural Revolution?

A 1967 Red Guard publication *The Explorer* (探索者 *Tansuozhe*) invokes the *Three Articles* in a piece entitled "Long Live the Spirit of the *Three Constantly Read Articles*" (老三篇精神万岁) dealing with China's substantial technical successes in recent years.[62] Another 1968 Red Guard publication argues that the natural sciences must be introduced to a new age governed by Mao Zedong Thought in which expert knowledge is no longer as important as the application of correct (i.e., red) thought (为自然科学进入毛泽东思想新时代而战斗).[63] The article begins, poetically, by drawing the analogy of Mao as the sun in the East. This sun, it is said, gives might to the natural sciences in China, which will make it possible for the power of the East to hit the rest of the world like a thunderstorm.[64] The Red Guards want to fight against the "great personalities" (大人物) and the "capitalist intellectuals" (向资产阶级, 大人物宣战来了), they want to rid themselves of these influences that have "taken over" and "usurped" the natural sciences (资产阶级知识分子夺了我们的权专了我们的政). And accordingly, the natural sciences, too, have class character (ibid., 1). The Red Guards declare:

> We want a brand new (崭新), a proletarian, theory for the natural sciences. This is our responsibility in this fight. We want [and here follows the well-known quotation] to "be resolute, fear no sacrifice, and surmount every difficulty to win victory" (下定决心, 不怕牺牲, 排除万难, 去争取胜利). For the advancement of our revolution, this is the most important article of faith (是我们将革命进行到底的坚强信心) (ibid., 11).

The text continues: "Our path is tough, the difficulties are huge, but our faith is strong and the future is bright" (ibid., 11). For these young scientists, then, Mao's words have become an article of faith, giving them strength to do "what our predecessors were never able to do" (我们正在做我们的前人从来没有做过的)—that is, to dethrone the "experts" in the natural sciences. The Foolish Old Man and the powerful words and heroic deeds Mao has associated with his story are able to teach and embolden these young men and women: with Mao Zedong Thought as their weapon, the difficulties they face only *seem* insurmountable.

This didactic quality of Mao's words is emphasized time and again in the stories spun off of the Foolish Old Man quotation. One such (reportage) story tells of a group of Red Guards from Dalian who, about to set off on their own "Little Long March," have not forgotten the important dictum, "Be resolute":

62. *HWBZL* 1980 Suppl. 1, vol. 2, 806–38: *Tansuozhe* (探索者) 1967 February, 5.
63. *HWBZL* 1980 Suppl. 1, vol. 2, 457–80: *Keda hongweibing* (科大红卫兵) 1968 February, 1–11.
64. Here it becomes clear what language Tan Dun echoes in his *Red Forecast* as discussed in Chapter 2.

At sunrise, the fifteen young students, opening their *Little Red Books* of *Quotations from Chairman Mao Tse-Tung*, read in chorus: "Be resolute, fear no sacrifice, and surmount every difficulty to win victory." To the applause of their teachers and fellow students, they set out towards the sun, towards Peking, towards Chairman Mao, their banner leading the way, all in high spirits, each with a book of the *Quotations* in his pocket.... It was over two thousand li from Talien to Peking, but, illuminated by Chairman Mao Tse-tung's thought, it was a bright socialist road. (*CL* 1967.3:75)

Indeed, they have to overcome many hardships, but at every step the words of Mao drive them on. With their faith, they are even able to help a model worker, Mr. Ma, as they pass through an area declared to have no sub-surface water by "bourgeois experts" in the past:

But after Ma and the local people read together Chairman Mao's article *The Foolish Old Man Who Removed the Mountains* they vowed they'd find water if they had to dig right to the other side of the globe. And sure enough find it they did ... at a depth of nearly three hundred feet. (ibid., 86)

Another such story published in 1968 tells of a young soldier stationed on a small island. In his early days as a veterinarian, he faced many difficulties. Castrating pigs, for example, made him extremely nervous, and he was mortified when the pigs squeaked, as so many people were watching him. He lay awake at night, not only because of his embarrassment but also because he felt terrible about having been so selfishly concerned with his reputation (*CL* 1968.9:62–74).

Yuan was so upset he couldn't sleep all night. He knew it was selfishness that had caused him to fail. Why else would he panic when the people gathered round to watch? He remembered Chairman Mao's account of the Foolish Old Man who removed the mountains. When the Wise Old Man laughed at him, he went right on digging. (Ibid., 70)

In this description, then, the Wise Old Man comes to stand for those too conceited to have faith in the masses. Why should I not be like the fool, Yuan thought. And, sure enough, the next day, he managed to castrate a pig successfully. But he faced another setback: he was teased and called "General Castrator" and, sure enough, he did not like that either:

He flung down his scalpel when he got back to camp and swore he'd never operate on pigs again. Hearing about this, one of the leadership called him in for a chat. He urged Yuan to use the *Three Constantly Read Articles* to cure his selfishness. Only then did Yuan take up his little knife once more. When Yuan told us how he revolutionized his thinking, he added with deep emotion: "You have to go after selfishness hammer and tongs, and not give it an inch, otherwise you can't be the kind of pure person Chairman Mao teaches us to be. In your mind there must be the concept of complete devotion to the public good. I'm going to study the *Three Constantly Read Articles* and fight selfishness all my life, so that the public service concept in my mind becomes absolutely pure." (ibid., 70–71)

Mao's words not only serve as an article of faith here, they also act as a mirror for the sinner in the story as well as the one outside it. Thus the story attains religious aura and might: Mao's words and their "spirit" function as a most effective "bad conscience" against which both protagonist and reader may measure themselves and their deeds. This religious quality is predominant in a peanut planter's story, too. He introduces himself as follows:[65]

I am a peasant. I was born in a poor-peasant family and I'm now 47 years old. I had four years of schooling as a child. In addition to studying Mao's *Three Constantly Read Articles*, I have also

65. *CL* 1971.2:18–26 Yao Shih-chang "Plant Peanuts Scientifically."

repeatedly studied Chairman Mao's brilliant philosophical works to arm myself with dialectical materialism, and I've made scientific experiments to increase peanut production.... Practice has made me understand profoundly that Chairman Mao's brilliant philosophic thinking is a beacon guiding our scientific experiments. (*CL* 1971.2:18)

One of his experiments entails going to the field every evening to record his observations. One night, it is pouring rain and he is reluctant to go—but then his conscience is tried with a quotation by Mao:

> The more this went over in my mind, the more I felt my idea of not going was wrong. Comrade Norman Bethune thought nothing of travelling thousands of miles to make revolution in China. Yet I had thought of not going to a peanut field only a quarter of a kilometre away just because of rain. The Foolish Old Man overcame every difficulty to remove the two big mountains, yet I had thought of giving up just because I was faced with a little bit of difficulty.... This was enough to make me get out of bed and hurry to the field. It was only after I had finished my observation that I noticed I was soaking wet and shivering. But when I recalled that I'd gone there because I had listened to Chairman Mao and had conquered difficulty, I felt warm all over. (Ibid., 21)

The peasant's self-critical thoughts are echoed in the experiences of a young intellectual sent to Inner Mongolia in November 1967. At first, she is quite unhappy about having to go there, But after she encounters the peasants for the first time, the experience becomes quite breathtaking:[66]

> The more I thought of these things the more it seemed to me that going to the countryside or to mountainous regions was a prospect with "no future" for educated young people. (*CL* 1968.11:51)

> It was winter when we arrived at our new home. The poor herdsmen rode out to welcome us when our car was still a distance from the pasture farm. All of them held high in one hand a bright red copy of *Quotations From Chairman Mao Tse-Tung* and as they galloped over shouted, "Long live Chairman Mao!" It was a thrilling moment for us. The first thing they asked on seeing us was whether we had seen Chairman Mao. (Ibid., 52)

> The grasslands are a wonderful part of the motherland, they are wonderful because the brilliance of Mao Tse-tung's thought illuminates them. The red sun shines into the Mongolian yurts, and into the hearts of the poor herdsmen. (Ibid., 53)

As time passes, the urban youths learn to get rid of their feelings of superiority: Mao's writings are their guidelines. One day, the young woman finds one of the herdsmen's jackets and decides to wash it as a surprise for him:

> I thought it would be a good idea to wash it for him. Picking it up for a look, I noticed that it was badly soiled and full of dirt and cow-dung. I began to have second thoughts. Shall I wash it? Chairman Mao's words came to my mind: "The workers and peasants were the cleanest people and, even though their hands were soiled and their feet smeared with cow-dung, they were really cleaner than the bourgeois and the petty-bourgeois intellectuals." It was as if dear Chairman Mao were criticizing me personally. Of course I must wash the old uncle's gown.

> From then on whenever something came up I thought of three things: First, what does Chairman Mao say; secondly, what would the poor herdsmen do, and thirdly what I myself should do. In this way I had a guiding principle, an example to follow and knew what to do. (Ibid., 57–58)

All the people featured in these stories are captivated by Mao's spirit: young intellectuals and soldiers, workers and peasants, old and young—essentially all important groups in a Communist

66. *CL* 1968.11:51–59 Wu Hsiao-ming "Be a Good Daughter of the Poor Herdsmen."

society (intellectuals appear least frequently during the Cultural Revolution, of course). In these stories, Mao and his writings become the one and only standard according to which every act and every individual is to be judged. His words have a charisma that makes people want to read and reread his words time and again, spending much energy contemplating them and applying them to their own situation. The stories suggest in fictional settings what has been described as the historical experience of Yan'an days. Mao, it is said, "was able to cast a spell . . . of sufficient strength that people would not only listen but also invest their time and energy in thinking about what he said" (Apter and Saich 1994, 82).

Many of the stories propagated during the Cultural Revolution support this ideal. One of the protagonists, who is named the "Good Cadre Boundlessly Loyal to Chairman Mao's Revolutionary Line" after his martyr-like death, is described as one devoted to the works of Mao:

> He could miss a meal or his sleep, but he could not bear not to study Chairman Mao's works. At night when his comrades were asleep Men Ho stayed up to study Chairman Mao's works under a small kerosene lamp even when the weather was far below freezing. . . . He said: "We must study Chairman Mao's works every day. If we miss one day, problems will pile up. Let two days pass and we start slipping backwards. Three days makes it impossible to live." (CL 1968.7/8:24)

He and his comrades were working to build a rocket that would disperse the clouds and prevent hailstorms in an effort to protect the collective crops. They were convinced that they would find a device because they had Mao's writings on their side: "With Chairman Mao backing us, no difficulty can scare us! We dare to cross mountains of swords and seas of fire. We are determined to take the road opened up by Chairman Mao" (ibid., 9–10). So they would say. And their hero acted accordingly:

> On the morning of September 5 [incidentally, the same day Zhang Side died], the weather suddenly changed and it began to drizzle. After studying the "Three Constantly Read Articles" . . . Men Ho went with the revolutionary masses to the site where the home-made rockets were being set up. On the way, he recited Chairman Mao's teaching: "Be resolute, fear no sacrifice and surmount every difficulty to win victory." This teaching increased his resolve to fight against the disastrous weather conditions. (Ibid., 5)

Like so many of his fellow models, the story's hero was even willing to die for his resolve. Yet he lives on in the hearts of the people as the perfect student of Mao Zedong. The story of his life and his devotion to Maoist writings is quite reminiscent of that of model soldier Lei Feng,[67] who is said to have established the popular Cultural Revolution practice of beginning his diary entries with quotes from Mao Zedong. A retelling of his life, dating to 1967, relates the crucial importance of Mao's works to him. The story ends by summarizing his life as follows: "Water has its source, a tree its roots. The source and root of Lei Feng's spirit were Mao Tse-Tung's thought and the teaching of the Party" (CL 1967.2:76). And indeed, Lei Feng himself records in his diary:

> To me Chairman Mao's works are like food and weapons, like the steering-wheel of a truck. We can't live without food, can't fight without weapons, can't drive a truck without a steering wheel, and can't make revolution without studying Chairman Mao's works. (Ibid., 44)

Not unlike many of the other protagonists in these stories, Lei Feng attains enlightenment through reading Mao's works. When he decides that he must "Serve the People", itself the Maoist dictum most closely related with his name, the Foolish Old Man stands as his model:

67. For visual material on Lei Feng, see DACHS 2009 Landsberger: Lei Feng.

Lei Feng drew boundless strength and wisdom from Chairman Mao's writings. From them by degrees he came to understand the meaning of life and revolution and the laws of social development; he came to understand how to treat the enemy, how to treat comrades and how to treat work. His vision became clearer, his mind more enlightened and the world began to open out before his eyes. (Ibid., 45)

I want to be of use to our people and our country. If that means being a "fool," I am glad to be a "fool" of this sort. The revolution and construction need "fools" of this sort. I have only one desire and that is to remain true to the Party, to socialism, to communism. (Ibid., 60)

Cultural Revolution stories such as these suggest that Mao's words exuding both enthusiasm and fascination inevitably translated into practice. And it is through this fascination that readers, too, were to become accomplice to, even active participants in such stories. Thus, these stories appear to respond to the demand made by the sent-down youth, cited earlier, who called for a transfer from words into action: in a sort of *mise-en-abyme* effect the didactic moment—the moment of teaching, learning, and then practicing what one has learned—is made explicit in almost every one of these stories (as it had been in the images and songs discussed at the beginning of this chapter).

One particularly striking example of this practice is the (true) tale of model soldier Wang Jie 王杰 (1942–65), who died saving the lives of a dozen of his comrades during a blast.[68] His life was posthumously recorded by the "Spare-Time Literary Group," made up of members of his unit. They remember how one day, while Wang let his tired comrades rest, he read them the story of the Foolish Old Man:

Then he asked them to compare themselves with the Foolish Old Man. "Start with our differences in age," he said. At this novel approach, everyone laughed.
"He was an old graybeard, while we're young and healthy. There's no comparison," said Chen, a . . . new soldier.
"All right," said Wang Chieh. "What about differences in difficulty?"
"The Foolish Old Man had two big mountains to get rid of," the soldiers replied. "We have to dig a few small mine holes. There's no comparison there either. His job was ten times harder than ours."
At this point several of the men said: "Come on, let's get on with it."
"Good, now let's compare ourselves with him in determination and skill."
This embarrassed the men. They rose and got ready to work. The outspoken Chang said what was on everybody's mind: "The Foolish Old Man stuck it out though people laughed at him. We lose heart at the first little difficulty we run into. We ought to be ashamed." (*CL* 1967.7:57–58)

The old model story (told within the frame of the new model story) becomes the measure and the didactic model for ever new stories and experiences. Thus, the audience was taught to draw conclusions relevant to their own specific situation and to create tactics and strategies accordingly. Flexibility and individual adaptation was the goal. If each story is an artful construction in which the narrative shifts constantly between individual experience on the one hand, and collective adaptation, on the other, then the individual narrative can easily be subsumed into the larger collective narrative, and every individual could in turn subsume his or her own experience under the more general version of the story. The Yan'an model of storytelling (described in Apter and Saich 1994, 78) is brought to perfection here by being incorporated as a pivotal narrative moment into almost every one of these stories.

68. On model soldier Wang Jie, see DACHS 2009 Landsberger: Wang Jie.

As alluded to above, in terms of subject matter, many of these stories are distinctly reminiscent of the model stories from the *Three Character Classic*. These relate the lives of those who did all kinds of extraordinary things, such as collecting fireflies, for example, in order to light up the night, or tying their head to a beam or pricking their thigh with an awl so as not to fall asleep over their books while studying (*Sanzijing* 279–83). The similarities between these and the later Maoist model stories illustrate that Mao's writings could quite easily be conceived and sold as a new classical canon. In the Maoist model story, however, the situation is always even more (much more) extreme than in the old model stories: people would be willing to sacrifice themselves after reading Mao's works. Moreover, unlike the Confucian tales, these stories never end with *one individual's* study of the (Maoist) canon. They are distinctly missionary in gesture and always include not just individual conversion to but *collective* consumption of Mao's writings. One peasant's story reads as follows:

> Shui-tsai considered being able to read Chairman Mao's works his greatest good fortune and carrying out Chairman Mao's teachings his most vital obligation. Whether in the frigid gales of winter or the sweat-pouring heat of summer, he tirelessly studied Chairman Mao's brilliant volumes every night in the light of a small oil lamp.
>
> In 1960 he asked someone going to the city to buy him a set of the *Selected Works of Mao Tsetung*. The man did so, and Shui-tsai was overjoyed. He told everyone he met about his wonderful acquisition. He studied the volumes avidly from beginning to end, memorized the *Three Constantly Read Articles*, and repeatedly went over twenty particularly important writings. . . .
>
> Not only did he study, he got the masses to study. He became the chief instructor in Chairman Mao's works in the brigade, and was named an activist in the living study and application of Chairman Mao's works for the entire county of Hsuchang. . . . "To really grasp Mao Tsetung thought," he said, "you have to study hard, that is, never let up in your reading, and repeatedly review such major items as the *Three Constantly Read Articles*." . . .
>
> The small oil lamp was still burning. On the table were the *Three Constantly Read Articles* and *Quotations From Chairman Mao Tse-tung*. Shui-tsai had been writing a plan for the living study and application of Chairman Mao's works and how to further build up the Shuitaoyang Brigade.
>
> Yang Shui-tsai, good son of the poor and lower-middle peasants, an old padded tunic draped over his shoulders, sat beside the table, dead.
>
> It was plain that in the last moment of his life, he again read the *Three Constantly Read Articles*, as was his custom before going to bed, and measured his words and actions for the day by the standards expressed in them, namely, to serve the people wholly and entirely in "the spirit of absolute selflessness."[69]

Another such story is that of Wang, "a fine proletarian fighter" who, even when he was on his death bed in hospital, organized a group of patients to study and discuss Mao's *Three Articles*. Not being able to read well, he would mark difficult words in the text to help him remember:

> One day he noticed a young patient reading a trivial book. "Look," he told him, "You young people are full of vigour and vitality, in the bloom of life. The most important task for you is to study Chairman Mao's works conscientiously." A few days later, Wang saw the young man absorbed in Chairman Mao's *Three Constantly Read Articles*.[70]

As he became weaker and weaker over time, he asked someone to continue the reading sessions after his death. With shaking hands he would thumb the writings of Chairman Mao and sing, in a

69. *CL* 1969.10:11–31 "To Live and Die for the Revolution—Yang Shui-tsai, a Fearless Communist," 25–26, 29–30.
70. *CL* 1970.5:3–24 "A Fine Proletarian Fighter," 22.

weak voice, the quotation song with the crucial lines from the Foolish Old Man's story: "Be resolute, fear no sacrifice." His last words were:

> "You must always follow Chairman Mao's teachings. . . . work hard . . . carry the revolution forward . . . do a good job in strengthening and building the Party . . . wield the people's power well. . . ."[71]

This type of interlocking of different levels of the narrative, of individual and collective experience, becomes even more complex as the Foolish Old Man's story is closely connected with that of model village Dazhai 大寨.[72] Since 1964, this rural brigade in Shanxi province had become the national model for agriculture. It had been "liberated" by the Communists and then successfully built upon most inhospitable ground, described in one of the many Cultural Revolution novels on Dazhai as follows:[73]

> Steep hills and rocks galore,
> A slope before each door;
> No *mu* of land that's flat,
> And floods on top of that. (*CL* 1974.2:4)

The Dazhai Production Team in Xiyang County was made a national model when Mao Zedong issued the call, "In agriculture, learn from Dazhai" (农业学大寨). Dazhai's mythical success story is said to have been based on its participants' self-reliance. Through bitter and painstaking work they were able to turn its infertile soil into productive land. Water had to be transported over many miles for irrigation, land was cleared in the mountains, and terraced fields were built that withstood drought and flood. By the early 1970s, Dazhai had become the benchmark for all agricultural production in China. There, men, women, and children of all classes and backgrounds had worked together, as suggested in depictions of Dazhai such as the *Little Foolish Old Men on*

71. Ibid., 23. Another such story involving the death of a hero accompanied by Mao's words is that of Jiao Yulu 焦裕禄 (1922–64), "Chairman Mao's good pupil," whose story is told in more detail in Chapter 6. When he died, his last words reportedly were: "The only thing . . . I leave you is the *Selected Works of Mao Tse-Tung*. This volume here, I can't give you yet. I still want to study Chairman Mao's works till I breathe my last" (*CL* 1969.9:4–72 "Chairman Mao's Good Pupil Chiao Yu-lu," 65).

72. Discussions of the industrial model Daqing 大庆 place less of an immediate emphasis on the story of the Foolish Old Man, although it can be found, as late as 1977, in a comic featuring "Iron Man Wang Jinxi" 铁人王进喜. Wang Jinxi 王进喜 (1923–70) was the pivotal figure in facilitating the opening up of the Daqing oilfield (between Harbin and Qiqihar in Heilongjiang) and China's becoming self-sufficient in oil in the early 1960s. Upon Mao's call, Wang and his famous No. 1205 Drilling Team, undeterred by temperatures of between 20 and 30 degrees below freezing, rushed to the bleak grasslands and began drilling. After five days of drilling, they struck oil. Within three years, Daqing became China's biggest first-rate oilfield. The miracle was achieved, so the comic tells us, by the people's determination. And this determination Wang Jinxi and his team derived from the Foolish Old Man's story. Constantly steeled by it, they used it collectively and individually: in order to do their job well, for example, the workers sang a song to remind themselves that they must keep up the Foolish Old Man's will power (石油工人钢铁汉, 山南海北来会战, 立下愚公移山志, 敢把钻机搬上天) (Comic *Tieren Wang Jinxi* 1977, 27). They reminded each other to "be resolute" whenever things became difficult (Ibid., 28). And especially at the crucial moment of the explosion at the borehole (ibid., 63), when Wang Jinxi was thrown down and barely managed to get up again, he screamed, "Be resolute" and continued on.

73. See Yang 1998. He found at least ten novels on the subject of "Learning from Dazhai." Excerpts from one of these novels are reprinted in *CL* 1974.2:3–64 Hu Chin "The People of Tachai" and *CL* 1974.3:15–84 Hu Chin "The People of Tachai."

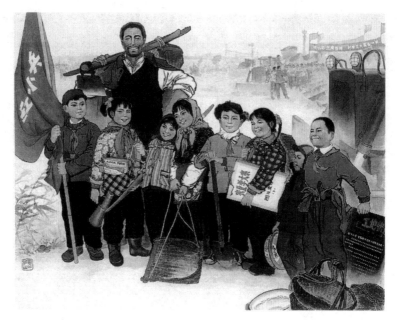

Ill. 4.12. Propaganda Poster *Little Foolish Old Men on the Fields*, 1977.
(Landsberger 1995, 27).

the (Dazhai) Fields (大寨田上小愚公) showing a group of children eagerly setting out to work to help create another miracle (**ill. 4.12**).

Accordingly, the Dazhai example had to be followed everywhere, regardless of local conditions. Daily, some 20,000 visitors passed through Dazhai to study this model of self-reliance. The project had its own special publication that thrived in the early 1970s, and Dazhai was cited in all different kinds of media well into the early 1980s, with publications such as *Pictorial China*, *Revolutionary Successor*, and *Aurora* all mentioning the model village. One village scene in *Revolutionary Successor*, which illustrates activities during the Anti-Confucius Campaign, shows all kinds of billboards criticizing Lin Biao and Confucius, but also includes one with the slogan, "In agriculture learn from Dazhai, in industry learn from Daqing" (农业学大寨, 工业学大庆) (*Geming jiebanren* 1974.3:32–33).

The texts reflect great diversity of locale, class, age, gender, and culture throughout China. One story relates how, in a village in Inner Mongolia, a propaganda team successfully advocated Mao's call to "Learn from Dazhai" (*Geming jiebanren* 1974.5:36). Another story shows—and this is quite a revolutionary scene in China—that even a few young girls can persuade old villagers to listen and be self-critical about their emulation of Dazhai if only their words, based on the thoughts of Mao, are convincing enough (*Zhaoxia* 1975.12:13).[74] Numerous other stories, pictures, and songs illustrate how villages all over China can be transformed into pure and idyllic paradise, if only everyone listens to Mao's call. And the model of Dazhai can be applied everywhere, not just in the rural areas: in one reportage, a librarian explains that even though Shanghai Library is not the largest library in the world, it prides itself in attaining glory by serving the Maoist ideas of studying Daqing in industry and Dazhai in agriculture (*Zhaoxia* 1975.12:28).

74. *Zhaoxia* describes a visit to a village near Shanghai that studied Dazhai. It mentions the many difficulties that the villagers went through, but concludes in the end that they were happy and successful (胜似春光) (1975.12:47–52 and 76).

The driving force behind Dazhai's apparent achievements was Party Secretary Chen Yonggui 陈永贵 (1914–86), who had organized the villagers into teams to perform the backbreaking work needed to convert barren Dazhai into a showcase agricultural model for the nation. Chen himself was a typical model hero: active in revolutionary work since 1942, he headed the cooperativization movement in 1952. As chairman of the cooperative (later commune) and Party branch secretary, he was nominated model worker on the provincial (1957) and national (1964) levels. Chen was illiterate until the age of 43, but using Mao's writings as a textbook, he became well-versed in Maoist revolutionary theory. From 1973 to 1980, he was a member of the Politburo, and from 1975 until 1980, he even served as one of China's vice-premiers. Only when Deng Xiaoping succeeded Hua Guofeng in the late 1970s did the model status of Dazhai, and with it Chen Yonggui's reputation, increasingly come under scrutiny.

In the typical plot line about Dazhai, emulation of the story within the story—that of the Foolish Old Man *mise-en-abyme*—becomes one of the most important narrative devices. In the Dazhai novel, accordingly, whenever people feel quite disillusioned, Chen Yonggui goes back to telling Mao's stories (enthusiastically received by the peasants whom Chen must remind repeatedly that these are not his, but Mao's, stories after all). The story that he uses most frequently, indeed at every moment of crisis in the narrative, is that of the Foolish Old Man:[75]

> To him it was obvious that on their way forward they were bound to run into difficulties; and only by battling on to wrest victory from their adversities could they show the stuff poor peasants were made of. The important thing at this juncture was to keep calm and strengthen the team's faith in victory so that they could conquer all set-backs and forge ahead. So during a break he called his team together to ask what problems they had and whether they were tired out. Old men and boys alike replied that they were all right, they could stick it out. But they could hardly keep their eyes open.
> "I'll tell you a story," said Chen Yung-kuei. "How about that?"
> At this, the youngsters livened up and the old fellows, sure that their team-leader had something new up his sleeve, sat up to listen.
> The story Chen Yung-kuei told them was about the Foolish Old Man who moved mountains. He described how the Foolish Old Man refuted the wise man's wrong advice and kept hard at work until god was moved to send angels to carry the two mountains away. Hearing this, the whole team laughed. And now that he held their interest, Chen Yung-kuei pointed out the moral of the story: "Chairman Mao wants us to learn from this Foolish Old Man's spirit. We're up against plenty of difficulties with our spring sowing, and the well-off middle peasants are jeering at us. What should we do?"
> Young Liang answered: "The Foolish Old Man could move mountains; compared with that, our difficulties are nothing. The wise man in the story is just like those 'stout fellows' who are scoffing at us. We should do like the Foolish Old Man—defeat them with our actions." (*CL* 1974.2:15–16)

This derivative plotline, the power of Dazhai, is really built on the power of Mao's words, as expressed in the philosophy of the Foolish Old Man. It recurs in every conceivable form and materiality, in text, in song, and in image. In "The Days in the Commune Are Bright Red" (公社 的日子赛火红), a song published in 1974, a generic model commune is depicted as a paradise on earth.[76] Wherever one looks, one sees blooming fields and fruit. The clear water, reflecting the mountains, radiates in silver while animals flock the hills. The first verse paints idyllic nature, and the second verse transfers this description to the people who work on the blossoming fields, those who are able to fill in lakes and even the sea and who are able to move even the highest of mountains. In the lyrics, the commune members are called "new Foolish Old Men" (填湖海移高

75. These are the instances when the story is cited: *CL* 1974.2:43, 45, 54, 59.
76. The song is found in CC Liu Collection Heidelberg: *Gongshe de rizi sai huohong.*

山社员都做新愚公). The song collection from which this song is taken, entitled *Songs of the Red Flag Canal* (红旗渠之歌, *Hongqiqu zhi ge*), contains a good dozen more songs that allude, some directly and some more indirectly, to Dazhai and the Foolish Old Man. This topic remained prominent in song collections throughout the mid-1970s, and its use did not subside during the interim period with Hua Guofeng, in the immediate aftermath of the Cultural Revolution either.[77] Dazhai and the Foolish Old Man remained important models, even after Mao's death.

The *China Pictorial*, which during the Cultural Revolution had presented a myriad of images encouraging people to study Dazhai, continued this practice after Mao's death, too (for example, in its October 1976 issue, *Renmin Huabao* 1976.10). A new set of Dazhai postage stamps was advertised in 1977 (see *Renmin Huabao* 1977.8). In the criticism of the "Gang of Four," Dazhai was presented as a model for a critical attitude toward those made responsible for the Cultural Revolution (*Renmin Huabao* 1977.2/3). Inevitably, such images make reference to the Foolish Old Man. His story is written into them, visible on banners or carved into stone, or it is cited in the songs and stories about Dazhai, thus continuing Cultural Revolution practice. A 1972 pamphlet introducing Dazhai as a model of agriculture reads as follows:

> They [the people of Dazhai] study Chairman Mao's three articles—"Serve the People," "In Memory of Norman Bethune," and "The Foolish Old Man Who Removed the Mountains"—and criticize the bourgeois world outlook that has selfishness as its core. Through this, the peasants become more devoted to the collective. Their vision is broadened and they are determined to make more contributions to socialism and the emancipation of mankind. A generation of socialist-minded peasants is maturing in China. (Tachai 1972, 24–25)

Since Dazhai is inspired by studying and learning from Mao's story of the Foolish Old Man, all villagers who study and learn from Dazhai have a double model. This literary amplification is based on Party rationale: Hua Guofeng, in a speech at a conference on "studying Dazhai in agriculture" in 1975, argued in support of this double model. He said that one needs to take on the rebuilding of villages according to the model of Dazhai as a great socialist task and then continued (with Mao's crucial quotation in boldface): "We must move mountains and regulate rivers and **change the face of China in accordance with the great spirit of the Foolish Old Man who moved the mountains**." Agricultural investment builds the collective spirit, and once this spirit is built, so the argument goes, it is possible to conquer nature, and who is able to conquer nature is also able to conquer capitalism and build socialism (Hua 1975, 24–25, bold retained from original).

When such political speeches are translated into the language of Cultural Revolution stories, Dazhai, itself inspired by the Foolish Old Man, becomes the model for the model heroes who then, in turn, try to transform their villages, factories, brigades, and detachments in accordance with this double model. These heroes themselves serve as models to the members of villages, factories, brigades, and detachments reading the stories. Sometimes, the effect of the fictional double model even becomes tripled or quadrupled, as is the case with a piece of reportage that relates the visit of a Shandong peasant to a model village modeled after Dazhai in the spirit of the Foolish Old Man.[78] He is so impressed with the model village that he decides to transform his own village into a model, too:

77. For more songs on Dazhai see Bryant 2004:111–13. See also CC Liu Collection Heidelberg: *Chuangzuo gequ xuan* 1975, *Xiao hechang biaoyanchang gequ xun guangxi* 1975, *Duchang Gequ xuan* 1976, *Hong Taiyang guanghui zhao caoyuan* 1977, *Shoufengqin banzou gequ 12 shou* 1977, and *Siyue zhange* 1977.
78. *CL* 1971.3:31–41, "Leader of the Hsiatingchia Production Brigade."

He said: "If only we listen to Chairman Mao and work in the spirit of the Foolish Old Man, we'll be able to do what the Lichia people have done."

"You just go ahead, Yung-hsing, and we'll be following behind," said the co-op members valiantly. "We'll pick the stars with you if you scale the heavens; and if you search the sea we'll help you catch the Dragon King. . . ."

Led by Wang, the collective "Foolish Old Man" succeeded in giving Hsiatingchai a new appearance . . . In the twenty years after Liberation, enlightened by Mao Tse-Tung Thought, Hsiatingchia has been transformed into a socialist new village whose mountains are green, fields level, ditches filled with water and reservoirs many. The villagers, who are in high spirits, work with all their might." These are the results of Chairman Mao's great thinking "Transform China in the spirit of the Foolish Old Man who moved mountains."(*CL* 1971.3:36–37)

Again and again, the model's model, which itself becomes a model, is invoked. Model village Shashiyu (沙石峪) in Hebei, for example, originally a dry and arid place which stood for nothing more than poverty, is "known far and wide as a model brigade in learning from Tachai" (*CL* 1976.3:85). Not surprisingly, a 1975 comic dealing with the village calls its people "present day Foolish Old Men" (当代愚公) (see ill. **6.4**). As the story goes, in 1957, when the village's Party Secretary was attending an agricultural exhibit in Beijing, he had been given a copy of Mao's "brilliant work, 'The Foolish Old Man Who Moved Mountains.'" The reaction was instantaneous: "He hurried back that same night to Shashiyu to fire the co-op members with the revolutionary determination to use their own two hands, just as the Foolish Old Man had done, to transform the countryside." And by toiling for 90 days, these iron men and women (铁汉子铁姑娘), as they were repeatedly called, were able to create a large three-*mu* terraced field from small plots the size of bowls (Comic *Shashiyu* 1975, 85). In this comic, the Foolish Old Man is constantly invoked—in the text, in placards on the wall, and in a booklet handed from one villager to the next that shines in the hands of those who read it (Comic *Shashiyu* 1975, 42–45, 64, 76, 109). Women, the elderly, and eventually children, too, all want to join the group and move mountains (ibid., 46, 53, 106), and those who doubt are made to repent and join in (ibid., 48, 52, 62, 79–80). Another comic that tells the story of Wang Guofu 王国福 (1922–69), a devoted peasant leader, again links the study of Dazhai and the Foolish Old Man.[79]

The multiple levels of models at work appear manifold in stories published in literary journals, in comics, on propaganda posters, or in song collections. In each of these texts, the Foolish Old Man is invoked not once but many times. There is a clear sense of deliberate "choreography" here. All of these texts, in their skillful use of Maoist quotation and not unlike the originals presented in Yan'an, are "writuals," as Apter and Saich would call them, yet here they somehow grow to "monstrous proportions" (Apter and Saich 1994, 73). No matter how artful the construction, the main complaint by our sent-down youth had been the fact that Mao's words and stories—the Mao *writuals*—were not effective in their rote repetition: in his view, the ritualized recital of MaoSpeak could not change the thoughts and the world view of the people precisely because it was so ritualized. No matter how often stories, images, newspaper reports, and political speeches asserted that they were able to do so, he maintained that they could not, in the end, move people. The failure the sent-down youth predicts of Cultural Revolution *writuals* may be due precisely to the fact that the Mao quote—the story of the Foolish Old Man being just one example—does not remain an abstract concept in these narratives, but is applied to numerous different yet very concrete situations and circumstances.

While these very concrete and individualized stories were an attempt to cater to as many different audiences as possible, the specific circumstances they described often had very little to do

79. Comic *Wang Guofu de gushi* 1977. Cf. also DACHS 2009 Landsberger: Wang Guofu.

with the harsh realities in which China's peasants, workers, and soldiers—the sent-down youth among them—actually lived. The protagonists in these stories weather many storms, but in the end, things always work out for the best, and the believers among them are victorious, happy, and content, while those who harbored doubts are shown to have been in the wrong.

Placing their faith in the Foolish Old Man's story, peasants in a Guangxi brigade would be able to transform a stony place full of thorns and brambles, devoid of water, and hampered by poor soil into rich and fertile fields. They would not be discouraged by setbacks or injuries. This scenario once more translates, almost word for word, the story of the Foolish Old Man into a contemporary setting.[80]

> Early in May 1968, Team Twelve climbed Peach Rise with three old pickaxes and a dozen old hoes. "What are you doing here?" some passersby asked, "building a house?" "No," the poor and lower-middle peasants replied. "We are learning to be like Tachai people. We're building Tachai-type fields, so as to produce more grain for the world revolution."
>
> "Any time a barren rise can be cultivated, a dead tree will bear seeds!" some one mocked. "Let those 'Wise Old Men' laugh," an old poor peasant said to his mates. "We must be a credit to our great leader Chairman Mao and to our great socialist motherland, and do our bit for world revolution."
>
> "Right," the team members replied. "We won't fall for their nonsense. We'll be like the Foolish Old Man. He and his family had the courage to tackle two big mountains. If we rely on our collective strength we certainly can improve this land."
>
> [When one of the Commune members was injured in the process], he said: "We're opening up the hills and building terraces for the revolution. A little injury doesn't matter. You can't learn from Tachai if you're timid." Reciting: "Be resolute, fear no sacrifice and surmount every difficulty to win victory," he resumed swinging his big hammer.
>
> He also got his whole family to learn from Tachai. They made a rule: "Read Chairman Mao's works every day, discuss practical application every five days, recall the bitterness of the past every ten days." The brilliance of Mao Tse-Tung Thought and the Tachai spirit made the whole family revolutionaries. (CL 1970.5:58)

Group and individual all agree in their devotion to the common cause. Together, the commune composes a song that again illustrates the immense sense of optimism and utopianism conveyed in these stories:

> Tachai spirit takes the lead,
> Stony gullies become good fields,
> Happy I see wave upon wave of paddy and corn,
> It's man, not nature, who decides. (Ibid., 63)

In all of these stories, it is indeed "man, not nature, who decides." In each of these texts, it is clear that one only needs to develop the collective spirit in order to be able even to make dreams come true: one story, appropriately entitled "Men Can Conquer Heaven," describes villagers building a dam and finally taming the floods that had cursed their village for hundreds of years. Upon seeing the sturdy dam and the "torrents tamed for the first time," one old villager exclaimed: "The dream of our forefathers for generation upon generation has come true at last!" He continued, "Because we have Chairman Mao's revolutionary line, we commune members can go all out to build socialism, removing mountains, and changing the course of rivers. That's what we mean when we say: 'Men can conquer Heaven.'"[81]

80. CL 1970.5:53–63 "In the Tachai Spirit."
81. CL 1976.2:70–86 Chang Szu-kung "Men Can Conquer Heaven."

Of course, the situation described here and everywhere in these stories constitutes a fantasy, an impossible utopia; and some of these writers therefore self-consciously acknowledged that their stories may seem rather unlikely, yet insisted on their being true after all—which is why most of them would appear in a section entitled "reportage" and not as "fiction." One 1977 story thus begins:

> Tachai's red banner raised on high
> Will make a mountain bow its head.
> Hack open the Taihang ranges
> And through the cliffs make a new river-bed!
> Is this just a militant folk-song? No, it is a fact.
> This has already been done by Hsikupi Production Brigade in Hsiyang County.[82]

Even today, one can still see faded slogans proclaiming "In agriculture, learn from Dazhai" in parts of rural China. Yet, real change began in the 1980s when, slowly, news came out that discredited the Dazhai model. It transpired, for example, that Dazhai's achievements were the result of extensive assistance from the PLA. Moreover, heavy machinery had been used, whereas Dazhai had been propagated as a model that relied on pure manpower, combined with a clear understanding of proletarian politics. The influence of the Dazhai campaigns seemed to have proven tenacious. By the late 1990s, Dazhai's inhabitants themselves, not unlike peasants all over China, no longer stressed self-reliance and hard work, but strove to become as well off as the rest of China's people. Not a single household is solely engaged in agriculture anymore, and more than 80 percent of the villagers now work in industry and the service sector, in particular tourism. Most of the arable land has been turned into orchards and dense woods.

There is evidence that this development was already beginning to unfold during the late Cultural Revolution, when rival forces at the state center clashed over agricultural policy, especially in terms of modernization versus self-reliance, and Dazhai became the battle ground. Yet, it is not obvious from the many trite and predictable depictions of the Dazhai model in the literary output of the time, nor from the extremely univalent artistic evidence (Pickowicz 2007, 34). Here again, as in the field of music and reading of the Classical Confucian canon, a significant disjunction between Party politics and cultural experience and production is at work (see Clark 2008, 1–9). Perhaps one of the most important findings about the Cultural Revolution as a cultural and artistic experience is the fact that the narrative mode in which something like Dazhai is presented shows no fissures or fragmentation that might reveal differences in opinion in the political realm. Dazhai and its people are present throughout the ten-year period declared to be the "Cultural Revolution" (and beyond) as models because they study Chairman Mao's *Three Articles* and are able to effectively criticize a bourgeois world outlook that is selfish at its core. Dazhai's peasants are devoted to the collective: "a generation of socialist-minded new peasants is maturing in China" (Tachai 1972, 24–25). By reading Mao, their vision is broadened and they are empowered to make more contributions to socialism and the emancipation of mankind.

During the Cultural Revolution, the reader is presented, time and again, with such devotees and the power of Mao's words in fictional and musical texts, in art as well as in political prose. No matter what the daily politics, the reader is bombarded with portraits of those who believe in Mao and his philosophy. Inevitably those believers are able to commit heroic deeds: a group

82. *CL* 1977.4:36–52 Sung Shu-wen and Sung Kuei-sheng "Heroes Split Mount Chialing."

of children sacrifice themselves for the sake of their village, fearlessly throwing themselves into the flames. Jumping into their death, they call out, "Be resolute, fear no sacrifice, and surmount every difficulty to win victory" (*Geming jiebanren* 1974.5:47). A ship painter sustains the chemical stench from the bad paint by again reciting, "Be resolute ..." to herself (*CL* 1971.6:57). One comic entitled "Fighting Nasty Waves with a Breast Filled with the Rising Sun" (胸怀朝阳战恶浪 *Xionghuai chaoyang zhan elang*) tells the story of a boat crew whose boat hits a reef, but who fight on nevertheless. When the boat is about to sink, two things other than the national flag are saved: the Mao portrait and the *Little Red Book* (Comic *Xionghuai* 1971, 12). Just the idea of managing to save the Mao portrait makes the crew more hopeful (ibid., 15–16). Several times during their fearless fight against the roaring waters, the crew calls out, "Be resolute" (ibid., 22, 31), and they sing "Red is the East" (ibid., 39). A huge wave meets them, but when they come up again, they continue their song for forty minutes, the singing strengthening their stamina (ibid., 40).

In another story, a war veteran who had lost both his legs during the Korean War rides his bicycle to the city in the depth of winter in order to get the construction materials necessary to rebuild his village into a new Dazhai.[83] As he crosses a piece of wasteland, his bicycle sinks deeper and deeper into the sand. With every step, he gathers all his might to face the sand and begins to sing, "Be resolute, fear no sacrifice ..." and thus fights his way to the city. His willpower, so it is said, "was greater than the number of sand corns in this wasteland" (*CL* 1970.5:47). In a similar story, a group of Red Guards fearlessly passes through a dangerous thorny thicket only to find, on their way, Mao's words to encourage them along:[84]

On a flat rock-face, some characters written in red chalk—a quotation from Chairman Mao, drew them like a magnet: "Be resolute, fear no sacrifice and surmount every difficulty to win victory...." How familiar and inspiring are the instructions of our great leader Chairman Mao at a moment like this! They are our source of strength, our compass for action. Reciting quotations from Chairman Mao by heart, the youngsters felt the strength surging back into their legs, which gradually became vibrant like well-pumped rubber wheels. Forgetting their weariness and the ache in their legs they shouted, "Comrades, get a move on! Perseverance means success!" to encourage each other, and dashed up the hill-top. (*CL* 1967.3:101–2)

And as if this were not enough: even the deaf and the dumb can speak and hear again with the help of Mao's words: a barefoot doctor in one such story grimly recites "Be resolute" while inserting acupuncture needles into a patient's body—and is successful (*CL* 1969.11–12:68–78). In this story, Mao's words appear as mantra on the walls of clinics and hospitals:

On a wall they wrote up Chairman Mao's teachings: "Serve the people whole-heartedly" and "Be resolute, fear no sacrifice and surmount every difficulty to win victory." They kept these constantly in mind and resolved to use invincible Mao Tse-Tung Thought to cure the "incurable." (*CL* 1969.11–12:70)

How plausible are such stories, however? "Of course these things are not entirely impossible, but some of these stories do appear as miracle stories," a businesswoman (1940s–) pointed out. In a 1972 collection of translations called *Miracles of Chairman Mao*, Maoist Thought appears always in hyperbole, as a "cure-all" (Urban 1971, xv). Wondrous, too, are the examples of the strength of MaoSpeak in the model works: the victorious fight against the waves in *Song of the Dragon River* (scene 5) is helped on by the rhythmical shouting of "Be resolute!" (see the Introduction and

83. *CL* 1970.5:40–52 "A Fighter of Steel Continues."
84. *CL* 1967.3:97–105 Sung Hung "A Night Climb Over 'Thorny Dam.'"

Chapter 1). The brigade members in *Song of the Dragon River* are firm in their use of Mao's Thought, and one scene shows Jiang Shuiying reading Norman Bethune's story together with her brigade members (scene 6; see ill 1.10). "Be resolute" resounds in the miraculous scenes in *Raid on the White Tiger Regiment*, too. At the end of scene 5, in a situation that is entirely hopeless, the fighters all call out, "Be resolute, fear no sacrifice, and surmount every difficulty to win victory!" (*Qixi baihutuan* 1967, 38–39). The commander repeats the sentence in his instructions, followed by the incantation of "Red Is the East" and a quasi-religious ritual moment of reverence. The battle comes to a climax that very night and ends in victory!

The impossible becomes possible by remembering Mao's famous quote: one of the little sisters in the comic version of *Children of the Grasslands* remembers Mao's phrase of being resolute to "overcome difficulties" when she has almost given up fighting the snow (Comic *Caoyuan Ernü* 1973, 63). But she is determined and won't let go, and soon enough, the snowstorm dies down (ibid., 64). Her determination (and her earlier diligent reading and memorizing of Mao's works with her father) has saved her (see **ill. 4.5**). These examples give only a few glimpses of how the wondrous powers of Mao and his thoughts are constantly invoked and evoked during the Cultural Revolution. One particularly striking example is the story of a bloody battle against American soldiers during the Vietnam War.[85] With our hero's boat sinking slowly and many members of the crew already dead, Mao's Thoughts still prevail:

> Their heads could crack, their blood could flow, but they'd never give up Mao Tse-tung's thought. Radio operator Huang Wei-chao, holding aloft his gleaming red copy of *Quotations From Chairman Mao Tse-Tung*, came charging out of the radio room. Like a flash of lightning in the night sky, the shining book seemed to illuminate the furiously thundering Gulf ... (*CL* 1967.11:59)

Two members of the crew have been thrown overboard in an explosion, but they find a safety vest, hold on to it, clean each other's wounds, and

> read from their books of Chairman Mao's quotations. With all their might they swam towards an island through the rolling sea, and they seemed to hear Chairman Mao's words, transcending all other sounds:
>
>> "Be resolute," recited one of them, pushing forward.
>> "Fear no sacrifice," continued the other, riding over a wave.
>> "And surmount every difficulty,"
>> "To win victory." (Ibid., 61)

This type of choral recitation, reminiscent of a ritual incantation that increases the bonds of a community built through a common text and language, is typical of works from the Cultural Revolution. In the revolutionary opera *On the Docks*, at the end of scene 1, Party Secretary Fang Haizhen reminds everyone that they must "be resolute" and ensure that no torn sacks will be loaded onto the ship. The dock workers are seen to answer the prompt immediately in choral fashion.[86] In a similar manner, at the beginning of *Taking Tiger Mountain by Strategy*, the regimental chief of staff begins the quote, and his soldiers answer in dialogue structure.[87]

85. *CL* 1967.11:54–71 "A Battle in the Gulf of Bac Bo."

86. *CL* 1969.13–53 "On the Docks," 10. In the 1972 version, this element is kept entirely unchanged. *CL* 1972.5:52–98, "On the Docks," 57.

87. *CL* 1970.1:5. See also *CL* 1971.6:44–49 "Red Hearts and Green Seas," where captain Kao and his team have to face a fierce storm: "'Comrades,' he shouted above the roar of the waves, 'remember Chairman Mao's teaching; "Be resolute, fear no sacrifice and surmount every difficulty to win victory."' The fishermen recited the quotation in chorus, and their confidence grew" (45).

As was the case with the Vietnam War hero mentioned above, reading or reciting the words of Mao usually occurs at moments when there would be no time or possibility for it in real life: in one story, the crew of a fishing freighter are caught in a heavy storm, their net entangled in a marine propeller. They think about simply tearing the net apart, certainly the most pragmatic solution. But somehow, they are not convinced it is the best solution. In the midst of torrential rains and heavy winds, they start reading the *Little Red Book* and come to the conclusion that they must save the net (*CL* 1971.6:46). Accordingly, they jump into the water, one after the other, in order to disentangle it. Concludes the text: "The gale was fierce and the seas were high, but what was that to men armed with Mao Tse-Tung Thought?" (Ibid., 49).

Within the particular logic of these stories, the question is not, "Are these stories simply too wondrous to be true?" What they produce is the hyperbole that is part and parcel of propaganda and that depicts "life on a higher plane." Some of them quite openly state that miracles can be performed with Mao Zedong Thought: Jiao Yulu 焦裕禄 (1922–64), a model cadre who had served in both industry and agriculture before his untimely death in 1964, appears in one such story as convinced of the miracle-working power of Mao's words.[88] When, after a first frustrating meeting, Jiao reads Mao's *Selected Works*, his outlook changes and he reflects: "Of all things in the world, people are the most precious. Under the leadership of the Communist Party, as long as there are people, every kind of <u>miracle</u> can be performed" (世间一切事物中，人是第一个可宝贵的. 在共产党领导下，只要有了人，什么人间奇迹也可以造出来) (ibid., 10; Mao 1969, 1401). But before all this, and to make plausible this outcome, the story begins typically, with an idyllic description:

> Golden waves gurgling merrily, the Yellow River flows incessantly onwards.... Lankao county in eastern Honan lies in a bend of this age-old Yellow River. (Ibid., 4)

Everybody in Lankao, so the text continues, is happy. They all wear their Mao buttons, and their smiles and laughter form a crass and sharp contrast with their own difficult past, which is described next in an act of doubling persuasion: the contrast makes the present shine even more brightly. The story then zooms in on a windy, dusty winter day in December 1962:

> To the gate of the Lankao County Party committee came a middle-aged man, wearing a washed-out black uniform and a faded fur cap. His face was dark, his eyes were sharp, and he carried on his back a tightly tied pack. (Ibid., 6)

This is none other than Jiao Yulu who, after reading Mao's encouraging words, can confidently say that while there may be a handful of difficult people in Lankao, some of them on the "capitalist way," the "revolutionary people of Lankao who want to take the socialist road number 380,000. Once they really grasp Mao Tsetung Thought, there is no difficulty they cannot overcome, no enemy they cannot defeat." After only a few months, he realizes that, indeed, this is the case. Teasingly testing his fellow peasants, he is pleased to see that they are extremely well-versed in Maoism and praises them: "That's the way for the living Foolish Old Man of socialism to talk. We poor and lower-middle peasants must have that kind of determination. The spirit of you comrades here should be studied by the people of the whole county." He sits down together with one elderly peasant to read the Foolish Old Man's story once more, murmuring: "The determination of you folks is exactly the spirit of the Foolish Old Man. With such a spirit there's nothing that can't be done well. I hope you will always keep it up" (ibid., 43).

88. *CL* 1969.9:4–72 "Chairman Mao's Good Pupil Chiao Yu-lu." Jiao reappears as a comic hero in Chapter 6 of this book.

Constant invocations of the power of Mao's words (in this short story, the Foolish Old Man is mentioned six times, while "Be resolute" is sounded four times) prove nothing, however, certainly no more than Boxer invocations of their own invulnerability once did. The references to "real-life" people and events also prove nothing. It is only within the stories themselves that Mao's words are shown to be powerful time and again, even as their heroes face death:

> One afternoon, Chiao suffered acute pain. His face was covered with cold perspiration. He curled up in bed, while his wife, very deeply distressed, shed tears by his bedside. Chiao wiped his face and said smilingly:
> "Chunya, I know you are disturbed. I have a method that can soothe your mind and ease me of my pain."
> His wife choked down her tears, picked up the *Selected Works of Mao Tse-Tung* from beside the pillow and asked, "Want me to read Chairman Mao's works to you, don't you?"
> "You've guessed it. When I hear Chairman Mao's words I'll feel no pain." ... The whole afternoon slipped by. It was on Mao Tse-Tung Thought that this man with iron will depended to overcome the repeated attacks of the disease. For a month or more, nobody heard him utter a single groan. He never flashed the red signal, made available for serious cases. (ibid., 62–63)

What, then, is the effect of this constant overdose of optimism? Do these stories ever provoke, in their very perfection, a moment of doubt in the minds of readers? In their formidable study on Mao's "Revolutionary Discourse," David Apter und Tony Saich observe that it had been Mao's wish to organize a "special discourse community." During the Yan'an days, he created these myth-like stories that would be told again and again like prayers or incantations:

> From these stories, like a magician pulling rabbits out of a hat, Mao pulled logical inferences that enabled others to break through their conventional thinking. The stories, which reflected shared experiences, became the basis of a logic, adapted both from Chinese traditions and Marxism, that enabled Mao to transform his stories into a single line, a mytho-logic. Each narrative established the conditions for the next. Each defined revolutionary obligations to China as a nation and to the peasantry as its class representative. (1994, 36)

Cultural Revolution art is an attempt to translate this logic onto multiple concrete levels—and a "higher plane." In Cultural Revolution art, all people are advocates of Mao's works; they are missionaries of the Maoist mytho-logic. This marks the crucial difference between the use of Mao's revolutionary discourse then versus in Yan'an: the Cultural Revolution stresses the study of decontextualized fragments of MaoSpeak presented in piecemeal fashion, and this alone changed its effects considerably (Leese 2006, 97). Second, whereas Mao's Yan'an discourse remained vague as to its specific application, Cultural Revolution art created very concrete models and heroes to serve as missionaries for the Maoist cause (see Leese 2006, 291).

The characters in these stories aspire to be "everyman" and "everywoman," but in fact, they are "really far away from reality" (Businesswoman, 1940s–). It is the will of the propagandists that they must be larger than life because they "embody the essence of history" (Wang 1997, 191). Although young and old, male and female, rich and poor were called on to emulate the "grandiose superhuman deeds" of these heroes, "history offered them little more than a front seat to watch and applaud the reenacted unfolding of the epic" (Wang 1997, 204). Testimonies such as these make it clear that the paradisiacal realities depicted in these works had very little to do with lived realities during the Cultural Revolution—even if many of the stories are entitled "reportage," invoking an aura of realism.

The sent-down youth cited above is not the only one dissatisfied with the apparent superficialities and obvious exaggerations of fragmented and ubiquitously applied MaoSpeak. Mao's words in

their ever-repeated glorification became a fetish. De Montaigne would have called this practice of quotation "parrot's talk"; he would have considered these texts no more than "patchworks of quotations" or a "Paté of conventionalities" and thus impotent (de Montaigne 1992, 806). And yet, the answer to the question of whether the quotation fever of the Cultural Revolution led to subversion of the authority principle that had dominated the use of classical quotation in China for centuries and decades is ambiguous: Wang Ban, a teenager during the Cultural Revolution years, remembers: "During the Cultural Revolution, I felt the strain of having to become more than I was. The Post–Cultural Revolution period was one of enlightenment as well as disenchantment. I grew increasingly tired and suspicious of all the imperious demands that Communist culture had made of me and many of my generation" (Wang 1997, vii). Patchworked, parroted MaoSpeak grew tiresome, even annoying to some. Ruth Earnshaw Lo remembers in her memoirs, for example:

> Personal letters between friends now began with quotations from the Red Book, as it became correct revolutionary procedure to preface any written document with reference to Chairman Mao's Thoughts. Chairman Mao was supposed to be in everyone's mind, and I expect he actually was for a great many. For self-protection even nonbelievers had to develop an ability for glib quotation. (Lo 1987, 73)

Although some expressed disbelief, others testified to the efficacy and utility of these quotations. Many remember how MaoSpeak did, in fact, enable them to continue working hard, that it cheered them up when they were tired, that it sustained them. Liang Heng recalls that his father would use "Be resolute" as a kind of worksong to encourage peasants to persevere (Liang and Shapiro 1984, 180–81). And Fulang Lo remembers an instructor training youth for their experience in the countryside who said:

> Chairman Mao is truth. His thoughts can solve all of your problems. Chairman Mao's quotations are the doctor's prescriptions that can cure diseases of the mind. Set the doctor beside your pillow so you can see him every morning and every evening. In this way you will never be sick with bourgeois diseases. (Lo 1989, 20)

Rae Yang, in her memoirs, recalls several instances in which quoting Mao helped others or herself. She remembers how a group of educated youths sacrificed themselves, trying to put out forest fires: "When they were engulfed by a roaring mountain of flame, they cried 'Long Live Chairman Mao!' and protected the Mao buttons on their chests. This way, they became revolutionary martyrs" (Yang 1997, 237). She also recalls her "long march" to the countryside with other young Red Guards who were much stronger than she was:

> Then it grew dark. Mountains turned into huge black shadows. Stars were all over the sky. There was no moon. The road sank into darkness. No village was in sight. No dogs barked. I was still some ten li away from my destination. I felt like crying. Not that I was afraid of ghosts or bad people. It was a sense of utter helplessness. "Would Hongjun cry? No! Hongjun would only shed blood. No tears!" "Chairman Mao teaches us, 'Be determined. Do not fear sacrifice. Overcome ten thousand difficulties to strive for victory. . . .'"
> In those years, millions of Chinese had recited this quotation in difficult situations to boost their morale. Saying it aloud, suddenly I saw lights shine out in front of me. Like a miracle! Dim and flickering at first. Bright and clear later. The lights came near. Oil lanterns lit up the faces of three male Yunnan Red Guards, including the team leader. They told me that they had long since reached the village that was our destination and waited for me. Then it got dark. There was still no trace of me. They decided to come back to meet me. (Yang 1997, 149)

So she is saved a first time. Later, she relates how she overcame physical exhaustion:

What was good for the morale? I told myself, This is the trial, the firing line. If I can hold out, I am the winner and the hero. If I collapse, I am no good. A pile of dog shit! Chairman Mao teaches us: "Be determined . . ." Auntie said a person must have *zhiqi* [志气 willpower] . . . And what did the peasants in this village say? "A person's strength is different from all other things. It won't be used up. The more you use it, the more it grows out of you." These words gave me hope. I persisted. By and by, new strength grew out of me. The peasants were right! (Yang 1997, 177)

Be they quotation songs or stories, their presence was somehow felt and, more or less faithfully, acknowledged. Writes Xing Lu: "Every time a new quotation song came out, we would practice and master it. My classmates and I organized a Mao Zedong's Thought propaganda team. We went to the Beijing Railway Station and sang new quotation songs to the travelers in the waiting rooms. Sometimes we used quotation songs to solve problems on the spot" (Lu 2004, 108). In the process of singing these songs some Chinese felt they had been transformed into true adherents of Mao's teachings, embracing his every utterance as a sacred, infallible, practical Truth. And there are other sources that support this observation. One foreign visitor describes a middle school mathematics class in the early 1970s:

> The next question was concerned with wage differentials in the Soviet Union. The proportion of high to low wages was given as 325:3, and the wages of a professor as 6,500 roubles per annum. 'What,' the teacher asked, 'would be the wage of a worker?'
>
> Before getting down to working out the calculation, the teacher asked 'What do you think of the question' and there ensued a lively discussion among the students of material incentives, piece rate, privilege and the lessons China should draw from developments in the Soviet Union. The students quoted freely from the *Selected Works of Mao Tse-Tung* which each had beside him on the desk.
>
> 'Good,' said the teacher, 'We have the political orientation clear but it's important to work out the figures correctly. An incorrect calculation will only waste time.'
>
> A student volunteered to come to the blackboard to work out the answer. He stuck at a certain point and hesitated in his calculations, scratching his head. A good humoured chorus came from the whole class 'Be resolute, fear no sacrifice and surmount every difficulty.' And the teacher chipped in, 'Because we are serving the people, we are not afraid of making mistakes.' Encouraged, or perhaps challenged, the lad went on to finish the sum and, indeed, came out with the correct answer (Mauger et al. 1974, 48).

Another couple of foreign observers, filmmakers Joris Ivens and Marceline Loridan, were convinced, too, of the powers of MaoSpeak. They called their monumental twelve-hour ethnographic documentary series *How Yukong Moved the Mountain*. In the film, which uses material mostly shot in 1972–73 and which was released in March 1976, the story of the Foolish Old Man is retold at the beginning of each of the twelve documentaries comprising the series. It shows a socially minded China, with everyone, from pharmacy worker to peasant, convinced that the most important thing is to "Serve the People." The film celebrates China's feat: the country was able to move the mountains of selfishness and avarice, to be sure, and has entered, so it appears, a state of perfected democracy. According to Ivens, "pure socialism was possible," for "nowhere else in the world had there ever been such socially minded children as in the China of the Cultural Revolution." (Schoots 2000, 318–19).[89] One main objection in foreign criticisms of the documentary series remained that the film gave an "unauthentic picture" of Cultural Revolution China. Did it

89. The film is an interesting example of collaboration between Chinese and French institutions: apparently, the French Centre National du Cinéma paid for 16 mm equipment, film, and laboratory costs. The Central Studio for New and Documentary Films in Beijing made a Chinese crew available. Ivens agreed to train Chinese crew members in modern film techniques. Travel costs and accommodation were met by the Chinese government (Schoots 2000, 324).

probe beneath visible reality? Did it penetrate to the underlying mechanisms of Chinese society? The critics did not think so. They argued that the danger of *cinéma vérité*, that the film only showed the exterior reality, a danger that Ivens himself had once warned about, had now infected his own documentaries to the core (Schoots 2000, 329).

This film series, as well as memoirs, diaries, and other testimonies of those who lived through the Cultural Revolution suggest that Cultural Revolution practice of revolutionary discourse—characterized by decontextualization and fragmentation (and the *Little Red Book* epitomizes this development)—was, if at all, only a partial failure. Mao's words were quoted as the most authoritative ideological norm to highlight art, literature, and political speeches, as well as everyday conversation (Yang 1998, 162). The Mao quote as a defining part of the overtly propagandistic language of the Cultural Revolution delimited this language to a standard set of keywords (Bryant 2004, 100). Although this restriction was acutely felt and resisted, one of its results was that MaoSpeak became part of everyday parlance. In Fulang Lo's memory of the tragic case of her classmate who had been declared a "black element," this is evident. She could have phrased differently, but returned to Maoist vocabulary: "Meimei carries a mountain which I can see but cannot help remove" (Lo 1989, 12). Not unlike phrases from the *Three Character Classic* that, in spite of all anti-Confucian movements, continue to make up the proverbial repertoire of an average Chinese, MaoSpeak, too, has become an integral part of linguistic memory.

In the next section of this chapter I discuss the significant after-effects of Cultural Revolution practices. If the absurdities and "miracles" of the Mao Cult during the Cultural Revolution led to an inflationary increase of model heroes and a unique rhetoric of worship, this has long since been subjected to harsh criticism as well as ironic and playful reappraisal in China, a practice dating back to the Cultural Revolution (Leese 2006, 3). It will become apparent that the commercial, satirical, or even subversive packaging sometimes used to present Mao's works today betrays the lasting powers of a progageme that, though engendered many decades earlier during Yan'an days, only experienced a (first?) climax some time during the Cultural Revolution.

(Hi)Story and Quotation beyond the Cultural Revolution

> The banner of Mao Zedong Thought can never be discarded. To throw it away would be nothing less than to negate the glorious history of our Party ... It would be ill-advised to say too much about Comrade Mao Zedong's errors. To say too much would be to blacken Comrade Mao and that would blacken the country itself. That would go against history. (Deng Xiaoping, October 25, 1980)[90]

A "new interpretation" of the Foolish Old Man's story published in the Shanghai newspaper *Wenhuibao* (文汇报) in 1980 unmasks the story as a "fairytale" (Liu 1980). The article publicly mocks the long-established foundational myth of the PRC—ridicules the very belief in the power of the people which it epitomizes. Should this be read as a sign that the power and might of MaoSpeak was no more? Beginning in the early 1980s, official press statements used Mao quotations much less frequently than before (see the statistics in May 2008). But does that mean that Mao's words were no longer the natural bearers of a universal proposition or an eternal Truth? Did the words of Mao, by being constantly repeated, lose their clear and unmistakable quality and appeal and thus their power to convince (not unlike Mao's image, which, around the

90. Deng's statement, which would determine the tenor of the Party Resolution in 1981, is found in Deng 1983, 262–63. The translation follows Barmé 1996, 118.

same time, was beginning to be presented as "out of focus," see **ills. 5.31**, 5.56, **5.57**, **5.68**)? Is it true that, by suggesting to read only small sections of his work and by supporting the production of the *Little Red Book* (*Wenge shiqi guaishi guaiyu* 1988, 125), Lin Biao is to blame for having "destroyed and diluted the power of Mao's words, their integrity and scientific value" (破坏了毛泽东思想的完整性科学性)?[91]

Probably not. The Foolish Old Man continues to be much quoted after the Cultural Revolution, even if his followers have their doubts about the efficiency of MaoSpeak in general. In a Chinese-German dictionary published by the Foreign Languages University in Beijing in 1988, the Chinese four-character phrase "well known everywhere, both in the countryside and in the cities" (家喻户晓) is explained not with a sentence referring to the *Three Character Classic* as one might have expected. It reads instead: "The story 'The Foolish Old Man Who Moved Mountains' is well known everywhere in our country" ('愚公移山'在我国家是个家喻户晓的故事) (*Xin Han-De Cidian* 1988, 387). The dictionary thus acknowledges the popular quality of the story that had been so amply illustrated in image, text, and song during the Cultural Revolution. Naturally, whether being "well known" meant having a good reputation remains an open question.

The continuous presence of the story is obvious when we look at a collection of Cultural Revolution jokes published in 1988. One of the jokes, entitled "Revolutionary Wedding Presents" (结婚的革命礼物), reports the exasperation of a newlywed couple who had been given 65 *Little Red Book*s and 37 sets of Mao's *Selected Works*:

> The bride says: "What are we going to do with such a huge mountain of books? We can't sell them or eat them, even less do we dare burn them. Not even our sons or grandsons will be able to use them all."
> The groom says: "Not to worry. Has not Chairman Mao instructed us: 'When my sons die, there will be my grandsons, and then their sons and grandsons, and so on to infinity.' We might be faced with a mountain of books, but it will never grow any taller and if we use one volume, it will be one volume less, so how should we not be able to use them all?" (*Wenge xiaoliao ji* 1988, 13)

The dialogue consists of well-known phrases, but their meanings are trivialized and thus ridiculed—considering non-antagonistic red mountains of books in comparison to rather more antagonistic mountains of hard stone (or feudalism and imperialism, in a less literal interpretation). The qualitatively and quantitatively different dimensions of the mountains dealt with in the stories create an ironic tension between the different texts. Critical distance from official tone and manner of speech is created precisely by appropriating official tone and manner of speech. As Schönhals argues: "Only by replicating or mimicking the formal qualities of the discourse of the state can critics of the state make their voices heard" (1992, 20–21). The joke may thus be interpreted a subversion in official guise. Like so many jokes, it also has a kernel of truth: during the Cultural Revolution some 40 billion volumes of Mao's works were printed and sold, and after the Cultural Revolution it was not just booksellers who faced the difficult task of moving the leftover mountains of books (Barmé 1996, 9). In its use of Mao quotations, and not unlike some of the Mao portraits painted after the Cultural Revolution and discussed in the next chapter, this joke is a strong, if not necessarily vicious, attack against Mao and the deification of his thoughts. The Mao quote crucial to this joke appears slightly "run-down," empty, blank, a mere container lacking convincing content; thus the joke may be interpreted as an "expression of mistrust toward the word and the tradition" as well (Miller 1961, 167–68).

This is the case too, for many of the other jokes that play on rote repetition of Mao quotations during the Cultural Revolution.[92] Some of them replicate daily conversations entirely through

91. This conclusion is drawn in the Party school publication *Wenge shiqi guaishi guaiyu*.
92. E.g., *Wenge xiaoliao ji* 1988, 4, 14, 16, 22, 114.

quotations by Mao, providing hilarious scenes of people sitting at the barber shop or negotiating at a photography studio, using totally disjunct quotations in everyday dialogues.[93] There is evidence in memoirs that the call to "revolutionize daily life" by replacing ordinary language with Maoist jargon was, in fact, followed (e.g., Gao 1987, 317). These jokes published after the Cultural Revolution but probably circulated earlier are one more indication that quite a few people may have felt the emptiness of Mao's words even during the Cultural Revolution, although as one editor commented, many only realized this after Mao's death:

> In the 70s, things changed a bit, they became better. But if you talk about people beginning to have their doubts, that really had something to do with Mao's death. Then people started thinking, for example: why would we say, "Long Live Chairman Mao" [毛主席万岁] instead of "Good Morning"? (Editor, 1930s–)

Mao's words and the words in praise of him had been emptied, stripped of significance and meaning. However, such emptiness could mark a new beginning, too: not unlike a revolutionary melody or a *Three Character Classic*, a Mao quotation, too, may bring new smells, new sounds, or a new atmosphere and thus may begin to form new associations and contextual connections in people's minds. One such example is Gao Xiaosheng's 高晓声 (1928–) short story *Li Shunda Builds a House* (李顺大造屋 *Li Shunda zaowu*), which was awarded a national literature prize when it was published in 1979 and thus became part of at least one type of official discourse.[94] In the story, Li Shunda, a short-sighted miser, compares himself with the Foolish Old Man. Huge mountains are substituted with a small house; the story of collective hope, the foundational myth of a strong nation, becomes a story of individual personal profit. This radical semantic shift is taken even further in an advertisement seen by Geremie Barmé on a billboard near the Shanghai Station in December 1991. To advertise wallpaper and other paraphernalia for interior decoration, it used the phrase "The Foolish Old Man Who Moved Mountains" (愚公移山) itself, suggesting that if one used the advertiser's interior decoration products (such as wallpaper depicting mountains), one would be able to move beautiful mountains into one's own living room (Barmé 1996, 35). Even more frivolous does the use of the phrase as the name for a wooden toy appear. Consisting of three pins designed to "move mountains" made of perforated wooden discs from one pile to another, the toy was made, as the advertisement tells us, to be enjoyed by old and young (foolish men) alike (DACHS 2008 Foolish Old Man, Wooden Toys).

Must these uses of Mao's story be considered blasphemic? The exploitation of Mao, his image and his words, in advertising was officially banned with the promulgation of the October 1994 advertising law, which went into effect in February 1995 (Barmé 1996, 65n158). Yet, his story (and his image, as the next chapter will show) nevertheless continues to be used in many different genres and media. In some cases, Mao is not openly acknowledged as the source, but this does not mean that knowledge of the story's Maoist background has passed away quickly. The continued emptying and refilling of long-familiar quotations (and sounds and images) from the Maoist canon is indeed typical for the era of Deng Xiaoping and his successors, who were convinced that "the banner of Mao Zedong Thought can never be discarded" (Deng 1983, 262–63).

This is obvious in at least two prize-winning advertisements (they received the "*Guangzhou Daily* Excellent Advertising Awards"): one was a "public [or official] advertisement" (公益广告) from 1996—a contribution to these public advertisements is requested from all commercial advertising firms—while another was a commercial advertisement from 2007. Both make use of the Foolish Old Man's story, which is presented, in both cases, as an "old legend." And in both

93. E.g., *Wenge xiaoliao ji* 1988, 14–15, 22–23; cf. Gao 1987, 317.
94. For an exhaustive analysis, see Wagner 1990, 430–80.

advertisements, the story is juxtaposed with other legendary stories or proverbial phrases but not openly associated with Mao, thus overtly acknowledging the guidelines of the advertising law while implicitly subverting them. The government-sanctioned public advertisement advises on how to live a good life: one needs to have dreams and strive to make them come true.

> Human life. It becomes great with dreams. One only has to be willing to strive, to make an effort and then one's lifetime will become meaningful. (人生. 因梦想而伟大. 只要有追求, 只要去努力, 生命才会有意义.) (Dachs 2008 Foolish Old Man, Advertisement 1996)

To illustrate this fact, the advertisement uses the story of the Foolish Old Man and two other stories taken from the *Classic of Mountains and Seas* (山海经 *Shanhaijing*), each illustrating endless stamina and willpower: that of Kuafu chasing the sun so that it would never set (夸父追日), and that of little bird Jingwei who tried, angrily, to fill up the sea with stones because its cruel waves had drowned the goddess Nüwa (精卫填海) (Dachs 2008 Foolish Old Man, Advertisement 1996). It may not be just by coincidence that these same associations with the Old Man's story are also mentioned in an earlier edition of the *Three Character Classic* (HZPYDZZZJSZJ 1959, 3). In quoting Mao in music, text, and image, many of the practices from the late 1950s and early 1960s were recovered in the 1980s and 1990s.

The second, a commercial advertisement for a real estate company, promises to build the perfect house. The company likens its methods to those of the Foolish Old Man, but not only that: they also promise to use the same skills as "Cook Ding," citing Zhuangzi's perfect cook who could cut oxen for years without his knife becoming blunt because he followed the natural lines of their sinews and muscles. The company further promises to work like "Sweaty Oxen," too, citing the story about Lu Zhi (陆质) (754–805), a famous Tang scholar whose enormous library would "fill a room to its brims" and, if carried around, "would make an oxen sweat" (汗牛充栋). Finally, they also promise to be thrifty and efficient "hole-drillers and light-stealers," alluding to Kuang Heng (匡衡) (fl. 36 BCE), the poor Western Han peasant boy who features as an exemplar in the *Three Character Classic* for his method of drilling a hole into his neighbors' wall to use their light to study at night (凿壁借光) (Dachs 2008 Foolish Old Man, Advertisement 2007).[95]

The story of the Foolish Old Man serves its purpose in each of these visions of building personal happiness in the name of Mao's collective hero. This usage is quite similar to that in Gao Xiaosheng's story: Li Shunda (who, as his name suggests, "follows the Great"—although it remains ambiguous whether this must be read ironically) tries against all odds to build a house for himself and his family. People are rather skeptical about his endeavor, but he dismisses their doubts: it cannot be more difficult to build a small house with three rooms than to move two large mountains, he thinks. Repeatedly, however, poor Li's ideas are thwarted. Every time he manages to assemble all the materials to build his house or to find all the money he needs to buy them, something reverses his luck and stops him short. In 1958, it is the Great Leap Forward and collectivization that make him lose everything. In 1966, at the beginning of the Cultural Revolution, his attempts to accumulate materials for his house are considered "capitalist," and he is advised to leave his wealth to the collective. Only after the Cultural Revolution is he finally able to build his house. His experience is in many ways similar to that of the Foolish Old Man whom many ridicule: in Gao Xiaosheng's short story, not unlike in the Maoist (and even more so in the *Liezi*) original, Shunda meets a number of "Wise Old Men" making fun of him (in this case his neighbors and his

95. The words in the section on the new Foolish Old Man read: 建房子只需几年, 拥有房子的人却要住一辈子, 所以对每个细节都要用心打磨. 有突兀的山峰, 磨平, 保持与建筑的风格统一, 有高出的峰角, 削平, 为了不挡风景. 在建发, 我们称之为愚公移山. 胜地阿哥, 厦门西岸, 一生之城.

father-in-law, for example, who has long since built a house that is, incidentally, later torn down while Li's stays).

In the first three decades of socialism, the meaning of the term "socialism" was tantamount to "wealth for everyone." For this purpose, China developed state industries and collective agriculture. Within this framework, the story of the Foolish Old Man had its special place and importance. For Li Shunda, on the other hand, "socialism" is the equivalent of "first floor plus second floor, electric light, and telephone" (楼上楼下，电灯电话), a popular slogan from the 1950s (and similar to 1980s ideas of improvement in housing conditions, inclusive of televisions and washing machines). In Li Shunda's mind, then, the functions of socialism are "pointedly reduced to providing better personal living conditions for the rural populace, the private house being the symbol" (Wagner 1990, 475). Li Shunda, by nature of his role as the new Foolish Old Man, fashions himself after this symbolic figure who might be taken to stand for "the best in the Chinese people." He adheres to his plan of building that house with an admirable stubbornness, which renders him akin to the Foolish Old Man. Gao Xiaosheng thus takes on the foundational myth of the PRC and rewrites it, subverting its "original meaning" quite radically (Wagner 1990, 474). No longer is collective determination in the foreground. It is substituted with individual fulfillment.

By thus undermining the Maoist message, Gao Xiaosheng's re-interpretation of the story becomes a perfect vehicle for a politics that was dominant at the time of the story's publication: the politics of reform and opening (改革开放 gaige kaifang). No matter how much irony accompanies the sudden equation between Communist and capitalist ideals, one could argue that the story of the Foolish Old Man is, here again, adapted to prevalent conditions and circumstances and is attributed with a compatible "orthodox" meaning, a technique already typical of the use of quotations in the ancient Chinese Classics. They, too, had studied, re-interpreted, and, most importantly, quoted from the ancient sages in order to solve the problems of the present (Mittler 2004, 118–72).

Surveys of the use of citation in Chinese history show that almost every time the past is employed, a "chemical reaction" between the old phrase and its new context takes place. Granted that in using the Classics, an author acquired the authority of the past and its Truth (*ipse dixit, ergo verum*),[96] this does not necessarily imply that what had once been said with authority in a particular context would mean the same thing forever. By way of citation, a new text would acquire some of the aura, the power, and the Truth of the old text, yet not its "particular" meaning. Even the case of Confucius shows that editing and passing on the Classics was not a passive act of transmission. In order to make the Classics palatable for his respective contemporary audience (and himself), Confucius, too, would pick and choose from them and (thus) change them. In citing the Classics he would be reinterpreting and transforming them, still holding onto the power of the original, yet changing its meaning according to his needs (cf. *Le Travail de la citation* 1995; Wagner 1995).

Gao Xiaosheng's reinterpretation of the Foolish Old Man's story, and even the commercial advertisement versions of the story, then, are not much different from what Mao had himself sanctioned for decades as proper usage: his original speech of June 1945 in which he first mentioned the Foolish Old Man, had dealt with imperialism and feudalism as the two large mountains blocking his house. This "original meaning" had long since been forgotten in Cultural Revolution interpretations and rereadings of the quotation, and it was even more neglected in the years following the Cultural Revolution. Still, when a national prize is awarded to a story that empties the original narrative of its heroic-collective dimensions and revives the hero in a new

96. Cf. van den Berg 2000, 24.

atmosphere of individualism and private economy, we must ask: how serious can this use of Mao's words be?

Very serious, indeed. For even after the Cultural Revolution, at a time when almost everything to do with the Cultural Revolution was considered bad, the Foolish Old Man continued to serve his purpose, spreading optimism and a belief in progress and the future. He is mentioned several times in the important "Resolution on Certain Questions in the History of Our Party" accepted at the Sixth Plenum of the Eleventh Central Committee on June 27, 1981. In this document, the Cultural Revolution is called the country's worst setback since the founding of the PRC in 1949. Nevertheless, the story of the Foolish Old Man, so prominent then, is mentioned among the 43 works canonized in the new "Resolution" (Resolution 1981, 32). More importantly, however, it reappears as concluding wisdom in the final section of the text. The last two sentences read:

> This plenary session calls on the Party, the army, and all nationalities of our country to unite around the banner of Marxism-Leninism and Mao's Thought and the Central Party Committee and to continue, with the spirit of the Foolish Old Man who moved mountains, to move determined and united, not fearing any difficulties to build our country into a modern and strong socialist country with a high degree of democracy and civilization. We want to reach our aim and we will definitely reach our aim. (Resolution 1981, 40)

> 一九四五年党的六届七中全会所一致通过的《关于若干历史问题的决议》，曾经统一了全党的认识，加强了全党的团结，促进了人民革命事业的迅猛前进和伟大胜利. 十一届六中全会相信，这次全会一致通过的《关于建国以来党的若干历史问题的决议》，必将起到同样的历史作用. 全会号召，在马克思列宁主义、毛泽东思想的伟大旗帜下，全党、全军、全国各族人民紧密团结在党中央周围，继续发扬愚公移山的精神，同心同德，排除万难，为把我们的国家逐步建设成为现代化的、高度民主的、高度文明的社会主义强国而努力奋斗！我们的目的一定要达到！我们的目的一定能达到！

As during the Cultural Revolution, the allegory is translated here into concrete and tangible truth. With hope and confidence, the Resolution introduces the new age of Deng Xiaoping by alluding to the old (*Liezi*) story once used by Mao Zedong. If this rhetoric convinced the audience (as did Li Shunda's story), it did so by ironically converting, yet again, the message it had promulgated throughout the Cultural Revolution.

That the state would take advantage of this story, however "capitalist" and "individualist" it now was, is not in itself too surprising. More surprising, however, is that one of the student leaders on Tian'anmen Square in 1989, Li Lu 李录 (1966–), would also recall the story and use it as a symbol of hope and strength of willpower among the Chinese. The 1994 film *Moving the Mountain* (移山), based on Li Lu's memoir of the same title, ends with Li reflecting upon this (Li 1990):

> When I think of my life so far through the confusion of images, the image that keeps coming to me is that of an old old Chinese legend that I first heard when I was ten and when the darkness of the Cultural Revolution was just beginning to lift. It was the story of the crazy old man who moved the mountain.
> [He tells the story and then continues.] Tian'anmen Square is just another attempt to move the mountain. Maybe we failed but we have not given up, and the mountain will be moved. (Li 1994, 78min)

The story of the Foolish Old Man in the film *Moving the Mountain* comes to stand for the hopes of the Chinese people "when the darkness of the Cultural Revolution was just beginning to lift." In the film, Mao is not mentioned as the source of the story. This may well be the case because of the primarily Western audience for whom the film was produced. In the book, on the other

hand, Li Lu remembers first hearing the story during the Cultural Revolution, when a teacher had told it to him and attributed it to Mao (Li 1990, 40–41). In spite of his knowledge of the source of the story and all that it symbolizes, Li still chose it to be included in his memoirs. Some part of him clearly believes in its Truth. Even in the film version, which denies the story its Maoist heritage, the end of the Cultural Revolution does not put an end to the pathos of Maoist gesture: Li Lu, the heroic leader of the student movement, styles himself into a foolish (young) man. In his memoirs, Li Lu's life story is narrated like the making of a (Maoist) hero: the young man rises, is carried by the power of collective energy, and reaches a triumphant end (Lee 1996, 132)—all by believing in the words of Mao (something that remains, naturally, only implicit in the film).

The case of Li Lu illustrates that the use of propaganda language was not a one-way street that ran from top to bottom only. MaoSpeak was not the prerogative of the Party. It also shows that the unpopular comparisons between the demonstrators on Tian'anmen and the Red Guards during the Cultural Revolution two decades earlier (see Calhoun and Wasserstrom 1999) are not so easily dismissed. Mao played an important role in 1989: processions with Mao posters during the hunger strike in May of 1989, the angry reaction when the Mao portrait on Tian'anmen was sullied (Heaven was angry, a storm broke out), the demonstrators' use of the "Internationale," and finally, Li Lu's return to the story of the Foolish Old Man are all examples of this.[97]

Li Lu's reinterpretation of the story keeps one important element of Mao's original speech alive: it uses the story as allegory. It does not give a concrete reading of the story through the life of some exemplary citizen, as do many of the narratives from the Cultural Revolution and early Deng era. Had Li Lu written his story during the Cultural Revolution, the famous tankman shown in the title image of his memoir (ill. 4.13)—or at least, the tankman's thoughts—would not have remained obscured. We would have known what was running through his mind while he stood up against these tanks: "Be resolute, fear no sacrifice, and surmount every difficulty to win victory." And it would have been to the sound of these words that numerous students and workers would have faced the machine guns of the PLA, too, although they would not have stayed invulnerable after all. Yet, Li Lu does not choose this type of narrative; he nowhere explains the story and its importance in a concrete manner, and thus by staying in the abstract, he returns to and retrieves something of its original (Yan'an) aura.

Even though Mao's master narrative is not mentioned as a source in the film, Li Lu captures the spirit of the story. He is full of hope, just like the Foolish Old Man (and just like Mao), that the impossible can become possible (even if, unlike Li Lu, Mao never dreamed of the same type of democratization of China's economic and political system), that utopia is within reach. Not just in dance and song, the old propaganda line that "Mao will live in our hearts forever" (毛主席永远活在我们心中) apparently still rang true in the 1990s.

This was so in spite of the fact that MaoSpeak had officially become less and less visible: a directive issued on March 23, 1978, restricted the use of bold print for quotations from Mao, as well as those from Engels, Lenin, Stalin, and Marx. Another directive of February 12, 1979, recalled the *Little Red Book*. A third, issued on September 6, 1979, even demanded the removal of all Mao slogans except those in line with the directives of the Eleventh Party Congress—which is why the Foolish Old Man survived![98] Due in part to the destruction of some Maoist writings in the early 1980s and restrictions surrounding their re-publication, there was a relative dearth of Mao's works on the market after 1982 (Barmé 1996, 10). The book with Mao's writings also disappeared as a visible symbol of his power and influence throughout the 1980s and 1990s. Examples of his

97. See Barmé 1996, 16–17; cf. also Pecore et al. 1999, 33–34, and Wasserstrom 1991, 320–22.
98. Barmé 1996, 128, 130, 131.

Ill. 4.14a. New Year Print *The Works of Marx and Engels Are Now Radiating Again*, 1988 (Collection Pierre Lavigne, maopost.com 0794-001M).

Ill. 4.14 b. Propaganda Poster *Study Well, and Be Loyal Forever to the Party and the People*, 1990 (Collection Pierre Lavigne, maopost.com 0060-001M).

Cultural Revolution—is visible in a few recently released New Year Prints discussed in the next chapter: they show Mao but not Mao alone as a God of Wealth and Longevity: while he is still *primus inter pares*, above or in front of everybody else, his successors Deng Xiaoping and Jiang Zemin now join in the spectacle (see **ill. 5.77**). By the 2000s Mao stands next to other holy figures, his

books being held up, radiating like a sun as seen in **ills. 4.2** and **4.3**, in propaganda posters and other visual materials from this period, become much more rare.

The one significant difference from Cultural Revolution practice, which in itself continued what had been prevalent in the 1950s and early 1960s,[99] is that Mao and his works are no longer exclusive heroes. As had been the case in the 1950s and early 1960s, the 1980s and 1990s saw the return of other heroes alongside Mao: Marx and Lenin's books, for example, or even a new marriage law (and the works of Confucius, as seen above), were promoted alongside Mao's works, some of them in red covers, others emanating sun rays (**ill. 4.14 a–c**).

Mao's loss of exclusivity—a status he actually attained only for a very short time during the

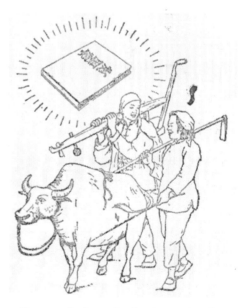

Ill. 4.14c. Radiating books: the marriage law (*Tongsubao* 通俗报, no. 45, April 15, 1953).

99. For Cultural Revolution practice, see *CL* 1967.11:59 and *CL* 1969.5:72.

image, as his words, no longer quite as exclusively powerful as before. Their authority, however, continued to hold fast and true.

In spite of the fact—openly discussed since the early 1990s—that works attributed to Mao were not all written by Mao himself, his words continue to "live on in the hearts and minds" of his people. It turns out that the *Three Articles*, the story of the Foolish Old Man included, had certainly *not* been written by Mao; at most, he may have corrected them. Instead, they were written by his political secretary at the time, Hu Qiaomu 胡乔木 (1912–92) (Barmé 1996, 28). Notwithstanding, the text remains a "Mao." The author's death in its literal and its figurative sense does not remove his aura from the text. An exegetic community (or, a "special discourse community") for Mao Zedong Thought continues to exist post-mortem, and its members are not limited to those who lived through the Cultural Revolution and knew "their Mao." Accordingly, the quiz show *The Sun and Truth*, which aired in the early 1990s on Beijing Television, debated not questions of authorship but dates and correct citations from "Mao."[100] In its very artificiality the setup in this show was somehow reminiscent of so-called quotation wars (语录战 *yuluzhan*) "fought" during the Cultural Revolution: every paragraph or statement a speaker made had to culminate in a quotation from Mao, and the number of quotations used decided how "learned" (and victorious) one was in the end (Dittmer and Chen 1981, 45).

There are moments of negation or annihilation, to be sure, as in the advertisements quoted above or in Li Lu's film, for example, where Mao is not mentioned as the (secondary) source of the "old Chinese legend." This annihilation may be systematic, to an extent: the renowned *Hanyu da cidian* (汉语大辞典), an exhaustive twelve-volume Chinese dictionary first published in 1990, mentions the story of the Foolish Old Man as a quotation from the *Liezi*, then gives further sources from the Tang, Song, Ming, and Qing dynasties. No connection is made to Mao's *Three Articles* version of the story, however.[101] In schools, the story of the Foolish Old Man taught in classes introducing Classical Chinese is based on the original *Liezi* version. Other, more recent, versions of the story point in a similar direction: a children's cartoon, probably from the mid-90s, replicates the *Liezi* story (inclusive of the inquisitive wife Mao had left out to make his hero more prominent) (DACHS 2008 Foolish Old Man Children's Cartoon), as does a more recent, educational children's comic (ill. 4.15; see also DACHS 2008 Foolish Old Man, Children's Comic). A trendy music bar in Beijing that opened in 2004 takes its name and logo from the story, showing a man chipping away at the characters for the Foolish Old Man Who Moved Mountains (愚公移山) in huge stone characters (ill. 4.16), but nowhere in the bar's self-description does either Mao or the *Liezi* feature prominently. All the bar says (incorrectly in the English version) about its own name is that "Yugong Yishan is a Chinese proverb about a foolish man who wants to remove a mountain" (DACHS 2008 Foolish Old Man, Music Club Beijing, section "About Us").

Not only is there ignorance, then, in the use of MaoSpeak, but there is open subversion, too: A 2008 online caricature by painter Chang Jin 常进 (1951–) named *The New "Foolish Old Man Who Moved Mountains"* (新"愚公移山"), whether consciously or not, completely reverts the Maoist logic: here, moving the mountains, the admirable feat managed by invincible determination and

100. Orville Schell has reported on this show, which was "taped before a live audience and presided over by a TV personality named Chao Shan (attired not in a Mao jacket and pug-nosed cap but in a Western-style suit, tie, and trendy dark glasses); the program pitted three-member teams from different state enterprises against each other in a competition to recite well-known Mao quotations on command and to identify the dates, places, and contexts of other Mao quotations." (Schell 1992 in DACHS 2008 Mao Citations, Sun and Truth; see also Schell 1994, 284, and Barmé 1996, 43). Unfortunately, I have not been able to identify the Chinese name of the show as yet.

101. Less surprisingly, the Taiwan *Zhongwen da zidian* (中文大字典) also does not mention Mao but only gives the original *Liezi* quote.

with the help of many sons and grandsons, is no longer a godsend but a negative prospect: the two mountains are named "natural resources" (the binome 资源 *ziyuan* is split for this purpose: one mountain is 资, the other 源). The subtitle of the caricature gives voice to the words of the happily naive Foolish Old Man in the picture, who says, "With thousands upon thousands of my descendants, these natural resources will very quickly be moved [i.e., used up]" (我的子孙千千万......"两座大山"很快完！) (ill.

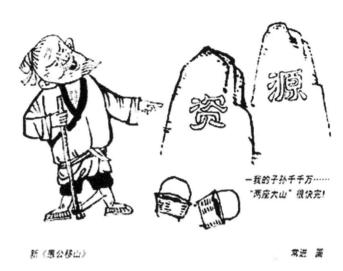

Ill. 4.17. *The New Foolish Old Man,* 2008 (DACHS 2008 Foolish Old Man Caricature).

4.17). The complete reversal of the optimism exuding from the story into pessimism or even fatalism is both comic and subversive. It also shows how important the story remains in cultural memory into the twenty-first century.

This is echoed in one of the previews introducing an officially produced,[102] generously funded, and nationally distributed[103] TV series originating with the Guangxi Arts and Movie Productions (*Sanwen yingshitai* 三文影视台) in Spring 2007 and first distributed by China Central Television (中国中央电视台, *Zhongguo zhongyang dianshitai* CCTV) in July 2008. The series, which was directed by Taiwanese director Wu Jiadai 吴家骀, begins with the following advertising lines in English and Chinese:

"The Foolish Old Man Who Moved Mountains" from *Liezi*'s Yangwen is known even to women and children.	列子之汤问 "愚公移山" 妇孺皆知
Mao's text "The Foolish Old Man Who Moved Mountains" is well known to every family, everywhere, in the cities and the countryside.	毛泽东著作 "愚公移山" 家喻户晓
An allegorical story with a tradition of thousands of years,	一个流传千年的寓言故事
A completely newly created grand mythical drama.	一部全新打造的神话大戏

102. DACHS 2008 Foolish Old Man, TV Drama Prepublication Announcement mentions a whole list of names of different institutions in Jiangxi, Henan, Shanghai, Beijing, Jinan, etc., involved in the film's conception and production: 该剧是由江西出版集团, 河南影视集团, 上海中进投资管理有限公司, 北京中视精彩影视文化中心和中共济源市委, 济源市人民政府等单位共同联合拍摄制作, 由著名作家曾有情, 熊诚执笔编剧.

103. DACHS 2008 Foolish Old Man, TV Drama Blog 1 mentions distributing stations in Beijing, Jiangxi, and Henan, among others (中央电视台, 中国国际电视总公司, 江西出版集团, 河南影视集团, 北京中视精彩影视文化中心).

A 30-part TV drama[104] following the story of the "Foolish Old Man Who Moved Mountains" will start being filmed in the Foolish Old Man's homeplace under the Wangwu Mountain in Jiyuan, Henan, on May 10, 2007.

一部根据寓言故事"愚公移山"改编的30集神话电视剧"愚公移山"将于2007年5月10日在愚公的故乡，河南省济源市王屋山下开机拍摄。[105]

This prepublication announcement thus emphasizes the two sources for the story but also highlights that it was Mao who made it become a household name.[106] The central publication poster further stresses the story's Maoist heritage by using Mao's calligraphy for the title and by placing his name next to it (ill. 4.18). In the conception and the production of the drama, too, clear moments of "Revolutionary Realism and Revolutionary Romanticism" (i.e., Maoist artistic pathos and style) shine through, although, naturally, in the review pieces, it is not necessarily designated as such. One critic even talks of the "performance techniques from realism and romanticism" (该剧采用现实主义和浪漫主义相结合的表现手法)—twice denying their "revolutionary" nature—a reversal reminiscent of the earlier refusal to use the term "socialist realism" for the socialist realist art produced in the PRC in spite of its stylistic characteristics that would classify it as such (DACHS 2008 Foolish Old Man, TV Drama Blog 1).

One such revolutionary romantic, Mao-style image is captured in a film still that was turned into an advertising poster: it shows the Foolish Old Man on the left, in profile, overlooking a plateau with clouds and mountains beyond (ill. 4.19). The image takes up on a prototype in depictions of Mao, the most prevalent of which is Liu Chunhua's 1967 oil painting *Chairman Mao Goes to Anyuan*, which became a "model painting" during the Cultural Revolution (see ill. 5.1).[107] Here, as there, the majestic depiction of clouds and nature must be understood as a direct reference to the hero's sublime disposition.

Some of the arguments in the critical reviews of the projected TV series sound distinctly Maoist: one comments that the Foolish Old Man's story has long since been used as an allegory for strength of will and fearless acceptance of difficulties, reflecting "the great strength and determination of the labouring people of old in their (re)creation of nature."[108] The first episode of the series begins with a long introduction emphasizing the Maoist heritage. This is underscored musically with a variation of the *haozi* worksong from the *Yellow River Cantata* by Xian Xinghai (discussed in Chapter 1). In spite of these Maoist aesthetics, the connection with Mao is not always highlighted. While one typical critique of the TV series briefly mentions Mao's 1945 speech as one of the sources for the story,[109] another such piece traces the story to the *Liezi* and leaves out Mao completely: "愚公移山的故事"改编自"列子·汤问"中的一则寓言。[110] Indeed, this piece

104. It turns out that the final product has 40 parts. See DACHS 2008 Foolish Old Man TV Drama, Episode 40.

105. DACHS 2008 Foolish Old Man, TV Drama, Prepublication Announcement.

106. Similar arguments are made in another prepublication critique that mentions both the *Liezi* and the *Three Articles* versions of the story. See DACHS 2009 Foolish Old Man TV Drama, Prepublication Material May 2007.

107. See also the lengthy discussion in Chapter 5; cf. ills. 5.18, 5.30, 5.34, 5.37, 5.73.

108. The text in Chinese reads as follows: "愚公移山"是我国古代寓言中的名篇，成功塑造了胸怀大志，坚韧不拔，不怕困难，战天斗地的愚公形象，反映了我国古代劳动人民改造自然，征服自然的伟大气魄和坚强毅力 (DACHS 2008 Foolish Old Man, TV Drama Blog 1). A much more neutral formulation is to be found in another review, where heroism is mentioned, too, but given a different twist: in the Old Man's determination, and in the god's willingness to help, the writer sees a clear connection between men and nature 从而构筑了一个天人合一，人神合一，人与自然合一的美好愿景 (DACHS 2008 Foolish Old Man, TV Drama Blog 2).

109. DACHS 2008 Foolish Old Man, TV Drama Blog 1.

110. DACHS 2008 Foolish Old Man, TV Drama Blog 2. For other pieces that replicate the arguments made in the two pieces discussed here, see DACHS 2008 Foolish Old Man, TV Drama 2007-8 Critical Views.

considers the TV version of the Foolish Old Man's allegory as a distinctly new departure from its "heavily politicized uses of old."[111]

The series is considered a "main-melody mythical film" (主旋律电影 *zhuxuanlü dianying*), the name given to extremely generously funded films made within the state system in China since the mid-1980s, and especially after the Tian'anmen student demonstrations in 1989, for the purpose of propagating current official policies (Ward 2007).[112] Accordingly, it is argued that the Foolish Old Man is a Chinese hero and that, Olympic Games aside, China needed heroes badly in 2008. In a deliberate act of national consciousness, the series was even advocated to be used to cheer up the earthquake victims in Sichuan.[113] This point about the TV series' role in providing encouragement to those who watch it —often at obligatory showings—is stressed in practically all of its reviews. The series teaches, says one prepublication announcement, how to deal with difficulties: not by ducking down, trying to evade them, but by facing up to them. And with this kind of spirit and attitude no difficulty is too great to be overcome; hopes and dreams will come true.[114]

This message is repeated over and over again in different critical responses to the series' production. Significantly, however, the vocabulary used here to essentialize the spirit of the story is never Maoist: nowhere do the texts use that familiar phrase, "Be resolute, fear no sacrifice" They may use similar formulations, but they make sure to vary them. This shows very clearly that Mao's story has regained a flexibility of interpretation it did not have during the Cultural Revolution. In a *Jiyuan Daily* 济源日报 article based on an interview with script writer Xiong Cheng 熊诚 (1950–) Xiong argues that the age-old story of the Foolish Old Man has resonated with people throughout the ages because of its spirit (熊诚说, 愚公移山是一个流传数千年的故事, 从古至今人们津津乐道, 是崇尚它寓含的精神). Xiong is cited as saying:

> In order to surmount all dangerous obstructions, he opens a way and leads his family in moving the Taihang and Wangwu Mountains. This is a great and difficult achievement; to some it is difficult even to fathom. But the Foolish Old Man has great willpower in his bosom, he does not let difficulties beat him down, he dares to think, he dares to speak, he dares to do things, and in the end, with the help of others, he is able to move the mountains away. This makes clear that with all things that are good for the people, no matter how dangerous, one needs to be <u>absolutely resolute and confident in one's certain victory</u>; only then can one—diligently continuing on, step by step, without wavering— victoriously <u>fight all difficulties</u> and make ideals into realities.

111. "愚公移山" 的故事长期以来一直是中共官方所推崇的寓言故事, 具有很浓的政治色彩. 而该剧正是对这一主流意识形态的另类诠释. (DACHS 2008 Foolish Old Man, TV Drama Blog 2).

112. According to Ward 2007 (DACHS 2008 Julian Ward, Zhang Side), in 1987 "a call was issued, during the anti-bourgeois-liberalism campaign, to 'emphasize the keynote [i.e., main melody] and persist with cultural diversity.'" He continues to explain: "Following the upheavals of 1989, considerable sums of state money were made available for the making of main melody films and, in 1994, Jiang Zemin, at that time the President of the PRC, called for them to be given greater priority. . . . Major events such as the fiftieth anniversary of the founding of the PRC in 1999, and the sixtieth anniversary of the end of Second World War in 2005, were marked by the orchestrated release of a slew of apposite films . . . A further batch of main melody films was released to coincide with the National People's Congress held in Beijing in October 2007. . . . As was the case in the 1950s and 60s, when state-produced films were required viewing, factories and work units again organized obligatory showings."

113. DACHS 2008 Foolish Old Man, TV Drama Blog 1: 该剧挖掘丰富了愚公形象, 颂扬了愚公精神, 具有深远的历史意义和重大的现实意义, 尤其是在全国人民万众一心, 众志成城地进行四川灾区重建家园的今天, 愚公移山的这种精神对鼓舞民心士气尤为重要.

114. DACHS 2008 Foolish Old Man, TV Drama Prepublication Announcement: 拍摄制作30集神话电视剧 "愚公移山," 就是要通过电视这个强势媒体, 弘扬愚公精神, 使我们的广大电视观众能够像愚公一样直面困难, 不躲不避, 不等不靠, 求真务实, 埋头苦干, 坚持不懈. 有了这样一股劲头, 就没有克服不了的困难, 没有干不成的事业, 没有实现不了的理想和愿望.

愚公为了排除险阻, 打开通道, 率领全家搬走太行, 王屋两座大山. 这是一件大而又艰巨的工程, 在有的人看来是难以想象的. 但是, 愚公胸怀大志, 不被困难所吓倒, 他敢想敢说敢做, 终于在别人帮助下把两座大山搬走了. 这就说明: 凡是对人民有利的事, 无论怎样艰险, 只要具有坚韧不拔的决心, 充满必胜的信心, 踏踏实实, 坚持不懈地努力做下去, 就能够战胜一切困难, 把理想变为现实.[115]

Many of the audience responses stress the feeling that this particular spirit of hope and perseverance, the "Foolish Old Man's spirit" is meaningful to them "at all times" (愚公精神不过时, incidentally the title of the *Jiyuan Daily* news article): in the cynical, all-too-scientific present, as well as in the cruel past and in the unfathomable future.[116] According to the journalist who wrote this review, the Foolish Old Man's spirit of perseverance is quintessentially Chinese. And according to him, this explains the continuing popularity of the story:[117]

The "Foolish Old Man Who Moved Mountains" is an allegorical story; it also is a mythical story, a genre of oral literature collectively created by the Chinese people. In everyone's mind the story carries a different meaning.

"愚公移山" 是一则寓言故事, 也是一则神话故事, 它是中国人民集体口头创作的一种文学形式, 在每个人的认识中, 这个故事有着不同的寓意.

He then compares it to a Chinese fruit, the date, which takes on the taste of whatever it is mixed with, and concludes that while different people may associate different things with the story, everybody will surely like the TV series.[118]

The reception of this serialized TV drama, then, shows one important element in the use of MaoSpeak today: without necessarily acknowledging its Maoist heritage, without directly referring to the Cultural Revolution hotbed which made the quote grow to monstrous as well as miraculous proportions, it is used in the twenty-first century in ways and manners that are very much akin to those used during the Cultural Revolution. The rhymed children's comic version of the story, published by Sina on its baby pages in March 2008 (cf. ill. 4.15), includes a gloss for parents replicating the Maoist demand for "living study and application" which grew to such enormous proportions during the Cultural Revolution. It reads:

After parents tell this proverbial story of the "Foolish Old Man Who Moved Mountains" to their children, they should connect it to things that have happened in their children's lives. They should lead the children in learning from the Foolish Old Man: in whatever they do, they should not be afraid of difficulties. When they encounter difficulties, they should at first think hard about possible solutions, and when they have come up with a solution they should immediately put it into practice; in whatever one does, one should be perseverant and unswerving: this is how, in the end, one will be successful.

家长给孩子讲完 "愚公移山" 这个成语故事后. 可以联系孩子生活中发生过的事情. 引导孩子向愚公学习; 做事情不要怕困难. 遇到困难首先要开动脑筋去想解决的办法, 想到办法后就马上动手去做: 在做事情时, 要有恒心有毅力, 坚持不懈地做下去, 这样才有可能最终取得成功.[119]

115. DACHS 2008 Foolish Old Man, TV Drama 2007–08 Critical Views.
116. Ibid.
117. Ibid.: 我们今天还喜欢与 "愚公移山" 有关的文艺作品, 就说明了 "愚公移山" 的精神, 不仅不会过时, 也不可能过时, 而且, 作为中国民族精神的典型代表的愚公移山精神, 今天乃至以后, 都是不可或缺的, 我们必须使之发扬光大, 世代相传.
118. Ibid.: 这就好比是一枚风干了的红枣, 你把它泡在红酒中, 它就是红枣的味道; 你把它泡在陈醋中, 它就是陈醋的味道; 你把它泡在烈酒中, 它就是烈酒的味道, 我们不可能把这个故事, 把愚公这个人演绎成和每个人想象的一样, 但我们绝对会把 "愚公移山" 拍摄成一部弘扬主旋律的精彩巨片和扣人心弦的神话大戏.
119. DACHS 2008 Foolish Old Man, Children's Comic.

The particular pathos in Chen Kaige's 2008 short public advertisement film clip, *A 2008 Version of Moving the Mountain* (2008分之-移山篇), its choice of colour, setting, imagery, and rhetorics, are all built upon the Cultural Revolution blueprint and employ important features of Revolutionary Romanticism and Revolutionary Realism. The ad, produced by the Shanghai Media Group (上海文广新闻传媒集团, SMG), is a deliberate answer to the Wenchuan earthquake (vid. 4.1). It aims to reflect the determination of the Chinese people by featuring China's basketball star Yao Ming 姚明 (1980–) and describing how he worked his way to fame. At first, Yao Ming is clearly marked as the main hero by lighting effects that highlight his presence in an otherwise extremely uninviting, dark and rocky mountain scene in extremely treacherous weather, with high winds, clouds passing by, and flashes of lightning striking. The background and his image are shown in constant shot-reverse-shot, a technique that draws the audience into the drama. The use of pathetic fallacy here says to viewers, "Our hero is in difficulty!" And yet, the first thing we see him fix his eyes on when he looks up at the stony rocks again is a red flag.

In the next cut, as the camera moves back from his face to the rocks once more, we see a basketball net suspended extremely high up on this rocky mountain. Yao Ming then begins to speak with a very low voice: "When I was small, I heard a story called *The Foolish Old Man Who Moved Mountains*" (小时候听过一个故事叫愚公移山). The clip makes constant cuts between his face in the darkness of the mountain scene and images of him playing basketball, jumping up to the net, which is shown in extreme closeup, never as a whole but always fragmented and in a blur. He then continues to speak, quoting a line by Su Xun 苏洵 (1009–66), who, in his *The Art of the Heart* (心术 *Xinshu*), says that one has to learn to "remain stoic even when Mount Tai collapses" (泰山崩于前而不变色).[120] While these words are spoken, the scene drastically changes. The basketball images show Yao Ming (in a *red* jersey) raising his fist (not unlike Cultural Revolution heroes in the model works) in victory. We hear applause and spectators screaming, cross-faded with the sonorous soothing sounds of a cello playing a soaring melody featuring two dramatic rising minor seconds and a victorious rising fourth. In the next cut, the red flag flutters gently in the wind on the now much more rugged-looking rocky mountain behind which the sun is rising. This image then fades again into one epitomizing a Cultural Revolution cliché: it shows Yao Ming in a bounteous wheat field heavy with fruit, walking towards the beautifully colored sky with a huge rising sun warming the entire scene.[121]

There are obvious differences—such as the fragmentations, the quick changes in cuts and perspectives—between this depiction of Yao Ming and earlier Cultural Revolution filmmaking and artistic rhetoric. But there are many continuities, too: the sense of crisis built up in the beginning and eventually victoriously overcome, the special lighting reserved only for our main hero (his face repeatedly appears lit up, making him come across as the only light part in this dark and dismal section of the film), the colors of his dress (red in victory), the red flag, and the rising sun.

Many of these elements epitomized in Cultural Revolution art and culture have also been used in the production of an enormously popular pop song invoking the Foolish Old Man (vid. 4.2 a&b).[122] The singer, Jiang Tao 江涛 (1969–), made his debut when, as an amateur, he won a nationwide singing competition in 1988. He became a professional singer with the Qingdao Song and Dance Troupe (青岛歌舞团) in 1990. In 1992 he took first place in another song competition,

120. Mount Tai is one of the Five Sacred Mountains of Daoism, associated with sunrise, birth, and renewal, and located north of the city of Tai'an, in Shandong province. Su Xun's *The Art of the Heart* is a work advising the cultivation of the mind. Su Xun is the father of famous Song poet Su Shi 蘇軾 (1037–1101).
121. DACHS 2008 Foolish Old Man, Advertisement 2008.
122. DACHS 2008 Foolish Old Man, Music.

this time organized by CCTV (全国第五届青年歌手大奖赛). His "Song of the Foolish Old Man," released in 1997, became his most popular hit so far. Its peculiar pathos can best be understood with the Cultural Revolution blueprint as a backdrop. The dominance of the color red; the forces of sun and fire that, time and again, serve to wash the entire stage in red; the demonstration of the collective as a visible force (in history); the impressive shots of nature—huge mountains, rocks and gorges,[123] immense sand steppes, majestic clouds; the juxtaposition of the collective working masses with technical achievements and feats such as airplanes, trains, huge bridges; the gestures Jiang Tao makes of holding his hands up into the sky, not at all unlike Yang Zirong in *Taking Tiger Mountain by Strategy* (see **ills. 1.5–1.7**); the sublime stone relief which appears, clearly reminiscent of the Cultural Revolution sculptures of the Foolish Old Man discussed in the beginning of this chapter; the (mostly red and sometimes yellow) Mao suit that Jiang Tao wears—all of these are elements typically found in Cultural Revolution artistic practice as well. There are differences, of course: some of the special effects, such as the superimposition of the old man as a ghost-like figure over parts of the setting, are obviously not the stuff that Cultural Revolution aesthetics were made of, but their similarities are much more striking than these negligible differences.

Jiang Tao's song talks of the younger generation's admiration (所以后来人为你感叹) for those members of the older generation who took up the difficult task of "opening up the roads" for them: "Not to have a road is hard, but to open one is even harder" (无路难呀, 开路更难). Curiously, Jiang Tao thus takes up one of the earliest twentieth-century texts to make use of the Foolish Old Man's story—that by Fu Sinian, who had argued that all cultural achievements and developments in the present are based on people moving mountains in the past (see my discussion above). The achievements of earlier generations, then, so argue both Fu and Jiang in their otherwise very different texts, make it possible for succeeding generations to enjoy easier and more carefree lives (引起了生活在今天幸福时代许多年轻人的共鸣).[124] To underscore this harmonious relationship, one of the concert recordings of Jiang Tao's song shows how enormously popular the song is among people from very different generations. In the performance venue, everybody, old and young, seems to know the song so well that they can sing along; the song clearly bridges the widening generation gaps in Chinese society (vid. 4.2c).

The song's links to past generations are not just restricted to this phrase, however. The beginning lines, "Hearing it, it sounds just freakish; talking about it, it seems more like a hoax" (听起来是奇闻, 讲起来是笑话), take up the element of doubt, skepticism, and wonder that must have accompanied every telling of the story in all of its variations. Particularly, however, this line may also be seen to engage in a dialogue with the hyperbolic use of the story and the miracles associated with it during the Cultural Revolution, a childhood memory for Jiang Tao. Yet, by juxtaposing images of barren steppes with blooming fields, and of technological achievements represented by airplanes, skyscrapers, suspension bridges, and railroads, with a shadow image of the haggard Foolish Old Man—it shows that what may sound freakish indeed does and will come to fruition in the long run: Mao's words of optimism and utopia are thus proven to be true (vid. 4.2b).

Clearly, Mao's story and its Cultural Revolution uses form an important backdrop for its contemporary effects and understandings. The continued employment of the story suggests that Mao is still an important figure in the Chinese pantheon. Partly due to the massacre on Tian'anmen in 1989 and in unison with the official celebrations of what would have been Mao's 100th birthday in 1993, Mao is reborn in new glory, and the time of his "dictatorship" now appears to some as a

123. A slightly different version of the video ends with an image of the sun rising over forests and waters; see vid. 4.2.b. Also cf. DACHS 2008 Foolish Old Man, Music, Nature Foregrounded.
124. DACHS 2008 Foolish Old Man, TV Drama 2007/08 Critical Views.

"golden age" compared to the present. The revival of the "old" story is still in full flow, both officially and unofficially. Even remakes of the well-known quotation song appear constantly on *Red Sun* tapes and CDs published since the 1990s (mus. 4.1).[125] There are websites dedicated to storing the MP3s of quotation songs for convenient choice and use. One of them contains several different versions of the song "Be Resolute," for example, under the title "Win Victory" (争取 胜利 zhengqu shengli). The second of these begins with the melody of "Red Is the East," which is then mixed with a rap version of "Be Resolute" (mus. 4.2).[126]

Officially, a memorial concert with the grandiose title *The Sun Is the Reddest, Mao Is the Most Beloved: A Large-Scale Epic Concert* (太阳最红, 毛主席最亲——大型史诗音乐会) organized on the 30th anniversary of Mao's death in 1996 also includes a set of songs based on the *Three Articles*, the Foolish Old Man prominent among them, in its "most meaningful" fourth part of the concert entitled "Long Live the People."[127] Clearly, then, Mao and his words, and even the story of the Foolish Old Man in particular, continue to play a role in Chinese popular culture as well as in the high arts. Popular writer and media star Wang Shuo can ironically be said to model himself on Mao, publishing his works in four volumes like Mao first did and capitalizing (though perhaps involuntarily) on his work by having it move from one medium to the next—between film and novel, between song and picture. Says one cultural critic: "No one in China has packaged his own words and his media image as successfully as Wang, except perhaps for Mao Zedong" (Huot 2000, 50). It appears that Wang Shuo and his protagonists continuously mock Mao. Their matter-of-fact use of Maoist language is, in its spectacular performative gestures, irreverent and significant at the same time: it manifests the continuing power of Mao's rhetoric in contemporary language.

One of the protagonists in Wang Shuo's novella *Flotsam* (浮出海面 Fuchu haimian), which first appeared in the journal *Modernity* (当代 Dangdai) in 1985, is an anti-hero narrator who goes around comparing himself to the Foolish Old Man. In a scene of heavy flirtation with the woman he hopes to win over as his girlfriend, he boasts, "They all call me a present-day 'Foolish Old Man.' Every day and without break, I use my mouth to chop away at that mountain" (人家都说我是 当代'愚公', 用嘴砍大山, 每天不止).[128] What right does this character, who so obviously negates all of the clean and healthy stamina and willpower embodied in the allegorically Foolish Old Man, have to be compared with such a model? On the other hand, this type of derision does not preclude that the same Wang Shuo would compare the Cultural Revolution to "a rock'n'roll concert with Mao as top rocker and the rest of the Chinese as his fans."[129] The much-decried "hooliganism" of Wang's characters is quite clearly rooted in his Cultural Revolution experiences and the prevalence of MaoSpeak at the time, which becomes an object both of derision and inevitability in his works (cf. Yao 2004).

A decade after the publication of *Flotsam* came Yan Lianke's 阎连科 (1958–) novel *Serving the People* (为人民服务), titled after that other story from the *Three Articles*. It not only plays dangerously with MaoSpeak (and thus risks censorship) but thereby also engages and negotiates with it and its significance. The novel is a patchwork of Maoist quotations put to everyday use. The storyline is based on a somewhat trite and familiar plot. Set in 1967, at the height of the Mao Cult:

125. For three different versions, see DACHS 2008 Yuluge *Foolish Old Man*, pop version, and DACHS 2009 Mao Yuluge Archive "Xiading juexin" with "Dongfang Hong."

126. DACHS 2009 Mao Yuluge Archive, p. 3.

127. DACHS 2008 Yuluge Mao Memorial Concert, September 8, 2006: 最具创意的是第四部分 "人民万岁:" 由配乐朗 诵: "人民, 只有人民才是创造世界历史的动力," 歌曲 "毛主席和我们在一起," "我们共产党人," 配乐朗诵老三 篇 '愚公移山' (节选) '纪念白求恩' (节选), '为人民服务' (节选) 等震撼人心的经典论述组成."

128. Wang 1992, 232; cf. also Wang 1985.

129. This is quoted in Huot 2000, 59; for an image depicting Mao as rock singer, see ill. 5.26.

a young wife (28) of an old, impotent army division commander (52) seduces a peasant-soldier (33) who is assigned to do the domestic chores for her husband. Eventually, they discover that by smashing things that have pictures of or quotations by Mao Zedong (an act that, if it becomes publicly known, will lead to death by firing squad), or by writing the slogan "Serve the People," they both can come to an incredible orgasm. The novel is a bluntly drawn, mildly erotic fable that teases reverence for Mao Zedong by poking fun at the soldier, a true "believer" who obeys the Chairman's precepts and takes his call to "serve the people" all too literally. Whether or not the 2006 "main-melody" film featuring Zhang Side,[130] which offers a much more serious (if not necessarily more deeply felt) take on "true belief" in the words and deeds of Mao, is a direct response to Yan Lianke's heresy remains unclear. It is significant, however, that even such open irreverence can in itself be read as a negotiation or reflection of (a former) devotion.

Not just throughout the 1980s and 1990s but into the early 2000s, then, Mao's words continue to influence contemporary speech patterns. They are used in elevated and artistic language as well as in the language of the everyday: an English-language blog explaining China to the world called "Fool's Mountain: Blogging for China" features the motto, "A wise one knows moving mountains is beyond human power, but a fool has other thoughts."[131] A book on ten "social enterprises" (社会企业), published in 2008 in Hong Kong, is entitled *The New Foolish Old Men: The Story of Ten Social Enterprises* (新愚公移山——十个社会企业创业者的故事).[132] A young woman in her blog claims that she will "be resolute" (like the Foolish Old Man) in her wish to slim down (下定决心减肥);[133] another uses the same phrase from Mao's legendary story to mark her decision to leave her abusive husband after a heavy beating (三年前的一次毒打使我下定决心离开他) (*Nongjianü* 1999, 8). Describing a friend's determination to preserve Chinese traditional music, one musician again uses the significant phrase to relate it:

> He had gone to Yunnan and heard all these folk songs, and he really thought, this is interesting. He then was very resolute [下个决心 *xiage juexin*], and he thought that we really must find a way of preserving this music. So he would collect all this stuff and attempt to authentically preserve this music of the minorities, not reformed as in advertising, no, [but] the authentic [music]. He even got divorced from his wife to go to Yunnan and do this. (Musicologist, 1922–)

MaoSpeak can be heard in both artistic and everyday language, then. In addition, it is part of intellectual discussions, too. During a symposium attended by young intellectuals in the early 1990s, one Beijing University student responded to all the questions about the recent Mao craze by quoting Mao's poems (Barmé 1996, 152). MaoSpeak continues to recur in political texts as well. Even a radically new political line such as the "Three Represents" (三个代表 *sange daibiao*)— first introduced by Jiang Zemin in 2001 to open Communist Party membership to up-and-coming entrepreneurs (or what would have been termed under Mao "capitalists")—came along in a language that could have been written in the early 1970s.[134] As if in response, a 2004 advertisement for a re-issue of the *Three Articles* argues that, indeed, these pieces should be used to study the "Three Represents," as they are the basis and logic behind them:

130. Ward 2007 discusses the film. In the film, Mao appears as the good spirit who helps and sustains Zhang's (and everybody else's) faith.
131. DACHS 2009 Fool's Mountain.
132. DACHS 2008 Foolish Old Man Book.
133. DACHS 2008 Xiading Juexin Slimline.
134. See DACHS 2009 Sange Daibiao.

On the 60th anniversary of the publication of Mao's "Serve the People" and the Party's 83rd birthday, and in response to broad demands by readers, we are republishing the three pieces "Serve the People," "In Memory of Norman Bethune," and "The Foolish Old Man Who Moved Mountains" so that readers are even better able to understand and study the important thoughts behind the "Three Represents."

在毛泽东 "为人民服务" 发表60周年和党的诞辰83周年之际, 应广大读者要求, 我们 重新出版 "为人民服务," "纪念白求恩," "愚公移山" 三篇文章, 以醒合广大读者更好地学习 "三个代表" 重要思想.[135]

Official support continues unabated: the first message sent in a recently inaugurated competition for "Red Short Text Messages," which ran between May and December 2009 and which was initiated in order to eradicate "unhealthy" text messaging—to substitute it with "healthy" and "uplifting" text messaging—was, as published on *People's Net* (人民网, www.people.com.cn), a best-in-class selection of Mao quotation songs.[136]

Perhaps the most powerful indication of the enduring popular importance of Mao's words is their continued use in commercial advertising, in spite of a law that actually prohibits such behavior. Products as different as a Lei Feng model running shoe by Chinese would-be Nike rival Li Ning and Chinese Linux 2000 software both use Mao's words and Maoist aesthetics to sell their products (without interference by the government). Chinese Linux 2000 was introduced in February 2001 in the form of a peculiar nineteen-second-short mix of model opera, quotation song, and loyalty dance performed not with *Little Red Books* but with Linux 2000 packages and computers (vid. 4.3).[137] The advertisement is a typical example of how Mao's words and Maoist gestures become part of a performative spectacle that but serves to entertain: before the stereotypical, stylized background of mountains and trees from the model works, a small detachment of men and women in army attire march, waving a red flag. They begin with a rhythmic recitation of a slogan as it is recited at the beginning of loyalty dances or quotation songs: "There is nothing wrong with revolution, to rebel is justified" (革命无罪, 造反有理).[138] Then, they sing to a melody modeled after the idiosyncratic wavelike melodic and marching rhythms and styles of quotation songs.

Their revolution is quite unlike that of Mao Zedong, but the language, visual as well as textual, in which this revolution is captured is quintessentially MaoSpeak. The advancement and the happiness of the masses are of primary importance, and the youngsters who carry computer equipment on their shoulders promise in their song: "In terms of scientific development, we are diligently creating new things, and so our culture can be spread and the masses can be made happy" (科技发展, 努力创新; 文化传播, 造福大众). The sketch ends in a dramatic pose, with each of the performers holding up a Chinese Linux 2000 box in a victorious gesture reminiscent of the visual rhetoric of the Cultural Revolution.

Marketed as a "national product," the green Lei Feng shoe with its fur and red star ornamentation in the style of model soldier Lei Feng's "original" army attire carries the quotation "Serve the People" undercover, on the back flap of the shoe.[139] The shoe is sold together with a green army

135. DACHS 2008 Lao Sanpian and Sange Daibiao, 2004.
136. DACHS 2009 Mao Yulu, Red SMS Competition Chongqing.
137. DACHS 2008 Foolish Old Man Yangbanxi Linux Hong Kong advertising. Thanks to my student Nora Frisch, who drew my attention to this and the Li Ning advertisement.
138. Mao is said to have written this on his first big-character poster in response to the Red Guards in the summer of 1966. It recurs in a whole series of articles in *Renmin Ribao*; see *RMRB* 1966.
139. DACHS 2009 Lei Feng Li Ning Running Shoes.

bag authentically embroidered in red. Openly and for all to see, shoe and bag and the little red notebook accompanying it are adorned (in some versions in relief all over the shoe) with a slightly parodied version of this quote from the *Three Articles* that simply reverses the order of the characters: 服务为民 (*fuwu wei min*) instead of 为人民服务 (*wei renmin fuwu*), and, significantly, using the recently popular Republican term for the people 民 (*min*) rather than the more clearly ideological binome 人民 (*renmin*). The visual impression of both bag and shoe, especially when looked at from afar, is quite "authentic." Only upon looking closer does one realize that the quote has been tampered with (ill. 4.20).

The prominence in recent years of MaoSpeak (there are even cell phone ring tones with his quotations now),[140] Mao memorabilia, Mao songs, Mao talismans, and other Mao products is more than a marketing strategy, more than just a question of what is chic. While Mao's words may be used as spectacle, as entertainment and "innocent" fun without conscious reference to their meaning by some (as in the Linux 2000 advertisement, for example), there are other ways of referring to them as well: Li Lu's use of the Mao quotation is one sign that Mao's words continue to be a "jargon of authority" (Smith et al. 1975, 240). The TV drama "The Foolish Old Man Who Moved Mountains" and the public service advertisement on the theme, featuring Yao Ming, both of which are used officially to serve the "national" purpose of strengthening the stamina of those hard hit by the earthquake, are other such signs. And even though they do not always openly acknowledge the Maoist text, in their entire aesthetic style, these and Jiang Tao's performances suggest the same: Mao has remained a Classic, capable of lending authority to all sorts of new things. With Mao and stories like that of the Foolish Old Man, the past is drawn upon, time and again, in order to change the present into a future (Apter and Saich 1994, 70).

The same can be postulated for Mao today that would have been said of Confucius and his sages earlier: old wisdom actually proves and supports new ideas (托古证今 *tuo gu zheng jin*). The sent-down youth, Li Lu, the pop singer Jiang Tao, and even the somewhat desperate peasant-soldier in Yan Lianke's novel, not to mention all those pop, rock, and other stars serving official or unofficial purposes while reinterpreting songs praising or using Mao's words—all present their personal and particular "true and authentic" interpretation of Mao's text. So even if the use of MaoSpeak has become more self-assured and independent after Mao's death, even if it is at times irreverent and ironic, even if expressed unconsciously, MaoSpeak has not lost its authoritative aura in the hands of Mao's grandchildren. More than ever, what theologian Origines (185–254) once said about the power of the Bible applies to Mao's words today:

> Every word of the Holy Script can be compared with a semen, the nature of which is such that it multiplies and spreads once thrown to the ground and grown into a fruit. If in the beginning, it is meagre and small, if it meets a worthy and devoted gardener who treats it in a cultivated and spiritual manner, then it takes on the form of a tree and spreads with its branches and twigs.[141]

Even today, China still appears to have enough devoted gardeners, each working for their own particular and very different reasons to make the tree grow stronger.

140. See DACHS 2009 Mao Yulu Cellphone Ring.
141. The quote appears and is contextualized in Compagnon 1979, 201.

Coda: Rethinking the Power of Words

"Nowadays," complained Mr. K., "there are innumerable people who boast in public that they are able to write great books all by themselves, and this meets with general approval. When he was already in the prime of life the Chinese philosopher Chuang-tzu composed a book of one hundred thousand words, nine-tenths of which consisted of quotations. Such books can no longer be written here and now, because the wit is lacking. As a result, ideas are only produced in one's own workshop, and anyone who does not manage enough of them thinks himself lazy. (Bertolt Brecht)[142]

[Mao] was more like a Chinese sage, a wise man, so to speak. (Xu Bing, 1955–)[143]

A prominence of quotation is quite commonplace in traditional Chinese writings—it is not Brecht alone who finds that with a text like the Zhuangzi "nine-tenths . . . consisted of quotations" (Brecht 2001, 13). Indeed, entire philosophical works are a patchwork of citations from earlier authoritative sources (*Travail de la Citation* 1995). Confucius himself once said that he would (only) "transmit," that is "quote," and not "create" (述而不作). In Chinese texts, then, quotation is a genuine and important mode of expression. The modular technique that typifies Chinese music and art (Ledderose 2000) is prevalent in Chinese prose and poetry as well. Whereas in a European context, quotation would be a "mere ornament of style intended to prove an author's erudition, and, occasionally, to give additional weight to an argument by conjuring up the ghost of a well-known authority," in the Chinese text quotation does more: it always takes credit for revealing the meaning of the original (Bischoff 2005, 12). It is possible, then, to redefine the "original sense" of the quotation at hand and, at the same time, to legitimize oneself with the voice of the (ancient) sages. This usage of quotation continues to be relevant in the PRC: whoever cites Marx, Lenin, and Mao Zedong (and more recently also Confucius again) at the right moment can win a great deal, even today.

Paradoxically, quotational density, which characterizes Cultural Revolution texts, brings them rather close to the Classical canon. In his quantitative study of Cultural Revolution literature, Lan Yang makes the following observation:

It was expected that the intensification of the direction to serve workers, peasants, and soldiers would further promote the colloquial style of CR novels. But quite the contrary emerged. The language of CR novels has a lower rate of . . . specific colloquial items and folk proverbs, in comparison with pre-CR novels. Moreover, since traditional Chinese literature was under attack during the Cultural Revolution, it was expected that bookish stylistic items derived from traditional literature . . . would be less densely distributed in CR novels than in pre-CR novels. Yet according to this study, CR novels have a higher density of these bookish stylistic items than pre-CR novels. (1998, 218)

It may be quite well taken, then, to study the *Little Red Book* both in the tradition of proverbial sayings by revered masters such as Confucius or the Buddhist sages and in relation to its antecedents in the history of world Communism such as Marx and Lenin who, "in their pedagogic predilection" used "highpowered maxims," too (Huang 1968, iii). Huang argues in his study of the *Little Red Book* that "symbols, malignant or benign, may stand for situations and forces that

142. Brecht 2001, 13. The German original reads: "Heute," beklagte sich Herr K., "gibt es Unzählige, die sich öffentlich rühmen, ganz allein große Bücher verfassen zu können, und dies wird allgemein gebilligt. Der chinesische Philosoph Dschuang Dsi verfaßte noch im Mannesalter ein Buch von hunderttausend Wörtern, das zu neun Zehnteln aus Zitaten bestand. Solche Bücher können bei uns nicht mehr geschrieben werden, da der Geist fehlt. Infolgedessen werden Gedanken nur in eigener Werkstatt hergestellt, indem sich der faul vorkommt, der nicht genug davon fertigbringt." (Brecht 1965, 110)

143. Xu 2008, 111.

are new. But the patterns and motifs that constitute the symbol have to be rooted in long traditions and old archetypes" (Huang 1968, ii). The *Little Red Book* can count naturally on Chinese canonic traditions for its reception; the connection and transfer between the two traditions and its respective sages is, accordingly, seldom missed. One Japanese observer mentions as early as 1960:

> When still a schoolboy, I studied *The Analects* of Confucius in which occurs the saying: "The firm, the enduring, the simple and the modest come close to supreme virtue." If Confucius were alive today to see what Chairman Mao has done, he would surely use these words to praise him! (*CL* 1960.9:9)

Chapter 3 elaborated on the question of how and why Confucius and Confucianism was attacked at several points during the Cultural Revolution. Yet, when one reads through Cultural Revolution model stories in this chapter, comparing them with those in the Neo-Confucian *Three Character Classic* discussed earlier, it becomes evident that some of the moral qualities advocated here and there, such as kindness, righteousness, altruism, generosity, friendliness, honesty, loyalty, and a sense of community, are consistently emphasized in heroic characters of both traditions (Yang 1998, 217). Both in the Confucian Classics and in Maoist discourse, the commanding authoritative exhortations are about self-transformation, self-correction, self-denial, and the demand to renounce excessive selfish instinct for some higher collective goal (Wang 1997, 103–4). While Cultural Revolution policies openly attack Confucius and Confucianism, then, many of the values they propagate and much of their treatment of Mao himself as a great sage are reminiscent, to say the least, of Confucius and Confucianism.

Like Confucius, Mao would call, repeatedly, for the "rectification of names" (*zhengming* 正名), one driving force behind his "Continuous Revolution." Like Confucius, Mao was convinced that great danger could ensue from even the slightest misunderstanding of his words (Huang 1968, 32): he thought rectification of names was a necessity to avoid the country's demise (Schönhals 1992, 2–3). Like Confucius, whom Sima Qian once praised in words emphasizing his absolute greatness, Mao would be praised, time and again, for his prowess:

> One can only look up to High Mountains, one can only follow Grand Virtue. Although one can never reach them, one's heart will continue to reach for them. (Sima 1972, 1947)
>
> 高山仰止, 景行行止. 虽不能至, 然心向往之. (史记·孔子世家)

As in the above passage from the *Records of the Historian*, where the first two phrases are themselves a quote from the *Book of Songs*, Mao, too, was compared to (and visually juxtaposed with) mountains and the sun. Hero worship was a Confucian practice: constantly looking backward to the great rulers of old created, even among the most revered sages, feelings of aspiration. Yet just as Mencius found it impossible to "second a Shun," humility would alternate with or change into empowerment (Wang 1997, 156), a modus which determines so much of Chinese cultural history and the Chinese psychological makeup to the present day. If one propaganda poster from the Anti-Confucius Campaign attacks Confucius for his fatalism and advocates the spirit of the "Foolish Old Man" instead,[144] it deliberately only tells one part of Confucius' story.

And Mao was an even larger-than-life figure than Confucius: Mao embodied the Confucian principle of Heaven, which, according to Confucius, was silent (天无口). All throughout the Cultural Revolution, Mao never addressed the masses except with a few short remarks. Everybody was always talking about his "words," but few had ever heard him speak (Leese 2006, 176). His

144. DACHS 2008 Online Exhibition, 22.

silence added further to his mystery and aloofness and the power of canonized "MaoSpeak." Mao (not unlike Confucian Heaven) thus "effectively became the supreme but empty symbol of the movement upon whom everyone could (and would, as the European student movements in the 1960s have shown) project his own ideals and wishes" (ibid., 177).[145]

In traditional China one could succeed as a statesman only if one spoke in the words of Confucius (and the Confucian Classics). In Maoist China, one had to speak Mao. Quotations from Mao during the Cultural Revolution and beyond it were not merely "ideological stylistic components" (Yang 1998, 162). They were signs of power: Mao's words are quoted as the most authoritative ideological norm to highlight particular arguments. According to H. C. Huang, every political campaign is a "semantic campaign," and the Cultural Revolution was the most virulent of these, "introducing or reviving a plethora of shibboleths and slogans with such determination and concentration that it sometimes borders on verbomania or graphomania. Mao strikes one as a true believer of word-magic" (Huang 1968, 47).

Cultural Revolution propaganda repeatedly emphasized this word-magic (so often that it would make the skeptic doubt its almighty power): MaoSpeak had inherent authority: *ipse dixit, ergo verum*. It was a mighty ideological weapon that, if used properly, would turn the masses into the smartest and most determined people in the world. In turn, its power was felt in such a way that Mao Zedong Thought prescribed all frameworks of thinking, all codes of conduct, and all categories of language and register (Cai 1998, 86); it "determined what was discursive, what was possible and what was acceptable during the Cultural Revolution" (Cai 1998, 16). "Materialized in practice" (Hall 1985, 104), Mao's words would be used to manage social relations and serve all revolutionary needs (Cai 1998, 70–71). For most of the Chinese populace, linguistic (self-)censorship was crucial to survival in a volatile situation in which one could be sentenced to death for unintentionally misspelling a quotation by Mao or for burning a newspaper with his image. The rhetorical and ritual demonstrations of loyalty to Mao, the different uses of MaoSpeak that came to dominate everyday life, cannot be understood without taking into account this frenzied atmosphere (Leese 2006, 218–19). A musician (whose testimony also appears in the Introduction) remembers this situation as follows:

> As for the loyalty dances and all that, I did not feel that these things were obnoxious [反感 fan'gan], no, none of that! It was just a bit too repetitive, perhaps, we had to sing the quotation songs all the time. We simply did not have the choice; that was the problem. It was too restricted. Mao wanted to restrict everyone's heart to loving the Communist Party! That was a bit too much.... (Musician, 1942–)

Amidst all the sounds and fury, hearing the same slogans and politically fashionable phrases repeated again and again, it may have been only natural—apart from being necessary—to imitate and use them (Huang 1968, 30). Yet, not everyone did so unthinkingly. One editor, born in the 1930s and quoted above, remembers that people did start wondering why they should say "Long Live Chairman Mao" instead of "Good morning" as a greeting. Doubts aside, Mao's words exerted a power during the Cultural Revolution (and before) that can still be felt today. As Li Tuo 李陀 (1939–) shows impressively, the after-effects of MaoSpeak cannot easily be dismissed:

145. Leese further explains that "The reasons for Mao's unwillingness to directly address the audience may have been that the integrating effect of his cult image would have been greatly diminished by actually hearing his high-pitched voice with the heavy Hunanese accent. His image as omniscient unmoved mover could thus have been contradicted" (2006, 177).

It was nearly impossible for me not to use them [i.e., words from the repertoire of MaoSpeak] whenever I encountered something in which I felt I had a stake. . . . It was as though I had to classify matters in which I had an interest with written words—the "best," the "worst," the "absolutely right," or the "utterly wrong"—before I could rest easy. Removing these modifiers felt like depriving myself of the potential benefits and the important right (here I refrain from saying "the most important" right) to pass judgment, for which I have struggled. To forego the right to pass judgment would mean renouncing not only my own long-held values related to this right, but also the system of ideas that generates and sustains such values. Some might accuse me of exaggerating either deliberately or inadvertently; after all, the use of an expression is only a matter of style, so what's all the fuss? But the question of style is what I am driving at. . . . The discourse and style found in China today both have their origin in Mao's own writing. I have called this style the "Mao Style," and it is a unified system of language style that has extended a solid grip on all realism of discourse. The widespread use of words such as "the most" and "extremely" (I am only one of the victims) is but one specific example of the widespread dominance of the Mao style in writing and speech. (Li 1993, 274)

How did what he calls "Mao Style" attain its power? And how was this power sustained? How did elements of MaoSpeak become propagemes that would influence not just contemporary actors but also future generations? This chapter has discussed some parallels in usage between Mao's words and the words of the sages in traditional China. The words of the sages in traditional China had a ritual aspect to them, and this ritual aspect acquires redundant dimensions in the performance of MaoSpeak during the Cultural Revolution. Learning by heart and reciting Mao quotations was one aspect; the construction of statues of Mao and altars for Mao was another.

According to Leese's recent study of the Mao Cult, it was especially in rural production brigades that ritual modes of worship increased rapidly in the early years of the Cultural Revolution. So-called Loyalty Chambers or Loyalty Halls (忠字屋/堂 zhongziwu/-tang) would be established where fresh flowers would be placed before Mao's picture, while his works would be put on display on "precious red book altars" (红宝书台 hongbaoshutai) (Leese 2006, 245–46). In many cases, Mao would effectively be incorporated into the local pantheon by replacing former deities on the house altar, a custom that continues even today, as shown in Chapter 5.

The printing and production of Mao's works and Mao badges, the daily rituals of loyalty such as "asking for instructions in the morning and reporting back in the evening" (早请示晚汇报) in front of a portrait of the Chairman, which meant that a whole day's thoughts and actions would be modeled upon his instructions, are further examples of the ritualization of Mao and his words (cf. Leese 2006, 211; Chen 1988, 48). Finally, the daily consumption of MaoSpeak on objects of everyday use is a last case in point: carpets and blankets were embroidered with quotations by Chairman Mao; towels, pillows, wooden furniture, wine bottles, medicine packages, wallets, toys, candy wrappers—all were imprinted with quotations. Some shops even arranged "loyalty cabinets" (忠字柜 zhongzigui), and shop windows would be turned into "loyalty windows" (忠字窗 zhongzichuang) (Leese 2006, 243). Most significantly in this context, "even traditional silk bags, previously used for Buddhist sutras and now imprinted with the character 'loyalty' were handmade to contain Mao's 'precious red books'" (ibid., 244). Symbolic qualities would be ascribed to even the smallest aspects of everyday life as ennobled by Mao's words, which "led to a sacralization of the images and commodities of the Chairman" (ibid., 292).

In many of the stories, songs, and images from the Cultural Revolution analyzed above, Mao's words appear as *deus ex machina*, able to solve all fathomable problems. In the language of propaganda, Mao's words have the quality of saintly emanations. And it is this quality that becomes ever more evident when the figures sit down, regularly, every evening, and of course in the hour of their death, too, and measure themselves up to the ethics (and heroes) in Mao's

writings, especially those from the *Three Articles*.[146] It is not just that Mao's words are collected in a "Red Bible," as it has often been called outside of China, but these stories suggest that their status and their embodiment is indeed comparable to that of the words of the Bible. This tradition goes back, at least to Yan'an days, according to Apter and Saich, who argue that "the Yan'anites enjoyed the special privilege of a 'people of the book' with the democracy of egalitarian entry. In this setting, text and party document took on the properties of scripture" (1994, 70).

A Mao quotation is powerful. Not unlike a sentence from the Bible in a Christian context, it bears a universal proposition, it propagates an eternal truth. Every quotation embodies, *pars pro toto*, the entire work and by extension Mao, the Red Sun, himself (van den Berg 2000, 17–18). Mao is like a god who is there, obviously, for everyone—workers, peasants, soldiers, even intellectuals.[147] And, just as obviously, everyone is enthusiastic about Mao. One foreign observer who collected the "miracles of Chairman Mao" describes the effect as follows:

> An aura of primitive religion pervades the extracts which follow. The legends being officially propagated cover the gamut of religious appeal from sacrifice and the sanctity of relics to the mystic union with the (still living) godhead. In China today a new hagiography is being seeded, appealing to the irrational in the name of a faith which claims exclusive commerce with a scientific understanding of history. (Urban 1971, xvi)

The concept of political religion, or in the words of Emilio Gentile, "sacralized ideology" (2001, 140), has been applied with varying rigidity to the Fascist dictatorships of Hitler and Mussolini as well as to Communist rule. In China, where rulers have for many centuries been superscribed as gods, Gentile's concept of political religion seems to fit quite neatly:

> By taking over the religious dimension and acquiring a sacred nature, politics went so far as to claim for itself the prerogative to determine the meaning and fundamental aim of human existence for individuals and the collectivity, at least on this earth. The resulting religion of politics is a religion in the sense that it is a system of beliefs, myths, rituals, and symbols that interpret and define the meaning and end of human existence by subordinating the destiny of individuals and the collectivity to a supreme entity. (Gentile 2001, xiv)

> *Political religion* is the sacralization of a political system founded on an unchallengable monopoly of power, ideological monism, and the obligatory and unconditional subordination of the individual and the collectivity to its code of commandments. Consequently, a political religion is intolerant, invasive, and fundamentalist, and it wishes to permeate every aspect of an individual's life and of a society's collective life. (Ibid., xv)

While the success of MaoSpeak may not necessarily be the result of the sacralization of politics, and while this sacralization was also, to a good extent, popular and not officially prescribed, it was certainly one of the conditions that contributed to the success of MaoSpeak. In spite of itself, the Maoist state often maintained its unity and identity over time by accepting and nourishing this form of lay religion founded on a code of shared beliefs and civic values (based on some values already long established through the Confucian tradition). By making this an invasive mechanism and intolerant standard that would embrace and influence every individual, the state was able to integrate the individual into society and to avoid disintegration and internal fragmentation from conflicts of values and interests (see Gentile 2001, xxii).

146. See e.g. *CL* 1969.10:11–31, 26, 30; *CL* 1971.2:18–26, 21; *CL* 1971.6:76–80, 79. On the deification of Mao and his words, see also Apter and Saich 1994; Kubin 2005, 54–75; Landsberger 1996, 2002; and most recently Leese 2006.
147. For diverging views on Mao's importance for different groups in China and elsewhere, see *Critical Introduction*, 2010.

The uses of MaoSpeak throughout the several decades of Communist rule in China make for a prime example of how political religion typically manifests itself: the CCP under Mao's ideological directive becomes the consecrated primary *secular collective entity* that is placed, with the help of Mao Zedong Thought, "at the center of a set of beliefs and myths that define the meaning and the ultimate purpose of the social existence and prescribe the principles for discrimination between good and evil." Mao Zedong Thought in its various forms, not least importantly in the form of the *Little Red Book* or the *Three Articles*, is formulized as an "ethical and social *code of commandments* that binds the individual to the sacralized entity and imposes loyalty, devotion, and even willingness to lay down one's life." Accordingly, Mao's followers are a *community of the elect*, they have a *messianic function*, they must "fulfill a mission of benefit to all humanity"; and, in their various "loyalty activities," which extend to the publication of Red Sun songs and commercial advertisements reincarnating "Mao style" today, they "create a *political liturgy* for the adoration of the sacralized collective entity through the cult of the person who embodies it, and through the mythical and symbolic representation of its *sacred history*."[148] It is important to remember that this political liturgy (complete with loyalty dances and quotation gymnastics) is created by the people and not just by the state or the Party factions who often even attempted to stop or at least retard it.

In 1992, Jia Lusheng and Su Ya published a book entitled *The Sun That Never Sets* (不落的太阳 *Buluo de taiyang*).[149] In it, they suggest that China's continued fascination with Mao reflects a longing for those early years when the country seemed more stable and had a "leader of mythic proportions" to revere. In view of the "Red Sun Fever" in music and the trendy commercial chic feel the revolution would acquire a few years later (with the Lei Feng sneaker by Li Ning and Linux 2000, and, more recently, Cultural Revolution-style restaurants or weddings, see ill. 5.79),[150] it was prophetic of them to argue in 1992, that the symbols of the Chinese Communist Revolution—indeed, its whole legacy—was able to evoke primal feelings for many Chinese of pride, respect, and awe. Looking back to a golden age of the mythical Yellow Emperor and other model rulers such as Yao and Shun had been common practice in traditional China. Communist China, however, had long since preached an evolutionary model of history. Yet it has now developed the fantasy of another golden age in the past: Maoist rule (including the periods of political campaigns and purges that reached their apogee in the late 1950s and 1960s). This explains why Mao is "easily the best-selling author in Chinese history" (Leese 2006, 122) and has continued to thrive as such (with the financial crisis, this has even increased);[151] this explains why his ideas are sold in Hong Kong and Taiwan—where, incidentally, the *Little Red Book* was recently republished in elaborate form, with a dedication that reads, "Given to all in this world who still have dreams" (献给对这个世界还有梦想的人),[152] and in Chinese communities abroad. Mao's success is based on, but it also exists in spite of, the ritual repetition it underwent especially, if not exclusively, during the Cultural Revolution. Ritual repetition and medial multiplication made his words into (not always disliked) propagemes. The next chapters will show how this was translated visually.

In her theory of citation, Dubravka Tolic talks of different cultures of citation: vertical cultures of citation feature a strict hierarchy of texts and genres. Quotations from those texts "higher" in the hierarchy are usually embedded in those "lower" in the hierarchy. Horizontal cultures of citation, on the other hand, may be caused by revolutions: quotations from formerly "higher" texts are now embedded according to a principal of "dialogue" in what would formerly have been

148. Gentile 2001, 138–39; for a similar case made for Nazi propaganda, see Gorr 2000.
149. Su & Jia 1992; see a lucid discussion in Schell 1992.
150. See DACHS 2009 Cultural Revolution Wedding Pictures.
151. See DACHS 2009 Mao Nostalgia.
152. See *Mao Zedong Yulu* 2005 and DACHS 2009 Red Book in Taiwan.

considered "lower" texts. In vertical citation cultures, the higher texts are taken to be a treasury from which the precious objects (i.e., words) are extracted in order to be reverently enclosed in the derivative text. The situation is the opposite in horizontal citation cultures, where the cultural tradition has lost its authority and canonic value. Quotation from a former canon is used in new texts in order to subvert or even destroy it (Tolic 1995, 69–70). Thus, while texts in the vertical tradition reverently *represent* the cultural canon, texts in the horizontal tradition self-confidently present their own selves (ibid., 73–74).

Maoist China was a vertical citation culture, to be sure, but has post-Mao China made the shift toward becoming a horizontal citation culture? Or could it be a combination of both? A set of quoting rules from 1978 prescribes: "When citing quotations by Marx, Engels, Lenin, Stalin, and Chairman Mao, one has to be serious and earnest" (引用马恩列斯和毛主席语录要严肃认真).[153] Officially, then, Mao's texts were expected to be revered even after the Cultural Revolution ended in 1976. Some of the more recent examples of uses of MaoSpeak in Party documents, songs, images, literature, and mainstream film illustrate that this vertically directed reverence is indeed still alive. Other examples, like Wang Shuo's or Yan Lianke's writings or the caricature and advertising uses of the Foolish Old Man's story, on the other hand, may be considered horizontal readings and at the same time, they are signs of the powerful and thus often traumatic effects of prescribed reverence and belief in the words of Mao during the Cultural Revolution and before.

In tracing the use of one particular Mao quotation, the Story of the Foolish Old Man from its first appearance in the mid-1940s to the present, I have argued that its constant evocation is the key to its power and its "magical" disposition. For even though not everyone intends to trace the original "orthodox" meaning of this foundational myth of the PRC—some producers might not even be aware of its association with Mao, while the recipients, likewise, may or may not make such a connection—even though the quotation acquires new and contradictory meanings through repetition and multiplication, it does so keeping its authority and symbolic capital intact. For those who can remember its strictly ritualistic use during the Cultural Revolution, it continues to function as a propageme. Whatever is left of the story in literature, in jokes and caricature, and in MTV, text messaging, mainstream film, and advertising shows that even the unconscious use of the propageme is not just superficial: the story itself manages to convey timely and relevant content, too. Quotational discourse surrounding the Foolish Old Man may have become more independent after Mao's death, but this does not mean it has exchanged a vertical for a horizontal usage completely. MaoSpeak has not lost its power as rallying symbol or talisman, as harrowing memory or as carefully studied quasi-religious text. Whatever it may mean, Maoist practice and Maoist gesture continue to be everywhere and remain important today.

153. *Guangbo bianji gongzuo* 1978, 161.

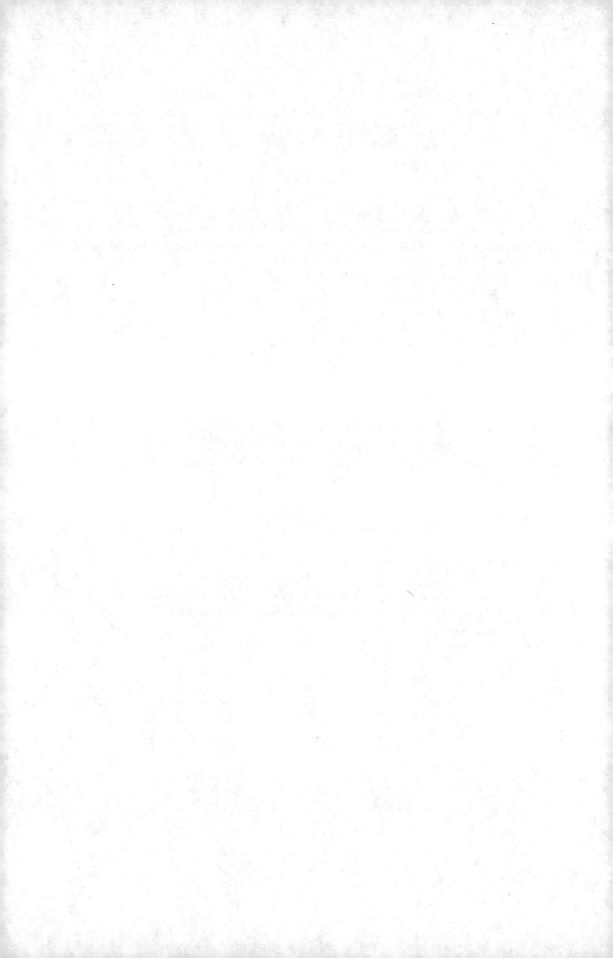

PART III

EYES: IMAGES

Of course, we had a portrait of Mao in our dormitory, then. Now, a lot of people collect these. (Guqin Player, 1940s–)

I never put up a picture of Mao. A lot of people would, but I would not. Yet, I collected a lot of buttons, a huge pile. I had a lot of the images from when Mao was very young. I preferred these Yan'an images. Then, Mao was so admirable [非常了不起 *feichang liaobuqi*]. The things he did later were not so good, but at that earlier time he really deserved everyone's reverence. Chiang Kaishek was so corrupt [腐败 *fubai*], but Mao was different. After liberation, however, things changed. Mao, too. Still, there is a difference between Stalin and Mao. Mao did not want this type of reverence for himself. But somehow, the cult [個人崇拜 *geren chongbai*] grew, and he was turned into a saint. Now, or rather again, there is still this phenomenon. His later mistakes have been criticized, but things have been over for more than 20 years. People forget easily. On the other hand, hanging up these portraits today is just a game—it is fun, it has nothing to do with real reverence for Mao, although, of course, it is a kind of historical memory. Mao is great; he unified China, such a big country. One cannot say that he is totally bad. (Musician, 1930s–)

Every family had the image of Mao hanging in their house. Mao buttons very quickly became a fad; they were "divine images" [宝像 *baoxiang*]! We all wanted them. I remember, in December 1966, we were walking on the street when we met Red Guards. One of them slipped, fell and hit the Mao button on his breast. He felt so sorry for Mao he was crying. Yes, his was really a "divine image." Around 1967, in Qinghua University, they were making a big painting of Mao with the words, "A Long Life to Chairman Mao and Lin Biao." It was difficult when Lin Biao fell. But only in the 1980s did these paintings really disappear: who would dare move them away! Nobody was in favor of destroying the statues, either. Mao helps keep Chinese society safe, so people think. Mao gives us security. Marxism is a religion, and Mao is one of its gods. (China Historian, 1950s–)

Mao is a great person, and his image will still be there on Tian'anmen even in 50 or 100 years.... I have a lot of pictures of Mao and statues in porcelain and other such things. He is very important to me. (Beijing Taxi Driver, 1958–)

I was on an artistic team then, because I liked painting. We would paint comics, for example, in the early 1970s. I was a worker and so I took part in these activities. Most of what we painted was rote—Mao's portrait, for example. We painted heroes, local as well as national heroes, those who sacrificed themselves for others. And, we also painted scenes from the model works. (Musicologist, 1950s–)

During the Cultural Revolution, many of the old comics were destroyed, but still, they would be read: I would read at home with my younger brother. But there was always this fear of Red Guards coming and "Smashing the Four Olds" [破四旧 *po si jiu*], so there was a difficulty with having such things at home. After having read them, therefore, we decided, piece by piece, whether it was safe to keep them. There was this comic strip on the Song hero Yue Fei [岳飞, 1103–42] which was a set of six little comic books: we decided to keep it. (Intellectual, 1958–)

In the 1970s, there were quite a few comics! We read them all: the *Dream of the Red Chamber*, the *Water Margin*, and the *Journey to the West* [西游记 *Xiyouji*], too. We thought those heroes in the stories were great! The new comics were not so interesting [沒有味儿 *mei you wei'r*], they were very basic. (Housekeeper, 1950s–)

★★★★★

PROLOGUE

> Of course this was a time when culture was restricted, and there was a lot of criticism, too. But in our private lives, there was not so much of that. A lot of painters were just doing their thing, going to work and then going home and painting their own paintings as they had before. Of course you could not publish the stuff ... just did it at home. Especially after 1970 and until 1978 these people were actually doing great work. Really, it is not true that everything only starts with 1978. I would really like to show all of these things that actually came before 1978. (Art Historian, 1940s–)
>
> A friend of mine, a well-known painter, painted most of his oeuvre during the Cultural Revolution, but, of course, he had a really hard time: he was such an eccentric. (Ethnomusicologist, 1940–)

A recent exhibition at the Guangdong Museum of Art, documented at length in *Red Art* (红色 美术 *Hongse meishu*), a film by Hu Jie and Ai Xiaoming (Hu and Ai 2007), featured officially sanctioned propaganda posters side by side with some of the modernist and traditionalist art— the exhibition called it the "floating avant-garde" (浮游前卫)—produced during the Cultural Revolution years in spite of political directives officially forbidding it. The exhibition and its discussion in the film are a remarkable attempt to recover the contradictions of political mandate and artistic creation during this period, a recovery which, in scholarly writing, has only recently begun (Silbergeld and Gong 1993). In her masterly study *Painters and Politics in China*, Julia Andrews acknowledges the stubborn habit of referring to the Cultural Revolution as the "ten lost years." She explains:

> For artists such as Ye Qianyu, who was beaten severely by his students and then jailed for nine years, such a formulation would be entirely appropriate. For those such as Lin Fengmian, who kept his work out of Red Guard hands by scrubbing it to pulp on a washboard, even more than one decade of creative activity was lost. The physical and psychological violence inflicted by some Red Guard students on their teachers, their party leaders, and on each other has, understandably, produced a revulsion against any activity associated with the Cultural Revolution. Older artists in particular associate the artistic images of the Cultural Revolution very directly with the torture they suffered. For most young and middle-aged artists, however, the ten "lost years" included a good deal of painting, even if it was not what we might consider high art. (1994, 314, see also Andrews 2010, 40–41)

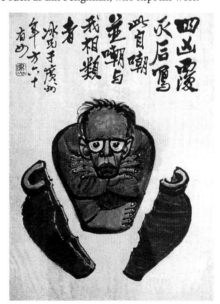

ill. III.1 Liao Bingxong, *Liberated after 19 Years*, 1979 (Sullivan 1996, plate 63).

Many artists probably felt like cartoonist Liao Bingxiong 廖冰兄 (1915–2006) who, in 1979, painted an impressive cartoon image of "Himself Liberated after 19 Years" showing himself breaking out of a vase, but with his body still formed exactly in the shape of the vase, his feet and arms crossed, his mouth dumbfounded (**ill. III.1**). Destruction and restriction of artistic practice accompanied by torture of the

artists involved peaked during the Cultural Revolution (Sullivan 1996, 154–55; Yang 1995, 344–47).

Earlier chapters of this book have illustrated that artistic production created according to official standards during the Cultural Revolution was extremely univocal and political during this time—but it never stopped and was accompanied by much that was only unofficial but equally alive. More so than any other political movement before or since, the Cultural Revolution was all sound and words, especially in the countryside—and it was, decidedly, also a visual event. This point is well illustrated in the exhibition discussed in *Red Art*, which shows, for example, huge propaganda posters (some of which had a width of 25 meters) *in situ* and follows the rote production of images such as Liu Chunhua's *Chairman Mao Goes to Anyuan*, of which a mythical 900 million copies are said to have been produced during the Cultural Revolution (Landsberger 2002, 152; Hu and Ai 2007). Cultural production, then, in all artistic fields including the visual arts, was a major element in the Cultural Revolution experience. Yet, the many cruelties that accompanied this experience, and the official condemnation of the event in the 1981 Resolution, have made it awkward and difficult for artists, musicians, and writers to discuss the work they produced during this time or to consider as positive its relationship to the art of preceding and succeeding periods (Andrews 1994, 314; Hawks 2003). Andrews explains that "even for those who were very active, the decade is often described as a 'big blank.' Many paintings made during the period have been destroyed, either iconoclastically or pragmatically—that is, by recycling the canvas for new paintings or for scrap" (1994, 314).

In terms of artistic merit, the loss of Lin Fengmian's 林風眠 (1900–91) oeuvre during the Cultural Revolution (He 2007) is certainly graver than the disappearance of some of the period's stereotyped propaganda images in the last decades. Yet, as the emergence of new forms of art after the Cultural Revolution shows very clearly, if we are to understand China's visual experience in the twentieth century we must not eradicate this record, which fills many of the otherwise missing links and explains some of its breaks but even more its continuities. Andrews, in a book that covers the period up to the 1980s, prophetically emphasizes the flourishing of new art forms in the 1990s:

> Although the post-Mao destruction of Cultural Revolution art has succeeded in achieving a "ten-year gap" in the history of Chinese painting, thus making literal a concept that was in part figurative, the Cultural Revolution did influence the development of Chinese art in important ways. (1994, 315)

In Part III of this book, therefore, I examine the Cultural Revolution as visual experience. What did people see, and why and what did they feel, when viewing these images? To what extent did these images imprint themselves in cultural memory? The two chapters to follow deal with Mao as the main (portrait) hero of the Cultural Revolution and with other (comic) heroes of the Cultural Revolution, as well as those produced before and after. In probing visual imaginaries and materialities, I will argue that cultural production during the Cultural Revolution must not be evaluated in historical isolation: it cannot be understood unless taking into account its myriad transformations throughout the twentieth and into the twenty-first century, as well as its myriad interactions with the world beyond China.

Why deal with images from the Cultural Revolution? Because in spite of everything said about the unsavory qualities of propaganda art, it was attributed with power, and because its many echoes in artistic production to the present day suggest that this power was and is considerable.[1] In the stories introduced in the previous chapter, and in the revolutionary songs and model operas discussed in Chapters 1 and 2, many a character fervently believes in the strength and sounds of

1. See illustrations following ill. 5.22.

Mao's words (or is horrified by the power Mao held over the country's psyche). Tireless "Granny Shi," who wants to grow cabbage to support the soldiers from the People's Liberation Army stationed in her small fishing village, is one of these believers:

> She walked from one place to another until finally she stopped at a hollow—a suitable spot she thought—and began tilling. As the earth was hard, for the island was rather rugged with rocks scattered about, digging was strenuous. However, stroke after stroke the hoe fell upon the ground. When she got tired, she stopped to draw strength by reciting a passage from *The Foolish Old Man Who Removed the Mountains* and then went on. After two days' laborious work, two vegetable plots were prepared. (*CL* 1969.6:86)

As it turns out, it is not the words of Mao alone that are the source of the old woman's strength: Each day, Granny Shi "never failed to look at the portrait of Chairman Mao" (*CL* 1969.6:85). In another story, a poor peasant, Aunt Chou, feels the powerful presence of Mao by looking at and speaking to his portrait, the embodiment of his might—even defying her own daughter's (and thus a potential reader's) skepticism:

> Aunt Chou, a poor peasant of over fifty, could neither eat nor sleep. Whenever she had time she sat down before a portrait of Chairman Mao and said: "Chairman Mao, Chairman Mao, do you know what has happened in our county?"
> Her daughter once said to her: "That's only Chairman Mao's picture. He can't hear you. Better go and eat."
> "Chairman Mao is right here," the old woman insisted. "I must say what's on my mind. With Chairman Mao supporting us, there is nothing in the world we need fear." (*CL* 1969.9:71)

Revolutionary China *as a visual experience* was characterized by constant and repetitive exposure to this heroism incarnate: "Chairman Mao is right here." Of the heroic figures to be seen and to be believed in quite religiously, Mao was merely the most prominent. Reverence for the hero was implicit as a function in visual presentation. The hero could but be understood as a model for emulation. Thus, the heroic image would be repeated on new levels, *mise-en-abyme* practiced over and over again in order to call for action. The imposing portrait of the nation's larger-than-life hero, Mao, becomes the inspirational model for the local heroes in the model works, model stories, and model comics. These local heroes in turn become models as portrayed on posters, teapots, cups, and cushions to inspire the individual brigade peasant leader who, again, would be depicted painting a picture or singing a song or telling a story of such a heroic model. And this leader would in turn become a model for each and every one of the peasants in his or her brigade, who in turn would be depicted in a model comic/poster/story as models for all peasants in China, and so on.

One example of this practice at work is the 1974 poster *Read Revolutionary Books, Learn from Revolutionaries, and Become an Heir of the Revolution* (读革命书学革命人当革命接班人) (**ill. III.2**). It shows a young girl reading model hero Lei Feng's diary. Above her head

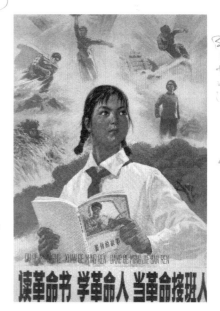

ill. III.2 *Read Revolutionary Books, Learn from Revolutionaries and Become an Heir of the Revolution*, 1974 (*Chinese Propaganda Posters* 2003, 3).

(i.e., in her thoughts) are a number of other revolutionary heroes: Liu Hulan 刘胡兰 (1932–47), the teenage girl who was beheaded by the Nationalists because she would not betray her faith in Communism, on the far right; above the girl the soldier Huang Jiguang 黄继光 (1930–52), who with his chest blocked American machine-gun fire in the Korean War; next to him Dong Cunrui 董存瑞 (1929–48), who used his own body as a post supporting explosives when blowing up an enemy bridge; and on the left Cai Yongxiang 蔡永祥 (1948–66), who, as an eighteen-year-old, jumped in front of a train to rescue others. In Anchee Min's 闵安琪 (1957–) memory of the poster, she reflects on its power of conviction:

> I wanted to be the girl in the poster when I was growing up. Every day, I dressed up like that girl in a white cotton shirt with a red scarf around my neck, and I braided my hair the same way. I liked the fact that she was surrounded by the revolutionary martyrs, whom I was taught to worship since kindergarten.... I continued to dream that one day I would be honored to have an opportunity to sacrifice myself for Mao and become the girl in the poster.
> I graduated from middle school and was assigned by the government to work in a collective labor farm near the East China Sea. Life there was unbearable, and many youths purposely injured themselves, for example, cut off their foot or hand in order to claim disability and be sent home. My strength and courage came from the posters that I grew up with. I believed in heroism and if I had to, I preferred to die like a martyr. (Min 2003, 5)

In the following chapters, I will discuss what it meant that the visual experience in revolutionary China entailed the constant, redundant confrontation with hyperbolic heroic models. Their function is didactic (and this didacticism had a religious quality to it): these heroes are manifestations of an attempt to translate the raw material of revolutionary ideology into images turned myths for general consumption and emulation. The Chinese writer Duo Duo 多多 (1951–) remembers his reactions to this visual regime:

> From the day I was born in 1951, I was subjected to a visual education from children's picture books, through school textbooks and books for teenagers, to a huge number of other images and propaganda posters. They all dealt with similar subjects and were my signposts through life. They made sure we did not make mistakes. (Duo 2003, 10).

Revolutionary art aims to construct, in the words of Golomstock, "a new culture according to its own image: i.e. according to the principle of the mega-machine, with no parts that are not strictly functional, with a rigid program and a universal aim. Anything that hinders its work is ruthlessly eliminated" (1990: xiii). Revolutionary art aims to refashion those living with it. Yet, such manipulation was not necessarily felt to be negative only: Propaganda posters were widely available and could be seen everywhere, brightening up the otherwise drab places where people lived (Landsberger 2003, 16). Did people like the posters? Why (or why not)? What role did the political message of the posters play? Who looked at them, and how intensively? Was their message felt to be convincing? Why (or why not)?

Reconsidering both the idea that Cultural Revolution visual culture brainwashed and manipulated its audiences, and, at the opposite extreme, the idea that it was always resisted and negated by those aware of the patronizing forces at work, we can see that neither of these interpretations appears to be adequate alone to the complexity of responses encountered in oral history. The interview snippets presented to introduce Part III range from outright denial to having "fun" collecting such propaganda images. Equally ambiguous is what Duo Duo writes:

> Four hundred propaganda posters to look at. After about two minutes I feel kind of numb. I try to be patient and flick through them all again from the beginning. Suddenly, 10,000 eternally blooming red

flowers float before my eyes—each one exactly the same as the others. Suddenly, I discover myself among them. I see my family, my neighbors, millions of people. A whole era comes flooding back. I keep looking at the posters. The person I am today observes the first half of my life. What emotions am I feeling? Apathy? Shame? Disgust? Abhorrence? Or nostalgia? None of the above? Or maybe a mixture of all of them? (2003, 10–11)

Duo Duo's reaction illustrates how difficult it is even for one individual to pin down, exactly, the effects of viewing this art, its attractions and revulsions. Anchee Min's memory of bringing home her first revolutionary work of art shows that such ambiguities in reception are by no means a construction of memory alone but were prevalent during and part of the experience of the Cultural Revolution as well:

My passion for the posters began when I was eight years old. One day, I brought home from school a poster of Chairman Mao. Although I did not know that the Cultural Revolution had started, my action made me a participant—I removed my mother's "Peace and Happiness" painting with children playing in a lotus pond from the wall, and replaced it with the Mao poster. My mother was not pleased but she tried not to show her disappointment. I remember my thoughts: why wasn't she happy about Mao looking down at us during every meal while others couldn't have enough of Mao? (2003, 5)

By telling the stories of those who created, those who abhorred and feared, and those who enjoyed revolutionary art, I will attempt a new reading of Cultural Revolution visuality and its meaning for contemporary China. The visual (propaganda) image will be discussed both as an instrument and as an agent: a tool for manipulation and an autonomous source of its own purposes and meanings at the same time (Mitchell 2005, 350). It will be studied not only for what it means and what effect it achieves but also for the secret of its obvious vitality (Mitchell 2005, 352): Why is it that Cultural Revolution comics were read avidly in spite of their trite and predictable structure and content? How does one explain the prevalence of reprints of these comics on sales tables in Beijing's bookstores as late as 2009? Why would Mao's image adorn private living rooms or hang as a talisman from taxi drivers' mirrors not just in the Maoist era but well into the early twenty-first century? What role did and do revolutionary propaganda posters, which have returned to places like back-alley restaurants in China today, play in the making of youthful identities who were not yet born during Mao's lifetime?

I will contend that Chinese propaganda art was successful insofar as it left a lasting impact on people's lives, one felt to the present day even among those who lived long after the Cultural Revolution ended. I will try to explain this impact by showing that there were several reasons for the lasting "success" of propaganda visuals in China: they could build on the "Socialist Internationale," which served as a powerful and systematic backdrop to the story; they made use of a "popular entertainment rationale"; and finally, as with "MaoSpeak," they took on the functions of popular religion.

Chinese revolutionary art has been taken to serve as one striking example of the universality of mechanisms which Golomstock calls "totalitarian culture." The particular nature of the raw material used in Chinese revolutionary visual arts—which adapted for the revolutionary cause both the Soviet model of oil painting and Chinese techniques of painting with ink and woodprint—may lend a specific flavor to the final product, but in essence, Golomstock contends, revolutionary arts are as similar as their aesthetics and technologies of production allow. Wherever in the world these arts began to function, he argues, whatever national soil served as their foundation, whatever realities were reflected in their "magic mirrors," which were always mirrors of faith—they depicted a hyperbolic (socialist) paradise where happy people under the guidance of wise and heroic leaders constructed a new life free of pain or suffering while harshly chastising their enemies (Golomstock 1990, xii).

Stylistically, political instinct and the needs of the ideological struggle would demand an art that makes hyperbolic "total realism" the standard (Golomstock 1990, xii). Revolutionary art works range, therefore, from the realistic depiction with a hint of romantic excitement conveyed by dynamics of color and compositional structure, to the solemn and frozen immobility that endows the image with the qualities of a (religious) icon (Golomstock 1990, xiii). Chinese revolutionary art offers variations on this theme, the *Socialist Visual Internationale*. The huge forearms and hands of revolutionary heroes—which appeared to be continually growing over time, at least until the mid-1970s—are one example. In describing this feature, Duo Duo translates it into bodily experience:

> I notice that the hands on the posters grow bigger and bigger. The hands that harvested corn-on-the-cob and carried watermelons now caress rockets. Looming over the enormous hands of the working class are the even more enormous hands of the Great Leader. Thousands upon thousands of waving hands, among them my own, moving vigorously back and forth in the air. (2003, 10)

Propaganda images portray the future in the present, showing not only "life as it really is" but also "life as it ought to be." They are painted in a naive and decorative style, their forms outlined in black and filled in with bright colors: reds especially, but also yellows, greens, and blues. Landsberger has aptly called them "factional." They are "a hybrid of fact and fiction, stressing the positive in life and papering over anything negative" (2003, 16).

Anchee Min, who had always wanted to be a poster girl, recalls how she eventually became one, but—with "total realism" at work—was hardly able to recognize herself in the end. Her description illustrates, step by step, how the "faction" of heroic images would be produced: she narrates how, when a "proletarian face" was needed, she was spotted, and how the professional propaganda artist Ha Qiongwen 哈琼文 (1925–)[2] met with her to choose proper "props" and "costume." The dialogue between them—the urban sent-down youth who cannot resist being the country girl after all, and the urban intellectual who knows that he really should know more about the country but can only translate certain characteristics into symbols and types—illustrates very clearly the many different levels of fact and fiction at work in the creation (and, in a second step, the reception) of propaganda art:

> I was surprised that he picked my green-colored worn-out army jacket which I had brought back with me from labor camp. I told him that it would only take a moment for me to wash off the muddy dirt on the shoulder. He stopped me and said that the dirt was the effect that he had been looking for. I began posing after Mr. Ha set up the camera. I didn't know how to pose and was just doing what he asked of me, which was to look into the far distance with confidence. I apologized for my sun-beaten skin and hair, and I tried to hide my fungicide-stained fingernails. He said that he liked the fact that I looked like a real peasant. He asked me what I would wear when working in the rice paddy. I replied that I would wear a straw-hat, I wouldn't wear shoes, and I would have my sleeves rolled up to the elbows and the pants up to the knees. He told me to do that. I obeyed. I kicked off my shoes and he saw the fungicide-stained toenails. I was embarrassed, but he told me that I shouldn't be, instead I should be proud. "I have been painting posters featuring peasants for years," he said, "and I never realized my mistake. From now on I will paint peasants' toenails in a brown color." A week later, Mr. Ha sent me a print of his favorite shot of me. I looked quite heroic, like the girl in the poster I had admired as a child. Months passed and I didn't hear from him. One day, during the Chinese New Year.... I saw myself in a poster on the front window of the largest bookstore. The woman in the poster had my face, my jacket, but her arms and legs were thicker. She wore a straw-hat, her sleeves and pants were rolled up, and all her nails were brown-colored. I rushed home to share the news with my family, and everyone was excited and proud. (Min 2003, 5)

2. For two typical examples of his propaganda art produced between the 1950s and 1980s, see Shen 2008, 157, 163.

Thus, the little urban girl becomes a peasant poster starlet. The description somehow insinuates that the relationship between Hollywood and Beijing (as well as Moscow and Cuba) is indeed "as close aesthetically as it is frequently divergent in terms of content" (Groys 2003, 20; see also Liu 1997) and for good reasons: following Mao's *Yan'an Talks* all art products had to "serve the masses." Art was distributed to the masses in an effort to capture their minds. The ideal was never to be "high art" but to be understood by the people (Heller 2008, 11). This requirement also entailed that propaganda art would employ many of the same methods and strategies as commercial mass art.

The most talented artists would be employed by the Chinese Communist Party to visualize the political trends of the day. Many of these artists, such as Ye Qianyu 叶浅予 (1907–95) and Zhao Hongben 赵宏本 (1915–2000), whose works I will discuss below, had once produced visuals for popular pictorials and magazines, commercial calendars, comics, and advertisements before the founding of the PRC in 1949. Artists like them were quickly co-opted and incorporated in the various governmental and party organizations set up to produce propaganda images precisely because of their skills in the commercial arts (Landsberger 2003, 16).

By creating alluring symbols, both aesthetically and formally, both propaganda and commercial art are designed to capture an audience. Branding narratives play a role in both.[3] One interviewee cited below remembers: "Those paintings are just like advertisements today, this was their function" (Businesswoman, mid-1940s–). In both cases—political propaganda and commercial advertising—the aim of strategic branding is not merely to raise the visibility of a particular product but also to infiltrate the subconscious in such a way as to trigger conformist behavior. The real objective of commercial as well as propagandist branding campaigns, then, is not primarily to create "educated consumers," but rather to capture the loyalty of a target group, by creating unique visual schemes that would be immediately recognized (Heller 2008, 8). According to this logic, Mao becomes a "trade character," his "Mona Lisa smile" (or the strong forearm of the country girl) transforming his corporeal self into myth (Heller 2008, 9).

By virtue of being both ubiquitous and redundant, revolutionary/commercial visuality, both in the form of mammoth monuments (for example, a giant blow-up Ronald MacDonald or a Mao statue) and the smallest quotidian objects such as cups and saucers, cushions, clocks, and handbags, becomes an integral part of an individual's daily life.[4] Duo Duo describes this in a typical manner: "I do not know who invented propaganda posters. One thing I do know: my life is reflected in them" (Duo 2003, 10).

3. Heller 2008; see also Borsò 2010 and Gries 2006.
4. See Heller 2008, 10; Snow 2010; for examples of small objects, see ill. 1.3; ill. 2.2; ill. 4.7b–c; **ill. 4.11a**.

CHAPTER 5

MAO WHEREVER YOU GO: THE ART OF REPETITION IN REVOLUTIONARY CHINA[1]

> By the time of the Cultural Revolution, technologies of visual culture were commonplace and the visual environment of everyday life was saturated with images of revolution—most notably, the proliferation of the image of Chairman Mao. (Davies 2007, 167)

> There is nothing that touches the hearts of the people more than the portraits of their lords and sovereigns . . . and they will pass them on, from one hand to the next, to their descendants . . . they honour them, they bless them. (Letter by an official in 1577 to the Duke of Nevers)[2]

Mao was one of the most prominent icons of Cultural Revolution China, yet he was not an icon of the Cultural Revolution alone. He remains an important symbol in present-day China. This is what Liu Xiaoqing 刘晓庆 (1951–), a famous actress from Sichuan, writes in her memoirs in 1992:

> Even now the songs I most often sing—the songs I am most familiar with, that I can sing from beginning to end—are ones written in praise of Chairman Mao. The works I can still recite by heart are Chairman Mao's poems. And I still quote Chairman Mao at the drop of a hat. I know and hold it to be true that Mao Zedong will live on in my heart forever. (Liu 1992, 96)[3]

Before and after the Cultural Revolution, the melodies associated with the Great Leader appeared in ever new and different musical styles, opening up a myriad of possibilities for interpretation on multiple levels. In music from the Cultural Revolution, by contrast, Mao would be invoked time and again with one and the same gesture. However predictably presented, though, MaoMusic still could and would be read and interpreted in different ways. A similar phenomenon has been observed in the use of MaoSpeak and the pervasive, constant repetition of citations and phrases by Mao before, during, and after the Cultural Revolution. The pluralism of MaoSpeak interpretations from before and after the Cultural Revolution period contained the critical, the cynical, the ironical, as well as the reverential. And even during the height of the Cultural Revolution with its extreme lack of tolerance toward ambiguity (Dittmer and Chen 1981, 6), Mao's words would be interpreted individually.

How do these findings relate to the uses and abuses of Mao portraits or MaoArt in revolutionary China? They are echoed. Like MaoMusic and MaoSpeak, MaoArt was ever-present in China not just during the Cultural Revolution but before and after that period. This chapter will further demonstrate that it was ever-present not just in monotonous repetition but in many variations. Mao did not appear as always the same Mao, and that is true not just before and after the Cultural

1. Some of the ideas presented in this chapter originated in an extremely useful discussion at the University of Westminster in London in February 2003, when I was still at a very early stage of writing. I am exceedingly grateful to the members of the audience, foremost among them Harriet Evans and Katie Hill, for their many useful comments and suggestions.
2. The letter is cited in Warnke 1993, 9 and reads in the German original: "Es gibt nichts, was die Herzen der einfachen Menschen mehr berührt als die Bildnisse ihrer Fürsten und Herren . . . sie lassen sie von Hand zu Hand gehen an ihre Nachfahren . . . sie ehren sie und segnen sie."
3. The translation follows Barmé 1996, 176.

Revolution but even during this period of alleged "cultural stagnation."[4] From 1966–71, for example, more than 10,000 different Mao badge designs were in circulation.[5] Although the range of possible variations of his image increased while the overdetermined one and only meaning for these images all but disappeared both before and after the Cultural Revolution period, evidence shows that even during the Cultural Revolution the actual interpretations of a single image could be quite varied in spite of all semantic limitations prescribed from above (e.g., Chen 1999). Once more, Cultural Revolution interpretative overdetermination, far from creating unified communication, continued to allow for multiple readings in spite of the propagandistic rhetoric accompanying it. Pre- and post–Cultural Revolution imagery was different, as it almost aggressively provoked and suggested multiple readings. Throughout the history of revolutionary China, the Mao image is contested ground: many suffered and were criticized for the ways in which they depicted the nation's "Great Leader." This continues to be true to the present day. It may be just as apt, therefore, to talk of "the danger" rather than "the art" of repetition to describe the perpetuation of MaoArt in revolutionary China.[6]

Looking at MaoArt in this chapter will mean looking at paintings and sculptures from high and low, from the academies and museums to the villages and student newspapers. I will also consider MaoArt in its most popular forms, on posters, badges, cushions, cups, paper money, and talismans, all of which were widely accessible even in more remote areas. This variety of materials illustrates, once more, that cultural production in revolutionary China was not something exclusively guided and supervised by a monolithic power structure. On the contrary, the production of MaoArt significantly relied on popular agency as well. In the first part of this chapter, I discuss MaoArt from the Cultural Revolution in order to uncover significant variation within the repetition of the Cultural Revolution years. I will then contextualize these images within a sea of images of Mao from before and after the Cultural Revolution. This juxtaposition of Cultural Revolution portrayals with those stemming from the years immediately before and after will illustrate how Mao's Cultural Revolution image came into being as a site of memory and how it developed after the end of that period. Thus, it will help uncover the deeper significance of the art of repetition, of redundancy and multiplicity, in Cultural Revolution China and beyond. This first part of the chapter deals mainly with the images, the artistic products themselves, as they have come down to us. It is my aim to read and compare these for signs of their implied audience.

The second part of the chapter turns to the actual audience of such pictures, recording their memories of viewing Mao images and their reactions to them. I will discuss why and how the Mao image was and still is an important and attractive motif both for the artist who produces and for the viewer who sees such images: Why did and do these people (still) (want to) engage with Mao? To what extent is taking on Mao a performative act—one that signifyies everything from self-aggrandizement to self-sacrifice and that reflects as much on the performer as on the image performed? Do personal motives and interpretations contradict or support what the images tell about their implied audience?

In spite of the countless Mao images from the Cultural Revolution, it is not all that easy to find source material discussing MaoArt. I have gone through memoirs, diaries, Red Guard publications,

4. In using MaoArt in this fashion, highlighting motivic continuity as well as variation in its individual execution, I am in agreement with Valjakka 2011. Her account of my argument (Valjakka 2011, 16–17) is rather reductive and misses the obvious consensus between our views as we both approach the triangular relationship between viewer, image, and the socio-cultural context in which particular pieces of MaoArt appear: we both try to see the full spectrum of feelings and emotions practiced in MaoArt, from admiration to respect and repugnance, all of which are expressed in parody, pastiche, and critical, even iconoclastic, artistic manifestations (Valjakka 2011, 86, 94).

5. See Schrift 2001. Benewick 1999, 131 even talks of 20,000 different badges.

6. Tilmann Spengler's *Die Stirn, die Nase, der Mund* is an eerie fictional study of precisely this phenomenon at work (1999). See also Zheng 2010. For a comparable situation in Nazi Germany, see Sarkowicz 2004.

and official propaganda media. It is astonishing how few and far between are the remarks on specific depictions of Mao. While Mao in general plays a significant role in all of these sources, and the non-specified "Mao image" (毛像 *Mao xiang*) does occur, hardly if ever did I find references to particular images. In order to substantiate the findings from these sources of oral history as well as my own interviews conducted in 2004, I have turned back to images, therefore, reading them intervisually, as signs and reactions to earlier images and thus as evidence for why and how Mao would be perceived through MaoArt.

MaoArt has changed dramatically in nature, but it has changed little in emotional impact. Mao represents running contradictions in Chinese history and politics. Although one cannot take him too personally in a charismatic, religious manner, he was significant and, at times, even omnipotent, but his importance waxed and waned over time, because the contradictions reflected in his image represent the contradictions that Chinese people have collectively undergone and are still trying to resolve. Recontextualizing Mao's image in myriad ways thus increases its aura and its ever-expanding emotional and intellectual appeal (Schrift 2001, 190).

Repeating Mao: MaoArt and Its Implied Audience

> If a 1979 statistic estimating the production of Mao's portraits during the Cultural Revolution at 2.2 billion—three copies for every citizen—is accurate, then the standardized image of Mao, best known in the West because of its prominent position as the frontispiece of the *Little Red Book* and through Andy Warhol's remake of the 1970s, may be the single most reproduced portrait in human history. (DalLago 1999, 48)

In his seminal essay of 1936, "The work of art in the age of mechanical reproduction,"[7] Walter Benjamin decries the art work's loss of "aura" through repetition. In his view, mechanical (or better, technical) reproduction degrades the art work. Instead of being singular and unique, it becomes one among many other reproductions of itself. Instead of being appreciated precisely for its rarity (*Kultwert*), it is now praised for being displayable and displayed (*Ausstellungswert*) (Benjamin 1963, 18–19). It thus becomes—and in Benjamin's terms, this is the beginning of its decline—popular. It becomes an object to be attained by anyone (ibid., 15, 29). At the same time, the art work is produced no more for the viewer to concentrate and become absorbed in it (*Versenkung/ Sammlung*) but to distract and divert (*Ablenkung/Zerstreuung*) (ibid., 38, 40). And thus, it allows no longer for independent thinking. To illustrate this point, Benjamin quotes the French writer Georges Duhamel (1884–1966) in his attack on cinema—one of those art forms, next to photography, that are, according to Benjamin, structured by repetition and mass reproduction. Duhamel complains: "I can no longer think what I want to think. Those moving pictures have substituted my own thoughts" (Duhamel 1930, 52). Benjamin concludes that through mechanical reproduction, the special ritual foundation of the art work is replaced by and becomes part of daily politics (Benjamin 1963, 18). Thus politics is aestheticized (*Ästhetisierung der Politik*) or art politicized (*Politisierung der Kunst*) (ibid., 44).[8]

All of this has much to do with MaoArt in revolutionary China, although at times in inverse mode. Quite obviously, the choreographers of China's revolution did not believe in the art work's loss of "aura" through repetition. Their unquestioning belief in modernization would also not

7. See Benjamin 1963. For a critique, see *Mapping Benjamin* 2003.
8. Benjamin associates the *Ästhetisierung der Politik* with Fascism, the *Politisierung der Kunst* with Communism. In the case of the MaoArt, however, discussed here, both descriptions appear to apply.

[handwritten marginalia: "Different Definition of art; purposed in introduction" and "Idea of the autonomous or individual artwork; elitist"]

allow for the idea that mechanical reproduction degraded an art work. And in their particular ideological understanding, an art work was worthy precisely when it was not singular and unique, or appreciated for its rarity, but when it was displayable and displayed to everyone. For this is how a work of art becomes popular—and in terms of Maoist ideology, this is its only *raison d'etre*. Only when the art work becomes an object to be attained by everyone and anyone does it serve the masses and can, therefore, be called a worthy piece of art. According to this ideology—which is habitually traced back to Mao's 1942 *Yan'an Talks*—such "popular" art is produced both to captivate and to absorb but also to distract and to divert the viewer. While Maoist ideology would not admit that, as such, MaoArt allows no longer for independent thinking but actually prescribes particular meanings to the interpretive community, it would emphatically agree with the idea that the special ritual foundation of the once exclusively bourgeois art work is now put to the service of daily politics. Mao becomes a substitute ritual object precisely because he is being reproduced so many times, and art is thus politicized and politics aestheticized in China.

Repetition?

> She: Everybody was happy to take part in some kind of an activity, so we would paint Mao's image all over the place, on any kind of wall, etc. Those paintings are just like advertisements today; this was their function. Painting them was not really dangerous. There would be a few students together, and they would paint such a picture. In the countryside, in the factory, we would take part in these "Red Propaganda" [红色宣传] activities, as they were called. He: You had to paint Mao in a particular way, a bit more prominent [突出 *tuchu*], otherwise you would be criticized. It was very political. (Businesswoman and Husband, mid-1940s–)

The period during which political aesthetics peaked in China was the Cultural Revolution: reproduction and repetition with always one and the same meaning are important hallmarks of Cultural Revolution Culture generally. One of the most important visual motifs during this period was Mao. I will discuss here a series of eight "model images" (八个样板画 *bage yangbanhua*) selected in analogy to the mythical eight "model works."[9] All of them were disseminated to a larger audience in the form of propaganda posters, at national exhibitions, or through application on all kinds of everyday goods— from stamps to paper money, from handbags to snack wrappers. I have chosen eight examples typical of Cultural Revolution style. The first in this random set is one actually declared to be a "model image" (样板画 *yangbanhua*): it is titled *Chairman Mao Goes to Anyuan* and shows a stately Mao in scholar's gown on his way to the mining town of Anyuan in eastern Hunan to support workers on strike there. Painted in 1967, it is, arguably, one of the most visible images during the Cultural Revolution (**ill. 5.1**).

ill. 5.1 Liu Chunhua's *Mao Goes to Anyuan*, ca. 1968 (IISH Stefan R. Landsberger Collection).

9. Chapter 1 has a discussion of the uses of this phrase: there were actually eighteen model works by the end of the Cultural Revolution.

ill. 5.2 Mao the Sun in Red Guard
Materials, 1967 (*Gongnongbin zengkan*
工农宾 (增刊) 1967.9 HWBZL 1980
Suppl. 1 vol. II, 681–728, here 683).

ill. 5.3 Propaganda poster depicting Mao the Sun, 1968
(DACHS 2009 Landsberger Mao Cult).

ill. 5.4 *Attack the Headquarters, Hail the Victory of the Great
Proletarian Cultural Revolution*, ca. 1968–69 (DACHS 2012
Propaganda Poster).

The second sample image, taken from a 1967 Red Guard publication (**ill. 5.2**), is a typical depiction of Mao as the sun. This type of image was, like all the others in this selection, quite ubiquitous.[10] Mao towers over his loving people, who appear schematized as symbols: they are often sunflowers inscribed with the character 忠 for loyalty.[11] The sample contains another such image, a 1968 propaganda poster (**ill. 5.3**).

Mao would, in many depictions, appear in giant size, not unlike a god, suspended in the sky, as an otherworldly, powerful guide overlooking and helping the revolutionary activities of his people: In a 1968–69 painting entitled *Attack the Headquarters, Hail the Victory of the Great Proletarian Cultural Revolution* (炮司令部, 无产阶级文化大革命全面胜利万岁) he holds a red brush in his hand and is writing propaganda slogans. His people in turn appear minute in size, washed in the red of the *Little Red Books* and flags they are waving (**ill. 5.4**).[12] Mao's power to show the way and to lead the teeming masses is emphasized here. Each one of these four images is typical of what was produced in the early phase of the Cultural Revolution: Mao appears, by size or by symbolic abstraction, quite apart from his people, otherworldly.

10. Depictions of Mao as the sun appeared on porcelainware, as book illustrations, on certificates, and more. For a variety of images on different materials, see Shen 2004; Shen 2006a; Xu 2006; and HRA 2008 The Sun. See also M. Wang and Yan 2000, 19; as well as HEIDicon 52579, 52570, 52613, 52802, 52582.
11. For comparative images on porcelain, for example, see HEIDicon, 5320.
12. For many similar images see Zhang 1994, plates 151–55.

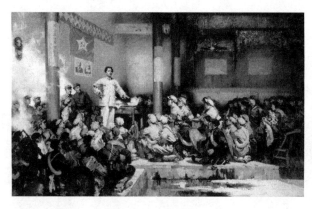

ill. 5.5 He Kongde, *The Gutian Conference*, 1970s (Andrews 1994, 361).

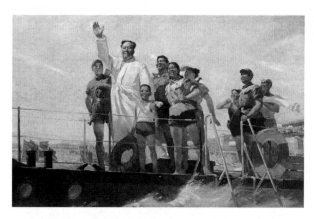

ill. 5.6 Tang Xiaohe and Cheng Li, *Forging ahead in Wind and Waves*, 1972 (IISH Stefan R. Landsberger Collection).

This is not the only mode of depicting him, however. An oil painting by He Kongde 何孔德 (1925–2003) from the early 1970s shows a very "worldly" young Mao mingling with his comrades at the Gutian Conference (**ill. 5.5**). Held in December 1929, this was the meeting at which the first policies concerning artistic production and theory were voiced.[13] The painting *Forging ahead in Wind and Waves* (在大风大浪中前进), on the other hand, created by painting couple Tang Xiaohe 唐小禾 (1941–) and Cheng Li 程犁 (1941–), shows a more mature Mao on a boat, in bathrobe, surrounded by youths and children after his famous Yangzi river swim of July 16, 1966 (**ill. 5.6**).[14] Versions of both of these images were produced in 1972 and displayed at the national exhibition in the same year (to commemorate the anniversary of Mao's *Yan'an Talks*, Andrews 1994, 360f.); the latter work even gave the 1972 national exhibit of revolutionary posters its name.

Other later portrayals also capture the intimacy typical of images of Mao in which he is visually brought very close to the masses and becomes "one of them plain folks" (HRA 2008 "Family" Situations). I have chosen two such pictures from the mid-1970s as part of my group of eight. One is entitled *The Growth of All Things Depends on the Sun* (万物生长靠太阳). It shows a large crowd of peasants in a cotton field, all beaming at Mao as he holds some cotton in one of his arms and a little girl in the other (**ill. 5.7**). Another, *The Hearts of Yan'an's Sons and Daughters Turn to Chairman Mao* (延安儿女心向毛主席), shows Mao receiving a small group of peasants from Yan'an. They are all sitting around a small table, intently focused on him (**ill. 5.8**).

Mao appears, in all of these depictions, either apart or among the masses, either old or young, in one and the same pose and character—red (红 *hong*), bright (光 *guang*), and shining (亮 *liang*)—conventions that go beyond those imported from Soviet art and that were refined during the Red Guard art movement and perpetuated through model books written to teach both laymen and

13. It was at this meeting that singing revolutionary songs became an integral part of cadre training (Wong 1984, 121), and the revolutionary song *The Three Main Rules of Discipline and the Eight Points for Attention* was endorsed as a Party song (Bryant 2007, 89).

14. For documentation of the use of this image in photographs supporting propaganda actions during the Cultural Revolution, see DACHS 2009 Documentary Photographs, Cultural Revolution, Swimming Mao, Thomas Hahn.

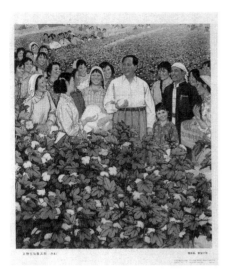

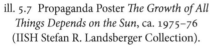

ill. 5.7 Propaganda Poster *The Growth of All
Things Depends on the Sun*, ca. 1975–76
(IISH Stefan R. Landsberger Collection).

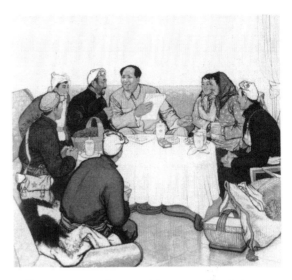

ill. 5.8 Propaganda Poster *The Hearts of Yan'an's Sons
and Daughters Turn to Chairman Mao*, 1974
(Andrews 1994, 363).

professionals how (not) to paint (Andrews 1994, 321ff., King and Walls 2010, 9–10; see ill. 5.9).
Two interviewees remember being involved in painting Mao and adhering to these rules:

> I did not paint a lot of Mao images, but we did woodcuts. There were these books with models that one
> could use. Mao had to be red, bright, and shining; there could not be any black in the pictures. (Artist,
> 1954–)

> We had to paint him in the same manner all the time; one's work was always checked at the end, before
> it was accepted. When you were about to finish, they would come and look at it. When I was painting,
> of course, I had some kind of a model to paint from, and, of course, I would paint it red, bright, and
> shining. (Musicologist, 1950s–)

How to achieve the qualities of red, bright, and shining? The images are illuminated in such a way
as to imply that Mao is the primary source of light. In the more obvious cases, sun rays actually
emanate from his head (**ills. 5.2** and **5.3**) or his cheeks shine brightly, as in the oil painting-turned-
propaganda-poster of his dip into the Yangzi (**ill. 5.6**) and the ink painting *Yan'an's Children*
(**ill. 5.8**); in the more subtle cases, all surfaces facing him appear to be illuminated. In this way,
slogans such as "Mao is the sun in our hearts" (毛是我们心中的太阳) are turned into visible
evidence (Andrews 1994, 360).

In all these depictions, Mao comes along with a strong-featured, well-balanced face—most
meticulously executed according to exact standards and directives, his flesh modeled in red and
other warm tones, his face "divisible into three equal sections, and his pigmentation following the
chromatic sequence in a color chart issued for that purpose." Peasant painter Tang Muli 汤沐黎
(1947–) explains that "pure red" had to be used, "burnt sienna for shading, and yellow ochre for
highlights. Blue and green must never be used on the face and the paint squeezed on one's palette
should be organized in a specific order, with cool colors in the least accessible spot." Indeed, cool
colors were to be avoided altogether in painting Mao, and those who did not abide by this rule
would be held responsible for their carelessness (Andrews 1994, 355–56). One art historian
remembers:

I painted Mao in school. When there would be a criticism session, I would paint. But there was a lot one had to be careful about. I had a family, so really, I had to be careful. But we all knew the rules. So we *were* very careful. And then, there was no problem about painting Mao. One of my father's students, however, whom he liked very much, was painting a bit absentmindedly [糊涂 *hutu*] one day. He painted a huge Mao. The color was like that of the propaganda posters, but for some reason when the image was printed, the body was somehow blackened. He was doomed—became a "black painter" who painted "black paintings" [黑画的画家 *heihua de huajia*]. It was not his fault. The black came out when it was printed, so it was really not his intention. But he recalls this story even today. And since my daughter keeps asking about how people died during the Cultural Revolution... I told her this story. There are many stories from that time which one just cannot believe today. (Art Historian, 1940–)

Readers may recall the 1967 caricature discussed in Chapter 2 in which a painter who attempts to darken a painting of the sun with black paint is himself covered with the paint, making him, literally, into a "black painter" (see **ill. 2.10**).

There were many other rules for how (not) to paint Mao. Conspicuous displays of brushwork, for example, were not acceptable, and especially "Mao's face should be smooth in appearance" (Andrews 1994, 360). Accordingly, it was a regular procedure for Mao's face to be touched up or even repainted completely by professionals for that purpose (ibid., 321). The most obvious example for this practice in my sample is that of the Gutian Conference (**ill. 5.5**), where Mao's face appears strikingly smoother (likely touched up by an "oil painting correction group") than the rest of the painting, which is executed in rather rough brushwork.[15] Otherwise, however, the painting adheres to Cultural Revolution standards: red tonalities dominate, and Mao is the brightest figure in the set (ibid., 360).

In all of these depictions, Mao stands out prominently; he is a stately figure, "lofty, grand, and complete" (高大全 *gao da quan*)—another mandatory trio from the toolbox of "Revolutionary Realism and Revolutionary Romanticism" (Yan 2008, 98). He stands with straight back and fixed gaze, calm and confident, always in a state of being rather than becoming. This pose is typical in totalitarian art generally, where it is also common to see a group of peasants, for example (**ills. 5.7 and 5.8**), or a crowd of young demonstrators, soldiers, or Party members (**ills. 5.4 and 5.5**) perhaps surrounded by nature (**ills. 5.1–3**), themselves all in a state of becoming (like their hero), moving along (to a better future).[16]

Mao's gestures suggest confidence and determination: his hand may form a fist (**ills. 5.1 and 5.7**), it may be raised high up into the skies (**ills. 5.2, 5.4, 5.6.**), it may be folded leisurely, propped into his waist (**ills. 5.3, 5.5**), or it may be holding some significant, symbolic objects: the fruit whose growth he supports as the Chinese sun, for example, and the book with which he instructs his "children" in Yan'an (**ills. 5.7, 5.8**). Mao looks either out of the picture, into the viewer's face, or, with his eyes slightly raised, into the grand and glorious future. All of these images convey the same message and depict one and the same Mao: Mao as superlative—the biggest and the greatest, Mao as the most important leader of the Chinese revolution who knows how and where to direct his country, always and for everyone. These pictures appeal to their implied audience to believe in and trust this bright and brilliant, strong and sturdy Mao.

In order to convey this message and to adequately describe Mao as the all-encompassing leader, these pictures tend to "generalize" Mao. In the more extreme cases, Mao becomes a mere decorative

15. He Kongde, the portrait's painter, was a member of the PLA and thus, as a successful soldier-painter-cum-professional, a pivotal figure in supporting government propaganda that advocated art from the masses for the masses (Andrews 1994, 360).

16. For examples from Stalinist art see Plamper 2003, 27; Clark 2003, 13.

symbol: the benevolent sun (as in **ills. 5.2** and **5.3**). Overall, Mao is portrayed not as an individual who changes and develops but as a standardized pattern. There is one way of depicting the young (as in **ills. 5.1** and **5.5**, or ill. 5.10) and another of depicting the mature, aged but timeless Mao (as in all the other images from the set and ill. 5.11). Even in pictures referring to specific events, such as Mao's trip to Anyuan in 1921 (**ill. 5.1**), Mao at the Gutian Conference in 1929 (**ill. 5.5**), or Mao swimming in July of 1966 (**ill. 5.6**), Mao the pattern—and not Mao the historical figure—is depicted. Moreover, many of these pictures, even those that refer back to particular historical events, are given stereotyped settings and vague backdrops, thus attaining a transcendent quality, as in the procession in gouache (**ill. 5.4**) as well as the depictions of Mao in bathrobe (**ill. 5.6**), visiting workers in the fields (**ill. 5.7**), or sitting in a peasant family's living room (**ill. 5.8**).

This point becomes most obvious, perhaps, in the case of the Anyuan painting (**ill. 5.1**). Clearly, although the picture is supposed to document Mao's historical first visit to Anyuan, the genre of history painting is here severed "from its mundane ties to an identifiable physical setting," and thus, as Julia Andrews puts it, "it doesn't matter where Mao is or what he is doing, for the transcendent nobility of his cause and character are clear" (1994, 339). The historical background to this picture is the hugely successful 1922 Anyuan miners' strike in Jiangxi, during which some 13,000 miners and 1,000 railway workers walked off their jobs together. After a five-day peaceful strike, with no loss of life, no injuries, and no serious property damage, negotiations brought higher wages, better working conditions, and a guarantee of security and financial backing for the newly founded labor union and workers' consumer cooperative, which the mining company had formerly threatened to close. The event is one of the most important legends in Chinese revolutionary history.

Of the three political figures active at the time—Li Lisan 李立三 (1899–1967), Liu Shaoqi 刘少奇 (1898–1969), and Mao Zedong—Mao was, undoubtedly, the least directly involved. Li Lisan opened a school for workers and their children in Anyuan (purportedly at Mao's suggestion), and this ignited a flame leading to the formation of the labor union and the organization of the strike. Liu Shaoqi was sent (apparently by Mao) to Anyuan when the school was forced to close to prevent mass violence, and he personally took part in the strikes there. Mao himself merely served, quite literally, as the "remote control" of the events.[17]

Nevertheless, Mao becomes the unquestioned hero of the story in the famous Anyuan painting by Liu Chunhua.[18] It was originally painted in response to an earlier 1961 depiction of the events by Hou Yimin 侯一民 (1930–), which had been exhibited at the Museum of Chinese Revolutionary History, but was attacked as a "poisonous weed" in 1967 and reportedly destroyed after Liu Shaoqi (who figures prominently in this depiction) was condemned as a traitor and capitalist roader.[19] The painting (ill. 5.12) shows Liu Shaoqi in the very center of a huge group of fierce-looking workers—men and boys—all striding forward menacingly, determined to stand united against their exploiters. Liu's central status is emphasized not just by his position, both close to but surrounded by the group of workers, but also by his bright shirt and face, which become the source of light in the painting reflected on the bodies and faces of those around him. Here, visually speaking, it is Liu, not Mao, who is the people's "sun."[20]

17. M. Wang and Yan 2000, 56–57; Perry 2008, 1150–53.
18. Liu's name was actually Liu Chenghua 刘成华, but when his Mao portrait was printed for distribution in the most important national newspapers in the summer of 1967, his name had been misprinted in hundreds of thousands of copies as Liu Chunhua 刘春华, which is why the painter decided to stick with the "new" name (Zheng 2008, 128).
19. Galikowski 1998, 150–51; Andrews 2010, 40–41.
20. This impression was apparently also given in a 1962 feature film covering the Anyuan strikes entitled *Prairie Fire* (燎原 *Liaoyuan*). See DACHS 2009 Anyuan Strikes; Galikowski 1998, 150.

As a response, a group of Red Guards in Beijing arranged an exhibition in the fall of 1967 under the title *The Brilliance of Mao Zedong Thought Illuminates the Anyuan Workers' Movement* (毛泽东思想的光辉照亮了安源工人运动展览会) (Zheng 2008, 119). A large group of artists was dispatched to the mine in Anyuan to "dig deep into life" (深入生活) and to talk with veteran miners about their past revolutionary activities (ibid., 122). Liu Chunhua then created his large painting, 2.2 meters in length and 1.8 meters in width, which made him a celebrity overnight (**ill. 5.1**). The painting was inspired, as the artist relates in perfect Maoist lore, by a folk song: "In the year 1921, the clouds suddenly cleared and we saw the blue sky: A man of ability named Mao Runzhi (i.e. Mao Zedong) traveled from Hunan and came to Anyuan" (直到一九二一年, 忽然雾散见晴天. 有个能人毛润之打从湘南来安源) (M. Wang & Yan 2000, 59; Zheng 2008, 123; Andrews 2010, 43).[21]

The new Anyuan painting, arguably the most famous of Cultural Revolution paintings, moved the emphasis away from the event itself to its origins. It was the message of this painting that Mao was the source of all the good fortune that was to come: he had visited Anyuan in the fall of 1921 and had discovered among the people enthusiasm about free education. He had consequently sent Li Lisan to build a school and teach there, and had thus initiated the creation of a base for the labor union and the workers' cooperative, which later became the impetus for the strike. It was Mao's wise strategy, then, his ideas, that had brought victory to the workers at Anyuan, so the painting insinuates.

It would be officially declared a model painting by 1968, when it was inserted as a full-color poster and circulated with copies of some of the most important Party publications, such as *People's Daily* and the military newspaper *Liberation Army Daily* (Yan 2008, 92), on July 1 to mark the anniversary of the founding of the Chinese Communist Party. Further reprints of the image appeared on the pages of Party publications such as the Party theory magazine *Red Flag* on July 1 and, a few days later, the daily *Dazhong Ribao* as well (ill. 5.13; DZRB 1968).[22] The *Dazhong Ribao* caption praises Mao who, like the sun, "shines everywhere and wherever the sun shines, it is bright" (an allusion to a line from the third verse in "Red Is the East"). It was in 1921, the caption continues, when "our great leader Chairman Mao went, on foot, to Anyuan. Ah, Chairman Mao, Chairman Mao: you have personally lit the flame of Anyuan's revolution. Great Leader, Chairman Mao, Ah! It is you who opened a path for China's revolution" (红太阳照四方照到哪里哪亮. 一九二一年秋, 我们伟大导师毛主席步行去安源. 毛主席啊, 毛主席! 是您亲手把安源的革命烈火点燃. 伟大领袖毛主席啊! 是您把中国革命航道开创).[23]

The image (and more conspicuously, its title and captions) thus remakes history by stressing the importance of Mao's visit to Anyuan for the later unfolding of events. At the same time, it negates history by representing Mao before a background that is no more fixed to a specific place or area than any other: Mao, the godlike savior, is present everywhere. This is what the painter of the image says, too:

> Scenes such as Chairman Mao visiting the coal-washing tower and the workers' quarters and canteen all had a strong local flavor. But these scenes would require the inclusion of other figures, and it would be difficult to keep the focus on the Chairman. It also occurred to me that the significance of the

21. For a reproduction on a stamp, see DACHS 2009 Mao Goes to Anyuan Stamp.

22. Many authors mention that *People's Daily* not only distributed free copies but also printed the image on July 1. A check of both the online database edition of RMRB and the paper version does not show these editions to contain the image in the first days of July, however.

23. *Red Flag*, when publishing the image on July 1, 1968, only slightly rephrased its caption: 一九二一年秋, 我们伟大导师毛主席步行去安源, 亲自点燃了安源的革命烈火 (In the fall of 1921, our great leader Chairman Mao, went, on foot, to Anyuan. He personally lit the flame of Anyuan's revolution).

Chairman's going to Anyuan was not so much that he went to that particular place, but rather that he went to be among the working masses, and from them he was moving toward the entire nation. In light of this, it wouldn't do for the scope of the painting to be confined to Anyuan. (Zheng 2008, 123)

Mao is thus painted on a mountain ridge that could be anywhere in China (or even elsewhere, as the interpretation of foreign and Chinese intervisualities below will show). The image sets the tone for an important iconographic element in depictions of Mao: the artificially arranged clouds, which now begin to appear more and more often in propaganda paintings of Mao "to allow nature to echo Mao's movements," as Julia Andrews (1994, 339) describes it, or, as the painter himself states, to express "the winds of revolution" (Zheng 2008, 123). By repeating a decontextualized and somehow transcendent stereotype rather than a figure historicized and localized, fixed in time and space, Mao's appeal and his claim to greatness is universalized, and he becomes the true hyperbolic and superhuman image familiar from that famous Cultural Revolution song "Red Is the East." He is, indeed, the "red red sun" and the "savior of the people," and this is supposed to be inscribed in the minds of the implied audience. Liu Chunhua summarizes the logic behind his painting as follows (quoting—not purely by coincidence—a familiar phrase from the story of the Foolish Old Man, fashioning Mao into a "maker of a road where there was none"):

We placed Chairman Mao in the forefront of the painting, tranquil, far-sighted and advancing towards us like a rising sun bringing hope to the people. We strove to give every line of his figure significance. His head held high and slightly turned conveys his revolutionary spirit, dauntless before danger and violence, courageous in struggle and daring to win. His clenched fist depicts his revolutionary will, *fearless of sacrifice, determined to surmount every difficulty* to free China and mankind, confident in victory. The old umbrella under his arm reveals his style of hard work and plain living, travelling in all weather over great distances, across mountains and rivers, for the revolutionary cause. Striding firmly over rugged terrain, Chairman Mao is seen blazing the trail for us, breaking past obstacles in the way of our advance and leading us forward in victory. The rising autumn wind, blowing his long hair and billowing his plain long gown, is the harbinger of the approaching revolutionary storm. A background of swift-moving clouds indicates that Chairman Mao is arriving in Anyuan at a moment of sharp class struggle, contrasting even more sharply with his calm and firm confidence. (Liu 1968, 5–6)

I have argued that the images in my sample are repetitions of one and the same stereotyped pattern: they are Mao, Mao, and Mao again, they depict a stereotype, a universalized symbol. Yet, one could look at these same images and give an entirely different interpretation. Instead of emphasizing their repetitive quality, as featuring one and the same major protagonist in one and the same superior pose and manner, one could stress that there is considerable variation among the images in terms of artistic style and techniques, for example. Liu Chunhua's Mao of 1967 is painted in oil (ill. 5.1). The Red Guard's Mao (ill. 5.2) is a woodcut figure for which templates could be obtained everywhere (ill. 5.9). The propaganda poster of 1968 depicting Mao as the sun can be read as an attempt to combine popular painting styles such as New Year Prints (年画 *nianhua*), with their highly stylized depictions of plants and animals, with "modern" woodcut and realist painting templates (ill. 5.3). The poster depicting Mao, the gigantic and triumphant guide to the masses of marching Red Guards (ill. 5.4), goes back to an anonymous painting in watercolor, a technique largely derived from European models but also used in Chinese peasant painting. *The Gutian Conference* (ill. 5.5) and the painting of Mao after his famous Yangzi swim (ill. 5.6), both composed in 1972, are typical examples of socialist realist adaptations of traditional European history paintings in oil, a style sold under the label of "Revolutionary Realism and Revolutionary Romanticism in China." The painting of Mao as the cause of bounteous harvests in the countryside *The Growth of All Things Depends on the Sun* (ill. 5.8), on the other hand, with its elaborate

depiction of plants and lush leaves, is held in the style of a Chinese New Year Print and thus takes up some of the native traditions of popular peasant paintings (ill. 5.14).[24] A significant element of realism is added in the sample picture, however. Finally, Mao with "Yan'an's sons and daughters" (**ill. 5.8**), painted by a "Shaanxi Municipal Art Creation Group" in 1973, most probably under the direction of Liu Wenxi 刘文西 (1933–), takes up the "new" New Year Prints movement of the early 1950s in which leaders were portrayed as close to the masses.[25]

Cultural Revolution art, and with it officially acknowledged MaoArt, then, is a mixed bag of many different styles, and each of the images themselves can be considered a peculiar and particular combination of only apparently missing stylistic links (caused by a more or less xenophobic as well as an idiophobic ideology prevalent throughout parts of the Cultural Revolution) as it juxtaposed, quite paradoxically, elements appropriated from both foreign and Chinese artistic heritage and style. So, on the one hand, the plasters at the Central Academy of Fine Arts, which included such works as Michelangelo's (1475–1564) *David* or the *Venus de Milo*, were destroyed in late August 1966 (Andrews 1994, 321–22). Yet, on the other hand, Liu Chunhua created a "model painting" when he took Raphael's *Sistine Madonna* (ca. 1513–14) as the major inspiration for his *Chairman Mao Goes to Anyuan* (ill. 5.15).

Although modernism was officially condemned as "bourgeois" during the Cultural Revolution, romanticist oil painting and (mildly) expressionist woodcut in the reconfigured style of socialist realism (or, in Chinese terms, "Revolutionary Realism and Revolutionary Romanticism") was evidently accepted. In the same manner, Chinese traditional painting techniques would be used, abandoned, proscribed, and then again reinvented in different phases during the Cultural Revolution years. Indeed, one of the most important directives for any artist in China during the Cultural Revolution was to produce the best "modern" art but with distinct national characteristics (民族性 *minzuxing*), always bearing in mind the class qualities of each of the elements employed. This directive goes back to Mao's *Yan'an Talks*.

If Liu Chunhua's Mao is modeled after a saintly figure from the European tradition, if there is indeed something of Raphael's *Sistine Madonna* in the movement of the feet and drapery of the gown, the background scenery and especially the structured mountains in Liu's work are more akin to Chinese landscape painting (ill. 5.16) than to European models. This Chinese element becomes all the more striking when we compare Liu's painting with a slightly earlier composition by Jin Shangyi 靳尚谊 (1938–) that, as Julia Andrews suggests, could well have stood as a model for Liu (**ill. 5.17**) and that recurs in many propaganda photographs (e.g., ill. 5.50).[26]

ill. 5.17 A predecessor to *Mao Goes to Anyuan*? Jin Shangyi's *Chairman Mao at Lushan*, 1966 (Andrews 1994, 341).

24. *Huxian* 1974; see also M. Wang and Yan 2000, 110–14; and Croizier 2010. The decorative Huxian variety of New Year Painting, quite akin to the depiction chosen as part of the sample here, has achieved international fame through a travelling exhibit in the mid-1970s.

25. For visual evidence, see DACHS 2009 New New Year Prints. A discussion is found in Landsberger 2002, 142–44.

26. In the image series by Thomas Hahn, it is seen in a rural home. See DACHS 2009 Documentary Photographs, Cultural Revolution, Sent-down Youth I, Thomas Hahn (p. 1, internal image no. 10).

Structurally, the two works are very similar in their design: they both present Mao as an overpowering figure on top of a mountain, with clouds and mountain peaks in the background echoing his movements. Yet, in the case of Jin, who depicts the older Mao in a Mao suit, the influence of the European model is much more evident: his mountains are flat, rolling, and smooth—much less rugged, cone-shaped, and sharp and thus far less akin to the Chinese landscape tradition (ill. 5.18). By adding iconographic elements from Chinese landscape painting into an oil composition in the style of "Revolutionary Realism and Revolutionary Romanticism," Liu, on the other hand, created the perfect synthesis, combining the best of European art with the best of China's traditions. The end result was a painting with apparently distinct national flavor—just as Mao had demanded in his *Yan'an Talks*.

The same result is achieved in woodblock prints like the Red Guard's 1967 depiction of Mao (the second image in the set, see **ill. 5.2**). Woodblock printing was an indigenous Chinese art form that had been modernized under the influence especially of German expressionism (the traditional heritage had little importance in China's modern woodcut movement). The movement was instigated, among others, by Lu Xun, one of the most important figures in the Chinese Communist cultural sphere according to Party lore.[27] By the 1940s, woodcut prints had become part of the Communist Party's "official art" (Andrews and Shen 1998, 213). To use this format was, once more, to adhere properly to the guidelines of creating contemporary Chinese art with Chinese flavor.

Mao as the sun of 1968 (**ill. 5.3**), on the other hand, is perhaps the most obvious example that propaganda did not necessarily achieve the most successful synthesis of elements from the two traditions. In this case, derivates from popular painting styles—the stylized sunflowers—are juxtaposed with elements from (almost photo-)realist painting—the Mao figure—but no attempt is made to adjust the two genres to complement each other. The piece was published as a propaganda poster, nevertheless: its message met with approval, and artistic quality does not necessarily determine propagandistic effect or success (although Mao would idealize this as the most effective art in his *Yan'an Talks*; see Mao 1942, 78).

The correct message is equally clear and dominant in the gigantic depiction of Mao as god of the marching processions (**ill. 5.4**). It is difficult to pin down exactly what is the distinctively "Chinese quality" of this painting, apart from the subject matter, Mao, the brush he holds, the Chinese characters dominating the picture, and perhaps the fact that water colors were also used extensively in peasant paintings. Nevertheless, the image certainly spoke the proper language: it was nothing but "red, bright, and shining" and, accordingly, an official success.

The same must be said both for the depictions, respectively, of Mao at the Gutian Conference and Mao in his bathrobe after the historic swim, both composed in 1972 (**ill. 5.5** and **5.6**). Both are immaculate depictions, in oil, in a (revolutionary) romanticist style, and both are successful despite their lack, stylistically speaking, of "national flavor." They are distinctly not "nationalized" oil paintings in which figures would be outlined or simplified in color to evoke the effects of a New Year (woodcut) Print, for example (Andrews 1998, 230). Yet they are "red, bright, and shining."

Chinese artistic elements are immediately recognized in the other two early 1970s pictures chosen for the set and showing Mao in the countryside (**ills. 5.7** and **5.8**). While the first takes up on the style of popular peasant paintings, which are dominated by repetitive natural elements, the second is a typical example of ink and color painting (彩墨画 *caimohua*), that is, a socialist realist

27. The modern woodcut movement introduced significant changes in the art form. For example, artists now carved and cut their own blocks rather than handing them on to a trusted professional carver as had been the practice traditionally (Andrews and Shen 1998, 213).

figure painting making use of Chinese material (ink and brush). It presents Mao with a group of peasants in ink and color on paper. The traditional black outlines of figures are largely retained, but chiaroscuro from the European tradition is added. Also retained is the plain and pale background from traditional practice, but added is a three-dimensionality of "European" descent in the picture's structural makeup (Andrews 1994, 363–64).

Each of these pictures, then, features different combinations of various artistic techniques and practices; each is a different answer to the straightjacket prescribed by Cultural Revolution artistic politics. In terms of style, it appears, then, that there is not just one and the same Mao reproduced and repeated again and again, but a different Mao for every taste and audience. For one such implied audience, he appears alone, in romantic harmony with nature; for another, he appears as one among many, in ink or oil, in intimate communion with the people.

Moreover, the many different groups of people depicted, all focusing on Mao, beaming towards him, even from very far apart—peasants, children and youths, Red Guards, revolutionary soldiers, men and women, young and old, all of which we have seen so far, and there are many others— these groups are references to the many implied audiences of these images. For however stereotyped the Mao figure itself appears, he still dresses differently for each occasion and for each implied audience: he is shown in scholar's gown and in bathrobe, in the official Sun Yatsen suit and in more casual wear. Thus, MaoArt during the Cultural Revolution featured Mao in many different materials and styles. Furthermore, each one of the Maos in our sample was in turn reproduced in a myriad of different formats, foremost among them posters, badges, and stamps, but also in things like cushions, cups, gift wrap, and clocks (see DACHS 2007 Mao Paraphernalia). There were, thus, manifold Maos for many different tastes, and they decorated all manner of things: living rooms, breasts, diaries, and letterheads.

Not to Be Repeated! Part 1: Modernisms?

> There are many images that simply could not be published. It was very obvious at that time: you could not just "paint Mao" but had to think about the implications all the time. (Intellectual, 1958–)

The Cultural Revolution had in store quite a few possible Maos, then, but it did not include others, presumably because they were not considered adequate to convey the one and only message to be believed during the time: that of Mao, the red, red sun and the savior of the people. In this section we will turn, therefore, to a number of images that would not have been circulated officially during the Cultural Revolution, and accordingly would not find their way onto porcelainware or propaganda posters. The question of "why exactly" this was so is more easily answered in some cases than in others (and it refers back to the many "Shall I's" which a composer would deliberate before starting to write a piece of music: in the same way, every painter needed to consider the "Shall I's" of artistic production).[28] The following discussion of Mao portraits from before and after the Cultural Revolution is an attempt to delineate what constituted an image's "right of existence" during the Cultural Revolution.

Mao is sitting at a long table together with a group of peasants in a 1946 woodblock print by Shi Lu 石鲁 (1919–82) entitled *Mao Zedong at the Heroes' Reception* (群英会) (ill. 5.19). Although Mao is the central focus of this image, the pictorial arrangement is not favorable to him: he is sitting slightly slack and awkward, and the very long rectangular room does not create a feeling of

28. These "Shall I's" are quoted in the Prologue to Part I.

intimacy and trust. Mao is obviously engaged in a friendly conversation with one of the peasants who has stood up and is gesticulating before Mao's open smile. Some of the peasants sitting close by are listening, some are carrying on their own conversations. In this image, Mao is depicted not as the unquestioned leader, the ravishing storyteller, but as himself an attentive audience. He sits there, slightly passive, relaxed, perhaps a bit too much at ease. This depiction is much different from what the following decades would bring. Shi himself, who had been experimenting with more

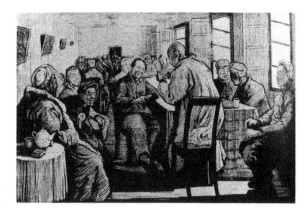

ill. 5.19 Shi Lu, *Mao Zedong at the Heroes' Reception*, 1946 (Andrews 1994, 108).

"revolutionary" (i.e., popular) art forms since his Yan'an days, admits to his inexperience with the woodcut technique at this point (Shi 1950, 30; Hawks 2003, 40; Andrews 1994, 106). The Mao he portrays is not the stately, serious, and—most importantly—dominating figure we are accustomed to from Cultural Revolution depictions.

A 1950 New Year Print (ill. 5.20) may have appeared equally problematic (from a propaganda point of view), in spite of the fact that it certainly puts Mao in a central position, even on a pedestal.[29] But in its naive primitiveness, doing what a New Year Print does—depicting the cheerful side of society—it presents not just the eight people surrounding Mao on right and left in mockery and sham—there are two soldiers moving along with movements that appear to be slightly too vigorous; two peasants apparently singing while trudging to the fields; two workers with their mouths wide open, also singing loudly, one with his hands in his pockets; and a woman sitting with an extremely straight back, reading to her child. The "Great Leader" himself, too, with his slightly deranged-looking body (the head, like a baby's, is much too large for the rest of the body), apppears as all but caricature. Not surprisingly, the picture was criticized soon after it was first produced (Wang 1950, 24); it would not have passed Cultural Revolution censors.

Chen Ziyun's 陈子云 (1931–) depiction of a young and scruffy Mao following an old man painted in 1959 illustrates some of the same "problems" although painted in an entirely different style, in oil (ill. 5.21). In the image, the old man, although much shorter than Mao, is clearly foregrounded, painted as the central focus of the image. He is *Leading the Way* (带路), as the picture is ambiguously entitled. He is moving confidently. He is comfortably clothed in pants, straw hat, and sandals, and his strong hands holding his walking stick are emphasized by the particular use of lighting, showing how he is striding forward energetically. Mao, on the other hand, follows him, looking quite worn and fatigued, wearing inappropriate shoes and holding up his cumbersome long gown. The scene depicts a moment just before the (disastrous) so-called Autumn Harvest Uprising (秋收起义 *Qiushou qiyi*) that Mao is said to have instigated in Hunan in 1927. A small army of peasants rebelled against the Nationalist Party and Hunan landlords. After the peasants were defeated, Mao and his supporters were forced to retreat to Jinggangshan, the remote mountains in the border region between Hunan and Jiangxi provinces. The image illustrates the closeness between Mao and the people, who are immediately willing to help him, as the narrative behind the image also explains: Mao took refuge with the old peasant who immediately

29. See Galikowski 1998, fig 2. On the history of the early PRC New Year Print movement from which this image stems, see Hung 2011, chap. 8.

took him on. The image thus shows Mao's ability and his willingness to make the people the heroes of history and thus accords with Maoist logic, but it does not make a heroic figure of Mao himself.

Accordingly, the implied audience for all of these pictures, by looking at them, could not be entirely convinced of Mao's superior qualities. With these early works of art, however, it is not likely that these "imperfections"—according to Cultural Revolution standards—in the depiction of Mao were purposeful and deliberate. Indeed, ongoing contemporary discussions illustrate amply the inadequacies some of the artists themselves saw in their portrayals. Although there was no explicit set of rules yet on how to paint Mao, some of these images were considered, even by the painters themselves, to be far from ideal.

ill. 5.22 Han Xin and Wei Jingshan,
With You in Charge, I Am at Ease, 1978
(Andrews 1994, 381, fig 132).

The situation is different with Han Xin 韩昕 (1955–) and Wei Jingshan's 魏景山 (1943–) 1978 painting *With You in Charge, I Am at Ease* (你办事，我放心), a realist depiction of Mao completed shortly before his death and painted after the last published photo of him (**ill. 5.22**). A very conscious depiction of Mao, it is somehow even less flattering than any of the images discussed so far. Smiling gleefully, Hua Guofeng is seen standing to the right of Mao, towering over him (and thus somehow leaving him in the shadow, in spite of Mao's brighter suit) and holding—or rather, supporting—his limp hand. Hua's depiction is a sharp contrast to that of "helpless Mao Zedong," who seems to foolishly want to look at the piece of paper he himself has written for Hua stating, "With you in charge, I am at ease" (Andrews 1994, 382). Quite obviously, none of the Cultural Revolution directives of "red, bright, and shining" are adhered to here, although they reigned dominant in Mao portraits of the time. This is clear when one compares Han Xin and Wei Jingshan's image to a 1977 version on the same theme by Peng Bin 彭彬 (1927–) and Jin Shangyi, which became the blueprint for huge propaganda posters seen throughout China after 1977.[30] Here, Mao and Hua are both seated, which makes their positions more equal than in Han Xin and Wei Jingshan's depiction, where Hua is clearly foregrounded. In the 1977 depiction, Mao's prominence is further emphasized by the use of a brighter suit and the placement of his enormously large hand, the central focus of the image, firmly on top of Hua's, as he is the one who thus draws on Mao's strength and not vice versa. A ray of light emanating from Mao illuminates Hua's face, the papers in his hand, and the table next to him (which is half-shaded by a shadow to stress the "sun-effect" associated with Mao). As in the other portrayal, the Chairman is seen here putting Hua "in charge," entrusting him with his own duties; yet here, he is the one who reigns supreme (**ill. 5.23**). Quite in contrast, Mao is not a stately and dominating figure in Han Xin and Wei Jingshan's depiction. His face is certainly not smooth but rather emaciated, pale, and sickly—he is anything but a radiant source of light.

30. *China* 2008, 58 has a photograph of the poster on Shanghai's bund. See also DACHS 2009 Mao Images for another, again more orthodox, version of this picture created by Zhang Huaqing 张华清 (1932–) in 1976.

Although commissioned and approved in draft for a Shanghai municipal exhibition, the painting would eventually not pass muster as "correct art" even in 1978. The two painters must have felt that, with the end of the Cultural Revolution, a new age of realism had arrived, when they created this slightly frivolous version, perhaps, of a revolutionary realist painting. While, the painting was in fact installed in the exhibition according to plan, the local administration removed it the night before the opening. For Mao's portrait, the visual norm remained, even after the Cultural Revolution, one not of realism but of "total realism," of "factionality," and thus of romantic idealization (Andrews 1994, 382).

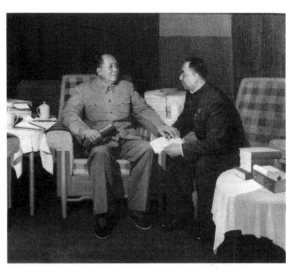

ill. 5.23 Peng Bin and Jin Shangyi, *With You in Charge, I Am at Ease*, 1977 (Andrews 1994, 380, fig 131).

It is important to see, however, that although the painting did not escape censorship then, while the artists' conviction that it just might do so shows that the implied audience of MaoArt after the end of the Cultural Revolution was no longer clear-cut. Some of the Mao portraits created in the 1980s and 1990s may illustrate this fact (ill 5.24, **ills. 5.25-5.27**): they purposely play with the idealized, perfect form and figure of Mao portraiture from the Cultural Revolution by citing it. Yet, the message has clearly changed.

It is not form but color and technique that would have made the flower-patterned, deliberately double-misprinted citation of an official portrait of *Mao at Tian'anmen* (毛泽东在天安门城楼上), painted in oil by Yu Youhan 余友涵 (1943–) in 1989, unacceptable by Cultural Revolution standards (ill. 5.24). As during the Cultural Revolution, Mao's image is obviously aestheticized here. With its open colors of light blue and army green (good colors in traditional operatic terms, as will be remembered), it could even be considered "bright and shining"—if not "red." Much unlike depictions proliferating during the Cultural Revolution, however, this portrait introduces an aesthetics not of Chinese revolutionary but of commercial, of "capitalist," popular culture, as well as PopArt (probably reflecting the 1985 Rauschenberg exhibition in Beijing). Due to the deliberate misprinting of the flower pattern, Mao's face is not entirely focused, and his features are white—he even shows off an "advertising smile." It is this hyperbole, in combination with the fuzziness created by the multiple patterns, that somehow points to the farcical quality of political propaganda.[31] On the other hand, it plays with and at the same time ridicules the obvious similarities between commercial art and propaganda (i.e., the use of techniques of "Revolutionary Realism and Revolutionary Romanticism"—which Yu Youhan unmasks elsewhere in his oeuvre as "Westernization").[32] The implied audience for a picture such as this has fallen precisely for the appeal of this—now unmasked—aesthetic double bind, which Yu repeatedly dissects in his paintings.[33]

31. DalLago 1999, 51. DalLago also discusses other images by Yu Youhan.
32. See, for instance, his use of a blond girl in *Mao and the Blonde Girl Analysed* (向世界招手).
33. Another interesting example is his *Mao and Whitney* (毛与惠特尼), painted in 1988, which juxtaposes Mao and American popular singer Whitney Houston. The two images mark the similarities in public image making in propaganda and in commerce.

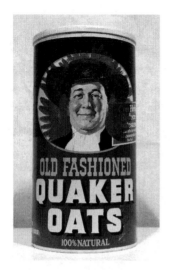

ill. 5.25 Zhang Hongtu, *Quaker Oats Mao*, 1987 (DACHS 2008 Zhang Hongtu).

The same somewhat paradoxical connection between mass culture and propaganda culture recurs in Zhang Hongtu's 张宏图 (1943–) *Quaker Oats Mao*, composed in 1987 (**ill. 5.25**). What we see is a can of "Old-Fashioned Quaker Oats" with (not quite) Quaker Man adorning it. The original Quaker Man's dark broad-brimmed bowler hat and his white curly hair is retouched in red. He is now wearing the green Mao Cap with a red star, and, most importantly, sun rays are emanating from his head. To thus associate Mao with a prime product of American capitalism—Quaker is one of the four largest consumer goods companies in the world, with a presence in China of a good century, and the Quaker Man was America's first registered trademark for a breakfast cereal in 1877—not to mention ethical and religious values, rather than the proletarian revolution, would of course have been out of order completely within a Cultural Revolution context. But even after the Cultural Revolution, this image appears slightly frivolous.

Zhu Wei's 朱伟 (1966–) reconfiguration of Mao as rock musician Cui Jian, complete with blindfold made of red cloth, in no. 16 of his *China Diary* (中国日记十六号) collection (1995–2002) alludes to that famous (censored) song *A Piece of Red Cloth* (一块红布) by Cui Jian (discussed in Chapter 2), which may be read as both a love song and a political song about a youthful love for Mao, the scorching sun, who turns out to be much less a savior bringing happiness than a dangerous master. It was mentioned in the last chapter that Wang Shuo had once called the Cultural Revolution "a rock 'n' roll concert with Mao as top rocker and the rest of the Chinese as his fans" (Huot 2000, 59): Zhu Wei illustrates precisely this sentiment (**ill. 5.26**). Mao with his characteristic mole, blue suit, and red armband—which does not read "Red Guard" but "Pink Floyd," a group Cui Jian considered one of the best bands in the history of rock[34]—stands at the microphone, with his hands in his pockets, himself slipping into the role of both enthusiast and accuser, singing:

> That day you used a piece of red cloth
> To blindfold my eyes and cover up the sky
> You asked me what I had seen
> I said I saw happiness (幸福). . . .

The painting's effect builds on incongruities: between Mao and the rock singer accusing him of delusion, between new paraphernalia like micro-phone and electronic guitar and the old dress and hairstyle of the guitar player in the back, between a contemporary theme and traditional painting styles (Zhu Wei uses the *gongbi* [工笔] technique, a modern term for fine outline and color painting,

ill. 5.26 Mao as rocker Cui Jian: Zhu Wei *China Diary, no. 16*, 1996 (Zhu 1996).

34. DACHS 2009 Cui Jian Pink Floyd.

distinguished from *xieyi* [写意] or *cubi* [粗笔] technique, which denotes loosely brushed ink painting). Zhu Wei is known for creating "symbols of reality." His musical painting, not unlike the very "pictorial music" that Cui Jian wrote and performed, is an only slightly irreverent reflection on Mao and his possible entanglements with and estrangements from the politics associated with his name. The piece has been called a thoughtful and thought-provoking "product of a distinct time and consciousness" (Jia 1996, 5), that of the turn to the twenty-first century when reflections of Mao also became ways of deliberating current issues and concerns. Mao and his obvious self-doubts portrayed in the painting are a projection of the self-doubts of a younger generation concerning their own or their parent's life under Maoism and the burning question of how (best) to live with this Maoist heritage.

Self-reflection turned reflection about Mao is the topic of Wang Xingwei's 王兴伟 (1969–) painting *The Eastern Way* (东方之路) (**ill. 5.27a**) from 1995 as well. It shows a sleek businessman on a "Journey South" (南巡)—similar to the trip Deng Xiaoping had taken a few years before the painting was conceived, in 1992, to support more expansionist economic policies. The young man, a double of the artist who recurs in a number of other enigmatic paintings from the same year,[35] appears here in Mao's stead: dressed in shiny ochre suit and tacky yellow shirt, he appears before a background that is a rather accurate copy of Liu Chunhua's famous model painting *Chairman Mao Goes to Anyuan* (**ill. 5.1**). The image thus cites a paradigmatic vision of Mao without showing Mao: the clouds above the young man in yellow and the majestic mountainscape at his feet are exactly the same as in the original. The young man cast in Mao's position holds, characteristically, the peculiar (here pinkish) umbrella in his hands (which, if read in conjunction with another image from this series, appears to be

ill. 5.27a Wang Xingwei, *The Eastern/Oriental Way*, 1995 (DACHS 2009 Wang Xingwei Going to Anyuan).

made no longer of paper, as in the hands of Mao, but of pink plastic, see ill. 5.27c). Yet this young man has turned away from Anyuan; he walks the other way, perhaps even decides to "go global" (走出去), a policy announced in 1999 that drew on the experiences of Deng's Journey South (Jungbluth 2011). Here, as in the other pictures of the series, Wang establishes visual parallels with well-known artistic themes, materials, and gestures, and thus creates, especially through the many subtle interconnections within the series, a rather complex set of associations.

Arguably the most enigmatic image of the series shows the same young man together with Hitler in a low-angle shot. This was a technique often used in scenes of confrontation to illustrate which character holds the higher position of power and thus an important aesthetic gesture in, for example, *film noir*—but also in Cultural Revolution model works, as we have seen. It is clearly the young man who is the one in power. While he, too, is seen from below, he appears much taller than Hitler. And apparently he is explaining to Hitler—who, in turn, is nervously clinging tightly to his

35. These images can be seen on DACHS 2009 Wang Xingwei Going to Anyuan. A discussion by Wang Xingwei himself, who is very much against calling them "conceptual art" (观念艺术) but prefers to call them attempts at "experimental art" (实验性绘画) instead, can be consulted in DACHS 2009 Wang Xingwei and Conceptual Art.

book, *Mein Kampf*—the need to make peace, not war. The title of the 1996 painting is *Mein Kampf—Wang Xingwei in 1936* (我的奋斗—王兴伟在1936) (ill. 5.27b).[36] The background is the inevitable cloudy blue sky, and both Hitler and the young man are looking up to this sky, a vision clearly before them. In Soviet protocol, to marvel at an immense sky or expansive view is a sign of the subject's confidence in the coming of the Communist utopia, part of the reason why Stalin in his official portrait (and Mao in his, as based on Stalin's) has his gaze fixed towards the sky (Hawks 2003, 297).[37]

Transfixed by Wang's vision, Wang and Hitler do not see an object lying, in flames, on the staircase right in front of them. What is it? What will happen? Here, as in many of the other images in this series, the characters are depicted as on a threshold (here, at the top of the stairs) beneath the open skies. All of them, so this visual device seems to suggest, are about to make a fatal move. In two other images of the series, the young man is seen, as in the Anyuan parody, at the top of a mountain ridge. One is in a seemingly hopeless situation, a dead end at the peak of the mountain, with a dog already turning back onto the one and only path down the hill (ill. 5.27c, *Blind* 盲 1996). The young man, his hands in determined fists and his (plastic) umbrella pointing forward, is marching on into the air (and thus his death?). He is blind, as the title of the painting suggests, and this fact, in combination with Maoist rhetoric in which "going forward" (往前进) is always considered the one and only direction one can and should take, makes for a very ambiguous message. This is all the more telling when we see an extremely kitschy sunrise (never innocent in China, to be sure, since that famous song "Red Is the East") in the background. What would be the purpose of this young man's going forward into his death? His would not be a heroic act but one of sheer waste. Does this throw a light on some of the other deaths caused by forcefully "going forward," blindly (if not blindfolded)?

In another image from the set entitled *Dawn* (曙光) and published in 1994 (ill. 5.27d), we see the young man together with a young woman, obviously in a romantic encounter, she seated, he standing up with his back to the viewer, once more pointing forward in a "revolutionary" gesture toward the far horizon where, again, the sun is rising. There are quite a few repetitions or echoes between the images: each of them is quoting and mixing different visual traditions and languages, but the intervisual echoes are not easy to read: Why Hitler next to the young man who obviously represents not just himself but Mao? Why the repeated references to the sun (and thus, Mao)? Why the revolutionary gestures, the fists, the strides forward (and turns backward), in inappropriate settings? Why is the hero (an "angry young man") almost always turning his back to the viewer, his conversation with Hitler being the exception? Is this a response to, and a denial of, the open portraiture of heroes that the painter has grown up with? Where will the finger pointing into the far distance lead Hitler or the loving couple? What happens to the blind man with his forceful strides? And to Hitler and the burning object? Will the sun (Mao, still?) protect them or simply shine on their senseless deaths? Is there hope? Is Mao (and his *Little Red Book*) introduced as an alternative to Hitler and *Mein Kampf* or likened to them? Or must one turn one's back on Mao, as the Anyuan parody suggests, in order to "go global" into a brighter future after all?

According to the artist, satirical play with well-known visual material was the most important aim behind all of his creations during these years; indeed, the hilarity of the rather unusual cases of mistaken identity he creates in these images, reflecting on and echoing each other, is rather irresistible (see DalLago 1999, 52). In the Anyuan parody, Mao is cited *ex negativo*: he is there as a silhouette formed by way of the familiar background. But what does it mean that in the Anyuan parody Wang/Mao has made the (fatal?) decision to turn away from Anyuan?

36. This later interpretation is given in a 2001 interview with the artist recorded in DACHS 2009 Wang Xingwei Interview.
37. For the official Mao portrait and its relationship to Stalin portraits, see HRA 2008 Images of Mao Zedong, esp. 7–9.

In a later parody, the painter takes up this question once more. The image, entitled *X-Ray* (X-光) uses the Anyuan picture to uncover, according to the artist, its several "psychic layers" (**ill. 5.28**). The original Anyuan image is reproduced in grey tones, with a grid pattern applied over it. The pattern surfaces two older Maos in the picture, right in front of the young Mao—one convulsively covering his head and face, turning back, ducking down, trying to hide behind the young Mao's back, the other moving forward forcefully, with his foot astride, somehow attempting to push the crouching Mao back again. Does this image reflect on the history of the Anyuan story? Or does it play with the young man's turn in the *Eastern Way* series? Is it suggesting that Mao, too, in his older days, had his regrets? That he, like so many around him, thought about turning back? And what does this say about the Maoist past and its legacy? Is it a way of coping with some of the more traumatic experiences

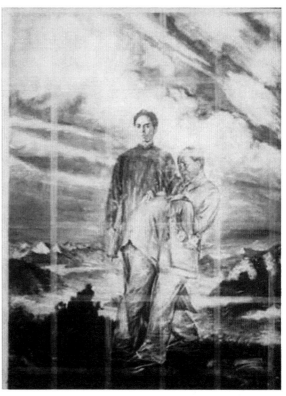

ill. 5.28 Wang Xingwei, *X-Ray*, 2000 (DACHS 2009 Wang Xingwei Going to Anyuan).

associated with the Mao era to be able to say that he might have turned his back on these policies, too? Do these images turn their backs on Mao's heritage or show new ways? And how dangerous are they? These are the kinds of questions these images pose but somehow do not answer.[38] They find their ultimate conclusion, perhaps, in Yue Minjun's 岳敏君 (1962–) painting *Liu Chunhua— Chairman Mao Goes to Anyuan* (刘春华—毛主席去安源), a landscape painting in hues of gray that replicates exactly the background of the Anyuan painting and thus encourages the viewer to ponder how salient Mao's image still is, though he himself is in fact no longer there to be seen, on the image.[39]

Even more unnerving, if easier to decipher, is another reinterpretation of Mao's iconic image entitled *The New Generation* (新一代) (ill. 5.29). Painted in 1990–91 by Liu Wei 刘炜 (1963–), it uses one of Mao's official portraits—which is in fact wonderfully red, bright, and shining—in all the correct colors, but with a background slightly schematized with a few too many wonderfully white clouds and wonderfully green trees painted in a decorative style. Somehow reminiscent of peasant painting, it caricatures it at the same time. The Chairman's figure towers over the composition, and although he remains a "flat poster on the wall" (put in the place he had naturally occupied for so long), he forms the dominant backdrop of the picture (DalLago 1999, 52). He is the one who looks the audience directly in their eyes, while the little boys, sitting on a bench in front of his portrait, are looking away. Although Mao's portrait is slightly distorted—one of the

38. Another set of parodies of *Chairman Mao Goes to Anyuan* that poses different questions is the 2005 set of ceramic statuettes in different often tasteless colors (Mao with shiny blue hair) by Liu Liguo. See DACHS 2009 Liu Liguo.

39. The image is reproduced in Valjakka 2011, 182.

eyes is a bit off, portrayed lower than the other, and the nose appears more than usually crooked—he is nevertheless still perfect enough to form a striking contrast with the two boys, who have strangely patched and many-colored faces, changing between grey and brownish red and white in color, thus vividly contrasted with the clear and saturated rich colors in the Mao portrait. Their distorted hands, here covering their crotches, still leave their genitals exposed, as they are wearing typical Chinese baby pants that are split open at the bottom to make diapers unnecessary. This is the "new generation"—Mao's "new generation"—as the title insinuates. Not unlike the Anyuan parodies by Wang Xingwei, this image is, again, a self-portrait, said to have been painted after the artist and his brother.[40] The two boys are at the center of the picture. What is the message of such a painting, and who is the implied audience? Those frustrated by and incapacitated because of Maoist policies, the so-called "lost generation" of the Cultural Revolution? Probably yes.

The critical content of a painting like this is much easier to decipher than the message of the preceding ones: are these citations of Cultural Revolution standards within completely contradictory contexts indeed an attempt to destroy "Mao as Myth"? Is the political symbol that he once stood for abused here as a cheap joke? Does art such as this indicate that Mao is just as good for capitalism as he was for Communism, that he can be seen in many different or even the same ways as before and still be "beautiful"? Where is beauty in this art, after all? Or must these images be read much more deeply as negotiations of their artists' psyches?

Not unlike Tan Dun's *Red Forecast* discussed in Chapter 2, and in spite of all the playfulness observed, these pieces also point to a need to deal with a harrowing memory. It is much more difficult to construct an unambiguous implied audience for MaoArt such as this (and here, this art is comparable to some of the rather innocent New Year Prints discussed above). This fact is perhaps the most significant difference between this art and MaoArt from the Cultural Revolution itself.

Of course, the ambiguity of these messages only comes into play when Cultural Revolution standards are read as their countertexts. Without these standards, nothing at all would be wrong with a picture such as Luo Gongliu's 罗工柳 (1916–2004) oil painting of 1961–62 depicting a pensive *Comrade Mao Zedong at Mount Jinggang* (毛泽东同志在井冈山), the place where he retreated after the failed Autumn Uprising to await the arrival of reinforcements under Zhu De 朱德 (1886–1976) and Chen Yi (ill. 5.30a). Indeed, the central figure of this image is a young, impressive-looking Mao, his strong and sturdy body marked through dark clothing that contrasts sharply with the grey and white background. The only burst of color in this picture is the red star on his Mao Cap and the red patches at the collar ends of his jacket, echoed several times in a few rather blurred reddish patches in the landscape. Mao's greatness is, according to traditional painterly principles, echoed in the greatness of nature: the rolling mountain peaks (above and behind him, they look as if lifted from a classical Chinese painting) complement the vastness of the rice paddies in front of him, where he sits, leisurely, on a rock. With a pile of papers by his side, he is taking a short rest from studying to smoke a cigarette. His eyes are directed straight and slightly upwards toward the left; he appears to look into the future.

This image has been praised in China as a successful experiment in the Sinicization of oil painting: Luo here uses the longer, curved strokes of Chinese painting, not the large and squared brush strokes used in the Russian painting tradition also taught in China. Instead, he employs regular vertical dabs to suggest foliage, a technique employed in Chinese landscape painting.[41] This apparent "rejection of Soviet models" would not be foregrounded in the Cultural Revolution, however (Andrews 1994, 245–46). Luo had been one of the most respected artists in charge of

40. For the importance of self-portraiture in contemporary Chinese art, see Wang 1993; Barboza and Zhang 2008.
41. Andrews 1998, 229. Luo's style is reminiscent of European pointillist traditions, too, which does make sense since he was trained under Lin Fengmian and his Francophile faculty at the National Hangzhou Arts Academy.

attaining art for the Central Museum of Chinese Revolutionary History in the 1950s and for the ten-year anniversary of the founding of the PRC (ibid., 228–29). And still this image did not make it onto propaganda posters or national exhibitions. Why?

Both in terms of color and style, this piece would have been unacceptable within the Cultural Revolution straightjacket of correct artistic expression. The cool colors dominating the picture are out of the ordinary in Cultural Revolution style. Moreover, the faintly pointillistic, modernist brushwork, even if it can be explained with a reference to Chinese tradition (an "aristocratic" tradition after all) was not appreciated during the Cultural Revolution.[42]

The implied audience of Cultural Revolution art was not supposed to appreciate the techniques of "formalist modernism" seen in Luo Gongliu's portrait. A comparison with a Cultural Revolution propaganda poster on the same subject, entitled *Chairman Mao at Mount Jinggang* 毛主席在井冈山 (1969) and based on an oil painting by Liu Chunhua and Wang Hui 王晖 (1943–), makes explicit what else could have been done "better"—in Cultural Revolution terms (ill. 5.30b). Here Mao is shown on top of the mountains, not at their feet. He is standing up straight and is the central focus of the image, not moved slightly off to the right as in Luo Gongliu's depiction. In the propaganda poster, Mao looks in the viewers' direction and he is at work, not taking a rest. Instead of holding a cigarette, his hand is propped assertively into his waist. The flowers around him are all averted toward him, their source of light, an impression strongly reinforced by the brightness of his shirt (M. Wang and Yan 2000, 69).

But only such explicit Cultural Revolution political standards for art would make Luo's picture into an ambiguous statement. By itself, it does nothing but imply reverence towards that benevolent, stately, handsome Mao with his bright, shining face looking hopefully into the distance, envisioning great victories before him. This is mentioned in the caption to the Cultural Revolution poster, which explains how Mao has opened the only correct and shining road of victory for the Chinese revolution (为中国革命胜利开辟了唯一的正确光辉道路) and has left some smaller losses behind him (a fact that would have explained his need for rest and his slightly slumped position in the Luo Gongliu depiction).

While Luo's depiction of Mao was created before the Party issued strict orders on how best to paint his portrait (so that the elephant would no longer look like an elephant, see **ill. 0.0**), Yan Peiming's 严培明 (1960–) 1992 portrait simply entitled *Mao* (毛), on the other hand, is another that must be read as a deliberate answer to Cultural Revolution standards (ill. 5.31a). And, indeed, Yan Peiming would say that his training was in propaganda art: "In China, I learned propaganda painting and in principle I still paint in that style" (*China Avant-Garde* 1994, 171). His image of Mao employs a combination of cold colors and heavily emphasized brushwork, which renders Mao's face anything but smooth. All of this would have been enough to make the work completely unacceptable during the Cultural Revolution. The fact that it is "slightly out of focus" makes its transgression more egregious, of course. The

ill. 5.31b Gerhard Richter, *Mao*, 1968 (DACHS 2009 Mao by Gerhard Richter).

42. Such brushwork had been the reason why, in He Kongde's image of the Gutian Conference, Mao's face had to be repainted, too, before it could be exhibited in 1972.

image reminds a European audience of a 1968 counterpart by Gerhard Richter (1932–), who depicts Mao through a haze that equally disfigures, or better, transfigures him (ill. 5.31b).[43]

Both his and Yan Peiming's image point to the complicated relation between our sensual perception of reality—which is always limited—and reality itself (it is "not like that" to continue the simile used in the Introduction). The "defacing," the almost abstract manner in which the face is designed, makes both portrayals into a strong—if ambiguous—statement about Mao past and present.[44] Yan's image is even more ambiguous, because the implied audience of an image like his is one not just appreciative of modernist style, not just reveling in his almost complete disappearance behind the haze, but also one for whom Mao is still an imposing personality, in every sense of the word: the painting is huge, at 2 × 3 meters.

Not to Be Repeated! Part 2: Traditionalisms?

National-style painting [国画 Guohua] in Mao images, hmm ... There were many different images of Mao, depending also on the times, and the photographs of him, of course. There was a Li Qi [李琦 1928–] portrait of Mao with a straw hat.[45] This was prevalent during the Cultural Revolution, but generally these kinds of images were not seen that often. There were very popular images like Chairman Mao Goes to Anyuan and this photograph that Snow took. These were the kinds of images we would see all the time. And there were oil paintings, yes, but the national-style type, no, if I think about it, I never saw any of them. (Guqin Player, 1940s–)

Of course there were Mao portraits in national style even before the 1970s. This style was not really restricted during the Cultural Revolution. (Housewife's Husband, 1950s–)

There were so many images of Mao. In some of them, he would actually be illuminated. Quite interesting. Then, there is this other one, by Li Qi, with the straw hat.... In the 1970s Chairman Mao Goes to Anyuan was extremely important. I am not sure about ink and color painting, I don't think this was pushed, really. (Intellectual, 1958–)

The modern national style paintings are not really traditional art. Thought and spirit are the important things in this art, not the use of the ink brush! When they use the moon or some such thing, it is not the real traditional meaning anymore. The most important part is missing. With the new landscape painting, it is the same: the philosophy behind it is no longer there! The heart and mind of today's painter is simply not the same as before. (Writer, 1958–)

The same reverse logic necessary to appreciate the lacunae of MaoArt during the Cultural Revolution in terms of modernist styles could also be applied to works using traditional styles and techniques, some of which became (more or less) unacceptable during the Cultural Revolution. Particular traditional art forms, such as bird, flower, and landscape painting in ink on paper, condemned as "feudal" or "aristocratic," were outside the range of official propaganda painting. Especially during the first five years, Cultural Revolution cultural politics managed to enforce a strongly anti-traditional approach to Chinese painting, thus negating a style that had flourished in the early 1950s, supported by a *laissez faire* attitude associated with Liu Shaoqi. He had questioned why one should fear "feudal" art: "Haven't we triumphed after all?" he once said (Dittmer 1974, 268).

43. On the significance of unfocused paintings in the European artistic tradition, see Hüppauf 2008. His last visual example, a poster for the 2003 exhibition "Genosse Gott—Stalin," is a very suggestive example of how this technique can also create the impression of transcendence (Hüppauf 2008, 565). For more unfocused Maos, see the interesting discussion in Viljakka 2011, 111–13.
44. Yan has more recently painted similarly scruffy images of Barack Obama, the Pope, and even Mona Lisa.
45. The interviewee refers to a 1960 image by Li Qi entitled *The Chairman Goes Everywhere* (主席走遍全国) in which Mao is seen, very relaxed, if a bit fatigued, with a straw hat in his hand. This portrait was reproduced very often. See e.g. Andrews 1998, plate 139; see also DACHS 2009 Mao Portrait Li Qi.

The Cultural Revolution allegedly produced a generation of artists for whom traditional Chinese painting, with its poetry and lofty ideals, became an art practiced by artists of the past (Andrews 1994, 315–16). This part of my chapter will show, however, that not unlike with sounds and words, with images, too, foreign and traditional elements did not disappear entirely during the Cultural Revolution. To the contrary: certain foreign styles—not those of modernism but those of socialist realism—were, as has been illustrated amply above, as naturally part of the iconographic vocabulary used in Cultural Revolution MaoArt as pentatonic romanticism was in MaoMusic. As Hawks, Andrews, and the recent Guangzhou exhibition have shown, not unlike with music, where "bourgeois styles" were being practiced even during the most radical years of the Cultural Revolution, many "forbidden styles" were still being produced artistically, too—even if behind closed doors or only among those who would not recognize it (Hu and Ai 2007; Gao 2008; Silbergeld and Gong 1993, esp. 49ff.).

Particular traditional styles, those that could be called "popular styles" (e.g., the Huxian peasant style, see ill. 5.14), would even be promoted throughout the Cultural Revolution decade in MaoArt, in a direct parallel to what was happening in other artistic fields. Official song collections, the *New Battle Songs*, for example, included regional and minority folk songs (Bryant 2004, 3), and the model works were based on traditional operatic forms. But just as players of what had been called "aristocratic" instruments in the early years of the Cultural Revolution would be called back in the later Cultural Revolution, so would painters of so-called "aristocratic" styles. Indeed, these styles became part of the distinctive expressive language of propaganda posters and MaoArt in the second half of the Cultural Revolution. Thus, the political straightjacket allowed for quite a few exceptions and reinterpretations in MaoArt even during the Cultural Revolution.

Although one could conjecture that these exceptions were allowed for in order to reach as broad an audience as possible, they also show that the Party was never quite monolithic about artistic policies even throughout the Cultural Revolution. During the first half of the Cultural Revolution, one sees no newly publicized compositions of MaoArt in a style comparable to that of Li Qi's 李琦 (1928–) 1958 painting *Mao at the Ming Tombs Reservoir* (在十三陵水库工地上), or his oft-quoted 1960 image of Mao with the straw hat (ill. 5.32a&b). Both paintings are in so-called national style (国画 *guohua*), retaining the loosely brushed qualities of traditional painting, the first painting even including a four-word archaizing poem praising how, under Mao's rule, "all hearts (are) united" (心连心). In these paintings, traditional techniques are used for the depiction of contemporary social settings. In *Mao at the Ming Tombs Reservoir*, for example, industrial labor is depicted and mighty cranes substitute for dainty trees before a typical Chinese-style landscape. The image shows Mao's ritualistic emergence into the labor movement in May 1958. Here he stands with shovel in hand, a worker offering him a sweat towel and other workers standing by, watching the scene happily. Many images like these have been produced in the twentieth century.[46] Here, Mao is the central focus; his position is slightly elevated with regard to all other protagonists. Accordingly, in terms of structural composition, this picture would not have been seen as problematic during the Cultural Revolution. And oral history suggests that Li Qi's 1960 picture of Mao with a straw hat remained a visual presence throughout the Cultural Revolution decade. Li Qi himself, however, did not fare so well: not only had he painted portraits of Liu Shaoqi—a fact which would have been dangerous for any Chinese artist in the early years of the Cultural Revolution (Andrews 1994, 328)—but the very "aristocratic" style of painting he employed, painting with traditional Chinese pigments on traditional Chinese paper, was officially condemned during the early years of the Cultural Revolution (Hawks 2003).[47]

46. For further examples see, Zhang 1994, 45, 65, 159.
47. Hawks, in Chapter 1 of her dissertation, gives a very useful history of attitudes toward national-style painting throughout the twentieth century.

It would be for the same reason that a 1953 poster like Jiang Zhaohe's 蒋兆和 (1904–86) *Listening to Chairman Mao* (听毛主席的话) (ill. 5.33)—showing Mao centrally positioned under a pine tree[48] and surrounded by a group of adoring Red Pioneer children—would not be republished during the early Cultural Revolution. Apart from perhaps not being sufficiently red, it presents a paradigmatic portrait of Mao—bright, shining, central, large, heroic, and convincing—which would have been very much in line with Cultural Revolution propaganda policies. Incidentally, not unlike Mao, Jiang had spent some time laboring at the Ming Tombs Reservoir in 1958 (Andrews 1994, 211). He is generally considered one of the most important influences in the development of figure painting with traditional media, painting in ink on absorbent Chinese paper. He had continually defended the need for landscape and bird and flower painting next to history painting in the Anti-Rightist Campaign, and in an earlier time and age would have been praised for using traditional techniques to "draw from life, scientifically" (ibid., 127–40). There were many more artists like Jiang who painted in traditional styles—Li Qi, already mentioned here, or Zhao Hongben, discussed in the next chapter, among them. Yet, their fates were bound up with their specialization.[49]

Accordingly, during the first half of the Cultural Revolution one would not encounter in official productions of propaganda posters works in the style of Shi Lu's famous and daring *Fighting in Northern Shaanxi* (转战陕北) of 1959, commissioned for the Museum of Chinese Revolutionary History and criticized for the first time in 1964 (**ill. 5.34**). The painting constitutes Shi Lu's very personal reinvention of national-style techniques: the medium, ink and color on paper, and the subject matter, landscape painting, was traditional; the large square format of the painting and the bright coloring were both new. His conception that the loftiness of man, or rather, Mao, might be reflected in the setting, comes straight from the Chinese tradition of "writing ideas" (写意 *xieyi*) (Andrews 1994, 237–38; see also Hawks 2003, 296–301). In this image, "Mao takes on the monumental persona of the vast, rugged ranges that stretch to the horizon" (Andrews 1998, 231). Yet, Mao also appears off-centered, a tiny figure among huge and majestic mountains, isolated on a cliff to the right of the picture, quite apart from the peasants visible near him (significantly, only one of them beams toward Mao). In a portentous pose rarely if ever seen during the Cultural Revolution—but one that can be traced back to the Chinese literati tradition of painting, especially from Song times: he has his back towards the viewer—Mao is perhaps deliberating his next move here.[50]

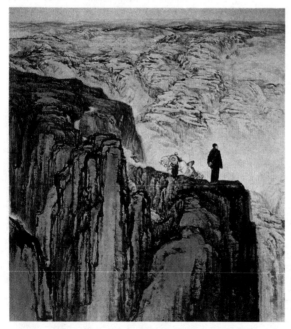

ill. 5.34 Shi Lu, *Fighting in Northern Shaanxi*, 1959 (Andrews 1994, plate 3, insert between 200–201).

48. The pine tree is the archetypal symbol of an intellectual because it is a tree that stands up to the cold, symbolizing longevity and steadfastness.

49. For documentation of many of these artistic tragedies, see CCRD.

50. Hawks 2003, 296–301. Whether and not his pose could still be considered a "Socialist Leader Pose" is deliberated in Noth 2009, 162.

Significantly, it is the position taken up by Wang Xingwei in his parodies on *Chairman Mao Goes to Anyuan*. Mao's pensiveness, the irresolute, wavering mood of the depiction, the dominance of black color, is decidedly not in accord with Cultural Revolution standards, which would insist on brightness and would cover up the dirt and some of the hardships entailed by heroism which hover in the somewhat heavy-handed background in this painting (Andrews 1998, 235).

In the second half of the Cultural Revolution and especially with the beginning of Ping-Pong diplomacy, around Richard Nixon's visit to China in 1972, the ban on bird, flower, and landscape painting was lifted, at least temporarily, until the beginning of the Anti-Confucius and Lin Biao campaign in late 1973 and the so-called "Black Art Exhibition" in February of 1974. Artists proficient in traditional styles had been called back personally in 1971 by Zhou Enlai to paint for hotels, restaurants, conference rooms, airports, and railway stations (which is the reason why the polemic term for this art would later be "Hotel Art" 旅馆艺术 *lüguan yishu*), in order to provide foreign visitors with an elegant, orderly image of "Red China" (Galikowski 1998 158–63; Silbergeld and Gong 1993, 53). Quite a few bird, flower, and landscape paintings were created to replace Red Guard slogans and portraits of Mao in public places, too. Many an artist, cartoonist Zhao Hongben and painter Shi Lu among them, became active again during this period.

During this time, Shi Lu painted a rather crassly and irregularly textured and loosely brushed traditionalist scroll of *Mount Hua*, complete with poetic inscription, emphasizing the enormity and inaccessibility of the peak (ill. 5.35). Quite conspicuously, paintings such as this did not include Mao.[51] Especially for those pieces of art made for foreign consumption, the concern not to "offend foreign sensibilities," which would play an ever greater role after the Cultural Revolution, was obviously already at work here as China was opening to the world after Nixon's visit in 1972.[52]

Although the production of "hotel art" was a short-lived affair, its influence was felt in the production of official MaoArt since the early 1970s. A rough statistical survey of several Cultural Revolution poster collections shows that a sample from 1966–71 contained only one-half the number of traditional-style images as a sample from 1971–76.[53] For example, in the first half of the Cultural Revolution, Mao would not be depicted in the same way as in New Year Prints and propaganda posters from 1962, as part of a traditional festive scene inclusive of drums, drapes, and symbolic flowers, for example. But by 1975, he would and could frequently be seen again as such (ill. 5.36 a&b). While in the first half of the Cultural Revolution, Mao would not appear, as he did in 1977, in an ink painting marked by its inscription of calligraphic poetry, he would already make a comeback as such by 1974 (ill. 5.37 a&b).

The last two paintings from my sample of eight, both from the 1970s, are examples of the use of traditional painting styles. Especially the second one showing Mao surrounded by his "Yan'an children," which is painted in ink on paper and which draws not on popular (as does **ill. 5.7**) but on "aristocratic" painting styles (**ill. 5.8**), is a sign of the change in acceptability that began in the early 1970s. This change had been heralded with the opening of a "Masterpieces of Chinese Traditional Painting" exhibit held at the Beijing Palace Museum (*Art and China's Revolution* 2008, 240) in 1971 and was continued in 1973 by the State Council special exhibition of national-style paintings (Andrews 1994, 350). Of this exhibit the propaganda media tell:

51. Compare images in Silbergeld and Gong 1993, e.g., 73, 75, 77, 78–81, and in Sullivan 1996, plate 4.
52. See Party documents restricting the use of Mao portraits, discussed in more detail below. Some of them are collated in Barmé 1996, 128–34, esp. 134.
53. The databases consulted for this rough statistics are the Westminster Collection (which, however, yielded faulty results because the number of posters from the 1960s is much too low), and maopost.com (9/281 to 41/688). See also the many depictions in M. Wang and Yan 2000, 150–59; Andrews and Shen 1998, e.g. plate 154–57, 173; or in Zhang 1994, plates 9, 24, 26, 28, 30, 54.

Artists of the traditional school of Chinese painting dip a brush, either wet or dry, into water colors and ink mixed to the requisite consistency, and paint on fine white Hsuancheng paper made in the south of Anhwei Province. This school of painting has its distinctive styles and techniques. The main categories of subjects are human figures, landscapes, flowers and birds.

In feudal China paintings, whether of human figures, landscapes or flowers and birds, reflected the life, views and sentiments of the feudal ruling class but ignored the major role of the labouring masses. This distortion of history has been corrected in modern Chinese paintings of the traditional school. The fundamental change apparent in this exhibition was that the themes of most paintings were working people going all out in socialist revolution and socialist construction under the leadership of the Chinese Communist Party and Chairman Mao.

The artists, guided by the principle that a work of art should have its origin in real life but be higher than real life, have evolved new means of expression from the life of the masses to depict heroic workers, peasants and soldiers, and have thus enriched and developed the artistic conventions of traditional style painting. (CL 1974.3:113–15)

It is the logic of the *Yan'an Talks* that is rehearsed here. All art forms can and should be used for the production of good propaganda art, but they should work toward the proper goal: to serve the masses in presenting models on a higher plane. Accordingly, the emphasis in the article explaining national-style art is not on its various continuities with tradition but on a break with this very tradition, and on revolution. The new development of this art as presented at the exhibition, so it is said, foregrounds the masses. After all, it was primarily national-style ink and color painting that was presented at the exhibition, in itself not an "old traditional" style: it was developed at the academies in the 1940s and 1950s, picking up on popular New Year Print aesthetics rather than the intellectualized, loosely brushed philosophical aspirations associated with national-style painting, and its purpose was now to serve political purposes (Andrews 1994, 363–64).

Thus MaoArt during the Cultural Revolution appeared in significant variations both at one moment in time as well as over a period of time. Cultural Revolution art also perpetuated many of the practices and styles developed much earlier, and it continues to dominate Chinese art production to the present day. MaoArt in the first half of the Cultural Revolution favored oil history painting, woodblock, and peasant painting; in the second half it also allowed for ink figure painting (with landscape, bird, and flower elements) to come back. This was accompanied, at the same time, by the decline of Red Guard popular MaoArt dominated by cartoon, caricature, and woodblock print and the production of Mao badges (M. Wang 2008; Schrift 2001). As early as 1969, the many spontaneous art productions and Red Guard publications were in fact (more or less successfully) recalled (Hu and Ai 2007). At the same time, the second half of the Cultural Revolution saw the ascent of professional MaoArt and the return and promotion to positions of authority of many of those condemned or criticized in its first years. The difference between the two forms of MaoArt was marked, but minor, in the end: one was perhaps more straightforward and popular but generalized and patterned than the other, which may have appeared more elitist and subtle at first sight but was in fact equally standardized and stereotyped.[54] During the Cultural Revolution, then, many more different renditions of Mao were created than one might at first assume. Variations occurred only within well-defined boundaries, to be sure, but it is also apparent

54. Julia Andrews (1994, 321–22, 361–62) undertakes an interesting comparison of two versions of a painting showing Mao receiving the Red Guards at Tian'anmen. The first is a Red Guard painting from 1967, the second a repainting of this work completed in 1972 by an illustrious group of painters. The two paintings reflect the political changes between 1967 and 1972: They are both in oil, both adhere to the style of Socialist Realism, both agree with Cultural Revolution aesthetics, particularly in their depictions of Mao. Nevertheless, they could not be more different. The Red Guard depiction, in spite (or even because) of its formal deficiencies, accords more clearly with the directives of the Three Prominences and therefore allows less for subversive readings than does the second.

that these boundaries were constantly shifting throughout the ten-year period now termed the "Cultural Revolution." Yet, these variations remained variations of one and only one dominant theme to be repeated time and again: Mao.

Repetition Squared: Repeating the Repeated

> In the year that I was working in the factory, I was granted two months off to paint Mao portraits, because all the factories needed them. The portraits were all in oil, and they were worn out very quickly, so then they had to be painted once more. They all had these portraits hanging. Since I could paint quite well, some of the other work units [单位 *danwei*] asked whether I could paint for them, too. And that is how I went around, painting all these portraits. (Musicologist, 1950s–)

Mao's image was not only painted and reconceived again and again by Chinese artists, but it was also endlessly copied by hand—both officially and privately: Tang Muli (1947–) recalls being able to stay away from hard work at the dairy farm he had been assigned to by taking over the task of repainting all the Mao portraits in his and the neighboring villages (Andrews 1994, 356–57). Many interviewees remember acts of producing Mao in different material forms. One says: "My mother painted these portraits for our own home, not so much for others. Sometimes she would do woodcut, sometimes even a little statue" (Intellectual, 1958–). Another remembers: "In the factory and in the home we had all these images and wooden statues. We thought they were art. Indeed, I even painted Mao myself, because I really liked to paint, and every place had to have an image of Mao anyway" (Journalist, 1949–).

Repetitions of Mao, the motif, were not just handmade, but they also resulted from (rather massive) mechanical reproduction: MaoArt in poster form had huge print runs. *Chairman Mao Goes to Anyuan* alone—next to Mao's standard portrait[55] undoubtedly one of the most important paintings during the Cultural Revolution—was, as already mentioned, allegedly printed in more than 900 million copies (Landsberger 2002, 152). One could argue that such rote repetition was simply a continuation of an age-old aesthetics of Chinese art production where copying and reproducing was an integral part of artistic practice (Ledderose 2000). Both in the case of the terracotta warriors, discovered in 1974 during the Cultural Revolution,[56] and in Mao's case, the motif could and would be put in scene through repetition in more or less spectacular ways: documentary photography suggests that Mao images not only appeared in private homes and public places but, most importantly, were part of marches and public processions all effectively featuring one and the same Mao (e.g., Yang 1995, 105; M. Wang and Yan 2000, 61), or many different versions of the same Mao motif (e.g., Yang 1995, 112, 238–39; M. Wang and Yan 2000, 63).[57] The most well-remembered "processions" of Mao images, *Chairman Mao Goes to Anyuan* and the standard portrait among them, are perhaps images of the "water processions" painted in commemoration of Mao's famous 1966 swim, which themselves have been produced and reproduced many times (e.g., *China* 2008, 26–27, and as a *nianhua* in M. Wang and Yan 2000, 212). Another of these processions shows thousands of different images of Mao being carried by Red Guards in Shenyang (*China* 2008: 200–201*).*

55. For the history and different versions of the standard portrait, see Wu 2005; Paul 2009; and HRA 2008 "Images of Mao Zedong." Geng 2011 provides a rather comprehensive overview of the literature on the Mao portrait (9–11).

56. The terracotta warriors are simply a more spectacular example of this common practice. See the documentation in Yang 1995 and *China* 2008:49.204–5.

57. Ample photographic evidence in Yang 1995 also testifies to the presence of the *Anyuan* picture in the countryside as well as in the cities, in private homes, and public processions. The *Anyuan* picture appears constantly in the documentary material used for *Red Art*, which includes excerpts from a number of documentary films from such processions as described above (Hu and Ai 2007).

Mao images—not unlike "Red Is the East" or quotations from the *Little Red Book*, which could be found as a song within a song or a story within a story—appear as pictures within pictures in many a propaganda poster, book illustration, or comic.[58] This book began with a discussion of precisely one such poster (see **ill. 0.5**), which included, next to model books, music, and other images in praise of the Maoist line in culture, a large placard reproduction of *Chairman Mao Goes to Anyuan* being carried by some participants in the grand procession depicted in the poster. A similar example of this practice of *mise-en-abyme* is the gouache from our sample of eight (**ill. 5.4**) where Mao is seen suspended above a sea of marching youth, many of them carrying poster portraits of Mao. The demonstrators themselves, their flags, and even their banners with slogans are so small that they can be seen only vaguely. Mao, on the other hand, and his "reproductions," are oversized and can thus be made out quite clearly, even if they are placed in the very far distance of the scene.

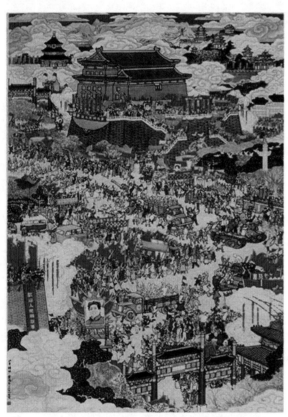

ill. 5.38 Ye Qianyu, *The Liberation of Beiping*, 1959 (DACHS 2009 Rethinking Cultural Revolution Culture, Ye Qianyu).

It is not surprising to find that this type of mass reproduction of Mao's image was commonplace during the Cultural Revolution, yet, not only then. *The Liberation of Beiping* (北平解放), disseminated as a 1963 propaganda poster based on an image by Ye Qianyu produced for the ten-year celebration of the founding of the PRC, illustrates the 1949 event by showing a mass rally featuring many images of Mao—and a few of Zhu De, too (**ill. 5.38**). The poster makes use of traditional iconography: the faintly colored clouds in the background, as well as the stylized and ornamental temples, pagodas, and trees, form a wholly untypical backdrop if compared to Cultural Revolution Mao-Art. Yet, the procession is led by an army wagon with Mao's picture set upon it, a characteristic "venerating curtain" around it. Mao's picture appears in different sizes at least eight times throughout the image. Zhu De, on the other hand, appears only about three times. The size of the images of both Mao and Zhu stands out by contrast with the minuteness of the people taking part in

the procession. Here, too, as in the 1968 gouache (**ill. 5.4**), the only thing to be made out clearly are these portraits, and among them, Mao's are much more notable (not only in terms of numbers but also of clarity) than Zhu's.

The same prominence of the Mao portrait can be observed in a 1950 depiction of the celebrations for the founding of the PRC as painted by Pan Yun 潘韵 (1905–85), a national-style painter whose

58. For some examples, see Landsberger 1996, 175.

image became part of a travelling exhibition to (East) Berlin in 1951 (ill. 5.39). It takes up New Year Print techniques in coloring and setup, depicting the procession in a way reminiscent of tiger and dragon dances performed traditionally at festive events (and indeed, a dragon and a tiger accompany the procession). A huge Mao portrait in an elaborate frame with venerating curtain, carried by some of the participants in the rally, is the focal point of the oblong image. The portrait is preceded by a group of dancers and musicians, many of them looking back towards the image, and followed by the tiger, a dragon, and larger and smaller banners praising the founding of the PRC, wishing Mao a long life and hoping for world peace. In the background another framed image, perhaps of Zhu De, is carried by the demonstrators. It is significant that Mao's image is clearly predominant. In this regard, the artwork would have been acceptable throughout the Cultural Revolution, bearing in mind its traditional style, however, perhaps more likely in the second half of the Cultural Revolution. Again, as with the artistic depictions of rallies and processions during the Cultural Revolution, these artistic interpretations of the events in 1949 are not purely fictional: they echo some of the documentary photographs from actual 1950s rallies, featuring Mao in prominent repetition as well (e.g., Yang 1995, 20–21).

So Mao was there, imposingly imposed in constant reiteration, long before the Cultural Revolution. Neither does he disappear as a repetitive symbol after it ends,[59] although it may be said that repetition, or multiplication, now takes to new grounds. In a work such as Ai Weiwei's 艾未未 (1957–) untitled 1986 triptych—significantly a format that goes back to the Christian art of altar painting—composed in grey, black, and white oils, Mao appears thrice in the same standard outline in white before a dark background (ill. 5.40). The outline (almost a silhouette) looks as if scratched in the first image, and then appears blotted in ink in the last image and faded in the central image. The triptych may be interpreted as a comment on the many fading images of Mao on walls and buildings all over China since the early 1980s,[60] and thus a muse on fading memories of Mao as well. But are they really fading?

Wang Guangyi 王广义 (1957–), in his own triptych *Mao Zedong Black Grid* (毛泽东黑格), composed a year later and exhibited at the fateful *China/Avantgarde* exhibition in Beijing in 1989, visually operates in a very similar manner to Ai Weiwei but understands his image as a critical answer not to fading memories of Mao but to the rising "Mao Fever" 毛热 of the late 1980s (ill. 5.41).[61] His image, which references Mao's standard portrait,

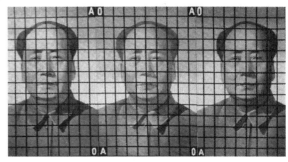

ill. 5.41 Wang Guangyi, *Mao Zedong Black Grid*, 1988 (Köppel-Yang 2003, 152).

repeating it three times in grey tones and putting it behind a grid (as if Mao were in a jail, looking out of the barred window, or, otherwise, as if someone were looking from the jail toward a "visiting" Mao), is considered "one of the most controversial and renowned works of Chinese avant-garde art from the 1980s" (Köppel-Yang 2003, 152). Recognizing its importance, the conveyors of the 1989 *China/Avantgarde* exhibition displayed it in the center of the exhibition

59. Yang 1995, 571, 574–75 contains many documentary photographs featuring Mao portraits from anti–Gang of Four processions in the late 1970s.

60. Wang Tong 王彤 (1967–) has created a fascinating series of photographs (1994–2003) of these Mao images in and from houses to be torn down, a few of which can be seen in DACHS 2008 Mao Images (Mao, Pictorial Works), 147. See also the shadows of Mao by Liu Yong 刘勇 (1956–), such as his 2006 work *Comrades* no. 9 (同志们).

61. One of the triptych's companion images, *Mao Zedong Red Grid* (毛泽东红格), is also discussed in Wu 2005, 184–86.

space on the first floor of the National Gallery. The reactions of both the public and the government revealed its ambiguities. Each corner of the grid has a letter attached, either an A or an O, and these were misread by some as A and Q: Mao behind the grid was thus connected with the fictional figure of Chinese everyman AhQ, a stubborn and stupid fellow Lu Xun had created in the 1920s to criticize the Chinese mind and prompt reform and revolution. Wang Guangyi immediately disclaimed this connection by painting over the Os and making them into Cs, thus stressing the arbitrariness of the choice of letters. It remains unclear whether the letters are or were supposed to mean anything.

To the Christian viewer who already reads meaning into the triptych form, these letters point to alpha and omega and the remark made by God in Revelation 1: 21–22: "Ego sum alpha et omega" (I am the beginning and the end). This opens up a discussion about Mao as a "spiritual being" necessary for China's existence. It can thus be interpreted as a direct response to the question of Mao's "fading nature" as addressed by Ai Weiwei's triptych. This would also tally with the artist's own vision of the image. He considers it a work of "rational painting" (理性绘画 lixing huihua): he uses colors with cold expressive qualities, conveying (e)motionlessness and thus critical distance and objectification, silence, and coldness. The grid, too, serves as a means of distancing the viewer from the viewed. Mao, the image—if considered from a distance—is demystified. The triptych thus presents a critical view not so much of Mao as a historical figure but as the object of (irrational) religious worship, a form of representation that had dominated Chinese visions of their political leader since the founding of the PRC and peaked during the Cultural Revolution. After a short (superimposed) lull in the early 1980s, it found its popular revival in the late 1980s (Köppel-Yang 2003, 157–58).

In an act of artistic self-referentiality, the grid (which, incidentally, reappears in Wang Xingwei's 2000 X-Ray discussed above, see ill. 5.28) also points to how Mao, the much-repeated icon, came into being, how he was in fact (mechanically) reproduced so many times. In traditional China, grids had been used for copying paintings, and this technique was naturally also employed for Mao portraits. The grid distances not just the viewer but the painter from his object: because it serves as a gauge and provides an analytical framework, it thus may work to liberate the artist engaging with the image from subjective expectations and emotions. Representation itself, as indicated by this hint towards its mechanical engendering, becomes a schema, a formula insinuating the semantic emptiness of the sign: Mao (Köppel-Yang 2003, 159; Wu 2005, 185).

The same attempt at emptying and distancing Mao, to explore his many possible meanings, is at the heart of Zhang Hongtu's Material Mao project of 1991–95 (ill. 5.42). He empties out Mao, makes him fade and disappear not by showing a scratched or blotted-out surface, not by putting a visible grid over his image, but by abandoning the painted outline altogether. He presents a long series of Mao silhouettes (i.e., cut-outs) of Mao's standard portrait in different "materials"—in brick, on a table tennis table, on a canvas splashed in red (lipstick), in corn, soy sauce, or feathers— all of which are arranged next to each other in the same space. Each of these portraits of Mao is only visible as a negative. Wu Hung calls the work an "anti-monument," negating "the very notion of the monument as an embodiment of history and memory" (Wu 2005, 204). Mao is present by repeated absences. What this art does, thereby, again, is to call into question the power of the ubiquitous object itself, which turns out to be but an empty shell—perhaps not quite unlike Mao (who did not even write his own words) during his own time?

Deliberations over the meaning (or the insignificance) of Mao's presence not just in the past but in the present persists for a good decade in Zhang's works. His 1989 depiction of twelve Chairmen Mao, arranged in three rows of four, makes the viewer see a number of defaced, denatured,

childlike, and comic Maos: Mao upside down; Mao out of focus or fading; Mao distorted, with his nose and eyes exchanged, or the two parts of his face swapped; Mao disembodied, with just his head rolling around—glowing like the sun, however; Mao like a toddler with traditional short braids; Mao naked, with his fatty breasts hanging; Mao with a tiger mask; and, Mao with a Duchamp-Mona-Lisa-Stalin beard (ill. 5.43).[62] The Mao presented here is a surreal Mao, the Mao one may perhaps encounter in dreams and nightmares.

By repeating the same old Mao portrait, Zhang's work is a reflection on the staged processions well familiar to Chinese audiences looking at this picture, yet this stereotypical Mao is presented in many different forms and from many

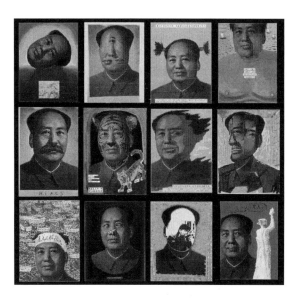

Ill. 5.43 Zhang Hongtu, *Chairmen Mao*, 1989 (DACHS 2008 Zhang Hongtu).

different perspectives: in some of the images, he is central to the frame. In others, his portrait appears skewed. Sometimes he is blown up, bursting the frame, with parts of his portrait cut off. The artwork may be considered blasphemous or satiric, but it does not speak an unambiguously critical language.

The connection with the Tian'anmen demonstrators made in the final set of four portraits is perhaps most difficult to read: Mao is lecherously ogling the Goddess of Democracy (with "Women" in the speech bubble), Mao carries a headband that reads "Serve the People" before a background of banner-waving student demonstrators in Tian'anmen Square. Is Mao seen as a hypocrite or as a real supporter of their ideas? What does it mean that he apparently fancies the Goddess of Democracy—must his ogling be reduced to sexual innuendo, or does he believe in her philosophy? Does he support the sea of demonstrators when he is shown as "one of them" with his headband (even if it carries a Maoist quote)? Is it deliberate that they resemble the Red Guards whom he openly supported by wearing their armband? Is he part of an alternative dream for Tian'anmen, or is he made responsible for the nightmare it became for many?

I have attempted to show both in the chapter on MaoMusic (with the example of "Red Is the East" and the "Internationale" as performed and parodied by rock bands on Tian'anmen) and in the chapter on MaoSpeak (with the example of Li Lu quoting the story of the Foolish Old Man in his memoirs of the event) that even though the young demonstrators insisted on being different from the Red Guards and the practices of the Cultural Revolution, they, not unlike the Red Guards (re-)interpreted, obviously also (re-)believed in the songs and words of Maoist China and in Mao, the image. Zhang is obviously playing with this.

His *Unity and Discord* of 1998, another conceptual piece that combines many of the methods used by Chinese artists to reflect upon repetitions of Mao, provides further clues. When read against the countertext of Cultural Revolution MaoArt, this must appear as a piece of open

62. The image, which is inscribed H.I.A.C.S. (He is a Chinese Stalin), parodies Duchamp's bearded Mona Lisa, L.H.O.O.Q. See Valjakka 2011, 169.

Ill. 5.44 Zhang Hongtu, *Unity and Discord*, 1998 (DACHS 2008 Zhang Hongtu).

subversion and criticism (**ill. 5.44**). In this work, Mao is repeated nine times in different variations of one standard Cultural Revolution pose, wearing the Red Guard armband and waving benevolently to the crowds of students and Red Guards. Yet this Mao pattern is repainted in a number of different styles from modernist art (for example Cubism and Expressionism), all of which were criticized during the Cultural Revolution. His portrait is, again, turned upside down, it is changed into a cartoon image, it is shown as a silhouette, or it is completely whitened out (not unlike the people's minds in Mao's imagination). Perhaps most viciously, the image is substituted in one frame by the dictionary entry for the character "Mao" 毛 in a Chinese-English dictionary, which can be read in various rather subversive ways: Mao means "mildew," Mao means "semi-finished," Mao is the name for a very "small denomination of Chinese paper money," Mao is to "depreciate in value" and "to lose one's temper."

Is Mao, the man, really all of that? What is the effect of such alternative readings? Is this blasphemy? It probably is. But at the same time, it is also testimony to the continued influence and importance of repetitions and reproductions of Mao in contemporary China. Although Zhang Hongtu moved to the United States of America in 1982, his art is still exhibited in China. The implied audience addressed in and through this picture, therefore, is quite fragmented. By repeating ever-changing disfigured Maos within the space of one picture, the artist may reflect on the many possible ways of seeing Mao (even during the Cultural Revolution): not unlike Ai and Wang, Zhang calls on the audience less to enjoy and more to reflect on and rationalize his pieces of MaoArt—and while the choices these images leave are not entirely unlike propagandistic practice during the Cultural Revolution, their ambiguous message and their latent call for critical self-reflection are remarkably different.

Repetitions of the Mao portrait in the work of a much younger artist, Zhang Chenchu 张晨初 (1973–), may illustrate that this self-reflection has significance for many a generation of artists in China, even those who hardly knew Mao, the man, during his lifetime. In his 2007 painting series entitled in English *Eastern Red Series* (东方红系列) which, more literally, would be translated as *Red Is the East Series*, Zhang presents a set of oil paintings reduced in colors to grey, red, white, and black, presenting Mao at different ages in black and grey before a bright red background. Mao's portrait is, in each case, strangely shadowed over, except for a small stretch of light (as if a flashlight) in the form of a bar running right through the middle of his face (ills. 5.45 a&b). Zhang Chenchu explained his work as follows:

> The life course of Mao is like an epic of the Chinese nation at that period. I choose well-written verses from his poems as the titles of my every painting. By selecting the lines from his poems, his inscriptions, or his famous quotations and marking the time when and place where they were written, I intend to strengthen the sense of reality in the series of Eastern Red and pursue a sense of historical literature. From start to finish, I paint with devoutness, and that is the serious attitude I think we should adopt toward the portrayal of historical figures. (DACHS 2008 Mao Images 2, no. 122)

毛泽东一生的历程就像中华民族这个时期的一部史诗，我又把他的诗词中精彩华章，用在我的每幅作品的题目上，我想用毛泽东的诗词或题字或著名的论断语录作为题目并标明当时的时间地点等，主要是想加强东方红系列求真的一面，追求历史文献感. 自始至终怀着虔诚的心情刻画，我认为这是对待历史人物肖像绘画该有的严肃态度. (DACHS 2009 Zhang Chenchu Writings on the Dongfang Hong Series)

Even for this generation, who hardly experienced life under Mao, he remains an object of honest engagement, if not devotion. The *Eastern Red Series*, though it seems to present Mao as persistently negotiated, could not be more different from a series of Bush portraits Zhang Chenchu painted in 2008. This latter series openly ridicules and satirizes Bush in a very direct manner by showing him with rather fatuous smiles and features (ill. 5.45c). Even though the *Eastern Red Series* contradicts or even subverts the standards set for painting Mao during the Cultural Revolution, its intent is not to bring down Mao as standard: the spectacular reduction to harshly contrasting colors of black, red, and white presented here accords quite literally with Zhang's aim of creating "a perfectly objective historical record of Mao Zedong" as well as to "leave a record of the bitter and harsh phase of red history" (我以我的视觉努力企图恢复对毛泽东形象较完整的客观的历史记述 ... 同时也从侧面反映中国上个世纪艰苦卓绝、波澜壮阔的红色历程) (DACHS 2009 Zhang Chenchu Writings).

The multiple layers in these negotiations of Mao and his significance for Zhang Chenchu are evident in another Mao series that appeared in 2006. Here, too, the bar of light occurs. But apart from that, this consists of a number of Mao's standard portraits in different (and very warm) colors (ill. 5.45d).[63] The series becomes the reference point to a number of other portrait series of political figures by Zhang: the light bar is used again in his 2006 painting *Leaders—Marx, Engels, Lenin, Stalin, Mao* (领袖—马恩列斯毛) followed by *Leaders One* (领袖之一) and *Leaders Two* (领袖之二), respectively, each of which shows China's leaders including Zhu De, Liu Shaoqi, Mao Zedong, Hua Guofeng, and Deng Xiaoping, first in color, and in the second version reduced to grey tones, but all with the same "crack-lighting" device applied. In 2007, Zhang created a series entitled *Three Great Men: Sun Yatsen, Mao Zedong, Deng Xiaoping* (三伟人—孙中山，毛泽东，邓小平) that retains the lighting effects but places them this time before a background of straight "Warhol colors": blue for Sun, yellow for Deng, and—naturally—red for Mao (ill. 5.45e).

The locked-in, the grey and immaterial, the formulaic and the sarcastic repetitions of Mao in the work of Ai, Wang, and Zhang Hongtu (all of which juxtapose different versions of the same image next to each other and thus evoke the historical models from which these images were derived), and those by Zhang Chenchu (which couple different images of the same man and the same types of images of different men), could not be more distinct from the many colorful Maos appearing next to each other in the space of one single framed image in Yu Youhan's 1990 piece *Mao in Different Stages of his Life* (毛泽东的生命里程) (ill. 5.46). The painting uses several flowery embroidered stencil patterns both as background to and as attire of Mao, juxtaposing him at several stages of his life (including death) with symbols from radically different iconographic traditions, including mandarin ducks (which stand for happy lovers in popular lore) and a phoenix (the auspicious ruler among the four magical animals), as well as a socialist hammer and sickle. These very disparate objects are laid out next to each other in this reassuring and positive image, the base color of which is red, the color of happiness in China. Objects and symbols are juxtaposed but not connected. What exactly does this mean? For Yu, Mao with his many pasts is clearly still a part of China's present. Yu is quoted as having said, "If we reject Mao, we reject part of ourselves" (Wu 2005, 203).

63. All of these images are featured in Zhang Chenchu's blog; see DACHS 2009 Zhang Chenchu Blog.

The changing but ever-present impact of the Maoist past in China's present is not just reflected in "Political Pop" (Li 1993a), the first form of contemporary Chinese art that was hugely successful outside of China, even as it was mis-understood as "dissident art" (cf. DalLago 1999; Wu 2005, 203–4 and forthcoming work by Tang Xiaobing). Repetitions of Mao sell, on a more popular level, not only in the West but also in China: a 1994 calendar, for example, presents multiple

ill. 5.47 Multiple Maos on a 1994 calendar collage (Barmé 1996, 99, fig. 30c).

visions of multiple Maos (ill. 5.47). One page shows Mao, sitting to the right, in a position very similar to that in Luo Gongliu's depiction of Mao at Jinggangshan (ill. 5.30a), facing a photo-collage billboard featuring images of himself in different stages of his life, hanging from a sky with majestic (and, as we have seen, since Liu Chunhua's *Chairman Mao Goes to Anyuan*, significant) clouds. Mao sitting on the bench is looking at this billboard of his own past intently, while another Mao is walking towards him, serenely and leisurely.

The message of this image is further complicated by the fact that it is accompanied by a commentary citing the concluding verses from a 1954 poem "Beidaihe" (北戴河, so titled because it was written at the seaside resort Beidaihe) in which Mao reflects on thousands of years of Chinese history: "Today the autumn wind still sighs. But the world has changed!" (萧瑟秋风今又是, 换了人间).[64] The commentary refers further to two of the more famous photographs of Mao contained in the collage, one with children sporting red bandanas, the other of Mao in a crowd of smiling visitors from the Third World. It reads, "A youth tied a red bandana around his neck; people of different races smiled in his presence. He, however, deeply questioned all of this: 'How many of them are true believers?' He was no different from anyone else; he didn't enjoy seeing the masses all wearing the same expression" (Barmé 1996, 99).

The message to be constructed from this picture is polyphonic, to say the least. Did Mao—who is seen sitting there, reflecting on his past (as he did on Jinggangshan, most catchingly depicted by Luo Gongliu, ill. 5.30a)—really doubt the faith of his followers when he saw them through precisely the images that had once constituted pervasive everpresent propaganda? Is he aware that only he could make them "wear the same expression" all the time? And if the world had changed so much, why was he, Mao, still there, on the pages of a calendar produced in the mid-1990s and sold at a good price? Is Mao just as long-lived as the autumn wind, then? Images like this must perhaps remain enigmatic in the final analysis, but they are, once more, reflections on and different answers to Mao's omnipresence in China's past as well as in her present.

Repeated Maos in works of art dated after 1976 offer different readings of his ubiquity in the past. None of these readings rendered Mao's form meaningless to the present; on the contrary, they reflected a continuous interest or need as well as an expanding freedom and creativity in interpreting Mao. Cultural Revolution repetition, which, as seen above, was never identical

64. The poem reads in its entirety: 浪淘沙, 北戴河—大雨落幽燕白浪滔天, 秦皇岛外打鱼船. 一片汪洋都不见, 知向谁边? 往事越千年, 魏武挥鞭, 东临碣石有遗篇. 萧瑟秋风今又是, 换了人间 (Mao 1993, 160).

repetition but included many distinct variations of Chairman Mao, nevertheless always did so with the same message: he was the "red, red sun" and the "people's savior." This probably contributed more to this art's loss of meaning than anything else. In paintings or art works from the years before and after the Cultural Revolution, on the other hand, Mao's image, as (once) officially guarded territory, is obviously (re-)gained, appropriated, and expanded. In visual terms, then, we see a situation similar to that in Cui Jian and Tan Dun's music or to that in the advertising or comic, literary, or caricatured use of Mao quotations. Paintings of Mao and repetitions of his image do not prescribe meaning but rather describe feelings. Thus, they appeal to a number of different groups, the young demonstrators on Tian'anmen among them who had only vague childhood memories of Mao, if any.[65] When Mao is adapted and appropriated time and again, there is sympathy and identification as well as derision and disgust. The ambiguities continue to grow, however, as repeating Mao becomes a fad in contemporary art and popular art forms alike.

Repetition Reconsidered

Statistics show that Mao's portrait is the single most reproduced portrait in human history. So far, the present discussion of MaoArt from the Cultural Revolution has uncovered significant variety within the repetitions of his image, which was, in terms of numbers, a weighty staple of the Cultural Revolution years. I have attempted to contextualize these Cultural Revolution images within a sea of MaoArt from before and after the Cultural Revolution in order to illustrate how Mao's Cultural Revolution image came into being and how it evolved after that period. It has become clear that Cultural Revolution MaoArt drew on a number of sources that had been developed before the Cultural Revolution, simplifying them in order to make them ever more accessible. Cultural Revolution MaoArt disdained subtleties of color, brushwork, and design that artists used extensively both before and after this period. Cultural Revolution MaoArt was bold and, most importantly, predictably straightforward in its message. In marked contrast to MaoArt before, but especially after, the Cultural Revolution, which is never easy to interpret, Cultural Revolution MaoArt is primarily intended as a medium of immediate persuasion. It is intended to be read in one way only.

In order to achieve this goal, Cultural Revolution MaoArt uses particular mechanisms of persuasion (Lu 2001–2), first, by identification, creating a Mao for everyone—peasants, soldiers, intellectuals, and workers, each depending on time and circumstance; and second by romanticization, offering a Mao as everyone would hope for, a Mao who looked and acted like the perfect father-hero-lover figure to all. Romanticization was indeed considered a major motivational power, and none of the Cultural Revolution depictions of Mao are therefore intended to be plainly realistic. They too, in accordance with the theoretical guidelines formulated for the model works and in a manner seen at work in stories written to illustrate the power of Mao's quotations, had to depict "life on a higher plane." These images of MaoArt are considered mighty constructions: they are meant to appeal through the level of artistic and politicized perfection achieved. Yet do they convince? Do they help imprint a certain social reality in their viewers' minds? Did pervasive distribution and, accordingly, pervasive viewing (and thus internalization) help construct an ideology and culture as desired by the Maoist state? Did it produce behavioral change in the audience and physical change in Chinese reality? (Lu 2001–2, 10).

65. Accordingly, I disagree with the rather too clear-cut generational differences in representing Mao in art categorized by DalLago 1999 and then taken up again in Valjakka 2011. There are differences, to be sure, between the ways in which artists depict Mao, but they may also cut across generations, as seen in the works analyzed here (as well as in Valjakka 2011, esp. 77–79, 96–101, or 107 to show the typical generation mix, with artists' birth dates ranging from the 1940s to the 1970s) in similar topical usage of the Mao image.

[handwritten annotation]

The rhetoric of persuasion found in the propaganda images studied in this chapter is skillful. The implied audience constructed within Cultural Revolution MaoArt is in awe of Mao. They adore him and carry his picture with them all the time, close to their hearts and minds—as on the *Red Book* or as a badge (one of the popular revolutionary songs taken up in the 1990s praises the feeling of wearing a Mao badge [毛主席像章挂在我胸前]). They are obviously inspired by Mao, their great model and an unquestionably popular leader. To them, these art works are, of course, convincing, and his followers would certainly live by the rules prescribed therein. Yet, how does this implied audience relate to an actual audience? And how is it different from the actual audience of MaoArt from the years before and after the Cultural Revolution, which, in many cases, is so much more difficult to pin down? This first part of this chapter has dealt with images in terms of how they set out to reach their audience. It is now time to ask whether they were successful in doing so, and how the audience reacted.

Receiving Mao: The Actual Audience of MaoArt

> Although many older people, including some of the artists themselves, may have privately thought that these pictures were ridiculous, the images very effectively influenced the children who saw them. (Shen 2008, 159)

> I don't really understand modernist art. And I have not seen the kinds of images you are talking about. What I think, however, is that the painters are writing their memories into these images. (Guqin Player, 1940s–)

The political aesthetics of repetition peaked during the Cultural Revolution, and the assumption that Mao was, in fact, everywhere influenced not just the production but the reception of MaoArt, too. The controversy over Tang Muli's 1972 painting *Acupuncture Anaesthesia* (针刺麻醉)—the question of whether Mao badges should be added to the surgical suits of nurses and doctors—may be considered exemplary in this regard: it illustrates that during the Cultural Revolution itself, a natural assumption was that Mao must be everywhere and that, therefore, Mao badges (and posters) would be seen even in an operating theater (where badges would of course *not* be worn for reasons of hygiene). The argument ran, however, that the image was going to be shown publicly and therefore must accord with assumptions about public visualities (Andrews 1994, 358). How ubiquitous was Mao, then, during the Cultural Revolution and beyond, and what did this ubiquity mean for the audience of MaoArt?

Ubiquity!

Photographic evidence supports the idea that during the Cultural Revolution, Mao was quite popular—at least in one sense of the word—inasmuch as he could be seen everywhere: in public at Tian'anmen (ills. 5.48 a&b) as well as at home (ill. 5.49), in the cities (ill. 5.50) as well as in the countryside (ill. 5.51), in the factories (ill. 5.52) as well as at the universities (ill. 5.53).[66] In all of these depictions, Mao the old and the young, or Mao the sun and pattern, can be seen hung in a fitting size in the most central and prominent places. These repetitious images are not exclusive to the experience of the Cultural Revolution.

66. See the many photographic collections such as Yang 1995 and *China* 2008, as well as DACHS 2009 Documentary Photographs, Cultural Revolution, William A. Joseph, "Serve the People."

Before and after the Cultural Revolution, too, Mao could not be missed in public at Tian'anmen, as for example during parades celebrating the Great Leap Forward in the late 1950s or during the Tian'anmen protests in 1989 (ills. 5.54 a&b).[67] Indeed, his presence at Tian'anmen has played a significant role since 1949. His giant portrait can be said to "have formed an intimate bond between the leader and his admiring flocks" (Hung 2011, 264), and its significance, representing the unity of the Chinese people, remains deeply felt and deliberated to the present day.[68] Mao only seems to become out of focus in Wang Guangyi's *Chinese Touristmap—Beijing* (中国旅游计划—北京) of 1989, which is an interesting study of Beijing weather and Tian'anmen at temperatures between minus five and seven degrees (ill. 5.55). Everything is well focused in this painting, even the slogan boards congratulating the People's Republic and the People's Congress, yet Mao's image is only a blotch of color, and, as well known in images of Mao, there are other cloudlike (!) blotches with color dripping out of them (like rain, predicted in the weather forecast) both in the sky and on the ground (these are red, perhaps suggesting blood dripping onto Tian'anmen in June 1989). What does it tell us about the reception of Mao's public ubiquity that Mao is out of focus here as in so many recent depictions?[69] What does this tell us about the reception of MaoArt? Is it such that one no longer wants to see him, the leader who is made responsible for what happened on Tian'anmen and during the Cultural Revolution or the Great Leap Forward? Or, quite the opposite, is it an expression of regret that one can no longer see him everywhere, due to the new politics of "socialist capitalism" now reigning high?

Indeed, fuzziness has become a hallmark in depictions of Mao after the Cultural Revolution: Mao is quite out of focus, simply disregarded, in a huge 1992 painting (2.4 meters high) by conceptual artist Zhao Bandi 赵半狄 (1963–), for example. It shows two very thin and rather bizarre-looking youngsters, he (the painter's alter-ego) with naked upper body, black umbrella, and almost transparent shorts, she (his girlfriend) with a white blouse and wide skirt, each walking right past Tian'anmen and Mao, in opposite directions in dramatic yet somewhat indifferent gestures. Mao, on the other hand, appears to be watching the scene from his portrait on the side (ill. 5.56). Several signs suggest a political reading of this image: the characteristic clouds above Tian'anmen are darkened, and the painter is holding his umbrella in such a way as to suggest that he is saving himself from the scorching sun—Mao.[70] Last but not least, the artist's alter-ego is the one who looks out of the image toward the viewer, a privilege usually reserved for Mao. All of these elements may help to explain the title of this image: *Listen to Me* (听我说). Is it Mao, calling for attention as he realizes that he has been pushed quite far off, if not out of the lives of these eccentric individualists? The prominence of images like this one shows that, for whatever reason, artists (and their audience) cannot do without him, and must return, time and again, to his image.[71]

67. For a historicization of the presence of the Mao portrait at Tian'anmen throughout modern Chinese history, as well as more images, both documentary and artistic, see Wu 2005, 68–84, and HRA 2008 Images of Mao Zedong.

68. See e.g. Wu 2005, 74. Mao's presence on Tian'anmen was reflected in a set of stamps issued in celebration of the establishment of the PRC (Wu 2005, 72). For an informative overview of the history of the portrait on Tian'anmen, see also Valjakka 2011, 45–50. She devotes an entire chapter (chap. 4) to contemporary "remakes" of Mao's presence on Tian'anmen.

69. Similar images are Lu Hao's 卢昊 (1969–) *Tian'anmen and Gold Fish* (花鸟虫鱼之鱼缸) seen in DACHS 2008 Mao Images 2 (Mao, Pictorial Works), 155; and Zeng Fanzhi's 曾梵志 (1964–) *Tian'anmen* (天安门) (2004), published in *Revolution Continues* 2008, 56–57. In both cases, Mao's image is blotted out. We saw several examples of Mao's portrait out of focus earlier; recall Yan Peiming's *Mao* and Zhang Hongtu's *Material Mao*. Another example is Yin Zhaoyang's 尹朝阳 (1970–) *Mao* (毛) in oil (2006), archived in DACHS 2008 Mao Images (Mao, Pictorial Works), 117.

70. A similar scorching effect is shown in Yin Zhaoyang's *On the Moment of Seeing Chairman Mao, Sharp Lightning and Loud Thunder Crossed the Sky* (看见毛主席那天电闪雷鸣, 风云激荡); see Valjakka 2011, 116.

71. A slightly different reading of the image is given in Wu 2005, 196; see also Valjakka 2011, 220–21.

Even anti-images such as Ai Weiwei's *A Study in Perspective* (透视学) in its 1997 version,[72] which consists of three photographs of power centers, shows this quite clearly. In each, the photographer holds the finger up to (1) the White House, (2) the Hong Kong Bank of China Tower Building, and (3) Tian'anmen. In the latter case, his finger is blotting out completely Mao's portrait (**ill. 5.57**). Such explicitly disrespectful disregard for Mao, deliberately writing him out of the picture, must be read as spiteful reaction to and reflection of Mao's considerable public presence before, during, and after the Cultural Revolution.

This may be even more true as Mao's presence was not just public but private, too, as reflected in popular propaganda materials since the 1950s, many of which show the Mao portrait in the living room and in familiar situations (**ill. 5.58**).[73] This presence is continually negotiated in contemporary artworks suggesting that even after his death and the end of the Cultural Revolution, Mao continues to "haunt" private homes. The more "innocent" pieces of evidence for this fact, small and in porcelain, include some of the flowery sculptures produced by Liu Liguo 刘力国 (1961–) around 2005, such as Mao as Laughing Buddha playing with his many children (**ill. 5.59**).[74] Larger and less innocent, perhaps, is *Ms. Mao* with exposed breasts in red fiberglass (red, bright, and shining), a sculpture produced in 2006 by brothers Gao Shen 高兟 (1956–) and Gao Qiang 高强 (1962–) and more apt to adorn a column in the garden rather than a display cabinet

ill. 5.57 Ai Weiwei, *A Study in Perspective*, 1997 (Barmé 1999, insert before 201).

in the living room (the work is 52 centimeters high) (**ill. 5.60**).[75] Mao's homely presence is reflected quite a bit more bitingly in a 1995 mixed media installation by entitled *Front Door* Zhang Hongtu: behind the innocent-looking doors can be made out (and heard, through a door knocking sound) Big Brother Mao, watching you as he peers through the peephole of your door (**ill. 5.61**).

And one could go on: pictorial Mao was and still is a presence in the countryside (**ill. 5.62**), and he remains an imposing figure in cities, in factories, as well as in the universities (**ill. 5.63**). In

72. See his blog in DACHS 2009 Ai Weiwei Blog, *A Study in Perspective*. He later added more photographs to the set.

73. The picture shows a newlywed couple moving into their own room: the first thing they do is to hang up a portrait of Mao Zedong (**ill. 5.58**, *Guangzhou funü* 广州妇女, 1953.1:12). Thanks to my former student Jennifer Altehenger for letting me use these materials, which she collected as part of her own PhD thesis on the marriage law campaigns in the early 1950s. For more such images, see HeidICON 59155 *Guangzhou funü* (广州妇女) 1953.4:24, which shows a living room of a work hero adorned with Mao's portrait; HeidICON 59164 *Huadong funü* (华东妇女) Oct. 20, 1952.4:22, which shows a young girl at her table at home, on the *kang*, learning her lessons for primary school (notable because she is the first ever in her family to attend school); HeidICON 59163 *Huadong funü* (华东妇女) Oct. 20, 1952.4:13, which shows a happy family under Mao's portrait, HeidICON 59212 *Zhibu shenghuo* (支部生活 1953.4:17), which shows a family celebrating one family member's entrance into the Communist Party; and HeidICON 59194 *Zhongnan nongmin* (中南农民) 1953.2:9, which shows a happy peasant in his home beneath a portrait of Mao on the wall, explaining how much happier he is since the foundation of the PRC.

74. For more Mao sculptures by Liu, see DACHS 2008, Liu Liguo; DACHS 2008 Mao Images 2 (Mao, Pictorial Works), 123; and his own website DACHS 2009 Liu Liguo.

75. DalLago 1999 discusses further examples of Mao transgendered.

"socialist capitalist" China, he gains ever greater currency, and literally so: one important carrier of Mao's visual presence that I have not touched on so far is paper money.[76] The ubiquity of Mao's image on Chinese *renminbi* (人民币) or *yuan* (元), however, is only a recent phenomenon: since its introduction in 1948, five series of paper bills have been issued. Only the last, released in 1999, displays a portrait of Mao, painted specifically for this purpose by Liu Wenxi, on all Chinese *yuan*-denominations. Earlier series were issued in 1948; longest in use (into the 1980s) were the second and third series first published in 1955 and

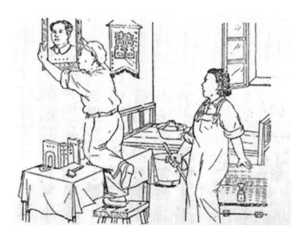

ill. 5.58 *Moving into the New Dorm, 1953 (Guangzhou funü* 广州妇女, 1953.1:12).

the early 1960s respectively. None of these carried Mao's image. Although in 1948 a suggestion had been made to depict Mao on paper bills (as on earlier money bills used in the early 1940s),[77] he rejected this idea in favor of depicting the working people, peasants, and soldiers. During preparations for the 1955 series, another attempt was made to introduce, if indirectly, Mao's image, either by showing Tian'anmen with his portrait, or by displaying a Mao portrait carried in a procession or attached on a locomotive. Again, these drafts were rejected by Mao personally— who, so the legend goes, is said to have strongly disliked even the touch of money (Quan 2006, 75–76). A last attempt was made in 1969, during the Cultural Revolution, to be disallowed by Mao once more. It was only in the late 1980s, when a new series of bills was being introduced, that they began to include portraits of the four early leaders of the PRC: Mao Zedong, Zhou Enlai, Liu Shaoqi, and Zhu De. These were replaced by bills featuring Mao on his own since 1999 (ill. 5.64). Since then, at least, Mao has been "highly current." How does the audience react?

Ubiquity?

> There were quite a few people who would make images of Mao. This shows clearly how much they cared about him. (Photographer, 1960–)

Veneration of Mao and proliferation of MaoArt had been rigidly prescribed during the Cultural Revolution. Red Guards would demand that every street and all parks ought to set up quotation boards. Bicycles and pedicabs, motor vehicles and trains, as well as every household must have a picture of the Chairman plus quotations by Chairman Mao. Ticket inspectors should make the propagation of Mao Zedong Thought and the reading of Chairman Mao quotations their primary task (Schrift 2001, 44–46). But all of these demands, though coming from both above and below, say nothing about their actual implementation. Immediately after the Cultural Revolution, on the other hand, continuous attempts were made to restrict the use of Mao images, especially in public.

76. It is Paola Zamperini who suggested that money should also be taken into consideration in this exploration of Mao imagery, thanks to her!

77. For examples of earlier local currency, some of which contained Mao's image, see DACHS 2009 Mao Money. See also Wang 2003.

Laborious work was undertaken to tear down statues and portraits (ill. 5.65). One interviewee remembers that this took place silently and without much ado: "During the Cultural Revolution there were all these images of Mao, but slowly they had been taken down. People were not against it. Perhaps in some places there was some resistance, but certainly not everywhere" (Journalist, 1949–). A Party document dated July 29, 1981, however, decrees as follows:

1. Henceforth, no official portraits will be displayed during meetings;
2. Portraits of Chairman Mao can be hung in public places but with due regard for moderation and dignity, and so as not to offend international sensibilities. Note that excessive numbers of portraits should not be hung, yet it is inappropriate to ban the display of portraits altogether;
3. No portraits of living central Party leaders are to be hung either during meetings or in public;
4. It is entirely up to the individuals as to whether they hang portraits of living or dead leading comrades in their homes or in private. It is forbidden for Party, state or army organizations at any level to interfere with individual preference in any way.[78]

The fact that this kind of document appeared, and is couched in such careful language, shows that the attempts to restrict the uses of Mao imagery in public (and private) after Mao's death had been unsuccessful. Indeed, the official dismantling of Mao statues had been recalled in 1980, on November 6, as removal of these statues had frequently caused public outrage (Barmé 1996, 134n6). Public discussions about whether or not to remove the statues were muted, however, in order "not to harm revolutionary feelings." Dealing with the physical remains of the Mao Cult turned out to be difficult, then: if over the following decade, Mao's statues diminished in numbers and some disappeared from factories and university campuses, this would usually occur under the pretext of conducting renovation works, yet it was considered a "disservice to the people of China if not a few statues of Comrade Mao Zedong were left standing." Mao's image was obviously too important to be tarnished, and both official and popular opinion evidently was split about how best to remember its deceased leader (Leese 2006, 283–84; see also Valjakka 2011, 68–69).

This ambiguous view of Mao's visual presence, both in the positive and in the negative sense, is not something that began with his death. In the mid-1950s, the Party center had at least once seen the need to announce a similarly lenient and flexible policy on Mao (and other political) portraits. A Party document published on June 25, 1956, reads:

From today on, there will be no uniform rule regarding the display of portraits in institutions or on public places. Whether or not to hang portraits and which person's portrait should be decided individually by the local authorities according to the local conditions.[79]

Apparently, Mao's presence was also negotiated by individuals on a case-by-case basis not only after and before but even during the years of the Cultural Revolution. When asked whether they hung up a Mao portrait in their homes during the Cultural Revolution, interviewees from a number of different backgrounds and generations gave rather contradictory answers: some denied having put up his portrait for different reasons ranging from simple reluctance to do so (and this marks a difference between cadres and intellectuals, workers and peasants, rightists and leftists in their inclination or ability to hang the portrait or not) to feeling that it was in fact too dangerous to do so. Many mentioned a clear difference between private and public space: there may have been leeway in private spaces for not hanging Mao, but not in public.

78. The document is translated in Barmé 1996, 134. For similar documents, see Leese 2006, 260.
79. Leese (2006, 51) thus translates a document he found in the Hebei Provincial Archives (HPA): 中央关于挂象问题的通知 *Zhongyang guanyu gua xiang wenti de tongzhi*, 25 June 1956, HPA 855-9-3983.

Cadre families would hang up these Mao portraits, and if your leaders came to visit, you would hang them up, of course. But I never did. I did not feel like it, anyway. I think most of these portraits people had were given them as presents. I sure would not go and buy one myself. (Librarian, mid-1950s–)

I don't remember a Mao portrait at home, no, we did not have one in my family. Of course, my family was a bit special. My father was a rightist, remember, he was also criticized quite severely during the Cultural Revolution, so his feelings toward Mao were very bad. I was small then, so I never thought about it, but apparently, there was also no directive saying that you must hang his portrait. (Musicologist, 1950s–)

At home, we did not have a painting of Mao. In 1972, when we got married, we would put one up for the wedding, but not forever. We would always just put it up when needed. Of course, the children in kindergarten had a portrait hanging in their classrooms and saw it all week. In official places, there would always be portraits, but not in our private spaces, really. It was not all that common to hang his portrait, certainly not in intellectual households, more in the worker and peasant households. (Ethnomusicologist, 1940–)

The Mao portrait, no, normally you would not have one hanging at home. If it were to become dirty or anything, you would become a counterrevolutionary—this was just too dangerous! (Editor, 1930s–)

Others immediately replied that—naturally—they put up Mao's portrait at home, that this is what they wanted, or else that it was in fact too dangerous *not* to do so. Still others remembered they did, but deliberately chose a portrait that was unorthodox:

We were sent to a factory. All the youngsters lived together. It was really fun. We were there from 1968–71. There were Mao portraits in our rooms. We put them up ourselves. I really liked him then; he is a great person, Mao, really. (Musician, 1942–)

During the Cultural Revolution, even in the second half, there were still many Maos around, porcelain statues or portraits. If you did not have a portrait of Mao, you could be declared a counterrevolutionary, so, of course, you would hang it up. (Photographer, 1960–)

Mao portraits—yes, we did put them up at home during the Cultural Revolution. We had this image of Mao working.[80] It was not the typical beautiful Mao portrait. I have a feeling that even among the Mao portraits, there is a certain hierarchy. Because my family was interested in fine arts, they would not just take the standard portrait. (Playwright, 1956–)

Quite a few would say that there was a difference between the first half of the Cultural Revolution and the second with regard to Mao portraits. Less would be seen in the later period. But people would then begin to doubt their own judgment by remembering a neighbor's example. Yet others would first answer in a sort of reflex reaction that—"of course"—they had had a portrait hanging, but, upon further reflection, came to the opposite conclusion; some began the other way round, saying at first that they had no portrait hanging, only to realize that, upon second thought, in some form or other, they had manifold objects emblazoned with Mao's face in their homes:

In 1971 we had long since taken the Mao pictures down. There was nobody who came and looked, really, so we did not have to be nervous. In Fudan University, there still is a statue of Mao, but the pictures were all taken down very early. In some of my friend's homes, there were a lot of propaganda posters; they were put up as ornamentation, really. There was nobody who forced you to hang up these pictures, so we simply did not! In the schools and work units, they would hang them, of course. In fact, they had ever new ones all the time. I collected Mao buttons, indeed, we all liked them, we were not forced to. This was simply fun [好玩 *hao wan*], but not really a sign that we loved him so much [热爱 *re'ai*]. (China Historian, 1957–)

80. From the description given, this could well be something akin to the 1958 portrait *Mao at the Ming Tombs Reservoir* by Li Qi (ill. 5.32a), mentioned above.

Only during the first few years of the Cultural Revolution would the portrait be hung in private households. In the second half of the Cultural Revolution, we stopped having one. Nobody really cared. On the other hand, I remember the story of one of my neighbors, who was a bit older than I. They still had a Mao portrait at home. The father was a director at university. At one point in time, he was so angry, he actually tore the painting apart. . . . (Playwright, 1956–)

She: As for the portrait of Mao, yes, of course, we had it hanging. He: But no, there was nobody forcing you, no requirement [要求 yaoqiu] to do so. You did not *have* to hang it up. People just felt that they *ought* to hang it. But we did *not* hang one up, anyway. She: Yes, it is true, in our dormitory we did not hang one. (Housewife and Husband, 1950s–)

We did not have to have a Mao painting at home. At least, after 1968, we did not have his image anymore. We had a photograph of Mao; that was enough. Some time later, my father brought a porcelain Mao back from Jingdezhen. That was enough. (Art Historian, 1940s–)

What becomes clear from these contradictory memories and reflections is that Mao's face was obviously felt to be there, even in its absence, whether in public or in private. While depictions of Mao before and especially after the Cultural Revolution may be hugely different in terms of both style and message from those prevalent during the Cultural Revolution, they (and the choice of the Mao image on *yuan* bills, too) are evidence that, somehow, if Mao once mattered, he still matters. Although the implied audiences of pre-, post-, and Cultural Revolution artistic production may differ greatly, their actual audiences perhaps do not. In the words of Wang Yuejin, Chinese "eyes had been tuned to Mao's frontal portraits for decades." These portraits, according to Wang, had been imbued "with a devotional imperative" (Wang 1993, 243). In his analysis of Luo Zhongli's 罗中立 (1948–) immense and widely discussed 1980 portrait of a peasant, *Father* (父亲), which somehow plays with substituting Mao's ubiquitous and enormous portrait by that of an anonymous peasant, Wang argues that "The death of Mao marked the end of the age of icon" (Wang 1993, 244). In my reading of MaoArt before, during, and after the Cultural Revolution, I would like to offer a slightly different take: in spite of Mao's death and the apparent end of the age of icon, this age has in fact not ended.

Mao was and remains part of the Chinese daily visual diet in manifold forms; he was there to be loved or to be debated, always so present that he must have been at least subconsciously registered in people's minds. The contemporary works of art already discussed here illustrate that Mao's image not only remained an iconic presence but also retained an iconic aura in spite (or because) of all its repetition. The post-Cultural Revolution audience appears obsessed with this presence even amid constant reminders to forget. The Cultural Revolution audience, on the other hand, might often have wanted to forget but could not escape constant reminders of Mao's importance. As discussed in Chapter 4, this audience would have read story after story in which the main heroes did not just live with MaoArt but would hear song after song and see image after image in which Mao's face would help save the world and keep everyone happy.

Maoist theory holds that confrontation with a model makes people want to recast themselves so that ultimately society as a whole will be transformed (Landsberger 2002, 147). The construction of the implied spectator of MaoArt during the Cultural Revolution shows how this theory would be put into artistic practice. This practice was perceived by the actual audience, too: Chen Xiaomei is not the only one to remember that Cultural Revolution propaganda posters "constructed and reconstructed who I was and what was socially expected of me."[81] How exactly did this artistic construction relate to reality? Was it in fact accepted, and did it translate into action?

In my discussion of MaoSpeak, I argued that one of the major problems with the hyperbolic stories and reports about the power of Mao's words was the fact that they described miracles

81. Chen 1999, 105; cf. also the testimonies by Duo Duo and Anchee Min cited in the Prologue to Part III.

seldom transferrable to the realities experienced by China's peasants, workers, soldiers, and intellectuals in Cultural Revolution China. In the case of MaoArt, with its depictions of an always-beautiful and vigorous Mao in ever-idyllic settings, this observation holds true: for with the great "discrepancy between what was visually presented . . . and what the peasants, (for example) actually lived through in their daily reality, irrationality and cynicism" could easily emerge. Thus, these very depictions could potentially be "the cause for 'rebellion'" (Lu 2001–2, 8).

Yet with images of Mao, rebellion is seldom seen, at least not publicly, certainly not during the Cultural Revolution: the references one can find to MaoArt in diaries and memoirs usually describe the images with fascination (e.g., Yang 1997, 111) or awe (e.g., *Zhiqing riji xuanbian* 1996, 24). One frequent "irregularity" in depictions of MaoArt is his reconception as a beautiful lover, yet this is only another (teenage) aberration of the role of (politically correct) great hero and the strict judge of one's own behavior in which he most often appears. Some of the ironical takes on MaoArt, on the other hand, may be read as a reflection of such feelings of "rebellion" born out of the Cultural Revolution. They may be considered acts of subversion—if not always in the aggressive sense—in direct response to the ideological streamlining practiced during the Cultural Revolution, and they are criticized as such, too. Deng Liqun 邓力群 (1915–), editor of *Red Flag* until the Cultural Revolution who served as head of the Party Central Committee Propaganda Department in the 1980s, and a staunch critic of the reform course, contends:

> The miasma of bourgeois liberalization, in particular this desire to negate, undermine, and vilify Comrade Mao, has polluted many young minds, infecting them with mistaken ideas, corrupting the facts and leading them to erroneous conclusions. . . . Their age and limited experience have made it impossible for younger people to resist this cancer. It is only natural, therefore, that for them it is necessary to go through a period of "searching" and "discovery" before they can find the true *mien* of the Chairman. (Deng 1991, 2–4; trans. Barmé 1996, 153)

Even two dozen years after this verdict, the period of "searching" and "discovery" is clearly not over. On the other hand, it is questionable whether any of the pieces I have discussed so far must be read as works primarily "vilifying" Mao. They are much different from Cultural Revolution MaoArt, of course. Although they perpetuate some of the gestures and many of the most important motifs from the Cultural Revolution repertoire, they are readings in deliberate individual difference and personalized ambiguity as well as answers to the formative powers of the ideology speaking through MaoArt of the Cultural Revolution. The irony, the sarcasm, the disregard and cheeky irreverence expressed here all parallel the vernacular humor, the jokes and quizzes focusing on Mao and the Cultural Revolution that had begun to flourish in the early 1980s (e.g., *Wenge xiaoliao ji* 1988 or Yan Lianke's *Serving the People*). In a lucid analysis of recent MaoArt, Francesca DalLago concludes that both visual and textual humor "provided an occasion of transgression and release that would facilitate the secularization of the figure of the Chairman" (1999). Her view is supported by evidence from the painters themselves. Zhang Hongtu would explain his Mao parodies as follows: "When I was growing up, Mao was everywhere. He was like a God. After 1989 I found myself wanting to play with that image, to transform it from a God's face into that of a . . . person" (Schell 1994, 290–91; see also Wu 2005, 204). Zhang is echoed by Yu Youhan, who would explain his Political Pop as follows: "I borrowed the method of Pop art and elements from Chinese folk art to represent an ordinary Mao in a way of resilience, a little humor, and few critical remarks, all mixed with a little admiration. I am proud that he is no longer a sacrosanct God in my paintings; he becomes an ordinary person" (Wei 2009). Sui Jianguo 隋建国 (1956–), a Beijing sculptor, had similar thoughts when, after finishing his *Legacy Mantel* (衣钵) series of Mao suits modeled in all sizes, all colors, and all materials but without a head (the first of which were produced in 1997)

(ill. 5.66),[82] he was finally "putting Mao to sleep" in a sculpture entitled *Chairman Mao Sleeping* (睡觉的毛主席) in 2003 (ill. 5.67).[83] He describes this experience as follows: "I realized Mao is not a God because God doesn't sleep. Now I should stop thinking about Mao and take care of my own life."

Thus, on the surface, these artists' ritual repetitions of Mao look similar to those by foreign artists such as Andy Warhol. For Warhol, processing Mao (as well as Marilyn Monroe) by repetition in fact meant emptying the image of emotive content. According to Warhol, "All painting is fact, and that is enough. . . . The paintings are charged with their very presence." It was precisely to emphasize his detachment from any emotive content in these images, and very much in the spirit of Benjamin, who would have stated exactly this about the effects of mechanical reproduction, that Warhol silkscreened them on to canvas in batches, implying that they could be repeated *ad infinitum* (Read 1985, 298). The Chinese artists' approach, on the other hand, even that of a self-appointed "rational painter" such as Wang Guangyi, is different: for them, creating repetitions of Mao, deconstructing and rationalizing Mao, the myth, was an attempt to deal with the formidable formative powers of his image that they themselves continued to feel so acutely. It was, therefore, precisely to create works with emotive content. Their attempt to transform Mao from god to human being was an attempt to create an image with whom they could carry on living more easily—for live with it they must continue to do.[84]

Sui emphasizes repeatedly that his realization that Mao was no longer a god began with creating *Legacy Mantel* and thus repeatedly "beheading" Mao. An exhibition like Liu Hung's[85] 刘虹 (1956–) *Where Is Mao?* (毛主席在哪里? Thailand, 2000), which features, among others, faithful copies of Mao's most famous historical photographs from the Cultural Revolution with Mao's face an empty white space (Wu 2005, 205); or images like Xue Song's 薛松 (1965–) 2005 parody of Dong Xiwen's 董希文 (1914–73) oft-revised propaganda image *The Founding of the Nation* (开国大典) (Wu 2005, 171–75), which again whites out Mao completely (**ill. 5.68**), all work according to this pattern of attempting to make a clean break with Mao, the myth—thus recovering Mao, the man. Numerous attempts are made by artists from all generations to disembody or reconfigure Mao, and all of them show how much power he holds over the minds of those who are trying to rid themselves of, or at least come to terms with, him. Qiu Jie's 邱节 (1961–) *Portrait of Mao* (猫的肖像) of 2007 (**ill. 5.69**), drafted in lead on paper, shows, in a humorous pun reminiscent of the dictionary entry in Zhang Hongtu's *Unity and Discord* discussed above, a

ill. 5.68 Xue Song, *The Founding of the Nation*, 2005
(DACHS 2008 Mao Images, plate 123).

82. For more images see Wu 2005, 208, and DACHS 2009 Sui Jianguo.
83. For a discussion of this and other works by Sui, see DACHS 2009 Sui Jianguo.
84. For this idea of repeatedly depicting Mao without this act serving to empty one of emotion, see also Valjakka 2011, 30. The following selection of examples cuts across generations radically, and I thereby take issue once more with DalLago (1999, 4; see also, affirmatively, Valjakka 2011, 31–32; cf. footnote 64 above), who attempts a clear-cut generational categorization which, in my reading of MaoArt, does not seem to hold.
85. Liu Hong would be the correct *pinyin* spelling; the painter, however, herself uses the romanization cited above.

cat (猫 *mao*, pronounced the same way as 毛 Mao, the Chairman)—wearing a Mao suit and presented, in devotional imperative, before a background of flowers and calligraphy.

The calligraphy includes a line from one of Mao's poems that in itself reverses a traditional lament about the loss of spring by Southern Song poet Lu You 陆游 (1125–1210).[86] Mao's poem, instead, greets the coming of spring, a trope used time and again to indicate the coming victory of revolution.[87] The image playfully mixes several iconographies, that of the official Mao portrait on the one hand and that of traditional symbolic paintings for good luck on the other: A cat, pronounced the same way as the octogenarian 耄, stood for long life in traditional images. Mao is thus reconfigured in the same surreal and yet highly complex manner as he is disembodied in Sui Jianguo's *Legacy Mantel* series. In both cases, Mao has quite literally "lost face"—not something that often happens to a god, and not an accidental pun in a Chinese context, to be sure. But if Mao appears in contemporary depictions such as these as out of focus, overwritten, transfigured, cross-

ill. 5.69 Qiu Jie, *Portrait of Mao*, 2007 (*Revolution Continues* 2008, 65).

faded, or disembodied, his portrait is not emptied of emotive content, but its emotive content is changed, taking on new meanings for ever new audiences.

Deity!

We really felt that Mao was a god and we were paying reverence to him. (Artist Couple; He, 1954–; She, 1959–)

There is some kind of religious spirit in the cult. It was very similar to the propaganda around Hitler. Then, during the Cultural Revolution, a lot of people actually believed in Mao. Whether or not they acknowledge it today, depends. But if you go interview those who had been Red Guards at the time, you will find that Mao was a kind of god for them. They knew it was going to be really hard, but all went to the countryside, anyway: why did they do so? Because they believed in Mao. (Photographer, 1960–)

China is a polytheistic society, Guan Yu and other such gods were real people. The God of Wealth [财神 *caishen*]—like Mao, was a real person. So, of course, people would consider Mao one of their gods. Even after the Cultural Revolution, the official view of Mao was to still revere him. I have not seen anyone who is really cold when it comes to Mao. (Intellectual, 1955–)

The previous chapter discussed how the *Little Red Book*, Mao's *Selected Works*, and especially the *Three Constantly Read Articles* almost literally became "Holy Scriptures" to be carried around,

86. The last line of Mao's poem is full of optimism, and happy smiles are cited on the image: 读陆游咏梅词,反其意而用之. / 卜算子咏梅 / 风雨送春归,飞雪迎春到. / 已是悬崖百丈冰,犹有花枝俏. / 俏也不争春,只把春来报. / 待到山花烂漫时,她在丛中笑. (Mao 1993, 236). The original poem, 卜算子咏梅, reads: 驿外断桥边,寂寞开无主. / 已是黄昏独自愁,更著风和雨. / 无意苦争春,一任群芳妒. / 零落成泥碾作尘,只有香如故. (Songci sanbaishou 2007, 194).

87. In scene 5 of *Taking Tiger Mountain by Strategy*, for example, Yang Zirong speaks of hoping to "order the snow to melt and welcome in spring to change the world of men" (*Zhiqu weihushan* 1971, 132ff.). This is then proclaimed possible: when, in scene 8, he concludes that "Standing in the cold and melting the ice and snow, I have the morning sun in my heart!" to the sounds of "Red Is the East" (*Zhiqu weihushan* 1971, 282–310).

studied, recited, and discussed in long study sessions during the Cultural Revolution. There is evidence that not just a select few were captured by the power of these rituals (Wang 1997, 215). This fact, in turn, met with both skepticism and pride in different factions of the Party depending on whether their members saw such "secular religious frenzy" as conducive to consolidating their power. In the late 1960s Mao shrines, so-called "Long Live the Victory of Mao Zedong Thought Halls" (毛泽东思想胜利万岁馆), or, for short, Long Live Halls (万岁馆), appeared all over the country, artifacts glorifying Mao were put on display for worshippers, fresh flowers were placed before Mao's picture, and his works were displayed on "Precious Red Book Altars" (红宝书台).[88]

Loyalty dances and quotation songs as well as the many processions involving the carrying of Mao's image and the Little Red Book were popular performative acts of ritual. Especially in the rural production brigades, the early months of the Cultural Revolution saw a rapid increase of such ritual modes of worship. In many cases, Mao was effectively incorporated into the local pantheon and replacing the former deities on the house altar, a habit that continues to be practiced to the present day (Leese 2006, 246). A Russian visitor to China in 1968 remarks that signs of a flourishing cult, "the godlike glorification of a modern political leader with mass medial techniques" (ibid., 6), were everywhere:

> Streets and squares in town and country are hung with pictures of the "leader." They are displayed in every shop window, in buses, trolleybuses and cabs, in every policeman's shelter and over the entrance of nearly every house and office. A plaster or marble effigy of the "helmsman" is to be found in nearly every public place.... "Where before there stood the three gods of happiness, fortune and longevity," the Shanghai paper *Tsehfang Jihpao* wrote, ... "today hangs the picture of Chairman Mao in a yard-high frame." His picture is worshipped in prayer as if an icon, and people go to genuflect before sculptural effigies of Mao.... Peasants go out to the fields carrying Mao's pictures. Sometimes the field where they may be working will be fenced off with Mao's pictures. Tibetan peasants have placed next to effigies of Buddha large and small busts of Mao Tse-tung and sanctified towels are presented as a votive offering in the same way as to Buddha. (Ibid.)

These depictions focus on Mao becoming a substitute Buddha, a substitute God. And, indeed, he came to stand or hang in some households in the central place on the family altar, or at least in the spot where it had once been located. Mao has been likened to the old Kitchen God, as he would keep an eye on what went on in the household, noting carefully, not unlike his predecessor, the virtues and vices of each of its members. Thus, the worship of Mao replaced the worship of old gods and what were considered "superstitious symbols" (Landsberger 2002, 154). Some of the earlier depictions of Mao on "new" New Year Prints can be considered part of this substitution campaign (ills. **5.19**, 5.20, 5.36a, **5.38**, 5.39), which, in this particular style and form, was taken up again in the second half of the Cultural Revolution (e.g., ill. 5.36b).

By that time, "it had become conventional to speak of portraits and pictures of Chairman Mao in religious terms, as though they actually embodied a god" (Andrews 1994, 342). It was the visual ubiquity of the portrait, combined with the power and prestige of the man it depicted, that contributed to the development of forms of religious adoration not just toward the Chairman but toward his substitute image as well: it began to share in the godlike nature of its referent (DalLago 1999, 49). Liu Chunhua's *Chairman Mao Goes to Anyuan* (ill. **5.1**), for example, was soon called a "divine image" (宝像) (Andrews 1994, 342). Liu remembers his own reverence while creating the work and compares it to that felt by painters of religious art in Europe (Zheng 2008, 127).[89]

88. Leese 2006, 245–46, 251; Andrews 1994, 345; Wang 1997, 215.
89. Further testimony is found in Lu 2004, 121.

Mao's image was to be created in a god-creation campaign (造神运动 *zaoshen yundong*) which entailed the production of a Red Sea of Mao portraits to establish his authority nationwide (Zheng 2008a, 32). His image was centrally involved in a nationwide, albeit short-lived, campaign to "Seek instructions in the morning and report in the evening" from the early years of the Cultural Revolution, praised, in some sources, as an invention of the masses.[90] Ritual obedience was paid to his image and his works, songs praising him were sung, his quotations were cited, and his long life prayed for collectively below his portrait every morning before work started and every evening after it ended (Schrift 2001, 139). Everybody was to model their thoughts and actions upon Mao's instructions daily, always reconsidering them under the eyes of the Chairman. The ritual is well-remembered, although not always enthusiastically. One couple recounts that nobody was interested in it, but that some had to take part in it nevertheless:

> She: Almost nobody would actually take part in this ritual of reverence to Mao in morning and evening [they laugh about how ridiculous [可笑] *kexiao* the practice was]. The military, sure, they had to do this every day for an hour or so, around 1967. He: This was until Lin Biao's death, then it stopped. After Lin's death, Mao toned it down. There was some pressure for those who had been criticized to participate, so they would. (Housewife and Husband, 1950s–)

But even those who had not been criticized felt the pressure: one editor, born in the 1930s, remembers: "We had to do that until maybe the time that Lin Biao died." An intellectual, 25 years his junior and a teenager at the beginning of the Cultural Revolution, on the other hand, recalls:

> For a short while this was very ordinary, around 1967 until the autumn of that year, perhaps, we did it. Not at home, of course, you would be crazy [有病 *you bing*] to do it there, but in your work unit: every day when you went to school or to work. But it did not last long, really. You needed a regular life for this kind of thing. You must go to work daily and go to school daily, but you did not necessarily do so during the Cultural Revolution, so this is why this practice did not last. I wonder whether you could call this common consciousness building, really! (Intellectual, 1955–)

Whether and for how long the ritual lasted, inclusive of a confession of misdoings during the day, is hard to tell. So, too, is its effect on the Chinese *mentalité* more generally. Oral history provides contradictory answers. That the practice existed and was memorable (if only to be ridiculed later), however, is certain. Relates Niu Niu:

> When the children had been fighting or had not done their homework, they had to say, "I have some faults to confess to Mao, yesterday I had a fight with a friend . . . I ask Mao to pardon me, and I ask all my classmates to forgive me, too. . . ." (1995, 96)

Ritual or not, Mao's (standard) portrait always appeared as an able judge. This effect can be traced to its particular iconography: not unlike a Byzantine icon, for example, it featured "God's gaze on the beholder" by integrating him or her in the image (Mondzain 1996, 119): whoever sees the icon is seen himself. The icon was constructed such that it gazed out of its own image frame, actualizing art's desire to become part of reality (Neumeyer 1964, 87). A set of perspectival lines departs from the icon's gaze; the image becomes part of reality or reality (and thus the beholder) is drawn into the (spell of the) image. The icon acts on the beholder. What one could call Zhang Hongtu's "Big Brother Mao" (ill. 5.61) is an acute reflection on how contemporary beholders felt drawn in by the presence of the "holy gaze" in spite of the fact that very few of them would ever have met with this gaze in real life.

90. Leese (2006, 211) discusses a document from Shijingshan Middle School that testifies to the invention of the ritual and its prescribed practice.

Apart from the engaging gaze of his (standard) portrait, many more elements in MaoArt attest to its closeness to religious art. The resemblance of *Chairman Mao Goes to Anyuan* to a Raphael Madonna is a striking example. Depictions of Mao as a radiant sun point in the same direction. And the image of Mao as a gigantic figure clearly set apart from—in his heavenly dimensions—the often tiny crowds of admiring believers is a third significant type proliferating all throughout the Cultural Revolution. It is the structural makeup, the use of particular compositional schemes, and the content of MaoArt, that can be seen in parallel to both Asian and European religious pictorial traditions (both of which were part of Chinese academy training). Markers of transcendence are signs from nature such as clouds or mountain peaks; size; the separation between the worldly and the otherworldly realities in which Mao moves; the depiction of scenes from his life (not unlike written records of the life of Christ, Buddha, or other religious figures); the tendency to abstraction and allegory, stripping him of all personal characteristics so that he becomes a standard-bearer, a superhero, the figure of the sun; his encounters with various sections of the population (not unlike the appearances of Christ among the people); and, last but not least, the votive practice in which his image as icon becomes the precondition for present and future happiness—all of these are an integral part of this particular semantic context within which MaoArt operated (Golomstock 1990; Paul 2009). The fact that portraits of Mao occurred so often in *mise-en-abyme*, as picture within pictures, emphasizing the image's inherent power, is another significant element bringing this art close to religious art both in China and elsewhere: a picture within a picture emphasizes the iconic status of that very picture and demonstrates, repeatedly, the power of the image and its impressive ubiquity.[91]

It was not just the stories and the songs, but first and foremost the images of Mao, that captured the minds of the people (not just during the Cultural Revolution, as it appears): "No one and nothing else had a stronger claim on one's emotions," says one participant to whom the "spiritual" nature of this single-minded devotion had a strong sensory and aesthetic aspect (Wang 1997, 205). In Wang's reading, paradoxically, even as the Cultural Revolution busily destroyed the old customs and habits, it resurrected ancient rituals and rites or created modern versions of them (Wang 1997, 215). Thus, by being ritualized, politics was indeed aestheticized, if not quite in accordance with the Benjaminian prototype (Wang 1997, 218).

According to Francesca DalLago, it was through the intense visual drumming to which Chinese individuals were exposed for decades that the icon was increasingly freed of its strictly ideological connotations, acquiring an aura of familiarity. She writes: "This process bestows the image with a hybrid quality that shifts between the objectivity of the everyday and the transcendence of the myth." What happens here, according to her, is not unlike with popular religion, where religious images become part of a "texture of everyday life" (DalLago 1999, 49). MaoArt shows how art can become a political tool, but it is the (religious and) charismatic power of this art that continues to fill the minds of successive generations with questions and fantasies about an incomprehensible era (Shen 2008, 162). At least in part, according to DalLago, it is this transcendent, mythical power that explains why Mao's image could recently undergo a "revival prompted by a set of practices comparable to the Western phenomenon of star adoration and celebrity worship." It created an "aura of immanent sacrality" (1999, 48).

MaoArt, then, can be considered yet another dimension of the "political religion" that Maoism had become. Quite in accord with Emilio Gentile's model, Maoism employs *mimicry*, as it consciously or unconsciously adopts the dominant religious traditions' methods of representation and practice (i.e., Mao taking the place of the kitchen god). It is also *syncretic*, because it transforms and adapts different traditions to its own mythical and symbolic universes (e.g., by using a triptych

as well as the image of the laughing Buddha to depict Mao). It is yet to be seen how *short-lived* Maoism will turn out to be as a political religion. Gentile would argue that a political religion's vitality "starts to expend itself because of the attrition of time, the passing of the circumstances that gave rise to it, generational change, or crisis and collapses in the political movement from which it was created" (Gentile 2001, 141). The longevity of Mao as a figure with God-like qualities, on the other hand, seems to have much to do precisely with changing realities in China. Notes one contemporary:

> When life is stable [稳定 *wending*], then you may not need a belief, but when life is quite unstable, then you need it. You need some stability. (Language Instructor, mid-1950s–)

Deity?

> People who put up Mao's portrait in their home made him into a god. Many people did this. It was a fashion [风气 *fengqi*] in all of society. Even after Mao died, he never really did; his ideas of "serving the people" etc., are great, they will stay! . . . Mao is a real god [神 *shen*] now; people still have his image in their homes like they would have a god's. . . . Now, there is all this talk about one's qualification [资格 *zige*] and one's freedom [自由 *ziyou*], and people want to make money. This is quite hard, so that is why this phenomenon has come into being. (Museum Curator, 1950s–)

> It seems to me that in China there are still a lot of people who believe in or revere [崇拜 *chongbai*] Mao. In China, faith is not exclusive; it is possible to believe in several things at the same time. This is very different from foreign religious faith. (Intellectual, 1955–)

Many of the very early Cultural Revolution Shaoshan badges and posters depict a rising sun over Mao's home, thus giving a symbolic and at the same time quasi-religious rendering of the origins of Communism (ill. 5.70).[92] These items reappeared in the 1990s, accompanied by stories still told today, even among youngsters who only barely had memories of the Cultural Revolution, if at all (the members of this group fell between the ages of 25–35 in 1993, and thus were born between 1968 and 1978): "They claimed, for example, that at the time of his birth a flash of red light was seen in the sky; again, a comet fell from the heavens when he died" (Barmé 1996, 265). Visitors to Shaoshan in the 1990s would "burn incense and paper money, and set off firecrackers before the statue of bronze Mao, some six meters, erected in the village square. Some kowtow to Mao as if he were a God who could grant a good fortune" (Landsberger 2002, 162). The practice has continued: on December 26, 2008, during a "night without sleep" (不眠夜) to commemorate Mao's 115th birthday, visitors burned incense, bowed in front of Mao's statue, and sang "Red Is the East," leading processions with the *Little Red Book* and huge portraits of Mao all through the streets of Shaoshan (DACHS 2009 Mao Memory). On April 2, 2009 (during the Qingming Festival for remembering the dead), some 30,000 people visited Mao's birthplace of Shaoshan (DACHS 2009 Mao Nostalgia). A recent survey also found that "11.5% of the families surveyed had a shrine in their homes of Mao, in the form of a statue or bust. This was only slightly less than the number of families (12.1 percent) that keep memorial tablets of their ancestors" (ibid.).

Knowing this, it might not be surprising to discover that the religious element continues to play an important role in MaoArt to the present day. The message of those images created after Mao may be ambivalent: Mao the sun, savior, and god is one possible meaning, but the images also allow for, or even evoke, different interpretations. Reproduction and repetition were important hallmarks of Cultural Revolution Culture. They helped confirm the godlike qualities of MaoArt.

92. For examples of badges, see Schrift 2001, 86.

Pre–and post–Cultural Revolution MaoArt, on the other hand, still practices and makes use of the same mechanisms and motifs of reproduction and repetition, but here repetition is not necessarily affirmative. It can be subversive, too. Now, repetition and reproduction serve the purpose not of redundantly multiplying one and the same, but of diversifying several possible meanings and interpretations: Mao is associated with holiness, if not religious frenzy: it is also questioned time and again whether he still is a god (or ever was).

Similarly, oral history provides contradictory voices on the godlike quality of Mao. Many would make religious analogies, only to question their religious quality. They would accuse Mao of having craved adoration like an emperor and not a god, but admit in the next sentence that he himself had said many times he did not want veneration:

> Yes, he was more than an individual; he was more than a normal person to many. He was like a messiah, the leader of the socialist movement: the reading of the *Three Articles* [老三篇 *Lao sanpian*] was a sign of that.... People loved him. He is the one who brought China out of all the bitterness and difficulties. He was the first to lead people to actually stand up; this really is something. It happened again in 1989, but before, never.... In China, there is so little competitive spirit, very little heroic spirit. To actually accomplish something together was almost impossible in China, but Mao did it. This is the kind of thing that creates reverence, but whether it is religious reverence is difficult for me to determine. (Playwright, 1956–)

> He: There are quite a few people who say that Mao is very good. There are even some people who say Mao is still here, but whether Mao is a god, I have not really made up my mind about this. This is very difficult to say. She: I don't think people think Mao is a god. The veneration of him never was religious. Indeed, to the present, there is really no real religion in China. (Housewife and Husband, 1950s–)

> He is not a god [神 *shen*], he is an emperor [皇帝 *huangdi*]. You become a god if others make you into one. This is different from an emperor: you can simply want it yourself. Snow was shocked at all the reverence, asking Mao: "Do you like all this, is this true?" Mao said two things: (1) It might be necessary, and (2) Of all of these titles, I only like that of "Great Teacher" [伟大的老师 *weida de laoshi*]. (Intellectual, 1955–)

These contradictions in reception notwithstanding, the visual evidence speaks another language: Godlike Mao lives on long after his death, still towering above everyone and everything as in a 1977 propaganda poster, where he is shown suspended above the monumental memorial hall completed in the summer of that same year: *Hold High the Great Banner of Chairman Mao and Carry on till the End the Continuous Revolution under the Dictatorship of the Proletariat* (高举毛主席的伟大旗帜把无产阶级专政下的继续革命进行到底) (ill. 5.71). Mao remains an imposing presence, white and brilliant as the sun, in his 1978 memorial statue *Mao Will Always Live in Our Hearts* (毛主席永远活在我们心中) (ill. 5.72). And up in the clouds, overlooking the vast landscape, he does look rather similarly transcendent and detached as in *Chairman Mao Goes to Anyuan* in another depiction given the appropriate title *Who Is in Charge of the Universe?* (问苍茫大地

ill. 5.73 Chen Yanning *Who Is in Charge of the Universe?* 1978 (DACHS 2009 Propaganda Poster Westminster Who is in charge of the universe?)

谁主沉浮),[93] painted by Chen Yanning 陈衍宁 (1945–) in 1978 (**ill. 5.73**).

Yet, at the same time, this godlike figure also finds more ironic reflections. Wang Keping's 王克平 (1949–) 1978–79 statue *Idol* (偶像) is one such example (**ill. 5.74**). Wang was a member of the so-called Stars (星星) group of painters, made up of former Red Guards. Their name is a naughty reference to a 1930 article by Mao, frequently quoted during the Cultural Revolution, in which he wrote, "A tiny spark [i.e., the stars] can start a prairie fire" (星星 之火可以燎原) (Mao 1952). Wang's Mao statue is a typical example of the strongly political tone of the group's artistic activities. Part of the Stars' outdoor exhibition in 1980, *Idol* visualizes the leader's godlike status, overlapping Mao's features with those of an ironically winking corpulent Buddha in late Tang or Song dynasty style (DalLago 1999, 51).

By choosing such a conspicuous name, the sculpture plays with Communist criticism of religious superstition by unmasking Mao, the Communist icon, as just one such object of superstitious worship. When Michael Sullivan visited Wang, he observed that Wang had even moved an abject kneeling figure in his atelier to face the idol in order to drive his point home (Sullivan 1996, 166). Yet, whether

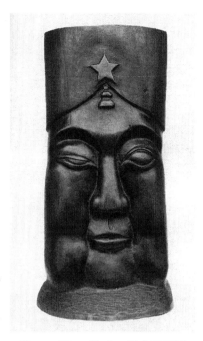

ill. 5.74 Wang Keping, *Idol*, 1978/79
(Andrews 1994, 399).

the statue indeed must be seen as a caricature of Mao has been questioned. Martina Köppel-Yang argues the opposite but says that the work's significance lies precisely in this "collective misunderstanding," the general consent that defines it as a Mao parody (2003, 120–30). Her analysis of this "collective misunderstanding" illustrates the importance of Mao as visual propageme (Gries 2005, 13–34). The audience's immediate association of the figure with Mao reveals the efficiency of Chinese political propaganda. Mao's image has been repeated so many times that he has indeed become an integral part of everyday life; propaganda's repertory of signs has infiltrated people's collective unconscious. The audience association of this sculpture with Mao also indicates the very sensibility with which Chinese people react to propaganda. By juxtaposing discordant elements—the physiognomy of a Buddha connotes dignity, while the facial expression suggests a comic mood, the Communist star and the traditional dignitary's hat do not tally with each other—the ensemble appears quite absurd. The work thus demonstrates the vanity of the object of the cult, thus questioning the significance of idols as such. Confronted with an ambivalence of signs, the viewer is also made aware of the mechanisms of propaganda, which integrates signs from different and contradictory domains. Wang thus criticizes the fanatic collective idol worship and propaganda (the aestheticization of politics) of the Cultural Revolution—super-idol Mao foremost among them—as the direct opposite of autonomous action. At the same time, he calls for the emancipation of the individual whose fundamental right it is to doubt authority (Köppel-Yang 2003, 124).

93. The title is from a line taken from a 1925 poem by Mao himself. The poem reads: 沁园春长沙 / 独立寒秋, 湘江北去, 桔子洲头。/ 看万山红遍, 层林尽染, 漫江碧透, 百舸争流。/ 鹰击长空, 鱼翔浅底, 万类霜天竞自由。/ 怅寥廓, 问苍茫大地, 谁主沉浮? / 携来百侣曾游。/ 忆往昔峥嵘岁月稠。/ 恰同学少年, 风华正茂; 书生意气, 挥斥方遒。/ 指点江山, 激扬文字, 粪土当年万户侯。/ 曾记否, 到中流击水, 浪遏飞舟? (Mao 1993, 1)

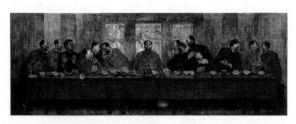

ill. 5.75a Zhang Hongtu, *The Last Banquet*, 1989 (DACHS
2008 Zhang Hongtu http://www.momao.com/).

Although several of the works discussed above continue this critical line against Mao, the icon—the two triptychs by Ai Weiwei (1986, ill. 5.40) and Wang Guangyi (1987, **ill. 5.41**) among them—more recent art works like Liu Liguo's Mao Laughing Buddhas (2005, ill. 5.59) and Zhang Hongtu's comic interpretation of the "red sun" as the "wrong sun" in his depiction of capitalist *Quaker Oats Mao* (1987, **ill. 5.25**) are more playful in their negotiations with Mao's godlike qualities.[94] In 1989, he makes direct reference to Mao as a holy figure again in a painting entitled *The Last Banquet* (**ill. 5.75a**). It is a very close parody of Leonardo da Vinci's (1452–1519) *The Last Banquet* (1495–98) except that everyone, including Jesus and each one of his disciples, is Mao (ill. 5.75b). It may be possible that this image is in fact the parody of a parody, as the participants in the (European Maoist) 1968 movement, too, had an image like this that included all their idols: Che Guevara and Mao Zedong next to Wolfgang Lefèvre, Rudi Dutschke, Gaston Salvatore, Fritz Teufel, Horst Mahler, Rainer Langhans, Karl-Heinz Roth, Bernd Rabehl, Daniel Cohn-Bendit, Christian Semler, and Hans-Jürgen Krahl (ill. 5.75c).

Zhang's *Last Banquet*, however, contains a "Christ Mao" in the center and a "Judas Mao" holding the *Little Red Book* who, in his eagerness, overthrows his rice bowl on the table. To whom does Zhang's image speak? Would the Chinese public be aware of the Christian background to the parody? Would they know the positions of God's son and the traitor? Does Zhang Hongtu play with Mao only because he realizes that Mao is a fad in the United States, where Zhang emigrated in 1982? Can the American public, on the other hand, understand the treason behind the *Little Red Book* and the overthrown rice bowl (and will they even realize that the surface of the painting is covered in text from the *Little Red Book* and that the landscapes seen through the windows in the background are Chinese? Are the Great Leap Forward and the famine it caused part of the message of "Judas Mao," then? Does the *Little Red Book* in Judas Mao's hand identify him with Lin Biao (who publicized it) or does it hint at the inefficiency or, even more so, the treachery of Mao Zedong Thought and thus, by implication, Mao himself? Is Mao himself thus made responsible for the two greatest atrocities in modern Chinese history, one associated with the rice bowl (the Great Leap Forward Famine) and the other with the *Little Red Book* (the Cultural Revolution) after all?

The message of these images remains ambiguous. One element can be made out clearly, however: all are pointed reflections of the fact that the Cultural Revolution Mao Cult was perceived and experienced as a religion by some. They confirm, therefore, that such a religion did exist at least in the minds of some. But by making it public in such a satiric and caricatured manner, are they able to destroy it? Does the political symbol become a mere joke? Or are these artistic works more adequately understood as deeply felt negotiations with the past and its meaning, both on the personal and on the national and even international level (which would put them close to Tan Dun's *Red Forecast*, Cui Jian's "I Have Nothing," and Wang Shuo's or Li Lu's "Maoist" texts)?

The popular counterpart to paintings such as these is the Mao talisman, used as a rearview mirror ornament by taxi or bus drivers to protect both vehicle and passengers from road accidents. For quite a long while, between the early 1990s and the early 2000s, it could be seen in almost all

94. Compare also Mao as Buddha in Liu Dahong's 劉大鴻 (1962–) 1993 *Butterflies and Flowers* (蝶恋花), reprinted in *Quotation Marks* 1997, 81–83. See the discussion of further works alluding to Buddhism in Valjakka 2011, 65–66.

Chinese taxis and many buses (ill. 5.76).[95] Many of these amulets were covered in temple-like frames of gold-colored plastic and had the typical red tassels and auspicious characters dangling from them (e.g., Barmé 1996, 79). Again, the adulation of Mao makes use of and translates ritual practices from folk culture and religion (Landsberger 2002, 162). This talisman, which can hardly be read ironically, is a rather straightforward piece of evidence for a strong religious strain—one among many—within this new chapter of Mao repetitions in modern Chinese history.

Since the early 1990s, Mao has been making a re-appearance in New Year Prints, often as the god of money (ill. 5.77; see also, e.g., Barmé 1996, 93). Many private entrepreneurs, representatives of the very economic model abhorred by Mao, have hung his picture behind their shop counters to bring good luck to their businesses. Even gamblers pray to him, hoping for good numbers (Landsberger 2002, 163). Mao wards off evil not just in New Year Prints but in anti-SARS propaganda, too. One image from the SARS crisis in 2003 shows Mao's standard portrait on Tian'anmen wearing a mask that reads "NO SARS." The caption reads: "(Mao's) latest instruction: You must handle the SARS affair well" (最新指示: 一定要把非典的事情办好) (ill. 5.78). Mao not only does not sleep in constantly giving out his instructions, but he comes alive again when his people need him; his words and portrait were used to build up morale during the 2008 earthquake, and he has been turned into a protective symbol against all kinds of other difficulties, social upheavals, and dislocations that have constantly marked the reform period. These images can be read as evidence for a popular longing for the orderly society and the imaginary golden past as seen in the propaganda posters of the 1950s through the 1970s (Landsberger 2002, 162–63, see also DACHS 2009 Mao Memory).

Quite evidently, the religious fervor for Mao Zedong once prescribed during the Cultural Revolution remains an important element in the popularity of the Great Helmsman, Great Leader, and Great Chairman, the "red, red sun in our hearts" even today: A *China Youth Daily* (中国青年报) poll of 1995 found that of 100,000 respondents, 60 percent of whom had been born after 1970, 94.2 percent named Mao as the most admired Chinese personality (with Sun Yatsen ranking second).[96] It is for this reason that millions would form the audience for

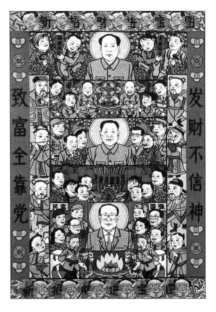

ill. 5.77 New New Year Print, 2003 (DACHS 2004 New New Year Print).

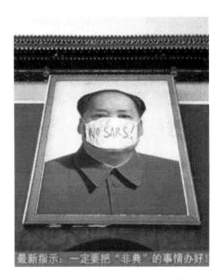

ill. 5.78 *Mao's Latest Instruction: "You Must Handle the SARS Affair Well!"* (DACHS 2009 Mao SARS).

95. Landsberger 2002, 162 gives 1991 as the beginning point of the trend.

96. The poll is cited and discussed in Landsberger 2002, 164. See a more recent poll with albeit similar results in DACHS 2009 Poll Popularity Mao. The article also gives some information on the international repercussions of Mao imagery in Europe, calling Mao an international icon.

the Red Sun songs, that many of them would take part and watch Red Sun quizzes and that they would be quite willing to eat their daily lunches in restaurants and celebrate their weddings in decorations with MaoArt, too (ill. 5.79).

Somehow, Mao's image remains holy to some, in spite of all the ridicule and parody to which it has been submitted. It no longer has to be "red, bright, and shining," necessarily, but it is not such that anyone can use it at will either. It was for this reason that, after furious Chinese blog responses from a large crowd of bloggers, Citroen recalled an advertisement in several Spanish newspapers in early 2008 and apologized to China. Within only two days, more than 35,000 bloggers had written complaints about the "defacing" (篡改 *cuangai*) of Mao, demanding respect and an apology to the Chinese people (向中国人民道歉).[97] The full-page advertisement featured Mao pulling a bizarre face with squinting eyes and screwed up lips, ogling a small sporty hatchback (ill. 5.80). Under the Biblical quote, "Render unto Caesar the things which are Caesar's" (Matthew 22:21; it continues ". . . and unto God the things which are God's") the advertisement emphasized Citroen's position as a car sales leader, further connecting it with Maoist revolutionary might and the advantages of Mao's Continuous Revolution: "It's true, we are leaders, but at Citroen the revolution never stops." The bloggers responded not to the text but to the image: How could Mao, who represented "the spirit of a nation," have been abused in such a way!

A similar story of outrage in view of disgracing Mao('s face) is told in 2005 by Chinese writer Xue Xinran 薛欣然 (1958–), who lived in London in the mid-1990s:[98]

> "I can make the Queen laugh or frown!" a Chinese student boasted during a party at my flat. Then she used a £10 note to show how she could change the Queen's expression from a big laugh into a frown simply by making two folds in the note. "Have you tried this on Chinese money with Mao's face? How would his face look?" asked a Western guest. "Oh, let's try it! Mao's face must be very funny." Some of the students became very excited. I, too, was curious to see what Mao's face would look like. I had never seen him make any public display of anger or sadness. Even though people have painted him very differently, all have shown him smiling, unceasingly.
>
> So I raised my hand to tell the students that I had a Chinese note with Mao's face on it. I was stopped by the middle-aged woman next to me. "Don't be silly, Xinran," she said. "Do not let them deface Mao, it is not good for you." "It's just a joke," I said. "And this is London, not China, and we are free to have our own views." I went to get the note. She stopped me before I could hand it to the students.
>
> "Do you want to be hated by the Chinese?" she asked. "You think the Chinese would hate me for playing a game with Mao's face? Do you believe they still regard Mao as God?" I was surprised by her attitude; she is, after all, a career woman living in the West, and has family with a Dutch man. "You often go back to China, so tell me why Mao's picture still hangs on the walls of so many people's houses, shops and offices," she said. "You think it is because the Chinese Government orders them to display them, or because those people have never heard Western views? Or do you think they don't know that Mao did terrible things to his people and how much he damaged his country?"
>
> "Be honest to our history, Xinran. I know your family has lost people under Mao's cruel policies, I know your parents were sent to prison for years. I am sorry to remind you of your unhappy memories. But don't look down on what Mao did for Chinese national pride . . . I feel it is unfair to Mao." I stopped her. "What about the millions of Chinese who died under his rule?" "If Westerners still believe their God just after he flooded the world for his own purpose, or George Bush could invade Iraq for moral good, why shouldn't Chinese believe in Mao, who did lots of positive things for the Chinese but also

97. The figure is given in *Zhongguo Xinwen Wang China News* 17 January 2008: "The Voices of Netters Not Forgiving Citroen for the Ad Abusing Chairman Mao's Portrait Do Not Stop," archived in DACHS 2009 Zhongguo Xinwen Wang. The collection of blog responses discussed here can be found in DACHS 2009 Citroen Ad Blog Responses. I would like to thank my student Nora Frisch, who drew my attention to this advertisement and the discussions around it.

98. The article, "Great Helmsman's Role Still Has Currency" (*The Guardian*, 5 September 2006) is archived in DACHS 2005 Mao Image.

lost lives for his own mission for good?" Her voice grew angry. A student snatched the note from my hand. "I told you, don't let them use Mao's face to play with!" She was so angry that she left at once.

I was so shocked by her loyalty to Mao that I couldn't enjoy the game with Mao's face and the note. A few weeks ago I heard some news. Peasants near Beijing, who had been campaigning since 2003 to stop a power station being built on their land, were attacked and six were killed by an armed gang. It was said to have been arranged by corrupt local officials.

I rang a journalist friend in Beijing to ascertain exactly what had happened. He told me what he had heard: "Many wounded peasants held Mao's picture and cried, 'This would never have happened when Mao was alive.'"

All of this made me think that it would be very difficult for a lot of Chinese people to change Mao's face in their memory or in their hearts—even in a time when their children were happy to play a game with a picture of Mao's face on a banknote that would have seen them jailed when Mao was alive.

One could give many examples of Mao reverence alive and well: the real[99] and virtual[100] memorial halls, the recent outrage in Hunan news at a girl having her photograph taken as she is "riding" on a Mao statue[101]—all of these are evident signs. The organized and prescribed veneration of Mao during the Cultural Revolution and the spontaneous and popular veneration of the Great Leader (which goes along with officially organized and prescribed veneration, for which official jubilee birthday celebrations and the constant renewal of Mao's portrait on Tian'anmen are examples) before and after the Cultural Revolution are manifestations of one and the same reality: Mao matters, and matters very much, to very many Chinese all throughout the history of revolutionary China. We have seen what form prescribed veneration took before and during the Cultural Revolution, and we have seen its repercussions during the Cultural Revolution and afterwards. Once more, the only difference between prescribed iconicized MaoArt of the Cultural Revolution and that prevalent before and after is that the first did not allow for more than one interpretation—at least officially—while the others, no just on the surface level, leave room for various possible (re-)interpretations.

In this discussion of MaoArt as viewed by contemporaries, I set out to find why and how the Mao image was and still is an important motif for artists and audiences. I have speculated that taking on Mao is a performative act reflecting as much on the performer's emotions as on the image performed. Put altogether, the analysis of repetitive Mao imagery and its effects on the audience, a reading of diaries and memoirs as well as oral history, suggests that the revolutionary Mao of the early Cultural Revolution years succeeded as a significantly popular image. From the evidence of post-Mao MaoArt, the nature and continued proliferation even of critical and ironic versions of Mao's image suggest that his significance may not have decreased over the years.

Artists like Sui Jianguo, who had lived through the Cultural Revolution as teenagers, would attempt to work out their ambiguous feelings toward Mao by the very act of painting or molding him and, thereby, putting him to sleep once and for all (if in the form of a sleeping Buddha...), for example. Sui said that in making Mao sculptures, "I felt I had solved the problem I had with Chairman Mao. Before I felt he gave me so much influence; he changed my life. But then I felt he's a person too; he's not a god" (Zhang 2009). Yet, did this rationalization work? Remarks one journalist, "When Sui takes you into the home that sits behind his studio, there is Mao personified, on a table near the door—three Mao suits—hollow, empty, but meaningful in their newly transformed state. And Professor Sui stands by them—and smiles for the new Mao he's discovered

99. See Barmé 1996, 19 and Landsberger 2002, 162, as well as the discussion in an earlier part of this chapter.
100. See DACHS 2009 Virtual Mao Memorial.
101. See DACHS 2009 Mao Reverence, which documents bloggers' responses to this "shameful incident." See also the discussion on the defilement of the portrait with a burning object by an Urumqi unemployd worker in Valjakka 2011, 72–73.

and come to terms with" (Zhang 2009). This new Mao is perhaps more human, but maybe not quite. For in an interview, Sui remarks: "Now, he sleeps like everyday people. I'm putting him to rest" (Hamlin 2005). But he would muse this piece again, showing Mao on top of a bed of colors made from 20,000 toy dinosaurs "made in China." Appearing as symbols of the "rising economic dragon," they form a map of Asia. In Sui's sculpture, Mao dreams as the disorderly continent churns beneath him: "Maybe someday he'll wake up, I don't know" (ibid.), adds the artist as he invokes an old joke about Mao:

> Deng was troubled by growing problems caused by his reforms, so one night he paid a visit to Mao's memorial hall at Tian'anmen Square. Looking at Mao lying in his crystal coffin, Deng murmured, "Chairman, pray tell me how to deal with the problems." Suddenly Mao sat up pointing a finger at Deng and said, "You come in, I go out. And all these problems will be solved!" (DACHS 2009 Mao Nostalgia)

MaoArt from after the Cultural Revolution suggests very clearly that the end of the Cultural Revolution did not mean that the halo surrounding charismatic Mao had been destroyed. Mao could now be understood as a human being as well as a god, but he has not lost his weighty power over people's minds.[102]

Revisiting Mao: MaoArt Then and Now

> Nostalgia restaurants, no, they are really not a political phenomenon at all. No matter what I think about the politics of being sent down to the countryside, I must call this the best time in my life, really! Tomorrow, for example, I will go to Shaanxi, to meet my best friends again. This is nostalgic, of course, but it has nothing to do with politics, really. (Intellectual, 1955–)

> The new cult is very much a thing of the lower classes: they actually think that Mao can save lives. He is a kind of god for them. It is not all the same as then: in the 1960s and 70s, reverence for Mao was very much a social thing. Society would call for it. Now, in the 90s it is only a fashion, a fad [风气 fengqi] prevalent in the lower classes. They are so blind. Now that their life is changing rapidly, they look back to Mao, nostalgic for this time when there was a lot more exchange between people. China is missing a real religious faith, so this is some kind of a substitute for it. (Ethnomusicologist, 1940–)

In *Shades of Mao*, his magnificent study of the recent Mao Cult, Geremie Barmé shows how different this posthumous cult is from the personality cult during the Cultural Revolution (Barmé 1996, 5–13). In the late 1980s and early 1990s, although it was channeled and used by at least some members of the Party, the cult was primarily initiated by the people rather than the authorities. This time, it was a highly (and, one could argue, primarily) commercialized and commodified affair (Ibid., 40–41).[103] This time the international dimension of the cult[104]—which finds its reflection in John Adams' (1947–) *Nixon in China* (1987), or, more recently, in ever more works

102. I here take issue with Barnouin and Yu 1993, 299, who argue that the Cultural Revolution ended Mao's godlike qualities completely.
103. One could argue, however, that during the earlier cult, some objects, especially badges, also had their prices and were haggled over repeatedly.
104. The earlier cult also had a very important international dimension, as the proliferation of propaganda publications such as *China Pictorial* or *Chinese Literature*, and receptive works such as Gerhard Richter's *Mao* (1968, ill. 5.31b) and Andy Warhol's (1928–87) *Painting Mao* (1972) show. See, e.g., *CL* 1968.3:84–97 "The World's People Love Chairman Mao." Cf. also the photographs in Yang 1995, 132.

such as SungJun Huur's *Mao Mosaic* (1999), pop artist Gudmundur ERRO's (1932–) *Cultural Revolution Art Lithograph Portfolio* with its parodies of *Chairman Mao Goes to Anyuan* and other famous paintings (ill. 5.81), and even advertising[105]—is driven first and foremost by commercial motives. Old and artistic Mao memorabilia have sold for record prices at Sothebys, while new creations of Mao memorabilia have appeared at Shanghaitang.[106]

Yet, a stroll through one of the specialized Chinese antique markets today not only illustrates this commercial dimension of the contemporary cult, but it also reveals the massive scope of commodification even within the original cult. Large metal shields engraved with loyalty characters or Mao portraits were produced during the Cultural Revolution to be attached to locomotives, motorcycles, and cars. Kitsch products like red plastic hearts imprinted with the Chairman's portrait and the character "loyalty" were produced then and now stand next to traditional silk bags, previously used for Buddhist sutras and then imprinted with the character "loyalty," handmade to contain the "precious red books." These products, objects of quite some haggling and speculation today, were originally often sold at prices below manufacturing costs or even distributed as gifts. During the years of the Cultural Revolution, one naturally had to avoid giving the impression of harboring ulterior motives of earning a profit on the sale of these objects. Those who wanted to purchase a Mao product would not use the character 买 (*mai*) for "buying" but instead the expression 请 (*qing*) for "requesting," previously used to acquire only sacrificial objects: commodification of the cult during the Cultural Revolution thus went hand in hand with its sacralization (Leese 2006, 244).

Apart from these differences (which do not seem all that great after all), there are actually many more significant similarities and interconnections between the two cults. Most strikingly, perhaps, both cults played with, used, and abused the image of the Chairman and Great Leader. In both cases, his image "was manipulated by diverse groups with totally conflicting interests."[107] Then and now, the proliferation of his image illustrates that he achieved "popularity with the urban subculture while still maintaining his status as an authoritarian figure." In both cases, the images suggest that he was loved or at least admired as a great leader or a guardian god. In both cases, too, the circulating images of Mao were not born in and out of a vacuum but built on a long iconographic tradition. Indeed, many of the artists active in the contemporary movement had been (re-)trained in the painting of MaoArt during the Cultural Revolution: Xu Bing is not the only one to remember having "gained the skills as a painter and artist at this time [i.e., while in the countryside]"; Liu Hung is another example. Xu remembers: "It was also the time when I started to become a 'contemporary artist,' although I had no idea what contemporary art was. But in a sense, lots of things that we did gave us the skills necessary to be artists and also [instilled in us] the spirit of 'avant-gardism'" (Xu 2008, 116).

The discussion of MaoArt presented in this chapter aimed at illustrating that Cultural Revolution Culture is not an isolated phenomenon but is closely tied to developments before, during, and after that ten-year period. Not unlike the Cultural Revolution, the new Mao Cult in the form of the "Mao Fever" (毛热) is quite prominently visual, but the close connection between its popular success and the propagandistic process of visual dissemination employed during the Cultural

105. In addition to the examples discussed above in the current chapter, see e.g., DACHS 2008 Mao Portrait Citroen (Mao Ad); DACHS 2008 Mao Images International.

106. First founded by David Tang 鄧永鏘 (1954–) in Hong Kong in 1995, the luxury shop soon opened branches in major cities all over the world (Barmé 1996, 35). The "Mao's pad" mousepad mentioned below and produced by, among others, China Books and Periodicals in San Francisco is another example of the popular and international dimensions of the cult.

107. Barmé 1996, 46 reserves the characterizations in the following lines for the contemporary cult.

Revolution I have traced here has, until recently, been neglected.[108] Certainly, the ever-presence of the Mao image has taken more varied forms in the more recent cult (as it did before the Cultural Revolution): today it is not just posters, silk screens, badges, paper cuts, postal stamps, Red Books, or nail-clippers—but bank notes, T-shirts, cuff links, glow-in-the-dark busts, lighters, pendants, talismans, watches, and, most ingeniously, perhaps, the "Mao's pad" mousepads (Barmé 1996, 42, 66n195) that carry his portrait, too. Moreover, these images are no longer as standardized as they were during the Cultural Revolution. Mao is no longer just the "carefully-cultivated persona fostered by Party propaganda," but he is many other things, too. Indeed, he is "much like water and electricity, now, a public utility" (Barmé 1996, 47–53). It becomes much more difficult to know who and what Mao is, and what he means, in the images to be seen after the Cultural Revolution, as oral history shows:

> I had never seen images like Ai Weiwei's *A Study in Perspective* (ill. 5.57). Everybody may have their own interpretation of this kind of image. (Photographer, 1960–)

> I have seen Wang Guangyi's *Mao Zedong Black Grid* (ill. 5.41) in an exhibition. I also know Zhang Hongtu. It is a big step forward that this kind of art is now possible. What it means? Well, I don't know! There are many ways of explaining it. It is now possible to give different interpretations of Mao. Take this book by Mao's doctor, Li Zhisui 李志绥 [1919–95]: you can read this in China now! You can even do research on Mao from all different points of view; you can start criticizing Mao's poems. (Intellectual, 1958–)

The meaning of Mao and MaoArt, the significance of the icon, can now be considered a discursive space where different, sometimes antithetical, ideological strategies are negotiated, often simultaneously. It is in this sense that "the renewed viability of this sign can be proposed as a paradigm of some of the complex, often contradictory forces at work in the contemporary cultural production of the People's Republic" (DalLago 1999, 47). The posthumous Mao Cult draws on a variety of factors including disillusionment, nostalgia, renewed national pride, religious traditions, and commercial interests, as Leese argues. I disagree with his conclusion, however, that the "EveryMao" who was created in the process thus became an "empty signifier" (Leese 2006, 297).

Although I have shown that even during the early and allegedly most radical phase of the Cultural Revolution, the range of MaoArt was not as restricted as it is usually made out to be, the Mao image appears both before and after the Cultural Revolution in an even more striking diversity of styles: it is not just presented in the naively realistic and reverently adoring style of "Revolutionary Romanticism," but possibilities range from traditional techniques rediscovered from the years preceding the Cultural Revolution and even the founding of the PRC, to photographic quality and avant-garde versions of pop art. The nature of these images, and their constant acts of negotiation, suggest that Mao always and continuously mattered, even in times of officially prescribed amnesia such as the early to mid-1980s.

Even some of the controversial pieces by the Chinese avant-garde since the late 1980s and early 1990s can be interpreted as products of an obsession with Mao: just like the Mao Cult, these images, according to art critic and curator Li Xianting 李宪庭 (1949–), are the sign of a fixation "that still haunted the popular psyche," combining "both a nostalgia for the simpler, less corrupt, and more self-assured period of Mao's rule with a desire to appropriate Mao Zedong, the paramount god of the past, in ventures satirizing life and politics in contemporary China."[109] Accordingly, for

108. DalLago (1999, 1) also decries this fact but provides little evidence for her argument. Works like M. Wang and Yan 2000, which look exclusively at the years of the Cultural Revolution, are similarly unable to trace the continuities between art during, before, and after the Cultural Revolution.

109. Li Xianting's "The Imprisoned Heart" is cited in Barmé 1996, 44–45 and translated on p. 216.

a painter to spend the better part of a decade creating Mao and only Mao almost exclusively was not the exception but rather the rule. This study has already named quite a number of artists who did so—Zhang Hongtu, Sui Jianguo, Liu Liguo, Wang Xingwei, and Yu Youhan among them. Perhaps the most radical example is Li Shan 李山 (1942–), whose work is primarily based on Mao who becomes a figure both of projection and of annihilation of the artist's self. Francesca dalLago analyzes Li's painting *Mao and the Artist* (1994, ill. 5.82) as follows:

> Here, Mao and Li coquettishly lean on each other, holding in their hands two sensually stylized flowers. Their facial traits demonstrate an effect of mutual assimilation, in which the older Mao is portrayed as a semiclone of the artist. The political icon is progressively absorbed within the artist's persona and rendered as the projection of his psychological journey during a decisive moment of his own history. By feminizing the traits of a desirable hero—and investing the icon that so profoundly marked the horizon of a whole generation with the signs of his own desire, Li attempts to rescue his individual self from "the pillaging that was history." And yet his portrait still maintains a degree of inaccessibility that locates it on a different level from that of the viewer. The iconic properties derived from the original version are preserved in the reworked format, endowing it with a puzzling aloofness. This resistance to a single mode of readings endows the "new" Mao with an undefinable quality that becomes a significant form of expression for a country traversing a period of intense moral and material changes. (1999, 58)

Thus, even in some of the (latently or overtly) critical or ironical (in-)versions of Mao, his charismatic power is clearly felt. Zhang Hongtu wrote in 1989: "The Mao image has a charisma of its own, it's still so powerful that the first time I cut up an official portrait of Mao for a collage I felt a pang of guilt, something gnawing away inside me."[110] And in 1995, he still reflects: "I realize that even though I have left China more than five years before, psychologically I couldn't eliminate Mao's image from my mind."[111] In the works of Chinese artists from all generations, we can find this sense of psychological involvement: for Zhang Hongtu and Sui Jianguo, painting Mao clearly became some sort of exorcism. Yet MaoArt by younger artists such as Zhu Wei, Wang Xingwei, or Zhang Chenchu illustrates that for them, too, Mao is *not* "reduced to an icon in the popular sense of the term, an idol with a visual relevance similar to that reached in the West by Marilyn or Elvis." He is *not* just "an item of wall decoration or an image without depth that does not retain any personal significance" (DalLago 1999, 51). On the contrary, defining Mao remains part of defining one's self to many Chinese artists (and non-artists alike, as the blog reactions to "defamations" of Mao's image discussed above illustrate). Even substituting Mao with the self is one such act of defiance.[112] These artists are thus as much performed by Mao as they purposely perform Mao. His image becomes a sign onto which, as is often the case in the system of celebrity cults, the viewer may "overlay his or her own interpretation . . . with his or her own sexual, personal and cultural identity" (DalLago 1999, 51). Quite accordingly,

ill. 5.83 Yin Zhaoyang, *Mao*, 2006
(DACHS 2008 Mao Images, 117).

110. Quoted in *New Ghosts, Old Dreams* 1992, xxvi.

111. This quote is taken from his website, which has been archived in DACHS 2008 Zhang Hongtu; cf. also DalLago 1999, 51.

112. ARTzine in "Why Do Artists Say: Look at Me" presents a selection of images in which this substitution becomes clear (Barboza and Zhang 2008).

Zhu Qi writes about Yin Zhaoyang 尹朝阳 (1970–) and his unfocused 2006 portrait of Mao in grey colors (**ill. 5.83**):

> Forget that Yin was born in the 1970s and only caught the last rays of the setting sun that was Mao. No one before or after Mao's death was really able to escape his indelible influence, at once one for awe and respect. But Yin's representations did not stop with that. Unlike those previous generations who lost their own identity in their fervent worship of Mao, Yin's art produced two distinct identities: one being Mao, the other his own. Of course, they were not "equal." One clearly overshadowed the other like an eclipse. But the background of their lively union was always the problematic of self, the question of destiny, the tapestry of human nature itself. With one mind they faced each other on the canvas, locked in a fatal strategy of mutual mimicry. This went well beyond the baseline of homage, portraiture, and even representation, even as it cast a sidelong glance at the forms of symbol play and post-ideological satire. Observation of Mao and Mao mimicry have been important ways of transcending the common boundaries of self throughout recent history. Yin Zhaoyang has certainly used the image of Mao to carry out an investigation into the possibilities of self. This investigation has two sides. First, it is acknowledgement of influence to a greater or lesser degree. On the other hand, it is tacit admission that one has entered into the same trajectory as Mao and is hurtling toward the same teleological endpoint. And it is this subtle point which distinguishes Yin's paintings from others which are tirelessly implicated in simple self-proliferation. His paintings, rather, systemically represent a kind of meta-self. And within this context each step acts in concert with the preceding step, each completed image echoes the psychology of the moment, which in turn gives new resonance to each completed image. Such a strategy precludes any sort of quest for the origins of Mao or the originary nature of self. Rather what is offered is a kind of sacrament to human nature. It is an experimental act of representation. (Zhu 2007, 20)

The Political Pop practiced by China's artists, then, reflects some of the cultural complexities of the recent Mao Cult. It can be explained in many different ways, as "residual social and cultural aftershocks of the original Cult" on the one hand, and thus, as genuinely felt, subversive criticism, and as the "tired tropes of po-mo, playing on the Chairman's image with all the resources that appropriation and pastiche could muster," on the other; "market-oriented dissent," too, may play its role (Barmé 1996, 45). Some Chinese would complain about recent MaoArt and its sellout to foreigners for this reason,[113] but at the same time many of them would also acknowledge that it is a way of dealing with the past, which is apparently much needed:

> This part of history is really bitter to go back to; it is very difficult to remember it. Many people think like that, and this is why there is all this black humor, just like in these images of the avant-garde: theirs is a very creative way of responding to the situation. . . . There is this aspect of being able to sell better abroad if one does political art, true, but there is also a lot of nostalgia and bitterness involved, too. (Musician, 1930s–)

> Really, some of these artists are not known in China at all but only abroad: this is so because their art is so political, so critical of politics. I think quite obviously they are influenced by foreigners: this is a very successful way of making money, but in China this art has no real future. (Art Historian, 1940s–)

> These kinds of images sell, of course, but I do not really care about this: the only thing I painted to do with the Cultural Revolution—I am not all that interested in this topic—was a red soldier, and some American was really keen on buying that. Now, I regret having sold it. I only have a photograph of this painting. But then I thought, that was the past, I am not interested, so I can sell it. (Artist, 1954–)

113. Yan Peiming's statement is very bold in this regard. He says: "When I lived in China, I painted propaganda portraits in order to glorify Mao's thought. But after I arrived in France, I painted Mao as a way of doing propaganda for myself. Very soon everyone knew my name." (Yan is cited in Nuridsany 2004, 46–47). Li Mingzhu 李明铸 (1973–) in his series of ceramic artworks entitled *Digestion* (消化) has criticized his contemporaries in their utilizing and consuming Mao in order to become better known. (Valjakka 2011, 130–32).

The avant-garde versions of Mao with their critical content are reacting to the situation during the Cultural Revolution, when you had to pay reverence to Mao absolutely. It began to be possible to challenge that, and so a lot of people started doing this. But then, avant-garde art is not important in China, and so they are really doing this to sell. All they want is to get foreign attention, and I am against it! (Journalist, 1949–)

If I think about it, I think: all they want is to attract the West. This kind of art sells well in the West, so of course they would do this kind of thing. So many foreigners come to China to buy images, and these types of images are easily sold. Whether this actually is some kind of psychological after-effect of seeing so many of Mao's images in their childhood and teenage years, I am not clear. I really think all they want is to get into foreign exhibitions and all that. I am not happy about that: Chinese art should have its own standards, it should not be made according to some foreign standard, there really should be some kind of national development. Many of my friends think this way. (Photographer, 1960–)

Looking at Mao images from the Cultural Revolution, as well as before and after, one realizes that while the *Little Red Book*, which stands for the icon of Mao, appears and disappears, the image of Mao, the man, lives on, not just on matchboxes, posters, talismans, T-shirts, greeting cards, New Year's calendars, but in the hearts of the people, too. The hackneyed phrase that "Chairman Mao will live in our hearts forever" (毛主席永远活在我们心中) remains significant: by the early 1990s, Mao had, once more, carved out "a niche in the traditional Chinese pantheon alongside such martial heroes as Guan Gong, Zhuge Liang, and Liu Bei," and this time, the interest in him sprung up voluntarily, from among the people (Barmé 1996, 19). He is worshipped in Buddhist temples next to other Buddhist deities (and in the company of Zhou Enlai and Zhu De, ill. 5.84). In Leiyang county, Hunan province, in the early 1990s, local peasants collected more than 21 million *yuan* (*renminbi*) in private funds to build the Three Sources Temple (三元寺). A huge edifice in traditional Buddhist style, the temple was dedicated to the revolutionary trinity of the Chinese Communist Party: Mao Zedong, Zhou Enlai, and Zhu De. The largest of the three idol halls contained a six-meter-tall statue of Mao. At the height of its popularity, in late 1994, the temple attracted some 40,000 to 50,000 worshippers daily, most of them elderly, coming from many parts of the country, who used the traditional methods of burning incense to offer their worship. The complex was closed by official orders in 1995, on the grounds that it encouraged superstition, but it seemed to be functioning again by 1997 (Landsberger 2002, 161–62).

All of this makes it questionable that "the religiosity and fervor that characterized the earlier Cult were noteworthy for their absence" in the later Cult.[114] Indeed, if the later Mao Cult came "at the end of a decade of fads that represented the voracious consumption and rejection of both nativist and foreign cultural 'quick fixes' to the dilemma which China faced as a nation that had lost both its value system and its sense of purpose," it came—among many other things—as a new system of relief and belief, too (Barmé 1996, 49). Receptive evidence suggests that the more recent and spontaneous Mao Cult might contain just as much devotion as the one instigated by government orders during the Cultural Revolution. The new Cult of Chairman Mao is no longer determined (if partly supported) by Party *fiat*, and the authorities know it. Although Mao no longer rules—as he once did—through Party organizations, overt propaganda, and ceaseless political campaigns, his ineffable spirit has become more omnipresent than before (Barmé 1996, 19). And even the "ironic" Mao revival of the 1990s, which continues into the 2000s, was only possible because Mao was once so—and once more is so—appreciated! The image of a despotic and tyrannical Mao only plays a minor role; it is superseded by popular, superstitious beliefs in the image of the go(o)d Mao, "one of the people, incorruptible and non-nepotistic in contrast to the

114. Barmé 1996, 13. Barmé argues later that Mao found a niche in the traditional pantheon of gods (cited above from Barmé 1996, 19).

post-Mao rulers who are dismissed as greedily and narrowly concerned only with their own" (DalLago 1999, 49).

The Mao image, in spite of its being no longer an officially prescribed emblem of everyone's loyalty, has returned as a powerful (decorative) motif in the everyday lives of most Chinese. Mao is part of teen culture,[115] but he appeals to all other generations, too, just as before. One could argue that the Mao Cult has "provided a common ground and a hazy realm of consensus in a society in which the generation gap was increasingly making its impact felt" (Barmé 1996, 48). It thus serves a similar function to the decades before. Initiated once from above and once from below, the ever-presence of the Mao image remains part of Chinese popular culture. In my view, therefore, there has not been a drastic transformation from "revolutionary icon" to "pop icon," as some would argue (Benewick 1999, 134). The displacement and identification of political power with consumerism was possible because of the close relation between socialist and consumerist systems of mass communication: the propagandistic object, the "Mao brand," with its power to represent a vast organization (Chinese society), continues to fulfill opposite ideological orientations (DalLago 1999, 1; Leese 2006, 22).

Does it mean that the Mao revival is a "backhanded slap," as Orville Schell argues? "To what extent is the new popular Mao a 'vulgarization of the revolution'? Is it true that the willingness of ordinary people to make Mao a part of their disco dreams represents a monumental change of attitude" (Schell 1992)? The visual evidence discussed in this chapter, which shows the endurance of negotiations with and of Mao, seems to me to speak a different language. As Francesca DalLago points out, "It is important to remember that the language of the Cultural Revolution was visual to begin with and that its visual currency very much facilitated its propagation and the depth of its ideological penetration." (DalLago 1999, 50). Barmé contends that "the older generation of Revolutionary Leaders, as Mao and his coevals are known, have become part of the audiovisual repertoire of mass pop culture" (Barmé 1996, 42). I would agree, but I would continue with "as they had been in the decades before!"[116]

The reasons for Mao's resurgence, if not his comeback, are manifold.[117] The loosening of restrictions on how to discuss Mao and even the acknowledgment that he, too, may have been only 70 percent good and 30 percent bad (as was decreed in the 1981 Party Resolution) certainly played a significant role in bringing forth such a spontaneous reverence for Mao, the god, as well as Mao, the man and human being, since the late 1980s. Precisely the fact that he and his image are no longer univalent but can be interpreted in different ways, precisely the fact that he can be (and has been) criticized, ridiculed, and even contradicted, and is thus humanized, makes ever new and genuine feelings of veneration possible.

115. See Schrift 2001 on consumption of Mao badges.
116. Melissa Schrift puts the situation this way: "Overwrought distinctions between official and popular culture unduly dichotomize and obscure the nuances of symbolic exchange. One would be hardpressed to find a better illustration of the tenuous nature of such divisions than Chinese popular culture, in which popular expression involves appropriation of centralized propaganda as much as grassroots creations. The participatory nature of Communist propaganda accommodates the inevitable dilution of state-initiated narratives" (2001, 7).
117. They are discussed in detail in Schell 1992; Barmé 1999; Benewick 1999; Dutton 1998; Landsberger 2002 and most recently, in Part II on Mao's Legacy in *Critical Introduction*, 2010.

CHAPTER 6

CHAIN(ED) PICTURES AND CHAINED BY PICTURES: COMICS AND CULTURAL REVOLUTIONS IN CHINA[1]

> These small rectangular books, a language without sound, planted the seeds for ideals and knowledge in the hearts and souls of these youngsters. (Cartoonist Jiang Weipu 姜维朴, 1926–)[2]

Chinese comics, in the form of small rectangular pocket-size books (ca. 9 × 13 cm) called "small people's books" (小人书 *xiaorenshu*) and containing narrated pictures called "chain(ed) pictures" (连环画 *lianhuanhua*), have been the most characteristic and dominant form of comic popular in China since the 1920s and at least until the late 1980s (Seifert 2008, 66). According to Chinese media reports (e.g., *Wenhuibao* 8.4.1962), as well as Western observers (e.g., Nebiolo 1973), and the memories of Chinese informants, these chain pictures would have been cheaply available not just in urban areas but arguably also in remote areas of China,[3] and almost anywhere: at the barbershop, on trains, at the hospital, and on the street.[4] Thus, by the very nature of the medium, they may be considered the most popular of all art forms throughout the twentieth century, not only during the Cultural Revolution.[5] And thus they may indeed have "planted the seeds for ideals and knowledge in the hearts and souls" of China's youngsters, as Jiang Weipu, one of the more famous comic artists and chroniclers of comic art in China, has stated. And indeed, one composer remembers: "When I was a child I would read lots of books, many of them in the form of chained pictures. . . . We always liked them; they gave us a kind of moral feeling [道德感 *daode gan*]" (Composer, 1937–). Remarks such as these suggest that (Cultural Revolution) comics are a culturally constitutive form: they create and support particular visual codings and through them fashion a particular habitus (Seifert 2008, 8–9). I end this book with a study of these types of comics,[6] so popular during the Cultural Revolution and beyond, as they appear to be in many ways the ultimate form of Cultural Revolution cultural production: they combine and repeat, as a composite, the most important and typical aspects of this culture. They present themselves as stories of the ordinary and the everyday for all to consume, and they draw on all the different

1. I would like to thank my Heidelberg students who took the class on Cultural Revolution comics in the summer of 2004 for reading and exploring these comics with me and pointing me in many hitherto unexplored directions. I also thank my colleague, Rudolf G. Wagner, for providing me with a copy of the 1972 version of the Sun Wukong story discussed here, and to Michael Puett of Harvard, who personally copied the 1979 opera version and the 1962 Chinese and 1964 English versions, all of which have been put to use in this chapter!

2. Jiang's memoirs are taken from DACHS 2008 Liu Xiaoming, Comics.

3. Some of the interviewees remarked that they brought comics to the countryside where the books would then become common goods: "I brought comic books with me. They had never seen these 'small people's books' and so they set up a little library, but since they had never seen them, all they did was keep looking at the images. Most of them could not read, really, they had not a shred of paper in their households" (University Professor, mid-1950s–).

4. DACHS 2009 Sun Wukong San Da Baigujing, Blog 2007.

5. Seifert 2008, 15ff. discusses in detail the difficulty of finding reliable statistics for both comic production and comic reception. Because comics have been considered trivia and "grey literature," they have not been systematically collected in libraries, for example. The Heidelberg Research Architecture has recently inaugurated a project digitizing Chinese comics from the Seifert collection, among others, and making them available to the scholarly public; see HRA 14 Heidelberg Chinese Comics Collection. In his Introduction, Seifert gives a carefully considered overview of existing literature dealing with Chinese comics and describes the rise and fall of chained pictures between the 1950s and 1990s. He also provides careful definitions of different terms for "comic" in Chinese and their genesis in literary history.

6. Different from Chinese scholarship on comics (surveyed meticulously in Seifert 2008), this chapter will only focus on "small people's books." It will not consider parallel developments such as cartoons or caricatures.

elements important to Cultural Revolution Culture as discussed throughout this book, MaoMusic, MaoSpeak, and MaoArt among them.

It is not uncommon, for example, to find characters in these comic books singing Mao's praise, reciting Mao's words, and admiring his portraits. In one comic, published in 1973 and named after Korean War model soldier Luo Shengjiao 罗盛教 (1931–52),[7] the soldiers are seen singing two familiar songs under the blazing sun: "Red Is the East" and "The Three Main Rules of Discipline and the Eight Points for Attention" (**ill. 6.1**). Another comic shows a scene where the villagers are all sitting around a small TV set, watching the revolutionary opera *Song of the Dragon River* together (**ill. 6.2**). Time and again, the protagonists' rooms are decked out with posters from the model works.[8]

The *Little Red Book*, or MaoSpeak, is a dominant motif in the Cultural Revolution comic, featured not only on book covers where heroes are frequently seen clutching Mao's writings or gesturing with them (ill. 6.3a–d), but on the inside pages as well: in one a young and energetic woman, talking of the glorious deeds accomplished by Shashiyu villagers, cites Mao's support for the Foolish Old Man (**ill. 6.4**). Repetition is at work here: the quotation is displayed as a poster on one of the sheds, the young woman is obviously reading it out aloud, some of the

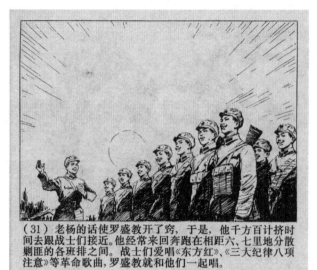

(31) 老杨的话使罗盛教开了窍，于是，他千方百计挤时间去跟战士们接近。他经常来回奔跑在相距六、七里地分散剿匪的各班排之间。战士们爱唱《东方红》、《三大纪律八项注意》等革命歌曲，罗盛教就和他们一起唱。

ill. 6.1 MaoMusic (songs such as *Red Is the East*) in Chinese comics (Comics *Luo Shengjiao* 1973, 31).

9 是啊，贫下中农能在自己家里看到伟大领袖毛主席的光辉形象，看到革命样板戏中的英雄人物，看到各条战线抓革命促生产，热气腾腾的跃进景象，怎不激动得热泪盈眶呢！

ill. 6.2 MaoMusic (model opera *Longjiangsong*) in Chinese comics (*Lianhuanhuabao* 1975.4:29–37, here 30/9 典型发言).

peasants are seen eagerly noting it down, and the passage appears, in bold, in the text at the bottom of the comic page as well.[9] Confucius and Confucian writings such as the *Three Character*

7. On Luo, see DACHS 2009 Landsberger: Luo Shengjiao.

8. For stories of peasants learning from Dazhai, see *Lianhuanhuabao* (hereafter *LHHB*) 1975.9:24–30 and 32–33, here 29; and *LHHB* 1975.9:35/no. 3.

9. The story of the Foolish Old Man appears repeatedly as an important inspiration in Cultural Revolution comics (e.g. *LHHB* 1976.2:36).

一九五七年，毛主席主持制定的《全国农业发展纲要》
公布了，给我国发展社会主义农业指出继续前进的方向。
这年，张贵顺到北京参观全国农业展览，看到了毛主席的
光辉指示："愚公移山，改造中国，厉家寨是一个好例。"

ill. 6.4 MaoSpeak (the story of the Foolish Old Man) in
Chinese comics (Comics *Shashiyu* 1975, 42).

53.　许多基层干部和贫下中农纷纷向县委提出改变兰考
面貌的建议。一位七十多岁的老贫农，跑了几十里路，找到
焦裕禄，为建设社会主义新兰考献计献策。

ill. 6.5 MaoArt (i.e. Mao's portrait) in Chinese comics
(Comics *Mao Zhuxi de hao xuesheng Jiao Yulu*, 1972, 53).

Classic are criticized in the comic world, too. One such comic claims, for example, that Confucius was hypocritical enough to pretend to care for the people while in fact declaring them to be despicable "small people" (小人 *xiaoren*) and difficult to educate.[10]

Next to MaoMusic and MaoSpeak, MaoArt appears prominently on the pages of Cultural Revolution comics. "Mao's Good Student Jiao Yulu" can be seen in one panel in conversation with a 70-year-old man. Hanging above and between them, thus featured in central position, is the portrait of Mao whose benevolent gaze watches and guides them (ill. 6.5). And this is not an exception.[11] The main cover hero in comic magazine *Lianhuanhuabao*, which takes up publication again in 1973, is none other than Mao (ill. 6.6).[12]

By analyzing comics from the Cultural Revolution, then, the different threads spun out throughout this book can be woven together. I will argue, first, that Cultural Revolution Culture, as manifested in Cultural Revolution comics, brought to an extreme what had been practiced for many years before, and epitomized what would remain important even decades later. Only in constituting an art form that, at least in theory, was completely univalent, an art that "chained" the reader to think and believe only one and the same thing, did Cultural Revolution comics differ from the chained pictures dating from before and after this period. However, and this is the second argument throughout the book, the idea of univalence of meaning in itself was not created during the Cultural Revolution. Many of the arguments used

10. *LHHB* 1976.4:34/no.9. For a large collection of comics from the Anti-Confucius movement and reactions to them, see some of the collectors' blogs, such as DACHS 2009 Cultural Revolution Comics: Criticizing Lin Biao and Confucius.

11. See e.g., *LHHB* 1975.7:7–16, and here especially *LHHB* 1975.7:11/no. 28.

12. See also *LHHB* 1975.1; 1975.5; 1975.12; 1976.6; 1976.7 (this volume contains an entire picture story, not a comic, however; see *LHHB* 1976.7:17–24); see also *LHHB* 1976.9 and *LHHB* 1976.10.

and abused during the Cultural Revolution to streamline Cultural Revolution art and cultural production can be traced back to ideas that came into being in the early twentieth century, and, most importantly, during a period that is now often considered the most "liberal" period in modern Chinese Cultural history: the other cultural revolution, the May Fourth Movement.

This chapter provides more evidence to show that the radical "hysterics" of Cultural Revolution cultural production have important precedents in the May Fourth Movement, including the destruction of the Confucian heritage and, most important for my discussion here, the idea of creating a new audience, the masses. This idea was not successfully implemented during the May Fourth period. May Fourth art, in spite of its proletarian ideals and leanings, remained elitist. It was later Cultural Revolution art and culture that succeeded in reaching what had been a May Fourth goal originally, of "popularization" (大众化 *dazhonghua*). The popularity of Cultural Revolution (comic) art in recent years, which finds its reflection on websites featuring "nostalgic comic collections" entitled "Red Classics" (红色经典) or "Red Memory" (红色记忆)[13] and lavish blown-up re-publications of this particular comic art,[14] seems to point in this direction. This again puts into question the claim of univalence of Cultural Revolution art, because its recent popular reception, as seen so clearly in previous chapters, also thrives on ambiguities of interpretation. And this brings me to this book's third argument: it is worthwhile to question our perception of the redundantly repetitive and restrictive quality of Cultural Revolution art that has been emphasized in many a study on Chinese cultural production during the Cultural Revolution. If looked at more closely, Cultural Revolution art and culture actually allowed for quite a few variations; it allowed for foreign and for Chinese traditional elements to play a role, for example. Most importantly, the Cultural Revolution cannot be seen as a single period that produced only one type of homogenous cultural product. As Chapter 5 has shown, cultural production in the late 1960s differed significantly from that in the early 1970s. Here I will discuss further evidence for this phenomenon.

Moreover, the theoretical ideal of what constituted Cultural Revolution Culture—as envisaged by the cultural makers around Jiang Qing—and the practical experience of what kinds of art and culture were in fact available during the Cultural Revolution (including much that was not actively and officially produced but was nevertheless available all throughout this period) were very much at variance: the experience of art and culture during the ten years now called the Cultural Revolution was neither singular nor straightforward. It differed substantially depending on the class background of a particular individual, his or her geographical location, educational background, and closeness to high revolutionary personnel, to mention but a few variables. Throughout this book, I maintain that the cultural experience of the Cultural Revolution, hitherto still understudied, is much more complicated than what mainstream talk of cultural stagnation would make of it. It is the purpose of this chapter to probe, one last time, into this unique but not all that exceptional experience.

13. E.g., DACHS 2009 Cultural Revolution Comics: Red Memories.
14. E.g., Comics *Haigang* 2007.

Heroes, Villains, and Sexuality

> It was not that they were supporting Zhao Hongben himself, but in fact his comic *Sun Wukong Thrice Defeats the White-Boned Demon* [孙悟空三打白骨精 *Sun Wukong san da baigujing*] had of course been published before the Cultural Revolution. . . . Mao needed people like him, so, therefore, he was able to come back. (Musicologist, 1950s–)

Almost imperceptible to the eye is a difference between the two sets of depictions below, taken from a comic book entitled *Sun Wukong Thrice Defeats the White-Boned Demon* and published twice, once in 1962 and once in 1972 (**ill. 6.7**). The comic is based on an opera that in itself takes up a set of scenes from the classic sixteenth-century novel *Journey to the West* (西游记 *Xiyouji*). The two scenes selected here show, first, the Monkey King named Sun Wukong (孙悟空), who is seen going off to search for a demon he knows is hiding, lurking somewhere in this barren region. Before leaving, Sun Wukong draws a circle around his companions with his magic rod (千钧棒) (**ills. 6.7 a&b**). Monkey King admonishes his companions—Scholar-Monk Tang Seng (唐僧), the pig Zhu Bajie (猪八戒) and Monk Sha (沙僧)—to remain seated within the circle and wait for his return. In his absence—and this is what the second set of pictures shows—the white-boned demon arrives in the form of a beautiful lady (**ills. 6.7 c&d**). She attempts to grab the ignorant pilgrims, who are so taken by her beauty, in order to eat them later, but she fails to capture them. The circle drawn by Sun Wukong is powerful: its radiance repels the demon.

ill. 6.7 a&b Political changes I: Differences between two versions of Zhao Hongben's Monkey King comic published in 1962 (a) and 1972 (b) (Comics SWKSDBGJ 1962:7 and ibid. 1972:7).

This comic book, which won a national prize in 1963 (Meng 2003, 7), was the work of one of the most famous Chinese cartoon artists, Zhao Hongben, who, during the late Republic, was counted in the comic art world as one among the "Four Greats" (四大名旦 *si da mingdan*). *Sun Wukong Thrice Defeats the White-Boned Demon* was first published not quite four years before the

ill. 6.7 c&d Political changes II: Differences between two versions of Zhao Hongben's Monkey King comic published in 1962 (c) and 1972 (d) (Comics SWKSDBGJ 1962:13 and ibid. 1972:13).

beginning of the Cultural Revolution; it was then criticized and taken off the market, only to be republished a few years later, in 1972, in the middle of the Cultural Revolution. It went on to see several more editions (and official translations) in the years following, all before the official end to the Cultural Revolution in 1976.[15]

This chapter will first introduce the reader to some of the characteristics of the officially idealized and canonized Cultural Revolution comic. In the course of this analysis, I will continuously come back to this controversial comic in order to show how, where, and why the "typical" Cultural Revolution comic was intertwined with some of the comics, texts, images, and sounds that were produced before and after the Cultural Revolution and how some Cultural Revolution comics (such as the *Sun Wukong* story) could in fact exist (and even thrive) during the Cultural Revolution in spite of not adhering to all of the characteristics routinely assigned to them. In this discussion, I will complicate a commonly held attitude, namely, that Cultural Revolution comics, because of their highly ideological and didactic content, were generally "dull and serious" (Farquhar 1999, 206).[16] I attempt to understand whether and how the chained pictures of the Cultural Revolution actually "chained" their readers: did they restrict the readers' vision against their will, or were these readers "chained" by consent? At least some of these comics were exciting

15. Wagner 1990, 156–57n34 mentions editions in 1973 and 1976 (a German version, identical to the 1962 edition, also appeared in 1974, and was reprinted in *Chinesische Comics* 1976). The editions used here are the 1962 version and its 1964 translation *Monkey Subdues the White-Bone Demon* (Beijing 1964), and the 1973 reprint of the 1972 edition (Comics *SWKSDBGJ* 1972). Further editions of the comic can be seen in a comic catalog *Zhongguo lianhuanhua* 2000, vol. I: the first version of the story mentioned there is from 1964, the second from 1972 (*Zhongguo lianhuanhua* 2000, vol. I, 109). The same catalog includes comic versions of many different monkey stories, all from the early 1980s (Ibid., 150–54), including another edition of *Sun Wukong Thrice Defeats the White-Boned Demon* (*Zhongguo lianhuanhua* 2000, vol. I, 166, 1980.5) and two further comics with Zhu Bajie as the main hero, (*Zhongguo lianhuanhua* 2000, vol. I, 179, 1982.11 and 1982.1). For a similar story, see also *LHHB* 1979.4:31–35.
16. For a first cautious reevaluation see Seifert 2008, 104ff.

and even fun to read after all—just as the model works appeared to have been fun to watch, the Mao Songs were fun to sing, his portraits fun to paint and collect, and his stories fun to listen to—in spite of the politics and trite aesthetic mechanisms which made them function.

If the Sun Wukong story, along with its creator Zhao Hongben, was criticized at the beginning of the Cultural Revolution, this criticism came in spite of the fact that the comic can be read as a perfect allegory of Cultural Revolution politics or, more specifically, the Maoist line. In a meticulous study, Rudolf Wagner has shown that the man-eating demon might be taken to stand for imperialism and revisionism, timid Tang Seng for the Party, voracious Zhu Bajie for the revisionists within the Party and among the people, and slightly dim-witted but ever faithful Monk Sha for the masses. Last but not least, the Monkey King, Sun Wukong himself, stands in this interpretation for Mao Zedong and his thought (Wagner 1990, 161ff). This association is visually obvious, as the powerful circle that Monkey draws throws radiance, shining like Mao, the Chinese sun that had risen in the East according to the words of that famous song, "Red Is the East."

With its radiance, Sun's circle repels the demons. The manner of depiction chosen here is directly taken from the iconography used to depict Mao, the sun himself, since the 1940s and, most frequently, throughout the Cultural Revolution (see e.g. **ill. 5.2; ill. 5.3**). And in comics, too, the same iconography (in many different variations) is used every time Mao and his powerful words and thoughts are mentioned: in *White-Haired Girl*, a comic published in 1971 and based on the model ballet by the same name, the power of the sun to make the people and their lives happy is quite evident in the final tableau, as everybody's hands are held up to the sky and the beaming sun in victory pose and their open smiles reveal happy determined faces (**ill. 6.8**). And if the audience is ever in doubt after seeing the picture, the text reinforces the message again: the people in the picture "move forward victoriously forever and ever, according to the instructions of the Great Red Banner of invincible Mao Zedong Thought" (在战无不胜的毛泽东思想下伟大红旗 指引下永远胜利向前进).[17]

(199) "出发!"大春挥手命令队伍前进。火红的战旗迎风漫卷，战斗的行列浩浩荡荡，象一股势不可挡的洪流，迎着朝阳阔步向前! 向前，向前，在战无不胜的毛泽东思想伟大红旗指引下，永 远胜利向前进! 誓把革命红旗插遍全中国，誓将无产阶级革命 进行到底!

ill. 6.8 *The White-Haired Girl*: Victorious finale in the sun, 1971 (Comics *Baimaonü* 1971, 199).

17. See also the concluding scene in *LHHB* 1976.7:14/no.51. This usage is not restricted to the Cultural Revolution years, however, as the sun continues to appear in the glorious final scenes of later chained pictures. See, for instance, *LHHB* 1977.4:30–34, here 34/no. 28 which in the final scene shows a group of girls in the sunshine led by an elderly woman.

Similarly, in the story of Mao's good student and model cadre Jiao Yulu 焦裕禄 (1922–64), the halo around the book containing Mao's words is dramatically put into scene by use of the dark background in which it is set. The text again repeats the visual impression, reconfirming that the brightness coming from Mao's words is what makes everyone strong (**ill. 6.9**). It is the moments of greatest dramatic impact in these stories, and the moments of enlightenment, that call for the appearance of the sun and its powerful rays. In the 1973 comic *Luo Shengjiao*, which relates the story of a young soldier, Luo, who loses his life saving a Korean child from drowning in 1952, the martyr is depicted at the decisive moment: he knows he will have to sacrifice himself and is encouraged by the words of Mao and the red sun shining upon him (ill. 6.10). Indeed, the sun itself is talking to him, in the words of Mao!

7. 在党组织的教育下，焦裕禄和大家一起认真学习毛主席著作，一句句革命道理使他心明眼亮。毛泽东思想的阳光雨露，哺育他茁壮成长。

ill. 6.9 *Mao's Good Student Jiao Yulu*: The power of the sun, 1972 (Comics *Mao Zhuxi de hao xuesheng Jiao Yulu* 1972, 7).

In *Sea Heroine* (海英 *Haiying*), a comic published in 1975, a very similar mechanism is at work: a sent-down youth is seen here in a moment of desperation in her fight against the creepy Chen Wulao 陈乌佬, who is crow-like not just by name and who is trying to sabotage her efforts to get a good fishing harvest (**ill. 6.11**). Haiying is inspired by Mao's powerful words: "Even great storms are nothing to be dreaded. It is in the midst of great storms that human society moves forward" (大风大浪也不可怕. 人类社会就是从大风大浪中发展起来的) (Mao 1957, 387). She understands that difficulties are there to be overcome.

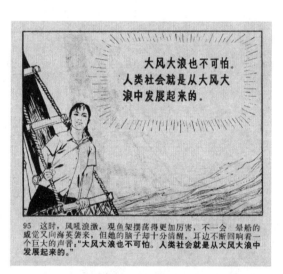

95 这时，风吼浪激，观鱼架摆荡得更加厉害，不一会 整船的感觉又向海英袭来，但她的脑子却十分清醒，耳边不断回响着一个巨大的声音："大风大浪不可怕。人类社会就是从大风大浪中发展起来的。"

ill. 6.11 *Sea Heroine*: The power of the sun, 1975 (Comics *Haiying* 1975, 95).

Mao's words, from a conference on propaganda work held on March 12, 1957, are, says the text, like the sun to her (and this is visualized in the image as they appear in a balloon that really is the sun); they warm her heart and enable her to make a spectacular catch.[18]

This type of depiction was powerful in comic rhetoric, and it could be seen before and even after the end of the Cultural Revolution, as in a number of 1950s comics (ill. 6.12 a&b) or in the 1977 comic on "iron-man" Wang Jinxi, the famous labor hero who started and brought to success Chinese oil production in Daqing (ill. 6.13).[19] Wherever Mao and his thoughts are remembered in

18. In many of the comics, every time a lamp shines, the mighty force of Mao seems to be quite near. See e.g., Comics *Shashiyu* 1975, 45, 54; Comics *Zhang Side* 1974, 54.
19. See Chapter 4, note 72.

comics before, during, and after the Cultural Revolution, the sun-like radiance appears and repels all evil. And it is obviously this same and distinctive radiance that Sun Wukong's circle also exudes in Zhao Hongben's comic. The comic book accords quite well with Cultural Revolution policies by using this iconography, and it does so, too, by pursuing a particular ideological line in the story, a point I will elaborate on below. The question thus remains: Why was it criticized?

Published in 1962, just a few months after the end of the devastating famine caused by Maoist economic policies during the Great Leap Forward, *Sun Wukong Thrice Defeats the White-Boned Demon* reflects an immediate and extremely politicized present (a feature typical of later Cultural Revolution comics, too).[20] Before he leaves his companions in the mighty circle, Monkey King admits that they have reached a desolate stretch with hardly a thing to eat (Comics *SWKSDBGJ* 1962, 6). He answers the starving Zhu Bajie: "This is a barren mountain and there's no sign of human life for miles around. I'd better go ahead and [on the way 顺便 *shunbian*] find you some fresh fruit."[21] In this situation, Monkey King (that is, Mao) is the only one who really knows what he is doing: he is the only one to understand and accept the fact that transition society (that is, society during and after the three famine years) is a barren land and that finding something to eat will be difficult. Still, finding food alone cannot be assigned top priority. Monkey does not forget about food, but it is only "on the way" to discover more about the dangerous region as a whole that he promises to "find" some. Monkey knows that to find a way through the barren land and to ward off the demons who threaten to devour the travelers is their most important task, not getting food. Zhu Bajie, on the other hand, is interested in nothing but food: he is a caricature of China's people, struck by the famine years after the Great Leap Forward (1958–61). Zhu adheres to something the Maoists would have called "Khrushchev's goulash communism." While the apprehensions of the public in the midst of famine are somewhat emphatically taken up in the figure of Zhu Bajie, they are, at the same time, critically reflected and associated with revisionism (Wagner 1990, 170–71).

Seeing all this, one would deduce that in 1966, this 1962 comic could and should have been the perfect tool for a fight against someone who was called China's first revisionist and "China's Khrushchev"—Liu Shaoqi (Dittmer 1974). This appears all the more probable as Mao himself had, on February 28, 1966, called for "local Sun Wukongs," i.e., local heroes, to become active. In a conversation with Kang Sheng, Mao had allegedly said: "I have always advocated that whenever the Central organs do something wrong, it is necessary to call upon the local authorities to rebel and attack the Central government. The local areas must produce several more Sun Wukongs to vigorously create a disturbance at the Palace of the King of Heaven."[22] But instead of being praised,

20. A fictional reflection on the consequences this had for comic painters is the description in Ha Jin's 哈金 (1956–) *Waiting* of a comic painter, cousin to Doctor Lin, who courts Manna Wu and tells her of his difficulties of getting a comic on which he had long labored published at a time when the policies were changing drastically and almost constantly (Ha Jin 1999, 116). Looking through *Lianhuanhuabao* in the second half of the Cultural Revolution, the realism of this depiction becomes very clear: every campaign is accompanied by fitting comics reiterating its themes (e.g., the campaign against *Shuihu* in *LHHB* 1975.10:1–5; *Dazhai* in *LHHB* 1975.11:17–20, 1975.12:1–7, 1976.1:1–7, 1976.2:1–20 and 36; *Pi Lin pi Kong* in *LHHB* 1976.7:15–16 and 25–34; or Mao's death in *LHHB* 1976.9 and 1976.9–10 and Zhou Enlai's in *LHHB* 1977.11–17). This policy of producing timely comics continued, however, well into the 1980s, with a series on the so-called "Gang of Four" (e.g., *LHHB* 1977.3, inclusive of a new version of the Sun Wukong story; cf. also *LHHB* 1977.4:27–29) ending with a quote that all must fight and criticize the "Gang of Four."
21. Translations are modified versions of the official 1964 English edition (here, picture no. 6), which bases itself on the 1962 Chinese version of the comic (Comics *SWKSDBGJ* 1962).
22. Mao 1974, 382 here alludes to another scene from Monkey King's Story, where he wreaks havoc in Heaven. Michael 1977, 155–56 gives another official source from 1967 that contains a similar quote: "We must overthrow the king of Hell and liberate the little devils. For that purpose we need more Sun Wukongs from various localities to disrupt the heavenly palace" (Joint Publications Research Service, 25 August 1967, 9). See the discussion in Wagner 1990, 204. Wagner also relates that at Beida (Beijing University) there was a powerful group of rebel teachers called "Massive Cudgel," an allusion to Monkey's magic rod. At Qinghua University there was a "Sun Wukong" Red Guard contingent in late 1966.

this Monkey comic and its artistic execution is criticized and banned; its painter, Zhao Hongben, is condemned, struggled, and nicknamed "The Comic Tyrant of the South" (连环画的南霸天 *Lianhuanhua de Nan Batian*), thus alluding to one of the most vicious bullies from the Cultural Revolution model works, the landlord Nan Batian who appears in the model ballet *The Red Detachment of Women*. Once again, then: why is Zhao Hongben and his comic criticized?

According to the Red Guards who attacked him,[23] there were three reasons for the criticism: (1) His demon is considered much too beautiful, (2) His hero, Sun Wukong, is not enough of a hero to hold up to Cultural Revolution standards of scrutiny, and (3) the comic contains too much "lewd sexual material" (and this is the difference between the two versions juxtaposed in the beginning of this chapter (**ill. 6.7**), perhaps not-so-obvious at first sight): in the prize-winning edition of 1962 Zhu Bajie appears half-naked, and his nakedness is blatantly obvious as his navel and nipples are showing (ills. 6.14–6.15, with details from **ill. 6.7**), but they have disappeared in the 1972 re-publication).[24] The three criticisms voiced against Zhao Hongben illustrate what was considered important in the production of "politically correct" comic art during the Cultural Revolution. First, not unlike any other artistic product created during this time, the ideal comic during the Cultural Revolution in its depiction of heroes and demons would have to abide quite clearly by the set of rules called the Three Prominences, which had first been developed for the model works.[25]

As discussed throughout this book, the Three Prominences are achieved by making use of all artistic possibilities first to emphasize the good, second to emphasize the heroes among the good, and third to emphasize the main heroes among the heroes. In comics, this basic theory causes

(143) 喜儿走到门口，刚要出去，突然一道闪电，一声霹雳，电光中她发现神台边坐着两个人，立刻认出了眼前的仇人："啊，是黄世仁，穆仁智！"

(144) "见仇人，烈火烧。"喜儿一见黄世仁和穆仁智，满腔的怒火就象火山爆发一样，她愤怒地向两人猛扑过去。

ill. 6.16 *The White-Haired Girl*: Heroes vs. villains, 1971 (Comic *Baimaonü* 1971, 143–44).

23. Much of the information in the preceding and the following paragraphs is taken from a personal interview with Zhao Hongben's son and daughter-in-law in Shanghai, 14 March 2004. They were careful to point out that the criticisms had been raised by Red Guards and need not necessarily reflect, therefore, official placet or even "Jiang Qing's opinion." Nevertheless, these criticisms were potent enough, as we will see when we compare the revised version of the comic published a decade later. All of this reveals just how effective Cultural Revolution anarchy was, after all.

24. Obviously the same standard did not apply to export editions of the work: the 1974 German edition reprinted in *Chinesische Comics 1976*, 142, shows Zhu Bajie with his navel and nipples (re)-installed! In the 1980s, too, Zhu Bajie has his navel prominently exposed (*Zhongguo lianhuanhua* 2000, vol. I, 179, 1982.11 and 1982.1). In *Zhongguo Lianhuanhua* 2000, vol. I, one can find a variety of usages: 179 (1982.11) and 194 (n.d., early 1980s) introduce Piggy with the navel exposed. In example 153, in a version with a February 1981 publication date, however, it is not to be seen. In the 1983 comic *Real and Fake Monkey*, on the other hand, as discussed in Wagner (1990, 221–27, illustration on 221), Zhu appears without exposed navel and nipples.

25. See the discussion on the theory of Three Prominences in Chapter 1, 71–72 and 84–85.

negative characters to disappear almost completely from sight, by, for example, effectively leaving them out of the panel frame, or by showing them from the back or the side but never in full view nor central to the picture. Instead, they are cast in the shadows, never straight and strong but sickly, crouched, and bent. Numerous examples can be given of comics published in the second half of the Cultural Revolution that abide by these rules. In the 1971 comic *White-Haired Girl*, for example, the main heroine meets and frightens her former landlord and his servant (two negative characters) who have taken to a mountain temple to escape a thunderstorm (**ill. 6.16**); in a similar scene in a 1972 comic, Mao's good student Jiao Yulu leads the people in their fight against rich landlords (**ill. 6.17**). Here, a sharp contrast is created between Jiao Yulu's towering statue and that of the cowering landlord (Huang Laosan 黄老三). Luo Shengjiao, too, the soldier hero from the Korean War, fights against vicious Americans who, however, look like skeletons even before death in a 1973 comic (**ill. 6.18**). And in the 1974 comic publication of *Song of the Dragon River*, based on the revolutionary opera of the same name (ill. 6.19), the main hero Jiang Shuiying appears in central position, set off nicely by the negative character Huang Guozhong (Comic *Longjiangsong* 1974, 58).

Cultural Revolution film and, of course, comics based on these films' stills use the same rhetoric of style of the Three Prominences. One comic based on a puppet theater film, *The Little Eighth Roader* (小八路 *Xiao Balu*) published in 1975, shows the negative (adult) characters in darkish-green lighting, with greenish faces and dark attire, behind the brightly lit, strong, straight, and positive child-hero, the "invincible" Tiger (虎子 *Huzi*), clad in bright colors, a red shirt, a white jacket, and blue trousers (ill. 6.20). Another comic based on film stills, *Spring Sprouts* (1976), which tells the story of a young female barefoot doctor, Chunmiao 春苗 (Spring Sprouts), even shows the negative characters not in the flesh but only as shadows on the wall (**ill. 6.21**). This

15. 在轰轰烈烈的剿匪反霸运动中，焦裕禄按照毛主席制定的阶级路线，访贫问苦，发动群众，终于逮住了大土匪头子黄老三，为人民除了一大害。

ill. 6.17 *Mao's Good Student Jiao Yulu*: Heroes vs. villains, 1972 (Comics *Mao Zhuxi de hao xuesheng* 1972, 15).

（72）两个美国鬼子爬上来. 张牙舞爪地想夺一个战士的枪，那战士枪膛里没子弹了，猛一下跳出了工事，高高地举起枪托，冲了过去。

ill. 6.18 Heroes vs. villains: *Luo Shengjiao*, 1973 (Comics *Luo Shengjiao* 1973, 72).

（122）杜文杰凑近钱济仁：“现在明确了，田春苗、方明有政治野心，上面叫我们马上组织反击。”钱济仁点头赞叹，“梁局长真英明！枪打出头鸟，先把田春苗、方明打下去……”两人进一步策划，要在老水昌的病上把文章做足！

ill. 6.21 Villains in *Spring Sprouts*: Shadows on the wall, 1976 (Comics *Chunmiao* 1976, 122).

predictable depiction of negative characters in Cultural Revolution iconography ensures they are easily discerned: they are despicable from the first moment of their appearance.

But it is not as if such exaggerated depictions were entirely peculiar to the Cultural Revolution comic, even if the technique became much more clear-cut and unambiguous during this time. Indeed, similar visual examples from before and after the Cultural Revolution can be found easily.[26] The covers of a number of 1950s comics make this very clear. One shows the ridiculed villain with a crooked official's hat (ill. 6.22). In another from 1959, the villain appears stricken on the floor, and his skin has the typical greenish tint that characterizes villains in the model works and Cultural Revolution art generally (**ill. 6.23**). After the Cultural Revolution, a series of Hitler comics published in 1985 continued to adhere to the standards of Three Prominences. Hitler, the villainous hero of the story, is presented in a position never quite central, never quite in the foreground, and with a bearing that is never quite straight and forward-looking. In one of the first panels of the comic, he is seen crouching on a set of stairs in front of a house. His crouching position is highlighted by the passers-by, who appear much larger in scale, and almost all of them disregard him almost completely—only one of them is turning to look at Hitler, but he does so contemptuously (**ill. 6.24**).[27] Hitler, the central figure in this comic, is marked, nevertheless, as a negative character in his gestures, in the type of lighting used to depict him, in his facial expressions, and more (e.g., ill. 6.25).[28]

In stark contrast with the villains, the positive characters, heroes, and especially the main heroes are, in their idealized form of the Cultural Revolution comic and in accordance with the principles of the Three Prominences, always shown in full view. They deserve many close-ups. In

ills. 6.23–24 Visual patterns: Villains in earlier Chinese comics, 1959 (*Zhongguo Lianhuanhua* 2000.I, 76.); Villains after the Cultural Revolution (Comics *Xitele* [Hitler] 1985, 2).

26. Further examples showing the prevalence of this technique of depicting negative characters throughout the Cultural Revolution (and beyond) are found in *Zhongguo lianhuanhua* 2000, vol. II, 59 (拾大歌 1966); ibid., 220 (猪场风云 1974); ibid., 239 (夜砸报国疗寮 1974); ibid., 221 (换靴记 1975); ibid., 306 (小船长历险记 1983). One of the rare contrary examples in which the negative characters are not really clearly set off is Glosser's translation of a 1950 comic propagating changes in the marriage law. The illustrations from the early 1950s in the *Three Character Classic against American Imperialism and Japanese Militarism*, on the other hand, display exactly the same techniques again (*FDMDWZRBSZJ* 1951, 8.17). See the HRA 14 Heidelberg Chinese Comics Collection for further examples.

27. Iconographically, this is not unlike Mao, who appeared neglected and disregarded in some of the depictions discussed in the last chapter, e.g., ill. 5.56. See also Comics *Xitele* 1985, 29.

28. See also Comics *Xitele* 1985, 96, 114, 130, 136, 141. This type of depiction of Hitler persists for some time, e.g., *LHHB* 1991.34:9–15. For other negative characters and the consistent use of particular disparaging techniques in depicting them, see e.g., *LHHB* 1991.43:4/no. 21 and 6/no. 37.

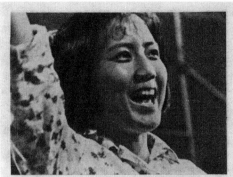

（187）人们欢笑，人们激动，张张笑脸深情地对着水昌伯。水昌伯纵情高呼，"毛主席万岁！"春苗和全场群众也振臂高呼，"毛主席万岁！"

（189）经过阶级斗争、路线斗争的锻炼，贫下中农自己第一代的医生迅速成长起来了。在丰收的田野里，赤脚医生田春苗身披霞光迎朝阳，战斗在风风雨雨的第一线。

（190）禾苗青青，春苗正在一片绿油油的稻田里欢快地劳动。突然，小龙又在田头叫唤，"春苗阿姨！春苗阿姨！"春苗二话没说，从田里拔起泥脚，拿起挂在树梢上的药箱，全心全意为贫下中农服务去了。

ill. 6.26 Heroes during the Cultural Revolution: Chunmiao in *Spring Sprouts*, 1976 (Comics *Chunmiao* 1976, 187, 189, 190).

Spring Sprouts, three of the final four panels show the heroine Chunmiao displaying her healthy, strong, and smiling face against different backgrounds significantly tinged with elements such as fields and electricity masts, which mark progress and prosperity (**ill. 6.26**).

In Cultural Revolution comics, main heroes are always depicted in bright light, with straight and strong bodies. One obvious example of this technique is seen in depictions of Jiao Yulu who, although seen at the same distance from the viewer as everyone else surrounding him, regularly appears bigger than any of the others (**ill. 6.27**). This technique of making heroes seem larger than life by drawing them larger in size than their entourage seems especially blatant when children as main heroes suddenly appear

31. 焦裕禄在主持第一次县委会上就强调说："我们要学习白求恩、张思德毫无自私自利之心，完全、彻底为人民服务的精神，要象愚公移山那样，除掉'三害'，改变兰考面貌。"

32. 根据毛主席关于"我们应当在自己内部肃清一切软弱无能的思想"的教导，焦裕禄还引导大家根除了思想灰尘，无所作为的论点。他说，"在自然灾害面前，有人主张走，这是逃兵；有人主张焦，这是懦夫、懒汉。我们不能当逃兵和懦夫、懒汉，要当革命者，要干！"

ill. 6.27 Heroes during the Cultural Revolution: Jiao Yulu, 1972 (Comics *Mao de hao xuesheng Jiao Yulu* 1972, 31–32).

much bigger and stronger than their adult friends, and even more importantly, their enemies. This is the case with the little trumpeter in the 1974 comic by the same name, for example (ill. 6.28 *The Little Trumpeter* 小号手 *Xiao haoshou*), but again, it is a feature that predates the Cultural Revolution and that recurs after 1976.[29]

Students of the comic would have it that the single frame is inconclusive by nature (Breithaupt 2002, 37). When it comes to identifying villains and heroes in Cultural Revolution comics, however, the chain of pictures following or preceding the single frame is not necessary for correct interpretation. In and of itself, each frame showing a villain or hero is an autonomous unit that tells the reader precisely what to think, whom to believe, and whom to distrust and despise. By exaggeration, the ideal version of a Cultural Revolution comic makes the single frame speak an unmistakable language: each of the panels depicting heroes and villains can stand by itself and be interpreted "correctly." Heroes are central to the depictions: they are strong and beautiful, they are always inspired and inspiring. The hero is, more often than not, "engulfed by a collective," not unlike the many portrayals of Mao in which he is caught in "familiar situations." Backed by the collective, the hero belongs to others as much as to himself, and he thus becomes ever more powerful, energetic, and vigorous (Wang 1997, 130).

This type of stylized depiction rather than individualized portraiture is not restricted to Cultural Revolution comics, and, indeed, it is not even restricted to Chinese comics, either. It is part of the rhetoric of the comic genre worldwide. With the birth of *Superman* in 1938, a hero boom had begun. This trend, which has been read as a continuation of ancient hero myths (Hoffmann-Curtius 2002, 153), continues to dominate the comic market all over the world (Platthaus 1989, 156; Witek 1989, 49; Murray 2011). In comics it is imperative that villain and hero be distinguished quite immediately from their looks. This "visual prejudice," which is then supported by the comic's narrative, makes it easier (or even possible) to understand the comic's message (Grünewald 1982, 39, 49). Not surprisingly, then, a passage about World War II comics could be used, almost word-for-word, to describe the comics of Cultural Revolution China as well: here, so it is said, "enemies are destroyed and die sniveling and whining, their faces but shadows or grotesque masks; they are like animals and they are killed like animals," while the heroes, on the other hand are "strong and valiant men, who live for victory," who are "never shattered in their confidence" and who will surely be victorious, always.[30]

In anti-Nazi propaganda as well as during the Cultural Revolution, the primary aim of comic art—to be understood easily and readily—became political necessity. The comics discussed above, published during the second half of the Cultural Revolution, accord very strictly with the demands of the Three Prominences. Zhao Hongben's 1962 comic, on the other hand, could not stand up to such scrutiny. First, the demon, in all its different incarnations representative of, in Cultural

29. Liu Hulan 刘胡兰, for example, is a typically hyperbolic child heroine, set off against ridiculously portrayed villains in *LHHB* 1977.1–2:59. See also *LHHB* 1976.6:28/no. 32, where the little girl hero towers over even Hua Guofeng and Zhou Enlai in a story called *Window* (窗口).

30. The German original reads: "Feinde werden . . . zerfetzt und sterben laut schreiend oder wimmernd und winselnd. Ihre Gesichter sind häufig bloße Schatten oder groteske Masken . . .; sie werden als Tiere bezeichnet und wie Tiere abgeschlachtet. Todesqual wird nicht gezeigt, nur ein Schreien oder Zucken, schmerzvolle Verwundungen erleiden nur 'unsere Jungs,' Rache muß folgen. Die Helden, aus deren Perspektive der ganze Strip gezeichnet ist: In der Regel britische Soldaten und Piloten, große, starke, kampflustige, tapfere Männer, deren ganzes Wesen darauf gerichtet ist, zu kämpfen und zu siegen. Der Held überlebt, der Held siegt, das ist ja Verpflichtung des Helden. Sein Kampfeswille wird nicht erschüttert, weder von Lebensgefahr noch von Verwundung oder Folter, Einkerkerung in einem KZ (auf die ein sofortiger Ausbruch folgt). Mut, stählerne Nerven, Tapferkeit des einzelnen schützen vor Bleikugeln und führen zu entscheidenden Siegen. . . . Aber das wirkliche Leiden, Töten, die ganze Kriegsmaschinerie, ihre Hintergründe und Interessen, das wird alles nicht zum Gegenstand dieser Comics, die allein zeigen wollen, wie herrlich und männlich es ist, ein Nazi-Nest mit einem witzigen Spruch im Mund auszuräuchern." (*Penny Dreadful* 1981:90)

Revolution terms, "the black line," (i.e. the capitalist and revisionist road), is depicted as much too beautiful a sight (see **ill. 6.7c**). Although viewed from above, which is typical of negative characters, she appears in central positions and in clear focus in some of the images: this could mislead the reader to think of her as more important than she is. And what about Zhao's hero? Sun Wukong (understood to be the stand-in for Mao Zedong and therefore under extremely close orders) is even shown to humiliate himself by begging forgiveness from his master, Tang Seng, who, in the original novel, is by no means a hero. In a scene depicted in the 1962 version of the comic, Monkey is shown from the side, crouching, overshadowed by the other protagonists, who are, indeed, less than his equals, but not visually (ill. 6.29). He is not a typical comic hero, but something less to be sure.

As for Zhao Hongben's last "mistake," the neglect of sexual propriety, one must observe, too, that a denial of sexuality is the rule in comics published during the second half of the Cultural Revolution. Accordingly, love stories that were once included in the plots are excluded or completely subdued; scenes in which sexuality, nudity, or even love or sentimentalism might play a role are eradicated.[31] All throughout the Cultural Revolution, sexuality was subdued. Remembers one contemporary, "We had no chance to actually understand a lot about sex" (Playwright, 1956–).

According to a summary of the "Forum on the Work in Literature and Art in the Armed Forces with which Comrade Lin Biao Entrusted Comrade Jiang Qing" (林彪同志委托江青同志召集部队文艺工作座谈纪要), sentimentalism, and especially romantic love between men and women, was taken to be bourgeois (*Hongqi* 1967.9:19–20). The white-haired girl in the 1971 comic (as well as in the earlier model ballet), is no longer raped by her landlord's son, and her romantic relationship with her fiancé Dachun is subdued, although always latent, in spite of continual erasure in successive revisions of the plot before and during the Cultural Revolution (Meng 1993): when they beam together in happiness, in the final and concluding picture, they still exude the togetherness worthy of a couple just married (see **ill. 6.8**).[32] This ending is an example of what Wang Ban (1957–), who experienced the Cultural Revolution as a sent-down youth in the countryside, describes as follows:

> Despite its puritanical surface, Communist culture is sexually charged in its own way. High-handed as it is, Communist culture does not—it cannot, in fact—erase sexuality out of existence. Rather, it meets sexuality halfway, caters to it, and assimilates it into its structure. (Wang 1997, 134)

Others echo his observations: "If you talk about love, then you don't love Mao; that was the idea. But it is impossible to tell a people not to talk about love, so everybody will do so in secret" (Playwright, 1956–). While underground art and literature reversed official restrictions quite openly, even official art did not completely eradicate love either, and love most certainly played a role in the perception of these works as well. Sexual desire remains present as a continuous and unmistakable undercurrent in these comic stories. Subdued, covert, but still ubiquitous appears the relationship between Fang Ming, the doctoral student at the village hospital, and Chunmiao, the barefoot doctor, in the 1976 comic *Spring Sprouts*. When Fang Ming and Chunmiao are shown together on a boating trip or working side by side with great eagerness and interest, their

31. This fact is bemoaned in a collection of Cultural Revolution jokes in which one protagonist warns his fellows against singing the model works that feature unmarried heroes or heroines by saying that whoever sings these ruins his chances for romantic love (*Wenge xiaoliao ji* 1988, 147).

32. Compare also their latent love in Comics *Baimaonü* 1971, 163. On love in this comic, see Seifert 2008, 107ff. Further examples can be found in almost any of the comics published during the Cultural Revolution. See also *LHHB* 1976.6:28/ no. 32, *LHHB* 1978.8:10.

（36）土根热情地摇船为春苗、方明送行。刚从城市下乡的方明感触极深，觉得这儿农村看病实在太不方便，土根却说比起解放前已经好多了。春苗也有同感，"是啊，我们湖滨大队也是一样。"

（37）她从土根手中接过橹，一面摇一面讲述解放前辛酸的村史。"……有一回村里发了病，一下子死的人都来不及埋呀，可有谁见过医生的面？又有谁吃过一片药？"春苗越说越激动，"我们贫下中农盼自己的医生，盼了多少代啦！"

ill. 6.30 Latent love in *Spring Sprouts*, 1976 (Comics *Chunmiao* 1976, 36–37).

(class-based) love is only latently evident. Clearly, it is only love for the Party, not for a potential sexual partner, that counts during the Cultural Revolution (**ill. 6.30**). Visually, depictions of them on a boat can be considered residual influences from representations of romantic outings shown in films made in Shanghai in the 1930s and 1940s.[33] This is especially so when the second of the images shows Chunmiao in full view, holding the paddle, as depicted from the (loving and adoring) perspective of Fang Ming himself. The romantic mood suggested in these images finds a sharp counterpoint in the text accompanying them: it speaks a very different language. The boating trip is in fact not a leisurely outing at all, and in seeing Chunmiao at the paddle Fang Ming is not occupied by thoughts of admiration and love. Instead, the two of them, together with a young village boy, Tugen 土根 (the name translates significantly as "with his roots in the earth"), are off to see a sick patient, and the conversation centers around grim realities: Fang Ming is quite astonished about the difficulties of reaching patients in the countryside. Yet, so Chunmiao and Tugen tell him, the situation has improved enormously since "Liberation" when villagers could never even dream of seeing a doctor in their lifetime.

Later, Chunmiao and Fang Ming are again shown at work together. Speaking from the pictorial evidence alone, their hands almost touching, their faces all smiles as they beam toward each other, one might conjecture that these two young people are in love. Yet, again, the text counters such assumptions: it is late at night, and Chunmiao is still studying while Fang Ming teaches her, so it reads (**ill. 6.31**; a similar image appears in Comics *Chunmiao* 1976, 83). Love as prescribed in these comics is always love

（41）深夜，春苗在临时宿舍里跟唐大姐学完注射、量血压，又来到门诊间，在自己手腕上练习扎针。方明医生坐在一旁，热情地进行指导。

ill. 6.31 Latent love in *Spring Sprouts*, 1976 (Comics *Chunmiao* 1976, 41).

33. Similar residual influences in a description of the 1959 film portraying composer Nie Er are given in Wang 1997, 138–46, esp. 144.

not for one individual but for a collective cause; it is not feelings of a singular or private self but collectively shared thoughts that may then take on a sacred value and produce uplifting effects— not quite unlike sexual love, after all (Wang 1997, 113). Love is the love of and for the Party as epitomized in many a revolutionary song sounding something like this: "Father is dear; Mother is dear, but they are not as loving as Chairman Mao. The rivers are deep and the seas are deep. Yet they are not as deep as class friendship."[34] Within this frame, then, sexuality and even nudity were clearly not acceptable. And, accordingly, the pig's nipples in Zhao Hongben's comic had to be removed for it to stay (or come back) during the Cultural Revolution (**ill. 6.7** and ills. 6.14–6.15).

Again, debates on the function of sexuality in art are not restricted to the Cultural Revolution period or to China, for that matter: the discussion over depicting nudes is one that has preoccupied China throughout the twentieth century (Laing 2004, 186; Cohen 1987, 46), and earlier and later Monkey comics, too, have eradicated Zhu Bajie's nudity.[35]

Not just in its treatment of heroism or sexuality, the straightjacket of rules established for what was deemed an "acceptable comic" by the second half of the Cultural Revolution, then, is not only not unique to China, but it is also not a Cultural Revolution invention. The fact that it has long been in the making is evident when surveying some of the theoretical articles on comics published in newspapers such as *People's Daily*, *Jiefang Junbao*, *Wenhuibao*, and the *Literary Gazette* (文艺报) *Wenyibao* since the 1950s.[36] What is more, the straightjacket established and described in these publications can in fact be traced back even further, to the first discussions on comics during the May Fourth Movement of the 1920s and 30s.

Apart from the stylistic and ethical formulae of Three Prominences and the prudishness mentioned already, a number of other aspects were important to the particular form this straightjacket took in China: it questioned the importance of comics with traditional themes, so-called old comics (老图画 *lao tuhua*), for example, accepting them, as was the case with Zhao Hongben's *Monkey* in the early 1970s, only reluctantly—that is, only if they conveyed (or were made to convey) proper moral and political values (no "sex and crime"). This point appears in discussions in *Wenhuibao* in 1961 and in *Lianhuanhuabao* as early as 1957 (WHB 27.11.1961; LHHB 1957.8:7). In these critiques of the old comic, the depiction of revolutionary history and the victory of the proletariat are emphasized. They argue that so-called "new comics" should always be of greatest importance. They also stress the political function of a comic: it should warn of the "black line" in literature and art and of the "capitalist road" in politics. It should openly criticize "feudal," "bourgeois," and "revisionist" ideology, and it should stir the revolutionary enthusiasm and the class consciousness of the masses by praising the thoughts of Mao Zedong. Accordingly, comics featured revolutionary heroes (as seen in many examples already, from Chunmiao to Little Invincible Tiger), national and international revolutionary history (with some of the comics based on real events or news reports, e.g., the story of Korean War soldier Luo Shengjiao), and stories from Chinese history or folklore that had revolutionary potential (such as *White-Haired Girl*).

34. The song, which was part of the *Red Sun* set published in the early 1990s, can be found online, set to documentary films with images from the Cultural Revolution: 天大地大不如党的恩情大，爹亲娘亲不如毛主席亲，千好万好不如社会主义好，河深海深不如阶级友爱深，毛泽东思想是革命的宝，谁要是反对他谁就是我们的敌人 (DACHS 2009 Mao Songs: Mao's Love). A slightly different version of the song is given in translation in Wang 1997, 203. See also *Nanwang de xuanlu* 1992, 2.

35. Notably, the 1954 Comic Code Authorities in the US had very similar ideas. Their guidelines sought to prohibit not only "displays of corrupt authority, successful crimes, happy criminals, the triumph of evil over good," but also "sensual females, divorce, illicit sexual relations" (Inge 1988, 79).

36. The media publications accompanying the longstanding reform of comics are most thoroughly discussed in Seifert 2008. See also Farquhar 1999; Seifert 2001; Hwang 1978, 61–62.

The pictorial evidence harvested so far seems to suggest that this straightjacket of de-emphasizing "old comics," which was reiterated in a series of articles published in *Liberation Daily* (解放日报 *Jiefang Ribao*) and *People's Daily* in early and mid-1974, was rather rigorously applied (see, e.g., *JFRB* 21 January 1974; *RMRB* 23 January 1974; *RMRB* 6 July 1974). The *People's Daily* stressed the importance of making proletarian heroes prominent in comic art. In one article, it reported that artists had awakened to this fact already and were now better able to transfer their knowledge gained from class struggle into their art (*RMRB* 23 January 1974). Partly due to artists' more open engagement with the masses and to a considerable increase in the number of laymen painters (and here, the article elaborates on exact numbers of laymen vs. professionals), it had become easier to successfully implement the Maoist line in literature and art.[37] The second article in *People's Daily*, which appeared only a few months later, repeated many of the phrases already found in earlier articles on comic production (*RMRB* 6 July 1974). It complained that before liberation, comics were full of "sex and crime," but it went on to applaud the practice of sending artists to the countryside, explaining that these artists' experiences there had allowed them to become much more knowledgeable about realities in China. Because they had begun to understand the real life of the people, artists no longer felt a need to go back to old stories of emperors and ministers or love stories in the old "scholar and beauty" (才子佳人 *caizi jiaren*) style, as had once been advocated by "revisionists" like Liu Shaoqi.[38] These strictly formulated and oft-repeated rules as to the forms comics must take certainly "chained in" both comic producers and comic readers. But is that all there is to the story?

The early years of the Cultural Revolution saw almost no official publications of new comics—only the criticism and subsequent withdrawal of already published comics such as Zhao Hongben's. Although during the 1950s several hundreds of new titles were published every year, this number went down dramatically and came to an almost complete standstill after 1966. It began picking up only since after 1970, when at first a good 100 and soon several hundreds of new titles appeared every year (Hwang 1978; Seifert 2001; Seifert 2008). While the comic presses did not publish much officially in the first half of the Cultural Revolution, a flood of comic strips and caricatures appeared in Red Guard newspapers and pamphlets. In February of 1967, for example, the Red Guard newspaper *Jinggangshan wenyi* (井冈山文艺) published a parody of *Sun Wukong Thrice Defeats the White-Boned Demon* (ill. 6.32).[39] Here, the white-boned demon, identified with Liu Shaoqi who was criticized as the "Chinese Krushchev" in the beginning of the Cultural Revolution, is defeated not just three but four times (孙悟空四打白骨精). The Red Guard comic chooses a traditional theme, making it an "old comic" and thus not quite in line with the straightjacket. But it does so in order to attack revisionism, a strategy which was well in line with the policies of the time (just like Zhao Hongben's comic had been, too, though). The Red Guard comic declares the white-boned demon to be the major revisionist. This is very apt, as Liu Shaoqi was indeed considered the greatest enemy in early Cultural Revolution political rhetoric. On the other hand, the comic still has Zhu Bajie appear lasciviously: with nipples and navel in full shape and form (ill. 6.33). The comic thus openly subverts the straightjacket, and to do so in 1967 would have

37. *RMRB* 23 January 1974: 文化大革命前, 上海创作连环画的工农兵业余作者不过五六人, 而一九七○年以来, 上海人民出版社出版的一百八十多本连环画中, 业余作者创作或参加创作的, 占一半以上, 现在经常和出版社联系的业余作者有一百多人, 其中五十人左右已具有一定的创作能力. 天津市已有二十多个区, 局和基层单位, 成立了以工人为主体的创作组. 广东省已有四十多个有业余作者参加的"三结合"创作小组.

38. See *RMRB* 6 July 1974: 解放前, 连环画的内容多是反动, 荒诞, 黄色的东西. 新中国建立后, 连环画的内容虽然也有些变化, 但在刘少奇反革命的修正主义文艺黑线的控制下, 大量的帝王将相, 才子佳人仍然占据连环画的阵地. 成为刘少奇一伙复辟资本主义的一种舆论工具.

39. The background of the story is given in Hinton 1972, 41ff.; a political interpretation can be found in Wagner 1990, 200–204.

ill. 6.32 Red Guard version of Monkey King's story *Sun Wukong Defeats the White-boned Demon Four Times* (Red Guard newspaper *Jinggangshan Wenyi* 井冈山文艺 in Wagner 1990, 201).

chained in some, bringing them—like Zhao Hongben—into labor service. But the rules were not equally applied across the board, especially to those who called themselves "Mao's Soldiers."

And there is more to be said about this: Admittedly, in the Red Guard comic, the sun shines at the right time, with our main hero Monkey King victorious at the optimistic end (**ill. 6.33**).[40] But the hero is still not depicted in the prominent manner he would deserve according to the rule of Three Prominences. Indeed, one could argue that it is the demon who achieves greater prominence, for in his/her different incarnations he/she actually receives more close-up shots than does Monkey King. Moreover, the other characters, too, Zhu Bajie most prominently among them, are shown almost as many times as Monkey King, which again serves to diminish his prominence. Although Monkey King is victorious in the end and seen as a centralized or superior figure in some of his fights with the demons (**ill 6.32** and **6.33**), this is not always the case in all panels. Indeed, there are several instances in which his fighting abilities do not appear superior and he is almost squeezed out of the picture by his enemy (**ill. 6.33**). Thus, even in heady 1967, undoubtedly one of the most politicized periods of the Cultural Revolution, the regulations of Cultural Revolution Culture could or would not be applied consistently. Again we see that this period, which has often been characterized as one of absolute dictatorship and monolithic rule over Chinese art and culture, is rather more anarchic than is generally assumed.

ill. 6.33 Heroic monkey? (Red Guard newspaper *Jinggang-shan Wenyi* 井冈山文艺 in Wagner 1990, 201, detail, panels 19–21).

40. For further examples of this pattern at work, see Comics *Haiying* 1975, 116 and Comics *Haihua* 1975, 98.

This observation holds true, too, for works officially published during the later half of the Cultural Revolution, when comic production was resumed and artists like Zhao Hongben were summoned back to work (Seifert 2008, 117–18). Recalls one contemporary (whose further argumentation is cited in the beginning of this section):

> The fact that Zhao Hongben's comics were resurrected had something to do with Mao. He managed to get all these people back. Mao himself wanted the comic *Sun Wukong Thrice Defeats* back, so that is how it then happened! Mao needed people like him, so therefore he was able to come back. (Musicologist, 1950s–)

In 1972, Zhao published his comic once more, in revised format (Comics *SWKSDBGJ* 1972). Some inconsistencies can be observed: although this version does include a number of changes from 1962, the missing navel and nipple being the most obvious, it contains few other changes and certainly does not remedy completely the points criticized by Red Guards in the early years of the Cultural Revolution. The republished version thus illustrates once more that the straightjacket for cultural production in the Cultural Revolution had its loopholes.

Admittedly, Sun Wukong had, in this more recent version, gained some heroic features: no longer does he appear as a supplicant, for example, in front of Tang Seng who dismisses him for killing the different incarnations of the demon (because a true follower of Buddha is not allowed to kill). In the revised version, Sun is the one who takes center stage and who appears much larger and stronger than everyone else, facing the viewer, while his companions are shown from the back or from the side (**ills. 6.34 a&b**). Similarly, some of the panels from the 1962 version in which he is told off or punished by Tang Seng are simply omitted or substituted to make him look better; he is never punished in the new version and he is never humiliated such that he has to stand on a lower level than everyone else. An image from the earlier version in which the monk is seen with his entourage looking down at Monkey King from a cliff and casting a punishing spell on him as he bends down awkwardly in pain (ill. 6.35a) is substituted with an image in which Monk Sha is now seen advising Tang Seng *not* to punish Sun. In this substitute image, Sun appears, significantly, in the center top, with his companions pushed to the side (ill. 6.35b).[41] The fact that he, Sun Wukong, is the only one who understands who is demon and who is human is mentioned in the text. It is made much more evident pictorially than before, by showing him in central advisory

ill. 6.34 Heroic changes: Differences between two versions of Zhao Hongben's Monkey King comic published in 1962 (a) and 1972 (b) (a: Comics *SWKSDBGJ* 1962, 108; b: Comics *SWKSDBJG* 1972, 114).

41. See also Comics *SWKSDBGJ* 1962, 53–55 and Comics *SWKSDBGJ* 1972, 57.

functions in additional panels (e.g., ill. **6.36**; see also Comics *SWKSDBGJ* 1972, 25, and Comics *SWKSDBGJ* 1972, 36–37). Monkey's exclusive claim to enlightenment is specifically mentioned in the preface to the 1972 edition, which emphasizes that while the monk is ultimately "educated by reality" Monkey shows wisdom, bravery, resolution and *a priori* knowledge. Unlike everyone else, he knows that "when you see a demon, you must wipe it out."[42] The 1972 version of the comic teaches that only complete reliance and blind belief in Sun Wukong (that is, Mao Zedong) enables one to discover the demons; the more appealing a proposal or theory may seem, the greater the probability that it is nothing but a demonic device used by "revisionists" to subvert the Maoist line (see Wagner 1990, 195–96).

In the 1972 version, Sun Wukong is equipped with greater and much more dramatic fighting presence than in the earlier version.[43] The panels are modified such that Monkey King becomes the dominant focus. In one case, for example, the background is reduced in order to make more space

ill. 6.36 Adding heroism: A new panel in Zhao Hongben's Monkey King comic published in 1972 (Comics *SWKSDBGJ* 1972, 117).

for more of Sun Wukong (ills. 6.37 a&b). Moreover, a second panel is added to the scene, putting him, who has just defeated the old woman demon, triumphantly and in dramatic pose, squarely in the center (ill. 6.37c). The new version of a final fight with the demon shows Sun changed into five monkeys not only once but repeatedly (Comics *SWKSDBGJ* 1972, 112). This panel further substitutes a panel from the original version in which Monkey King is seen from the back, and actually has him kill the demon much more dramatically in a fire (**ills. 6.38 a&b**). Comparatively speaking, however, and although each of the added eight panels is to his credit, Sun does not gain all that much from revisions on his behalf.

The demons, on the other hand, are not made significantly uglier or less impressive in 1972: the young woman remains the same (ills. 6.39 a&b), the old woman only gains a little in ugliness through a close-up depiction (see ills. 37 a&b), and the old man is made to appear a little more helpless when his death is shown from behind rather than from the front (ill. 6.40 a&b).[44] The number of scenes in which the demon appears central is reduced in the later version. Two panels (9 and 10) are exchanged for this purpose. The demon is placed more toward the corner and looks more cruel (ill. 6.41 a&b), or is seen from the side rather than the center (**ills. 6.41 c&d**). All of this serves to deemphasize the demon's visibility and thus to elevate Monkey King to greater prominence. Nevertheless, with regard to the villains, the number of changes is rather insignificant in view of the comic's radical critique.

Thus, even the modified 1972 re-publication of the comic is by no means in accordance with every aspect of the Cultural Revolution straightjacket. It is a Maoist allegory, but it appears in traditional attire, praises Mao's thought only implicitly, if at all, features feudal thought and heritage

42. The preface is also discussed in Farquhar 1999, 228.

43. Additional and modified panels in the 1972 edition are Comics *SWKSDBGJ* 1972, 38, 39, 86–88, 112–13.

44. For a complete comparison between the two editions (in German), see HRA 14 Heidelberg Chinese Comics Collection.

ill. 6.38 Visualizing the death of a real Demon: Differences between two versions of Zhao Hongben's Monkey King comic published in 1962 (a) and 1972 (b) (a: Comics *SWKSDBGJ* 1962, 107; b: Comics *SWKSDBGJ* 1972, 113).

ill. 6.41 Visualizing the demon more demon-like? Differences between two versions of Zhao Hongben's Monkey King comic published in 1962 (c) and 1972 (d) (c: Comics *SWKSDBGJ* 1962, 82; d: ibid. 1972, 85).

(especially Buddhism), and still, in spite of the revisions, does not really showcase its heroes. Nor does it vilify the villains as much as an "ideal" Cultural Revolution comic would. It is published nevertheless. Once more, the power of much-decried "centralized bureaucratic planning" (see Farquhar 1999, 212) in the comic (and, more generally, the cultural) industry during the Cultural Revolution is to be questioned.

Although the production of Zhao Hongben's original Sun Wukong comic had been suspended during the first years of the Cultural Revolution, the second half of the Cultural Revolution saw its almost integral recovery (and the lack of nipples and navel to which Zhao Hongben agreed in revising his comic could, in this context, perhaps even be read ironically). Significant differences between standards of cultural production in the late 1960s and the early 1970s can be seen, then. Why else would Zhao Hongben's comic first be criticized and then published? At the same time, as the 1960s publication of the Red Guard comic shows, both during the early and the later period of the Cultural Revolution, different works would be accepted with varying degrees of tolerance. The discussion presented here may serve to illustrate, therefore, that neither period produced comics all in complete accordance with its own rules. The question remains, however: are the examples analyzed here exceptions? How straight was the Cultural Revolution straightjacket, really? And if it was not as straight as we have assumed it was, what, then, is unique about the Cultural Revolution comic after all?

Readers, Readings, and Popularity

> I read both old and new revolutionary chained pictures. My father really liked them. He always showed us some, especially those by He Youzhi [贺友直 1922–]... We read a lot during the Cultural Revolution, too, mostly those from before the Cultural Revolution. But of course we would also read the new ones, for example those with model works or these revolutionary stories. Later, there was one on Lu Xun. We would buy it and only care about whether or not it was painted well. (Art Historian, 1940s–)

> The painting teacher I had, had all these old comics, like *Romance of the West Chamber* [西厢记 *Xixiangji*], or *Butterfly Lovers*, or *The Peacock Flies Southeast* [孔雀东南飞 *Kongque dongnanfei*]. But he lost them all: now he does not have a single copy, they were taken away or they burnt them. Indeed, there are actually very few comics from the 1950s still extant. Some were later published again in the 1980s. But as for those not published in the 1950s, it turned out to be very difficult to keep them. The originals all got lost. Even the authors don't have them any more. (Intellectual, 1958–)

Neither navel and nipple, nor heroic or demonic depiction, nor even traditional or contemporary theme appear to be decisive enough to make a straightforward judgment of Cultural Revolution comics, their forms and contents. A "Cultural Revolution comic" can be many things. Even in this cursory survey of arbitrarily picked examples, most of which are taken from the second half of the Cultural Revolution after comic production picked up again, I have been able to show a large number of rather disparate comic styles: comic ballet in *White-Haired Girl*, film comic in *Spring Sprouts*, painted comic in *Mao's Good Student Jiao Yulu*, animation-comic in *The Little Trumpeter*, puppet-theater-turned-comic in *The Little Eighth Roader* (小八路 *Xiao Balu*), and traditional-style painting comic in Zhao Hongben's *Sun Wukong*, and the list could go on: even the model works were published in not just one but several different versions.[45] These comics did not all accord with the tenets of the Three Prominences, and many of them did not eradicate romantic love completely. Does the departure from the straightjacket explain these comics' popularity? Or

45. For more examples of this great variety see the comic collectors' blog: DACHS 2009 Chinese Comics, Model Works.

is the very nature of the straightjacket such that it makes the "unsaid" even more interesting? As for sex, one could easily see how its "not being there" in fact made it "all the more exciting." In spite of its "desexualization" and its "disembodiment which dries up the blood and freezes the limbs," Cultural Revolution comics, like other Cultural Revolution art, clearly did "exert an emotional impact" and thus had a strong hold on China's "imagination" in spite of its superficial sterility (Wang 1997, 133).

In light of these observations, common statements made about the Cultural Revolution comic should be reconsidered. Mary Ann Farquhar's interpretation of the form in her study of children's literature, for example, reads as follows:

> It is not necessary to document lots of examples from the Cultural Revolution. Chinese comics and book illustrations from this period bear an unmistakable style, recognizable just by flipping through the pages. In comics, the unique characteristics of the form – features that made it such an effective means for popularization – were all but ignored. Reviews from the period concentrate narrowly on political message and not on the story medium. This medium lost its distinctive character. It was subsumed by revolutionary operas into pale sycophants of their dramatic action; the unabated emphasis on stereotyped proletarian heroes with prescribed rules for portrayal reduced the arts to a continued glorification of a disembodied triumphant Marxist 'truth'; and the 'three prominences' commonly led to a pedestal effect with heroes elevated like well-lit statues while reactionaries skulked in the shadows. (1999, 237–38)

What Farquhar finds, we have found as well. Indeed, there is an inherent and repetitive logic in the Cultural Revolution comic. It "bears an unmistakable style"; it clicks according to one set of rules and comes to one set of conclusions, and Mao plays the most important role in all of this. Yet, does that mean that these comics are not worth looking at? That they have lost the "unique characteristics" that make the comic as a genre so popular before and after the Cultural Revolution?

The danger of stereotyping has been invoked by many a comic critic not just of Cultural Revolution comics but of comics generally. Witek argues that as the 1954 Comic Code cemented black and white productions and the triumph of good over evil, this served to stifle the quality and popularity of comics (1989, 49). Indeed, his description of the effects of the Comic Code—in theory quite a different matter from the Cultural Revolution straightjacket, as it was not imposed by the government but rather consisted of self-imposed guidelines (not even legally binding) on comic production that were in practice quite effective, however—sounds almost like a description of the Cultural Revolution comic in its stiffest straightjacket (if substituting "revolutionary" for "bourgeois" and "political" for "moral," respectively):

> The Code did serve to articulate in an unusually direct and peremptory form the bourgeois artistic (read "moral") standards of postwar America. The bureaucratically enforced wholesomeness of American comic books ... made the medium a socially circumscribed cultural space in which the terms of social rebellion were strictly defined: a comic book which violated the supposedly universal "standards of good taste" was simply not suffered to exist....
>
> The final effect of the Comics Code was to force comic books to depict a world that was either a denatured view of American social reality or an overtly fantastic never-never land of superpowered Manichean fistcuffs. Historical narratives in comic book form became nearly impossible; the ban on "all scenes of horror, excessive bloodshed, gory or gruesome crimes, depravity, lust, sadism, (and) masochism" can be taken to rule out nearly everything in the history of Western civilization except inspirational biographies and patriotic exemplum. Of course, the rule forbidding "disrespect for established authority" made political satire nearly impossible.... Its naïve assumption of the unproblematic nature of terms like "good" and "evil" and "excessive violence" would be laughable were its effects not so repressive of free speech; the bland and tedious comic books it mandated are a literary stigma from which the medium has been hard-pressed to recover. (Witek 1989, 49–50)

In spite of all this, testimony from comic readers all over the world appears to negate the idea that stereotyping makes for boring comics. In China, everyone seems to remember the characteristically trite storyline in Cultural Revolution comics. Interviewees recall that some of the comics were drawn in poor quality, quite obviously by laymen. Indeed, some talk of taking part in the making of comics themselves. One musicologist reports that he would draw comics from the model works and the *Three Constantly Read Articles*: "It was very easy, because there would be these manuscript versions and story outlines, so in our factory team we actually created some of these heroic stories" (Musicologist, 1950s–). In some cases, when the same protagonist seems to look rather different from one picture to the next, one can still detect this type of communal production of comics by several different laymen at work (see **ill. 6.27**).[46] One of these laymen painters remembers:

> In these creation teams, there were different types of people, there were the workers and the professionals. The last draft of a comic always went through the professionals. So even though the workers or the peasants would draw or paint the images themselves, they would always do so under the leadership of a professional. Everything that was published underwent censorship. They propagated that the peasants should paint and so they would publish their things, but none that really showed poor painting quality . . . (Musicologist, 1950s–)

No matter how trite or unaccomplished these comics ended up being, almost everyone seems to remember having enjoyed reading a variety of comics during the Cultural Revolution.[47] Interviewees from different generations all remarked on this multiplicity of available texts, while often voicing a preference for reading old comics:

> We would read model works and revolutionary stories, sure, but what we read most were the old comics from before the Cultural Revolution. (Art Historian, 1940s–)

> Comics, yes, there was the *Romance of the Three Kingdoms*, *Water Margin*, and *Dream of the Red Chamber*. There were also some revolutionary comics that I remember reading. I recall that after 1969, there were hardly any new comics to be seen. Sure enough, I did not need these comics, because there were enough books in my family. But when I was in primary school, between 1964–72, I would have read some of them . . . Of course, I was especially interested in those that had been criticized! It was no trouble to get them out of the library; if it did not become too obvious: we could ask the teachers to get them for us! (China Historian, 1957–)

It would be difficult to figure out whether the popularity of comics during the Cultural Revolution matches that of earlier and later times: because they are exchanged among friends and lent out quite frequently, comics usually have a much larger market than what the publishing statistics based on actual sales suggest. Indeed, according to Seifert, in the 1930s, the larger part of all comics produced was given to lending libraries and not sold. This practice seems to have continued into the years after 1949 (Seifert 2008, 49). In 1952, for example, in Shanghai alone, 350,000 small bookstalls are said to have rented out comics to between 200,000 and 400,000 people each day (Farquhar 1999, 202). Such figures are unreliable as well as few and far between, however. Memories of reading comics at such stalls, which often held several hundred titles on average (Seifert 2008,

46. This phenomenon of slightly faulty painting technique is not restricted to the period of the Cultural Revolution alone but can also be seen before and after. See e.g., Comics *Li Shuangshuang*, which was published in 1977 but goes back to a 1964 original: 4, 5, 70, 81, 122, 171.

47. See the image of a woman patient reading a comic of *Red Detachment of Women* in DACHS 2009 Documentary Photographs, Cultural Revolution, William Joseph, no. 285, 1972.

85), however, can be found frequently among those who lived through the early decades of the PRC (and have been added in memory blogs as well).[48]

> We went to this rental stall that had the comic books. My relative had rented some space out to the owner of the stall and so he was really nice to me. I could simply read all those comic books [*xiaorenshu*] for free. So I read the *Romance of Three Kingdoms* and the *Journey to the West*. Many of these comic books were very well painted. I really liked them, and now, I still have some of them, reprints from the 1980s when they came out again. (Journalist, 1946–)

Illustrations that show these bookstalls renting out comics can be found throughout the twentieth century. In one 1976 depiction, a little girl, her arms full of comic books, stands in front of a pushcart stall and next to a set of chairs, shouting out loud to attract an audience. Behind her, a boy is already starting to flip through some of the comics displayed on the pushcart (**ill. 6.43a**). Images like these suggest an unabated fascination with the comic form, and this fascination probably did not stop during the Cultural Revolution.

In a 1940s depiction, a group of women, men, and children sit on a bench in front of the stall's shelves or browse the shelves, most of them with their backs toward the viewer and immersed in their reading activity. All of them are guarded by an old man with large hat and beard, seated on a large chest (**ill. 6.43b**).

Thirty years later, a 1974 propaganda poster entitled *Fascinating* (引人入胜) appears as almost a mirror copy of this earlier image: it shows a group of boys and girls sitting not on a bench but on small chairs at such a stall, the shelves behind them filled with typical comic readings from the Cultural

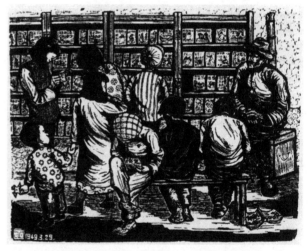

ill. 6.43 a&b Lending libraries: (a, top) Reading comics during the Cultural Revolution, 1976. (Collection Pierre Lavigne, maopost.com C00632). (b, bottom) Reading comics in the 1940s (Seifert 2008, 41).

Revolution: comics from the model works, the story of Mao's good student Jiao Yulu, the story of Norman Bethune, one of the *Three Constantly Read Articles*. Not unlike in the earlier image, the children are depicted reading intently and quite obviously enjoying themselves, laughing together or pointing to details in the books, although here they are all facing the viewer, so that their enjoyment can be perceived all the more easily (**ill. 6.43c**).

While libraries and private homes may have been ransacked in the early years of the Cultural Revolution, and their comic collections taken away, street stalls for comic books remained intact

48. For blogs on Cultural Revolution (and earlier) comics, see DACHS 2009 Comics. For more experiences in different times and regions cf. Mao 1966, 75–78; Liang 1999; Zheng 2002.

and in use throughout the Cultural Revolution (Seifert 2008, 112). A recently published, undated photograph shows yet another similar scene, most probably from the 1980s, the heyday of comic production, according to Seifert (2008, 124). Again, the image shows boys and girls sitting on small benches, now with their backs to the audience again, but reading just as intently as in the other images (**ill. 6.43d**).

From memory reports, interviews, and sales statistics of Cultural Revolution comics (Seifert 2008), one must assume that even these politicized and predictable stories found an audience. Indeed, in one recent blog set up specially to remember Cultural Revolution comics, one of the bloggers writes: "Reading comics was one of the nicest parts of my childhood" (看小人书是小时侯最快乐的事情之一).[49] One contemporary participant observer, Gino Nebiolo, expresses his ardent interest in comics from his observations during a train ride he took in China in the early 1970s:

> My first Chinese comic book came with the tea, on the night train from Hangzhou to Shanghai. The girl handed one out, along with the steaming cup, to every passenger. . . . This first one to fall into my hands told the true and edifying story of a soldier. . . . Wounded by the explosion of a cannon that he was tending during army maneouvers, he lost an eye and a hand, but no sooner did he get out of the hospital than he ran to re-enlist.
>
> I noticed that the other passengers, when they had finished their books, made a silent and obviously customary exchange. In this way, I obtained a book about a peasant revolt that shook Northern China in the ninth century, at the end of the Tang dynasty. Famine, floods, droughts, taxes, landowners and monks who exploited the farm workers, outrageous waste at the imperial court, and elsewhere poverty of the worst kind. After a flood of the Yellow River an intellectual called Huang Chao put himself at the head of thousands of tenant farmers and desperate, landless persons. . . . The poor people's army swelled in numbers, routed the emperor's cavalry in Shandong and his infantry in Henan, finally attacking and occupying the capital. But, the text tells us, Huang had no ideological drive. Little by little, he let himself be corrupted by power, failed to carry on the revolution or to effect agrarian reform, and drew away from the common people. Defeated because he could not feed his hungry men, he killed himself

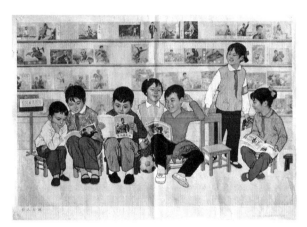

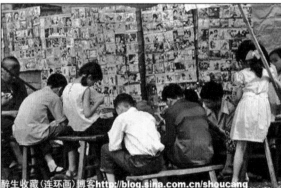

ill. 6.43 c&d Lending libraries: (c, top) Reading comics during the Cultural Revolution, 1974 (Collection Pierre Lavigne, maopost.com 0707-001). (d, bottom) Reading comics in the 1980s (DACHS 2011 Comic Readers).

49. DACHS 2009 Sun Wukong San Da Baigujing, Remembering Old Comics Blog.

with his own sword. "The day will come," explains an anonymous soldier on the last page, "when we shall all join together under a single banner and the people's justice will triumph over evil."

All through the night we exchanged comic books, without ever speaking.... The comic books did not tell heroic tales or episodes from history alone; some of them reflected everyday life, particularly in the country. One that fell into my hands was entitled "A Pailful of Manure," whose peasant heroine Qian Erxiao was, to be sure, a conscientious worker, but was corroded by the subtle poison of bourgeois selfishness. From her personal latrine she removed a pailful of potential manure for use in her own vegetable garden. Fortunately, her husband was a good citizen, ready to give up the manure for the good of the community and, indeed to scatter it over the collective field. This story was set at a time before the Cultural Revolution, when peasants were allowed to have small plots of land of their own. No law or regulation prevented putting the manure to personal use, only socialist ethics. Around the smelly pail the entire village took part in a doctrinal dispute, and social considerations, quite rightly, won. Qian understood what she was supposed to, happily gave in to her altruistic husband, and thanked the villagers for opening her eyes.

I observed my companions—workers, petty officials, and peasants. The train was moving slowly, at a speed well under the conventional forty miles an hour, and the heating system was out of order. Only two women and one old man laid aside their comic books and fell asleep. Among the others, no one paid attention to the cold or to the repeated stops; they were all completely absorbed in their reading. And if one of them finished his comic book before the others, he looked around him with restrained impatience, and then, when he got the next one, plunged into it without delay. Several times the stewardess came into the compartment with more hot water for the tea, but no one noticed, and the conductor had to knock his ticket puncher against the metal rim of the baggage rack, as if to arouse sleepers, in order to get any attention. At dawn, just a few minutes before arrival at the central station of Shanghai, one of the passengers collected the comics, smoothed frayed corners, and turned them over to the stewardess who wrapped them in a plastic case.[50]

What is it that makes for the appeal of the Cultural Revolution comic, which comes out so clearly in this description? To explain the obvious fascination with Cultural Revolution comics in spite of (or perhaps, because of) their triteness and predictability, we must turn to the comics themselves; we must read them and try to understand their text machine and thus the popular enthusiasm they continued to create. We may also reconsider the question of whether, in being trite and predictable, Cultural Revolution comics are at all special. For it is one of the characteristic elements of comic art generally that comics, which have been described as "the crassest commercial exploitation of rote generic formulas" (von Wilpert 1961, 158; cf. Witek 1989, 5),[51] (must) work according to a trite logic and predictable patterns, a point they have always been criticized for all over the world.

The fact that quite a few comics published during the Cultural Revolution received artistic awards at a comic competition held in 1981 (the first to be held since 1963) speaks to the same problem: they were not only read widely, across geographical and class boundaries, but they were popular, and they continued to be appreciated even after the Cultural Revolution ended.[52] I would further argue that Chinese comics, even during the Cultural Revolution, were—at least from the point of view of their reception—distinctly not "a single flower blossoming" as Deng Xiaoping once said about the model works, in accordance with which all other art was supposed to be created (*Peking Review* 28 May 1976, 7). Stereotyped sameness, in terms of structure, artistic execution, and content, was of course one typical characteristic of the Cultural Revolution comic (as of all Cultural Revolution art), but it is possible to show, nevertheless, that each "piece of cast metal turned out from within a desert" (Farquhar 1999, 238) was in fact a tiny bit different from

50. The text follows Nebiolo 1973, vii–viii, spelling has been adjusted to pinyin.
51. Von Wilpert in the original German reads: "Präfabrizierte Klischees schalten das logische Denken aus und verhindern jede Differenzierung des Weltbildes."
52. Meng 2003, 40–96. For a discussion of this paradoxical situation, see also Seifert 2008, 123.

another and that many more pieces than officially approved were in fact available to people. Finally, not unlike with music, art, and literature, each piece therefore appeared in communion with these many other pieces of art and writing.

What kind of comic could and did one see during the Cultural Revolution, then, and what exactly accounts for their attractiveness?[53] In order to consider the question, I will follow the categories mentioned in Nebiolo's train record: among the comics he mentions is one so-called old comic (老图画 *lao tuhua*) or old-style comic (古装连环画 *guzhuang lianhuanhua*), with a traditional theme, slightly modified to fit contemporary contexts. Huang Chao 黄巢 (d. 884), whose peasant rebellion brought the Tang dynasty to crisis, is criticized in the comic for having lacked "ideological drive," perhaps alluding to failed contemporary politicians such as Lin Biao or Liu Shaoqi, for example.

Old comics, in agreement with the Maoist principle of "wielding through the old to create the new," would use the past to serve the present (Mao 1964b, 598).[54] Just like Zhao Hongben's Monkey story, which had been read in allegory in the early 1960s,[55] the old comics published during the Cultural Revolution would be tailored to make a stab at the present. Nebiolo's testimony and the revision of Zhao's comic in 1972 both make it clear that this kind of "old comic" was in fact available during the Cultural Revolution, especially in the 1970s when, during the Anti-Confucius Campaign, all kinds of traditional heroes and villains were resurrected (if only to be criticized)[56] and a national exhibition exclusively featured images from comics in traditional Chinese styles.[57] Yet, even in the early years of the Cultural Revolution, when comic printing stopped almost completely and when the movement against the "Four Olds" was most virulent (Mittler 2010b), old comics continued to be read, exchanged, and circulated. Some would point to their destruction by Red Guards. But only a few would say that they completely disappeared during the Cultural Revolution, only to be resurrected much later, in the 1980s:

> When I was small (in the 1950s) I looked at a lot of comics. All kinds of traditional Chinese stories were among them, the *Dream of the Red Chamber*, the *Journey to the West* and the *Water Margin*, for example.... Later, I also read some revolutionary stuff. Since there was no television, we all read chained pictures. There were even performers singing the chained pictures. But our father was so poor because he was sick, so we would buy them only at very special occasions, and then I would lie on my bed and read them. During the Cultural Revolution traditional comics were not to be seen [没有 *meiyou*]. But after the Cultural Revolution, they came up again. They never became as popular as before, however; there is so much competition now. (Musician, 1942–)

In spite of even official book burnings and the maltreatment and suspension from work of many a comic artist involved with the production of old comics in the early years of the Cultural Revolution (Seifert 2008, 111), most interview reports still contained memories of reading

53. Information used in this section has been gathered mostly from the catalog of comic production since 1949, *Zhongguo lianhuanhua* 2000 (which is, of course, not complete), and a growing collection of comics currently made available online through HRA 14 Heidelberg Chinese Comics Collection. On the question of availability of reliable resources to estimate the extent of comic production and reception throughout PRC and Chinese history, see Seifert 2008, 15ff.

54. This principle has been discussed in detail with regard to the model works in Chapter 1 above. For some early examples of this practice in the comic world, see Seifert 2008, 97ff.

55. The added panel at the end of the 1972 edition, where Monkey King warns of the demons (like Lin Biao) still among us, is one example of this policy at work. See Comics *SWKSDBGJ* 1972, 117, and **ill. 6.36.**

56. *Geming jiebanren* 1974.4: 35–36, for example, describes the courageous fight of slaves against Confucius. Confucius is described as a running dog of the slaveholding class. The comic depicts several heroes who have fought against Confucius and the Confucians, "peasant rebels" like the Yellow Turbans among them.

57. This was called "The National Exhibition of Chinese-Style Comics" (全国连环画中国画展览). For the exhibition, see *Quanguo lianhuanhua Zhongguohua zhanlan* 1973.

traditional comics—more or less stealthily—almost as a matter of course even during the Cultural Revolution. Indeed, it is often the traditional comics that are mentioned first.

> We read very many chained pictures. *Romance of the Three Kingdoms, Dream of the Red Chamber*, and many others, also *Song of Youth* [青春之歌 *Qingchun zhi ge*]. Even though many of these were criticized, never mind, we still looked at them, also at some of the translations of Western things. (China Historian, 1949–)

> Comics? Yes, of course, I remember reading *Romance of the Three Kingdoms* and *Journey to the West*, for example, but also some of the revolutionary comics. . . . During the Cultural Revolution . . . there were in fact very few chained pictures that were painted in national style [国画 *guohua*], but there was a group painted by particularly famous artists—*Dream of the Red Chamber*, for example, was one of them. These artists painted chained pictures because they did not have the opportunity to paint anything else. (Intellectual, 1955–)

When comic production was taken up again after 1970, some old comics such as Zhao Hongben's were among them. Publication records suggest that the number of old comics published during the Cultural Revolution does not match that published before and after the Cultural Revolution, when they made up the majority of printed comics.[58] Nevertheless, Rae Yang's and others' memories of reading comics in the 1950s—when statistics show that production of old comics actually increased rather than decreased[59]—sound very similar to the experiences related by those who would have been comic readers in the 1960s and 70s:

> When I was a child I would read lots of books, many of them in the form of chained pictures. I read quite a bit. Stories from Western films, for example, made into comics, and then, of course, all these classical stories, such as *Romance of the Three Kingdoms*, for example. This was when I was around ten or so. . . . We always liked them. . . they were not at all political. . . . (Composer, 1937–)

> "Small people's books" in China were not only popular among children, even adults enjoyed reading them. . . . The stories were of a wide variety: some were classical, others were foreign. Many were about revolutionary heroes. Small people's books were not expensive. In those days, they cost about twenty Chinese cents a piece. . . . It was from them that I first got to know Monkey King and Piggy (Zhu Bajie) in *Journey to the West*, Zhuge Liang and his generals in *Three Kingdoms*, the 108 heroes in *Water Margin* as well as *Hamlet*. (Rae Yang 1997, 53)

In his description, Nebiolo mentions one "old comic" and two "new comics." It is clear from my interviews and from the period's many memoirs that old comics, while more scarcely produced than new ones, were in fact available and were being read all throughout the Cultural Revolution. Although some of the catalogs of comic publications from this time (which are now available) and editions of the comic journal *Lianhuanhuabao* (which resumed publication in 1973) contain very few old comics published then, it is the old comics that are being remembered, not the new comics. While we lack exact numbers of old comics available or published in the second half of the Cultural Revolution, it is obvious that traditional elements, usually condemned as "aristocratic" and "feudal," were, in fact, in print during this period. Some of them were even officially sanctioned, as

58. I therefore question *Chinesische Comics* 1976, 134. Here, Wolfgang Bauer writes about Zhao Hongben's lavishly printed comic (which also uses a slightly different, square format) and its 1964 translation and contends that it seems to be an isolated phenomenon and perhaps only produced for export: "Die Bildgeschichte Affenkönig und Knochengespenst, erschienen 1964, knüpft zwar noch eindeutig an überkommene Themen an, es ist jedoch auffallend, daß diese Bildgeschichte in ihrer Aufmachung ziemlich isoliert dasteht. Der Verdacht ist naheliegend, daß sie weitgehend nur für den Export hergestellt wurde."

59. Seifert 2008, 92.

the case of Zhao Hongben's comic shows (cf. *Zhongguo lianhuanhua* 2000). Against the tide of all the talk about the ten-year-break the Cultural Revolution made with Chinese traditional culture, this book has attempted to show that the second half of the Cultural Revolution actually reintroduced it (and sometimes with a vengeance) in art, in music, and in philosophy, too. The assumed "anti-traditionalism" of (some of the) cultural policy makers did not influence the production of comics during the Cultural Revolution as dramatically as is sometimes argued. Says one interviewee (echoing many others):

> In the 1970s, there were quite a few comics! We read them all: *Dream of the Red Chamber, Water Margin, Journey to the West*. We thought they were great! The modern ones were not so interesting [没有味儿], they were so basic. All of this is, of course, traditional Chinese culture in a way, so really, it was sustained even during the Cultural Revolution. (Housekeeper, 1950s)[60]

Next to its alleged anti-traditionalism, the Cultural Revolution is also habitually characterized by its xenophobic outlook. During this time, it is said, and rightly so, foreign heritage and knowledge were rejected. Not surprisingly, Nebiolo does not mention any "foreign comics" in his description. Yet again, our general perception does not bear out some of the evidence: in the publication catalogs, comics with foreign plots and themes appear in great numbers both in the 1950s and early 1960s (ill. 6.44), some of them with rather licentious covers (e.g., *Zhongguo lianhuanhua* 2000, vol. I, 286). In the 1980s again, everything from the White House to Romeo and Juliet, Tarzan, Spartacus, and Hitler came to play a role (ill. 6.45).

But during the Cultural Revolution, too, as these catalogs show, the number of foreign titles and themes was not as limited as one would assume. Most of the publications seem to adhere to Cultural Revolution standards and aesthetics rather closely: these "foreign comics" are obviously constructed according to the rule of Three Prominences, as the rather predictable depiction of a villain being caught by a policemen dating from a few months before the Cultural Revolution may illustrate (ill. 6.46). The two foreign partisan fighters, with their extremely strong forearms in front of the red sun (ill. 6.47), accord perfectly with Mao's guidelines. Less obviously "in style" because of its extremely "bourgeois" look is the comic "The Indian King's Diamond" of 1967, however (ill. 6.48). This "foreign comic" was published at a time when very few comics were published at all.[61] And, again, what was not published was available nevertheless, the situation being similar to that described for literature more generally by Yang Lan: "It needs to be noted that the general criticism of foreign literature in propaganda could not lead to the thorough elimination of any practical influence of individual foreign literary works on Chinese CR literature" (1998, 27). Indeed, continued reading of no-longer-published comics, both foreign and traditional in topic and style, must not be neglected if we hope to understand the Cultural Revolution as a cultural experience.

Nebiolo was focusing on what was officially available, and in the set he is provided with on his train ride, there are no "foreign comics." He does acknowledge two "new comics," however. Indeed, the dominant kind of comic during the Cultural Revolution was the "new comic," based on themes related to contemporary China. A rather coincidental collection of some 160 Cultural Revolution Comics at Heidelberg University[62] consists exclusively of such new comics with contemporary

60. Her testimony has been used in the introductory quotes to Part III.

61. More examples of foreign-themed comics published during the Cultural Revolution are found in *Zhongguo Lianhuanhua* 2000, vol. I: 1971 (276) 九号公路大捷 (Great victory on Street 9); 1972 (233) 欧人. 鲍狄埃 (Eugène Pottier); 1972 (243) 英勇杀敌 (Courageously killing the enemy); 1972.5 (252) 英雄八山班 (The hero); 1972.5 (252) 阿福 (Child hero Afu); 1972.12 (252) 琼虎 (Qionghu, the partisan fighter).

62. This collection and other private collections of comics are available through HRA 14 Heidelberg Chinese Comics Collection.

themes, and the Cultural Revolution comics available at contemporary flea markets in China, too, appear to be mostly new comics. The prevalence of new comics in production during the second half of the Cultural Revolution was a unique (and extremely short-lived) phenomenon in Chinese comic history, however—and accordingly, its significance and power over people's imaginations must be reconsidered.

For the first time since the introduction of the comic to China in the early 1900s, the "new comic" dominated the market. This was so in spite of the fact that there had been, as already mentioned, calls for new comics ever since the foundation of the PRC, and earlier, too. Such calls were necessary because, to Maoists, the long-standing attempts to develop a genuinely revolutionary and popular culture in China had quite obviously failed, again and again.

By the early 1960s, Mao was frustrated to find that most literature (not unlike opera, about which he voiced the same types of criticisms) was still "feudal" and "capitalist." In 1963, he lamented that in the arts, "very little had been achieved so far in socialist transformation . . . Isn't it absurd that many Communists are enthusiastic about promoting feudal and capitalist art, but not socialist art?" (Mao 1967, 10–11). This view was supported in official publications by "voices from the masses." One letter published in *Gongrenbao* (工人报) tells of a worker, Pan Yuchun, who, arriving home from work, finds, to his disgust, that his children are drawing pictures of "emperors, generals, prime ministers, scholars, beauties, and the like," but not of "workers, peasants, and soldiers." Why? They are copying the pictures from the comic books they own or have borrowed, all based on old stories. He concludes that as children are so interested in and keen on comic books, it should be imperative that the leaders get rid of some of the "hackneyed comic books with pictures of emperors, generals, prime ministers, scholars, or beauties." In his view, such comics could "do great harm in the education of children, having a bad influence on them." He mentions that the stalls also lend out good comics "reflecting life in the struggle for socialist construction and revolution," and that these have indeed "great educational significance as reading matter for children." But, according to him, the leadership must "check and purge according to plan all *lianhuanhua* to be published, issued, or offered for hire" in order to avoid that "unwholesome *lianhuanhua* should be allowed to poison the minds of our youth and children."[63] His orthodox and probably fictive message predates the Cultural Revolution but already speaks the same tongue.

The Cultural Revolution was the most successful attempt to counter the prevalence of old comics over new (as it was in countering the prevalence of old operas over new). This "Maoist revolution in comics," which created a flood of new comics, can and must be traced back not just to criticisms predating the Cultural Revolution by several years, but to the very beginnings of comic production in China during the late Qing and, more prominently, the May Fourth Movement. As had been shown in theater reform and in the evolution of the *Three Character Classic*, the May Fourth Movement, which itself recycled many ideas developed during the late Qing, became a crucial text machine in the making of a grammar of revolutionary culture in China, the application of which peaked during the Cultural Revolution. This connection has been neglected in scholarship on cultural production in revolutionary China so far, as David Wang argues perceptively:

> Little, however, has been discussed about the gradual *implosion* of a Chinese revolutionary poetics, which was initiated by late Qing and May Fourth literati and reached its logical (dead) end in the hands of Mao and his literary cohorts. (2004, 152)

63. The letter from *Gongrenbao* 18.5.1965 is cited in Farquhar 1999, 234. Unfortunately, I have not been able to locate the particular *Gongrenbao* she cites, as there are many newspapers of this same name.

One of the important protagonists in the May Fourth Movement, steeped in late Qing ideas and culture, was one of China's finest writers, Lu Xun. It is an almost precise version of his evaluation of comics that endures and is institutionalized after 1949 and finally thrives during the Cultural Revolution.[64] In a number of essays on comics from the 1930s (Lu 1930 and Lu 1932 a, b), he would declare comics a crucial and influential form of art for the mass market (already recognized in the West), readily loved and appreciated by the people: "The masses want them, the masses appreciate them" (大众是要看的大众是感激的) (Lu 1932a, 44). At a time when the League of Left-Wing Writers was involved in the polemics surrounding the use of mass literature for revolutionary propaganda (see Qu 1932 and Lu 1930), comic books, a form considered lowly and trivial by the elites, would thus be defended on the very basis of their popularity.

Accordingly, Lu Xun repeatedly made the point that the most important aspect of comic book illustration was its "intelligibility" to the masses (Lu 1932b, 34).[65] This point is retold in the form of a children's story by Mao Dun 茅盾 (1896–1981) written in 1936. It provides a fictional illustration of Lu Xun's theoretical demand: Big Nose, an illiterate young vagabond, spends his life scavenging for food and shelter in Shanghai's streets. When one day he finds five coppers, he spends them all at "The Street Library" reading comics on his favorite topic of women sword fighters. He loses himself in the first story, only to find that, at the climax, the pictures stop telling the story and the written text takes over. Just when a monk looks as if he would aid the woman and child fleeing from three evil monks and a Daoist, and when Big Nose thus turns the page wondering "Will he help them?," the next picture shows only the monk talking. By the last picture, the woman is shown safely home. What happened? Big Nose is extremely annoyed with the artist: "A climax, and he can't even draw it, just words to fill the gap" (Mao Dun 1936, 56). What the poor man complains about is of course part of the intrinsic aesthetic of the comic, which, as one critic put it, walks on two legs: text and image, and one cannot just leave one leg standing there and walk on with the other (Cao 1993, 26).

Why would Lu Xun and others around him preach that comics must strive to be intelligible? Because it was their aim to use the comic for didactic purposes: to teach the masses. It is for this very reason, argued Lu Xun, that one must take popular forms such as the comic very seriously (not unlike film, for example; see Lu 1932a, 39–40). And he does so by ennobling the comic as an art form. What he deals with as "comics" in his essay is not in fact the comic art appreciated by the likes of Big Nose, featuring women sword fighters, for example. It is decidedly not this type of sensationalist comic that Lu Xun is interested in.[66] His essay includes brief reviews of socially critical (satirical) images and picture stories in the tradition of Kollwitz and Masserel. It was written in response to an essay by Su Wen 苏汶 (1907–64), spokesperson for a literature *non-engagée*, published in the Shanghai magazine *Modern Times* (现代 *Xiandai*) in 1932. Su had argued that comics, as a form that would never produce a "Tolstoy or Flaubert," simply did not have a future (Su 1932). This devastating remark prompted Lu Xun to take up his pen (Lu 1932a, 39–44) and reply that even if comics would not produce a "Tolstoy or Flaubert," the genre had in fact produced great artists "like da Vinci or Michelangelo. For what else were paintings like the *Last Banquet* if not propaganda paintings, or Christian comics of the day?" (那原画却明明是宣

64. See the discussion in Seifert 2008, 68ff, which shows how influential the writings of Lu Xun and Qu Qiubai were in forming Mao's canonized *Yan'an Talks*. A shorter summary is given in Farquhar 1999, 197ff. Seifert (2008, 72ff. and again 80ff.) also elaborates on the institutional background that made it possible to supervise and strictly censor the content of chained pictures.

65. His demand is later translated into the directive to make sure that image and text form a very closely knit whole. See Seifert 2008, 76–77.

66. How this kind of genealogy, which Lu creates, influences the writing of Chinese comic history in the PRC is lucidly shown in Seifert 2008, 62–65.

传的连环画) (Lu 1932a, 40). His aim was clearly to extol the comic, which is why the bulk of his essay is a study of socially critical art, which he considers to be the best of "comic art." Lu Xun thus somewhat schizophrenically emphasizes the visual side of the comic (in an attempt to cater to the illiterate public as described in Mao Dun's story) while defending its artistic value: according to him, the comic not only can easily be "turned into art," more importantly, "it already has its rightful place in the palace of art" (连环图画不但可以成为艺术并且已经坐在艺术之宫的里面) (Lu 1932a, 44).

Only what is intelligible can be made into a potentially potent educational medium, one that would, as Lu Xun argues in a later essay, enlighten (启蒙 qimeng) the people (Lu 1932b, 34). Mao Dun, in an article on comics written in December of the same year, concludes: "If this form is used in a clever way, it will certainly become the most powerful form in mass literature and art" (Mao Dun 1932). One such element of "clever usage" was the readjustment of content according to didactic criteria. Deemphasizing the old style comic, by far the most popular form of comic literature since the 1920s (Seifert 2008, 54), was one such readjustment. Lu Xun and many of his "enlightened" contemporaries would draw a clear line between popular old comics preferred by the likes of Big Nose, such as Zhao Hongben's warrior knights comics (ill. 6.49), which they deemed harmful,[67] and the popularization of new, didactically effective comics (Farquhar 1999, 213). Although their idealized vision of new comics never really caught on in the late Republican period and early years of the PRC, this May Fourth idea would become the kernel for later restrictions and delimitations of old comics and the emphasis on new comics that would peak during the Cultural Revolution.

In the 1930s, considerations such as intelligibility and appeal to the masses still took precedence over changing the comic content from the favorite themes of the supernatural, the chivalrous warrior knights and sword fighters, and the adventurous (Hollywood) romance to more revolutionary themes. Not wanting to risk losing their audience, even May Fourth representatives would rather package their radical messages in old attire (Mao Dun 1932, 77). And perhaps this is the reason why the old comic was not immediately ruled out after 1949 nor throughout the 1950s and early 1960s either. Yes, comics were popular, confirmed an article on problems with the reform of comics in *The Literary Gazette* in 1949. Comics were read by children, women, shopkeepers, workers, thus basically by "the entire class of semi-literate people in the cities" (*WYB* 1949 November 25). The fundamental problem with these readers was, however, that they had a taste for old comics with traditional and sensationalist themes. The article thus warned of "reactionary, vulgar and pornographic picture books" as they "poisoned the minds of our people and had a particularly pernicious influence on children" (ibid.)

Yet, despite the outrage of intellectuals, nothing really changed (and the evidence from oral history bears this out). By 1952, another *Literary Gazette* article calls out for the need to publish more new comics, which nevertheless continued to fail to take over the territory of old comics. The article again reiterates how massive comic circulation is, and concludes that comics as one of the most popular art forms must be taken seriously especially by those involved in educating the masses (*WYB* 1952 January 25). Given the potential "danger" of the enormous and growing reading market for (mostly old) comics, reform of the comic book was and remained a political imperative.[68] Yet publication statistics show that the old comic still thrived throughout the 1950s and 60s. Regularly, the official media would take up the topic, referring to the formula of "wielding

67. See the discussion of sensationalist comics without didactic intent in Seifert 2008, 43–45 and 47. For reprints of a number of these comics by Zhao Hongben, see e.g. Zhao Hongben's Warrior Knights Comics (小无义) in *Lao Lianhuanhua* 1999:65.

68. See Farquhar 1999, 201–2.

through the old to create the new," as in two articles in the Shanghai daily *Wenhuibao* in the early 1960s,[69] both of which discuss the "problem" of the audience's stubborn persistence in preferring old comics and how this can (and must) be changed.

And even during the Cultural Revolution or, more precisely, between 1970 and, perhaps, 1978, when an emphasis on new comics was in fact successfully implemented, the old comics (*Sun Wukong*, for example, as well as remnants of even older old comics) never completely disappear from sight, as we have seen. A recent set of blog articles on China's comic history testifies to the fact that Zhao's Monkey comic is among those best-remembered from the Cultural Revolution: in one blog that mentions the "ten small people's books from childhood days that are hardest to forget" (童年最难忘的10种小人书), Sun Wukong comes in third. Seven of the ten most memorable comics are old comics or comic sets such as *Three Kingdoms*; only the last three in the set are new comics (8, 9, 10).[70] Quite apparently, then, chained pictures chained their readers simply by being attractive, but they never chained them in such a way as to restrict their likes and dislikes completely, not even during the Cultural Revolution.

[handwritten marginal note: weak evidence]

Monkeys, Demons, and Continuity

> The literature in images which is not read by the critics nor taken notice of by the literati has at all times been very potent and effective perhaps even more so than the literature proper. (Toepffer 1982, 9)[71]

Comics link all the important facets of Cultural Revolution Culture touched upon in this book—MaoMusic, MaoSpeak, and MaoArt—and thus repeat the same message in a new medium. The structure, the aesthetic make-up, the themes and plots of Cultural Revolution comics—much more varied and flexibly handled than generally assumed—form a continuum with what went on before and afterwards. We can find, in 1977, an entire picture story entitled *Singing "Red Is the East" Forever* (永远高唱 东方红) dealing with a returned overseas Chinese who hears the sounds of "Red Is the East" as he is about to touch Chinese ground and who is then told the story of its origins (*LHHB* 1977.9:35–37). The Foolish Old Man's story is told and retold that same year, too, for example in an item relating the good works of one party cadre in Henan who was able to move the masses by working extremely hard (*LHHB* 1977.1–2:44–45, citation in 45/no. 9). Last but not least, Mao's portrait keeps reappearing throughout the years in connection with comics and comic production.[72] Mao indeed continues to be a "poster child" as well as a major protagonist in comic publications throughout the rest of the 1970s and into the 1980s and even 1990s.[73]

Thus, it may not be surprising that 1977 saw the publication, in *Lianhuanhuabao*, of yet another version of Monkey King's fight with the demon (*LHHB* 1977.3:14–17). This time, the white-boned demon is a stand-in for the now demonized "Gang of Four" who is thrice defeated by Sun Wukong,

69. *WHB* 27 November 1961 and *WHB* 8 April 1962.

70. DACHS 2009 Sun Wukong San Da Baigujing, Remembering Old Comics Blog.

71. The German original reads: "Die Literatur in Bildern, mit der sich die Kritik nicht beschäftigt und von der die Gelehrten wenig ahnen, (ist) in allen Epochen sehr wirkungsvoll, vielleicht sogar wirkungsvoller als die eigentliche Literatur. "

72. E.g., *LHHB* 1978.9:9–16; even though this comic tells the story of Zhou Enlai caring so much for an old peasant and the peasant admiring Zhou Enlai, it has him revere Mao's portrait (while one of Zhou is placed below); 1978.9:10/no. 7 and 1977.1–2:45/no. 9. See also *LHHB* 1978.12:0–2, 3–9, 10, and 11; *LHHB* 1977.6:9–12; 1976.2:13/no. 14–15; and *LHHB* 1975.2:24, 1975.8:13/no. 22 & 14/no. 26.

73. See, e.g., *LHHB* 1977.1–2; 1977.3; 1977.6; 1977.7; 1977.9, 1977.12; 1978.1; 1978.10; 1978.12 (which includes a set of stories from Mao's early years, e.g., *LHHB* 1978.12:0–2; 1978.12:3–9; 1978.12:10 and 1978.12:11). By the 1990s Mao has still not completely disappeared, although he appears much less exclusively than before, e.g., *LHHB* 1991.9.

and this time Monkey King comes to symbolize not Mao but the revolutionary masses (亿万革命人民), as the preface explains. It is for this reason that the circle Sun draws does not throw radiance, either (**ill. 6.50**). In its use of a reduced ornamental style, this comic is artistically rather different from both the refined Zhao Hongben and the cruder Red Guard versions discussed above. It is different, too, in terms of its practice of Three Prominences. Ironically, this post–Cultural Revolution version of the comic accords much better with the artistic directives associated with Jiang Qing and the so-called "Gang of Four" than either of the two examples published during the Cultural Revolution and discussed above.

The new version does allow Zhu Bajie's nipples and navel to be seen, but apart from that, it goes along with all the rules of Three Prominences raised as important in our description of the Cultural Revolution straightjacket for comics. It thus surpasses Zhao's revised 1972 version in its "orthodoxy:" the demon, for example, is much more clearly marked than in any of the earlier versions. When she first appears, in the form of a young maiden, her real nature is immediately made explicit in a shadow above her (something that happens only at the very end of the Zhao Hongben comic, when Xuanzang is brought to discern Truth from Fiction).[74] When the demon is defeated for the first time in this new version, her real format appears again as she disappears through a wisp (**ill. 6.51**). Thus, her hypocritical nature is unmasked, twice, at the very first instance.

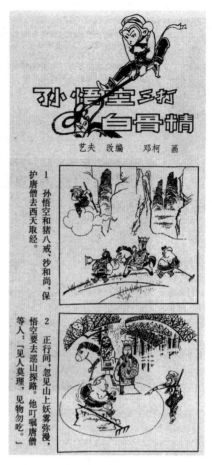

ill. 6.50 After the Cultural Revolution: Monkey's circle without radiance (*LHHB* 1977.3:14/1–2).

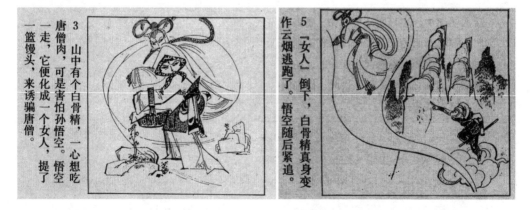

ill. 6.51 After the Cultural Revolution: The Demon unmasked (*LHHB* 1977.3:14/3 and 5).

74. See Comics *SWKSDBGJ* 1962, 94, 96, 99 corresponding to ibid., 1972, 99, 101, 104.

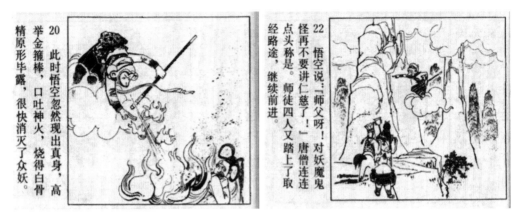

ill. 6.53 Lucid Monkey pointing the Way (*LHHB* 1977.3:16/20 and 22).

Monkey King, on the other hand, is the dominant and victorious presence in this version of the comic; commanding in all his appearances, he is either showing the way or reigning in battle. He appears in 15 of 22 total pictures and is shown as victorious in battle in 7 out of these 15 (ill. 6.52). All images show him as clearly superior to his comrades, not only in fighting but also in deliberating and understanding the gravity of the situation.

Five times he is shown pointing the way or pointing toward Truth, (illuminating the real nature of the demon, e.g., in **ill. 6.53**).[75]

Thus, Monkey King becomes the true hero of the comic, while the white-boned demon in all her incarnations becomes a clearly marked negative character with fierce and crooked features both in her real shape and in her different disguises (**ill. 6.54**).[76] Although the demon appears in an equal number of images as the hero (15/22), her position is clearly inferior. Indeed, faced with Monkey King, the demon always loses out. She receives three full images while Sun has four;[77] more importantly, Sun is always depicted in dominant position, above or central to the image, much different from the demon.[78] The fact that Tang Seng is at first not to be convinced that it was righteous to kill, that he even believes in the false message sent off by none other than the demon (not Buddha) and, accordingly, sends Sun away only to be attacked again, becomes even more striking in its short-sightedness, as Sun Wukong is

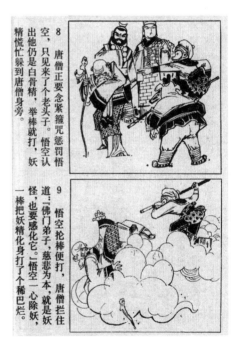

ill. 6.54 Ugly Demons (LHHB 1977.3:15/8 and 9).

75. See also *LHHB* 1977.3:14ff./nos. 2, 5, 8, 20.
76. For her real shape, see e.g., *LHHB* 1977.3:14ff./nos. 3, 5, 12, 18, 19. For her disguises, see *LHHB* 1977.3:14ff./no. 12. See also *LHHB* 1977.3:14ff./nos. 3, 4, 6, 8, 9.
77. For images of the demon, see *LHHB* 1977.3:14ff./nos. 3, 12, 18. For images of Monkey King, see *LHHB* 1977.3:14ff./nos. 4, 7, 11, 17.
78. E.g., *LHHB* 1977.3:14ff./nos. 1, 2, 9, 15, 16, 20, 22.

now being depicted as such an unmistakably superior hero. Only at the very end, when Sun comes to his rescue, is Tang Seng finally brought to his senses.

For quite some time after the Cultural Revolution, the Chinese comic in the form of "small people's books" continued to be popular. And although it stayed rather in line with Cultural Revolution aesthetics throughout the late 1970s,[79] it soon became ever more diversified both in terms of aesthetic appeal and in terms of subject matter (with, by the late 1980s, explicit love and sex scenes, sometimes almost pornographic, entering the field, for example).[80] It continues to play out many of the same features that also characterized it before and during the Cultural Revolution. The comic book format of image plus text sustains, but style (modernist, oil, gouache, classical painting varieties) and image size begin to vary considerably. Some of the more recent comics use inset images within the "panels" to raise the level of psychological depth or to allow for several points of view at the same time.[81] Quite consistently, the "small people's books" refrain from using speech bubbles (and thus resist asymmetrically conceived claims for the bubble's universality).[82]

The 1980s saw the appearance of an increasing number of traditional stories as well as translated comics: in a 1988 edition of *Lianhuanhuabao*, for example, a French, a Turkish, and a Russian comic can be found next to many Chinese productions (*LHHB* 1988, 2). At the same time, didacticism continued to play a role.[83] Be it with lessons about not deferring marriage too long (*LHHB* 1978.1:34–35) or about not neglecting scholarly learning (*LHHB* 1978.2:37)—something dismissed a few years earlier during the Anti-Confucius Campaign—some of these comics continue to serve Party politics. One example that appears in a short *manhua*-style (漫画) comic, for example, tells the story of a father admonishing his son to catch up on his school work in order to make a contribution to society. His son, however, does not feel like studying: "I can always go to the countryside" (怕什么? 文化学不好, 下农村), he retorts, but is cut short by his father who is seen, in the next image, taking the stubborn boy to the countryside to show him how it has changed: all the peasants present their certificates, indeed, they are better educated than he is. The final image, which shows the boy converted, depicts him studying under a plaque on the wall that reads: "We must get rid of the pernicious influences of the Gang of Four" (彻底肃清四人帮 的流毒) (*LHHB* 1978.2:37).

Especially the years immediately following the end of the Cultural Revolution contain an artistic and ideological rhetoric well familiar from the years before. A comic on Iron Man Wang Jinxi ends with the familiar words: "We are determined to follow Chairman Hua and his words: We have to uphold the Red Banner of Daqing which has first been noted by Chairman Mao and take Iron Man Wang Jinxi as our model, never fear hardship and suffering as we take on the Red Banner of Daqing and walk on until we have reached Communism" (Comics *"Tieren" Wang Jinxi* 1977, 146).

Such heavily political didacticism remains felt in the "chained pictures" or "small people's books" published throughout the late 1970s and into the 1980s, too.[84] Heroes and villains continue

79. It is for this reason that I would agree with a periodization of strong Cultural Revolution influences until at least 1978, as is suggested in Shen and Shen 2002. For a discussion of different approaches to periodization, see Seifert (2008, 103–5 and 125), who argues for a periodization 1964–76. I would extend this to at least 1964–78. On periodization, see the Conclusion.

80. See e.g. *LHHB* 1991.10:15–24, esp. 18, a translated American comic, and the Belgian comic in *LHHB* 1988.4:28–35, esp. 31.

81. E.g. *LHHB* 1988.5:3–10; *LHHB* 1988.10:25–26. Cf. examples in Seifert 2008, 141.

82. For this asymmetrically conceived view, see Holländer 2002, 123: "Die Universalität der multifunktionalen Blase scheint das bestimmende Merkmal des Comics zu sein."

83. Breitkreuz 1994, 22 mentions the founding of a number of institutions overseeing the production of comics.

84. Seifert 2008, 144–45 gives some blatant examples from 1989 and the following years.

to be clearly discernible. Some of their personnel has remained intact (with Mao, Marx, and Engels as evergreen heroes, e.g., *LHHB* 1978.5:17–20), although some has significantly changed. New heroes of a different type, like the mathematician Chen Jingrun 陈景润 (1933–96) who is depicted in exactly the way that Cultural Revolution heroes were, are the subject of three comics in *Lianhuanhuabao* (*LHHB* 1978.3:1–9). Each of these ends in an apotheosis describing the feelings of happiness that come after the "smashing" of the so-called "Gang of Four." The "Gang," in turn, appears as veritable villains, not just in the form of the white-boned demon discussed above but as all kinds of other metaphorical and historical figures. One comic imitating paper puppet theater, for example, features them as the Four Hegemons (四霸 *siba*) and pulls out all possible tools from the toolkit of Cultural Revolution art: pathetic fallacy when doom is announced in the thunderstorm, and an apotheosis in the red sun when, in the final scene, the glorious and victorious masses march under their superior leaders toward ever greater happiness (*LHHB* 1978.5:10–11).

But it is not didacticism alone that reigns high in the production of comics after the Cultural Revolution. At the end of its 1988 volume, *Lianhuanhuabao* published a readers' survey, complete with return envelope. It hoped to know whether what it had offered readers that year in terms of materials, ideas, and artistic styles suited their tastes. It also asked for suggestions and requests and begged readers to disclose their reasons for reading comics: whether they do so for love of art (美术爱好), in order to increase their knowledge (增长知识), or simply for entertainment (娱乐消遣) (*LHHB* 1988.12:51). The questionnaire was probably responding to the fact that chained pictures had been in decline since the 1980s, the fusion of the two largest comic magazines *Lianhuanhuabao* (连环画报) and *Zhongguo lianhuanhua* (中国连环画) being one sign of this trend.[85] While it is possible, in early 2009, to find on the sales tables in Chinese bookstores large-size reprints of comics such as *On the Docks* and other such famous politicized "small people's books" from the Cultural Revolution, these appear to be catering to a market different than in earlier years (cf. Seifert 2008, 146–48). One interviewee remarks:

> Now the situation is very different: there are Japanese manga [漫画 *manhua*] and foreign-style cartoons [卡通 *katong*]. *Katong* have only in the last few years become so popular. The children now have a much better situation than we did; they have all kinds of different things to choose from. (Journalist, 1946–)

The "small people's book" was, for a long time, an element of Chinese popular culture that could not be overlooked. The features it shares with comics of different styles that have come to dominate the Chinese market recently are prevalent in popular culture generally, too. A certain predictability is partly to account for this, and, accordingly, some would contend that it was neither political content nor artistic triteness and boredom that caused the decline of these "small people's books." If so, they should have declined during the Cultural Revolution, but they did not. Indeed, this particular form of comic, which had assimilated very little from the comic world surrounding it since the 1910s and which even throughout the 1980s stayed largely resistant to alternative international models, saw a veritable revival during the second half of the Cultural Revolution (Seifert 2008, 124). On the other hand, one can observe that the ensuing decline of these "small people's books" in the 1980s went along with an increasing sophistication of text selection and artistic structure,[86] as well as a change in the media world surrounding it. The alternative worlds of *manga* and foreign cartoons, which introduced splash panels, speech bubbles, and other such

85. An elaborate survey of the literature discussing the decline of "small people's books" especially is given in Seifert 2008, 137.

86. Seifert 2008, 143–45.

techniques to an audience accustomed to increasingly more multimedia vistas and sights, have lessened the appeal of "small people's books" for a younger part of the population; those in their 40s and 50s remain nostalgic for the little books and still groom growing collections.[87]

Quite accordingly, Sun Wukong's fight against the white-boned demon, which remains a hit on the comic book markets[88] and appeared recently in the Japanese form of Songoku-*manga*, too, continues to be found in many different media apart from "small people's books" in China: on MTV, as puppet theatre, rap-dance, and large-scale dance drama.[89] Sun Wukong's home can be visited on Huaguoshan (花果山) in Jiangsu, where visitors may find a huge statue of him fighting the white-boned demon there.[90]

Recognized both by the (propagandist) producer and by the audience, the power of the comic is still unbroken. The Monkey King's story, yet another which is "known to everyone" (家喻户晓) according to critical reviews of operatic and other performances,[91] is praised for establishing a worthy model.[92] Many an audience member still wants to "eradicate ghosts" and "to be like Sun Wukong with his ability to distinguish ghosts and humans, and his broad mind, but not like Tang Seng who does not even know how to distinguish between ghosts and humans and who reverses black and white" (我喜欢孙悟空，我们应该要向孙悟空学习，学习他人妖分明，胸怀宽广，不要学唐僧人妖不分，黑白颠倒，对于妖怪我们必须见恶必除). Quite clearly, they speak the orthodox language of the ideologues, which could have passed muster even during the Cultural Revolution. These reactions also show that the aspiration expressed at the very beginning of this chapter has indeed come true: "Small people's books" did indeed plant "the seeds for ideals and knowledge in the hearts and souls of these youngsters," as Jiang Weipu put it, and they continue to transmit "a kind of moral feeling" (Composer 1937–). Yet, although audiences may speak in a language reminiscent of the ideologues, they do not seem to feel that they have been chained by the chained pictures and their multimedia siblings. If their reactions are genuine, this also tells us something more about the persuasiveness of Cultural Revolution Culture, its precedents as well as its descendants.

87. Seifert 2008, 124.

88. A short survey of Internet bookstores yields a good two dozen new versions of the comic published after 1976. For the importance and the long life of the story in comic form see Seifert 2008, 99. See also King and Walls 2010, 16.

89. See DACHS 2009 Sun Wukong San Da Baigujing, MTV 2009; DACHS 2009 Sun Wukong San Da Baigujing, Puppet Theater 2009; DACHS 2009 Sun Wukong San da Baigujing, RAP; DACHS 2009 Sun Wukong San Da Baigujing, Dance Drama 2009.

90. DACHS Sun Wukong San Da Baigujing, Huaguoshan.

91. See e.g., DACHS 2009 Sun Wukong San Da Baigujing, Puppet Theater 2009; DACHS 2009 Sun Wukong San Da Baigujing, Peking Opera.

92. A number of blogs testify to this; see e.g. DACHS 2009 Sun Wukong San Da Baigujing, Blog 2007.

CONCLUSION

HANDS: TOUCH

★★★★★

How should I talk of the "culture" of the Cultural Revolution: it did not have any [没有文化]. (Huang Miaozi, 1913–)

To consider the Cultural Revolution as does the 1981 Resolution, as a cultural desert, is a view that should be rejected from my own point of view: it is not true. This definition is ideological and very simplified. We all don't think about it this way now. (Ethnomusicologist, 1940–)

We really felt very unhappy [不满足 *bu manzu*] with the restrictions of culture during the Cultural Revolution. (Journalist, 1946–)

Restrictions? Not really.... Even as a peasant, I could have bought the *200 Famous Foreign Songs* [外国名歌二百首]; I would have owned a radio so that I could hear all kinds of traditional theatrical forms, like dramatic ballads [弹词 *tanci*], Shanghai Opera [沪剧 *huju*], Cantonese opera [粤剧 *yueju*]. After the Cultural Revolution, on the other hand, there was no such thing anymore ... the *Rice Sprout Song* [秧歌 *yangge*] and all that, it is all gone. All these different cultures are gone. Mine was not quite like the experience of other intellectuals, but they, too, would feel that culture now is rather more bland and monotonous [单调 *dandiao*] than before. (Musicologist, 1950s–)

The Cultural Revolution certainly destroyed Chinese culture. Very little of the traditional arts were preserved, only those few things that Jiang Qing happened to like. (Editor, 1930s–)

He: There are many different experiences, it depended on your age, for example. We were quite naïve and young. She: My older sister is a good example. Without the Cultural Revolution, she would have gone to university and been a doctor, but then the Cultural Revolution interrupted her schooling and she was sent down to the countryside and ended up a teacher. For her generation the Cultural Revolution was not a good experience. He: But on the other hand, even some of the worst things may have had good effect. She: There were victims, though. But as for people from my generation, I can say this for myself, to be sure, for me it was not that bad, I basically studied the arts. But older people who already had a family, they had a very hard time: so much work. They could just live from one day to the next. (Artist Couple; He, 1954–, She, 1959–)

Especially those old opera friends of my father's thought that these revolutionary operas were no good. They only served the revolution. (Journalist, 1946–)

At first, it appears that these years were a kind of blank [空白时期], but if we look back, there was something quite valuable in them, too.... In 1981, for example, I wrote a song for *pipa*. I had to rewrite it, and making use of my knowledge of mountain songs [山歌], I did. It is true that during the Cultural Revolution, one could actually learn quite a bit. Especially for those doing research on folk song and folk music, it was really very good. Every one of them had their musical outlook, and their universe of music broadened. (Ethnomusicologist, 1940–)

For me, these years were really lost and wasted [荒废 *huangfei*]. (Photographer, 1960–)

In order to live, the human being needs art and culture, just like you need bread to eat. During the Cultural Revolution, there was no real choice. You really had to find your own ways of getting things when you were hungry, and you did not always find something really tasty to eat. Whatever was offered, you would take. When you are really hungry, everything tastes good anyway. This is how we saw art and culture ... If you compare it to before and after the Cultural Revolution, you realize there was much less abundance [丰富] during the Cultural Revolution. On the other hand, if you don't have this kind of experience, your individual experience may actually be quite rich: ... it is like my finding Kafka during the Cultural Revolution: if I had not had the need to look for these things, I may not have found them. (Language Instructor, mid-1950s–)

The Cultural Revolution: Years of bitter happiness [苦乐年华 *kule nianhua*]? (Anonymous Sent-Down Youth, cited in Davies 2007, 171)

★★★★★

CONCLUSION

CULTURAL REVOLUTION CULTURE AND POPULAR CULTURE: THEORIZING PRACTICE AND EXPERIENCE

> My biggest mistake in trying to serve politics [为政治服务] was in rewriting the song "Socialism is good" [社会主义好]. I composed a variation on that [plays it on the piano, it is quite a parody]. They hated me for it! Those who are responsible for politics should do politics. But musicians are not politicians, so they cannot be responsible for politics either. (Composer, 1937–)

The Introduction to this book relayed a 1940s joke about Nazi Propaganda Minister Goebbels that played on the manipulative, insincere, and evil qualities of propaganda. In his study of early Chinese revolutionary art, David Holm relates to this idea and writes:

> The general feeling is of course that propaganda is lies—in the words of Dr. Goebbels—and that therefore a study of propaganda will yield nothing of value except perhaps a moral lesson about the wickedness of a totalitarian regime. I would suggest that, on the contrary, propaganda is interesting— and revealing—precisely because it is an attempt to manipulate and persuade. (1984, 5)

Although cultural production during the Cultural Revolution was, theoretically speaking, an exceptionally politicized art form, in practice and experience it was not only denigrated and ignored, abhorred and feared, but liked and enjoyed as well. Much of it remains popular and relevant even today. In the Introduction, I put forth a number of tentative answers why this would be so. These were probed throughout the book. This Conclusion will attempt to touch ground again, offering, as did the Introduction, much evidence from oral history, from personal experiences, as well as some hands-on thoughts on how we could begin to theorize the experience of Cultural Revolution Culture, dealing with questions of its grammar and rhetoric, of space and of time.

Propaganda's Grammar

Clad in red clothes,
(s)he stood on top of the cliff,
pointed in the right direction
and sang a song of praise to the Red Sun.
(Poem about the model works, from a collection of Cultural Revolution jokes)[1]

When Wang Ban asks himself uneasily how it came to be that "politics can be made to look and feel like art" and how politics can "take on an intensity, passion, pleasure, and pain of the individual's lived experience" (Wang 1997, 15), his question is based on the implicit assumption that politics

1. *Wenge xiaoliao ji* 1988, 147. The poem reads: 身穿红衣裳，站在高坡上，挥手指方向，歌颂红太阳。

and art, or propaganda and art, are at antipodes, never to be reconciled. When the composer quoted above advocates a separation between (or the autonomy of) art and politics, he, too, agrees with this basic assumption. In my attempt to see with fresh eyes what I have called "Cultural Revolution Culture"—a phenomenon that has turned out to be much more expansive, both in space and in time, and could more aptly be called "revolutionary" or "Socialist" rather than just "Cultural Revolution" culture—I have attempted to avoid commonplace distinctions between high and "pure" art and low and "dirty" politics[2] but focused instead on the dynamics between these poles, which is where the experience of Cultural Revolution Culture seems to be played out.

Although Cultural Revolution Culture is indeed very political and extremely predictable, as hinted at in the poem above, and although, as one contemporary put it, the reform of Chinese opera and of other Chinese artistic forms during the Cultural Revolution had only one purpose— "We all were supposed to love Mao!" (Musician, 1930s–)—it may be important to consider that propaganda as art is not an invention of the Chinese Communist Party, Mao, or the Cultural Revolution, but a long-term Chinese reality. Richard Kraus puts this succinctly:

> China's arts have long existed in greater intimacy with the state than is typical in the West. Imperial grandeur and Maoist revolution both presumed that art would serve the state; while few artists attained positions of power, emperors, ministers, and Communist officials took care to present themselves as serious poets, calligraphers, and connoisseurs of painting. Art was twinned with power in a political culture in which claims to authority could be validated by association with beauty or undermined by poor aesthetic achievement. Morality was understood to be revealed through beauty, and Chinese politicians accordingly enfolded themselves in the habiliments of culture. In imperial times, politics and society were loosely enough ordered that this tradition allowed a great deal of slack for much cultural life to thrive at some remove from the state. The Chinese revolution's modernizing project reorganized society more tightly, so that the traditional linkage of art and morality became an intense politicization of the arts. After 1949 it became increasingly difficult for artists to stand back from the Party's cultural policies. The Cultural Revolution (1966–76) was the climax of this trend. (2004, vii–viii)

Political art, then, or propaganda, may have been a standard more easily accepted in China than elsewhere, which may have tilled the ground to make way for the success of Cultural Revolution Culture. Even more importantly, however, it may have been the very language of Cultural Revolution propaganda, its style and grammar, that ensured its longevity in spite of all the drastic political turns that China underwent before and after this period. Within Cultural Revolution Culture, all the typical elements outlined in an *ABC of Propaganda* are present:[3] the *name-calling*— for example, "revisionist," "capitalist," "slave-holder," "landlord," "aristocrat"—to stimulate hate and fear and at the same time to create "empty signifiers" into which people could project whatever they wished; the *glittering generalities* that only the sun—Chairman Mao and his representatives— know how to save the people, only they know who is truthful, what is freedom, where is justice; the *transfer* of authority, sanction, and prestige of something generally respected and revered—such as the canonized words of the sages or the Confucian Analects, or belief in the kitchen god—onto something the propagandist would have us accept—Mao Zedong Thought and the *Little Red Book*, or the Chairman's portrait, for example.[4] And there is *testimonial* to bolster an idea or plan by

2. See Wang 1997, 15–16.

3. The propaganda characteristics mentioned in the following lines are enumerated in a 1930s handbook for propaganda discussed in Sproule 1997, 135.

4. See descriptions in Wang 1997, 215, who also notes how the Cultural Revolution perpetuated many traditional ritual forms, an aspect also discussed in ter Haar 2002 and Landsberger 2002.

using a statement from some recognizable figure—by use of heroes who themselves agree with heroes who in turn listen to the main hero: Mao Zedong. Perhaps most importantly, ordinary, *plain folks,* by reinscribing those very heroes—Yang Zirong, Jiao Yulu, the Foolish Old Man, Hong Changqing, and even Mao Zedong—wise and good as they are, as ordinary *"wie Du und ich"* in order to court the public by appearing one *with* them by being one *of* them.

The use of *hyperbole* (depicting paradisic, dreamlike life "on a higher plane") and *redundancy* (elements of serialism, intertextuality, and repetition)—the cross-referential, parodic nature (practicing "repetition with a difference" by making "classical" patterns recur in ever new forms) of this multimedia art[5] in which the Foolish Old Man might appear in many a *Three Character Classic,* Mao's portrait in comics and operas, Mao songs and quotations from his writings in the model works, as well as *Three Character Classics* or model stories, while Beijing Opera gestures and masks are used in ballet and painting, symphonic elements in opera and so on—as well as *multiplication* (the appearance of a propageme in various materialities, which makes it possible for it to be adapted to almost all the routines of daily life, even if they are in constant flux),[6] all of which leads to *overdetermination,* where everything has to do with very few essential contents and one of these very essential contents is Mao, the sun and savior, himself. Last but not least, the constant acts of *embodiment*—of performing, singing, painting, writing, living the propaganda message, of "acting revolutionary opera and becoming revolutionary people" as Chen Xiaomei puts it (Chen 2002, 248), i.e., the agency involved in the making as well as the receiving of this propaganda art. All of these create a mix whose power lay not so much in its educational or ideological message as in its Durkheimian "mythical atmosphere" and, accompanying this, its "affective aura," which was, accordingly, permeating various fixed forms and prescribed activities—or "rituals."[7]

Ritual may be mesmerizing and hypnotic and thus lead to conviction by consent. According to one contemporary, "Revolutionary ritualization made life an interminable round of talking, performing, singing, chanting, criticizing. In this repetitive beat, time seemed to cease to exist, for every moment was the same as the next; every act was identical to another" (Wang 1997, 218). Thus, he continued to reflect, a person's "emotion is capable of being modified and re-educated, one's aesthetic taste and unconscious cravings can be trained, altered, and then pushed in the service of the authoritarian order" (ibid., 217). One artist couple supported this observation:

> First, it was not a question of whether you liked the propaganda or not, you just *had* to listen. But then, really, we also did not feel that opposed [反感 *fan'gan*] to it. The propaganda was actually quite successful; it was good for the majority of the people [老百姓]. Of course, the intellectuals did not like it that much, but the people generally liked it. I guess, we were very naïve [盲目 *mangmu*] then. We actually thought that to have a picture of Mao at home was quite nice. Only because we think differently now, we should not discredit [怀疑 *huaiyi*] what we did then. We quite believed in Mao then. He was like a god for us, and we also paid reverence to him in the morning and in the evening. That was what it was like. We would wish him a long, long life even before we ate [万寿无疆，毛主席，万岁，万岁，万万岁]. Not every day, perhaps, but in school, before every class we would do that. We would also sing [*they get up, singing and dancing*] "Our dearest Chairman Mao is the Sun in our hearts" [亲爱的毛主席是我们心中的红太阳]. We would sing and dance this and then start class. (Artist Couple; She, 1959–, He, 1954–)

5. Wang 2004 studies this in other (literary) works of revolutionary art, not only from the Cultural Revolution.
6. Cf. Wang 2004, 178 and Winter 1997, 81.
7. See Durkheim 1926; Wang 1997, 216.

[handwritten marginalia at top: Giddens, security, Weber?.]

By means of its grammar and style, then, propaganda is capable of intensifying existing trends of choice, to sharpen and focus them and, above all, to lead them to *action*. This is especially so if propaganda is able to fill a *need* (Qualter 1985, 88). Some, who had been cast out of the stabilizing groups such as family, home, or religious faith during the Cultural Revolution, as they or their family members were sent down to the countryside or made to labor in the factories, were "thrown back" upon their own resources and experienced isolation, loneliness, and ineffectuality. In this situation, propaganda gave them "a *raison d'être*, personal involvement and participation in important events, an outlet and excuse for … doubtful impulses, righteousness." Indeed, the propagandist depends on the "intense collaboration of the propagandee" who must become a believer (Kellen 1965, n.p.). Here, social setting is extremely important. Individuals acquire many of their attitudes and values ready-made from the groups to which they feel they belong. This narrows the effective choices they make and their willingness to believe:

> We actually were much more impressed by the propaganda than the generation before us. Those who had experienced the 1950s had their difficulties. They had experienced hunger and all that. But now society had already become very stable. We were quite happy, and indeed, the Communist Party seemed really great to us. They gave us a healthy and simple life. The life of the poor had been improved. It may have been similar to the early Nazi period. There was some repression, but that was not the main thing! What's more, we really thought the things they said were bad were in fact bad. (Writer, 1958–)

It is propaganda's standard desire to persuade through symbolic communication, and its grammar and style are adapted accordingly (Qualter 1985, 120–24). Yet, it does not always succeed. A propaganda message "may be ignored, discounted, misinterpreted, quickly forgotten, or simply absorbed into the existing attitude set." If the "recipient modifies it by personal interpretation … the understanding and effect may not be that intended by the sender" (ibid., 81). Not everyone followed the rituals enacted in Cultural Revolution propaganda. In spite of its abundant use of persuasive rhetoric, generational as well as individual differences influenced people's willingness to accept propaganda' message:

> My father did not like the model works, and he would criticize Jiang Qing and her reforms at home. If this had been heard by the neighbors, it would have been very dangerous, so I always asked him to speak more softly. I myself felt that these revolutionary operas were in fact a sign of progress [进步 *jinbu*], so I tried to moderate him. There were some children who accused their parents. I did not do that. My father was very outspoken, but he would not say anything in public. (Journalist, 1946–)

> As for literature, this emphasis on class struggle, all the way into the individual psyche of the protagonists, makes for the fact that these characters are all the same and that it is quite monotonous. It seemed that if you thought something was interesting, it was sure to be criticized. I really like reading novels, but not these … During the Cultural Revolution, there was nothing worth looking at. In terms of music and art, Cultural Revolution propaganda was quite impressive, but not in literature. (Musicologist, 1950s–)

From these testimonies, and from the evidence presented throughout this book, we must acquiesce that "The impact and power of propaganda to produce change or maintain stability, depends less upon the professional skills of the propagandist and more on the psychological state of the audience" (Qualter 1985, 87). Propaganda is an interactive process, with response dependent upon the background of each individual. Both the audience as homogenous mass and the "omnipotent propagandist" are fictional characters in a story with unpredictable outcomes (ibid., 87).

[handwritten marginalia in left margin: But does the propaganda still need evidence.]

Propaganda's Space

> During the Cultural Revolution, everything was controlled from above. As a student of the journalism school, I had to learn according to Mao's teaching methods; there was no question of being willing to follow or not, you just *had* to follow. (Journalist, 1946–)

The idea that the China of the Cultural Revolution was the realm of the "omnipotent propagandist," a space completely occupied by propaganda, is paradoxical, because the onset of the Cultural Revolution brought the dissolution of the old Central Propaganda Department.[8] Many of the art forms that spontaneously erupted, and later became emblematic of the cultural experience of the Cultural Revolution (perpetuating what was standard in official propaganda and sometimes also more), such as loyalty dances and quotation gymnastics, Red Guard newspapers and (comic) art, alike, were criticized and suppressed by the center.[9] Propaganda art, then, can be read both as top-down manipulation and as an opportunity for agency from below, and again, this agency was not always completely "unexpected" or "accidental": at certain, often very short-lived, historical junctures (the Red Guard movement being one example), it was in fact part of the top-down intentions, too. Complicity between "the Party" and "the People" (neither of which can be considered monolithic) is in fact much more commonplace than one would assume, and the unfolding contradictions and their resolutions during and after the Cultural Revolution also proved the Party's very flexibility.[10]

On the other hand, the participatory nature of Communist propaganda accommodates the inevitable dilution of state-initiated narratives (Schrift 2001, 7). Put differently, this also means that the Party's ability to control is far less absolute than is often assumed, and at no time is this more (and less) so than during the Cultural Revolution. The mobilizing, inspirational, energizing, and populist character of mass politics during the Cultural Revolution meant that we have many individualized and localized experiences of the spread and reach of Cultural Revolution official and unofficial propaganda. One woman, originally from Beijing, reported that when she was sent to the countryside in 1969, she had never seen a loyalty dance before: "In the countryside, I saw it for the first time, but did not know what it was. Some things really did not happen in Beijing" (Housewife, 1950s–). Another maintained that much of the official mass culture, even the model works, never reached the part of the countryside where she was staying: "That rich cultural fabric, Cultural Revolution Culture, was in fact quite elitist, an urban, city culture." She also noted that, in the Northeast, where she was living then, people had other things to worry about: "They were occupied with much more basic things then. All the babies died in the first year I was there, for example, because of malnutrition" (University Professor, mid-1950s–). The army, on the other hand, appears to have been a stronghold for all kinds of artistic experiences, not just official propaganda:

> We watched movies all the time, many of them such as *Daughter of the Party* [党的女儿], *Red Children* [红孩子], *Heroic Sons and Daughters* [英雄儿女], *Landmine War* [地雷战], from before the Cultural Revolution. We would watch them all the time. We also watched a lot of Russian films, not just *Lenin in 1918*. Watching films of almost any kind was really no problem for us. (Librarian, mid-1950s–)

8. Leese 2006, 56.

9. Leese 2006 gives many examples of such criticism from the center, which ended up being more or less ineffectual, however. This is one more sign of the anarchy that the cultural experience of the Cultural Revolution was in very practical terms.

10. It is for another book to discuss in greater detail Red Guard Art and Red Guard Media as those art forms that most clearly demonstrate the production of "propaganda art" as a self-organized, self-initiated grassroots activity. This study has not been able to do justice to this quest.

Among the relatively small sample of people interviewed for this book, most of whom came from urban areas (while many of them spent long sojourns in the countryside), memories of Cultural Revolution propaganda vary substantially with age, class, and locality. Their experiences illustrate the importance of delving deeper into the multiple Cultural Revolutions that took place in multiple spaces, geographically as well as sociologically. Most importantly, it is time to let the peasants and the workers speak for themselves. Although it is something this book has not been able to do, their voices—so often muted—have been heard in Han Dongping's pioneering work (Han 2008) and in some of the essays collected in *The Chinese Cultural Revolution as History* (2006) and *Re-Envisioning the Chinese Revolution* (2007).[11] We need to listen more closely to these multiple voices in order better to explain some of the repercussions of Cultural Revolution propaganda in China's cultural production today: is it the power of revolutionary propaganda that has taken hold of peasants who treasure fond memories of Mao and his times?

Their affection for Mao often appears rooted in elements that we consider integral to the official and unofficial propaganda messages of the Cultural Revolution, for example anti-Japanese resistance and the defeat of the Nationalists, both of which are immediately associated with Mao's leadership and appear as dominant themes within many of the model artistic works discussed here (Pickowicz 2007, 46). In the 2002 Liaoyang protests involving some 30,000 workers from as many as twenty factories, workers marched down the streets carrying a huge portrait of Mao taken from one of the worker's homes. They explained that by taking the Mao portrait (which was eventually—and somewhat paradoxically—confiscated by police), they wanted to illustrate the contrast they felt between the past and the present. Their collective memories of the Maoist era, clearly infused with propagemes from official propaganda, were at the heart of their demands for a standard of justice now lost in reform (Lee 2007, 160): "In those days, we were paid only 20 yuan, but we felt secure because we were never owed any wages. That's the superiority of socialism" (ibid., 158–59).

These workers' responses were not that singular, however: Maoist propaganda was not totalistic and universalized enough (can propaganda ever be?) to ensure that all workers throughout China "project the Maoist period as fairer to the working class than the present day" (Unger and Chan 2007, 133). Indeed, some argue the opposite, saying that they feel "entitled today to generous treatment by enterprises precisely because they had materially sacrificed and been deprived during the decades under Mao"; it is not a general rule that one can find a portrait or other memento of Mao hanging in a worker's home (ibid.).

The idea, then, that the China of the Cultural Revolution was a space of total propaganda, the propagandist omnipotent, must appear paradoxical in view of the different memories it produced. It is also paradoxical in view of the astounding, yet deeply under-researched, evidence of alternative spaces (and thus experiences) of cultural life during the Cultural Revolution—those that took place behind closed doors and in undisclosed niches underground. A musicologist and a playwright, both in their teenage years during the Cultural Revolution, remember some of these alternative artistic spaces:

> Yes, there were these songs by the sent-down youth [知青歌 *zhiqingge*] and there was hand-copied literature [手抄本 *shouchaoben*], too. I still have all the handwritten copies I made of this. When you look back over them, you realize that these works were not really deep, indeed, kind of trivial [流行]. They were often written in great haste, too. The songs were an important stock for later pop songs, although in the beginning, directly after the Cultural Revolution, these songs were forbidden, quite strictly. It did not matter; they were in my head, anyway. (Musicologist, 1950s–)

11. Neither of these books deals first and foremost with art and culture during the Cultural Revolution, however.

We were able to watch quite a few films that were actually only for "internal distribution" [內部 *neibu*]. Some of them were really interesting. We realized that there are worlds that are totally different to our own daily experience, which was all about "criticize this, criticize that." So, watching these was great. But, of course, not everybody had this kind of opportunity. Then, there were these novels we exchanged. Again, most of them only for "internal distribution," Russian, German, and Japanese stories: I even read Hitler and Goethe. Again, we were really impressed: each of them opened up such a different world from ours. . . . The influence of these kinds of books was very strong. After Nixon's visit, when all these foreign orchestras came, this was a big change, once more. There had been so much repetition of songs during the first half of the Cultural Revolution, although, even then, we would sing some songs about love and all that, from the *200 Famous Foreign Songs*, for example, or humoristic songs. This kind of music was totally different from the mainstream, of course. And there were these popular songs, too, that were invented then. . . . The longer the Cultural Revolution lasted, the more restrictions there were. But the underground culture was extremely rich [丰富 *fengfu*]. In fact, it was so strong because there was all this repression. Of course, it was not permitted to engage in all of this, and the Security Bureau [公安局 *gong'anju*] would often come to our school and check. But we would copy that stuff nevertheless. A lot of it was about love, and of course, if you talk about love, then you don't love Mao. . . . But anyhow, it was possible to somehow go against the tide with this literature. (Playwright, 1956–)

This book has mentioned, here and there, some of the secret reading, painting, and listening to music that took place during the Cultural Revolution. Throughout, reference to this clandestine enjoyment of works of art has served to show how the official propaganda art discussed here was unofficially contextualized. In this study, these memories of alternative cultural consumption have, however, only served as pointers. The works themselves have not actually been analyzed in detail. Future histories dealing with the cultural experience of the Cultural Revolution, however, ought to engage with this legacy of underground and alternative as well as semi-alternative/semi-official (for example, Red Guard) cultures: the hand-copied works as well as the translations from foreign literatures, literary and philosophical works from the Chinese traditional canon, foreign and Chinese music and film, as well as painting traditions, and the many compositions, texts, and artworks that were created only to be hidden for some time from the public.

In addition, a wealth of official art that did not become model art but that was nevertheless performed, read, and practiced throughout the Cultural Revolution, locally, as well as nationally, should be (re-)considered. Only by highlighting these neglected works, as well as the underground popular arts created at the local and grassroots levels, can we begin to capture the diversity and complexity that characterized cultural life in China during the Cultural Revolution; only then is it possible to understand the strong competition that Cultural Revolution propaganda was faced with and why—in spite of everything else that happened during those years—it has been able to remain popular decades later.

Here emerges one more spatial dimension of Cultural Revolution Culture that has only been mentioned in passing in this study: it is one that transcends China's territory, as recent successful auctions in Sotheby's and more distant responses like Andy Warhol's *Mao* series from the early 1970s show.[12] The story of the international repercussions and transcultural dimensions of Cultural Revolution cultural experiences should be told in another book. We know that Jiang Qing loved to watch Hollywood movies, but which ones did she see and how did they influence her conception of the model works? And did they influence the many changes she suggested that, in post-Cultural Revolution polemics, eventually made the elephant look anything but like an elephant—in other words, revolutionary Beijing opera no longer Beijing opera? Chinese artists were trained on

12. See Paul 2009 for uses of the Mao portrait in contemporary foreign art.

Russian models, but which of the many Mao portraits used which models? And why? Were audiences ever aware of this? If Stalin, too, is the sun, his physical body a signifier for nature just like Mao's became, can we make out the flows between one iconographic culture and another?[13] How did they translate into audience reception?

There were flows in both directions, as Europe, and the West more generally, have extensively used the propagemes from Cultural Revolution propaganda since the days of the 1960s student movements.[14] This in turn caused a sense of competition in the Soviet Union, as one contemporary observer noted:

> The deification of Mao during the Cultural Revolution was carried beyond Chinese borders to the Communist parties in Asia, Europe, Africa, Australia and other parts of the world. Mao's extreme revolutionary program appealed chiefly to a younger generation of Communists, impatient with the policy of the Soviet Union and of Communist parties acting under Soviet direction.... The *Little Red Book* ... became a propaganda tool abroad affecting students far beyond the membership of the Communist political organization. In many non-Communist countries, radical Maoist student groups supported what were characteristically simplistic and sloganized expressions of their hazy revolutionary thoughts. The Soviets were naturally very concerned with this Maoist challenge which threatened the Soviet world role as the leading Communist power and even challenged the orthodox Communist system itself in an attempt to build a worldwide Maoist leader cult. In reaction, propaganda emanating from Moscow more and more maligned Mao as a "petit bourgeois fanatic," a type of anarchist who had never truly understood Marxism-Leninism. (Michael 1977, 177)

Thus, the popularity of Cultural Revolution propaganda is clearly not just a Chinese internal affair but should be reconsidered from quite a few spaces far removed.[15] These transcultural flows of Maoist propaganda and people's individual experiences with this propaganda have seldom been traced and described in detail.[16] The history of Maoist propaganda and its legacy beyond China, as well as its flows back into China, in turn remains largely unwritten. What appears to be crucial in future studies of Cultural Revolution Culture, then, is a focus on the international, the national, as well as the local and the personal dimensions of this experience.

Propaganda's Time

> I don't agree with the term "Ten-Year Cultural Revolution" [十年文革 *shinian wenge*]. This is very simplistic and not really adequate to the situation. If you look at it objectively, there is no such thing as a "Ten-Year Cultural Revolution." (China Historian, 1957–)

Propaganda's space, although officially delineated as covering the entire nation, in actual practice still shows a lot of patches on the map. Similarly, propaganda's time, even though officially declared, must remain contested. With the 1981 Resolution, the Cultural Revolution was fixed as the decade between 1966 and 1976. Historical writing has followed in step. The idea that for ten years, the China of the Cultural Revolution was the realm of the omnipotent propagandist, a space of total propaganda, is not paradoxical to those who believe in this periodization. But it tallies not with the cultural experience of the Cultural Revolution, which was felt quite differently:

13. See HRA 2008 The Sun; Plamper 2003, 24–26.
14. See *Kulturrevolution als Vorbild* 2008.
15. Grossberg 1997, 17.
16. Diehl 2006 is a first work that goes in this direction.

The ten years were not always the same; the real Cultural Revolution was between 1966–68. After 1969 things were not the same. We thought it was very strange to continue to call what followed a "Cultural Revolution" [文革 wenge]. Later, during movements like the Anti-Confucius Campaign, the feeling was similar again, but not the general atmosphere to be sure. (China Historian, 1949–)

In the 1970s, our classical training was really not bad at all. Before, however, there had been no real teaching of this tradition: we had just read modern literature. Teaching the Classics ended with the beginning of the Cultural Revolution. So, really, the Cultural Revolution is more like two periods: in the 70s things changed a lot. (Musician, 1930s–)

Between 1966 and 1976, in these ten years—no, really, the end was really 1974—in these eight years, then, I did not play the guqin at all. I don't know about others, but I simply did not have the time to play. My father continuously played, he would play these revolutionary songs like "Red Is the East," on the guqin. He had done that even before the Cultural Revolution. After 1974, all earlier activities were resumed; the experts were again engaged. So, in 1975, we even went to Japan as part of a performing troupe [艺术团 yishutuan], and I went, too, playing both pipa and guqin. (Guqin Player, 1940s–)

During the first part of the Cultural Revolution, his experience was really cruel [残 can], but in the second part [the 1970s] they felt they could make use of him again, so then they asked him to come back. But they wanted him to change his art of painting nevertheless. (Cartoonist's son about his father, born in the 1910s)

As for the "Ten-Year Cultural Revolution," if you separate the period from the point of view of politics and propaganda, then 1966–68 was perhaps the strongest period; the next began after Lin Biao's death in 1971. At that time, we really thought that Mao was a kind of god, but now that Lin Biao, who had preached the faith, died, there was a big change. This was a new period in the Cultural Revolution. In 1973–74 the publishers started publishing again. Zhou Enlai was strong. In 1974–75 the "Gang of Four" tried a comeback. (Editor, 1930s–)

One of the greatest problems with discussions on the Cultural Revolution and Cultural Revolution Culture is the fact that they are formulated as statements about a static ten-year period. Yet, vast differences exist in terms of cultural and artistic practice and experience between the mid-1960s and the 1970s. The mid-1960s, as the most brutal and destructive period, saw the murderous mass campaigns of the first few years of the Cultural Revolution, the unleashing of the largely self-organized Red Guard artist movement, the campaign to "Smash the Four Olds" (破四旧 po sijiu), and the beginnings of the Mao Cult as well as free revolutionary travel (大串联 da chuanlian). This was followed, beginning in 1968, by massive moves of educated youth (知情 zhiqing) sent down to the countryside. In the early 1970s, the tides changed as Nixon's visit brought Ping-Pong diplomacy and paved the way for other visits by foreign sportsmen, orchestras, musicians, and more, as well as many a national exhibition, even during the height of the Anti-Confucius Campaign. The final years of the Cultural Revolution canonized the "Establishment of the Four News" (立四新) with the filming and nationwide distribution of the model works, and signaled a return to intellectual engagement with the reopening of universities and journals that had temporarily been closed since the late 1960s.

Many interviewees would contrast what they made out as two very distinct periods of cultural and artistic experience, and these experiences were reflected materially in the artworks produced and openly enjoyed (or not) during particular times:

In the mid-1960s, the piano teachers would teach variations of "Red Is the East," for example. Chopin and other such music was not played—at least not in the open. It simply was hidden. After 1972, however, anything was free and there was no trouble at all anymore. That is when people stopped worrying about playing these things, too! (China Historian, 1957–)

My generation listened to and sang a lot of songs from Albania, for example. We also watched Romanian and Vietnamese and Korean films. Vietnamese films in particular were very good. In the

1970s we could watch them, while in the 1960s this was much more difficult. After Lin Biao's death, however, many things seemed to be possible again. (Writer, 1958–)

I think the second half of the Cultural Revolution was really the best time. During the first half, there was a lot of open criticism, but in the second half, this was much less obvious. In the 1970s quite a few really very good national-style paintings [国画 *guohua*] were produced. (Art Historian, 1940s–)

A very strong impression from the later years of the Cultural Revolution is when I was driving a car to the Beijing train station. I suddenly felt very strange. Why? Because the stores on Wangfujing [王府井] were no longer decked out as "worker-peasant-soldier stores" [工农兵商店 *gongnongbing shangdian*]. No longer were they all called "Red Sun whatever." Instead, they used the old names again. It really gave us a feeling that things had changed. The memory of the Cultural Revolution was still very strong: of looting homes [抄家 *chaojia*] or beating people to death. But now, suddenly, this was over. (Playwright, 1956–)

Apart from these memories, which seem to suggest a split of the cultural and artistic experience of the Cultural Revolution into at least two parts, quite a few people would offer alternative periodizations, depending on what they considered the most important element in the experience of Cultural Revolution Culture. Only for some, things had immediately and drastically changed in 1976. In the memory of one housewife, for example, being able to listen to Chen Gang and He Zhanhao's *Butterfly Lovers Violin Concerto* again on the radio was a clear marker of the end of the Cultural Revolution and its culture: "After the Cultural Revolution, at New Year's, there would be the *Butterfly Lovers*. This was really quite a success. So then I thought: society is changing!" (Housewife, 1950s–). Others did not feel the change was palpable until the 1980s (but had really been anticipated during the Cultural Revolution years themselves):

There was a big change in personal lifestyle after the beginning of the reform policies [改革开放 *gaige kaifang*]. This began not in 1976, but more in 1979. Or, one could also say, it really started in the 1980s, because the economic development caused many changes. Already in the second half of the Cultural Revolution, there were many connections to the outside world, however. And so one can say that many of the changes we felt later actually had begun then! But the death of Mao in 1976 made a big difference. Therefore, 1976 was a break—it's just that its effects were more clearly felt with the rise of Deng Xiaoping a few years later. Economic development was something that did not play a role during the Cultural Revolution; it was all about politics. So that is the big difference. (University Professor, mid-1950s–)

For many, then, the ten-year period might even be extended in one or the other direction: for one interviewee, the characteristic feature of his particular cultural experience in the Cultural Revolution was its restrictions on traditional Chinese culture, especially the Confucian canon. He said: "Basically, this began in 1963 and was only recovered in the 1980s" (Ethnomusicologist, 1940–). He also reckoned that his sojourn in the countryside was a distinct period of artistic experience for him, during which he (and others with the same background) were immersed in local music traditions. Yet this, too, extended beyond 1976:

From 1973–78, I was in Shandong. I learned an enormous amount about local popular music traditions [民间音乐 *minjian yinyue*]. I analyzed them, studied folk songs [民歌 *min'ge*], the local operas [地方 戏 *difangxi*], and participated in the writing of their history. I also learned a lot about the storytelling traditions [说唱 *shuochang*] and percussion [打鼓 *dagu*] and all that. I also went to listen to wind-and-percussion performances [吹打 *chuida*]. There were all these very good performers. I was immersed in it and learned a lot from it! (Ethnomusicologist, 1940–)

Discussing alternative periodizations of the Cultural Revolution experience, interviewees often ended up adopting a *longue durée* approach: some would see connections with the early years of

the People's Republic, others all the way into the present. Interviewees marked changes over time while also observing the qualities of "continuous revolution" in their experience with propaganda art. The idea, then, that the Ten-Year Cultural Revolution was exceptional and unprecedented is relativized in these descriptions, which describe it as one among so many moments during which culture became an object of political power play:

It really depends from what point of view you look at it. In terms of culture, there was a lot of continuity between 1964 and 1978. Surely, the dispersal of the Gang of Four [四人帮] in 1976 was an important step, but then Hua Guofeng, who caught them, in fact favored the artistic styles of the Cultural Revolution, and accordingly, the art surrounding him was really quite "Cultural Revolutionary." He hoped that in terms of propaganda culture the Cultural Revolution would continue.

But if you think about it, these Cultural Revolution styles go back even further: already in 1962, there was an attack on Beethoven. Mao's call to "never forget class struggle" [千万不要忘记阶级斗争 *qianwan bu yao wangji jieji douzheng*] was immediately translated into the cultural field. There was even a drama with that title. Then came the Hai Rui pieces, and the criticism of Wu Han's Hai Rui opera, and this went on and on. (Journalist 1949–)

A kind of open situation reigned until maybe 1957; after that it was all, "You want to eat, you follow the line." The time before 1957 was actually much more open. We published a lot of translations, Keynes [1883–1946], for example, a lot of Russian things, but also Hegel [1770–1831], and a lot of Classics: Shakespeare, etc. Then, things changed . . . all the way to 1979. . . . It was not always bad, but the 1970s were even worse than the 1960s, at times; nothing had really changed. (Editor, 1930s–)

1966–1976: was that the Cultural Revolution? In reality it was just the period between 1966 and 1972, or you could also say between 1951 and 1972 perhaps, because so many cultural criticisms were going on much earlier already, and the reform of opera, too, started in 1964. (Intellectual, 1958–)

All of the model works go back to earlier times. . . . And with everything else, too, there is really no such thing as a "Ten-Year Cultural Revolution." Look at Dazhai and Daqing—we are still doing this . . . even though now it may be a bit more symbolic. Now we may also demand that even Dazhai must change. In 1974, Jiang Qing wanted to make Dazhai and Daqing her models. Deng Xiaoping did the same thing. But he changed their spirit! And so did Zhu Rongji [朱镕基 1928–]. The crazy thing is, though, that these things are still done the same way even today. (China Historian, 1957–)

There is relativization, then, of the Cultural Revolution: it need not be treated as an exception but can be compared to what came before and what came afterward. Some of its "typical characteristics," such as the destruction of traditional heritage, are also found in other periods of Chinese history. Even those who see more differences and change and emphasize them over continuities do not deny such elements of perpetuation throughout Chinese history.

Was the Cultural Revolution a special time in Chinese history? It was a very "feudal" [封建 *fengjian*] movement, if you ask me, very Chinese-style "feudal." China, the Communist Party, they are so "feudal," they don't even give you the right of speech. I have been hit three times in recent decades for political reasons, and I do not see that there is any improvement. . . . The Cultural Revolution did not come by fluke [偶然]; it could be foreseen from the first day of the Chinese Communist Party's foundation.

There is a long history of criticisms: after 1949, first in 1952 we have the movement to criticize the novel *Dream of the Red Chamber*, then in 1953 the film *Biography of Wu Xun* 武训转 [*Wu Xun zhuan*], in 1955 the movement criticizing Hu Feng [胡风 1902–85], in 1957 the Anti-Rightist Movement, in 1959 the criticisms of Peng Dehuai [彭德怀 1898–1974], then the Cultural Revolution. Really, this is all connected. And it started even earlier, in the 1930s, and was continued in Yan'an, with rectification, etc. (Composer, 1937–)

The model works are a development that goes back to the children's operas by Li Jinhui [黎锦辉 1891–1967], who was active in Republican times. Li Jinhui used the techniques from folk songs to write his pieces. He was criticized for it, because they were considered lewd songs, but his musical techniques were precisely those later used in the model works. (Musician, 1930s–)

Already in the early 1960s, culture was politicized, the dramatic ballads *tanci* performed before the Cultural Revolution were not necessarily old stories either. During the Cultural Revolution, things changed, of course, but it was not a great and big change ... especially if compared with the early 1960s. ... The Cultural Revolution was certainly not a "sudden change" [突变], as is always said now, either, it was a very natural development! (Musicologist, 1950s–)

Some thus held views of a long and continuous revolution in culture that went far beyond the officially prescribed years of the Cultural Revolution (and the use of propaganda language like "feudal" for one's individual arguments here is an example of the perpetuation of much of this culture into the present). Speaking of the cultural products typically identified with the Cultural Revolution, we can make out a distinct and reductive style of heroic prominence that covers the period between 1964 (when the debate over depictions of heroes was decided in favor of Maoist prominences) and 1978 (when the era in which Hua Guofeng substituted a new sun for an old sun ended).[17] Yet, within this period, constant shifts and changes took place: the resurrection of parts of China's traditional fine arts and music in the early 1970s (which did not subside significantly with the criticisms of China's traditional (Confucian) heritage only a few months later) is one such example; the use of unaccepted motifs (such as Piggy's navel) in Red Guard Publications and art is another. It is the long-term view presented here that makes visible the connections between these phenomena and earlier and later occurrences of these propagemes. And it is this view that undoes the idea of the Cultural Revolution as an exceptional, unprecedented, and unrepeatable period in Chinese history.

Turning the Pages of History?[18]

A lot of people say contradictory things: of course, this must be so. (Intellectual, 1958–)

It is notoriously difficult to summarize the Cultural Revolution experience: no matter how one person describes it, another will say that it was not "like that": there is no way to paint a proper likeness (ill. 0.0).[19] Yet, in spite of this, neither does it make sense to speak of Cultural Revolution Culture merely as the culture of an exceptional period (非常时期), as is the officially accepted manner of speech (提法 *tifa*). Such terminology is regularly used for traumatic periods, as Rana Mitter explains:

One way to deal with trauma is to erase it from memory, or at least separate it out from "normal life." It is not always a good idea to transfer the psychology of individual human beings to the "psyches" of nations as a whole, but it is noticeable that nations do tend to deal with the most horrific parts of their histories by treating them as anomalous, in the way that a person claims that he did some dreadful deed while he was "not himself." Nazi Germany, Rwanda during the Hutu genocide of the Tutsis, or Cambodia under the Khmer Rouge are just some of the prominent examples of this phenomenon which our writing of history neatly sections off with the final-sounding dates of 1933–45, 1994, or 1975–8. Something similar has often occurred with the Cultural Revolution, 1966–76. (Mitter 2004, 207)

17. Seifert (2008, 104) offers important insights in alternative periodizations for the Cultural Revolution, taking cultural production itself and its changing styles into consideration.
18. My title parodies a phrase from Wang 1997, 146.
19. See **ill. 0.0**, "Record of Painting an Elephant" (画象记) in *LHHB* 1978.9:37 discussed at the beginning of my Introduction.

As we have seen, the Cultural Revolution experience is hardly accepted by anyone as one that can be separated off neatly from everything before and after with the dates assigned to it, nor has it been accepted as one that is entirely "exceptional" or "anomalous" except perhaps insofar as that it meant doing everything in hyperbole, on a larger scale, or, in Cultural Revolution rhetoric, "on a higher plane." That this is the case—differently from the understanding of the Nazi experience in Germany, for example—may have to do with the fact that the experience of the Cultural Revolution is, after all, not so unanimously accepted as "trauma" by everyone. Just a few years after the end of the Cultural Revolution, individuals had already begun their attempt to reclaim what they considered their "lost past" (Barmé 1999, 319). They did so by recovering the propaganda art of this past, as art generally enables an audience both "to *feel* as well as *think* the past" (Watson 1994, 8).

In order to do justice to the cultural experience of the Cultural Revolution, it only makes sense, then, to take its contradictory and complicated nature seriously and to follow both those traces that show that it was a period of destruction and restriction as well as those that show that it was a period of continuous practice and development in the arts. It is easy to list quotations for both standpoints. The Cultural Revolution cultural experience is remembered as destructive, instructive, or constructive—indeed, some contemporaries even mention all of these elements at one and the same time (and continue to blame factors other than the Cultural Revolution, such as television, as destructive of culture just as well):

> A person with a high position in the Communist Party would call the museum. He had all these precious objects at home, and he knew he could not keep them. So he asked us to go and ransack his home [*chaojia*], saving all these objects. And so we did: we put on these Red Guard things, went to his home, and took all his porcelain and other precious belongings: all of these are now in the Shanghai Museum. And indeed, he was not the only one; there were quite a lot of people, all of them with some kind of a position in society, and they would all call and do this. Of course, there was a lot of real ransacking, without anyone calling and asking for it, but this kind also took place regularly. Through the "Smashing of the Four Olds" then, quite a few very valuable objects came to the museum. Many of them were never returned to their owners, and would have been kept for the owners free of charge. Since the Shanghai Museum was never ransacked, it was able to keep many of these objects, to preserve and save them. I must say, these experiences made a very strong impression on me. (Museum Curator, 1950s-)

> There was a lot of destruction. The Cultural Revolution truly was a cultural desert. It was about 99 percent destruction. Complete destruction, really. . . . Even the folk songs [民歌 *min'ge*] were destroyed, because the original words could not be sung, so now very few people remember them. They were singing folk songs behind everybody's back, but they always thought they should not sing too much. Of course, what really destroyed the folk song tradition is television, after the opening, the media. So there is no basis any more for singing these folk songs today. This is not a destruction by politics, but by these new media, then. Take the example of the folk song that was turned into the revolutionary song *To rebel Is Justified* [造反有理]. Nobody knows the original text anymore . . . Now, of course, if you are strict, this does not start with the Cultural Revolution but with Yan'an, or even the May Fourth Movement, although then they still would have a basis of culture from which they could begin. We have lost all our traditional knowledge [传统知识 *chuantong zhishi*]. And we have destroyed it. There is no appreciation of this kind of culture anymore. (Intellectual, 1955-)

Those whose memories of Maoist propaganda are positive often recall the signs and symbols of this art, the feelings and emotions it created, not its political content (e.g., Bryant 2004, 222):

> The model works? Oh, I really liked to watch them! When they were played somewhere, say, in the theater [人民剧场 *Renmin Juchang*] or the stadium [北京工人体育场 *Beijing Gongren Tiyuchang*], we would stay there a whole evening . . . we would go there the night before, around nine o'clock or so, and

we would wait the whole night, not sleeping but waiting in line to get the tickets. I really liked to watch them, and the tickets were always very quickly sold out. There were lots of people who wanted to buy tickets from us. (Historian, 1950s–)

Those whose memories of the Cultural Revolution are more negative, on the other hand, remember Maoist propaganda with relation to the trauma created by its politics:

In the Cultural Revolution, really, politics was everything, that was true. It was possible not to participate, but it was really quite difficult. For example, if you were sick, ok, but only then. . . People like Lao She [老舍 1899–1966], Ba Jin were hit. Of course you could say that they, too, all had a responsibility for what happened. . . . The cruelty [残酷 canku] committed then is a collective experience; we all have a responsibility, but people don't take on this responsibility. Many people feel they were blind then. True, they did not really think about the kinds of questions and problems that would come up later. (Journalist, 1949–)

Some would implicitly (by not really wanting to admit the popularity of propaganda art) or even openly (by stating how knotty it is, even today, to talk about it) address the difficulty of trying to assess the Cultural Revolution and its propaganda art in one way or another:

The model works are not really all that popular today. A lot of people still think they are quite objectionable. But since we have not heard them for a while, now, they can be attractive because they are still so very familiar [亲切 qinqie]. And really, they are very nice, they don't sound that bad [难听 nanting] after all, so maybe some younger people even think they are chic. Then, there is nostalgia. This is really rather complicated. Still, I think it is not common. But there are even more intricate aspects to be considered: Does China have religious music, for example? Where is the Chinese religious spirit, really? In Daoism? What about Buddhism? Can it be considered a Chinese religion after all? A national religion? No, not really, there are other religions, too, and not everybody believes in these. This is a special characteristic of Chinese culture, it is quite strange. You can even revere [崇拜 chongbai] a real and living person in Chinese religion. So the model works are a kind of religious music. Do people now believe in socialism, hanging up the image of Mao? This has a religious quality. Very early in Chinese history this was so: Huangdi, the Yellow Emperor, he was a real person and he was being revered, too. (Language Instructor, mid-1950s–)

While this book must leave many questions unanswered, many materials untouched, it has put its attention to one crucial aspect of the Cultural Revolution: artistic and cultural production and experience.[20] In shifting the focus away from politics and toward art and culture, this study attempts to conceptualize how the history of the Chinese Cultural Revolution could be reconceived and rewritten. In this endeavor, oral history has played an important role: it makes visible the contradictions in the Cultural Revolution experience as it reveals "dissonances" among people's different recollections of the past, as it presents "fragmented memories" (Lee and Yang 2007, 5). It helps reconstruct a history full of inexplicable fissures and disjunctures, and this is perhaps the only history adequate to relating the experience of the Cultural Revolution. Many interviewees would say one thing when prompted and its opposite only moments later, sometimes even in the same sentence. The constant ruptures within and between individual memories show the immense complexity of this cultural experience (and its memory work) at hand. It is true that "once the post-Mao leadership set to work—dismantling the Maoist strategy, expunging its achievements from the public record, and forbidding anything but a negative verdict on every aspect of the entire

20. This follows Wang's suggestion that "the word 'cultural' in Cultural Revolution merits fresh attention and careful inquiry" (Wang 1997, 194).

Cultural Revolution decade—everyone, willingly or not, came under the spell of the new official line" (Pepper 1991, 589). This was obvious in the beginning phase of all my interviews, too: even today, it is not easy to talk about the experience of the Cultural Revolution outside prescribed mnemonic stereotypes. Yet because it produced a propaganda art that allowed for individual agency and pluralistic reception even as it served as an instrument for maintaining power and control, the experience of Cultural Revolution Culture as a whole meant many different things in different places to different people and even to one and the same person.

The Introduction to this book invoked Jung Chang's *Mao: The Unknown Story* and criticized it for not responding to one of the most pressing issues in China today, one formulated succinctly by Wang Ban—the legacy of Cultural Revolution Culture and the mark it has left on so many, if not everyone:

> Why is it, as many have asked, that almost all of us (except a few resistant souls), including the best educated and most sober minded, engaged in these rituals with an enthusiasm that was as blind as it was sincere, as irrational as it was earnest? Why did we acquiesce in the rituals and the cult, in the modern myths, which led to the national disaster? (Wang 1997, 216)

This book has attempted to offer some tentative answers to these questions. It suggests that Cultural Revolution propaganda served and continues to serve particular needs, that it gave and gives security and vision, and that it built on a tradition of earlier art works (also propaganda), which made possible the sedimentation of its message in cultural memory. As it was ritually repeated and thus became habitual, it made use of a number of different cultural genres and forms in order to best serve distinctive groups in the population and, thus, has become popular among many.

Theorizing the propaganda culture of the Cultural Revolution, its experience as well as its practice, this book comes to an end by calling for a more open and expansive treatment of Cultural Revolution Culture both as material practice and as experience. In doing so, it advocates reassembling the history of the Cultural Revolution into several histories: localized and segmented, reconsidered in terms of its time and its space, on the micro and macro level of its (generational) experience—all of which must be considered from their respective individual, local, national, and international viewpoints, and scrutinized in their official, unofficial, and private facets and as an experience of the everyday and the ordinary as well as of the exceptional and extraordinary.[21] This book does not even begin to finish the tale of art and culture in China's Cultural Revolution. It can only end where it started—bowing in humility to the many voices of contemporaries I have attempted to make heard—with artist Huang Yongyu's apt description: "We have to admit that the Cultural Revolution was a very interesting drama. Unfortunately, the price of the ticket was too expensive."[22]

21. On the "festive" nature of the Cultural Revolution experience, see Mittler 2006 and the theme volume of *Journal of Modern European History* entitled "Dictatorship and Festivals," in *JMEH* 2006.
22. Huang 1990–92, 132.

LIST OF INTERVIEWEES (ORDERED BY AGE)

Occupation	Year of birth	Gender	Family background	Place and date of interview	Experience in factory/ countryside
1. Family of a Cartoonist	1915	male	well educated	Shanghai, 14 March 2004	
2. Musicologist	1922		parents underground Communists, PLA members, later declared rightists	Shanghai, 15 March 2004	
3. Musician	1930s	male	intellectuals, musicians	Shanghai, 14 March 2004	
4. Editor	1930s	male	father rich landowner, died early, family poor, working-class background; mother a nanny; son became CCP member quite early	Beijing, 19 March 2004	cadre school, ca. 1968–71
5. Composer	1937	male	father in the military, Yan'an background, died before 1949; mother traditional background, bound feet	Beijing, 18 March 2004	propaganda troupe (文工团 wengongtuan), PLA, 1949–57; sent to countryside 1964–78
6. Art Historian	1940s?	male	parents from landowning class, well-educated *wenren* literati family	Shanghai, 12 March 2004	
7. Businesswoman (and husband)	1940s	female (and male)	father declared a "counterrevo-lutionary"	Shanghai, 14 March 2004	
8. Guqin Player	1940s	male	father musician	Beijing, 22 March 2004	four years in countryside in Henan
9. Ethnomusicologist	1940	male		Beijing, 20 March 2004	Shandong song and dance troupe
10. Musician	1942	male	father worker	Shanghai, 9 March 2004	
11. Journalist	1946	female	parents from intellectual family, grandparents Shanghai "capitalists"	Shanghai, 11 March 2004	
12. China Historian	1949	male	parents illiterate peasants	Shanghai, 12 March 2004	
13. Housekeeper	1950s?	female		Beijing, 17 March 2004	
14. Journalist	1949	male	family: "capitalists" from Guangdong	Shanghai, 12 March 2004	factory, 1968–74

Occupation	Year of birth	Gender	Family background	Place and date of interview	Experience in factory/ countryside
15. Museum Curator	early 1950s	male	grandfather "middle peasant," father "capitalist," owned a small store	Shanghai, 13 March 2004	
16. Artist	1954	male	parents intellectuals	Beijing, 22 March 2004	two months' work in village near Beijing, 1969
17. Housewife (and husband)	1950s	female (and male)	he: "capitalist" background	Beijing, 20 March 2004	she: sent to Dongbei until 1972; he: left alone in Beijing
18. University Professor	mid–1950s	female	family: from the countryside, cadres at film academy, father in PLA but maybe GMD background	Beijing, 17 March 2004	sent to countryside of Heilongjiang, ca. 1967
19. Intellectual	1955	male	family: "capitalists," "land-owners," intellectuals; father declared "rightist"; translators for the Foreign Office	Beijing, 18 March 2004	entire family in Shanxi, gaizao
20. Playwright	1956	male	parents intellectuals	Beijing, 17 March 2004	in the country-side as a teenager
21. Language Instructor	mid–1950s	male		Heidelberg, 5 December 2000	
22. China Historian	1957	male	parents intellectuals, Party members	Shanghai, 10 March 2004	
23. Librarian	mid–1950s	male		Heidelberg, 6 January 2001	in the PLA throughout the CR
24. University Professor	mid–1950s	female	parents intellectuals, mother foreigner	Heidelberg, 2 January 2001	in countryside 1969–71 and again 1971–73
25. Intellectual	1958		family intellectuals and artists/ musicians	Beijing, 20 March 2004	
26. Writer	1958	female	parents well-off intellectuals and cadres before CR, father in a shipping business	Shanghai, 10 March 2004	
27. Musicologist	1950s	male	father declared "rightist"	Beijing, 19 March 2004	
28. Artist	1959	female	parents workers	Beijing, 22 March 2004	
29. Historian	1950s	male	parents both university teachers	Beijing, 21 March 2004	Sichuan countryside
30. Photographer	ca. 1960	male	parents long-time workers	Shanghai, 11 March 2004	factory worker
31. Music Student	1969	male	parents musicians	Shanghai, 15 March 2004	
32.–40. Taxi Drivers	1930s–1970s	male	diverse	Shanghai and Beijing, 2004, 2010	

INTERVIEW QUESTIONS[1]

General Information
Date of birth
Family background
Personal experience during the Cultural Revolution (1966–76)
How old at the beginning and end of the Cultural Revolution?
Countryside/Military/Factory?
What did you do/learn at school?

Culture Generally, Art and Life
What do you associate with the Cultural Revolution in terms of cultural products? (*Yulu*? Posters? Books? Poetry? Music?)

What was available to you in terms of cultural products during the Cultural Revolution? Which films/books/ pictures/pieces of music/poetry do you remember? Why? Was Mascagni's *Cavalleria Rusticana*, or He Zhanhao and Chen Gang's *Butterfly Lovers Violin Concerto* forbidden music? How did you know what was forbidden and what was not?

Did you have a feeling of reduction of aesthetic possibilities and of thematic restriction during the Cultural Revolution? Did you know which books (not) to read, which songs (not) to sing, which records (not) to buy? How would changes in cultural policies affect your everyday life, and how would they be made public? Was it obvious to someone living through the Cultural Revolution that at one point in 1969 only five records could officially be sold? Did you realize that you could see fewer films than before?

Did you ever participate in internal screenings of films, secret record listening sessions, secret book readings, etc.? Where did you turn to read literature, see films, and listen to music?

When did cultural production play a role? Were there peak times throughout the ten-year period?

Pervasiveness of the Art
How did the particular battle-call rhetoric of the Cultural Revolution influence your lives?

Did you use MaoSpeak? When and why?

Did you realize that Cultural Revolution literature is characterized by short sentences? Were you taught stylistic features such as this in school?

Did you feel a difference between the underground and official literature you read? In terms of style? Subject matter?

Did you ever participate in poetry declamations? Revolutionary/quotation dances or music-making, model works productions, etc.? Was it fun? Did one believe in what one did? Were there insecurities as to whether you were performing the right and correct versions of the model works?

How new did the model works and other Cultural Revolution cultural products appear to you? How familiar were you with their stories from before the Cultural Revolution?

Was there a Chinese version of *Chinese Literature* and *China Reconstructs*? Did you ever read those foreign-language journals?

Who did you learn to think of as the composer of "Red Is the East": He Luting or Li Youyuan?

1. These questions have been translated into English; interviews were conducted in Chinese.

Model Works

Were the model works really the model that needed to be emulated in everything?

Which of the model works do you remember? Why?

How were the model works publicized? Did you know about Jiang Qing's role in their production?

How were changes in the model works publicized? Did you know about the political discussions that took place around them?

Are the model works good art? Are they Chinese art?

Models

What appeal do the models from the model operas, books, and comics have for you? Whom do you admire?

When does credibility of models imposed from above stop? (For example, with Zhang Haidi or before?)

Who are the heroes and models you remember from the Cultural Revolution? What did they mean to you? Were they discussed or even questioned as "persons"? Were there specific heroes for specific times? What martyrs were most prominent during the Cultural Revolution? Why?

Was the idea of modeling oneself on the model heroes feasible? Did you ever envisage yourself in terms of a revolutionary hero or martyr? Which? Did these heroes set "fashions" or "standards of beauty" for you to aspire to? Which heroes do you remember best: those from literature, the model works, comics, paintings?

How relevant were directives such as the Three Prominences or Revolutionary Realism and Revolutionary Romanticism to your experiences during the Cultural Revolution?

Politics/Campaigns

How political was the Cultural Revolution? Were you aware of factional fighting? How did this influence your lives, your artistic production?

How tangible was the control that the Cultural Revolution Group around Jiang Qing had over the media?

How did you feel about the different campaigns throughout the Cultural Revolution (and before and after)? What is the greatest difference between these campaigns? And was there ever a lukewarm response to the campaigns? Were different groups more or less enthusiastic? Did the Anti-Confucius Campaign actually reach the masses? How weary were people of campaigns by 1975; did they still believe in them?

Three Character Classic

In the campaigns against Confucius, did you hear of the attacks on the *Three Character Classic*? Did you read and understand the text, and its innuendos? Why? What did you know about Confucius and Confucian morals? How much of the criticisms against Confucius did people believe? What did these do to their attitudes toward Confucianism generally?

Did people believe in the negative descriptions of Confucius? What did or did they not know about him? Did their knowledge increase because of the Anti-Confucius Campaign? How much did they read? What? How? What did they think of it?

Is it true that people felt relieved when ritual practices such as those performed under Lin Biao were stopped? Do you remember when they were stopped?

What textbooks were used in school? Was the *Three Character Classic* among them? When was it used?

Periodization

Were different periods in the Cultural Revolution experienced in different ways?

In terms of contents: what precisely changed during different periods of the Cultural Revolution?

Memory

Would you be able to use one word to remember the Cultural Revolution by? Did the Cultural Revolution feel like a "time of youth," or a "holocaust"?

How long did the Cultural Revolution as a "continuous" movement last in your mind? When did it begin? What were the great changes one could feel?

To what extent must the Cultural Revolution be described in the terms prescribed by the State? Or in terms of nostalgia? Can you explain the Cultural Revolution nostalgia? Is it a broad social phenomenon? Does it apply to specific groups or everyone?

Do you understand Cultural Revolution nostalgia? What is its relationship to nostalgia for the "golden" 1920s and 30s in great cities such as Shanghai?

Did you ever visit a museum during the Cultural Revolution? Were museums powerful (weapons of state propaganda) during the Cultural Revolution? Does the Cultural Revolution itself need a museum?

How does reconceived Cultural Revolution art (in the form of avant-garde paintings, revolutionary pop songs, films, etc.) appeal to you?

What pieces of avant-garde art/music/literature/film/television that you know most adequately capture the atmosphere of the Cultural Revolution?

Does the audience determine the way one talks about the Cultural Revolution and its culture? Do you feel free to write your own and individual version of Cultural Revolution cultural memory?

Does the meaning of Cultural Revolution Culture change if performed/seen/read today?

In what ways has the Cultural Revolution facilitated particular changes after its end (particularly in the cultural field)?

APPENDIX 3

CHRONOLOGY OF THE MODEL WORKS

Operas
Shajia Village 沙家浜 *Shajiabang* (1964)
The Red Lantern 红灯记 *Hong Dengji* (1964)
Taking Tiger Mountain by Strategy 智取威虎山 *Zhiqu weihushan* (1964)
Raid on White Tiger Regiment 奇袭白虎团 *Qixi baihutuan* (1964)
On the Docks 海港 *Haigang* (1966)
Red Detachment of Women 红色娘子军 *Hongse niangzijun* (1971)
Song of the Dragon River 龙江颂 *Longjiangsong* (1971)
Azalea Mountain 杜鹃山 *Dujuanshan* (1973)
Fighting on the Plain 平原作战 *Pingyuan zuozhan* (1973)
Boulder Bay 磐石湾 *Panshiwan* (1975)

Ballets
The White-Haired Girl 白毛女 *Baimaonü* (1966)
The Red Detachment of Women 红色娘子军 *Hongse niangzijun* (1966)
Ode to the Yi Mountain 沂蒙颂 *Yimengsong* (1972)
Children of the Grasslands 草原儿女 *Caoyuan ernu* (1972)

Symphonic works
Symphony based on *Shajia Village* 沙家浜 *Shajiabang* (1966)
The Red Lantern accompanied by Piano 钢琴伴唱红灯记 *Gangqin Banchang Hong Dengji* (1967)
The Yellow River Piano Concerto 黄河钢琴协奏曲 *Huanghe gangqin xiezouqu* (1969)
Symphony based on *Taking Tiger Mountain by Strategy* 智取威虎山 *Zhiqu weihushan* (1973)

WORKS CITED

Ahn 1972: Ahn, Byung-Joon. "The Politics of Peking Opera, 1962–1965." *Asian Survey* 12 (1972): 1066–81.

Altheide and Johnson 1980: Altheide, David L., and John M. Johnson. *Bureaucratic Propaganda*. Boston: Allyn and Bacon, 1980.

Ames 1994: Ames, Roger T. *The Art of Rulership. A Study of Ancient Chinese Political Thought*. Albany: SUNY Press, 1994.

Andors 1976: Andors, Stephen. "The Dynamics of Mass Campaigns in Chinese Industry: Initiators, Leaders, and Participants in the Great Leap Forward, the Cultural Revolution, and the Campaign to Criticize Lin Biao and Confucius." *Bulletin of Concerned Asian Scholars* 8, no. 4 (1976): 37–47.

Andrews 1994: Andrews, Julia. *Painters and Politics in the People's Republic of China, 1949–1979*. Berkeley: University of California Press, 1994.

Andrews 1998: Andrews, Julia. "The Victory of Socialist Realism: Oil Painting and the New Guohua." In *A Century in Crisis: Modernity and Tradition in the Art of Twentieth Century China*. New York: Guggenheim Museum, 1998: 228–37.

Andrews 2010: Andrews, Julia. "The Art of the Cultural Revolution." In *Art in Turmoil: China's Cultural Revolution, 1966–76*, edited by Richard King. Vancouver: University of British Columbia Press, 2010, 27–57.

Andrews and Shen 1998: Andrews, Julia, and Kuiyi Shen. "The Modern Woodcut Movement." In *A Century in Crisis: Modernity and Tradition in the Art of Twentieth Century China*. New York: Guggenheim Museum, 1998: 213–25.

Apter and Saich 1994: Apter, David E., and Tony Saich. *Revolutionary Discourse in Mao's Republic*. Cambridge: Harvard University Press, 1994.

Art and China's Revolution 2008: *Art and China's Revolution*, edited by Melissa Chiu and Zheng Shengtian, New York: Asia Society, 2008.

Bai 1997: Bai, Di. "Feminist Brave New World: The Cultural Revolution Model Theater Revisited," Ph.D. Diss., Ohio State University, 1997.

Bai 1988: Bai Jieming 白杰明. "Yaogun fanshen le?" 摇滚翻身了 (Does Rock emancipate?). *Jiushi niandai* 九十年代 11 (1988): 94–95.

Bakken 2000: Bakken, Borge. *The Exemplary Society: Human Improvement, Social Control, and the Dangers of Modernity in China*. Oxford: Oxford University Press, 2000.

Barboza and Zhang 2008: Barboza, David, and Lynn Zhang. "Why Do Artists Say: Look at Me." In *ArtZine: A Chinese Contemporary Arts Portal*, archived as DACHS 2009 Barboza and Zhang.

Barmé 1987: Barmé, Geremie R. "Revolutionary Opera Arias Sung to a New, Disco Beat." *Far Eastern Economic Review* 05 February 1987: 36–38.

Barmé 1996: Barmé, Geremie R. *Shades of Mao: The Posthumous Cult of the Great Leader*. New York: M. E. Sharpe, 1996.

Barmé 1999: Barmé, Geremie R. *In the Red: On Contemporary Chinese Culture*. New York: Columbia University Press, 1999.

Barmé 2008: Barmé, Geremie R. "Olympic Art and Artifice." *The American Interest Online*, July/August 2008. Archived as DACHS 2012 Barmé, Olympic Art.

Barnouin and Yu 1993: Barnouin, Barbara, and Changgen Yu. *Ten Years of Turbulence: The Chinese Cultural Revolution*. London: Kegan Paul International, 1993.

Barrett 1993: Barrett, T. H. "Lie tzu." In *Early Chinese Texts. A Bibliographical Guide*, edited by Michael Loewe. Berkeley: Society for the Study of Early China and the Institute of East Asian Studies, University of California, 1993: 298–308.

Barthes 1957: Barthes, Roland. *Mythologies*, Paris: Seuil, 1957.

Belting 1990: Belting, Hans. *Bild und Kult: Eine Geschichte des Bildes vor dem Zeitalter der Kunst*. Munich: C. H. Beck, 1990.

Benewick 1999: Benewick, Robert. "Icons of Power: Mao Zedong and the Cultural Revolution." In *Picturing Power in the People's Republic of China: Posters of the Cultural Revolution*, edited by Harriet Evans and Stephanie Donald. Lanham: Rowman and Littlefield, 1999: 123–37.

Benjamin 1963: Benjamin, Walter. *Das Kunstwerk im Zeitalter seiner technischen Reproduzierbarkeit.* Frankfurt: Edition Suhrkamp, 1963.

Van den Berg 2000: van den Berg, Wim. "Autorität und Schmuck: Über die Funktion des Zitates von der Antike bis zur Romantik." In *Instrument Zitat: Über den literarhistorischen und institutionellen Nutzen von Zitaten und Zitieren,* edited by Klaus Beekman and Ralf Grüttemeier. Amsterdam: Rodophi, 2000: 11–36.

Bergman 1984: Bergman, Pär. *Paragons of Virtue in Chinese Short Stories during the Cultural Revolution.* Goteborg: Graphic Systems, 1984.

Bischoff 2005: Bischoff, Friedrich Alexander. *San Tzu Ching Explicated: The Classical Initiation to Classic Chinese Couplet I to IX.* Vienna: Verlag der österreichischen Akademie der Wissenschaften, 2005.

Bonnell 1999: Bonnell, Victoria E. *Iconography of Power: Soviet Political Posters under Lenin and Stalin.* Berkeley: University of California Press, 1999.

Boorman 1963: Boorman, Howard L. "How to Be a Good Communist: The Political Ethics of Liu Shao-Ch'i." *Asian Survey* 3, no 8 (1963): 372–83.

Borsò 2010: Borsò, Vittoria *Die Macht des Populären. Politik und Populäre Kultur im 20. Jahrhundert.* Bielefeld: Transcript Verlag, 2010.

Brandl 2001: Brandl, Rudolf Maria, and Zaoqian Wang. *Nuo: Tänze der Geistermasken im Erdgottkult in Anhui (China) Band I,* Göttingen: Edition Re, 2001.

Brecht 1965: Brecht, Bertolt. "Keuner-Geschichten—'Originalität.'" In *Prosa.* Frankfurt a.M.: Suhrkamp, 1965, Bd. 2: 110.

Brecht 2001: Brecht, Bertolt. *Stories of Mr. Keuner,* translated by Martin Chalmers, San Francisco: City Lights Books, 2001.

Breithaupt 2002: Breithaupt, Fritz. "Das Indiz. Lessings und Goethes *Laokoon*-Texte und die Narrativität der Bilder." In *Ästhetik des Comic,* edited by Michael Hein, Michael Hüners, and Torsten Michaelsen. Berlin: Erich Schmidt, 2002: 37–49.

Breitkreuz 1994: Breitkreuz, Ira. "Chinesische Comics. Entstehungsgeschichte, Typologie und Probleme der Interkulturellen Adaption und Rezeption." Diploma Thesis, Mainz, 1994.

Broken Silence 1995: Flipse, Eline. *De Oogst van de Stilte/Broken Silence.* Goirle, Holland: Scarabee Film, 1995.

Brooks 1999: Brooks, Jeffrey. *Thank You, Comrade Stalin! Soviet Public Culture from Revolution to Cold War.* Princeton, NJ: Princeton University Press, 2000.

Brown 2003: Brown, Jeremy. "Putting Culture Back into the Cultural Revolution." Archived as DACHS 2009 Jeremy Brown, Cultural Revolution Culture.

Bryant 2004: Bryant, Lei Ouyang. "New Songs of the Battlefield: Songs and Memories of the Chinese Cultural Revolution." Ph.D. Diss., University of Pittsburgh, 2004.

Bryant 2007: Bryant, Lei Ouyang. "Flowers on the Battlefield are more Fragrant." *Asian Music* 38, no. 1 (Winter/Spring 2007): 88–122.

Bussemer 2000: Bussemer, Thymian. *Propaganda und Populärkultur: Konstruierte Erlebniswelten im Nationalsozialismus.* Wiesbaden: Deutscher Universitätsverlag, 2000.

Cai 1998: Cai, Guanjun. "A Chinese Rhetorical Tradition? Case Studies in the History of Chinese Rhetorical Theory and Practice." Ph.D. Diss., University of Arizona, 1998.

Calhoun 1994: Calhoun, Craig. *Neither Gods nor Emperors: Students and the Struggle for Democracy in China.* Berkeley: University of California Press, 1994.

Calhoun and Wasserstrom 1999: Calhoun, Craig, and Jeffrey N. Wasserstrom. "Legacies of Radicalism: China's Cultural Revolution and the Democracy Movement of 1989." *Thesis Eleven* 57 (1999): 33–52.

Cao 1993: Cao Zuorui 曹作锐. *Lianhuanhua bianxie tanyou* 连环画编写探幽 (Background on the editing of comics). Beijing: Zhongguo lianhuanhua, 1993.

CC Liu Collection Heidelberg
Chinese Revolutionary Songs. Hong Kong: no publisher, n.d.

Chuangzuo gequ xuan 创作歌曲选 (A selection of songs), edited by Heilongjiang sheng qunzhong yishuguan 黑龙江省群众艺术馆. Vol. 3. Harbin: Heilongjiang renmin 1975.

Dongfang hong gequ ji 东方红歌曲集 ("Red Is the East," a collection of songs). Hong Kong: Sanlian shudian, 1965.

Dongting xin'ge: Geming gequji 洞庭新歌：革命歌曲集 (New songs from Dongting: A collection of revolutionary songs). Hunan: Hunan renmin, 1972.

Duchang gequ ji 独唱歌曲集 (A collection of solo songs). Guangdong: Guangdong renmin, 1974.

Duchang gequ xuan 独唱歌曲选 (A selection of solo songs). Beijing: Renmin wenxue, 1973.

Duchang gequ xuan 独唱歌曲选 (A selection of solo songs). Vol. 3. Beijing: Renmin yinyue, 1976.

Geming gequ dajia chang 革命歌曲大家唱 (Everybody sings revolutionary songs). Beijing: Yinyue, 1964.

Gongshe de rizi sai huohong 公社的日子赛火红 (The days in the commune are bright red). In *Hongqiqu zhi ge* 红旗渠之歌 (Songs of the Red Flag Canal). Zhengzhou: Henan Renmin, 1974: 70–71.

Hong taiyang guanghui zhao caoyuan 红太阳光辉照草原 (The radiance of the red sun falls onto the grasslands). Beijing: Renmin yinyue, 1977.

Mao Zhuxi, nin shi women xinzhong bu luo de hong taiyang 毛主席您是我们心中不落的红太阳 (Chairman Mao, in our hearts you are the sun that never sets). Beijing: Renmin yinyue, 1977.

Meili de caoyuan, wo de jia 美丽的草原, 我的家 (Beautiful grasslands, my home). Beijing: Renmin yinyue, 1982.

Shiyue zhange 十月战歌 (October battle songs). Beijing: Renmin yinyue, 1977.

Shoufengqin banzou gequ 12 shou 手风琴伴奏歌曲 12 首 (Twelve songs with accordion accompaniment). Beijing: Renmin yinyue, 1977.

Wo ai ni, Zhongguo 我爱你中国 (I love you, China). Beijing: Renmin yinyue, 1982.

Xiao hechang biaoyanchang gequ xuan 小合唱表演唱歌曲选 (Selection of songs for a small choir). Guangxi: Guangxi renmin, 1975.

Xuetangge zhi fu: Shen Xingong 学堂歌之父—沈心工 (Shen Xingong: Father of the schoolsong). Taibei: Zhonghua minguo zuoqujia xiehui 1983.

Zhandou gesheng 战斗歌声 (Battle songs). Shanghai: Shanghai Renmin, 1974.

Zhongguo qunzhong gequ xuan 中国群众歌曲选 (Selection of Chinese songs for the masses). Tianjin: Zhonghua quanguo yinyue gongzuozhe xiehui, 1952.

CCP Central Committee 1966: "Decision Concerning the Great Proletarian Cultural Revolution." *Peking Review* 33 (1966): 6–11.

CCRD 2002: *Chinese Cultural Revolution Database.* Hong Kong: Chinese University of Hong Kong, 2002.

CCRD 2002a: *Guanyu ba xuexi Mao Zhuxi zhuzuo tigao dao yi ge xin jieduan de zhishi* 关于把学习毛主席著作提高到一个新阶段的指示 (Directions on elevating the study of Mao Zedong Thought to a new level), 18 September 1966.

CCRD 2002b: *Lin Biao zai zhongyang zhengzhiju kuoda huiyi shang de jianghua* 林彪在中央政治局扩大会议上的讲话 (Talk by Lin Biao at the Central Politbureau meeting), 24 January 1966; *Lin Biao zai quanjun zhengzhi gongzuo huiyi shang de baogao zhong de zhongyao zhishi* 林彪在全军政治工作会议上的报告中的重要指示 (Important directions given in Lin Biao's speech to the all-Army working meeting), 24 January 1966.

CDSZJ 1934: Zhang Taiyan. *Chongding sanzijing: Zhang Bingling chongding* 重订三字经: 章炳麟重订 (A newly ordered Three Character Classic: Newly ordered by Zhang Bingling), Shanghai: Hanwen zhengkai yinshuju, 1934.

Chan 1985: Chan, Anita. *Children of Mao: Personality Development and Political Activism in the Red Guard Generation.* Seattle: University of Washington Press, 1985.

Chan et al. 1984: Chan, Anita, Richard Madsen, and Jonathan Unger. *Chen Village: The Recent History of a Peasant Community in Mao's China.* Berkeley: University of California Press, 1984.

Chan 1996: Chan, Margaret W. W. "The 'Yellow River Piano Concerto' as a Site for Negotiating Cultural Spaces for a Diasporic Chinese Community in Toronto." Ph.D. Diss., York University, 1996.

Chang 1991: Chang, Jung. *Wild Swans: Three Daughters of China.* New York: Simon & Schuster, 1991.

Chang and Halliday 2005: Chang, Jung, and John Halliday. *Mao: The Unknown Story,* New York: Knopf, 2005.

Chang 1974: Chang, Parris H. "The Anti–Lin Piao and Confucius Campaign: Its Meaning and Purposes." *Asian Survey* 14, no. 10 (October 1974): 871–86.

Chao 1991: *Nuandong: Jiuling Kewang re* 暖冬—九零'渴望'热 (Warm winter: the "yearning" fever in 1990), edited by Chao Xi 潮汐 and Yi Fu 一夫. Beijing: Zhongguo guoji guangbo, 1991.

Chedi polan jiu shijie 1966: *Chedi polan jiu shijie* 彻底破烂旧世界 (Let's destroy the old world completely), edited by Shanxi gongnongbing yishu xuexiao "Hongweibing." No place, no publisher, 1966.

Chen 1988: Chen, Jo-Hsi. "Chairman Mao Is a Rotten Egg." In *The Execution of Mayor Yin and Other Stories form the Great Proletarian Cultural Revolution.* Bloomington: Indiana University Press, 1988.

Chen 1960: Chen, Shih-hsiang. "Multiplicity in Uniformity: Poetry and the Great Leap Forward." *China Quarterly* 3, no. 9 (1960): 1–15.

Chen 1995: Chen, Shing-Lih. "The Yellow River Piano Concerto: Politics, Culture, and Style." Ph.D. Diss., University of British Columbia, 1995.

Chen 1999: Chen, Xiaomei. "Growing up with Posters in the Maoist Era." In *Picturing Power in the People's Republic of China: Posters of the Cultural Revolution*, edited by Harriet Evans and Stephanie Donald. Lanham: Rowman and Littlefield, 1999: 101–22.

Chen 2002: Chen, Xiaomei. *Acting the Right Part: Political Theater and Popular Drama in Contemporary China*. Honolulu: University of Hawaii Press, 2002.

Chen 1992: Chen, Kaige, *Longxue shu* 龙血树 (The dragon-blood tree). Hong Kong: Tiandi Tushu, 1992.

Cheng 1986: Cheng, Nien. *Life and Death in Shanghai*. New York: Penguin, 1986.

Chi 2007: Chi, Robert. "'The March of the Volunteers': From Movie Theme Song to National Anthem." In *Re-Envisioning the Chinese Revolution: The Politics and Poetics of Collective Memories in Reform China*, edited by Lee Ching Kwan and Guobin Yang. Stanford: Stanford University Press, 2007.

China 2008: *China: Portrait of a Country*, edited by Liu Heung Shing. Hong Kong: Taschen, 2008.

China Avant-Garde 1994: *China Avant-Garde*, edited by Jochen Noth et al. Heidelberg: Brausdruck, 1994; Oxford: Oxford University Press, 1995.

The Chinese Cultural Revolution as History 2006: *The Chinese Cultural Revolution as History*, edited by Joseph W. Esherick, Paul G. Pickowicz, and Andrew G. Walder. Stanford: Stanford University Press, 2006.

Chinese Literature (CL)

CL 1960.9:6–17. "Meeting Chairman Mao."

CL 1965.5:3–48. "The Red Lantern."

CL 1967.2:29–76. Chen Kuang-sheng, "Chairman Mao's Good Fighter—Lei Feng."

CL 1967.3:73–90. Ching Chun, "Red Guards on a Long March."

CL 1967.3:97–105. Sung Hung, "A Night Climb Over 'Thorny Dam.'"

CL 1967.4:137. "New Gramophone Records Propagating Mao Tse-tung's Thought."

CL 1967.5–6:154–58. "New Foolish Old Men of Dashu."

CL 1967.7:40–96. "Wang Chieh."

CL 1967.8:129–81. "Taking the Bandits' Stronghold."

CL 1967.10:13–58. "Raid on the White Tiger Regiment."

CL 1967.11:54–71. "A Battle in the Gulf of Bac Bo."

CL 1968.3:84–97. "The World's People Love Chairman Mao."

CL 1968.5:89–99. "Heroes in the Epoch of Mao Tse-Tung's Thought: Szuma Li-hsuan 'Faithful Always to Chairman Mao, Serve the People Whole-heartedly.'"

CL 1968.7–8:3–25. "Chairman Mao's Good Cadre."

CL 1968.9:62–74. "Tempered in the Emerald Sea."

CL 1968.11:51–59. Wu Hsiao-ming, "Be a Good Daughter of the Poor Herdsmen."

CL 1969.1:3–53. "On the Docks."

CL 1969.6:85–88. "Cabbage to Support the Army."

CL 1969.9:4–72. "Chairman Mao's Good Pupil Chiao Yu-lu."

CL 1969.10:11–31. "To Live and Die for the Revolution—Yang Shui-tsai, a Fearless Communist."

CL 1969.11–12:68–78. "Deaf-Mutes Can Speak Now."

CL 1970.1:3–57. "Taking Tiger Mountain by Strategy," October 1969 Script.

CL 1970.1:58–74. "Strive to Create the Brilliant Images of Proletarian Heroes—Appreciations in Creating the Heroic Images of Yang Tzu-jung and Others."

CL 1970.1:108–13. Wei Hsia-an, "The Most Powerful Song."

CL 1970.2:81–92. "Draw on Life but from a Higher Plane: Some Impressions Regarding the Creation of Proletarian Heroes in Dance."

CL 1970.2:93–104. "Brilliant Example of the Revolution in Peking Opera Music."

CL 1970.5:3–24. "A Fine Proletarian Fighter."

CL 1970.5:40–52. "A Fighter of Steel Continues."

CL 1970.5:53–63. "In the Tachai Spirit."

CL 1970.7:3–18. "A Party Branch Secretary."

CL 1970.8:8–52. "The Red Lantern."

CL 1970.10:3–40. "Builder of Bridges."

CL 1970.11:3–62. "Shachiapang."

CL 1971.2:18–26. Yao Shih-chang, "Plant Peanuts Scientifically."

CL 1971.3:31–41. "Leader of the Hsiatingchia Production Brigade."

CL 1971.6:44–49. "Red Hearts and Green Seas."

CL 1971.6:50–58. "The First Step."

CL 1971.6:76–80. Lolao, "An Old Man Studies Chairman Mao's Works."

CL 1971.12:41–44. "Verses Composed during a March."

CL 1972.5:52–98. "On the Docks."

CL 1973.1:78–87. "Critique of the Film 'Naturally There Will Be Successors.'"

CL 1974.2:3–14. "A Vicious Motive, Despicable Tricks—A Criticism of M. Antonioni's Anti-China Film 'China.'"

CL 1974.3:15–84. Hu Chin, "The People of Tachai."

CL 1974.3:113–17. Chi Cheng, "New Developments in Traditional Chinese Painting."

CL 1974.6:86–91. Shih Hua-tsu, "Confucius, 'Sage' of All Reactionary Classes in China."

CL 1974.6:96–101. Chieh Chun, "Why Are We Denouncing Confucius in China?"

CL 1975.6:104–9. Hsin Ping, "New Children's Songs from a Peking Primary School."

CL 1976.2:70–86. Chang Szu-kung, "Men Can Conquer Heaven."

CL 1976.3:84–90. Hao Jan, "A Visit to Shashihyu."

CL 1976.7:113–15. "New Group Sculpture: Song of the Tachai Spirit."

CL 1977.4:36–52. Sung Shu-wen and Sung Kuei-sheng, "Heroes Split Mount Chialing."

Chinese Propaganda Posters 2003: *Chinese Propaganda Posters*, edited by Anchee Min, Duo Duo, and Stefan R. Landsberger. Cologne and Los Angeles: Taschen, 2003.

Chinesische Comics 1976: *Chinesische Comics: Gespenster Mörder Klassenfeinde*, translated and with a preface by Wolfgang Bauer. Düsseldorf: Eugen Diederichs Verlag, 1976.

Ching 1974: Ching, Julia. "Confucius and his Modern Critics: 1916 to the Present." *PoFEA*, 1974.10:117–46.

Chow 1960: Chow, Tse-Tsung. "The Anti-Confucius Movement in Early Republican China." In *The Confucian Persuasion*, edited by Arthur. F. Wright. Stanford: Stanford University Press, 1960: 288–312.

Clark 1987: Clark, Paul. *Chinese Cinema: Culture and Politics since 1949*. Cambridge: Cambridge University Press, 1987.

Clark 2003: Clark, Katerina. "Socialist Realism and the Sacralizing of Space." In *The Landscape of Stalinism: The Art and Ideology of Soviet Space*, edited by Evgeny Dobrenko and Eric Naiman. Seattle and London: University of Washington Press, 2003: 3–18.

Clark 2008: Clark, Paul. *The Chinese Cultural Revolution: A History*. Cambridge: Cambridge University Press, 2008.

Clunas 1999: Clunas, Craig. "Souvenirs of Beijing: Authority and Subjectivity in Art Historical Memory." In *Picturing Power in the People's Republic of China: Posters of the Cultural Revolution*, edited by Harriet Evans and Stephanie Donald. Lanham: Rowman and Littlefield, 1999: 47–61.

Cohen 1987: Cohen, Joan Lebold. *The New Chinese Painting (1949–1986)*. New York: H. N. Abrams, 1987.

Connell and Gibson 2003: Connell, John, and Chris Gibson. *Soundtracks: Popular Music, Identity and Place*. London and New York: Routledge Press, 2003.

Comics

Baimaonü 白毛女 (The white-haired girl). Tianjin: Tianjin renmin meishu, 1971.

Caoyuan ernü 草原儿女 (Little sisters of the grasslands). Beijing: Foreign Languages Press, 1973.

Chuangye 创业 (Pioneers). Tianjin: Tianjin renmin meishu, 1975.

Chunmiao 春苗 (Chunmiao). Shanghai: Shanghai renmin, 1976.

Haihua 海花 (Sea flower). Bejing: Beijing renmin 1975.

Haiying 海英 (Sea heroine). Beijing: Beijing renmin meishu, 1975.

Li Fengjin 1950: *Li Feng Jin—How the New Marriage Law Helped One Woman Stand Up*, edited and translated by Susan Glosser from a 1950 Chinese original. Portland: Opal Mogus Books, 2003.

Li Shuangshuang 李双双. Shanghai: Shanghai renmin, 1977 (first published 1964).

Little Sisters of the Grasslands. Beijing: Foreign Languages Press, 1973.

Longjiangsong 1974: *Longjiangsong* 龙江颂 (Song of the dragon river). Shanghai: Shanghai renmin meishu, 1974.

Luo Shengjiao: Guojizhuyi zhanshi Luo Shengjiao 国际注意战士罗盛教 (Luo Shengjiao, fighter for internationalism). Shanghai: Shanghai renmin, 1973.

Mao Zhuxi de hao xuesheng Jiao Yulu 毛主席的好学生焦裕禄 (Mao's good student, Jiao Yulu). Zhengzhou: Henan renmin, 1972.

Shashiyu 沙石峪 (Valley of Sand and Stones [i.e., the name of a village]). Shijiazhuang: Hebei renmin, 1975.

SWKSDBGJ 1962: *Sun Wukong san da baigujing* 孙悟空三打白骨精 (Sun Wukong thrice defeats the white-boned demon). Shanghai: Shanghai meishu, 1962.

SWKSDBGJ 1964: *Monkey Subdues the White-Boned Demon*. Beijing: Foreign Languages Press, 1964.

SWKSDBGJ 1972: *Sun Wukong san da baigujing* 孙悟空三打白骨精 (Sun Wukong thrice defeats the white-boned demon). Shanghai: Shanghai renmin, 1973.

"Tieren" Wang Jinxi "铁人" 王进喜 ("Iron Man" Wang Jinxi). Shanghai: Shanghai renmin, 1977.

Wang Guofu de gushi 1977: *Wang Guofu de gushi* 王国福的故事 (The story of Wang Guofu). Beijing: Renmin meishu, 1977.

Xiao balu 小八路 (The little eight roader). Shanghai: Shanghai renmin 1975.

Xiao haoshou 小号手 (The little trumpeter). Shanghai: Shanghai renmin, 1974.

Xionghuai 1971: *Xionghuai chaoyang zhan elang* 胸怀朝阳战恶浪 (Fighting nasty waves with a breast filled with the rising sun). Tianjin: Tianjin renmin meishu, 1971.

Xitele 希特勒 (Hitler). *Disandiguo de xingwang* 第三帝国的兴亡 (Rise and fall of the Third Reich). vols. 1–8. (Hitler comic series in 8 vols.), Chengdu: Sichuan meishu, 1987.

Zhang Side de gushi 张思德的故事 (The story of Zhang Side). Shenyang: Liaoning renmin, 1974.

Compagnon 1979: Compagnon, Antoine. *La Seconde Main ou le Travail de la Citation*. Paris: Seuil, 1979.

Crespi 2009: Crespi, John A. *Voices in Revolution: Poetry and the Auditory Imagination in Modern China*. Honolulu: University of Hawai'i Press, 2009.

Critical Introduction 2010: *A Critical Introduction to Mao*, edited by Timothy Cheek. Cambridge: Cambridge University Press, 2010.

Croizier 2010: Croizier, Ralph. "Hu Xian Peasant Painting: From Revolutionary Icon to Market Commodity." In *Art in Turmoil: China's Cultural Revolution, 1966–76*, edited by Richard King. Vancouver: University of British Columbia Press, 2010, 136–66.

Crone 2011: Crone, Raimund. "'5.000 Jahre'—Instrument oder Tradition." M.A. Thesis, Heidelberg 2011.

CTMXCS 1986: *Chuantong mengxue congshu* 传统蒙学丛书 (A collection of books of traditional children's education). Changsha: Yuelu shushe, 1986.

Cuccolini 2002: Cuccolini, Giulio C. "Ein Bastard auf Papier." In *Ästhetik des Comic*, edited by Michael Hein, Michael Hüners, and Torsten Michaelsen. Berlin: Erich Schmidt, 2002: 59–69.

Cushing and Tompkins 2007: Cushing, Lincoln, and Ann Tompkins. *Chinese Posters: Art from the Great Proletarian Cultural Revolution*. San Francisco: Chronicle Books, 2007.

DACHS (Digital Archive for Chinese Studies)

DACHS 2004: Lu Xin-An. "Dazhai: Imagistic Rhetoric as a Cultural Instrument" http://www.sino.uni-heidelberg.de/archive2/2012/04/07/lu120407/ac-journal.org/journal/vol5/iss1/articles/lu.pdf

DACHS 2004 New New Year Print http://www.sino.uni-heidelberg.de/archive2/2006/09/18/prc060918/1070887388_2.jpg

DACHS 2004 "Old-time Primers Revive in Modern Classroom." (*Xinhua* 1 January 2004). http://www.sino.uni-heidelberg.de/archive2/2009/11/03/xihuan091103.htm

DACHS 2005 Mao Image: "Great helmsman's role still has currency." (*The Guardian* 05 September 2006). http://www.sino.uni-heidelberg.de/archive2/2012/05/10/theguardian120510/www.smh.com.au/news/opinion/great-helmsmans-role-still-has-currency/2005/09/04/1125772404603.html

DACHS 2006 Bernstein, Thomas Chang Jung http://www.sino.uni-heidelberg.de/archive2/2006/01/31/bernstein060131.txt

DACHS 2007 Karaoke "Shehui zhuyi hao" 社会主义好 (Socialism is good) http://www.sino.uni-heidelberg.de/archive2/2008/01/24/maozhuxiwansuikaraoke080124.html

DACHS 2007 Mao Ceramics http://www.sino.uni-heidelberg.de/archive2/2007/12/19/culturalrevolutionsite071219/www.zitantique.com/colorceramics.html

DACHS 2007 Mao Paraphernalia http://www.sino.uni-heidelberg.de/archive2/2007/12/19/culturalrevolutionsite071219/www.zitantique.com/cr1.html

DACHS 2007 Mao, the Unknown Story http://www.sino.uni-heidelberg.de/archive2/2005/11/documents/people/cpl051122/www.wellesley.edu/polisci/wj/chinalinks-new/whatsnew.html

DACHS 2007 "Red Is the East" http://www.sino.uni-heidelberg.de/archive2/2008/01/24/internationaltheeastisred080124.html

DACHS 2007 Wu Qinghua http://www.sino.uni-heidelberg.de/archive2/2007/12/21/along071221.htm

DACHS 2007 *Yellow River* http://www.sino.uni-heidelberg.de/archive2/2011/03/14/langlang110314/

DACHS 2007 Yellow River Children's Song 2007
http://www.sino.uni-heidelberg.de/
archive2/2008/01/24/
yellowriverconvertobeijing080124.html

DACHS 2008 Bruder Jakob, Anti-Warlord Song,
Guomindang 1926
http://www.sino.uni-heidelberg.de/
archive2/2008/06/30/youtube080630.html

DACHS 2008 Bruder Jakob, Instrumental,
Anti-Warlord Song, Guomindang 1926
http://www.sino.uni-heidelberg.de/
archive2/2012/04/05/frerejacques120405/www
.youtube.com/watch@v=ceu7pvq24ae
&feature=related.htm

DACHS 2008 Chinese National Anthem, Story
http://www.sino.uni-heidelberg.de/
archive2/2008/05/15/wubeiguang080515.htm

DACHS 2008 Chinese National Anthem,
Chronology
http://www.sino.uni-heidelberg.de/
archive2/2009/04/07/guoge090407.htm

DACHS 2008 Cui Jian "A Piece of Red Cloth"
http://www.sino.uni-heidelberg.de/
archive2/2011/03/23/cui110323/www.youtube
.com/watch@v=l8upst1zksw.htm

DACHS 2008 Cultural Revolution Art
http://www.sino.uni-heidelberg.de/
archive2/2011/11/17/xu111117/www.jyzarts
.com/index1.htm

DACHS 2008 Cultural Revolution Photos
http://www.sino.uni-heidelberg.de/
archive2/2008/04/09/liupeng080409a.htm

DACHS 2008 Cultural Revolution Wedding
http://www.sino.uni-heidelberg.de/
archive2/2008/04/09/liupeng080409.htm

DACHS 2008 Dazhai
http://www.sino.uni-heidelberg.de/
archive2/2011/03/23/chen110323/data.book
.hexun.com/chapter-2014-3-4.shtml.htm

DACHS 2008 Dongfang Hong, Banquet Singing
(0:34–1:40)
http://www.sino.uni-heidelberg.de/
archive2/2008/03/11/banquet080311/
theeastisredbanquet080311.html

DACHS 2008 Dongfang Hong, Chinese Women's
Soccer Team
http://www.sino.uni-heidelberg.de/
archive2/2008/03/11/womensoccer080311/
dongfanghongwomensoccer080311.html

DACHS 2008 Dongfang Hong, International
Exchange Students
http://www.sino.uni-heidelberg.de/
archive2/2008/03/11/donghua080311/
dongfanghongexstud080311.html

DACHS 2008 Dongfang Hong, Karaoke
http://www.sino.uni-heidelberg.de/
archive2/2008/03/11/
dongfanghongkaraoke080311.html

DACHS 2008 Dongfang Hong, Laowai 2007
http://www.sino.uni-heidelberg.de/
archive2/2008/03/11/honglaowai080311/
dongfanghonglaowai080311.html

DACHS 2008 Dongfang Hong, Sexy
http://www.sino.uni-heidelberg.de/
archive2/2008/04/10/hunantiyu080410.htm

DACHS 2008 Farewell My Concubine, Beginning
Section
http://www.sino.uni-heidelberg.de/
archive2/2008/02/06/tangchen080206/
farewellmyconcubinepart1080206.html

DACHS 2008 Foolish Old Man, Advertisement
1996
http://www.sino.uni-heidelberg.de/
archive2/2009/04/09/cnad090409.htm

DACHS 2008 Foolish Old Man, Advertisement
2007
http://www.sino.uni-heidelberg.de/archive2/2009
/04/02/68design090402.htm

DACHS 2008 Foolish Old Man, Advertisement
2008 (initiated by 上海文广新闻传媒集团
[SMG])
http://www.sino.uni-heidelberg.de/
archive2/2009/04/09/dishuiyuan090409.htm

DACHS 2008 Foolish Old Man, Advisory Book
2008 "新愚公移山–十个社会企业创业者
的故事"
http://www.sino.uni-heidelberg.de/
archive2/2011/03/25/kubrik110325/www
.kubrick.com.hk/photo/book/b18091.jpg

DACHS 2008 Foolish Old Man, Caricature
http://www.sino.uni-heidelberg.de/
archive2/2012/04/07/sxshuhua120407/www
.sxshuhua.com/news_view.asp@newsid=803.htm

DACHS 2008 Foolish Old Man, Children's Cartoon
http://www.sino.uni-heidelberg.de/
archive2/2011/03/25/tudou110325/tudou.htm

DACHS 2008 Foolish Old Man, Children's Comic
http://www.sino.uni-heidelberg.de/
archive2/2009/04/17/youerhuabao090417.htm

DACHS 2008 Foolish Old Man, Children's Comic
(published 2008/3/24 by Sina.com 新浪网)
http://www.sino.uni-heidelberg.de/
archive2/2009/04/17/youerhuabao090417.htm

DACHS 2008 Foolish Old Man, Music
(江涛《愚公移山》)
http://www.sino.uni-heidelberg.de/
archive2/2011/03/25/jiang110325/tudou.htm

DACHS 2008 Foolish Old Man, Music Club Beijing
http://www.sino.uni-heidelberg.de/
archive2/2011/03/27/yugongyishan110327/
www.yugongyishan.com/default.htm

DACHS 2008 Foolish Old Man, Music, Live
(Interaction with Public)
http://www.sino.uni-heidelberg.de/
archive2/2012/03/20/jiang120320/o8pCP9kL8z4
.htm

DACHS 2008 Foolish Old Man, Music, Nature
Foregrounded
http://www.sino.uni-heidelberg.de/
archive2/2009/03/28/yugongyishan090328.htm

DACHS 2008 Foolish Old Man, TV Drama,
Episode 1
http://www.sino.uni-heidelberg.de/archive2/2009
/05/05/01tvyugongyishan090505.wmv

DACHS 2008 Foolish Old Man, TV Drama,
Episode 4
http://www.sino.uni-heidelberg.de/archive2/2009
/05/26/05tvyugongyishan090526.avi

DACHS 2008 Foolish Old Man, TV Drama,
Episode 40
http://www.sino.uni-heidelberg.de/
archive2/2011/03/27/wu110327/www.tudou
.com/programs/view/j6gunsf_3wm/default.htm

DACHS 2008 Foolish Old Man, TV Drama 2007–8
《愚公移山的故事》 Director: 吴家骀,
Premiere: July 2008 on CCTV
http://www.sino.uni-heidelberg.de/
archive2/2009/04/02/haifeng090402.htm

DACHS 2008 Foolish Old Man, TV Drama Blog 1
http://www.sino.uni-heidelberg.de/
archive2/2012/04/17/sanwen_a120417/www
.sanww.com/www/0021203/2578.html

DACHS 2008 Foolish Old Man, TV Drama Blog 2
http://www.sino.uni-heidelberg.de/
archive2/2012/04/17/sanwen_b120417/www
.sanww.com/www/0021202/1889.html

DACHS 2008 Foolish Old Man, TV Drama 2007–8
Critical Views
http://www.sino.uni-heidelberg.de/
archive2/2009/04/17/yugongyishansina090417/
ent.sina.com.cn/v/m/f/ygys/index.html

DACHS 2008 Foolish Old Man, TV Drama
Prepublication Announcement
http://www.sino.uni-heidelberg.de/
archive2/2011/03/27/xinlang_a110327/ent.sina
.com.cn/v/m/2007-04-13/14501518245.html

DACHS 2008 Foolish Old Man, TV Drama
Images (7)
http://www.sino.uni-heidelberg.de/
archive2/2011/03/27/xinlang_b110327/ent.sina
.com.cn/d/2007-12-16/22541837137.shtml.htm

DACHS 2008 Foolish Old Man, Wooden Toys
http://www.sino.uni-heidelberg.de/
archive2/2011/03/25/hannuota110325/market
.jinti.com/market-82-530480-zzdanni.html

DACHS 2008 Foolish Old Man, Yangbanxi Linux,
Hong Kong Advertisement
http://www.sino.uni-heidelberg.de/
archive2/2009/03/26/linux090326/linux090326
.html

DACHS 2008 Internationale (Tang Dynasty
Version)
http://www.sino.uni-heidelberg.de/
archive2/2011/03/27/tangchao110327/
internationale-cn-tang-chao.mp3

DACHS 2008 Internationale, Lyrics Changes
http://www.sino.uni-heidelberg.de/
archive2/2009/04/07/lvyuan090407.htm

DACHS 2008 Julian Ward, Zhang Side
http://www.sino.uni-heidelberg.de/
archive2/2009/03/28/ward090328/www.latrobe
.edu.au/screeningthepast/22/zhang-side.html

DACHS 2008 Lao Sanpian and Sange Daibiao, 2004
http://www.sino.uni-heidelberg.de/
archive2/2011/03/27/mao110327/book.danawa
.com.cn/book/169312.html

DACHS 2008 Liu Liguo
http://www.sino.uni-heidelberg.de/
archive2/2008/02/08/liuliguo080208/www
.asiaartcenter.org/_exhib_/e-20070228-7.php.htm

DACHS 2008 Liu Liguo, Buddha
http://www.sino.uni-heidelberg.de/
archive2/2009/02/26/liuliguo090226/artist
.zhuokearts.com/2/default.asp@base_id=10223
.htm

DACHS 2008 Liu Xiaoming, Comics
http://www.sino.uni-heidelberg.de/
archive2/2008/02/06/lianhuanhua080206/
liuxmm51.51.net/lhh10.htm

DACHS 2008 Mao Citations, Sun and Truth
http://www.sino.uni-heidelberg.de/
archive2/2008/03/06/schello80306.htm

DACHS 2008 Mao Images (Mao, Pictorial Works)
http://www.sino.uni-heidelberg.de/
archive2/2009/02/24/contempartchina090224
.pdf

DACHS 2008 Mao Images 2 (Mao, Pictorial Works)
http://www.sino.uni-heidelberg.de/
archive2/2009/02/24/contempartchina090224b
.pdf

DACHS 2008 Mao Images International
1. Kenmore Dishwasher
http://www.sino.uni-heidelberg.de/
archive2/2009/02/25/bravogroup090225/
adsoftheworld.com/media/print/kenmore
_dishwasher_mao.htm

2. Jim Riswold http://www.sino.uni-heidelberg
.de/archive2/2009/02/25/bernstein090225.htm

DACHS 2008 Mao's Pad!
http://www.sino.uni-heidelberg.de/
archive2/2009/04/17/radicaljack090417.htm

DACHS 2008 Mao Paraphernalia, "Red Is the East"
http://www.sino.uni-heidelberg.de/
archive2/2008/06/30/theeastisred080630/www
.theeastisred.com/index2.htm

DACHS 2008 Mao Portrait Citroen (Mao Ad),
Censured Advertisement 2008
http://www.sino.uni-heidelberg.de/
archive2/2009/03/31/bbc090331/news.bbc.co
.uk/2/hi/asia-pacific/7190249.stm.htm

DACHS 2008 Mao Song Texts Collected
http://www.sino.uni-heidelberg.de/
archive2/2009/04/07/mowutianya090407/tieba
.baidu.com/f@kz=206120581.htm

DACHS 2008 Mao to Mozart
http://www.sino.uni-heidelberg.de/
archive2/2008/01/23/sterno80123/index.htm

DACHS 2008 Mao to Mozart, Cello Child Prodigy
http://www.sino.uni-heidelberg.de/
archive2/2008/05/21/shanghaidaily080521.htm

DACHS 2008 Melvin/Cai "Why This Nostalgia for
Fruits of Chaos?" *New York Times* 29 October
2000
http://www.sino.uni-heidelberg.de/
archive2/2008/01/29/melvino80129.htm

DACHS 2008 News of the Communist Party of
China
http://www.sino.uni-heidelberg.de/
archive2/2011/11/17/shi111117/cpc.people.com
.cn/gb/64150/64154/4482098.html

DACHS 2008 Online Exhibition, 22
http://www.sino.uni-heidelberg.de/
archive2/2008/06/30/unihd080630/www.sino
.uni-heidelberg.de/conf/propaganda/bild22.html

DACHS 2008 Qi Baima, Origins of Dongfang Hong
http://www.sino.uni-heidelberg.de/
archive2/2008/05/15/xinhuaneto80515.htm

DACHS 2008 Red Book, Landsberger
http://www.sino.uni-heidelberg.de/
archive2/2008/09/06/maozedong080906/www
.iisg.nl/~landsberger/myl.html

DACHS 2008 Red Book, Heidelberg
http://www.sino.uni-heidelberg.de/
archive2/2008/06/30/unihd080630/www.sino
.uni-heidelberg.de/conf/propaganda/exhibition
.html

DACHS 2008 Sailing the Seas Depends on the
Helmsman (Background Stories) 大海航行靠舵
手'流行的前前后后, from Culture Friday 文化
星期五. Originally published in Retracing the
Moments 追忆瞬间, Jiangsu: meishu, 2002.

http://www.sino.uni-heidelberg.de/
archive2/2009/04/07/lizhensheng090407.htm

DACHS 2008 Sailing the Seas Depends on the
Helmsman, English Version (background movie
Dongfang Hong, 1964)
http://www.sino.uni-heidelberg.de/
archive2/2008/08/04/youtube080804g.html

DACHS 2008 Sanzijing Essay by Li Jianming
李键明
http://www.sino.uni-heidelberg.de/
archive2/2008/06/07/lijianming080607/www
.sc168.com/epaper/files/20070512/
f200705120004.html

DACHS 2008 Satellite "Red Is the East"
http://www.sino.uni-heidelberg.de/
archive2/2008/03/10/eastisreado80310.html

DACHS 2008 Shashiyu
http://www.sino.uni-heidelberg.de/
archive2/2012/04/13/shashiyu120413/
lianhuanhua.momo01.com/xd/2010/1107/4642
.html

DACHS 2008 We Shall Overcome, Chronology
(McIntyre)
http://www.sino.uni-heidelberg.de/
archive2/2008/07/10/mcintyreo80710.htm

DACHS 2008 Workers Criticizing Lin Biao and
Confucius
http://www.sino.uni-heidelberg.de/
archive2/2010/08/13/qiudeshu100813/
qiudeshu100813.htm

DACHS 2008 Xiading juexin Slimline
http://www.sino.uni-heidelberg.de/
archive2/2009/03/28/thinfoo90328/www.thinfo
.org/bbs/read.php@tid=1212&fpage=
0&toread=&page=1.htm

DACHS 2008 Yangbanxi Model Works, Foreign
Uses
http://www.sino.uni-heidelberg.de/
archive2/2007/11/21/walton071121.htm

DACHS 2008 Yizhi yangbanxi
http://www.sino.uni-heidelberg.de/
archive2/2008/02/29/anxiano80229.htm

DACHS 2008 Yizhi yangbanxi 2
http://www.sino.uni-heidelberg.de/
archive2/2008/02/29/chenpixiano80229/www
.spph.com.cn/books/bkview.asp@
bkid=79656&cid=188153.htm

DACHS 2008 Yuluge "Jinian Bai Qiu'en"
纪念白求恩, Song
http://www.sino.uni-heidelberg.de/
archive2/2009/03/31/oldmusic090331.htm

DACHS 2008 Yuluge "Foolish Old Man,"
Pop Version
http://www.sino.uni-heidelberg.de/
archive2/2008/09/06/yugongyishano80906.mp3

DACHS 2008 Yuluge Mao Memorial Concert, September 8, 2006
http://www.sino.uni-heidelberg.de/archive2/2012/04/13/beijing1hao120413/bj1h.blog.hexun.com/5513972_d.html

DACHS 2008 Yuluge "Wei Renmin Fuwu" 为人民服务, Score
http://www.sino.uni-heidelberg.de/archive2/2008/09/06/weirenminfuwu080906.htm

DACHS 2008 Zhandi Xin'ge
http://www.sino.uni-heidelberg.de/archive2/2011/04/06/wu110406/www.zdxg.com/default.htm

DACHS 2008 Zhang Hongtu
http://www.sino.uni-heidelberg.de/archive2/2008/01/16/zhanghongtu080116/momao.com/default.htm

DACHS 2008 Zhang Side
http://www.sino.uni-heidelberg.de/archive2/2009/04/07/zhangside090407/zsd.chinaspirit.net.cn/lwrmfw.htm

DACHS 2008 Zhang Yihe 章诒和 Beijing Opera Zhang Yihe 章诒和 "Jingju jinxiao chongxin kaishi zong bi bu kai hao" 京剧进校—重新开始总比不开始好 (Beijing Opera enters the schools—to begin again is always better than not to begin at all). Nanfang Zhoumo, 28 February 2008.
http://www.sino.uni-heidelberg.de/archive2/2008/06/09/zhangyihe080609.htm

DACHS 2008 Zhimayou, Origins of Dongfang hong
http://www.sino.uni-heidelberg.de/archive2/2008/06/09/yumei080609.htm

DACHS 2008 Zhongziwu as Children's Entertainment, Danced in the 21st Century
http://www.sino.uni-heidelberg.de/archive2/2009/04/21/hkbbs090421/www.youtube.com/watch@feature=related&hl=de&v=icwropahtuk&gl=de.htm

DACHS 2008 Zhongziwu, Xiading juexin, Wedding Performance, 2007, 21st Century, with US Flag
http://www.sino.uni-heidelberg.de/archive2/2008/08/04/youtube080804f.html

DACHS 2008 Zhongziwu, Zaofan you li: "To Rebel is Justified"
http://www.sino.uni-heidelberg.de/archive2/2009/04/21/hkbbs090421/www.youtube.com/watch@feature=related&hl=de&v=icwropahtuk&gl=de.htm

DACHS 2009 Ai Weiwei Blog, A Study in Perspective
http://www.sino.uni-heidelberg.de/archive2/2012/04/13/ai120413/www.bullogger.com/blogs/aiww/archives/212063.aspx.htm

DACHS 2009 Anyuan Strikes, Film Version, The Earth is Burning 燎原 1962 (上海天马电影制片厂)
http://www.sino.uni-heidelberg.de/archive2/2009/09/04/xiaojianping090904/qkzz.net/magazine/0492-0929/2005/08/131287.htm

DACHS 2009 Jeremy Brown, Cultural Revolution Culture ("Putting Culture Back into the Cultural Revolution")
http://www.sino.uni-heidelberg.de/archive2/2009/08/28/brown090828.htm

DACHS 2009 Censorship of Cultural Revolution Books
http://www.sino.uni-heidelberg.de/archive2/2007/01/22/martinsen070122.htm
http://www.sino.uni-heidelberg.de/archive2/2009/09/25/martinsen090925.htm

DACHS 2009 Cinema Performances in the Countryside
http://www.sino.uni-heidelberg.de/archive2/2012/04/13/morningsun120413/www.morningsun.org/living/movies/theater.swf

DACHS 2009 Citroen Ad Blog Responses
http://www.sino.uni-heidelberg.de/archive2/2009/03/25/yiwenkaiyinzai090325/shjl2008.blog.sohu.com/76534675.html
http://www.sino.uni-heidelberg.de/archive2/2009/03/25/laoshupio090325.htm
http://www.sino.uni-heidelberg.de/archive2/2009/03/25/lafengdelaonio090325.htm
http://www.sino.uni-heidelberg.de/archive2/2009/03/25/wangzhehuigui090325.htm

DACHS 2009 Chinese Comics, Blog
http://www.sino.uni-heidelberg.de/archive2/2011/10/26/zuisheng111026/blog.sina.com.cn/shoucang.htm

DACHS 2009 Chinese Comics, Model Works
http://www.sino.uni-heidelberg.de/archive2/2009/08/12/zuishengdo090812.htm

DACHS 2009 Chinese Comics, 1950s and 60s
http://www.sino.uni-heidelberg.de/archive2/2009/08/12/zuisheng090812.htm

DACHS 2009 Cui Jian Pink Floyd
http://www.sino.uni-heidelberg.de/archive2/2009/03/18/rockempire090318.htm

DACHS 2009 Cultural Revolution Comics: Opening Page
http://www.sino.uni-heidelberg.de/archive2/2011/10/26/zuisheng111026/blog.sina.com.cn/shoucang.htm

DACHS 2009 Cultural Revolution Comics: Representative Selection
http://www.sino.uni-heidelberg.de/archive2/2009/08/12/zuishenge090812.htm

DACHS 2009 Cultural Revolution Comics: Criticizing Lin Biao and Confucius http://www.sino.uni-heidelberg.de/archive2/2009/07/21/zuisheng090721b.htm

DACHS 2009 Cultural Revolution Comics: Red Memories, Child Heroes http://www.sino.uni-heidelberg.de/archive2/2009/07/21/zuisheng090721a.htm

DACHS 2009 Cultural Revolution Style Restaurants heidelberg.de/archive2/2011/08/31/flickr_a110831/www.flickr.com/photos/derekindalian/2213062203/default.htm heidelberg.de/archive2/2011/08/31/flickr_b110831/www.flickr.com/photos/derekindalian/2213049273/default.htm

DACHS 2009 Cultural Revolution Wedding Pictures http://www.sino.uni-heidelberg.de/archive2/2009/10/26/associated091026/www.montereyherald.com/news/ci_13427577.htm http://www.sino.uni-heidelberg.de/archive2/2012/04/19/hongzhuang120419/www.51hongzhuang.com/anlishow.asp@id=1971.htm http://www.sino.uni-heidelberg.de/archive2/2012/04/19/yang120419/yangdahai.blshe.com/post/3036/410779.htm

DACHS 2009 Documentary Photographs, Cultural Revolution, William A. Joseph, "Serve the People" http://www.sino.uni-heidelberg.de/archive2/2011/09/02/joseph110902/www.wellesley.edu/polisci/wj/china1972/intro.html

DACHS 2009 Documentary Photographs, Cultural Revolution, Anti-Confucius Movement, Thomas Hahn http://www.sino.uni-heidelberg.de/archive2/2012/04/27/hahn_a120427/hahn.zenfolio.com/p936730597.htm

Documentary Photographs, Cultural Revolution, Swimming Mao, Thomas Hahn http://www.sino.uni-heidelberg.de/archive2/2012/04/27/hahn_b120427/hahn.zenfolio.com/p897104878.htm

Documentary Photographs, Cultural Revolution, Sent-Down Youth I, Thomas Hahn http://www.sino.uni-heidelberg.de/archive2/2012/04/27/hahn_c120427/hahn.zenfolio.com/p53209267.htm

Documentary Photographs, Cultural Revolution, Sent-down Youth II, Thomas Hahn http://www.sino.uni-heidelberg.de/archive2/2012/04/27/hahn_d120427/hahn.zenfolio.com/p733311863.htm

DACHS 2009 Dongfang Hong, PRC 60 Years Anniversary http://www.sino.uni-heidelberg.de/archive2/2009/08/25/zhengtingting090825.htm

DACHS 2009 Dongfang Hong, "Red Is the East," Original Words http://www.sino.uni-heidelberg.de/archive2/2009/09/11/morningsun090911/www.morningsun.org/about/index.html

DACHS 2009 Erro Mao http://www.sino.uni-heidelberg.de/archive2/2009/12/09/childlit091209/www.childlit.com/battledore/shop/index.php@productid=147.htm

DACHS 2009 Foolish Old Man TV Drama, Prepublication Material May 2007 http://www.sino.uni-heidelberg.de/archive2/2009/09/02/sina090902/news.mdbchina.com/sections/news/20070524/404207.html

DACHS 2009 Fool's Mountain (Yugong yi shan), Overseas Chinese Blog San Francisco http://www.sino.uni-heidelberg.de/archive2/2009/09/18/foolsmountain090918/blog.foolsmountain.com/default.htm

DACHS 2009 Gao Brothers Interview http://www.sino.uni-heidelberg.de/archive2/2009/02/26/fanguai090226/www.artist.org.cn/artist/11/1/200408/1207.html

DACHS 2009 Hamlin on Sui Jianguo http://www.sino.uni-heidelberg.de/archive2/2009/02/24/hamlin090224.htm

DACHS 2009 Heroes Old and New http://www.sino.uni-heidelberg.de/archive2/2009/07/31/lilei090731.htm

DACHS 2009 Hong Taiyang Sales Figures http://www.sino.uni-heidelberg.de/archive2/2009/03/19/ecrsco090319.htm http://www.sino.uni-heidelberg.de/archive2/2009/03/19/xumin090319.htm

DACHS 2009 Hu Jie 胡杰, Though I Am Gone 我虽死去, 2006 http://www.sino.uni-heidelberg.de/archive2/2008/01/24/though_i_am_gone080124/index.htmPart 1

DACHS 2009 Jeremy Brown, Cultural Revolution Culture ("Putting Culture Back into the Cultural Revolution") http://www.sino.uni-heidelberg.de/archive2/2009/08/28/brown090828.htm

DACHS 2009 Landsberger: Dazhai http://www.sino.uni-heidelberg.de/archive2/2009/03/18/landsberger090318.htm

DACHS 2009 Landsberger: Jin Meisheng
 http://www.sino.uni-heidelberg.de/
 archive2/2009/08/28/landsberger090828/www
 .iisg.nl/landsberger/sheji/sj-jms.html
DACHS 2009 Landsberger: Lei Feng
 http://www.sino.uni-heidelberg.de/
 archive2/2009/09/02/landsbergerd090902.htm
DACHS 2009 Landsberger: Liu Yingjun
 http://www.sino.uni-heidelberg.de/
 archive2/2009/09/02/landsberger090902.htm
DACHS 2009 Landsberger: Luo Shengjiao
 http://www.sino.uni-heidelberg.de/
 archive2/2009/09/04/landsberger090904.htm
DACHS 2009 Landsberger: Mao Cult
 http://www.sino.uni-heidelberg.de/
 archive2/2009/11/17/langsberger091117.htm
DACHS 2009 Landsberger: Norman Bethune
 http://www.sino.uni-heidelberg.de/
 archive2/2009/03/18/langsberg090318.htm
DACHS 2009 Landsberger: Wang Guofu
 http://www.sino.uni-heidelberg.de/
 archive2/2009/09/02/landsbergerc090902.html
DACHS 2009 Landsberger: Wang Jie
 http://www.sino.uni-heidelberg.de/
 archive2/2009/09/02/landsbergerb090202.htm
DACHS 2009 Lei Feng, Li Ning Running Shoes
 http://www.sino.uni-heidelberg.de/
 archive2/2009/02/26/haibao090226.htm
DACHS 2009 Liu Liguo
 http://www.sino.uni-heidelberg.de/
 archive2/2009/02/26/liuliguo090226/artist
 .zhuokearts.com/2/default.asp@base_id=10223
 .htm
DACHS 2009 Liu Liguo, Mao Buddha
 http://www.sino.uni-heidelberg.de/
 archive2/2009/02/26/zhuqi090226/www.artist
 .org.cn/yanlun/2/4/200706/27026.html
 http://www.sino.uni-heidelberg.de/archive2/
 2009/02/26/liuliguo090226/news.zhuokearts
 .com/newsdetails.aspx@id=61312.htm
DACHS 2009 Lynn Zhang
 http://www.sino.uni-heidelberg.de/
 archive2/2009/02/24/zhang090224.htm
DACHS 2009 Mao by Gerhard Richter
 http://www.sino.uni-heidelberg.de/
 archive2/2009/02/13/richter090213.htm
DACHS 2009 Mao Cult
"Mao Writings Mined for Tips on Capitalism"
 (Christoper Bodeen), The Guardian 24 December
 2003
 http://www.sino.uni-heidelberg.de/archive/
 documents/ccp/bodeen031230.htm
DACHS 2009 Mao Images
 http://www.sino.uni-heidelberg.de/
 archive2/2009/12/10/dongfanghong101209/bbs
 .daheshoucang.com/viewthread.php@tid=37234
 .htm

DACHS 2009 Mao Memory
 http://www.sino.uni-heidelberg.de/
 archive2/2009/08/12/dengxia090812.htm
DACHS 2009 Mao Money
 http://www.sino.uni-heidelberg.de/
 archive2/2009/07/31/honggushi090731/www
 .honggushi.com/article/lishituku/200902/6800
 .html
DACHS 2009 Mao Nostalgia
 http://www.sino.uni-heidelberg.de/
 archive2/2009/09/11/wuzhong090911/www
 .atimes.com/atimes/china/ke06ad02.html
DACHS 2009 Mao Portrait Li Qi
 http://www.sino.uni-heidelberg.de/
 archive2/2011/10/26/li111026/www.fox2008.cn/
 article/2011/20110321031033_50132.html
DACHS 2009 Mao Reverence
 http://www.sino.uni-heidelberg.de/
 archive2/2009/02/24/msn090224/msn.ynet.com/
 view.jsp@oid=48747211.htm
DACHS 2009 Mao SARS: Zhang Erping "SARS:
 Unmasking Censorship in China," Association for
 Asian Research 8 November 2003
 http://www.sino.uni-heidelberg.de/
 archive2/2011/05/12/zhang110512/www
 .asianresearch.org/articles/1502.html
DACHS 2009 Mao Songs, Chic Variété Version
 (Audience in Their 60s)
 http://www.sino.uni-heidelberg.de/
 archive2/2012/04/08/hu0120408/www.tudou
 .com/programs/view/kovkmvgdkoc/default.htm
DACHS 2009 Mao Songs, Jingdong Dagu Version
 京东大鼓
 http://www.sino.uni-heidelberg.de/
 archive2/2012/04/08/tudo_b120408/www.tudou
 .com/programs/view/25uwe-zh20s/default.htm
DACHS 2009 Mao Songs, Mao's Love
 http://www.sino.uni-heidelberg.de/
 archive2/2009/05/22/maosong090522/v.youku
 .com/v_show/id_xndixodgyndg=.html
DACHS 2009 Mao Songs, Pop Version with
 Documentary Photographs
 http://www.sino.uni-heidelberg.de/
 archive2/2012/04/08/mao_v120408/v.ku6.com/
 show/4vhhrbrb6we5wako.html
DACHS 2009 Mao Songs, Pop Version with MTV
 Girls and Nature
 http://www.sino.uni-heidelberg.de/
 archive2/2011/11/02/wole111102/play_album
 -aid-7477216_vid-NDQ1NzQ4Nzg.html
DACHS 2009 Mao Songs, Pop Version, Very
 Professional MTV Nature
 http://www.sino.uni-heidelberg.de/
 archive2/2011/11/02/youku_a111102/v.youku
 .com/v_show/id_xotaxnja2mzy=.html

DACHS 2009 Mao Songs, Private Karaoke Version
http://www.sino.uni-heidelberg.de/
archive2/2011/10/26/maosong_b111026/video
.sina.com.cn/v/b/20950783-1337970873.html

DACHS 2009 Mao Songs, Private Performance in
Mao Clothes with Red Book
http://www.sino.uni-heidelberg.de/
archive2/2011/11/02/youku_b111102/v.youku
.com/v_show/id_xnjg2mjgomti=.html

DACHS 2009 Mao Songs, Red Guard Party Karaoke
Version
http://www.sino.uni-heidelberg.de/
archive2/2011/10/26/maosong111026/v.youku
.com/v_show/id_xmtm4otuznja=.html

DACHS 2009 Mao Songs, Traditional Instrument/
Choir Version
http://www.sino.uni-heidelberg.de/archive2/
2012/04/08/tudo_a120408/www.tudou.com/
programs/view/-9jsn3ot1cs/default.htm

DACHS 2009 Mao Yulu Cellphone Ring
http://www.sino.uni-heidelberg.de/archive2/
2009/09/02/fengyepiaoling090902/q.yesky.com/
group/review-9583982.html

DACHS 2009 Mao Yulu, Red SMS Competition,
Chongqing
http://www.sino.uni-heidelberg.de/archive2/
2009/09/02/yangjia090902/leaders.people.com
.cn/gb/9209303.html

DACHS 2009 Mao Yuluge Archive
http://www.sino.uni-heidelberg.de/
archive2/2012/04/17/maosong120417/yuluge
.html

DACHS 2009 Mao Yuluge Archive: "Xiading
Juexin" with "Dongfang Hong"
http://www.sino.uni-heidelberg.de/
archive2/2012/04/17/maosong120417/
zhengqushengli2.mp3

DACHS 2009 New New Year Prints
http://www.sino.uni-heidelberg.de/
archive2/2011/10/20/hongjunqi111020/www
.mzdbl.cn/huaji/huaji-3.html

DACHS 2009 Poll Popularity Mao
http://www.sino.uni-heidelberg.de/
archive2/2009/03/18/beiqingwang090318/www
.ynet.com/event.jsp@eid=13110576.htm

DACHS 2009 Propaganda Posters, Landsberger
Collection (edited by Stefan Landsberger)
http://www.sino.uni-heidelberg.de/archive/
documents/history/www.iisg.nl/~landsberger/

DACHS 2009 Propaganda Posters, Maopost.com
(edited by Pierre-Loic Lavigne and Pierre
Budestschu)
http://www.sino.uni-heidelberg.de/archive2/
continuous/055/www.maopost.com/

DACHS 2009 Propaganda Posters, University of
Westminster Collection (edited by Katie Hill)
http://www.sino.uni-heidelberg.de/
archive2/2009/09/11/westminster090911/home
.wmin.ac.uk/china_posters/default.htm

DACHS 2009 Propaganda Posters Westminster
Statue 1978
http://www.sino.uni-heidelberg.de/
archive2/2009/09/11/westminster090911/home
.wmin.ac.uk/china_posters/n18.htm

DACHS 2009 Propaganda Posters Westminster:
"Who Is in Charge of the Universe?"
http://www.sino.uni-heidelberg.de/
archive2/2009/09/11/westminster090911/home
.wmin.ac.uk/china_posters/n41.htm

DACHS 2009 Red Book in Taiwan
"Mao Zedong's Red Book Selling Well in Taiwan,"
China View View China, 07 October 2005.
http://www.sino.uni-heidelberg.de/
archive2/2009/08/28/chinaview090828.htm

DACHS 2009 Rethinking Cultural Revolution
Culture, Ye Qianyu
http://www.sino.uni-heidelberg.de/
archive2/2008/06/30/unihd080630/www.sino
.uni-heidelberg.de/conf/propaganda/bild05.html

DACHS 2009 Sange Daibiao
http://www.sino.uni-heidelberg.de/
archive2/2011/10/20/xinhuanet111020/news
.xinhuanet.com/ziliao/2003-01/21/
content_699933.htm

DACHS 2009 SARS Yangbanxi
http://www.sino.uni-heidelberg.de/
archive2/2011/10/20/caozitou111020/dev.focus
.cn/msgview/128/3581673.html

DACHS 2009 Sotheby I & II
http://www.sino.uni-heidelberg.de/
archive2/2012/04/20/cao120420/world.yzdsb
.com.cn/system/2009/11/03/010209793.shtml
.htm
http://www.sino.uni-heidelberg.de/
archive2/2012/04/20/joe120420/chinasmack
.com.2009. pictures.emperor-qianlong-jade
-imperial-seal-london-auction.html

DACHS 2009 Sui Jianguo
http://www.sino.uni-heidelberg.de/
archive2/2009/02/24/suijianguo090224/mnc
.people.com.cn/big5/54849/72046/73434/index
.html

DACHS 2009 Sun Wukong San Da Baigujing, Blog
2007
http://www.sino.uni-heidelberg.de/
archive2/2009/08/12/yangguangjiexio090812.htm

DACHS 2009 Sun Wukong San Da
Baigujing, Dance Drama 2009
http://www.sino.uni-heidelberg.de/
archive2/2009/08/12/chuiyan090812.htm

DACHS 2009 Sun Wukong San Da Baigujing,
Huaguoshan
http://www.sino.uni-heidelberg.de/
archive2/2009/09/18/lifujin090918.htm

DACHS 2009 Sun Wukong San Da Baigujing, MTV
2009
http://www.sino.uni-heidelberg.de/
archive2/2011/10/19/sohu111019/my.tv.sohu
.com/u/vw/1518633.htm

DACHS 2009 Sun Wukong San Da Baigujing,
Peking Opera
http://www.sino.uni-heidelberg.de/
archive2/2009/07/24/lixinshuang090724.htm

DACHS 2009 Sun Wukong San Da Baigujing,
Puppet Theater 2009
http://www.sino.uni-heidelberg.de/
archive2/2009/08/12/luoyuanyuan090812.htm

DACHS 2009 Sun Wukong San Da Baigujing, RAP
http://www.sino.uni-heidelberg.de/
archive2/2009/08/12/yingni090812.htm

DACHS 2009 Sun Wukong San Da Baigujing,
Remembering Old Comics Blogs 2007
http://www.sino.uni-heidelberg.de/
archive2/2011/10/12/tu111012/static8.photo
.sina.com.cn/bmiddle/49d1472e45c6fa3fbd4c7
.jpg
http://www.sino.uni-heidelberg.de/
archive2/2009/08/12/zuisheng090812.htm

DACHS 2009 Tan Dun in Mao Suit ("*Beyond the
Wall*: Chinese Music at the Barbican,"
Musiccriticism.com, 11 February 2009.)
http://www.sino.uni-heidelberg.de/
archive2/2009/10/15/graham091015.htm

DACHS 2009 Virtual Mao Memorial
http://www.sino.uni-heidelberg.de/
archive2/2011/10/20/hongjunqi111020/www
.mzdbl.cn/default.htm

DACHS 2009 Wang Tong, Images of Mao
http://www.sino.uni-heidelberg.de/
archive2/2009/02/26/wangtong090226/
wangtong.artron.net/exhibi.php@
aid=a0008194&cate=1196&p=1.htm

DACHS 2009 Wang Xingwei and Conceptual Art
http://www.sino.uni-heidelberg.de/
archive2/2009/02/13/wangxingwei090213.htm

DACHS 2009 Wang Xingwei Going to Anyuan
http://www.sino.uni-heidelberg.de/
archive2/2009/02/13/nuonuoguilai090213.htm

DACHS 2009 Wang Xingwei Interview
http://www.sino.uni-heidelberg.de/
archive2/2009/02/13/zhuqi090213.htm

DACHS 2009 Wang Yigang Contemporary Art
(王易罡)
http://www.sino.uni-heidelberg.de/
archive2/2011/10/12/wang111012/www.y2arts

.com/artist/wang-yigang-_25e7_258e_258b_25e6
_2598_2593_25e7_25bd_25a1.htm

DACHS 2009 Yellow River, Lang Lang playing for
the tenth anniversary of the return of Hong
Kong:
Part 1: http://www.sino.uni-heidelberg.de/
archive2/2011/10/20/langlang_a111020/www
.youtube.com/watch@v=
5zwkv5f8ebi&feature=related.htm
Part 2: http://www.sino.uni-heidelberg.de/
archive2/2011/10/20/langlang_b111020/www
.youtube.com/watch@
v=ureunqkymum&feature=related.htm
Part 3: http://www.sino.uni-heidelberg.de/
archive2/2011/10/20/langlang_c111020/www
.youtube.com/watch@v=_bsaqqujjf4&nr=1
.htm

DACHS 2009 Yu Youhan, Wei, Ying. "`80s Chic: Yu
Youhan's Chairman Mao." In *ArtZineChina. A
Chinese Contemporary Art Portal.*
http://www.sino.uni-heidelberg.de/
archive2/2009/02/24/weiying090224.htm

DACHS 2009 Zhang Chenchu Blog, Complete
Works
http://www.sino.uni-heidelberg.de/
archive2/2009/03/18/zhangchenchu090318/
www.70arts.com/blog/user1/zhangcc/index.html

DACHS 2009 Zhang Chenchu, Dongfang Hong
Series
http://www.sino.uni-heidelberg.de/
archive2/2011/05/23/zhang_b110523/auction
.artxun.com/paimai-3015-15070697.shtml.htm

DACHS 2009 Zhang Chenchu, Sun Mao Deng 2007
http://www.sino.uni-heidelberg.de/
archive2/2011/05/23/zhang_a110523/auction
.artxun.com/paimai-3020-15095793.shtml.htm

DACHS 2009 Zhang Chenchu, Writings on the
Dongfang Hong Series
http://www.sino.uni-heidelberg.de/
archive2/2009/03/06/zhangchenchu090306.shtml

DACHS 2009 Zhongguo Xinwen Wang 中国新闻
网 17 January 2008
http://www.sino.uni-heidelberg.de/
archive2/2009/03/25/zhangyanhong090325.htm

DACHS 2011 Comic Readers
http://www.sino.uni-heidelberg.de/
archive2/2011/10/26/zuisheng111026/blog.sina
.com.cn/shoucang.htm

DACHS 2012, ArtZine, Barboza & Zhang: Barboza,
David, and Lynn Zhang. "Why Do Artists Say:
Look at Me." In *ArtZine: A Chinese Contemporary
Arts Portal.*
http://www.sino.uni-heidelberg.de/
archive2/2012/03/13/barboza120313/www
.artzinechina.com/display.php@a=208.htm

DACHS 2012 Barmé, Olympic Art. http://www.sino.uni-heidelberg.de/archive2/2012/06/01/barm%C3%A9120601/www.the-american-interest.com/article.cfm@piece=441.htm

DACHS 2012 Propaganda Poster "Attack the Headquarters" http://www.51dh.net/magazine/html/408/408057.htm

DACHS 2012 Steiner "Thinking Pictures" http://www.sino.uni-heidelberg.de/archive2/2012/04/07/steiner120407/www.imageandnarrative.be/inarchive/thinking_pictures/steiner.htm

Dai 1980: Dai Houying. 戴厚英 Ren a, ren! 人啊，人! (Stones of the Wall 石墙). Guangzhou: Guangdong renmin, 1980.

Dai 1994: Dai Jiafang 戴嘉枋. Zou xiang huimie: "Wenge" wenhua buzhang Yu Huiyong chenfu lu 走向毁灭："文革"文化部長于會泳沉浮錄 (The way to destruction: A record of Cultural Minister Yu Huiyong's demise). Beijing: Guangming ribao, 1994.

Dai 1995: Dai Jiafang 戴嘉枋. Yangbanxi de fengfengyuyu: Jiang Qing, yangbanxi ji neimu 样板戏的风风雨雨：江青，样板戏及内幕 (The model works' turbulent times, Jiang Qing and what happened behind the scenes of the model works). Beijing: Zhishi, 1995.

Dai 2000: Dai, Sijie. Balzac et la Petite Tailleuse Chinoise, Paris: Gallimard, 2000.

DalLago 1999: DalLago, Francesca. "Personal Mao: Reshaping An Icon in Contemporary Chinese Art—Chinese Political and Cultural Leader Mao Zedong." Art Journal 58, no. 2 (1999): 47–59.

Davies 2007: Davies, David J. "Visible Zhiqing: The Visual Culture of Nostalgia among China's Zhiqing Generation." In Re-envisioning the Chinese Revolution: The Politics and Poetics of Collective Memories in Reform China, edited by Ching Kwan Lee and Guobin Yang. Stanford: Stanford University Press, 2007: 166–92.

Dejunco 2002: Dejunco, Mercedes M. "Hybridity and Disjuncture in Mainland Chinese Popular Music." In Global Goes Local: Popular Culture in Asia, edited by Timothy Craig and Richard Krug. Vancouver: University of British Columbia Press, 2002: 25–39.

Deng 1983: Deng Xiaoping 邓小平. Deng Xiaoping wenxuan 邓小平文选. Shanghai: Shanghai renmin, 1983.

Deng 1991: "Guanyu 'Mao Zedong re'—Deng Liqun tongzhi da benkan jizhe" 关于"毛泽东热"—邓力群同志答本刊记者 (On the "Mao Craze"—

Comrade Deng Liqun responds to our journal's reporter). Zhongliu 中流 12 (1991):2–4.

Denton 1983: Denton, Kirk. "The Revision of the Model Opera Zhi-qu Wei Hu Shan: The Formation of a Myth." M.A. Thesis, University of Toronto, 1983.

Denton 1987: Denton, Kirk. "Model Drama as Myth: A Semiotic Analysis of Taking Tiger Mountain by Strategy." In Drama in the People's Republic of China, edited by Constantine Tung et al. Albany: State University of New York Press, 1987, 119–36.

DeWoskin 1991: DeWoskin, Kenneth. Holding an Ear to the Tracts: Interpretation of Early Musical Remains in China, International Symposium: The Archaeology of Music—Sources, Methods and Issues. 7–10 December 1991, Darwin College, Cambridge.

DGNMHSZJGS 2002: 137 duo gongneng manhua sanzijing gushi 137 多功能漫画三字经故事 (More than 137 practical comics of Three Character Classic stories), edited by Li Donglei 李东雷. Hangzhou: Zhejiang shaonian ertong, 2002.

Diehl 2006: Diehl, Laura K. "Mao und die '68er': Eine historisch-publizistik-wissenschaftliche Untersuchung der Wahrnehmung Mao Zedongs durch die 68er Bewegung in der Bundesrepublik Deutschland." M.A. Thesis, University of Mainz, 2006.

Dittmer 1974: Dittmer, Lowell. Liu Shao-ch'i and the Chinese Cultural Revolution: The Politics of Mass Criticism. Berkeley: University of California Press, 1974.

Dittmer and Chen 1981: Dittmer, Lowell, and Ruoxi Chen. Ethics and Rhetoric of the Chinese Cultural Revolution. Berkeley: Center for Chinese Studies, University of California, 1981.

Dolby 1976: Dolby, William. A History of Chinese Drama. London: Paul Elek, 1976.

DSDYSZJ 2005: Dianshi dianying sanzijing 电视电影三字经 (Sanzijing in film and on television). Beijing: Zhongguo dianying, 2005.

Du 1996: Du Honglin 杜鸿林. Hunduan mengxing: Zhongguo zhiqing shanshan xiaxiang fengyun jishi 魂断梦醒—中国知情上山下乡风云纪实 (Broken souls awakening from their dreams: Reports by sent-down youths from times of trouble). Ningbo: Ningbo, 1996.

Duara 1995: Duara, Prasenjit. Rescuing History from the Nation: Questioning Narratives of Modern China. Chicago: Chicago University Press, 1995.

Duhamel 1930: Duhamel, Georges. Scènes de la Vie Future. 2nd edition. Paris: Mercure de France, 1930.

Duo 2003: Duo Duo. "Looking at the Propaganda Posters." In *Chinese Propaganda Posters*, edited by Anchee Min, Duo Duo, and Stefan R. Landsberger. Cologne and Los Angeles: Taschen, 2003: 10–11.

Durkheim 1926: Durkheim, Émile. *The Elementary Forms of the Religious Life: A Study in Religious Sociology*, translated by Joseph Ward Swain. London: Allen & Unwin, 1926.

Dutton 1998: Dutton, Michael. *Streetlife China*. Cambridge: Cambridge University Press, 1998.

DZRB 1968: *Dazhong Ribao* 04 July 1968, 4 (Mao Goes to Anyuan).

Eberhard 1986: Eberhard, Wolfram. *A Dictionary of Chinese Symbols: Hidden Symbols in Chinese Life and Thought*. London: Routledge, 1986.

Eco 1979: Umberto Eco. *The Role of the Reader: Explorations in the Semiotics of Texts*. Bloomington: Indiana University Press, 1979.

Edelstein 1997: Edelstein, Alex S. *Total Propaganda: From Mass Culture to Popular Culture*. Mahwah, NJ: Erlbaum, 1997.

Ellul 1965: Ellul, Jacques. *Propaganda: The Formation of Men's Attitudes*. New York: Knopf, 1965.

ETSZJ 1956: Xin Anting 辛安亭. *Ertong sanzijing* 儿童三字经 (Three Character Classic for children). Changsha: Tongsu duwu, 1956.

Evans and Donald 1999: Evans, Harriet, and Stephanie Donald. "Introducing Posters." In *Picturing Power in the People's Republic of China: Posters of the Cultural Revolution*, edited by Harriet Evans and Stephanie Donald. Lanham: Rowman and Littlefield, 1999: 1–26.

Farquhar 1999: Farquhar, Mary Ann. *Children's Literature in China: From Lu Xun to Mao Zedong*. Armonk: M. E. Sharpe, 1999.

FBSZJ 2004: Gao Puchao. *Fangbing sanzijing* 防病三字经 (A Three Character Classic to avoid illness). Beijing: Changhong, 2004.

FDMDWZRBSZJ 1951: *Fandui meidi wuzhuang riben sanzijing* 反对美帝武装日本三字经 (A Three Character Classic against American imperialism and Japanese militarism), edited by Fei Xin 费辛. Shanghai: Shanghai Fangxiang, 1951.

Feigon 2002: Feigon, Lee. *Mao: A Reinterpretation*. Chicago: Ivan R. Dee, 2002.

Felbinger and Scherl 2005: Felbinger, Rolf, and Katja Scherl. "Flieger sind Sieger." In *Kultur der Propaganda*, edited by Rainer Gries and Wolfgang Schmale. Bochum: Winkler, 2005: 119–65.

Feng 1975: Feng You-lan 冯友兰. *Lun Kong Qiu* 论孔丘 (On Confucius). Beijing: Renmin, 1975.

Feng 1991: Feng, Jicai. *Voices from the Whirlwind: An Oral History of the Chinese Cultural Revolution*. New York: Knopf, 1991.

Feng 1996: Feng, Jicai. *Ten Years of Madness: Oral Histories of China's Cultural Revolution*. San Francisco: China Books and Periodicals, 1996.

Feng 2002: Feng Shuangbai 冯双白. *Xin Zhongguo wudao shi* 新中国舞蹈史 *1949-2000* (A history of dance in New China), Changsha: Hunan meishu, 2002.

Fengyu yangbanxi 风雨样板戏 (The turbulent times of the model works). Booklet and 2 VCDs (1: Hong Dengji, 2: Sha Jiabang), no date, no place (ca. 2004).

Feuerwerker 1968: Feuerwerker, Albert. "China's History in Marxian Dress." In *History in Communist China*, edited by Albert Feuerwerker. Cambridge: MIT Press, 1968: 14–44.

Fish 1968: Fish, Michael B. "Bibliographical Notes on the San Tzu Ching and Related Texts." M.A. Thesis, Indiana University at Bloomington, 1968.

Fish 1980: Fish, Stanley. *Is There a Text in This Class? The Authority of Interpretive Communities*. Cambridge: Harvard University Press, 1980.

Fiske 1989: Fiske, John. *Understanding Popular Culture*. Boston: Unwin Hyman, 1989.

Fiske 1997: Fiske, John. "Populäre Texte, Sprache und Alltagskultur." In *Kultur Medien Macht: Cultural Studies und Medienanalyse*, edited by Andreas Hepp and Rainer Winter. Opladen: Westdeutscher Verlag, 1997: 65–84.

Fitzgerald 1976: Fitzgerald, Charles P. *Mao Tsetung and China*. London: Hodder & Stoughton, 1976.

FJRMSZJ 2002: *Fojiao rumen sanzijing* 佛教入门三字经 (A Three Character Classic to understand Buddhism). Shanghai: Guji, 2002.

FNSZJ 1950: *Funü sanzijing* 妇女三字经 (The Three Character Classic for women). Hankou: Xinhua shudian, 1950.

Fokkema 1991: Fokkema, Douwe. "Creativity and Politics." In *Cambridge History of China*. Vol 15, *The People's Republic. Part 2: Revolutions within the Chinese Revolution, 1966-1982*, edited by Roderick MacFarquhar and John K. Fairbank. New York: Cambridge University Press, 1991: 594–615.

Forster 1986: Forster, Keith. "The Politics of Destabilization and Confrontation: The Campaign against Lin Biao and Confucius in Zhejiang Province, 1974." *The China Quarterly*, September 1986: 433–62.

Fu 2002: Fu Jin 傅谨. *Xin Zhongguo xiju shi* 新中国戏剧史 1949–2000 (A history of drama in New China). Changsha: Hunan meishu, 2002.

Fu 2003: Fu Sinian 傅斯年. "Rensheng wenti faduan" 人生问题发端 (A first attempt on the question of human life). In *Fu Sinian quanji* 傅斯年全集 (Complete works by Fu Sinian). Changsha: Hunan jiaoyu, 2003: 83–94.

Galikowski 1998: Galikowski, Maria. *Art and Politics in China: 1949–1984*. Hong Kong: The Chinese University Press, 1998.

Gao and Li 1999: Gao Yilong 高义龙 and Li Xiao 李晓 *Zhongguo xiju xiandaixi shi* 中国戏曲现代戏史 (A history of Chinese drama and contemporary theater). Shanghai: Shanghai Culture Press, 1999.

Gao 2008: Gao, Minglu. "No Name Group. Contemporary Recluses—the Bo Yi's and Shu Qi's of the Cultural Revolution." In *Art and China's Revolution*, edited by Melissa Chiu and Zheng Shengtian. New York: Asia Society, 2008: 178–85.

Gao 1987: Gao, Yuan. *Born Red: A Chronicle of the Cultural Revolution*. Stanford: Stanford University Press, 1987.

Gardner 1981: Gardner, John. "Study and Criticism: The Voice of Shanghai Radicalism." In *Shanghai: Revolution and Development in an Asian Metropolis*, edited by Christopher Howe. Cambridge: Cambridge University Press, 1981: 326–47.

The Gate of Heavenly Peace 1995: Hinton, Carma, and Richard Gordon. *The Gate of Heavenly Peace*. Brookline: Long Bow Group, 1995.

GBSFSZJ 2001: *Gangbi shufa sanzijing* 钢笔书法三字经 (Three Character Classic to practice calligraphy by style). Guangdong: Guangdong lüyou, 2001.

GCSYGLSZJ 1963: *Gengchu siyang guanli sanzijing* 耕畜饲养管理三字经 (Three Character Classic on husbandry). Beijing: Xinhua 1963.

Geming jiebanren 革命接班人 (Revolutionary Successor)

Geming jiebanren 1974.2:3–7 "Yuandan xianci" 元旦献词 (A speech on New Year's Day).

Geming jiebanren 1974.3:32–33 "Pi Lin pi Kong fanxiu fangxiu" 批林批孔反修防修 (Criticize Lin Biao and Confucius, oppose revisionism, prevent revisionism). Image by Zhang Boyuan 张伯元 et al.

Geming jiebanren 1974.3:36–60 Lan Xueyi 兰学毅 and Xing Fengzao 邢凤藻. "Chunshan changqing" 春山常青 (Strong youngster Chunshan).

Geming jiebanren 1974.3:64 "San da jilü, baxiang zhuyi" 三大纪录八项注意 (The three main rules of discipline and the eight points for attention) song.

Geming jiebanren 1974.4:35–45 "Lidai laodong renmin fan Kong douzheng" 历代劳动人民的反孔斗争 (The worker's historical struggle against Confucius).

Geming jiebanren 1974.5:33–40 "Caoyuanhua zheng hong" 草原花正红 (The flowers on the steppe are very red).

Geming jiebanren 1974.5:46–48 Zhou Encong 周恩聪. "Zhi zai dingfeng de ren jue bu zai banpo hui tuo "志在顶峰的人决不在半坡回头. (Who has his will set on the peak will not turn his head in the middle of the slope).

Geming lishi gequ jingcui 1992: *Geming lishi gequ jingcui* 革命历史歌曲精萃 (A collection of songs from revolutionary history), edited by Shanghai yinyue chubanshe 上海音乐出版社. Shanghai: Shanghai yinyue, 1992.

Geming xiandai jingju Hong Dengji 1970: *Geming xiandai jingju Hong Dengji* 革命现代京剧红灯记 (The modern revolutionary opera The Red Lantern), edited by Zhongguo jingjutuan 中国京剧团. Beijing: Renmin, 1970.

Geming xiandai jingju pinglunjizan Pingyuan zuozhan 1975: *Geming xiandai jingju pinglunjizan Pingyuan zuozhan* 革命现代京剧评论集赞'平原作战' (A collection of critical reviews in praise of the modern revolutionary opera *Fighting on the Plain*). Shanghai: Shanghai renmin, 1975.

Geming xiandai jingju Pingyuan zuozhan pinglunji 1974: *Geming xiandai jingju Pingyuan zuozhan pinglunji* 革命现代京剧平原作战评论集 (A Collection of critical reviews of modern revolutionary opera *Fighting on the Plain*), Beijing: Renmin wenxue, 1974.

Geng 2011: Geng, Yan. "Art in Transition: Representing Mao Zedong in the Early People's Republic of China 1949–1953." Ph.D. Diss., University of Heidelberg, 2011.

Gentile 2001: Gentile, Emilio. *Politics as Religion*. Princeton: Princeton University Press, 2001.

Giles 1910: Giles, Herbert A. *San Tzu Ching: Elementary Chinese*, translated and annotated by Herbert A. Giles. 2nd rev. ed. Shanghai: Kelly & Walsh, 1910.

GNBHPSZJ 1975: *Gongnongbing henpi sanzijing* 工农兵狠批三字经 (Harsh criticisms of the Three Character Classic by workers, peasants, and soldiers). Shanghai: Shanghai renmin, 1975.

GNBSZJ 1931: *Gongnongbing sanzijing* 工农兵三字经 (A Three Character Classic for workers,

peasants, and soldiers). Xingguo xiancheng: Zhongguo gongnong hongjun zhengzhi zongbu, 1931.

Goldman 1975: Goldman, Merle. "China's Anti-Confucian Campaign, 1973–74." *The China Quarterly* 63 September 1975: 435–62.

Golomstock 1990: Golomstock, Igor. *Totalitarian Art in the Soviet Union, the Third Reich, Fascist Italy, and the People's Republic of China*. London: Collins Harvill, 1990.

Gombrich 2004: Gombrich, Ernst. "Pygmalion's Power." In *Art and Illusion: A Study in the Psychology of Pictorial Representation*. London: Phaidon Press, 2004: 93–115.

Gooi 2002: Gooi, Tah Choe. "Making an Identity: A Study of Three Compositional Strategies in the Music of Tan Dun." Ph.D. Diss., School of Visual and Performing Arts, Nanyang Technological University Singapore, 2002.

Gorr 2000: Gorr, Doris. *Nationalsozialistische Sprachwirklichkeit als Gesellschaftsreligion: Eine Sprachsoziologische Untersuchung zum Verhältnis von Propaganda und Wirklichkeit im Nationalsozialismus*. Aachen: Shaker, 2000.

Gregor and Chang 1979: Gregor, A. James, and Maria Hsia Chang. "Anti-Confucianism: Mao's Last Campaign." *Asian Survey* 19, no. 11 (November 1979): 1073–92.

Gries 2005: Gries, Rainer. "Zur Ästhetik und Architektur von Propagemen: Überlegungen zu einer Propagandageschichte als Kulturgeschichte." In *Kultur der Propaganda*, edited by Rainer Gries and Wolfgang Schmale. Bochum: Winkler, 2005: 9–35.

Gries 2006: Gries, Rainer. *Produkte & Politik: Zur Kultur- und Politikgeschichte der Produktkommunikation*. Vienna: Facultas, 2006.

Grossberg 1997: Grossberg, Lawrence. "Der Cross Road Blues der Cultural Studies." In *Kultur Medien Macht. Cultural Studies und Medienanalyse*, edited by Andreas Hepp and Rainer Winter. Opladen: Westdeutscher Verlag, 1997: 13–30.

Groys 2003: Groys, Boris. "Utopian Mass Culture." In *Traumfabrik Kommunismus: Die visuelle Kultur der Stalinzeit*, edited by Boris Groys. Frankfurt: Schirn-Kunsthalle, 2003: 20–38.

Groys 2003a: Groys, Boris. "The Art of Totality." In *The Landscape of Stalinism: The Art and Ideology of Soviet Space*, edited by Evgeny Dobrenko and Eric Naiman. Seattle: University of Washington Press, 2003: 96–122.

Grünewald 1982: Grünewald, Dietrich. *Comics. Kitsch oder Kunst? Die Bildgeschichte in Analyse und Unterricht. Ein Handbuch zur Comic-Didaktik*. Weinheim: Beltz, 1982.

Guangbo bianji gongzuo 1978: *Guangbo bianji gongzuo shouce* 广播编辑工作手册 (Guidebook on propaganda and editorial work), edited by Beijing Guangbo Xueyuan Xinwenxi 北京广播学院新闻系. Beijing: Beijing Guangbo Xueyuan Xinwenxi and Guangdong renmin Guangbo diantai, 1978.

Guangming Ribao 9 March 1976: "Wenyi de chuntian yongyuan shuyu wuchanjieji" 文艺的春天永远属于无产阶级 (Spring in the arts will always belong to the proletarians).

Gumbrecht and Marrinan 2003: Gumbrecht, Hans Ulrich, and Michael Marrinan. *Mapping Benjamin: The Work of Art in the Digital Age*, Stanford: Stanford University Press, 2003.

Guo 1968: Guo Moruo 郭沫若. "Ba Mao Zedong sixiang weida hongqi chashang kexue jishu de zui gaofeng" 把毛泽东思想伟大红旗插上科学技术的最高峰 (Stick the great red banner of Mao Zedong Thought in the highest peaks of science and technology). Speech given on 14 March 1968. In Zhongguo Kexueyuan (Jingqu) shou jie huoxue huoyong Mao Zedong sixiang jijifenzi daibiao dahui 中国科学院 (京区) 首届活学活用毛泽东思想积极分子代表大会, April 1968.

Guo 1972: Guo Moruo. "Zhongguo gudai shi de fenqi wenti" 中国古代史的分期问题 (The problem of historical periodization in ancient Chinese history) *Hongqi* 红旗 1972.7:56–62.

Ha Jin 1999: Ha, Jin. *Waiting*. New York: Vintage Books, 1999.

Haigang 2007: *Haigang* 海港 (On the docks). Beijing: Zhongguo dianying, 2007.

Hall 1985: Hall, Stuart. "Significance, Representation, Ideology: Althusser and the Poststructuralist Debates." *Critical Studies in Mass Communication* 1985.2:91–114.

Hamlin 2005: Hamlin, Jesse. "Chinese Artist Sui Jianguo Puts Mao to Rest in Colorful Metaphor." *San Francisco Chronicle*, 16 February 2005. Archived as DACHS 2009 Hamlin on Sui Jianguo.

Han 2008: Han, Dongping. *The Unknown Cultural Revolution. Life and Change in a Chinese Village*. New York: Monthly Review Press, 2008.

Han 1981: Han Kuo-huang 韩国璜. *Zi xi cu dong* 自西徂东 (From west to east). Vol. 1. Taibei: Shibao shuxi, 1981.

Han 1985: Han Kuo-huang 韩国璜. *Zi xi cu dong* 自西徂东 (From west to east). Vol. 2. Taibei: Shibao shuxi, 1985.

Hanyu da cidian 汉语大词典 (The great dictionary of Chinese). Shanghai: Hanyu Da Cidian, 1990.

Harris 2000: Harris, Rachel. "From Shamanic Ritual to Karaoke: The (Trans)migrations of a Chinese Folk song." *CHIME* 14: 48–60.

Harris 2010: Harris, Kristine. "Re-makes/Re-models: *The Red Detachment of Women* between Stage and Screen." *Opera Quarterly* 26, nos. 2–3 (2010): 316–42.

Hawks 2003: Hawks, Shelley Drake. "'Painting by Candlelight' during the Cultural Revolution: Defending Autonomy and Expertise under Maoist Rule (1949–1976)." Ph.D. Diss., Brown University, 2003.

He 1992: He, Joe. "A Historical Study on the 'Eight Revolutionary Model Operas' in China's Great Cultural Revolution." M.A. Thesis, University of Nevada at Las Vegas, 1992.

He 2003: He Shu 何蜀. "Wenhua da geming zhong de gequ" 文化大革命中的歌曲 (The songs from the Cultural Revolution). *Wenshi Jinghua* 文史精华 152 (2003): 18–31.

He 2007: He, Hua. *Lin Fengmian: Ein expressionistischer Maler in China*, Frankfurt: Peter Lang, 2007.

Hegel 1987: Hegel, Robert E. "Making the Past Serve the Present: From the Yan'an Forum to the Cultural Revolution." In *Drama in the People's Republic of China*, edited by Constantine Tung et al. Albany: State University of New York Press, 1987: 197–223.

HeidICON (Heidelberg Visual Database) https://heidicon.ub.uni-heidelberg.de/

Hein et al. 2002: *Ästhetik des Comic*, edited by Michael Hein, Michael Hüners, and Torsten Michaelsen. Berlin: Erich Schmidt, 2002.

Heller 2008: Heller, Steven. *Iron Fists: Branding the 20th Century Totalitarian State*. New York: Phaidon, 2008.

Hinton 1972: Hinton, William. *The Hundred Day War: The Cultural Revolution at Tsinghua University*. New York: Monthly Review Press, 1972.

Ho 2009: Ho, Denise. "Antiquity in Revolution: Cultural Relics in Twentieth-Century Shanghai." Ph.D. Diss., Harvard University, 2009.

Hoffmann-Curtius 2002: Hoffmann-Curtius, Kathrin. "Unikat und Plagiat: Die Meistererzählung im Comic." In *Ästhetik des Comic*, edited by Michael Hein, Michael Hüners, and Torsten Michaelsen. Berlin: Erich Schmidt, 2002: 153–69.

Holländer 2002: Holländer, Hans. "Zeit-Zeichen der Malerei." In *Ästhetik des Comic*, edited by Michael Hein, Michael Hüners, and Torsten Michaelsen. Berlin: Erich Schmidt, 2002: 103–24.

Holm 1984: Holm, David. "Folk Art as Propaganda." In *Popular Chinese Literature and Performing Arts in the People's Republic of China, 1949–1979*, edited by Bonnie McDougall. Berkeley: University of California Press, 1984: 3–35.

Holm 1991: Holm, David. *Art and Ideology in Revolutionary China*. Oxford: Clarendon Press, 1991.

Hong Taiyang 1993: *Hong taiyang: Mao Zedong songge xin jiezou lianchang* 红太阳: 毛泽东颂歌新节奏联唱 (Red sun: Songs in praise of Mao with new rhythms). Shanghai: Shanghai Zhongguo changpian gongsi, 1993.

Hongqi 红旗 (Red flag)

Hongqi 1964.2–3:58–60 He Ming 何明 "*Tichang xiandai xiju*" 提倡现代戏剧 (Supporting modern theater).

Hongqi 1965.3:32 "Dachang shishou geminggequ: Dahai hangxing kao duoshou" 大唱十首革命歌曲: 大海航行靠舵手 (Let's sing ten revolutionary songs: Sailing the seas depends on the helmsman).

Hongqi 1967.6: 25–27 Jiang Qing 江青. "Tan jingju geming" 谈京剧革命 (On opera revolution).

Hongqi 1967.9:19–20 "Lin Biao tongzhi weituo Jiang Qing tongzhi zhaoji budui wenyi gongzuo zuotanhui jiyao" 林彪同志委托江青同志召集部队文艺工作座谈会纪要" (Notes from the forum on work in literature and art in the armed forces with which Comrade Lin Biao entrusted Comrade Jiang Qing).

Hongqi 1970.5:47–56 "Wei suzao wuchan jieji de yingxiong dianxing er douzheng" 为塑造无产阶级的英雄典型而斗争 (Fighting to create proletarian heroic models).

Hongqi 1971.12:10–11 "Guojige" 国际歌 (The "Internationale").

Hongqi 1972.7:56–62: Guo Moruo 郭沫若. "Zhongguo gudai shi de fenqi wenti" 中国古代史的分期问题 (The problem of historical periodization in ancient Chinese history).

Hongqi 1972.11:26–54 "Qixi baihutuan" 奇袭白虎团 (Raid on white tiger regiment), script.

Hongqi 1973.7:48–75 "Pingyuan zuo zhan" 平原作战 (Fighting on the plain), script.

Hongse niangzijun 1970: Wu Zuqiang et al. *Hongse niangzijun* 红色娘子军 (The red detachment of women). Beijing: Renmin yinyue, 1970.

Hongweibing ziliao (*HWBZL*) (Red Guard publications)

HWBZL 1980: *Hongweibing ziliao* 红卫兵资料 (Red Guard publications). Washington: Center for Chinese Research Materials, 1980.

HWBZL 1980 Suppl. 1, vol. II, 457–480. *Keda hongweibing* 科大红卫兵 (Red Guards of Technical University), February 1968.

HWBZL 1980 Suppl. 1, vol. II, 806–838. *Tansuozhe* 探索者 (The explorer), February 1967.

HWBZL 1980 Suppl. 1, vol. II, 681–728. *Gongnongbing zengkan* 工农兵增刊 (Workers, peasants, soldiers—additional edition), September 1967.

HWBZL 1980 Suppl. 1, vol. II, 782 & 805. *Dapo dali* 大破大立 (Great destruction, great construction), September 1967.

HWBZL 1980 Suppl. 1, vol. III, 1083. *Wenge fengyun* 文革风云 (Cultural Revolution happenings), May 26, 1967.

HWBZL 1980 Suppl. 1, vol. III, 1190–1233. *Wenge fengyun* 文革风云 (Cultural Revolution happenings), August 25, 1967.

HWBZL 1980 Suppl. 1, vol. V, 2324–35. *Xuexi cailiao xuanbian* 学习材料选编 (A selection of study materials), September 15, 1966.

HWBZL 1980 Suppl. 1, vol. VII, 3233. *Dadao Liu Shaoqi: Guanyu Liu Shaqi dang'an cailiao de chuli* 打到刘少奇: 关于刘少奇档案材料的处理 (Beat down Liu Shaoqi: On the handling of materials relating to Liu Shaoqi), edited by Qinghua Jinggangshan Red Guards 清华大学井冈山兵团二十八团. February 1967.

Hörning 1997: Hörning, Karl H. "Kultur und soziale Praxis: Wege zu einer 'realistischen' Kulturanalyse." In *Kultur Medien Macht: Cultural Studies und Medienanalyse*, edited by Andreas Hepp and Rainer Winter. Opladen: Westdeutscher Verlag, 1997: 31–46.

Horsthemke 1996: Horsthemke, Stefan A. *Das Bild im Bild in der italienischen Malerei: Zur Darstellung religiöser Gemälde in der Renaissance*, Glienicke: Galda & Wilch, 1996.

Hou 1986: Hou, Sharon Shih-jiuan. "Women's Literature." In *The Indiana Companion to Traditional Chinese Literature*, edited by William H. Nienhauser, Jr. Bloomington: Indiana University Press, 1986: 175–94.

Howe 1981: *Shanghai: Revolution and Development in an Asian Metropolis*, edited by Christopher Howe. Cambridge: Cambridge University Press, 1981.

HRA 2008 Images of Mao Zedong http://www.sino.uni-heidelberg.de/ archive2/2012/04/17/maoimage120417/

HRA 2008 Family Situations http://www.sino.uni-heidelberg.de/ archive2/2012/04/17/familiar120417/familial_situations.pdf

HRA 2008 The Sun http://www.sino.uni-heidelberg.de/ archive2/2012/04/17/sun120417/the_sun.pdf

HRA 14 Heidelberg Chinese Comics Collection http://www.sino.uni-heidelberg.de/ archive2/2012/04/17/kjc120417/www.asia -europe.uni-heidelberg.de/en/research/ heidelberg-research-architecture/hra-projects/ hra14-chinese-comics.html

HTZZLSSZJ 1917: *Huitu zengzhu lishi sanzijing* 绘图增注历史三字经 (Illustrated Three Character Classic of history with commentaries). Nanchang: Guangyi shuju yinhang, 1917.

Hu and Ai 2007: Hu Jie and Ai Xiaoming. *Hongse meishu* 红色美术 (Red art). Hong Kong: Visible Record Company, 2007.

Hua 1975: Hua, Guofeng. *Die ganze Partei mobilisieren für noch grössere Anstrengungen in der Landwirtschaft und für den Aufbau von Kreisen vom Typ Dadschai: Zusammenfassender Bericht auf der Landeskonferenz über das Lernen von Dadschai in der Landwirtschaft 15.10.1975*. Beijing: Verlag für fremdsprachige Literatur, 1975.

Huang 1968: Huang, H. C. *The Little Red Book and Current Chinese Language*. Berkeley: Center for Chinese Studies, University of California, 1968.

Huang 1990: Huang, Yongyu 黄永玉. "Da ya bao hutong jia erhao anhunji" 大雅宝胡同甲二号安魂祭 (Memorial record for Dayabao lane one residence number two). *Jiushi niandai* 1 (1990): 81–85; and *Jiushi niandai* 2 (1990): 128–33.

Hughes 1990: Hughes, David W. "Japanese 'New Folk Songs' Old and New." *Asian Music* 22, no. 1 (Fall/Winter 1990–91): 1–49.

Hung 1994: Hung, Chang-tai. *War and Popular Culture: Resistance in Modern China, 1937–1945*. Berkeley: University of California Press, 1994.

Hung 1996: Hung, Chang-tai. "The Politics of Songs: Myths and Symbols in the Chinese Communist War Music, 1937–1949." *Modern Asian Studies* 30, no. 4 (1996): 901–29.

Hung 2011: Hung, Chang-tai. *Mao's New World: Political Culture in the Early People's Republic*. Ithaca: Cornell University Press, 2011.

Hunter 1969: Hunter, Neale. *Shanghai Journal: An Eyewitness Account of the Cultural Revolution*. New York: Praeger, 1969.

Huot 2000: Huot, Claire. *China's New Cultural Scene: A Handbook of Changes*. Durham: Duke University Press, 2000.

Hüppauf 2008: Hüppauf, Bernd. "Unschärfe: Unscharfe Bilder in Geschichte und Erinnerung." In *Das Jahrhundert der Bilder. II: 1949 bis heute*, edited by Gerhard Paul. Göttingen: Vandenhoeck & Ruprecht, 2008: 558–65.

Huxian 1974: *Peasant Paintings from Huhsien County*, edited by the Fine Arts Collection Section of the Cultural Group under the State Council of the People's Republic of China. Beijing: Foreign Languages Press, 1974.

Huxley 1965: Huxley, Aldous. *Brave New World Revisited*, New York: Harper & Row, 1965.

Hwang 1978: Hwang, John C. "Lien Huan Hua: Revolutionary Serial Pictures." In *Popular Media in China: Shaping New Cultural Patterns*, edited by Godwin C. Chu. Honolulu: University of Hawaii Press, 1978: 51–72.

HZPYDZZZJSZJ 1959: *Hanzi pinyin duizhao zhongzhuangjia sanzijing* 汉字拼音对照种庄稼三字经 (Three Character Classic on cultivating crops in characters and pinyin), Beijing: Tongsu duwu, 1959.

Inge 1988: Inge, M. Thomas. *Handbook of American Popular Literature*. New York: Greenwood Press, 1988.

JDLHWGRMCD 1981: *Jindai laihua waiguo renming cidian* 近代來华外国人名辞典 (Dictionary of names of foreigners who have come to China in Republican times), edited by the Zhongguo shehui kexueyuan jindaishi yanjiusuo fanyishi 中国社会科学院近代史研究所翻译室. Beijing: Zhongguo shehui kexue, 1981.

Ji 1998: Ji Xianlin 季羡林. *Niupeng zayi* 牛棚杂忆 (Memories from the cowshed), Beijing: Zhonggong zhongyang dangxiao, 1998.

Jia 1996: Jia Fangzhou. "Zhu Wei and His Determination." In *China Diary*. Hong Kong: Plum Blossoms, 1996: 5–8.

Jia 2008: Jia Lusheng 贾鲁生. *Kewang xiaotiao* 渴望萧条 (Longing for desolation). Beijing: Renmin wenxue, 2008.

Jiang 1967: Jiang Qing 江青. "Tan jingju geming" 谈京剧革命 (On opera revolution). *Hongqi* 1967.6:25–27.

Jianguo yilai Mao Zedong wengao 1998: *Jianguo yilai Mao Zedong wengao* 建国以来毛泽东文稿 (Scripts by Mao Zedong since the foundation of the People's Republic of China). Vol. 13 (January 1969–September 1976). Beijing: Zhongyang wenxian, 1998.

Jiefang Ribao 解放日报 (*JFRB*)

JFRB 8 July 1943: Wang Jiaxiang 王稼祥. "Zhongguo gongchandang yu Zhongguo minzu jiefang de daolu" 中国共产党与中国民族解放的道路 (The Chinese Communist Party and the Chinese nation's path to liberation).

Jin, 1999: Jin, Qiu. *The Culture of Power. The Lin Biao Incident in the Cultural Revolution*. Stanford: Stanford University Press, 1999.

Jinggangshan wenyi 1967: "Sun Wukong sida baigujing" 孙悟空四打白骨精 (Sun Wukong beats the white-boned demon four times). *Jinggangshan wenyi* 井冈山文艺 (Literature and art from Jingganshan) 1967.1 (2.2.1967), edited by Beijing: Qinghua daxue jinggangshan bingtuan bupagui zhandoudui 清华大学井冈山兵团不怕鬼战斗队.

JMEH 2006: *Journal of Modern European History* 78, no. 4 (Theme: Dictatorship and Festivals), 2006.

Jones 1992: Jones, Andrew F. *Like a Knife: Ideology and Genre in Contemporary Chinese Popular Music*. Ithaca, NY: East Asia Program, Cornell University, 1992.

Jones 1994: Jones, Andrew F. "The Politics of Popular Music in Post-Tiananmen China." In *Popular Protest & Political Culture in Modern China*, edited by Jeffrey Wasserstrom and Elizabeth J. Perry. Boulder, CO: Westview Press, 1994: 148–65.

Jones 2001: Jones, Andrew F. *Yellow Music: Media Culture and Colonial Modernity in the Chinese Jazz Age*. Durham: Duke UP, 2001.

Jones 1999: Jones, Stephen. "Chinese Ritual Music under Mao and Deng." *British Journal of Ethnomusicology* 8 (1999): 27–66.

Jowett and O'Donnell 2006: Jowett, Garth S., and Victoria D. O' Donnell. *Propaganda and Persuasion*, Armonk, NY: M. E. Sharpe, 2006.

Judd 1987: Judd, R. Ellen. "Prescriptive Dramatic Theory of the Cultural Revolution." In *Drama in the People's Republic of China*, edited by Constantine Tung et al. Albany: State University of New York Press, 1987: 94–118.

Judd 1991: Judd, R. Ellen. "Dramas of Passion: Heroism in the Cultural Revolution's Model Operas." In *New Perspectives on the Cultural Revolution*, edited by William Joseph et al. Cambridge, Mass: Harvard University Press, 1991: 265–82.

Jungbluth 2011: Jungbluth, Cora. "Politische, ökonomische und interkulturelle Aspekte im Internationalisierungsprozess chinesischer Unternehmen." Ph.D. Diss., University of Heidelberg, 2011.

Kämpfer 1997: Kämpfer, Frank. *Propaganda: Politische Bilder im 20. Jahrhundert: Bildkundliche Essays*. Hamburg: Kämpfer, 1997.

Kaufmann 1976: Kaufmann, Walter. *Musical References in the Chinese Classics*. Detroit Monographs in Musicology, no. 5. Detroit: Information Coordinators, 1976.

Kellen 1965: Kellen, Konrad. "Introduction." In *Propaganda: The Formation of Men's Attitudes*, edited by Jacques Ellul. New York: Vintage, 1965, n.p.

Kern 2005: Kern, M. "Quotation and the Confucian Canon in Early Chinese Manuscripts: The Case of 'Zi Yi' (Black Robes)." *Asiatische Studien* 59, no. 1 (2005): 293–332.

Kim 2005: Kim Suk-Young. "Revolutionizing the Family: A Comparative Study on the Filmed Propaganda Performances of the People's Republic of China and the Democratic People's Republic of Korea, 1966–1976." Ph.D. Diss., Northwestern University, 2005.

Kindler 1979: *Kindlers Malerei Lexikon*. Cologne: Lingen Verlag, 1979.

King 1984: King, Richard Oliver. "A Shattered Mirror: The Literature of the Cultural Revolution," Ph.D. Diss., University of British Columbia, 1984.

King and Walls 2010: King, Richard, and Walls, Jan. "Vibrant Images of a Turbulent Decade." In *Art in Turmoil: China's Cultural Revolution, 1966–76*, edited by Richard King. Vancouver: University of British Columbia Press, 2010: 3–24.

Kinsky-Weinfurter 1993: Kinsky-Weinfurter, Gottfried. *Filmmusik als Instrument staatlicher Propaganda: Der Kultur- und Industriefilm im Dritten Reich und nach 1945*. Munich: Ölschläger, 1993.

Köppel-Yang 2003: Köppel-Yang, Martina. *Semiotic Warfare: The Chinese Avant-Garde, 1979–1989. A Semiotic Analysis*. Hong Kong: Timezone 8, 2003.

Koushu lishi xia de Lao She zhi si 口述历史下的 老舍之死 (Lao She's death in oral history), collected by Fu Guangming 傅光明. Jinan: Shandong huabao, 2007.

Kouwenhoven 1990: Kouwenhoven, Frank. "Mainland China's New Music (1): Out of the Desert." *CHIME* 2 (1990): 58–93.

Kouwenhoven 1991: Kouwenhoven, Frank. "Mainland China's New Music (2): Madly Singing in the Mountains." *CHIME* 3 (1991): 42–75.

Kouwenhoven 1992: Kouwenhoven, Frank. "Mainland China's New Music (3): The Age of Pluralism." *CHIME* 5 (1992): 76–134.

Kraus 1989: Kraus, Richard Carl. *Pianos and Politics in China: Middle-Class Ambitions and the Struggle over Western Music*. New York: Oxford University Press, 1989.

Kraus 1991: Kraus, Richard Carl. *Brushes with Power: Modern Politics and the Chinese Art of Calligraphy*. Berkeley: University of California Press, 1991.

Kraus 2004: Kraus, Richard Carl. *The Party and the Arty in China: The New Politics of Culture, State and Society in East Asia*, Lanham, MD: Rowman and Littlefield, 2004.

Kroes 2007: Kroes, Rob. "The History of Photography and the Photography of History." In *Photographic Memories: Private Pictures, Public Images, and American History*, edited by Rob Kroes. Hanover, NH: Dartmouth College Press, 2007: 57–82.

Kubin 2005: Kubin, Wolfgang. *Die Geschichte der Schwärze und andere Geschichten*. Vienna: 4/4 Verlag, 2005.

Kultur der Propaganda 2005: *Kultur der Propaganda*, edited by Rainer Gries and Wolfgang Schmale, Bochum: Winkler, 2005.

Kultur Medien Macht 1997: *Kultur Medien Macht: Cultural Studies und Medienanalyse*, edited by Andreas Hepp and Rainer Winter, Opladen: Westdeutscher Verlag, 1997.

Kung 2001: Kung, Hsiao-yun. *Von der Moderne zur Tradition: Jiang Wenye und Sein Musikschaffen*. Berlin: Mensch & Buch Verlag, 2001.

Laing 1988: Laing, Ellen Johnston. *The Winking Owl: Art in the People's Republic of China*. Berkeley: University of California Press, 1988.

Laing 2000: Laing, Ellen Johnston. "Reform, Revolutionary, Political and Resistance Themes in Chinese Popular Prints, 1900–1940." *Modern Chinese Literature and Culture* 12, no. 2 (Fall 2000): 123–75.

Laing 2004: Laing, Ellen Johnston. *Selling Happiness: Calendar Posters and Visual Culture in Early Twentieth-Century China*. Honolulu: University of Hawai'i Press, 2004.

Landsberger 1995: Landsberger, Stefan. *Chinese Propaganda Posters: From Revolution to Modernization*, Armonk, NY: M. E. Sharpe, 1995.

Landsberger 1996: Landsberger, Stefan. "Mao as the Kitchen God: Religious Aspects of the Mao Cult During the Cultural Revolution." *China Information* 11, nos. 2–3 (1996): 196–214.

Landsberger 2002: Landsberger, Stefan. "The Deification of Mao: Religious Imagery and Practices during the Cultural Revolution and

Beyond." In *China's Great Proletarian Cultural Revolution: Master Narratives and Post-Mao Counternarratives*, edited by Woei Lien Chong. Lanham: Rowman and Littlefield, 2002: 139–84.

Landsberger 2003: Landsberger, Stefan. "The Rise and Fall of the Chinese Propaganda Poster." In *Chinese Propaganda Posters*, edited by Anchee Min, Duo Duo, and Stefan R. Landsberger. Cologne: Taschen, 2003: 16–17.

Landsberger 2008: Landsberger, Stefan. http://iisg .nl/~landsberger/nb.html (Norman Bethune). Archived as DACHS 2009 Landsberger: Norman Bethune.

Landsberger 2008a: Landsberger, Stefan. http://iisg .nl/~landsberger/dz.html (Dazhai). Archived as DACHS 2009 Landsberger: Dazhai.

Lao Lianhuanhua 1999: *Lao Lianhuanhua* 老连环画 (Old comics), edited by Wang Guanqing 汪观清 and Li Minghai 李明海. Shanghai: Shanghai huabao, 1999.

Ledderose 2000: Ledderose, Lothar. *Ten Thousand Things: Module and Mass Production in Chinese Art*. Princeton: Princeton University Press, 2000.

Lee 2007: Lee, Ching Kwan. "What Was Socialism to Chinese Workers? Collective Memories and Labor Politics in an Age of Reform." In *Re-envisioning the Chinese Revolution: The Politics and Poetics of Collective Memories in Reform China*, edited by Lee Ching Kwan and Guobin Yang. Stanford: Stanford University Press, 2007: 141–65.

Lee 1995: Lee, Gregory. "'The East Is Red' Goes Pop: Commodification, Hybridity and Nationalism in Chinese Popular Song and Its Televisual Performance." *Popular Music* 14, no. 1 (1995): 95–110.

Lee 1996: Lee, Leo Ou-fan. "Visualizing the Tiananmen Student Movement." *The China Journal* 35 (1996): 131–36.

Lee and Yang 2007: Lee, Ching Kwan, and Guobin Yang. "Introduction: Memory, Power, and Culture." In *Re-envisioning the Chinese Revolution: The Politics and Poetics of Collective Memories in Reform China*, edited by Lee Ching Kwan and Yang Guobin. Stanford: Stanford University Press, 2007: 1–20.

Leese 2006: Leese, Daniel. "Performative Politics and Petrified Image: The Mao Cult during China's Cultural Revolution." Ph.D. Diss., International University Bremen, 2006.

Lefebvre 1947: Lefebvre, Henri. *Kritik des Alltagslebens*. Frankfurt: Fischer, 1987. Originally *Critique de la Vie Quotidienne*. Paris: L'arche, 1947.

Levenson 1965: Levenson, Joseph R. *Confucian China and Its Modern Fate. Vol. 3: The Problem of Historical Significance*. London: Routledge, 1965.

Leyda 1972: Leyda, Jay. *Dianying: Electric Shadows. An Account of Films and the Film Audience in China*. Cambridge, MA: MIT Press, 1972.

Li 2001: Li Bihua 李碧华. *Bawang bieji* 霸王别姬 (Farewell, my concubine). Guangzhou: Huacheng, 2001.

Li 1997: Li Cuizhi 李翠芝. *Xiandai geming jingju (yangbanxi): cong Yan'an dao Beijing* 现代革命京剧 (样板戏): 从延安到北京. Unpublished manuscript for an Academia Sinica project of art and culture between the 1940s and 1960s (文藝理論與文化:四〇~六〇年代主題研究計畫). Taibei 1996–98.

Li 1996: Li, Hsiao-t'i. "Opera, Society and Politics." Ph.D. Diss., Harvard University, 1996.

Li 1990: Li, Lu. *Moving the Mountain: From the Cultural Revolution to Tiananmen Square*. London: Macmillan, 1990.

Li 1994: Li, Lu. *Moving the Mountain*. Michael Apted Film USA, 1994.

Li 1993: Li, Tuo. "Resisting Writing." In *Politics, Ideology, and Literary Discorse in Modern China: Theoretical Interventions and Cultural Critique*, edited by Liu Kang and Tang Xiaobing. Durham: Duke University Press, 1993: 273–77.

Li 1993a: Li Xianting. "Major Trends in the Development of Contemporary Chinese Art." In *China's New Art, Post-1989*, edited by Valerie C. Doran. Hong Kong: Hanart T. Z. Gallery, 1993.

Li 1991: Li, Xiaoping. "Ideology and Propaganda: An Integrative Approach." Ph.D. Diss., University of Windsor, 1991.

Lianhuanhuabao 连环画报 Comics Magazine (*LHHB*)

LHHB 1957.8:7–9. "Nianguanji de dansheng" 捻管机的诞生 (The birth of the *nianguanji*).

LHHB 1975.2:13–16 & 21–24. "Sanfen qingzhan shu" 三份请战书 (Three letters of request to participate in struggle).

LHHB 1975.7:7–16. "Naxin" 纳新 (Reinvigorating the Party).

LHHB 1975.8:10–14. "Xinlai de kezhang" 新来的科长 (The new section chief).

LHHB 1975.9:24–30. "Tie guniang dazhan Hongshiya" 铁姑娘大战红石崖 (Iron maidens' great battle at Red Stone Cliff).

LHHB 1975.9:31–34. "Shi doudou" 拾豆豆 (Picking beans).

LHHB 1975.9:35. "Yu ren yao zhua gang" 育人要抓纲 (In educating people one has to grasp the key link).

LHHB 1975.10:1. "Xuexi Mao Zhuxi zhongyao zhishi: Kaizhan dui 'Shuihu' de pinglun" 学习毛主席重要指示: 开展对水浒的评论 (Study Chairman Mao's important directive: Launch the criticism of "Water Margin").

LHHB 1975.10:2–5. "Shuihu Song Jiang toujiangpai de beilie zuilian" 水浒宋江投降派的卑劣嘴脸 (The despicable features of Water Margin Song Jiang's capitulationist clique).

LHHB 1975.11:17–20. "Changzheng lushang qixiang xin" 长征路上气象新 (A new atmosphere on the road of the Long March).

LHHB 1975.12:1–7. "Shu xiongxin li zhuangzhi wei puji Dazhaixian zuochu xin gongxian" 树雄心立壮志为普及大寨县作出新贡献 (With lofty aims and a strong will propagate Dazhai and bring forth new contributions).

LHHB 1976.1:1–7. "Jianchi dapi zibenzhuyi, jianchi dagan shehuizhuyi" 坚持大批资本主义坚持大干社会主义 (Uphold great criticisms of capitalism and uphold great actions of socialism).

LHHB 1976.2:1–6. "Huohong de xin" 火红的心 (A heart as red as fire).

LHHB 1976.2:7–10. "Tutiejiang daxian shenshou" 土铁匠大显身手 (The rural blacksmith's good account).

LHHB 1976.2:11–16. "Dayong de gushi" 大勇的故事 (A story of great courage).

LHHB 1976.2:17–20. "Jiumao bian xinyan, jinxi liangzhong tian" 旧貌变新颜, 今昔两种天 (The old takes on a new look, the old and the new are two different worlds).

LHHB 1976.2:36. "Nongye xue Dazhai baotouxuan" 农业学大寨报头选 (A selection of mastheads for use in the campaign in agriculture study Dazhai).

LHHB 1976.4:33–34. "Kong Lao'er shi fan'an fubi kuang" 孔老二是翻案复辟狂 (Old Confucius is a madman who wants to reverse the verdict and return to the old order).

LHHB 1976.6:23–28. "Erjie baguan" 二姐把关 (Second girl guarding the pass).

LHHB 1976.7:6–14. "Yangguang canlan zhao zhengtu" 阳光灿烂照征途 (The brilliant sunshine shines on the way).

LHHB 1976.7:15–16 & 25–34. "Gongda xinmiao" 共大新苗 (New sprouts in the Communist labor university).

LHHB 1976.7:17–24. "Gensui Mao Zhuxi changzheng" 跟随毛主席长征 (Following Chairman Mao on the Long March).

LHHB 1977.1–2:44–45. "Lao Zheng kao shijiang" 老郑考石匠 (Old Zheng takes the exam to become a stone mason).

LHHB 1977.1–2:58–67. "Liu Hulan" 刘胡兰 (Liu Hulan).

LHHB 1977.3:14–17. "Sun Wukong san da baigujing" 孙悟空三打白骨精 (Sun Wukong thrice defeats the white-boned demon).

LHHB 1977.4:27–29. "Zhan yaofeng, po mihun, gaoju Daqing hongqi" 战妖风破迷雾高举大庆红旗 (Beating the evil winds and breaking through dense fog [we] uphold the red banner of Daqing).

LHHB 1977.4:30–34. "Chuangye zhuang" 创业庄 (A village undertaking a great task).

LHHB 1977.6:7–9. "Yingfeng zhaozhan" 迎风招展 (Fluttering in the breeze).

LHHB 1977.9:35–37. "Yongyuan gaochang 'Dongfang Hong'" 永远高唱东方红 (Loudly singing "Red Is the East" forever).

LHHB 1978.1:34–35. "Mofang de hunli" 模仿的婚礼 (A model wedding).

LHH 1978.2:37. "Bu ke" 补课 (Catching up on schoolwork).

LHHB 1978.3:1–9. "Qingnian shuxuejia Chen Jingru de gushi" 青年数学家陈景润的故事 (The story of young mathematician Chen Jingru).

LHHB 1978.5:10–11. "Siba nao xue" 四霸闹学 (How the Four Hegemons create havoc).

LHHB 1978.5:17–20. "Weida de Wuchanjieji geming daoshi Makesi he Engesi" 伟大的无产阶级革命导师马克思和恩格斯 (The Great Proletarian Revolutionary leaders Marx and Engels).

LHHB 1978.8:6–14. "Chuangkou" 窗口 (Window).

LHHB 1978.9:9–16. "Weile Zhou Enlai de zhutuo" 为了周恩来的嘱托 (Entrusted by Zhou Enlai).

LHHB 1978.12:0–2. "Songlai" 送来 (Sent).

LHHB 1978.12:3–9. "Yizhi liangjun de xinsheng" 一支良军的新生 (A good soldier's new life).

LHHB 1978.12:10. "Biandan xie" 编单鞋 (Woven shoes).

LHHB 1978.12:11. "Tiaoliang lushang" 挑粮路上 (On the pole-carrying road).

LHHB 1979.4:31–35. "Zhu Bajie xue benling" 猪八戒学本领 (Zhu Bajie studies his skills).

LHHB 1988.4:28–35. "Shashou de xiachang" 杀手的下场 (The murderer's destiny).

LHHB 1988.5:3–10. "Bangzhu" 帮主 (The helper).

LHHB 1988.10:25–26. "Ranshao de hei xiangshu" 燃烧的黑橡树 (The black burned oak tree).

LHHB 1988.12:51. Reader's questionnaire (no title).

LHHB 1991.9:2–8 "Aozhan dihou" 鏖战敌后 (After a fierce battle).

LHHB 1991.9:9–15. "Di'er ci shijie dazhan huiyilu" 第二次世界大战回忆录 (Memoir of World War II).

LHHB 1991.10:15–24. "Nacui anbao" 纳粹暗堡 (The Nazi bunker).

Liang and Shapiro 1984: Liang, Heng, and Shapiro, Judith. *Son of the Revolution*. New York: Vintage, 1984.

Liang 1993: Liang, Maochun. *Zhongguo Dangdai Yinyue 1949–1989* 中国当代音乐 (Contemporary music of China, 1949–1989). Beijing: Beijing guangbo xueyuan, 1993.

Liang 2003: Liang Maochun. "Lun 'yuluge' xianxiang" 论'语录歌'现象 (On the phenomenon of Mao quotations songs). *Huangzhong* 黄钟: *Wuhan Yinyue Xueyuan xuebao* 武汉音乐学院学报 (Journal of the Wuhan Conservatory of Music) 1 (2003): 43–52.

Liang 1999: Liang Xiaosheng 梁晓声. "Wo de nianlun he wo de wenxue" 我的年轮和我的文学 (My growth rings and my literature). *Dongfang yishu* 东方艺术 (Oriental Art) 3 (1999): 4–5.

Lin 1967: Lin Biao 林彪. "Zai ban qianyan" 再版前言 (Preface to the second edition). In *Mao zhuxi yulu* 毛主席语录 (Quotations by Chairman Mao). Beijing: Zhongguo renmin jiefangjun zong zhengzhibu, 1967.

Lin 1970: Lin Biao 林彪. *Lin Fuzhuxi yulu* 林副主席语录 (Quotations by Vice-Chairman Lin). Beijing: Zhongguo renmin jiefangjun zong zhengzhibu, 1970.

Lin 1970a: Lin Biao 林彪. *Tiancailun* 天才论 (On genius). Second Plenary Session of the Ninth Central Committee of the Communist Party of China 九届二中全会, 1970.

Liu 1968: Liu, Chunhua. "Painting Pictures of Chairman Mao Is Our Greatest Happiness." *China Reconstructs* 17, no. 10 (1968): 2–6.

Liu 1993: Liu Daren 刘大任. *Liu Daren ji* 刘大任集 (Collected works of Liu Daren), Taibei: Qianwei, 1993.

Liu 1985: Liu, James T. C. "The Classical Chinese Primer: Its Three-Character Style and Authorship." In *Journal of the American Oriental Society* 105, no. 2 (1985): 191–96.

Liu 1981: Liu Jidian 刘吉典. *Jingju yinyue gailun* 京剧音乐概论 (An introduction to the music of Beijing Opera). Beijing: Yinyue, 1981.

Liu 1986: Liu Jingzhi 刘靖之. "Xin yinyue mengyaqi" 新音乐萌芽期 (The sprouting of New Music). In *Zhongguo xin yinyueshi lunji* 中国新音乐史论集 (Collected essays on the history of New Music in China, 1946–1976), edited by Liu Jingzhi. Hong Kong: Centre for Asian Studies, 1986: 15–71.

Liu 1998: Liu Jingzhi 刘靖之. *Zhongguo xin yinyueshi lun* 中国新音乐史论 (On the history of New Music in China). Taibei: Shaowen, 1998.

Liu 1990: *Zhongguo xin yinyueshi lunji* 中国新音乐史论集 (Collected essays on the history of New Music in China, 1946–1976), edited by Liu Jingzhi 刘靖之. Hong Kong: Centre for Asian Studies, 1986.

Liu 1990a: Liu Jingzhi 刘靖之. "Wenge shiqi de xin yinyue" 文革时期的新音乐 (New Music in the Cultural Revolution, 1966–76). In *Zhongguo xin yinyueshi lunji* 中国新音乐史论集 (Collected essays on the history of New Music in China, 1946–1976), edited by Liu Jingzhi. Hong Kong: Centre for Asian Studies, 1990: 113–210.

Liu 1997: Liu, Kang. "Popular Culture and the Culture of the Masses." *Postmodernism and China*, edited by Arif Dirlik and Zhang Xudong. *Boundary* 24, no. 3 (Autumn 1997): 99–122.

Liu 1980: Liu Maoying. "A New Interpretation of the Story of the 'Foolish Old Man Who Moved the Mountains.'" *Wenhuibao* 文汇报 13 August 1980. Translated in FBIS-CHI 28 August 1980, L2.

Liu 1965: Liu Shaoqi *Wie Man ein guter Kommunist wird* (How to be a good communist). Originally delivered as a speech at Yan'an in 1939 entitled 论共产党员的修养. Beijing: Verlag für Fremdsprachige Literatur, 1965.

Liu Suola 1986: Liu Suola 刘索拉. "Zuihou yizhi zhizhu" 最後一隻蜘蛛 (The last spider). *Beijing wenxue* 北京文学 6 (1986): 24.

Liu 1992: Liu Xiaoqing 刘晓庆. "Wo zai Mao Zedong shidai" 我在毛泽东时代 (Myself in the Mao's times). *Zhongguo zuojia* 中国作家 1992.5: 88–98.

Liu 1992b: Liu, Xuemin. "Poetry as Modernization: 'Misty Poetry' of the Cultural Revolution." Ph.D. Diss., University of California at Berkeley, 1992.

Liu 1998–99: Liu Yiman. "Gedichte aus der Kulturrevolution" (Poems from the Chinese Cultural Revolution). Term Paper, University of Heidelberg, Winter 1998–99.

Liu n.d.: Liu, Hongyu. *Sozialistische Bildpropaganda in China zwischen 1949 und 1979*. Saarbrücken: Verlag Dr Müller, no date.

Lo 1989: Lo, Fulang. *Morning Breeze: A True Story of China's Cultural Revolution*. San Francisco: China Books and Periodicals, 1989.

Lo 1980: Lo, Ruth Earnshaw, and Katharine S. Kinderman. *In the Eye of the Typhoon: An*

American Woman in China During the Cultural Revolution. New York: Da Capo Press, 1980.

Lo 1987: Lo, Ruth Earnshaw. *In the Eye of the Typhoon: An American Woman in China during the Cultural Revolution*. Revised edition. New York: Da Capo Press, 1987.

Longjiangsong 1975: *Longjiangsong zongpu* 龙江松总谱 (Score to Song of the Dragon River). Beijing: Renmin, 1975.

Louie 1980: Louie, Kam. *Critiques of Confucius in Contemporary China*. New York: St. Martin's Press, 1980.

Louie 1986: Louie, Kam. *Inheriting Tradition: Interpretations of the Classical Philosophers in Communist China, 1949–1966*. New York: Oxford University Press, 1986.

Louie 2001: Louie, Kam. "Sage, Teacher, Businessman: Confucius as A Model Male [Constructions of Male Identity in the Modern World]." In *Chinese Political Culture, 1989–2000*, edited by Shiping Hua. Armonk, NY: M. E. Sharpe, 2001: 21–41.

LSSZJ 1963: *Lishi sanzijing* 历史三字经 (Three Character Classic on history). Beijing: Renmin jiaoyu, 1963.

Lu 1997: Lu, Guang. "Modern Revolutionary Beijing Opera: Context, Contents, and Conflicts." Ph.D. Diss., Kent State University, 1997.

Lu 1996: Lu, Sheldon Hsiaopeng. "Postmodernity, Popular Culture, and the Intellectual: A Report on Post-Tiananmen China." *Boundary* 23, no. 2 (Summer 1996): 139–69.

Lu 2001–2: Lu Xin-An. "Dazhai: Imagistic Rhetoric as a Cultural Instrument" http://www.geocites.com/submit20012002/Dazhai_Rhetoric.htm, archived as DACHS 2004 Lu Xin-An.

Lu 2004: Lu, Xing. *Rhetoric of the Chinese Cultural Revolution: The Impact on Chinese Thought, Culture, and Communication*. Columbia: University of South Carolina Press, 2004.

Lu 1930: Lu Xun 鲁迅. "Wenyi de dazhonghua" 文艺的大众化 (The popularization of literature and art). *Dazhong wenyi* 大众文艺 2, no. 3 (March 1930): 639–40.

Lu 1932a: Lu Xun 鲁迅. "Lianhuantuhua bianhu" 连环图画辩护 (A discussion of comics). In *Lu Xun Quanji* 鲁迅全集 (Collected works by Lu Xun). Vol. 5. Beijing: Renmin wenxue, 1981: 39–44.

Lu 1932b: Lu Xun. "Lianhuantuhua suotan" 连环图画琐谈 (A trifling chat about comics). In *Lu Xun Quanji* 鲁迅全集 (Collected works by Lu Xun). Vol. 6. Beijing: Renmin wenxue, 1981: 33–34.

Lu 1975: Lu Xun. *Lu Xun pi Kong fan Ru wenji* 鲁迅批孔反儒文辑 (Selection of Lu Xun's criticisms of Confucius and Confucianism). Beijing: Renmin wenxue, 1975.

Luo 1991: Luo Chuankai. "Double Cultural Contact: Diffusion and Reformation of Japanese School Songs in China." In *Tradition and Its Future in Music: Report of the International Musicological Society*. Tokyo: Mita Press, 1991: 11–14.

Luo 1990: Luo, Zi-Ping. *A Generation Lost: China under the Cultural Revolution*. New York: Henry Holt & Company, 1990.

MacFarquhar and Schönhals 2006: MacFarquhar, Roderick, and Michael Schönhals. *Mao's Last Revolution*. Cambridge: Harvard University Press, 2006.

Mackerras 1973: Mackerras, Colin. "Chinese Opera after the Cultural Revolution (1969–72)." *The China Quarterly* 55 (1973): 478–83.

Mackerras 1975: Mackerras, Colin. "Opera and the Campaign to Criticize Lin Piao and Confucius." *Papers on Far Eastern History* 11 (1975): 169–98.

Mackerras 1981: Mackerras, Colin. *The Performing Arts in Contemporary China*. London: Routledge & Kagan, 1981.

Mackerras 1983: Mackerras, Colin. "Theater and the Masses." In *Chinese Theater: From Its Origins to the Present Day*, edited by Colin Mackerras. Honololu: University of Hawaii Press, 1983: 145–83.

Malan 1856: Malan, S. C. *The Three-Fold San-tze-king or the Trilateral Classic of China as Issued I. by Wang-Po-keou, II by Protestant Missionaries in That Country, and III by the Rebel-Chief, Tae-ping-wang*. London: D. Nutt, 1856.

Mao Dun 1932: Mao Dun 茅盾. "Lianhuan tuhua xiaoshuo" 连环图画小说 (A story about comics). In *Mao Dun Wenji* 矛盾文集 (Collected works by Mao Dun). Vol. 9. Hong Kong: Jindai tushu gongsi, 1966: 75–78.

Mao Dun 茅盾 1936: Mao Dun. "Da Bizi de gushi" 大鼻子的故事 (The story of the nose). In *Mao Dun Wenji* 茅盾文集 (Collected works by Mao Dun), vol 8. Beijing: Renmin wenxue, 1959: 61–62.

Mao 1991: Mao, Yurun. "Music under Mao: Its Background and Aftermath." *Asian Music* 22 (1991): 97–125.

Mao 1942: *Mao Zedong's Talks at the Yan'an Conference on Literature and Art, a Translation of the 1943 Text with Commentary*, translated and edited by Bonnie McDougall. Ann Arbor: Center for Chinese Studies, 1980.

Mao 1956: Mao Zedong. "How Yu Kung Removed the Mountains." In *Selected Works of Mao Tse-tung*. Vol. 4. London: Lawrence & Wishart, 1956: 316–18.

Mao 1957: Mao Zedong. "Speech at the National Conference on Propaganda Work." In *The Writings of Mao Zedong: 1949–1976*, edited by John K. Leung and Michael Y. M. Kau. Vol. 2. Armonk, NY: M. E. Sharpe, 1992: 375–90.

Mao 1957a: Mao Zedong 毛泽东. "Dongfeng yadao xifeng" 东风压倒西风 (The east wind prevails over the west wind). Beijing: Renmin ribao, 1957: 14–15.)

Mao 1964: Mao Zedong 毛泽东. *Mao Zedong xuanji zhuanzhu heding yijuanben* 毛泽东选集 专著 合订一卷本 (Selected works by Mao Zedong in one volume). Beijing: Renmin, 1964.

Mao 1964a: Mao Zedong 毛泽东. *Mao Zhuxi zai dui zhongyang yinyue xueyuan de yijian* 毛主席 在对中央音乐学院的意见 (Mao's suggestions to the Central Conservatory). In *Jianguo yilai Mao Zedong wengao* 建国以来毛泽东文稿 (Drafts of Mao's works since liberation). Vol. 11. Beijing: Zhongyang wenxian, 1998: 172–73.

Mao 1964b: Mao Zedong 毛泽东. "Zhi Lu Dingyi" 致陆定一 (To Lu Dingyi). In *Mao Zedong Shuxin Xuanji* 毛泽东书信选集 (Selection of letters by Mao Zedong). Beijing: Renmin, 1983: 598.

Mao 1965: Mao Zedong. "A Single Spark Can Start a Prairie Fire." In *Selected Works of Mao Tse-tung*. Vol. 1. Beijing: Foreign Language Press, 1965: 117–28.

Mao 1966: Mao Zedong. *Quotations from Chairman Mao Tse-Tung*. Beijing: Foreign Languages Press, 1966.

Mao 1967: Mao Zedong. *Five Documents on Literature and Art*. Beijing: Foreign Languages Press, 1967.

Mao 1969: Mao Zedong 毛泽东. "Weixin lishiguan de pochan" 唯心历史观的破产 (The bankruptcy of the idealistic conception of history). In *Mao Zedong Xuanji*. Vol. 1 毛泽东选集一卷本. Beijing: Xinhua, 1969: 1398–1406.

Mao 1974: Mao Zedong "Down with the Prince of Hell." In *Miscellany of Mao Tse-tung Thought*. Vol. 2. Arlington: Joint Publications Research Service, 1974.

Mao 1993: Mao Zedong 毛泽东. *Mao Zedong shici dadian* 毛泽东诗词大典 (The standard collection of Mao Zedong's poetry), edited by Su Jia 苏桂. Nanning: Guangxi renmin, 1993.

Mao Zedong Yulu 2005: *Mao Zedong yulu* 毛泽东 语录 (Selected citations by Mao). Taibei: Dongguan guoji wenhua, 2005.

Marin 2001: Marin, Louis. "In Praise of Appearance." In *On Representation*, edited by Louis Marin. Stanford: Stanford University Press, 2001: 236–51.

Marschik 1997: Marschik, Matthias. "Kleines Glück: Botschaften der Werbung als Rückgrat des Selbst." In *Kultur Kultur Medien Macht: Cultural Studies und Medienanalyse*, edited by Andreas Hepp and Rainer Winter. Opladen: Westdeutscher Verlag, 1997: 215–24.

Marx 1845: Marx, Karl. *Theses on Feuerbach* (1845). In *Marx and Engels, Selected Works*. Vol. 1. Moscow: Progress Publishers, 1969: 13–15.

Mauger et al. 1974: Mauger, Peter, et al. *Education in China*. London: Anglo-Chinese Educational Institute, 1974.

May 2008: May, Jennifer. "Sources of Authority: Quotational Practice in Chinese Communist Propaganda." Ph.D. Diss., University of Heidelberg, 2008.

Medhurst 1843: Medhurst, Walter Henry. *Sanzijing* 三字经 (The Three Character Classic). Hong Kong: Yinghua shuyuan, 1943.

Mei 1997: Mei Shaowu 梅绍武. *Yi dai zongshi Mei Lanfang* 一代宗师梅兰芳 (A master of his time: Mei Lanfang). A pictorial album. Beijing: Beijing CBS, 1997.

Meisner 1999: Meisner, Maurice J. *Mao's China and After: A History of the People's Republic*. New York: Free Press, 1999.

Melvin and Cai 2004: Melvin, Sheila, and Jindong Cai. *Rhapsody in Red: How Western Classical Music Became Chinese*. New York: Algora Publishing, 2004.

Meng 2003: Meng Fanjun 孟繁军. *Quanguo 1–4 jie lianhuanhua pingjiang huojiang zuopin tulü* 全国 1–4届连环画评奖获奖作品图录 (Pictorial record of prize-winning works from the 1st–4th national comic competitions). Harbin: Heilongjiang meishu, 2003.

Meng 1980: Meng, Te-Sheng. "The Anti-Confucian Movements in the People's Republic of China 1966–1974." Ph.D. Diss., St. John's University New York, 1980.

Meng 1993: Meng, Yue. "Female Images and National Myth." In *Gender Politics in Modern China: Writing and Feminism*, edited by Tani Barlow. Durham: Duke University Press, 1993: 118–36.

Michael 1977: Michael, Franz. *Mao and the Perpetual Revolution*. New York: Barron's, 1977.

Michel 1982: Michel, Klaus. "Die Entwicklung der Peking-Oper im Spiegel der politischen Auseinandersetzungen um das Theater in der

Volksrepublik China von 1949 bis 1976." Ph.D. Diss., University of Heidelberg, 1982.

Miller 1961: Miller, Norbert. "Die Rolle des Zitierens: Rezension von Herman Meyer *Das Zitat in der Erzählkunst. Zur Geschichte und Poetik des Europäischen Romans.*" *Sprache im Technischen Zeitalter*, vols. 1–4 (1961): 164–69.

Min 2003: Min, Anchee. "The Girl in the Poster." In *Chinese Propaganda Posters*, edited by Anchee Min, Duo Duo, and Stefan R. Landsberger. Cologne: Taschen, 2003: 4–5.

Mitchell 1994: Mitchell, W. J. Thomas. "The Photographic Essay: Four Case Studies." In *Picture Theory: Essays on Verbal and Visual Representation*. Chicago: University of Chicago Press, 1994: 281–322.

Mitchell 2005: Mitchell, W. J. Thomas. "What Do Pictures Want?" In *What Do Pictures Want? The Lives and Loves of Images*. Chicago: University of Chicago Press, 2005: 28–56.

Mitter 2004: Mitter, Rana. *A Bitter Revolution: China's Struggle with the Modern World*. Oxford: Oxford University Press, 2004.

Mittler 1994: Mittler, Barbara. "Sprachlose Propaganda—Politik und Musikalische Avantgarde in Hong Kong, Taiwan und der Volksrepublik China." In *Yaogun Yinyue: Jugend-, Subkultur und Rockmusik in China: Politische und Gesellschaftliche Hintergründe eines Neuen Phänomens*, edited by Thomas Heberer. Münster: LIT, 1994: 33–46.

Mittler 1996: Mittler, Barbara. "Chinese New Music as a Politicized Language: Orthodox Melodies and Dangerous Tunes." *Indiana East Asian Working Paper Series* No. 10, 1996: 1–22.

Mittler 1997: Mittler, Barbara. *Dangerous Tunes: The Politics of Chinese Music in Hong Kong, Taiwan and the People's Republic of China since 1949*. Wiesbaden: Harrassowitz, 1997.

Mittler 1998: Mittler, Barbara. "'Mit Geschick den Tigerberg erobert': Zur Interpretation einer multiplen Quelle." In *Lesarten eines globalen Prozesses. Quellen und Interpretationen zur Geschichte der europäischen Expansion, Festschrift für Dietmar Rothermund*, edited by Andreas Eckert. Münster: LIT, 1998: 35–51.

Mittler 2000: Mittler, Barbara. "Ohrenbetäubende Stille: Chinas musikalische Avantgarde als Politikum." *Berliner China Hefte* 19 (2000): 65–76.

Mittler 2001: Mittler, Barbara. "'Eine Schule des Volkes.' Die Pekingoper unter Mao." *Spektrum der Wissenschaft*, July 2001: 76–83.

Mittler 2002: Mittler, Barbara. "Western Music and Modern China: From Mozart to Mao to Mozart." *World New Music Magazine* 12 (2002): 36–50.

Mittler 2003: Mittler, Barbara. "Cultural Revolution Model Works and the Politics of Modernization in China: An Analysis of Taking Tiger Mountain by Strategy." *The World of Music, Special Issue: Traditional Music and Composition* 2 (2003): 53–81.

Mittler 2004: Mittler, Barbara. *A Newspaper for China? Power, Identity and Change in Shanghai's News Media, 1872–1912*. Cambridge: Harvard University Press, 2004.

Mittler 2004a: Mittler, Barbara. "Against National Style—Individualism and Internationalism in New Chinese Music (Revisiting Lam Bun-Ching and Others)." In *Proceedings of the Symposium at the 2003 Chinese Composers' Festival*, edited by Daniel Law and Chan Ming Chin. Hong Kong: Hong Kong Composer's Guild, 2004: 2–26.

Mittler 2006: Mittler, Barbara. "Alltag als Fest: Mao als Ikone der chinesischen Kulturrevolution (1966–1976)." *Minima Sinica* 2 (2006): 25–47.

Mittler 2007: Mittler, Barbara. "Sound Patterns of Cultural Memory: Wound/Scar Music and Its Making in Contemporary China." *World New Music Magazine* 17 (2007): 33–54.

Mittler 2007a: Mittler, Barbara. "'My Brother Is a Man-Eater': Cannibalism before and after May Fourth." In *Zurück zur Freude: Studien zur Chinesischen Literatur und Lebenswelt und ihrer Rezeption in Ost und West. Festschrift für Wolfgang Kubin*, edited by Marc Hermann, Christian Schwermann, and Jari Grosse-Ruyken. Monumenta Serica Monograph Series 52. Sankt Augustin-Nettetal: Steyler Verlag, 2007: 627–55.

Mittler 2008: Mittler, Barbara. "Kulturrevolution als Propaganda? Der lange Marsch des Maoismus in China." In *Kulturrevolution als Vorbild: Maoismen im deutschsprachigen Raum*, edited by Sebastian Gehrig, Barbara Mittler, and Felix Wemheuer. Vienna: Peter Lang, 2008: 203–19.

Mittler 2008a: Mittler, Barbara. "Musik und Identität: Die Kulturrevolution und das 'Ende chinesischer Kultur.'" In *Zwischen Selbstbestimmung und Selbstbehauptung: Ostasiatische Diskurse des 20. und 21. Jahrhunderts*, edited by Michael Lackner. Baden-Baden: Nomos, 2008: 260–89.

Mittler 2008b: Mittler, Barbara. "'Von verrückten alten Männern, die Berge versetzen wollten' Die Überzeugungskraft der Worte Maos." In *Überzeugungsstrategien*, edited by A. Chaniotis, A. Kropp, and C. Steinhoff. Heidelberger

Jahrbücher Band 52. Heidelberg: Springer Verlag, 2008: 38–60.

Mittler 2008c: Mittler, Barbara. "Wider den 'Nationalen Stil': Individuelles und Internationales in Chinas Neuer Musik." In *Proceedings des Internationalen Kongress der Gesellschaft für Musikforschung in Weimar, 16-21.9.2004* (in press).

Mittler 2008d: Mittler, Barbara. "Popular Propaganda? Art and Culture in Revolutionary China." *Proceedings of the American Philosophical Society* 152, no. 4 (2008): 466–89.

Mittler 2009: Mittler, Barbara. "Mao mal ganz anders: Vom chinesischen Umgang mit (kultur-) revolutionärer Vergangenheit." In *Jahrbuch für Historische Kommunismusforschung 2009*, edited by Ulrich Mählert et al. Berlin: Aufbau Verlag, 2009: 89–105.

Mittler 2010: Mittler, Barbara 梅嘉乐. "Duochong fugai de xuanchuan: Mao Zhuxi xingxiang de yiyi yu quanli" 多重覆盖的宣传毛主席形象的意义与权利 (Superscribing propaganda: Vision, memory, meaning and power in images of Chairman Mao). In *Liang'an fenzhi: xueshu jianzhi, tuxiang xuanchuan yu zuqun zhengzhi* 兩岸分治：學術建制、圖像宣傳與族群政治, 1945–2000 (Divided rule across the Taiwan Strait: Educational reorganization, visual propaganda, and ethnic politics (1945–2000), edited by Yu Miin-ling 余敏玲. Taibei: Zhongyang yanjiu yuan, 2012.

Mittler 2010a: Mittler, Barbara. "'Eight Stage Works for 800 Million People': The Great Proletarian Cultural Revolution in Music—A View from Revolutionary Opera." *Opera Quarterly* 26, nos. 2–3 (2010): 377–401.

Mittler 2010b: Mittler, Barbara. "Enjoying the Four Olds! Oral Histories from a 'Cultural Desert.'" *Transcultural Studies* 2012 (under submission).

Modern Asian Studies. Special Issue: War in Modern China. 30, no. 4 (October 1996): 901–29.

Mondzain 1996: Mondzain, Marie-Jose. *Icone, Image, Economie*. Paris: Seuil, 1996.

De Montaigne 1992: de Montaigne, Michel. *Essais, nebst des Verfassers Leben nach der Ausgabe von Pierre Coste*, translated by Johann Daniel Tietz, 3 Vols. Zürich: Diogenes, 1992.

Moody 1974: Moody, Peter R. "The New Anti-Confucian Campaign in China: The First Round." *Asian Survey* 14, no. 4 (April 1974): 307–24.

Moravia 1968: Moravia, Alberto. "A Chinese Writer." *Encounter*. January 1968: 74–75.

Murray 2011: Murray, Christopher. *Champions of the Oppressed: Superhero Comics, Popular Culture, and Propaganda in America During World War II*. New Jersey: Hampton Press, 2011.

Nanwang de xuanlu 1992: *Nanwang de xuanlu: Mao Zedong songge jingxuan* 难忘的旋律：毛泽东颂歌精选 (Melodies difficult to forget: A selection of the best of songs praising Mao), edited by Li Hong 李红 et al. Hainan: Hainan sheying meishu, 1992.

NCFNSZJ 1952: *Nongcun funü sanzijing* 农村妇女三字经 (Three Character Classic for country women), edited by Zhonghua Quanguo Minzhu Funü Lianhehui Huadong Minzhu Funü Lianhehui 中华全国民主妇女联合会. Shanghai: Huadong renmin, 1952.

Nebiolo 1973: *The People's Comic Book: Red Women's Detachment, Hot on the Trail and Other Chinese Comics*, edited by Jean Chesneaux, Umberto Eco, and Gino Nebiolo. New York: Anchor Press, 1973.

Neumeyer 1964: Neumeyer, Alfred. *Der Blick aus dem Bilde*. Berlin: Gebrüder Mann, 1964.

New Ghosts, Old Dreams 1992: *New Ghosts, Old Dreams: Chinese Rebel Voices*, edited by Geremie Barmé and Linda Jaivin. New York: Times Books, 1992.

Niu-Niu 1995: Niu-Niu. *No Tears for Mao: Growing Up in the Cultural Revolution*. Chicago: Academy Chicago Publishers, 1995.

Nivison 1956: Nivison, David. "Communist Ethics and Chinese Tradition." *Journal of Asian Studies* 16, no. 1 (1956): 51–75.

NJSZJ 1997: *Nongjia Sanzijing* 农家三字经 (Three Character Classic for peasants). Heilongjiang: Kexue jishu, 1997.

Nongjianü 1999: *Nongjianü baishitong* 农家女百事通 (Rural women). Shanghai: Shanghai kexue puji, 1999.

Noth 2009: Noth, Juliane. *Landschaft und Revolution. Die Malerei von Shi Lu*. Berlin: Dietrich Reimer Verlag, 2009.

Nuridsany 2004: Nuridsany, Michel. *China Art Now*. Paris: Flammarion 2004.

NYJSSZJ 1964: *Nongye jishu sanzijing* 农业技术三字经 (Three Character Classic of agricultural techniques). Changchun: Jilin renmin, 1964.

Opera Quarterly 2010: *The Opera Quarterly. Performance + Theory + History* 26, nos. 2–3 (Autumn 2010). Guest-edited by Judith Zeitlin and Paola Iovene.

Pang 2005: Pang, Laikwan. "The Pictorial Turn: Realism, Modernity, and China's Print Culture in

the Late Nineteenth Century." *Visual Studies* 20 (2005): 16–36.

Pang 2007: Pang, Laikwan. "Advertising and the Visual Display of Women." In *The Distorting Mirror: Visual Modernity in China,* Honolulu: University of Hawai'i Press, 2007: 103–30.

Paul 2009: Paul, Gerhard. "Das Mao-Porträt. Herrscherbild, Protestsymbol und Kunstikone." *Zeithistorische Forschungen/Studies in Contemporary History* 6, no. 1 (2009): 58–84.

PDSZJ 1994: *Pinde sanzijing* 品德三字经 (Morality Three Character Classic). Shanghai: Cishu, 1994.

Pecore et al. 1999: Pecore, Joanna T., et al. "Telling the Story with Music: The Internationale at Tiananmen Square." *Education about Asia* 4, no. 1 (1999): 30–36.

Peking Review 28 May 1976: "Negating the Revolution in Literature and Art Aims at Restoring Capitalism." *Peking Review* 22, nos. 5–7 and 18.

Penny Dreadful 1981: *Vom Penny Dreadful zum Comic. Englische Jugendzeitschriften, Heftchen und Comics von 1855 bis zur Gegenwart. Ausstellung im Stadtmuseum Oldenburg.* Oldenburg: Bibliotheks- und Informationssystem der Universität Oldenburg, 1981.

Pepper 1991: Pepper, Suzanne. "Education." In *Cambridge History of China, Vol 15. The People's Republic, Part 2: Revolutions within the Chinese Revolution, 1966–1982,* edited by Roderick MacFarquhar and John K. Fairbank. New York: Cambridge University Press, 1991: 540–93.

Pepper 1996: Pepper, Suzanne. *Radicalism and Education Reform in 20th-Century China: The Search for An Ideal Development Model.* New York: Cambridge University Press, 1996.

Perris 1983: Perris, Arnold. "Music as Propaganda: Art at the Command of Doctrine in the People's Republic of China." *Ethnomusicology* 27, no. 1 (1983): 1–28.

Perris 1985: Perris, Arnold. *Music as Propaganda: Art to Persuade, Art to Control.* London: Greenwood Press, 1985.

Perry 2008: Perry, Elizabeth J. "Reclaiming the Chinese Revolution." *Journal of Asia Studies* 67, no. 4 (2008): 1147–64.

Peterson 1997: Peterson, Glen. *The Power of Words: Literacy and Revolution in South China, 1949–95.* Vancouver: University of British Columbia Press, 1997.

Philosophy Is No Mystery 1972: *Philosophy Is No Mystery: Peasants Put Their Study to Work.* Beijing: Foreign Languages Press, 1972.

Pi Lin pi Kong zawen 1974: *Pi Lin pi Kong zawen* 批林批孔杂文 (Essays criticizing Lin Biao and Confucius). Vol. 2. Shanghai: Shanghai renmin, 1974.

Pian Chao 1984: Pian Chao, Rulan. "Review of Colin P. Mackerras, *Performing Arts in Contemporary China.*" *Ethnomusicology* 28 (1984): 574–76.

Pickowicz 2007: Pickowicz, Paul G. "Rural Protest Letters: Local Perspectives on the State's Revolutionary War on Tillers, 1960–1990." In *Re-envisioning the Chinese Revolution. The Politics and Poetics of Collective Memories in Reform China,* edited by Lee Ching Kwan and Guobin Yang. Stanford: Stanford University Press, 2007: 21–49.

Picturing Power 1999: *Picturing Power in the People's Republic of China: Posters of the Cultural Revolution,* edited by Harriet Evans and Stephanie Donald. Lanham: Rowman and Littlefield, 1999.

Ping 1975: Ping, Hsin. "New Children's Songs from a Peking Primary School." *Chinese Literature* 1975.6:104–9.

Plamper 2003: Plamper, Jan. "Spatial Poetics of Personality Cult—Circles around Stalin." In *The Landscape of Stalinism: The Art and Ideology of Soviet Space,* edited by Evgeny Dobrenko and Eric Naiman. Seattle: University of Washington Press, 2003: 19–50.

Platt 2006: Platt, Kevin M. F. *Epic Revisionism: Russian History and Literature as Stalinist Propaganda.* Madison: University of Wisconsin Press, 2006.

Polletta 2006: Polletta, Francesca. *It Was Like a Fever: Storytelling in Protest and Politics.* Chicago: University of Chicago Press, 2006.

PPSZJCKCL 1974: *Pipan 'Sanzijing' cankao cailiao* 批判三字经参考材料 (Reference material for criticism of the Three Character Classic). Beijing: Renmin, 1974.

Platthaus 1989: Platthaus, Andreas. *Im Comic vereint—Eine Geschichte der Bildgeschichte.* Frankfurt: Insel, 1989.

Program Notes "5. Sinfoniekonzert der Essener Philharmoniker." Essen: no publisher, February 1999.

PSZJKG 1974: *Pi Sanzijing Kouge* 批《三字经》口歌 (Songs criticizing the Sanzijing), edited by Gansusheng diyi jianzhu gongchengju diyi zhongxue da pipanzu 甘肃省第一建筑工程局第一中学大批判组. Gansu: Gansu renmin, 1974.

Qi 1988: Qi Lingchen 齐令辰. *Sanzijing jianzhu* 三字经简注 (Simple commentary on the Three

Character Classic). Beijing: Baowentang shudian, 1988.

Qianjunbang manhua 1967: *Qianjunbang manhua* 千钧棒漫画 (Magic Rod Comics), edited by Shoudu geming zaofanpai 首都革命造反派. Beijing: Shoudu geming zaofanpai, 1967.

Qixi baihutuan 1967: *Qixi baihutuan* 奇袭白虎团 (Raid on White Tiger Regiment), edited by Shandongsheng jingjutuan jiti chuangzuo 山东省京剧团集体创作. Tianjin: Baihua wenyi, 1967.

Qu 1985: Qu Dajun 屈大均. *Guangdong xinyu* 广东新语 (Tidings from Guangdong). Beijing: Zhonghua shuju, 1985.

Qu 1932: Qu Qiubai 瞿秋白. "The Question of Popular Literature and Art," translated by Paul Pickowicz. *Bulletin of Concerned Asian Scholars* (January–March 1976): 48–52.

Qu 1932a: Qu Qiubai 瞿秋白. "Pu luo dazhong wenyi de xianshi wenti 普罗大众文艺的现实问题 (The question of popular literature and art)." In *Qu Qiubai wenji* 瞿秋白文集 (Collected works by Qu Quibai). Vol. 2. Beijing: Renmin wenxue, 1953: 853–74.

Qualter 1985: Qualter, Terence H. *Opinion Control in the Democracies*. London: Macmillan Press, 1985.

Quan 2006: Quan Yanchi. *Mao Zedong. Man, Not God*, translated by Wang Wenjiong. Beijing: Foreign Languages Press, 2006.

Quanguo lianhuanhua Zhongguo huazhanlan 1973: *Quanguo lianhuanhua Zhongguo huazhanlan (guohua zhuanji)* 全国连环画中国画展览(国画专辑) (An exhibition of Chinese comics, with a special section on comics in national style). Beijing: Renmin meishu, 1974.

Quotation Marks 1997: *Quotation Marks: Chinese Contemporary Paintings*, edited by the Singapore Art Museum. Singapore: Singapore Art Museum, 1997.

Rampton and Stauber 2003: Rampton, Sheldon, and John Stauber. *Weapons of Mass Deception: The Uses of Propaganda in Bush's War on Iraq*. New York: Penguin, 2003.

Rawski 1979: Rawski, Evelyn Sakakida. *Education and Popular Literacy in Ch'ing China*. Ann Arbor: University of Michigan Press, 1979.

Read 1985: Read, Herbert. *A Concise History of Modern Painting*. New York: Praeger, 1985.

Re-envisioning the Chinese Revolution: The Politics and Poetics of Collective Memories in Reform China, edited by Lee Ching Kwan and Guobin Yang. Stanford: Stanford University Press, 2007.

Renmin Huabao 人民画报 *China Pictorial* (*RMHB*). Beijing: Renmin huabao she.

Renmin Ribao 人民日报 *People's Daily* (*RMRB*)

RMRB 27 January 1956. "Jinian weida de Audili yinyuejia Mozha'erte" 纪念伟大的奥地利音乐家莫札尔特 (Remembering the great Austrian composer Mozart).

RMRB 10 February 1964. "Yong geming jingshen jianshe shanqu de hao bangyang" 用革命精神建设山区的好榜样 (Using revolutionary spirit to create a good model for the mountainous regions).

RMRB 10 June 1966. "Hengsao yiqie niugui sheshen" 横扫一切牛鬼蛇神 (Sweep away all ox ghosts and snake spirits).

RMRB 25 October 1966. "Yong Mao Zedong sixiang gaizao linghun—jiefangjun moubu fuzhidaoyuan Wang Daoming tan huoxue huoyong *Lao Sanpian* gaizao sixiang de tihui" 用毛泽东思想改造灵魂—解放军某部副指导员王道明谈活学活用"老三篇"改造思想的体会 (Use Mao Zedong Thought to change one's soul— PLA Section Deputy Instructor Wang Daoming speaks about the experience of living study and application of the *Three Constantly Read Articles* to change one's thoughts).

RMRB 4 December 1967. "Weida lingxiu Mao Zhuxi he Lin Biao fuzhuxi jiejian haijun he tongxinbing deng geming zhanshi" 伟大领袖毛主席和林彪副主席接见海军和通信兵等革命战士. (Great Leader Chairman Mao and Vice Chairman Lin Biao receive the revolutionary fighters from marine and communications).

RMRB 24 May 1971. "Yanzhe wenyi wei gongnongbing fuwu de fangxiang qianjin" 沿着文艺为工农兵服务的方向前进 (Walk on in the direction of literature and arts serving the workers, peasants, and soldiers).

RMRB 03 June 1972. "Gongnongbing huanying xin huagu— ji Hunan sheng wengongtuan huagu judui yizhi geming xiandai jingju *Shajiabang*" 工农兵欢迎新花鼓—记湖南省文工团花鼓剧队移植革命现代京剧"沙家浜" (The workers, peasants and soldiers welcome the new Huagu Entertainment—Recording the revolutionary modern transplant opera *Shajiabang* by the Huagu Troupe in the Hunan Wengongtuan).

RMRB 29 March 1973. "Xue yu chuang" 学与创 (Study and creation).

RMRB 11 August 1973. "Shidai jingshen yu junzhong tese—tan difang xiqu de geming"

时代精神与剧种特色—谈地方戏曲的革命 (The spirit of the times and the quality of drama—On the revolution of local opera).

RMRB 23 January 1974. "Lianhuanhua chuangzuo he chuban xihuo fengshou" 连环画创作和出版喜获丰收 (Reaping a bumper harvest for comic creation and publication).

RMRB 8 February 1974. "Tiegang gongren yongdang pi Lin pi Kong de chuangjiang—Shanghai diwu gangtie gongren pipanhui jishi" 钢铁工人勇当批林批孔的闯将—上海第五钢铁厂工人批判会纪实 (The steel workers are courageous pathbreakers in their criticism of Lin Biao and Confucius—Record from the workers' criticism meeting at the Shanghai Fifth Steel Factory).

RMRB 16 February 1974. "Shougang gongren fahui pi Lin pi Kong zhulijun de zhandou zuoyong henpi 'keji fuli' fandui fubi daotui" 首钢工人发挥批林批孔主力军的战斗作用狠批"克己复礼"反对复辟倒退 (Workers of the First Steel Company unleash a struggle as the main force in criticisms of Lin Biao and Confucius, criticizing harshly the idea of "overcoming the self and returning to the rites" and opposing restorationist ideas).

RMRB 20 February 1974. "Gongnongbing pipan Lin Biao Kong Qiu fubi daotui de zuixing" 工农兵批判林彪孔丘复辟倒退的罪行 (The workers, peasants, and soldiers are criticizing Lin Biao and Confucius for the crime of restorationism).

RMRB 4 March 1974. "Qunzhong shi lishi fazhan de dongli—pipan Lin Biao, Kong Lao'er guchui 'Shang zhi, xia yu' de weixin shiguan" 群众是历史发展的动力—批判林彪、孔老二鼓吹"上智下愚"的唯心史观 (The masses are history's moving force—Criticize Lin Biao and Old Confucius' advocacy of the idealist view of history that "above are the sages, below the stupid").

RMRB 3 April 1974. Liang Xiao 两校. "Kongqiu qi ren" 孔丘其人 (That man Confucius).

RMRB 6 July 1974. Song Ying 宋英. "Tan lianhuanhua de renwu xingxiang suzao" 谈连环画的人物形象塑造 (On the making and form of comic figures).

RMRB 20 November 1974. "Jianchi shidai jingshen yu juzhong tese de tongyi—difangxi yizhi geming yangbanxi yinyue sheji de jidian qianjian" 坚持时代精神与剧种特色的统一:地方戏移植革命样板戏音乐设计的几点浅见 (Upholding the spirit of the times and the special quality of theater: A few shallow thoughts on the musical set up in the local transplant revolutionary model works).

RMRB 2 December 1975. "Wenyi geming xin chengguo—Ji guoqing wenyi huiyanzhong difangxi yizhi geming yangbanxi de yanchu" 文艺革命新成果—记国庆文艺汇演中地方戏移植革命样板戏的演出 (New achievements for the revolution in the arts—reporting on the performances of local operas and transplant model works from the National Day joint performance).

RMRB 9 December 1975. "Huaiju kaile xin shengmian—ji Shanghai shi renmin Huaijutuan xuexi geming yangbanxi gaige Huaiju de chengguo" 淮剧开了新生面—记上海市人民淮剧团学习革命样板戏改革淮剧的成果 (Huaiju opens with a new look—Reporting on the success of the Shanghai City People's Huaiju Troupe in studying the model works and changing them into Huaiju).

RMRB 24 February 1976. Liang Xiao 两校. "Zai lun Kong Qiu qi ren" 再论孔丘其人 (More on that man Confucius).

RMRB 8 March 1976. "Geming yangbanxi yongyuan guanghui: Shanghai jingjutuan wenyi zhanshi yu yangbanxi de juda chengguo fanji youqing fan'an feng" 革命样板戏永放光辉:上海京剧团文艺战士以样板戏的巨大成果反击右倾翻案风 (The revolutionary model works will always shine: the cultural fighters of the Shanghai Beijing Opera Troupe use the great success of the model works to counterattack the right deviationist reversalist wind).

RMRB 7 September 1976. "Quyi geming de fengshou chengguo—tan quyi yizhi geming yangbanxi guan" 曲艺革命的丰硕成果—谈曲艺移植革命样板戏观 (A substantial success for the revolution of Quyi—a view taken from the Quyi transplant model works).

RMRB 30 December 1976. Liu Yuanyan 刘元彦, and Yuan Shujuan 袁淑娟. "Ping 'Zai lun Kongqiu qi ren'" 评《再论孔丘其人》 (A critical commentary on "More on that man Confucius").

RMRB 20 April 1999. Lai Xinxia 来新夏. "Kexue duidai wailai wenhua" 科学对待外来文化 (Treating foreign cultures scientifically).

Resolution 1981: "Resolution on Certain Questions in the History of Our Party Since the Founding of the People's Republic of China," edited by the CCP Central Committee. *Beijing Review* 1981.27: 20–26.

Revolution Continues 2008: *The Revolution Continues,* edited by the Saatchi Gallery. London: Random House, 2008.

Riegel 2001: Riegel, Jeffrey. "Shi-ching Poetry and Didacticism in Ancient Chinese Literature." In *The Columbia History of Chinese Literature,* edited by Victor H. Mair. New York: Columbia University Press, 2001: 97–109.

Roberts 2006: Roberts, Rosemary. "From Zheng Qiang to Jiang Shuiying: The Feminization of a Revolutionary Hero in Maoist Theatre's Song of the Dragon River." *Asian Theatre Journal* 23, no. 2 (Fall 2006): 265–91.

Roberts 2010: Roberts, Rosemary. *Maoist Model Theatre: The Semiotics of Gender and Sexuality in the Chinese Cultural Revolution (1966–1976).* Leiden: Brill, 2010.

Rose 2001: Rose, Gillian. "Toward a Critical Visual Methodology." In *Visual Methodologies: An Introduction to the Interpretation of Visual Materials.* London: Sage, 2001: 5–32.

San Ai (Chen Duxiu) 1904: San Ai 三爱 (Chen Duxiu). "Lun xiqu" 论戏曲 (On Drama). *Anhui suhuabao* 安徽俗话报 11 (10 September 1904): 1–2.

Sarkowicz 2004: Sarkowicz, Hans. *Hitlers Künstler: Die Kultur im Dienst des Nationalsozialismus.* Frankfurt am Main: Insel Verlag, 2004.

Schell 1992: Schell, Orville. "Once Again, Long Live Chairman Mao." *Atlantic Magazine* 270, no. 6 (December 1992): 32–36. Archived as DACHS 2008 Mao Citations, Sun and Truth.

Schell 1994: Schell, Orville. *Mandate of Heaven.* New York: Simon & Schuster, 1994.

Schönhals 1989: Schönhals, Michael. "Unofficial and Official Histories of the Cultural Revolution: A Review Article." *Journal of Asian Studies* 48, no. 3 (1989): 563–72.

Schönhals 1992: Schönhals, Michael. *Doing Things with Words in Chinese Politics: Five Studies.* Berkeley: University of California Press, 1992.

Schönhals 1996: Schönhals, Michael, ed. *China's Cultural Revolution, 1966–1969: Not a Dinner Party.* Armonk, NY: M. E. Sharpe, 1996.

Schönhals 1999: Schönhals, Michael. "Review of *The Cultural Revolution: A Bibliography, 1966–1996.*" *China Quarterly* 59 (1999): 744–45.

Schoots 2000: Schoots, Hans. *Living Dangerously: A Biography of Joris Ivens.* Amsterdam: Amsterdam University Press, 2000.

Schrift 2001: Schrift, Melissa. *Biography of a Chairman Mao Badge: The Creation and Mass Consumption of a Personality Cult.* New Brunswick: Rutgers University Press, 2001.

Schwartz 2008: Schwartz, Vanessa. "Film and History." In *The Sage Handbook of Film Studies,* edited by James Donald and Michael Renov. London: Sage, 2008: 199–215.

Schwermann 2006: Schwermann, Christian. "Alles entsteht aus der Einfalt. Untersuchungen zum Ideal der Einfachheit (yu) in der chinesischen Geistesgeschichte." M.A. Thesis, Bonn, 2006.

Scott, A. C. *Actors Are Madmen: A Notebook of a Theatergoer in China.* Madison: University of Wisconsin Press, 1982.

Seifert 2001: Seifert, Andreas. "Comics in China." In *Lexikon der Comics, Teil 3: Themen und Aspekte,* edited by Heiko Langhaus. Meitingen: Corian Verlag, 2001: 1–59.

Seifert 2008: Seifert, Andreas. *Bildproduktion: Bildgeschichten für Chinas Massen: Comic und Comicproduktion im 20. Jahrhundert.* Cologne: Böhlau, 2008.

Serve the People 1967: Mao Zedong. *Serve the People. In Memory of Norman Bethune. The Foolish Old Man Who Removed the Mountains.* Beijing: Foreign Languages Press, 1967.

Shen 2004: Shen Hong 沈泓. *Suiyue liuhen—Lao piaozheng de shoucang touzi* 岁月留痕—老票证的收藏投资 (The scars left by the years—a treasure of old certificates). Shanghai: Keji jiaoyu, 2004.

Shen 2006: Shen Hong 沈泓. *Laohua xinzhuan* 老画新传 (Old pictures in new stories). Shanghai: Keji jiaoyu, 2006.

Shen 2006a: Shen Hong 沈泓. *Biaopai wangshi* 标牌往事 (The history of brands). Shanghai: Keji jiaoyu, 2006.

Shen 2008: Shen, Kuiyi. "Propaganda Posters and Art during the Cultural Revolution." In *Art and China's Revolution,* edited by Melissa Chiu and Zheng Shengtian. New York: Asia Society, 2008: 148–63.

Shen and Shen 2002. Shen Yeliu and Shen Peng. "Wenge lianhuanhua niandai jieding chu lun" 文革连环画年代界定初论 (First ideas on the periodization of Cultural Revolution comics. In *Wengeban lianhuanhua chutan* 文革版连环画初探 (A first discussion of Cultural Revolution comics), edited by Tian Weiming 田伟明. Sanming: Sanmingshi lianhuanhua shoucang yanjiuhui, 2002: 206–8.

Shi 1950: Shi Lu 石鲁. "Nianhua chuangzuo jiantao" 年画创作检讨 (An examination of New Year Prints). *Renmin Meishu* 人民美术 2 (1950): 30–31.

Shi 2002: Shi, Ming. "Dienst am Volk statt Pierre Cardin—Grobe Worte für die Masse: In China wird die Sprache des Klassenkampfes wieder schick." *Frankfurter Allgemeine Zeitung* 22 October 2002: 40.

Silbergeld and Gong 1993: Silbergeld, Jerome, and Jisui Gong. *Contradictions: Artistic Life, the Socialist State, and the Chinese Painter Li Huasheng.* Seattle: University of Washington Press, 1993.

Sima 1972: Sima Qian 司马迁. *Shiji* 史记 (Records of the historian). Vol. 5. Beijing: Zhonghua Shuju, 1972.

Smith et al.: Smith, A. C. H., et al. *Paper Voices: The Popular Press and Social Change 1935-65.* London: Chatto & Windus, 1975.

Snow 2010: Snow, Nancy. *Propaganda, Inc.: Selling America's Culture to the World.* 3rd ed. New York: Seven Stories, 2010.

Songci sanbaishou 2007: *Songci sanbaishou quanjie* 宋词三百首全解 (A complete commented edition of 300 *ci* from the Song), compiled and edited by Cao Yi 蔡义. Shanghai: Fudan daxue, 2007.

Songge 1992: *Songge jinqu yibaishou* 颂歌金曲一百首 (One hundred golden songs of praise), edited by Mei Xue 梅雪. Vol. 1. Baoding: Hebei daxue, 1992.

Spaces 1999: *Spaces of Their Own: Women's Public Sphere in Transnational China*, edited by Mayfair Mei-Hui Yang. Minneapolis: University of Minnesota Press, 1999.

Spence 1990: Spence, Jonathan D. *The Search for Modern China.* New York: W. W. Norton & Company, 1990.

Spengler 1999: Spengler, Tilman. *Die Stirn, die Augen, der Mund: Roman.* Reinbek: Rowohlt, 1999.

Spiegel spezial 1988: *Spiegel spezial. Die Wilden 68er*, 1 January 1988.

Sproule 1997: Sproule, J. Michael. *Propaganda and Democracy: the American Experience of Media and Mass Persuasion.* Cambridge: Cambridge University Press, 1997.

Starr 1974: Starr, John B. "China in 1974: 'Weeding Through the Old to Bring Forth the New.'" *Asian Survey* 15 (1974): 1–19.

Steen 1996: Steen, Andreas. *Der Lange Marsch des Rock 'n Roll. Pop- und Rockmusik in der Volksrepublik China.* Hamburg: LIT, 1996.

Steiner 2007: Steiner, Shep. "Street Smart: 'Thinking Pictures' in the Tradition of Street Photography." *Image & Narrative* 18 (2007), archived as DACHS 2012 Steiner "Thinking Pictures."

Su 1932: Su, Wen 苏汶. "Guanyu *Wenxin* yu Hu Qiuyuan de wenyi lunban" 关于"文新"与胡秋原的文艺论辩 (A debate with Hu Qiuyuan on literature and art in *Wenyi xinwen* 文艺新闻). *Xiandai* 现代 (Modern times) 1, no. 3 (1932): 378–85.

Su and Jia 1992: *Buluo de taiyang* 不落的太阳 (The sun that never sets), edited by Su Ya 苏娅 and Jia Lusheng 贾鲁生. Zhengzhou: Zhongyuan nongmin, 1992.

Sullivan 1989: Sullivan, Michael. *The Meeting of Eastern and Western Art.* Berkeley: University of California Press, 1989.

Sullivan 1996: Sullivan, Michael. *Art and Artists of Twentieth-Century China.* Berkeley: University of California Press, 1996.

SWSSZJ 1964: *Song wenshen sanzijing* 送瘟神三字经 (The Three Character Classic of the god of epidemics). Shanghai: Shanghai jiaoyu, 1964.

SZJ 1986: *Sanzijing* 三字经 (The Three Character Classic), edited by Ding Shuangping 丁双平. Changsha: Yuelu shushe, 1986.

SZJBJXQZW 1988: *Sanzijing Baijiaxing Qianziwen* 三字经百家姓千字文 (The Three Character Classic, the One Hundred Surnames, and the One Thousand Character Classic). Shanghai: Shanghai guji, 1988.

SZJBJXQZW 1991: *Sanzijing baijiaxing qianziwen* 三字经百家姓千字文 (The Three Character Classic, the One Hundered Surnames, and the One Thousand Character Classic), edited by Wang Yunzhu 王云珠. Jinan: Qilu shushe, 1991.

SZJBJXZG 1988: *Sanzijing Baijiaxing zengguang* 三字经百家姓增广 (An expanded Three Character Classic and One Hundred Surnames). Chengdu: Bashu shushe, 1988.

SZJDSZFDDW 1974: *"Sanzijing" deng shizhong fandong duwu pizhu huiji wuhan quan yanchang* "三字经"等十种反动读物批注汇集武汉卷烟厂 (The "Three Character Classic" and ten more such reactionary books: Collected criticisms by the Wuhan cigarette factory). Wuhan: Wuhan shifan xueyuan 1974.

SZJJSFBJ 1974: *Sanzijing jiu shi fubijing* 三字经就是复辟经: 工农兵批林批孔文集 (The Three Character Classic is a restorationist classic after all: A selection of texts by workers, peasants, and soldiers criticizing Lin Biao and Confucius). Hubei: Hubei renmin, 1974.

SZJJZ 1988: *Sanzijing jianzhu* 三字经简注 (The Three Character Classic with simple commentary), edited by Qi Lingchen 齐令辰. Beijing: Baowentang shudian, 1988.

SZJPZ 1974: *Sanzijing pizhu* 三字经批注 (A critical commentary of the Three Character Classic), edited by the theoretical group of Guangdong railroad workers and a team of specialists from Sun Yatsen University 广州铁路局广州工务段工人理论组, 中山大学中文系汉语专业. Guangdong: Guangdong renmin, 1974.

SZJSHRJ 1974: *Sanzijing shi hairenjing* 三字经是害人经 (The Three Character Classic is a classic hurtful to the people), edited by Linyi County Yunnan Production Brigade Political Evening School 临猗县云大队政治夜校. Shanxi: Shanxi renmin, 1974.

SZJSPMKMZDDPRJ 1974: *Sanzijing shi panmai Kong Meng zhi dao de pianrenjing* 三字经是贩卖孔孟之道的骗人经 (The Three Character Classic is a cheater's classic of the treacherous Confucian and Mencian teachings), edited by the theoretical group representing the Beijing City industrial workers (北京市代表工业局工人理论小组). Beijing: Beijing renmin, 1974.

SZJSPRJ 1974: *Sanzijing shi pianren jing* 三字经是骗人经 (The Three Character Classic is a cheater's classic). Shanghai: Shanghai renmin, 1974.

Tachai 1972: *Tachai: Standard Bearer in China's Agriculture.* Edited by Xin Huawen and Chao Feng-nien. Beijing: Foreign Languages Press, 1972.

Tan Dun 1996: Tan, Dun. *Orchestral Theatre III: Red Forecast.* New York: G. Schirmer Inc., 1996.

Tan Santuchu 1974: *Tan Santuchu chuangzuo yuanze* 谈三突出创作原则 (The creative principle of the *Three Prominences*). Taiyuan: Shanxi renmin, 1974.

Teiwes and Sun 1996: Teiwes, Frederick C., and Warren Sun. *The Tragedy of Lin Biao Riding the Tiger During the Cultural Revolution.* Honolulu: University of Hawaii Press, 1996.

Teoh 1985: Teoh, Vivienne. "The Reassessment of Confucius and the Relationships Among Concepts, Language, and Class in Chinese Marxism 1947–1977: A Study in the Thought of Feng Youlan and Yang Rongguo on the Scope of Benevolence." *Modern China* 2, no. 3 (1985): 347–75.

Ter Haar 2002: ter Haar, Barend J. "China's Inner Demons: The Political Impact of the Demonological Paradigm." In *China's Great Proletarian Cultural Revolution: Master Narratives and Post-Mao Counternarratives*, edited by Chong Woei Lien. Lanham: Rowman & Littlefield, 2002: 27–68.

Terrill 1984: Terrill, Ross. *Madame Mao: The White-Boned Demon.* Toronto: Bantam Books, 1984.

Thurston 1987: Thurston, Anne F. *Enemies of the People.* New York: Knopf, 1987.

Toepffer 1982: Toepffer, Rodolphe. *Essay zur Physiognomie.* Siegen: Machwerk-Verlag, 1982.

Tolic 1995: Tolic, Dubravka Oraic. *Das Zitat in Literatur und Kunst: Versuch einer Theorie*, translated by Ulrich Dronske. Vienna-Cologne: Böhlau, 1995.

TPSZJ 1971: *Taiping Tianguo shiwen chao* 太平天国诗文钞 (Taiping Writings), edited by Luo Yong 罗邕 and Shen Zuji 沈祖基. In *Jindai Zhongguo shiliao congkan* 近代中国史料丛刊 (A Collection of historical texts from modern China), edited by Shen Yunlong 沈云龙. Vol. 715:1 & 715:2. Taibei: Wenhai, 1971.

Le Travail de la citation 1995: *Le Travail de la Citation en Chine et au Japon*, edited by Karine Chemla, Francois Martin, and Jacqueline Pigeot. Paris Saint-Denis: Presses universitaires de Vincennes, 1995.

Trébinjac 1990: Trébinjac, Sabine. "Que Cent Chants Rivalisent, qu'une Musique Eclose: Étude sur le Traditionalisme d'État en Chine." *Archives Européennes de Sociologie* 31 (1990): 60–79.

Trébinjac 2000: Trébinjac, Sabine. *Le Pouvoir en Chantant.* In *Memoires de la Societe d'Ethnologie.* Vol. 5. Nanterre: Societe d'Ethnologie, 2000.

Tregear 1980: Tregear, Mary. *Chinese Art.* London: Thames and Hudson, 1980.

Tschen 1977: Tschen, Yung-gui. *Die "Viererbande" gründlich kritisieren, einen neuen Aufschwung in der Bewegung zum Aufbau von Kreisen vom Typ Dadschai im ganzen Land herbeiführen*, Beijing: Verlag für fremdsprachige Literatur, 1977.

Tuohy 1999: Tuohy, Sue. "Covering Mao in the 90s: Revolutions in Chinese Revolutionary Music." Unpublished lecture given on September 24, 1999, accompanying the exhibition "Picturing Power: Posters of China's Cultural Revolution" at Indiana University.

Tuohy 2001: Tuohy, Sue. "Making Sense of Music of the Chinese Cultural Revolution: Standards, Covers, and Crossovers." Unpublished paper prepared for the conference "Rethinking Cultural Revolution Culture" held at the University of Heidelberg, February 22–24, 2001.

Tuohy 2001a: Tuohy, Sue. "The Sonic Dimensions of Nationalism in Modern China: Musical Representation and Transformation." *Ethnomusicology* 45, no. 1 (2001): 107–31.

Unger and Chan 2007: "Memories and the Moral Economy of a State-Owned Enterprise." In *Re-envisioning the Chinese Revolution: The Politics and Poetics of Collective Memories in Reform China*, edited by Ching Kwan Lee and Guobin Yang. Stanford: Stanford University Press, 2007: 119–40.

University of Westminster: "University of Westminster China Posters Online," edited by Katie Hill, archived as DACHS 2009 Propaganda Posters, University of Westminster Collection.

Urban 1971: Urban, George. *The Miracles of Chairman Mao: A Compendium of Devotional Literature, 1966–1970*. Los Angeles: Nash Publishing, 1971.

Utz 2002: Utz, Christian. *Neue Musik und Interkulturalität: Von John Cage bis Tan Dun*. Stuttgart: Franz Steiner, 2002.

Valjakka 2011: Valjakka, Minna. "Many Faces of Mao Zedong." Ph.D. Diss., Helsinki University, 2011.

Van Leeuwen 2000: van Leeuwen, Andreas. *Die Neue chinesische Oper in Werk und Diskurs (1920–1966): Eine Schwerpunktanalyse*. Berlin: Mensch und Buch, 2000.

Viatkin 1976: Viatkin, R.V. "Some Questions in the History of Chinese Society and Culture and the Critique of Confucius Campaign in the Chinese People's Republic." *Soviet Anthropology and Archaeology* 15, nos. 2–3 (1976–1977): 103–32.

Wagner 1990: Wagner, Rudolf. *The Contemporary Chinese Historical Drama: Four Studies*. Berkeley: University of California Press, 1990.

Wagner 1992: Wagner, Rudolf. "Konfrontation im *Imaginaire*: Institutionelle Struktur und Modernisierung in der Volksrepublik China." In *Revolution und Mythos*, edited by Dietrich Harth and Jan Assmann. Frankfurt: Fischer, 1992: 313–46.

Wagner 1995: Wagner, Rudolf. "Der Vergessene Hinweis: Wang Pi über den *Lao-Tzu*." In *Text und Kommentar: Archäologie der Literarischen Kommunikation*, edited by Jan Assman and Burkhard Bgladigow. Munich: Wilhelm Fink, 1995: 257–78.

V. Wagner 1995: Wagner, Vivian. "Lieder der Roten Garden." M.A. Thesis, University of Munich, 1995.

Walsdorf 2010: Walsdorf, Hanna. *Bewegte Propaganda: Politische Instrumentalisierung von Volkstanz in den Deutschen Diktaturen*. Würzburg: Königshausen & Neumann, 2010.

Wang 1990: Wang An'guo. "Zhongguo jiaoxiang yinyue chuangzuo 1946–1976" 中国交响音乐创作 (Chinese symphonic creation). In *Zhongguo xin yinyueshi lunji* (Collected essays on the history of New Music in China, 1946–1976), edited by Liu Jingzhi. Hong Kong: Centre for Asian Studies, 1990: 285–306.

Wang 1997: Wang, Ban. *The Sublime Figure of History: Aesthetics and Politics in Twentieth-Century China*. Stanford: Stanford University Press, 1997.

Wang 1950: Wang Chaowen 王朝闻. "Guanyu xuexi jiu nianhua xingshi" 关于学习旧年画形式 (On studying the form of the old New Year Prints). *Renmin Meishu* 人民美术 2 (1950): 23–26.

Wang 2004: Wang, David Der-wei. *The Monster That Is History: History, Violence, and Fictional Writing in Twentieth Century China*. Berkeley: University of California Press, 2004.

Wang 1974: Wang, Gungwu. "Burning Books and Burying Scholars Alive." *Papers in Far Eastern History* 9 (1974): 137–86.

Wang 2003: Wang Helen. "Mao on Money." *East Asia Journal* vol. 1, no. 2: 86–97.

H. Wang 2008: Wang, Helen. *Chairman Mao Badges: Symbols and Slogans of the Cultural Revolution*. London: The British Museum Press, 2008.

M. Wang and Yan 2000: Wang Mingxian 王明贤 and Yan Shanchun 严善錞 新中国美术图史. *The Art History of the People's Republic of China* (sic). Beijing: Zhongguo qingnian, 2000.

Wang 2008: Wang, Mingxian. "The Red Guards' Fine Arts Campaign." In *Art and China's Revolution*, edited by Melissa Chiu and Zheng Shengtian. New Haven: Yale University Press, 2008: 187–200.

Wang 1999: Wang Renyuan. *Jingju Yangbanxi yinyue lungang* 京剧样板戏音乐论纲 (A draft on the music of the Beijing Operas among the model works). Beijing: Renmin yinyue, 1999.

Wang 1978: Wang Shuo 王朔. "Dengdai" 等待 (Waiting). *Jiefang jun wenyi* 解放军文艺 11 (1978): 25–29.

Wang 1985: Wang Shuo 王朔浮. "Fuchu Haimian" 浮出海面 (Flotsam). *Dangdai* 当代 6 (1985): 141–76.

Wang 1992: Wang Shuo 王朔. "Fuchu haimain" 浮出海面 (Flotsam). In *Wang Shuo wenji* 王朔文集. Beijing: Xinhua shudian, 1992: 196–293.

Wang 1965: Wang Yingling 王应麟. *Kunxue jiwen* 困学记闻 (Record from arduous studies). Taibei: Taiwan zhonghua shuju, 1965.

Wang 1993: Wang, Yuejin. "Anxiety of Portraiture: Quest for/Questioning Ancestral Icons in Post-Mao China." In *Politics, Ideology, and Literary Discourse in Modern China: Theoretical Interventions and Cultural Critique*, edited by Liu Kang and Tang Xiaobing. Durham: Duke University Press, 1993: 242–72.

Wang 1991: *Sanzijing baijiaxing qianziwen* 三字经百家姓千字文 (The Three Character Classic, the One Hundred Surnames, and the One Thousand Character Classic), commented by Wang, Yunzhu 王云珠. Jinan: Qilu Shushe, 1991.

Ward 2007: Ward, Julian. "Serving the People in the Twenty-First Century: *Zhang Side* and the Revival of the Yan'an Spirit." *Screening the Past* 22 (December 2007). Archived as DACHS 2008 Julian Ward, Zhang Side.

Warnke 1993: Warnke, Martin. "Einleitung." In *Bildindex zur politischen Ikonographie mit einer Einführung von Martin Warnke*, edited by Elisabeth von Hagenow and Petra Roettig. Hamburg: Privatdruck, 1993.

Wasserstrom 1984: Wasserstrom, Jeffrey N. "Seeing Red and Being Red during the First Revolutionary Civil War: A Thick Description." Term Paper, University of California at Berkeley, 1984.

Wasserstrom 1991: Wasserstrom, Jeffrey N. *Student Protest in Twentieth-Century China*. Stanford: Stanford University Press, 1991.

Watson 1994: Watson, Rubie, ed. *Memory, History, and Opposition under State Socialism*. Santa Fe, NM: School of American Research Press, 1994.

Wei 1989: Wei, Cao. "A New Discovery of Jiahu Bone-Flute of 8,000 Years Ago." *Archeologica Musicalis* 1–2 (1989–90): 158–59.

Wei 2009: Wei, Ying. "'80s Chic: Yu Youhan's Chairman Mao." In *ArtZineChina. A Chinese Contemporary Art Portal*. Archived as DACHS 2009 Yu Youhan.

Wenge ciqi tujian 2002: Fan Jianchuan 樊建川. *Wenge ciqi tujian* 文革瓷器图鉴 (Cultural Revolution porcelain wares). Beijing: Wenwu, 2002.

Wenge shiqi guaishi guaiyu 1988: *Wenge shiqi guaishi guaiyu* 文革时期怪事怪语 (Strange things and terms from Cultural Revolution times), edited by Jin Chunming 金春明, Huang Yuchong 黄裕冲, and Chang Huimin 常惠民. Beijing: Qiushi, 1988.

Wenge xiaoliao ji 1988: *Wenge xiaoliao ji* 文革笑料集 (Collection of Cultural Revolution jokes), edited by Cheng Shi 橙实 et al. Chengdu: Xinan caijing daxue, 1988.

Wenge yiwu 2000: *Wenge yiwu shoucang yu jiage* 文革遗物收藏与价格 (An archive and price list of relics from the Cultural Revolution), edited by Tie Yuan 铁源. Beijing: Hualing, 2000.

Wenhua da geming bowuguan 1995: *Wenhua da geming bowuguan* 文化大革命博物馆 (Museum of the Cultural Revolution), edited by Yang Kelin 杨克林. Hong Kong: Dongfang, 1995.

Wenhua da geming cidian 1993: *Wenhua da geming cidian* 文化大革命辞典 (Dictionary of the Cultural Revolution), edited by Chao Feng 巢峰. Hong Kong: Ganglong, 1993.

Wenhuibao 文汇报 (*WHB*)
> *WHB* 27 November 1961. "Guanyu guzhuang lianhuanhua de yixie wenti" 关于古装连环画的一些问题 (A few problems concerning old-style comics).
> *WHB* 8 April 1962. "Duzhe ai kan shenme de lianhuanhua" 读者爱看什么样的连环画 (What comics do readers like?).

Wenyibao 文艺报 (*WYB*)
> *WYB* 25 November 1949. Yun Geng 耘耕. "Lianhuan tuhua zhi gaizao wenti" 连环图画之改造问题 (Problems in reforming comics).
> *WYB* 25 January, 1952. Chen Su 陈肃. "Jiaqiang dui xin lianhuantuhua bianhui yu chuban gongzuo de sixiang lingdao" 加强对新连环图画编绘与出版工作的思想领导 (Strengthen guiding ideas for the editing and publishing of new comics).

Wheeler-Snow 1973: Wheeler-Snow, Lois. *China on Stage: An American Actress in the People's Republic*. New York: Vintage Books, 1973.

Whyte and Law 2003: White, Lynn T., III, and Kam-yee Law. "Explanations for China's Revolution at Its Peak." In *The Chinese Cultural Revolution Reconsidered: Beyond Purge and Holocaust*, edited by Kam-yee Law. Houndmills: Palgrave Macmillan, 2003: 1–24.

Wichmann 1983: Wichmann, Elizabeth. "Traditional Theater in Contemporary China." In *Chinese Theater: From Its Origins to the Present Day*, edited by Colin Mackerras. Honolulu: University of Hawaii Press, 1983: 184–201.

Winter 1997: Winter, Rainer. "Cultural Studies als kritische Medienanalyse: Vom "Encoding/Decoding"-Modell zur Diskursanalyse." In *Kultur Medien Macht. Cultural Studies und Medienanalyse*, edited by Andreas Hepp and Rainer Winter. Opladen: Westdeutscher Verlag, 1997: 49–65.

Von Wilpert 1961: von Wilpert, Gero. *Sachwörterbuch der Literatur*. Stuttgart: Alfred Kröner, 1961.

Witek 1989: Witek, Joseph. *Comic Books as History: The Narrative Art of Jack Jackson, Art Spiegelman, and Harvey Pekar*. Jackson: University Press of Mississippi, 1989.

Witke 1977: Witke, Roxane. *Comrade Chiang Ch'ing*. Boston: Little, Brown and Company, 1977.

Wong 1984: Wong, Isabel K.F. "Geming gequ: Songs for the Education of the Masses." In *Popular Chinese Literature*, edited by Bonnie McDougall. Berkeley: University of Californai Press, 1984: 112–43.

WSSZJ 1951: Wang Zhaohuai 王肇槐. *Weisheng sanzijing* 卫生三字经 (Three Character Classic on hygiene). Hankou: Zhongnan renmin, 1951.

Wu 1998: *The Cultural Revolution: A Bibliography, 1966–1996*, edited by Eugene Wu. Cambridge: Harvard University Press, 1998.

Wu 1962: Wu, Han 吴晗 "Tan Sanzijing" 谈三字经 (On the Three Character Classic)." In *Sanjiacun zhaji* 三家村札记 (Random Thoughts from Three Family Village), edited by Wu Nanxing 吴南星. Beijing: Renmin Wenxue, 1979: 19–22.

Wu 2005: Wu, Hung. *Remaking Beijing: Tian'anmen Square and the Creation of a Political Space*. Chicago: The University of Chicago Press, 2005.

Wu 1977: Wu, Joseph S. "A Critique of the Maoist Critique of Confucius: A Clarification of 'Ke chi fu li.'" *Asian Thought and Society* 2 (1977): 224–28.

Wu 1919: Wu Yu 吴虞. "Li jiao chiren" 礼教吃人 (The rites eat people). *Xin Qingnian* 新青年 6 June 1919: 578–80.

Wu 1994: Wu Yuqing 吴毓清. "Ruxue chuantong yu xiandai yinyue sichao." 儒学传统与现代音乐思潮 (The Confucian tradition and ideological trends in contemporary music). *Zhongguo yinyuexue* 中国音乐学 no. 4 (1993): 7–15.

Wu 1991: Wu Zhao 吴钊. "Jiahu guiling gudi yu Zhongguo yinyue wenming zhi yuan" 贾湖龟铃骨笛与中国音乐文明之源 (Bells of tortoise shell and bone flutes from Jiahu and the origins of Chinese musical culture). *Wenwu* 文物 3 (1991): 50–55.

Wuqi 1968: *"Wuqi" Han-Ying ciyu huibian* 五七汉英词语汇编 (The May 7 collection of terms and expressions (Chinese-English), edited by Huazhong shifan xueyuan geming weiyuanhui Waiyu xi geming weiyuanhui 华中师范学院革命委员会外语革命委员会编). Wuhan: Huazhong shifan xueyuan geming weiyuanhui Waiyu xi geming weiyuanhui, 1968.

Wylie 1867: Wylie, Alexander. *Memorials of Protestant Missionaries to the Chinese*. Shanghai: American Presbyterian Press, 1867. Reprinted Taibei: Chengwen Publishing Company, 1967.

XBZGSZJ 1995: *Xinbian Zhongguo sanzijing* 新编中国三字经 (Newly edited Chinese Three Character Classic). Beijing: Tongxin, 1995.

Xiju bao 戏剧报 (Theatre journal) "Haigang de zaochen" 海港的早晨 (Morning at the harbor). *Xiju bao* 9 (1964): 21–23.

Xin Han-De Cidian 1988: *Xin Han-De Cidian* 新汉德辞典 *Das neue chinesisch-deutsche Wörterbuch*, edited by Herausgebergruppe "Neues Chinesisch-Deutsches Wörterbuch" des Germanistischen Seminars der Fremdsprachenhochschule Beijing. Beijing: Shangwu yinshuguan, 1988.

Xin Qingnian 新青年 (New youth) *Xin Qingnian* 1923.1:6–10 and 151–52. "Guojige" 国际歌 ("The Internationale").

Xinhua 2004: "Old-Time Primers Revive in Modern Classroom," 1 January 2004, archived as DACHS Revive in Modern Classroom 2004 "Old-Time Primers."

XMZZY 1975: *Xin Minzhuzhuyi geming shiqi gongnongbing sanzijing xuan* 新民主主义革命时期工农兵三字经选 (Selection of Three Character Classics for the workers, peasants and soldiers of the new democratic revolutionary age). Beijing: Wenwu, 1975.

XSZJ 1995: *Xin sanzijing* 新三字经 (New Three Character Classic). Guangdong: Guangdong jiaoyu, 1995.

XSZJ 1995a: *Xin sanzijing* 新三字经 (New Three Character Classic), edited by Li Hanqiu 李汉秋. Beijing: Shehui kexueyuan, 1995.

XSZJ 1995b: *Xin sanzijing* 新三字经 (New Three Character Classic). Shanxi 1995.

Xu 2008: Xu, Bing. "Artist Notes." In *Art and China's Revolution*, edited by Melissa Chiu and Zheng Shengtian. New York: Asia Society, 2008: 206–17.

Xu 2002: Xu Binggen. "Dui wengeban lianhuanhua niandai de butong kanfa" 对文革版连环画的不同看法 (An alternative view on Cultural Revolution comics). In *Wengeban lianhuanhua chutan* 文革版连环画初探 (A first discussion of Cultural Revolution comics), edited by Tian Weiming 田伟明. Sanming: Sanmingshi lianhuanhua shoucang yanjiuhui, 2002: 209–10.

Xu 1964: Xu Changhui (Hsu Tsang-houei) 許常惠. *Zhongguo yinyue wang nali qu* 中国音乐往哪里去 (The trend of music in China). Taibei: Book World Cooperation, 1964.

Xu 1990: Xu Changhui 許常惠 (Hsu Tsang-houei). "Zhongguo xin yinyueshi: Taiwan bian 1945–87" 中国新音乐史：台湾编 (History of New Music in China: Taiwan chapter). In *Zhongguo Xin Yinyueshi Lunji* 中国新音乐史论集 (Collected essays on the history of New Music in China,

1946–1976), edited by Liu Jingzhi. Hong Kong: Centre for Asian Studies, 1990: 211–32.

Xu 2006: Xu Shanbin 许善斌. *Zhengzhao bainian—jiuzhipian de zhongguo shenghuo tujing* 证照百年—旧纸片的中国生活图景 (One hundred years of certificates: Old paper-images of Chinese life). Beijing: Zhongguo xinshi, 2006.

Xu 2007: Xu Shanbin 许善斌. *Zhengzhao Zhongguo 1949–1966—Zhongguo tezhu niandai de zhishang lishi* 证照中国 1949–1966—中国特殊年代的纸上历史 (Certificate China 1949–1966: A history in paper of a special time in China). Beijing: Huawen, 2007.

Xue 1993: Xue Ji 雪季. *Yaogun mengxun—Zhongguo yaogunyue shilu* 摇滚梦寻—中国摇滚乐实录 (Rock n' Roll dream search: A true record of Chinese Rock n' Roll music). Beijing: Zhongguo dianying, 1993.

Xuexi yu pipan 学习与批判 (Study and criticism) XXYPP

XXYPP 1973.1:53–58. "Shilun Qu Yuan de zunfa fanru sixiang" 试论屈原的尊法反儒思想 (An attempt to discuss Qu Yuan's law-abiding and anti-Confucian thoughts).

XXYPP 1973.2:83–91. Liu Xiuming 刘修明. "Kongzi zhuan" 孔子传 (A biography of Confucius).

XXYPP 1973.3:3–6. "Zhengque renshi luxian douzheng de changqixing" 正确认识路线斗争的长期性 (Understanding the long-term nature of the two-line struggle).

XXYPP 1974.1:3–5. Xue Yuanzhi 薛源之 and Zhai Ping 翟平. "Dajia lai chang *sanda jilü baxiang zhuyi*" 大家来唱三大纪律八项注意 (They have all come to sing "Three Main Rules of Discipline and the Eight Points for Attention").

XXYPP 1974.1:54–57. Kang Li 康立. "Kongzi, rujia he li" 孔子儒家和礼 (Confucius, the Confucians and the rites).

XXYPP 1974.1:58–59. Yu Renyuan 于任远. "Manhua po 'li'" 漫话破'礼' (Free thoughts on how to break the "Rites").

XXYPP 1974.2:3–18. "Gongnongbing shi pi Lin pi Kong de zhulijun" 工农兵是批林批孔的主力军 ("Workers, peasants, and soldiers are the key detachment in the criticism of Lin Biao and Confucius").

XXYPP 1974.5:3–7. Shi Lun 石仑. "发扬'五四'精神深入批林批孔" (Make full use of the spirit of May Fouth in criticizing Lin Biao and Confucius).

XXYPP 1974.6:27–31. "Women gongren nenggou xuehao zhexueshi" 我们工人能够学好哲学史 (We workers are (in fact) able to study the history of philosophy).

XXYPP 1974.7:9–14. "Sanzijing xuanyang Kong Meng zhi dao de hei biaoben" 三字经宣扬孔孟之道的黑标本 (The Three Character Classic is a black sample advocating the way of Confucius and Mencius).

XXYPP 1974.7:23–28. "Lidai fan Kong xiaohua shiwu ze" 历代反孔笑话十五则 (Fifteen historical jokes opposing Confucius).

XXYPP 1974.7:14 & 36. "Sanzijing: gong pipan yong" 三字经：共批判用 (The Three Character Classic for public criticism).

XXYPP 1974.9:36–38. "Bokai nü'erjng de fandong huapi" 剥开女儿经的反动画皮 (Peeling off the skin of the Women's Three Character Classic).

XXYPP 1974.10:3–9. "Laozi shi yibu bingshu" 老子是一部兵书 (The Laozi is a book on the art of war).

XXYPP 1974.12:16–19. "Shen Gua he Wang Anshi bianfa" 沈括和王安石变法 (On the reforms by Shen Gua and Wang Anshi).

XXYPP 1975.1:61–69. Liu Dajie 刘大杰. "Du 'Hong yu Hei'" 读红与黑 (Reading *Red and Black*).

XXYPP 1975.2:61–64. Han Tianyu 韩天宇 and Wang Guorong 王国荣. "Shen Gua yu Mengxi bitan" 沈括与"梦溪笔谈 (Shen Gua and his *Brush Talks from the Dream Brook*).

XXYPP 1975.5:3–24. "Xuexi wuchan jieji zhuanzheng lilun shenru pipan xiuzheng zhuyi luxian" 学习无产阶级专政理论深入批判修正主义路线 (Study the theory of proletarian dictatorship in order to enter deeply into a criticism of the bourgeois line).

XXYPP 1975.8:18–29. "Xuexi Mao Zhuxi junshi zhuzuo pipan Lin Biao zichan jieji junshi luxian" 学习毛主席军事著作批判林表资产借记军事路线 (Studying Chairman Mao's works on military affairs in order to criticize Lin Biao's capitalist road in military affairs).

XXYPP 1976.2: 29–34. Chen Xulu 陈旭麓. "Shi chaimiao haishi butian" 是拆庙还是补天 (Is it tearing down a temple or touching up Heaven?).

XXYPP 1976.3: 38–43. Jin Bonian 靳柏年 "Kang shengren yu Kong shengren" 康圣人与孔圣人 (Sage Kang and Sage Kong).

XXYPP 1976.4:49–53. Shi Jing 石镜. "Lun Taiping Tianguo neibu zun Kong he fan Kong de douzheng" 论太平天国内部尊孔和反孔的斗争 (About the Taiping Heavenly Kingdoms and their internal struggle over revering or opposing Confucius).

XXYPP 1976.5: 67–72. Kang Li 康立. "Sima Guang dengtai yinian" 司马光登台一年 (The year when Sima Guang took on power).

XXYPP 1976.6:26–27. Wen Bo 文波. "Weiba, Shuihu ji qita" 尾巴水浒及其他 (The tale, the *Water Margin*, and other such things).

XWHSZJ 1958: *Xue wenhua Sanzijing* 学文化三字经 (A Three Character Classic for the study of culture). Changsha: Hunan renmin, 1958.

XXSZJ 1902: Yu Yue 俞樾. *Xinxue sanzijing yinzhu tujie chubian* 新学三字经 — 音注图解初编 (Three Character Classic of new learning with illustrations and explanations). Shanghai: Ziqiang xuezhai, 1902.

XYSZJ 1992: *Xinyi sanzijing* 新译三字经 (Newly translated Three Character Classic), edited by Huang Peirong 黄沛荣. Taibei: Sanmin shuju, 1992.

Yakovlev 1968: Yakovlev, M. "The Making of an Idol." In *Za Rubezhom* 5 (1968). Partially reprinted in *The Miracles of Chairman Mao: A Compendium of Devotional Literature 1966–1967*, edited by George Urban. London, 1971: 171–78.

Yan 2005: Yan, Lianke. *Serve the People!*, translated by Julia Lovell. NY: Black Cat/Grove/Atlantic, 2005.

Yan 2008: Yan, Shanchun. "Painting Mao." In *Art and China's Revolution*, edited by Melissa Chiu and Zheng Shengtian. New York: Asia Society, 2008: 90–101.

Yang Ban Xi 2005: *Yang Ban Xi—The Eight Model Works*, directed by Yuen Yan-Ting, Rotterdam: Scarabee Films, 2005.

Yang 1979: Yang Bojun 杨伯峻. *Liezi jishi* 列子集释 (A collection and translation of the *Liezi*). Beijing: Zhonghua Shuju, 1979.

Yang 2007: Yang, Guobin. "'A Portrait of Martyr Jiang Qing': The Chinese Cultural Revolution on the Internet." In *Re-envisioning the Chinese Revolution. The Politics and Poetics of Collective Memories in Reform China*, edited by Ching Kwan Lee and Guobin Yang. Stanford: Stanford University Press, 2007: 287–316.

Yang 2005: Yang Haocheng 杨昊成. "Mao Zedong tuxiang yanjiu" 毛泽东图像研究 (A Study of Mao Zedong images). Ph.D. Diss., Nanjing Normal University, 2005.

Yang 1995: Yang Kelin 杨克林. *Wenhua da geming bowuguan* 文化大革命博物馆 (Museum of the Cultural Revolution). Hong Kong: Sanlian, 1995.

Yang 1998: Yang Lan. *Chinese Fiction of the Cultural Revolution*, Hong Kong: Hong Kong University Press, 1998.

Yang 1999: Yang, Mayfair Mei-Hui. "From Gender Erasure to Gender Difference: State Feminism, Consumer Sexuality, and Women's Public Sphere in China." In *Spaces of Their Own. Women's Public Sphere in Transnational China*, edited by Mayfair Mei-Hui Yang. Minneapolis: University of Minnesota Press, 1999: 35–67.

Yang 1997: Yang, Rae. *Spider Eaters*. Berkeley: University of California Press, 1997.

Yang 1991: Yang, Xiao-ming. "The Rhetoric of Propaganda: A Tagmemic Analysis of Selected Documents of the Cultural Revolution in China, 1966–1976." Ph.D. Diss., Bowling Green State University, 1991.

Yao 2004: Yao, Yusheng. "The Elite Class Background of Wang Shuo and His Hooligan Characters." *Modern China* 30, no 4 (2004): 431–69.

YBMXCS 1989: *Yuanban mengxue congshu* 原版蒙学丛书 (A collection of primers in their original). Hainan: Hainan renmin, 1989.

Yeh 2007: Yeh, Catherine. "Refined Beauty, New Woman, Dynamic Heroine or Fighter for the Nation? Perceptions of China in the Programme Selection for Mei Lanfang's Performances in Japan (1919), the United States (1930) and the Soviet Union (1935)." *European Journal of East Asian Studies* 6, no. 1 (2007): 75–102.

Yen and Kao 1988: Yen Chia-chi and Kao Kao. *The Ten-Year History of the Chinese Cultural Revolution*. Taibei: Institute of Current China Studies, 1988.

Yin 1969: Yin, Chengzong. Music score to "Yellow River Concerto." In Chen Shing-Lih. "The Yellow River Piano Concerto: Politics, Culture, and Style." Ph.D. Diss., University of British Columbia, 1995: 89–150.

Yong Makesi zhuyi guandian 1974: *Yong Makesi zhuyi guandian pipan fandong de sanzijing* 用马克思主义观点批判反动的三字经 (Using Marxism to criticize the reactionary Three Character Classic). Lanzhou: Gansu renmin, 1974.

YTSZJ 1995: *Youtong Sanzijing* 幼童三字经 (A children's Three Character Classic). Shanghai: Shaonian ertong, 1995.

Yu 2006: Yu Miin-Ling 余敏玲. "Cong gaoge dao dichang: Sulian junzhong gequ zai Zhongguo" 从高歌到低唱: 苏联群众歌曲在中国 (From singing loudly to chanting lowly). *Zhongyang yanjiuyuan jindaishi yanjiusuo jikan* 中央研究院近代史研究所集刊 53 (2006): 149–91.

Yu 2004: Yu, Siu Wah. "Two Practices Confused in One Composition: Tan Dun's 'Symphony 1997:

Heaven, Earth, Man.' " In *Locating East Asia in Western Art Music*, edited by Yayoi Uno Everett and Frederick Lau. Middletown, CT: Wesleyan University Press, 2004: 57–71.

Yung 1984: Yung, Bell. "Model Opera as Model: From *Shajiabang* to *Sagabong*." In *Popular Chinese Literature and Performing Arts in the People's Republic of China, 1949–1979*, edited by Bonnie McDougall. Berkeley: University of California Press, 1984: 144–64.

ZGCTYWHPJCS 1988: *Zhongguo chuantong yuyan wenhua puji congshu* 中国传统语言文化普及丛书 (A Collection of traditional texts popularizing Chinese language and culture). Xi'an: Shanxi renmin, 1988.

ZGDLSZJ 1963: *Zhongguo dili sanzijing* 中国地理三字经 (Three Character Classic on geography). Beijing: Renmin jiaoyu, 1963.

ZGFJMXWHPS 1989: Wu Siqian 吴思千. *Zhongguo fengjian mengxue wenhua pingshu* 中国封建蒙学文化评述 (A critical description of China's feudal primer culture). Xi'an: Shanxi renmin, 1989.

ZGGDMXJD 1994: *Zhongguo gudai mengxue jingdian* 中国古代蒙学精典 (Some outstanding examples of old Chinese primers). Beijing: no publisher, 1994.

ZGLSSZJ 1963: *Zhongguo lishi Sanzijing* 中国历史三字经 (Three Character Classic on Chinese history). Beijing: Renmin jiaoyu, 1963.

Zhai 1992: Zhai, Zhenhua. *Red Flower of China*. New York: Soho Press, 1992.

Zhandi xin'ge 1972: *Zhandi xin'ge* 战地新歌 (New songs from the battlefield). Vol. 1. Beijing: Renmin wenxue, 1972.

Zhandi xin'ge 1974: *Zhandi xin'ge* 战地新歌 (New songs from the battlefield). Vol. 3. Beijing: Renmin wenxue, 1974.

Zhang 2009: Zhang, Lynn. "Mao's New Tailor: Sui Jianguo." Archived as DACHS 2009 Lynn ZHANG.

Zhang 1994a: Zhang Xialiang 张贤亮. *Wo de putishu* 我的菩提树 (My bodhi tree). Beijing: Zuojia, 1994.

Zhang 1962: Zhang Zhigong 张志公. *Chuantong yuwen jiaoyu chutan* 传统语文教育初探 (A first exploration of traditional language education). Shanghai: Shanghai jiaoyu, 1962.

Zhang 1994: Zhang Zhonglong 张忠龙. *Mao Zedong lishi shixiang jingdian haibao huace* 毛泽东历史视象 经典海报画册 (Mao Zedong, portrait views from history: A picture album of classical poster images). Hong Kong: Ci wenhua tang, 1994.

Zhang et al. 1999: Zhang, Juzhong et al. "Oldest Playable Musical Instruments Found at Jiahu Early Neolithic Site in China." In "Letters to Nature." *Nature* 401 (1999): 366–67.

Zhao 1969: Zhao Cong 赵聪. *Zhongguo Dalu de xiqu gaige* 中国大陆的戏曲改革 (Opera reform on the Chinese mainland). Hong Kong: Chinese University, 1969.

Zhaoxia 朝霞 (Aurora)

Zhaoxia 1974.2. "Gongnongbing shi pi Lin pi Kong de zhulijun" 工农兵是批林批孔的主力军 (Workers, peasants, and soldiers are the key detachment in the criticism of Lin Biao and Confucius).

Zhaoxia 1974.2:3–5. "Gongren jieji shi pi Lin pi Kong de zhulijun" 工人阶级是批林批孔的主力军 (The working class is the key detachment in the criticism of Lin Biao and Confucius).

Zhaoxia 1974.2: 6–16. Lin Zhengyi 林正义. "Shanguang de junhao" 闪光的军号 (The flashing bugle).

Zhaoxia 1974.2:11–81. "Kong Lao'er de gushi" 孔老二的故事 (The story of old Confucius).

Zhaoxia 1974.3:1. "Shenru pi Lin pi Kong tigao luxian douzheng juewu" 深入批林批孔提高路线斗争觉悟 (Enter deep into criticisms of Lin Biao and Confucius and heighten people's awareness of the continuing two-line struggle).

Zhaoxia 1974.3:3–6. "Nuhou" 怒吼 (Angry roar).

Zhaoxia 1974.3:22–25. "Pi Lin pi Kong paosheng long" 批林批孔炮声隆 (The canon sounds are welling in criticisms of Lin Biao and Confucius).

Zhaoxia 1974.3:64–71. "Kongjiadian erlaoban Meng Ke de gushi" 孔家店二老板 孟轲的故事 (Second Boss in the Confucius shop: the Story of Mencius).

Zhaoxia 1974.4:3–7. "Pujiang anpan de zhange" 浦江岸畔的战歌 (Battle song at the Pujiang shores).

Zhaoxia 1975.6:41. "Yao wei geming xue pinyin" 要为革命学拼音 (Study pinyin for the revolution).

Zhaoxia 1975.12: 8–14. Liu Guande 刘观德. "Li chun" 立春 (Spring's beginning).

Zhaoxia 1975.12: 25–28. Sun Ke 孙颖 "Chuankou" 窗口 (The window).

Zhaoxia 1975.12: 37–42. Ling Yan 凌岩. "Xiyang banyue" 昔阳半月 (A fortnight in Xiyang).

Zhaoxia 1975.12: 47–52. Chen Xianfa 陈先法 and Zhou Linfa 周林发. "Shengsi chunguang" 胜似春光 (Victory like radiant Spring).

Zheng 2002: Zheng Feng. "Tongnian jiyi zhong de san jia xiaorenshudian" 童年记忆中的三假小人

书店 (Three comic shops from my childhood memories). In *Wengeban lianhuanhua chutan* 文革版连环画初探 (A first discussion of Cultural Revolution Comics), edited by Tian Weiming 田伟明. Sanming: Sanmingshi lianhuanhua shoucang yanjiuhui, 2002: 219–22.

Zheng 1995: Zheng, Qingyi. "The Effects of 'The Great Cultural Revolution' on Sports in China, 1966–1976." Ph.D. Diss., University of Idaho, 1995.

Zheng 2008: Zheng, Shengtian. "Chairman Mao Goes to Anyuan: A Conversation with the Artist Liu Chunhua." In *Art and China's Revolution*, edited by Melissa Chiu and Zheng Shengtian. New York: Asia Society, 2008: 119–31.

Zheng 2008a: Zheng, Shengtian. "Art and Revolution: Looking Back at Thirty Years of History." In *Art and China's Revolution*, edited by Melissa Chiu and Zheng Shengtian. New York: Asia Society, 2008: 19–39.

Zheng 2010: Zheng Shengtian. "Brushes are Weapons: An Art School and Its Artists." In *Art in Turmoil: China's Cultural Revolution, 1966–76*, edited by Richard King. Vancouver: University of British Columbia Press, 2010, 93–106.

Zheng 1921: Zheng Zhenduo 郑振铎. "Guangming yundong de kaishi" 光明运动的开始 (The beginning of the enlightenment movement). *Xiqu* 戏曲 (Theater), July 1921: 1–3.

Zhiqing riji xuanbian 1996: *Zhiqing riji xuanbian* 知青日记选编 (Selected diary entries by sent-down youth). Beijing: Zhongguo shehui kexue, 1996.

Zhiqu weihushan 1971: *Geming xiandai jingju Zhiqu Weihushan zongpu: Shanghai jingju Zhiqu Weihushan juzu jiti gaibian ji yanchu* 革命现代京剧智取威虎山 总谱 上海京剧智取威虎山剧组集体改编及演出 (A Score of the modern revolutionary opera Taking Tiger Mountain by Strategy: Reformed and performed by the Shanghai Beijing Opera Taking Tiger Mountain by Strategy Theatrical Group). Beijing: Renmin, 1971.

Zhongguo lianhuanhua 2000, Vols. I & II: *Zhongguo lianhuanhua* 中国连环画 (Chinese comics). Harbin: Heilongjiang, 2000.

Zhongguo Xinwen Wang 中国新闻网 17 January 2008. "Wangyou bu liangjie Xietielong egao Mao Zhuxi guanggao, dizhi zhi sheng bu jue" 网友不谅解雪铁龙恶搞毛主席广告, 抵制之声不绝 (The voices of netters not forgiving citroen for the ad abusing a Chairman Mao's do not stop). Archived as DACHS 2009 Zhongguo Xinwen Wang.

Zhongwen da cidian 中文大辞典 (Great Chinese dictionary). Taibei: Zhongguo Wenhua 1990.

Zhou 2002: Zhou, Derong. "Es brennt. Wie Chinas erfolgreichste Serie die Macht der Partei bedroht." *FAZ*, 23 October 2002: 40.

Zhu 1987: Zhu Jian'er 朱践耳. "Guanyu 'Diyi jiaoxiangqu'" 关于第一交响曲. *Yinyue yishu* 音乐艺术 1 (1987): 44–54.

Zhu 2007: Zhu, Qi. "The Solitary Existence of a Utopian: A Hermeneutic Analysis of Yin Zhaoyang's Mao Paintings." In *Contemporary Chinese Art Catalogue No. 101–195*, edited by Koller Art Zurich, Zurich: Koller Art, 2007.

Zhu 1996: Zhu Wei. *China Diary*. Hong Kong: Plum Blossoms Galler, 1996.

Zhu 1998: Zhu, Xiaodi. *Thirty Years in a Red House: A Memoir of Childhood and Youth in Communist China*. Amherst: University of Massachusetts Press, 1998.

Zhuang and Fang 1991: Zhuang Yongping and Fan Fangsheng. *Jingju changqiang yinyue yanjiu* 京剧唱腔音乐研究 (A study of Beijing opera vocal singing). Beijing: Zhongguo xiju, 1991.

Zou 1998: Zou Jingzhi 邹静之. *Zhiqing xian dan lu* 知青咸淡录 (Records of what sent-down youth talked about). Shanghai: Renmin, 1998.

ZSNSZJ 1901: Zhu Haowen 朱浩文. *Zhushi Nü Sanzijing* 朱氏女三字经 (Mr. Zhu's Women's Three Character Classic). In *Tingyutang congke* 听雨堂丛刻 (Collections from the Tingyu Hall), edited by Zhang Chengxie 张承燮. Jiaozhou: Ting yu tang, 1901.

Zung 1964: Zung, Cecilia S. L. *Secrets of the Chinese Drama: A Complete Explanatory Guide to Actions and Symbols as Seen in the Performance of Chinese Dramas: With Synopsis of 50 Chinese Popular Plays and 240 Illustrations*. New York: B. Blom, 1964.

INDEX OF NAMES, TITLES, AND SLOGANS

SUBJECT INDEX

HARVARD EAST ASIAN MONOGRAPHS
(*OUT-OF-PRINT)